D1257572

A to Z of
CANADIAN ART

artists & art terms

A to Z of
CANADIAN ART

artists & art terms

Blake McKendry

A to Z of Canadian Art, Artists, and Art Terms

Blake McKendry

© 1997
Blake McKendry
9 Baiden Street
Kingston, Ontario K7M 2J7
1-613-546-6861

ISBN 0-9693298-1-4

Book Design and Editing by Jennifer McKendry

FRONT COVER: *Indian Encampment with Dogs* by Joseph Julius Hümme, c1880, Toronto, oil, 43 x 60 cm. (private collection; photo by Blake McKendry)

BACK COVER: *Bust of a Butcher* by Jean-Baptiste Côté, mid 19th century, Quebec, polychromed wood, h. 47 cm (Canadian Museum of Civilization, Hull, QC; photo by Blake McKendry)

CONTENTS

HOW TO USE *A to Z of Canadian Art*

For ease in use the thousands of entries for art terms and artists are arranged in alphabetical order. Each entry provides a concise statement about its subject followed by a series of citations of relevant books and catalogues to which, if necessary, further reference can be made for more information. Each citation is identified in the entry and in the bibliography by the author's name and the year of publication. Thus when considering the citations in an entry in *A to Z*, a choice can be made in the citations as to the author and the date of his/her publication, depending on availability of the publication or a preference for particular author. The more than 1000 entries in the Bibliography are arranged alphabetically by author.

The art terms defined in this guide are ones pertinent to Canadian Art and, where feasible, references are made to Canadian artists and to other entries included in *A to Z* through cross references. Thus each entry has a solid foundation in the literature, as well as in its relation to other entries.

A typical entry reads:

> **REID, GEORGE AGNEW** (1860-1947), Toronto, ON. Painter, muralist and art teacher; OSA 1885; RCA 1890. Reid studied under ROBERT HARRIS and JOHN A. FRASER, and in the USA and Europe. He painted murals and portraits, as well as genre, historical, and landscape subjects. In 1885 Reid married MARY AUGUSTA HIESTER REID, and in 1922 he married MARY EVELYN WRINCH REID. Reid taught at the ONTARIO COLLEGE OF ART 1890-1928. Several paintings by Reid are in the NATIONAL GALLERY OF CANADA. See McMann 1997, pp. 340-3, for a dated list of paintings by Reid. **Citations**: MacTavish 1925; Robson 1932; Colgate 1943; Miner 1946; McInnes 1950; McLeish 1955; Jackson 1958; Hubbard 1960; Harper 1966, 1970; MacDonald 1967; Mellen 1970, 1978; Boggs 1971; Thomas 1972; Lord 1974; Forsey 1976; London 1978; Reid 1979, 1988; Sisler 1980; Laing 1982; NGC 1982; Miller 1987; Marsh 1988; Duval 1990; Hill 1995; Silcox 1996; McMann 1997.

The cross references in this entry to other entries in *A to Z* are in upper case and are:

> OSA; RCA; ROBERT HARRIS; JOHN A. FRASER; MARY AUGUSTA HEISTER REID; MARY EVELYN WRINCH REID; ONTARIO COLLEGE OF ART; NATIONAL GALLERY OF CANADA.

At the end of the entry are **citations** of sources and reference books. They are identified by the author's name and date of publication, for example 'MacTavish 1925' refers to the entry in the Bibliography which reads:

> **MACTAVISH 1925** Newton MacTavish. *The Fine Arts in Canada*. Toronto: Macmillan.

PREFACE & ACKNOWLEDGEMENTS

A to Z of Canadian Art is a comprehensive reference book on Canadian Art that is written and designed to give concise answers to the many questions that arise when researching, discussing, studying and writing about Canadian art and artists. It is not a critical dictionary but rather a fully cross-referenced encyclopaedia of art terms and artists (more than 2500 entries) with numerous citations from a bibliography of more than 1000 books - one of the most comprehensive bibliographies of Canadian art reference books ever published. In the interest of producing an inclusive art history book, I have attempted to include as many artists of different ethnic and cultural backgrounds as possible.

In the case of an entry for an art term, a concise definition is given with one or more references to Canadian artists wherever possible. This unique feature, as well as the many citations of art reference books, can be particularly valuable to anyone interested in Canadian art. Throughout the book thousands of cross-references to other related entries are supplied. Entries for art terms and for artists are arranged in one alphabetical order for ease of access.

In the case of an artist, each entry includes the full name; date of birth and death; place of activity as an artist; whether a painter, a sculptor or another type of artist; some pertinent information about the work as well as the relationships of the artist to other artists; numerous cross-references to other entries; public galleries where examples of the work of the artist may be seen; and many citations from the bibliography of Canadian art reference books that include further information on the artist as well as illustrations of the work of the artist. Both early and modern Canadian artists are included from the seventeenth century to the present. I include more than a hundred folk artists who are referred to in the literature and /or have had work in exhibitions.

In general, Canadian art reference books have been concerned with main-stream academic art and artists while ignoring folk or naïve art and artists. This may suggest a hierarchical attitude of placing greater value on formal training, and seems to me to belie the fact that a talented artist is an artist whether he or she works in an academic style or a naïve style. Witness the many recognized, formally trained artists who borrow freely from naïve and primitive art, for example Pablo Picasso (1881-1973), Paul Gauguin (1848-1903), Jean Dubuffet (1901-85) and Maurice Utrillo (1885-1955), as well as Canadian artists Jean-Philippe Dallaire (1916-1965), Alfred Pellan (1906-1988) and Jean-Paul Lemieux (b1904). For these reasons, and to make the book useful to a wider audience, I have included folk-art terms and a wide representation of folk artists.

Previous works that have been of great value in preparing *A to Z of Canadian Art* are *A Dictionary of Canadian Artists* by Colin S. MacDonald 1967, *Early Painters and Engravers in Canada* by J. Russell Harper 1970, *Art and Architecture in Canada* by Loren R. Lerner & Mary F. Williamson 1991, and *Royal Canadian Academy of Arts: Exhibitions and Members 1880-1979* by Evelyn de R. McMann 1981 (reprint 1997). Students of Canadian art who are looking in depth into a particular topic should also consult these references when using the *A to Z of Canadian Art*.

My thanks to Jennifer McKendry who edited the manuscript and designed the book, as well as making available expert advice based on her knowledge as an author, a publisher and an art historian. Also, thanks to my wife, Ruth McKendry, for understanding that this was a project that had to be finished regardless of how long it took. And I must not forget the many authors whose works form the base for the present book. In particular, I am indebted to J. Russell Harper (1914-1983) for his friendship and advice over many years, as well as insights he shared through discussion and his writings.

Blake McKendry
Kingston
July 1997

Painting in Canada has mirrored a northern people's growth during three centuries of evolution from colony to nationhood. It shows how a highly sophisticated European culture has been imported into and adapted for the New World.

J. Russell Harper, *Painting in Canada,* 1966

❧

Picasso's primitivism marked a broadening of the Western language of art, erasing distinctions between "high" and "low."

William Rubin, *"Primitivism" in 20th Century Art,* 1984

❧

The work of naïve artists is as old as Man's need for artistic activity. All art is naïve to begin with. From the end of the 19th century onwards, ever since the advent of Henri Rousseau on the artistic scene, and throughout the 20th century so far, naïve art has outlasted the ever-changing variety of aesthetic styles. Although subject to its own laws, naïve art remains nevertheless an essential part of the artistic scene in any period.

Oto Bihalji-Merin, *World Encyclopedia of Naïve Art,* 1984

❧

When I do moralize - either subtly as in "The Burning Barn," or overtly as in the abortion paintings - I do so in the belief that it would be dishonest for me to simply produce art for art's sake.

William Kurelek, *Someone With Me: The Autobiography of William Kurelek,* 1980

❧

Today the influences of the world outside reach us very quickly. They reach other countries equally fast, so that we have paintings from all over the world which resemble one another because all are derived from the same sources.

A.Y. Jackson, *A Painter's Country: The Autobiography of A.Y. Jackson,* 1958

❧

When the genius of other lands is drawn to us for inspiration instead of ours being drawn to the old well-mellowed cultures of Europe, then will the fetters of the past be struck off, and we shall know that "the sweetest songs yet remain to be sung".

F.B. Housser, *A Canadian Art Movement: The Story of the Group of Seven,* 1926

ARTISTS & ART TERMS

A

ABBOTT, J. (act. 1863), Montréal, QC. Painter. Abbott is known for a naïve painting in oil of a Québec sleighing scene included in the exhibition PEOPLE'S ART: NAÏVE ART IN CANADA. The subject matter of the painting is similar to that of several slightly earlier paintings by CORNELIUS KRIEGHOFF, although Abbott's composition is less lively and without humour. **Citations**: Harper 1973, 1974; Kobayashi 1985(2); McKendry 1988.

ABORIGINAL ART. See PRIMITIVE ART.

ABSTRACT ART, ABSTRACTION. Abstract art (non-objective art) does not depict the actual appearance of objects. Abstraction is always present in art to some degree, as it must be, when real objects are simplified in form and represented by line, colour and/or volume. EXPRESSIONISM, and more narrowly FAUVISM and CUBISM, at the beginning of the 20th century opened the way toward a more pure abstraction. The Russian artist WASSILY KANDINSKY had a great influence on the trend toward abstraction. In Canada (see Harper 1966, ch. 26), the first painters to adopt an abstract approach to art included BERTRAM BROOKER, LIONEL LEMOINE FITZGERALD, FRITZ BRANDTNER, LAWREN HARRIS, and JOCK MACDONALD. The first group exhibition by Canadian abstract artists was held in April 1946 in Montréal (Reid 1988, p.228). For a discussion of later inroads of abstraction into Canadian art, see Harper 1966, ch. 27 and 28. For Lawren Harris's comments on the kinds of abstraction, see FULFORD 1982, p. 170. In the case of FOLK ART, the overriding stylistic characteristic is REALISM. In Canadian folk art, two artists whose work tends to be abstract to a noticeable degree are SCOTTIE WILSON and ARTHUR VILLENEUVE. See also Les AUTOMATISTES, SURREALISM. **Citations**: Harper 1966, 1973, 1974; Arnason 1968; Duval 1972; Gagnon 1972; Osborne 1981; Fulford 1982; Chilvers 1988; Piper 1988; Reid 1988; Murray 1996(1).

ABSTRACT EXPRESSIONISM. See EXPRESSIONISM.

ACADEMIC ART. Academic art is the personal artistic expression of professional artists who are trained in the principles, history and techniques of art. Many FOLK ART works, while displaying personal artistic expression, differ from academic art because they have been executed with less or no

knowledge of technique. AMATEUR artists may have some knowledge of the principles, history and techniques of art, but lack the imaginative skill of academic or folk artists. For a discussion of the early art academies, see Osborne 1970, Chilvers 1988, and Piper 1988.

ACADEMY BOARD. A good quality pasteboard used as a SUPPORT for oil paintings since early in the 19th century. Sometimes academy board is embossed in imitation of canvas weave. It is inexpensive and has been much used by amateur and folk artists. **Citations**: Mayer 1970; Chilvers 1988.

ACADIAN FOLK ART. See Folk Art, Acadian.

ACHIM, ANDRE (1793-1843), Longueuil, QC. Sculptor of religious works for churches. **Citations**: Falardeau 1940; Lerner 1991.

ACKERMANN, GEORGE (act. 1866-77), Belleville, ON. Painter. Although Ackermann was educated and taught art at the Ontario Institution for the Deaf and Dumb, Belleville, his watercolour paintings of rural Ontario have a naïve flavour. His landscapes are TOPOGRAPHICAL and usually include people and buildings. There is some confusion between the work of this artist and that of ROBERT ACKERMANN. **Citations**: Harper 1966, 1970, 1973; Allodi 1974; Cooke 1983; Kobayashi 1985(2); McKendry 1988.

ACKERMANN, ROBERT (born c1816), Brockville, ON. Painter. His work is similar to that of GEORGE ACKERMANN. **Citations**: Bell 1973; Cooke 1983; McKendry 1988.

ACRES, JOHN EDWARD (act. 1815-23), Halifax, NS. Painter. Acres studied under Benjamin West in England and, in 1815, emigrated to Halifax where he painted MINIATURE portraits professionally. Sometimes he signed his paintings "A." **Citations**: Harper 1970; McKendry 1988.

ACRYLIC PAINT. The MEDIUM in acrylic paint is an acrylic resin which makes it a versatile, water-soluble quick-drying synthetic paint, rivalling OIL PAINT in popularity. **Citations**: Mayer 1970; Pierce 1987; Chilvers 1988; Piper 1988.

ADAM (ADAMS), EDWARD (act. 1880-1900), Yarmouth County, NS. Painter. Adam painted several competent ship portraits in oil, usually in classic views but sometimes "hove down in a gale of wind," as in the case of *The Autocrat* (illustrated in Armour 1975). He often painted different versions of the same ship. **Citations**: Armour 1975; Field 1985; McKendry 1988.

ADAMESQUE. See NEOCLASSICAL.

ADASKIN, GORDON (b1931), Winnipeg, MB. Painter. He is a landscape painter who has worked with various media. **Citations**: Sisler 1980; NGC 1982; Lerner 1991; McMann 1997.

AEAC. See AGNES ETHERINGTON ART CENTRE.

AERIAL PERSPECTIVE. An effect caused by haze in the atmosphere making distant areas of a landscape appear bluish and blurred. Aerial perspective (sometimes called atmospheric perspective) is often used in ACADEMIC ART but seldom in FOLK ART. **Citations**: Osborne 1970; Pierce 1987; Chilvers 1988; Piper 1988.

AESTHETIC CRITERIA. The *Oxford English Dictionary* defines aesthetics as "the philosophy or theory of taste, or of the perception of the beautiful in nature and art," See also EXHIBITIONS; FOLK ART, CANADA; PICTURESQUE. **Citations**: Osborne 1970; Pierce 1987; Chilvers 1988; Piper 1988.

AFRICAN TRIBAL ART. African tribal art is the primitive art of Africa found in masks and cult artifacts connected with traditional ceremonial, dance, and recreational activities. See also PRIMITIVE ART; AGNES ETHERINGTON ART CENTRE. **Citations**: Osborne 1970; Fry 1984.

AGNES ETHERINGTON ART CENTRE (AEAC). The Agnes Etherington Art Centre of Queen's University, Kingston, ON, was founded in 1957. Its first director was ANDRE BIELER. The Art Centre collects paintings, prints, drawings and sculpture, primarily by Canadian artists, and also has large and important holdings of African Sculpture from the Justin and Elisabeth Lang Collection, as well as collections of northern BAROQUE paintings, European prints and drawings, and MODERNIST paintings. Canadian Inuit sculpture and prints are included in the Art Centre's collections, as are decorative arts including silver, Canadian pressed glass, and local modern and traditional quilts. Many exhibitions (with catalogues) have been mounted by the Art Centre. In the case of folk art, the Art Centre has held

one-artist shows for folk artists HERTHA MUYSSON and GEORGE COCKAYNE, multi-artist shows "Contemporary Primitives," "A Fair Field: Folk Art of Eastern Ontario," and exhibitions of quilts. **Citations**: Smith 1968, 1980; MacGregor 1974; Farr 1982, 1988; Fry 1984, 1987, 1988; Silcox 1996.

AGNS. See ART GALLERY OF NOVA SCOTIA.

AHEARN, MORRIS (or **MAURICE**), (act. 1886), Ottawa, ON. Painter. Ahearn was a grocer who painted portraits and anecdotal sketches in his spare time. He executed some sketches of telephone line construction in 1886. **Citations**: Harper 1970; McKendry 1988.

AHIER, CHARLES (act. 1900-10), Québec. Painter. Ahier painted views of the lower St. Lawrence and Labrador, as well as some religious subjects. **Citations**: Harper 1970; McKendry 1988.

AHRENS (AHERNS), CARL HENRY VON (1863-1936), Toronto and Galt, ON. Painter, illustrator and printmaker. Ahrens studied under J.W.L. FORSTER, GEORGE A. REID, LUCIUS O'BRIEN and others. He worked for a time in the United States but later in Ontario. Ahrens was known as a painter of trees and landscapes. His work is represented in the NATIONAL GALLERY OF CANADA. **Citations**: MacTavish 1925; Robson 1932; Page 1939; Hubbard 1960; Harper 1966, 1970; Hubbard 1960; MacDonald 1967; Sisler 1980; NGC 1982; Hill 1988; Lerner 1991; McMann 1997.

AIDE-CREQUY, JEAN-ANTOINE (1746-80), Québec City, QC. Painter. Aide-Créquy copied European prints and engravings as well as paintings by FRERE LUC. In 1773, he became a parish priest and spent long hours painting portrait and religious canvases to decorate churches at Baie-Saint-Paul, Les Eboulements and Ile-aux-Coudres. **Citations**: Barbeau 1931(1); Morisset 1936; Harper 1966, 1970; NGC 1965, 1982; Trudel 1967 (Peinture); Kobayashi 1985(2); McKendry 1988.

AINSLIE, HENRY FRANCIS (c1803-79), Québec and Ontario. Painter. Ainslie was in Canada from 1838-43 with the British Army. He executed TOPOGRAPHICAL sketches and paintings of landscape along the St Lawrence, Chaudiere, Rideau and Ottawa rivers (illustrated in Bell 1973.) Some of Ainslie's work shows an ineptness with perspective that gives it a naïve appearance. **Citations**: Harper 1970; Stewart 1973; Bell 1973; Kobayashi 1985(2); Mika 1987; McKendry 1988.

AIR-BRUSH. This hand-controlled instrument uses compressed air to spray paint. It is often used by commercial artists but seldom used in ACADEMIC or FOLK ART. **Citations**: Pierce 1987; Piper 1988; Chilvers 1988.

AIREY, Sir RICHARD (1803-81), Port Talbot, ON. Painter. While with the British Army in Canada from 1830 to 1852 (except for a short return to England), Airey painted TOPOGRAPHICAL landscape views in watercolour of the London and St Thomas districts. **Citations**: Harper 1970; Kobayashi 1985; McKendry 1988.

AIROLA, PAAVO (b1915), British Columbia. Painter. **Citations**: Sisler 1980; NGC 1982; McMann 1997.

AKL, KAROLINA (act. 1982), Kingston, ON. Painter. Akl was born in Czechoslovakia and came to Kingston in 1969. She paints remembered scenes from her homeland in an intentionally naïve style with bold colours and rhythmic patterns, usually in acrylic. **Citations**: *Whig-Standard* 6 March 1982; McKendry 1988.

ALARY, ZENON (ZACHARY) (act. mid 20th century), Lavaltrie, QC. Sculptor. Alary is a folk artist who carves naïve sculpture in wood of people. **Citations**: Gauvreau 1940; Kobayashi 1985(2); McKendry 1988.

ALBERTA. The current boundaries of Alberta (AB) were determined in 1905, when it became a province, and it was only after that date that there was much settlement by non-natives. It is thought that PAUL KANE, in 1846, was the first professional artist to paint here. WILLIAM G.R. HIND who followed in 1862-3, sketched buffalo hunts and native life scenes. In 1875-7 RICHARD BARRINGTON NEAVITT sketched and painted the wilderness landscape, forts, native encampments, and day-to-day life on the frontier. Later painters who worked in AB include EDWARD NORMAN YATES, CATHARINE and PETER WHYTE, G.L. TAYLOR, W.L. STEVENSON, ROBERT SINCLAIR,

CARL RUNGIUS, WALTER J. PHILLIPS, MARION and JAMES MCLAREN NICOLL, J.E.H. MACDONALD, A.C. LEIGHTON, HARRY KIYOOKA, ILLINGWORTH KERR, MAXWELL BATES, ANNORA BROWN, BELMORE BROWNE and A.Y. JACKSON. In the 1890s, ETHNIC ART was introduced when UKRAINIANS settled in central Alberta, followed in 1915 by DOUKHOBORS settling in the southwest and in 1917 by HUTTERITES settling in the south. WILLIAM PANKO of Drumheller may be the best known naïve painter; KOST PAWLYK and ALLAN SNOWIE are known for their naïve sculpture. See Harper 1966, pp. 345-6, and ALBERTA SOCIETY OF ARTISTS. **Citations**: Edmonton 1921; Colgate 1943; Highlights 1947; Nicoll 1955; Jackson 1958; Hubbard 1960; Harper 1964, 1966; Wilkin 1973, 1980; Render 1970, 1974; *Canadian Collector* (Jan./Feb.) 1976; Banff 1977; *artscanada* (Oct./Nov.) 1979; Bingham 1979, 1980, 1981; Baker 1980; Alberta 1981; Marsh 1988; Masters 1987; Reid 1988; Lerner 1991.

ALBERTA SOCIETY OF ARTISTS. This Society was founded by A.C. LEIGHTON in 1931. Exhibitions were held annually and, in later years, catalogues were issued. The 1977 and 1979 catalogues are particularly useful. See JAMES MCLAREN NICOLL. **Citations**: Highlights 1947; Render 1971, 1974; Lerner 1991.

ALDEN, JAMES MADISON (1834-1922), Washington D.C., USA. Painter. Alden was with the American Navy and made TOPOGRAPHIC drawings and paintings along the Pacific coastal area of Canada as well as inland in the Rocky Mountains. **Citations**: Harper 1970; Render 1974; NGC 1982.

ALDWINCKLE, ERIC (1909-80), Toronto, ON. Painter, illustrator, MURALIST and graphic designer. He came to Canada at age 15, began studying other artist's works, and was influenced by the GROUP OF SEVEN, CHARLES COMFORT and several British artists. He visited Russia in 1954 with F.H. VARLEY. Aldwinckle taught at the ONTARIO COLLEGE OF ART. **Citations**: Colgate 1943; McInnes 1950; MacDonald 1967; Sisler 1980; NGC 1982; McMann 1997.

ALEXANDER, CHARLES (1864-1915), Ontario. Painter and photographer. **Citations**: Sisler 1980; NGC 1982; McMann 1997.

ALEXANDER, DAVID (b1947), Saskatoon, SK. Painter. He was influenced by the work of TOM THOMSON. **Citations:** NGC 1982; Murray 1994, 1996(1).

ALEXANDER, HUGH (b1913), Weyburn, SK. Painter. Although Alexander started painting in the 1950s, most of his work dates from 1970. His naïve paintings - reflecting his life as a farmer - of prairie landscape show rich harvests and scenes of daily life on western farms. Alexander attended a few art classes and has some ability in the technical aspects of painting. **Citations**: Thauberger 1976; Kobayashi 1985(2); McKendry 1988.

ALEXANDER, LADY EVELINE MARIE (act. Canada 1841-9), Ontario and Québec. Painter. She was an AMATEUR painter and wife of SIR JAMES EDWARD ALEXANDER. Her work included sleighing scenes and a LITHOGRAPH of a military steeplechase at London, ON, 1843. **Citations**: Harper 1970.

ALEXANDER, SIR JAMES EDWARD (1803-85), Ontario and Québec. Painter. He was an AMATEUR painter and husband of LADY EVELINE MARIE ALEXANDER. He served in Canada in the British Army and wrote several publications illustrated with his own sketches and those of his wife. He designed the Wolfe monument on the Plains of Abraham, Québec. **Citations**: Harper 1970.

ALEXANDER, WILLIAM WALKER (1869-1948), Toronto, ON. Printmaker and illustrator. He studied with GEORGE A. REID and others. Three of his ETCHINGS are in the NATIONAL GALLERY OF CANADA. **Citations**: NGC 1982; Hill 1988; Lerner 1991.

ALEXIE, (or ALLXCEE, ALEXCEE or ALEXEE) FREDERICK (FRED) (c1853-1939), Port Simpson, BC. Painter. Alexie painted naïve watercolour paintings of Skeena River and Fort Simpson landscapes and executed wood sculpture, sometimes of monsters for Tsimshian secret society rites. He was an Iroquois who married into the Tsimshian tribe of Skeena River. **Citations**: Barbeau 1928; Harper 1970; Gilmore 1980; McKendry 1988; Lerner 1991.

ALFRED, PAUL (pseudonym of Alfred Ernest Meister) (1892-1959), Ottawa, ON. Painter and

illustrator. He studied in England. Examples of his drawings and paintings are in the NATIONAL GALLERY OF CANADA. **Citations**: Hubbard 1960; NGC 1982; Hill 1991.

ALFSEN, JOHN MARTIN (1902-71), Toronto, ON. Painter; RCA 1959. Alfsen studied with ARTHUR LISMER, J.E.H. MACDONALD, J.W. BEATTY, EMANUEL HAHN AND C.M. MANLY, as well as in Europe. Although influenced by the old masters, he developed his own personal ideas and themes in painting (see Harper 1966, pl. 302.) Two of his paintings are in the NATIONAL GALLERY OF CANADA. **Citations**: McInnes 1950; Harper 1966; Duval 1972; Lord 1974; Sisler 1980; NGC 1982; Hill 1988; McMann 1997.

ALGONQUIN LEGEND PAINTERS. A group of native painters founded by NORVAL MORRIS-SEAU that included SAMUEL ASH, JACKSON BEARDY, GOYCE and JOSHIM KAKEGAMIC, CARL RAY, ALLEN SAPP and BLAKE DEBASSIGE. **Citations**: Highwater 1980; Lerner 1991.

ALGONQUIN PARK GROUP (SCHOOL). This informal group included TOM THOMSON and his friends who made sketching trips into ALGONQUIN PROVINCIAL PARK. **Citations**: MacTavish 1925, pp. 153-4; Mellen 1970.

ALGONQUIN PROVINCIAL PARK. The park was established for public use in 1893. It is located 210 km north of Toronto and lies across the Canadian shield between Georgian Bay and the Ottawa River. The rugged landscape of the park soon attracted TOM THOMSON and the artists who formed the GROUP OF SEVEN. **Citations**: MacTavish 1925; Saunders 1947; Jackson 1958; Addison 1969; Mellen 1970; Town 1977; Marsh 1988; Lerner 1991; Hill 1995; Murray 1996(1).

ALGONQUIN SCHOOL. See ALGONQUIN PARK GROUP.

ALLAMAND, JEANNE-CHARLOTTE (1760-1839), Montreal, QC. Art teacher. She was the wife of WILLIAM VON BERCZY. **Citations**: Tippett 1992.

ALLARD, EMILE (b1873), Saint Mathieu, QC. Sculptor. When Allard was 84 or 85 years old, he constructed a YARD-ART village with models of a church and houses having a connection with members of his family. His other yard-art works included a bird-box complex modelled on the buildings of a mine near Rouyn, and a large assembly of whirligigs and figures (illustrated in de Grosbois 1978). **Citations**: de Grosbois 1978; McKendry 1988.

ALLEN, RALPH (b1926), Kingston, ON. Painter, teacher. Allen has been described as a LYRICAL ABSTRACTIONIST (Harper 1966, p. 399 and pl. 365). He painted the mists over Lake Ontario and later was involved with OP ART painting. One of Allen's paintings is in the NATIONAL GALLERY OF CANADA. **Citations**: Harper 1966; Duval 1972; Barwick 1975; Sisler 1980; NGC 1982; Burnett/ Schiff 1983; Hill 1988; Farr 1988; Lerner 1991; Silcox 1996; McMann 1997.

ALLEYN, GEORGE EDMUND (b1931), Québec City, QC; Paris, France; Montréal, QC; Ottawa, ON. Painter, sculptor and printmaker. Alleyn studied under JEAN-PAUL LEMIEUX and was influenced by GOODRIDGE ROBERTS and ALFRED PELLAN. He was in Paris 1955-71. Since 1972, he has taught art at the University of Ottawa. Examples of his work are in the NATIONAL GALLERY OF CANADA. **Citations**: Hubbard 1960, 1963; Harper 1966; MacDonald 1967; NGC 1982; Hill 1988; Marsh 1988; Reid 1988.

ALLISON, FRANK DRUMMOND (1883-1951), Québec and New Brunswick. Painter and sculptor. **Citations**: NGC 1982; IBM 1940; Lerner 1991.

ALLOUCHERIE, JOCELYNE (b1945), Québec. Sculptor. She produced enclosed INSTALLA-TIONS similar to the work of the American sculptor Louise Nevelson. **Citations**: NGC 1982; Murray 1988; Lerner 1991; Tippett 1992.

ALLWARD, WALTER SEYMOUR (1876-1955), Toronto, ON. Sculptor; RCA 1920. Allward studied with WILLIAM CRUIKSHANK but was largely self-taught as a sculptor. He designed several war memorials including the great Vimy Ridge Canadian War Memorial in France. Two of Allward's sculptures are in the NATIONAL GALLERY OF CANADA. He was the father of the architect Hugh L. Allward. **Citations**: Mavor 1913; Bridle 1916; Stevenson 1927; Maurault 1929; Colgate 1943; Sisler 1980; NGC 1982; Hill 1988; Lerner 1991; McMann 1997.

ALMEIDA, ROSAIO HENRY (act. 1961), Toronto, ON. Painter and printmaker. He was born in Venezuela, came to Toronto in 1957, and now resides in England. An example of his work is in the NATIONAL GALLERY OF CANADA. **Citations:** Hill 1988.

ALTAR. The Christian altar is a table consecrated for celebration of the sacrament. Fine ROCOCO wooden altars were carved for Québec Roman Catholic churches during the 18th century, and on or near them were placed elegant silver sacred vessels such as CIBORIA, RELIQUARIES, and MONSTRANCES. See also PHILLIPPE LIEBERT, SILVERSMITHING, FURNITURE. Citation: Janson 1977.

ALTARPIECE. This is the term for a picture or decorated (carved) screen located behind or above an ALTAR in a Christian church, and may be a single panel, a DIPTYCH, a TRIPTYCH or a POLYPTYCH. The central panel usually portrays a well-known scene in the life of Christ, often the Crucifixion or the Virgin and Child. The side panels portray events connected with Christ or the Virgin, or with the saints to whom the particular church is dedicated. Sometimes a portrait of a patron is included. Québec altarpieces are among the earliest examples of painting and wood carving in Canada. A good example of a painted altarpiece is one by FRERE LUC (illustrated in Harper 1966, pl. 5), about which Father Le Clercq wrote in 1691: "This good religious [Frère Luc] laboured for fifteen months on many works, which he has left as so many marks of his zeal: the painting over the high altar of our church and that of the chapel; he enriched the parish church [Notre-Dame-de-Québec] with a large painting of the Holy Family, that of the reverend Jesuit Fathers with an Assumption of the Blessed Virgin; and he completed that of the high altar, representing the Adoration of the Wise Men. The churches at Ange Gardien, Chateau-Richer, the Côté de Beaupré [sic], at Saint-Famille on the Ile d'Orléans and of the Hospital [Hôtel-Dieu, Québec] were also indebted to him for works ..." OZIAS LEDUC is a later painter who decorated the altarpieces of many Québec churches. **Citations:** Traquair 1947; Gowans 1955; Harper 1966; Ferguson 1967; Osborne 1970; Ostiguy 1974, 1974(1); Pierce 1987; Lerner 1991.

AMATEUR ART. Usually an amateur artist is considered to be one who creates for his own pleasure rather than to earn a livelihood. However, when "amateur" is used as an adjective in "amateur art", it may indicate art that has a superficial resemblance to FOLK ART art because of inept handling of perspective, tonal gradation, scale and so on, but it is set apart by lack of the intuitive, original and personal visions of a folk artist. The difficulty in distinguishing amateur art from folk art is similar to that of distinguishing technically competent amateur art from professional academic art solely on the basis of technique. In either case, the only really important distinction lies in being able to conclude whether or not a work is based on imaginative skill that strikes an emotional response in the viewer - if it is not, it is amateur art; if it is, it is either folk art or professional academic art and in most cases they are easily distinguished from each other. **Citations:** Housser 1929; Colgate 1943; Bell 1973; McKendry 1983, 1987, 1988; Chilvers 1988; Piper 1988; Lerner 1991.

AMEEN, Sister ANNE (act. 1976), St John's, NF. Painter and textile artist. There is a fine sense of naïve decoration pervading Sister Anne Ameen's paintings and hooked rugs that is at odds with the sobering effect of the bold religious texts often included in her work. For her counselling centre for pregnant teenagers, she painted a set of large wall panels with naïve landscape and stylized figures, illustrating the prominent religious texts lettered across the scenes. She made and sold decorative hooked rugs, with or without religious texts, to help finance her social welfare projects. **Citations:** Lynch 1980; Grattan 1983; McKendry 1988.

AMERICAN FOLK ART. See Folk Art, the United States.

AMIOT (AMYOT), LAURENT (1764-1838), Québec City, QC. Silversmith. He studied in Paris and established a workshop in Québec City by 1791. Amiot executed many fine church pieces and table ware in the NEOCLASSICAL style. FRANCOIS SASSEVILLE was apprenticed to Amiot and succeeded to the business. Several examples of Amiot's work are in the NATIONAL GALLERY OF CANADA. See also SILVERSMITHING. **Citations:** Traquair 1940; Langdon 1960, 1966, 1968; NGC 1982; Hill 1988.

AMISH. See MENNONITE.

AMYOT. See AMIOT.

ANDREWS, BILLY (act. 1970), Bradford, ON. Sculptor. Andrews came to Canada as a hired farm hand in the 1920s and began carving birds and farm animals in his spare time. His naïve sculptures, in POLYCHROMED wood, combine realism and humour. Although he carves for his own pleasure, he has sold some carvings which are now in the hands of private collectors and museums, for example, in the CCFCS collections. **Citations**: Price 1979; NMM 1983; McKendry 1983, 1988; CCFCS.

ANDREWS, STEPHEN JAMES (b1922), Canada and Spain. Painter. Andrews studied with L.L. FITZGERALD and travelled widely. **Citations**: Sisler 1980; NGC 1982; Hill 1988; McMann 1997.

ANDREWS, SYBIL (b1898), Campbell River, BC. Printmaker. Andrews is known for her colour LINOCUTS. **Citations**: NGC 1982; Lerner 1991; Tippett 1992.

ANGERS, HENRI (1870-1963), Québec City, QC. Sculptor. As a young man, Angers was an apprentice of LOUIS JOBIN and later studied in Belgium. Back in Québec by 1905, he carved large statues for churches. His work, in painted or gilded wood, reflects the style of Jobin and that of the early Québec sculptors of religious figures. **Citations**: Trudel 1967(sculpture), 1969; Laliberté 1986; Porter 1986; McKendry 1988; Hill 1988.

ANGES, LA MERE (act. 1671-95), Québec. Sculptor. Her work as a sculptor includes low-RELIEF altar carvings and church decorations. **Citations**: Tippett 1992.

ANIMALS. Animals and BIRDS have always been a popular theme in FOLK ART from PREHISTORIC TIMES to the present. There are many example in prehistoric primitive art such as the figures of bison, deer, cattle and horses incised and painted on the rock surfaces of caves in Europe. In Canada, the native people of the northwest coastal regions, in a continuing tradition, carve animals on totem poles and family crests and, in the Arctic regions, the Inuit carve animals in stone. In English Canada, farm animals often appear in naïve paintings, HOOKED RUGS, weathervanes and wood sculpture, while in French Canada more attention is paid to wild animals such as BEAVER, deer and FISH. Animals may be used symbolically in RELIGIOUS art for example, LAMBS, DOVES, SERPENTS, SALMON, and RAVENS. See also NATIVE ART OF CANADA, BRITISH COLUMBIA. **Citations**: Barbeau 1957; Osborne 1970; Janson 1974; McKendry 1983; NMM 1983.

ANNAND, ROBERT WILLIAM (b1923), Truro, NS. Painter. Annand studied painting under STANLEY ROYLE, JOHN ALFSEN, NICHOLAS HORNYANSKY and GEORGE PEPPER. He travelled in Mexico and Europe. One of his paintings can be seen at the NATIONAL GALLERY OF CANADA. **Citations**: Hubbard 1960; NGC 1982; Hill 1988.

ANTIQUES. See DECORATIVE ARTS; APPLIED ARTS; FURNITURE; SILVERSMITHING.

APPLIED ARTS. Applied arts are those that primarily serve a functional or utilitarian purpose, such as architecture, interior decoration, pottery, metalwork, furniture, graphics and so on, as contrasted with the FINE ARTS which serve only aesthetic purposes. See DECORATIVE ARTS. **Citations**: Osborne 1970; Piper 1988; Chilvers 1988.

APRIL ANTIQUES AND FOLK ART SHOW. Founded in 1974 in Bowmanville, ON, this annual commercial show continues to offer the public a wide selection of FOLK ART. Other shows include folk art but have not achieved the reputation of the April Show for folk art, possibly because of the early support of numerous acquisitions from the show for the collection of the Canadian Museum of Civilization. **Citations**: Shakespeare 1975; McKendry 1983, 1987.

APSE. A large niche at the end of the NAVE of a church. It is usually semi-circular and dome-roofed. **Citations**: Pierce 1987.

AQUATINT. A method of toned etching which produces a print having an appearance similar to that of a wash drawing. It was practiced as early as 1775 by the English artist PAUL SANDBY and in the twentieth century by PABLO PICASSO. Although the aquatint process is unlikely to be used by folk artists, it may appear in TOPOGRAPHICAL ART, in which wash drawings are quite common and are sometimes reproduced as aquatints. See also GEORGE HERIOT. **Citations**: Osborne 1970; Mayer

1970; Eichenberg 1976; Pierce 1987; Chilvers 1988; Piper 1988.

ARBUCKLE, GEORGE FRANKLIN (b1909), Toronto, ON; Montreal, QC. Painter; RCA 1945. Arbuckle studied with J.W. BEATTY, FREDERICK S. CHALLENER, FRED S. HAINES, FRANZ JOHNSTON and J.E.H. MACDONALD. An example of his work is in the NATIONAL GALLERY OF CANADA. **Citations**: Colgate 1943; McInnes 1950; Hubbard 1960; Sisler 1980; NGC 1982; Hill 1988; Lerner 1991; McMann 1997.

ARCH. An arch is the closure spanning an opening in a wall by which downward thrust is converted into outward thrust - in masonry usually topped by a KEYSTONE. **Citations**: Osborne 1970; Lucie-Smith 1984.

ARCA. The acronym for Associate Member of the ROYAL CANADIAN ACADEMY.

ARCHAMBAULT, LOUIS DE GONZAQUE PASCAL (b1915), Montreal, QC. Sculptor; RCA 1969. He was an instructor in sculpture at the ECOLE DES BEAUX-ARTS, Montreal. **Citations**: McInnes 1950; Hubbard 1960; Sisler 1980; NGC 1982; Hill 1988; McMann 1997 .

ARCHITECTURE. Architecture is a division of the fine arts that is concerned with the design and style of buildings. Canadian architecture has tended in the past to be traditional in form, based on remembered styles in France, the British Isles and New England. This was reinforced by the popularity of architectural pattern books published in France, England and the USA. Early houses, churches and other clerical buildings in Québec reflect origins of their styles in France with certain adaptations to the harsher climate of Canada. About the middle of the 19th century the custom of master builder as designer yielded to architect as designer, and architectural drawings, accompanied by written contracts, became more elaborate. Famous Canadian architects and master builders include Claude Baillif (1635-98), Gaspard Chaussegros de Léry (1682-1756), THOMAS BAILLAIRGE (1791-1859), , John Merrick (c1756-1829), William Thomas (1799-1860), William Coverdale (1801-65), JOHN G. HOWARD (1803-90), George Browne (1811-85), Frederic Cumberland (1820-81), William G. Storm (1826-92), Charles Baillairgé (1826-1906), E.J. Lennox (1855-1933), Samuel Maclure (1860-1929), John Lyle (1872-1945), John C. Parkin (1911-75), Ronald J. Thom (1923-86), Arthur Erickson (b. 1924), Eberhard Zeidler (b. 1926), Raymond Moriyama (b. 1929), Douglas Cardinal (b. 1934), Moshe Safdie (b. 1938), and Peter Rose (b. 1943). The most recent and comprehensive history of Canadian architecture is Kalman 1994. **Citations**: Hale 1933, 1952; Colgate 1943; Traquair 1947; Gowans 1955, 1966; Palardy 1963; MacRae 1963; 1975; Hubbard 1977, 1989; Marsh 1988; Lerner 1991; Kalman 1994.

ARCTIC. For the most part the Arctic regions of Canada are important to Canadian art for the PRIMITIVE and NAÏVE, stone and ivory carvings of the Inuit people, and for the TOPOGRAPHICAL drawings and paintings executed by people from England who were involved in exploration or in searches during the 1840s and '50s for Sir John Franklin. In both cases, and to some degree, the work borders on FOLK ART. Some artists from the south have gone to the Arctic in search of subject matter, for example LAWREN HARRIS, A.Y. JACKSON, TONI ONLEY, FREDERICK H. VARLEY and DORIS McCARTHY. See also NATIVE ART OF CANADA, SOAPSTONE, JAMES HOUSTON, GEORGE SWINTON. **Citations**: Jackson 1958, 1982; Harper 1966; Groves 1968; Harris 1969; Swinton 1972; Goetz 1977; Boulet 1981(2); Varley 1983; McKendry 1983; Marsh 1985; Lerner 1991.

ARGILLITE. Argillite is a compact sedimentary rock composed mainly of clay materials. It is a traditional material from which the HAIDA people carve many decorative and ceremonial objects such as plates, bowls, musical instruments, boxes, and totems. For the best account of these carvings, see Barbeau (Haida) 1957.

ARISS, HERBERT (HERB) JOSHUA (b1916), London, ON. Painter. He studied with L.A.C. PANTON, J.W. BEATTY and FRANK CARMICHAEL. **Citations**: Sisler 1980; NGC 1982; Hill 1988; Lerner 1991; McMann 1997

A.R.L. See A.R. LANIGAN.

ARMATURE. A framework forming a skeleton around which a work of sculpture is formed. FOLK

ARTISTS usually favour a more direct approach, with the result that most naïve sculpture is carved from solid wood. **Citations**: Chilvers 1988; Piper 1988.

ARMINGTON, CAROLINE HELENA WILKINSON (1875-1939), Paris, France. Painter and printmaker. She was a Canadian artist who worked in France most of her adult life. She was the wife of FRANK MILTON ARMINGTON. **Citations**: NGC 1982; Hill 1988; Lerner 1991.

ARMINGTON, FRANK MILTON (1876-1941), Paris, France. Painter. Armington studied under J.W.L. FORSTER from 1892 to1899. He and his wife CAROLINE HELENA ARMINGTON, although born in Canada, painted in France for many years. **Citations**: NGC 1982; Hill 1988; Duval 1990; Lerner 1991.

ARMORY SHOW. An important, influential, international exhibition of modern art held at the 69th Regiment Armory, New York, in 1913, for the purpose of exhibiting progressive works, which were being neglected in other shows. DAVID MILNE who, at that time, was using pure interacting colours, exhibited in this famed show. See also FAUVISM; MODERN ART; DAVID MILNE. **Citations**: Buchanan 1950; Harper 1966; Britannica; Lord 1974; Tovell 1980; Reid 1988; Chilvers 1988; Read 1994; Hill 1995; Silcox 1996.

ARMSTRONG, WILLIAM (1822-1914), Toronto, ON. Painter. Armstrong studied art in Dublin before emigrating to Toronto in 1851 to work as a railway construction engineer. He sketched and painted scenes from Québec to the Rocky Mountains, often showing native people and pioneer life, as well as executing marine, portrait and animal paintings. Armstrong was an associate of FREDERICK J. ROWAN. See also WILLIAM HENRY EDWARD NAPIER. **Citations**: Duval 1954; Spendlove 1958; Harper 1966, 1970; Hubbard 1967; Carter 1967; Eckhardt 1970; Corbeil 1970; Campbell 1971; Allodi 1974; Sisler 1980; Cooke 1983; Sweeney 1983; Oko 1984; Marsh 1988; McKendry 1983, 1988; Cavell 1988; Hill 1988; Lerner 1991; McMann 1997.

ARMSTRONG, WILLIAM WALTON (b1916), Montreal, QC and Toronto, ON. Painter and art teacher. He studied with CARL SCHAEFER, CHARLES COMFORT and ALAN JARVIS. His work is represented in the NATIONAL GALLERY OF CANADA. **Citations**: Hubbard 1960; NGC 1982; Hill 1988; Lerner 1991.

ARSENAULT, REAL (b1931), Montreal, QC. Painter and sculptor. He studied with JEAN PAUL LEMIEUX and ALBERT DUMOUCHEL. His work is represented in the NATIONAL GALLERY OF CANADA. **Citations**: NGC 1982; Hill 1988; Lerner 1991.

ART. When referring to the FINE ARTS, the term 'art' refers to the fine arts collectively and to a class of objects subject to AESTHETIC CRITERIA. From an artist's viewpoint "Art cannot be taught. It can be given opportunity and encouragement to grow ... it can only be elicited; it is inherent in each one of us. Indeed, nothing of abiding value can be taught; everything eternal must be elicited." (Harris 1969 p. 74). Unfortunately in the case of 'FOLK ART' the term is often used loosely to include utilitarian objects and FOLKLORE artifacts which do not meet the aesthetic criteria usually associated with the fine arts. The question "is it art?" haunts us and was expressed by Rudyard Kipling (1865-1936) in *The Conundrum of the Workshops*:

> When the flush of the new-born sun fell first on Eden's green and gold,
> Our father Adam sat under the Tree and scratched with a stick in the mould,
> And the first rude sketch that the world had seen was joy to his mighty heart,
> Till the Devil whispered behind the leaves, "It's pretty, but is it art?"

Citations: Harris 1969; Janson 1977; McKendry 1983, 1987; Marsh 1988; Lerner 1991.

ART ASSOCIATION OF MONTREAL. See MONTREAL MUSEUM OF FINE ARTS.

ART BRUT. A term coined in France by JEAN DUBUFFET (1901-85) in 1945, but now used widely in other countries for powerfully expressive art by NAÏVE artists, often including work by people in prisons or institutions for the mentally ill. **Citations**: Osborne 1970, 1981; Janson 1977; Pierce 1987; Chilvers 1988; Piper 1988; Read 1994.

ART DECO. This style in design and decorative arts flourished between ART NOUVEAU and World

War II, particularly in the 1920s and '30s in France and the USA. Art deco tends to be exotically decorative but sometimes streamlined. **Citations**: Britannica; Lesieutre 1978.

ART FOR ART'S SAKE. James Whistler (1834-1903) who spent most of his career in England, advocated Art for Art's Sake, which freed the artist to paint for formal qualities alone (line, form, colour, etc.). This had important significance for modern art. Whistler had a strong influence on Canadian artist JAMES WILSON MORRICE. **Citation:** Janson 1977.

ART GALLERY OF NOVA SCOTIA (AGNS). The Art Gallery of Nova Scotia (Halifax) collection comprises primarily the works of Nova Scotia regional artists, including an important collection of naïve paintings and sculpture by Nova Scotia folk artists, for example COLLINS EISENHAUER, JOSEPH SLEEP, CHARLES TANNER, SIDNEY HOWARD, CHARLES ATKINSON and DONALD MANZER. Among the FOLK ART exhibitions and catalogues originating from this Gallery are: "Folk Art of Nova Scotia," 1976; "Ellen Gould Sullivan, Hooked Mats," 1980; "Charles MacDonald (1874-1967)," 1980; "Joe Sleep: Retrospective," 1981; "Gameboards," 1981; "Francis Silver (1841- 1920)," 1982; " Folk Art in 4 Dimensions," 1983; "Charlie Tanner (1904-1982)," 1984; "Decoys of Nova Scotia From the Collection of Gerald Ferguson," 1984; "Canadian Folk Painting from the Collection," 1985; "A Record of Time," 1985; "Interior Decorative Painting in Nova Scotia," 1986; "Spirit of Nova Scotia: Traditional Decorative Folk Art 1780-1930," 1987; "The Illuminated Life of Maud Lewis," 1997.

ART GALLERY OF ONTARIO (AGO). The Art Museum of Toronto, founded in 1900, became the Art Gallery of Toronto in 1919 and, in 1966, the Art Gallery of Ontario (AGO). The AGO is a major gallery with a permanent collection extending from old masters to Canadian works dating from the 18th century to the present. The collection of Henry Moore sculpture is the largest anywhere. **Citations**: Colgate 1943; McInnes 1950; Harper 1966; Duval 1972; Lord 1974; Withrow 1974; Watson 1974; Sisler 1980; Bringhurst 1983; Marsh 1988; Reid 1988; Lerner 1991; Silcox 1996; Murray 1996(1).

ART GALLERY OF TORONTO. See ART GALLERY OF ONTARIO.

ARTHUR, PAUL (b1924), Ottawa, ON. Graphic designer. **Citations**: Sisler 1980; NGC 1982; Lerner 1991.

ARTHUR VILLENEUVE'S QUEBEC CHRONICLES EXHIBITION. This important one-man exhibition of over 250 works by the folk artist ARTHUR VILLENEUVE was mounted by the MONTREAL MUSEUM OF FINE ARTS in 1972. It travelled to Québec City and to Vancouver, and was the occasion of the publication of an extensive catalogue (see Gagnon 1972), which includes the best account of Villeneuve's life and work. J. RUSSELL HARPER referred to this exhibition as, at that date, "Canada's most ambitious effort in recognition of Canadian primitives." See FOLK ART EXHIBITIONS. **Citations**: Gagnon 1972; Harper 1974.

ART MUSEUM OF TORONTO. See ART GALLERY OF ONTARIO.

ARTIFACT. In general, an artifact is any object made by man. In the context of folk art, there are two kinds of artifacts. The one includes artifacts which can be referred to as FOLK ART, and which primarily display the personal artistic expression of people who are untrained in the principles and techniques of professional ACADEMIC art. The other includes objects which primarily display folklore information and can be referred to as FOLK CULTURE ARTIFACTS, see McKendry 1983.

ARTISTS' JAZZ BAND. Around 1962 a group of artists associated with the Isaacs Gallery in Toronto formed the Artists' Jazz band to express their common interest in jazz music. These artists included MICHAEL SNOW, GRAHAM COUGHTRY, GORDON RAYNER, NABUO KUBOTA, HARVEY COWAN, TERRY FORSTER, and ROBERT MARKLE. **Citations**: Burnett/Schiff 1983.

ARTISTS' ORGANIZATIONS. See Marsh 1988 for an overview of this subject.

ART NOUVEAU. Art nouveau is a decorative style which was popular in the late 19th and early 20th centuries. Its main theme is long, sinuous lines, often derived from natural forms. It was followed mainly in France and the USA by the ART DECO style. **Citations**: Buchanan 1950; Harper 1966; Arnason 1968; Osborne 1970; Lord 1974; Lesieutre 1978; Janson 1977; Chilvers 1988; Piper 1988; Reid 1988; Read 1994.

ARTS AND CRAFTS MOVEMENT. This movement, originating in England in the second half of the 19th century and inspired by designer William Morris (1834-96), was a social and AESTHETIC movement promoting HANDICRAFT articles. It was brought about by widespread dissatisfaction with the quality of factory manufactured goods. To some extent the movement died out due to acceptance of modern industrial methods in the 20th century, although aspects have survived in the work of such DECORATIVE ARTS artisans as potters, weavers and furniture makers. Recently these products made by artisans have been included in some so-called FOLK ART exhibitions. **Citations:** Osborne 1970; Bovey 1976; Chilvers 1988; Piper 1988; Fowke 1988.

ARTS AND LETTERS CLUB. The Arts and Letters Club was a social club for artists, musicians, actors, and patrons at 14 Elm St., Toronto, ON. Artists from GRIP LIMITED, including those who were to form the GROUP OF SEVEN, met at the Club for lunch and held exhibitions there. Dr JAMES MACCALLUM was president 1916-18. **Citations:** MacTavish 1925; Colgate 1943; Bridle 1945; Jackson 1958; Reid 1969, 1988; Mellen 1970; Murray 1971; Housser 1974; Fulford 1982; Lerner 1991; Tippett 1992; Hill 1995.

ASH, SAMUEL (b1951), Sioux Lookout, ON. Painter. Ash who paints legends of his Algonquian people, is an Ojibway artist with a disability. **Citations:** Highwater 1980; Lerner 1991.

ASH, STUART B. (b1942), Ontario. Graphic designer and printmaker. **Citations:** Sisler 1980; NGC 1982; Lerner 1991.

ASHEVAK, KENOJUAK. See KENOJUAK.

ASHOONA, PITSEOLAK. See PITSEOLAK.

ASKEVOLD, DAVID MARIUS (b1940), Toronto, ON and Halifax, NS. VIDEO artist and photographer. **Citations:** NGC 1982; Hill 1988; Lerner 1991.

ASPELL, PETER NOEL LAWSON (b1918), Vancouver, BC. Painter and art teacher. He studied under CHARLES H. SCOTT. **Citations:** McNairn 1959; Hubbard 1960; Hill 1988; Lerner 1991.

ASSEMBLAGE. A term coined in the 1950s by JEAN DUBUFFET and used for CONSTRUCTIONS formed of found objects, as is often the case in YARD ART. See also INSTALLATION. **Citations:** Pierce 1987; Chilvers 1988; Piper 1988.

ASTMAN, BARBARA ANNE (b1950), Toronto, ON. She is a lecturer at the ONTARIO COLLEGE OF ART. Her work includes manipulated photographs. **Citations:** NGC 1982; Lerner 1991; Tippett 1992.

ATKINS, CAVEN ERNEST (b1907), Toronto, ON. Atkins studied under L.L. FITZGERALD among others. He is a painter, printmaker and illustrator. **Citations:** Hubbard 1960; Barwick 1975; Farr 1988; Hill 1988; Lerner 1991; Silcox 1996.

ATKINSON, BOBBY (act1976), Montréal and Rosemère, QC. Landscape and street scene painter. **Citations:** Atkinson 1976; NGC 1982.

ATKINSON, CHARLIE (1904-77), South Side, Cape Sable, NS. Sculptor. Atkinson, who lived all his life in South Side, whittled and carved over a good many years, until he had a crippling heart attack a few years before he died. His work included naïve wood sculpture of people and birds, YARD ART and decorative bird boxes. Most of his work is distinguished by bright spotted painting. Atkinson remarked on his own carving: "Didn't have much learnin' you know ... just what came to my head ... I made birds' cages and churches and things like that" **Citations:** Elwood 1976; NMM 1983; Kobayashi 1985(2); McKendry 1988.

ATKINSON, ERIC (b1928), ON. Painter and printmaker. **Citations:** Sisler 1980; NGC 1982.

ATKINSON, WILLIAM EDWIN (1862-1926), Toronto, ON. Atkinson studied with JOHN A. FRASER and ROBERT HARRIS; sketched with WILLIAM CRUIKSHANK and CURTIS WILLIAMSON; and was an associate of PAUL PEEL and ERNEST THOMPSON SETON. He studied and travelled in the USA and Europe. **Citations:** MacTavish 1925; Robson 1932; Colgate 1943; Hubbard 1960; Harper 1966, 1970; Sisler 1980; NGC 1982; Reid 1988; Hill 1988; Lerner 1991.

ATLANTIC PROVINCES. See MARITIME PROVINCES.

ATMOSPHERIC PERSPECTIVE. See AERIAL PERSPECTIVE.

ATTRIBUTION. A term used for the assignment to an artist of a work of uncertain authorship. **Citations**: Chilvers 1988; Piper 1988.

AUBIN, ERNEST (1892-1963), Montée Saint-Michel, QC. Painter. Aubin was a member of the group les PEINTRES DE LA MONTEE SAINT- MICHEL. He was thought of as 'le Père de la Montée'. **Citations**: Laliberté 1986; Lerner 1991.

AUCLAIR, ANDRE (1803-65), Montréal, QC. Sculptor of religious figures. **Citations**: Falardeau 1940; Lerner 1991.

AUDET, EDOUARD (act. 1975), Maria, QC. Sculptor. Audet constructed several small scenes of carved figures, people and farm animals, usually depicting activities with which he was familiar on his farm. His work, although executed in a naïve manner, shows an innate ability to compose and render life-like expression. Several examples of his work are shown in de Grosbois 1978 and a particularly good example in NMM 1983, pl. 104. **Citations**: de Grosbois 1978; NMM 1983; McKendry 1988.

AUTOMATISTES. A group of seven Montréal artists lead by PAUL-EMILE BORDUAS formed the Automatiste movement in 1942. The movement was based on abstract, spontaneous, stream-of-consciousness painting and was influenced by SURREALISM. The Automatistes Montréal exhibition of 1946 was the first exhibition by a group of abstract painters to be held in Canada. **Citations**: Guy 1964; Harper 1966; Osborne 1970, 1981; Wilkin 1976; Davis 1979; George 1980; Reid 1988; Chilvers 1988; Marsh 1988; Piper 1988.

AYOT, PIERRE (b1943), Montréal, QC. Printmaker. **Citations**: NGC 1982; Hill 1988; Lerner 1991.

AYOTTE, LEO (1909-77), Québec. Painter. **Citations**: Bergeron 1946; NGC 1982; Lerner 1991.

B

BACHMAN. See BACKMAN.

BACK, Sir GEORGE (1796-1878), London, England. Painter. Back was with the British Navy on various expeditions to the Arctic between 1818 and 1836. He accompanied Sir John Franklin on Arctic expeditions, as well as leading an expedition in search of Sir John Ross. Back was the most important Arctic TOPOGRAPHER of his day and made a great many quick sketches as well as sophisticated watercolour paintings of Arctic scenes. Examples of his work are in the NATIONAL GALLERY OF CANADA. **Citations**: Harper 1964, 1966; Carter 1967; Bell 1973; Allodi 1974; Hood 1974; Wight 1980; NGC 1982; Marsh 1988; McKendry 1988; Hill 1988; Lerner 1991; Dickenson 1992; Houston 1994.

BAICH. See PAUL VON BAICH.

BAIE SAINT-PAUL PRIMITIVES. See CHARLEVOIX COUNTY.

BAILLAIRGE, FRANCOIS (1759-1830), Québec City, QC. Sculptor, painter and architect. François Baillairgé studied art in Paris but spent most of his life in Québec city as a carpenter, an architect, a wood sculptor and a painter. His paintings and sculptures were used in many Québec churches and numerous examples survive today. François Baillairgé had widely diverse interests which included carving trade signs, coats of arms, niche statues and figureheads for ships. Several examples of his work are in the CCFCS collections. He is the fourth son of JEAN BAILLAIRGE, a brother of PIERRE-FLORENT BAILLAIRGE, and the father of THOMAS BAILLAIRGE. **Citations**: Vaillancourt 1920; McInnes 1950; Barbeau 1934(1), 1957(Québec); Morisset 1959; Harper 1966; Trudel 1967 (Peinture and Sculpture); Lavallée 1968; Hubbard 1967, 1973; Gauthier 1974; Cameron 1976; NGC 1982; Porter 1986; Marsh 1888; McKendry 1988; Hill 1988; CCFCS; Piper 1988; Lerner 1991; Béland 1992; Kalman 1994.

BAILLAIRGE, JEAN (1726-1805), Québec City, QC. Sculptor and architect. Jean Baillairgé was a

master carpenter, joiner, wood sculptor and architect. For many years he executed religious sculpture in POLYCHROMED wood and provided decorative woodwork for churches in the Québec City area. Jean Baillairgé is the father of FRANCOIS and of PIERRE-FLORENT BAILLAIRGE. **Citations**: Trudel 1969; Osborne 1970; Gauthier 1974; Cameron 1976; NGC 1982; Marsh 1988; McKendry 1988; Chilvers 1988; Lerner 1991; Kalman 1994.

BAILLAIRGE, PIERRE-FLORENT (1761-1812), Québec City, QC. Sculptor. Pierre-Florent Baillairgé, who was a son of JEAN BAILLAIRGE and a brother of FRANCOIS BAILLAIRGE, executed sculptures of religious figures in POLYCHROMED wood. **Citations**: Barbeau 1957(Québec); Trudel 1969; Gauthier 1974; Cameron 1976; NGC 1982; Porter 1986; McKendry 1988; Lerner 1991.

BAILLAIRGE, THOMAS (1791-1859), Québec City, QC. Sculptor and architect. Thomas Baillairgé is best known as an architect of churches in the NEOCLASSICAL style, such as the parish church of Deschambault, 1834-8. He also was a skilled sculptor of religious figures in POLYCHROMED or gilded wood. He is a son of FRANCOIS BAILLAIRGE. **Citations**: Vaillancourt 1920; Trudel 1967 (Sculpture), 1969; Lavallée 1968; Gauthier 1974; Cameron 1976; NGC 1982; Porter 1986; Marsh 1988; McKendry 1988; Lerner 1991; Kalman 1994.

BAILLY, EVERN EARL (1903-77), Lunenburg, NS. Painter. He studied in the USA and with STANLEY ROYLE and BERTHE DES CLAYES in Nova Scotia. One of his paintings is in the NATIONAL GALLERY OF CANADA. **Citations**: Hubbard 1960; NGC 1982; Hill 1988; Lerner 1991.

BAIN, FREDA GUTTMAN (b1934), Montréal, QC. Printmaker. **Citations**: NGC 1982; Hill 1988; Lerner 1991.

BAINBRIGGE, PHILIP JAMES (JOHN) (1817-81), Maritimes, Québec and Ontario. Painter. Bainbrigge painted numerous TOPOGRAPHICAL sketches in watercolour of landscape in the Maritimes, Québec and Ontario. In Québec, he executed views of Québec City and St. John's and, in Ontario, of Amherstburg, Chatham and Cobourg. Bainbrigge was with the British Army in Canada. **Citations**: Harper 1970; Bell 1973; Allodi 1974; NGC 1982; Cooke 1983; Mika 1987; McKendry 1988; Cavell 1988; Beland 1992.

BAINES, HENRY EGERTON (1840-66), Québec. Painter. While Baines was with the British Army in Canada, he painted TOPOGRAPHICAL views in watercolour of Québec landscape. He died at Québec City from injuries sustained while fighting the fire of 14 October 1866. **Citations**: Allodi 1974; McKendry 1988.

BAIRD, REBECCA GLORIA-JEAN (b1954), Edmonton, AB. Native artist. **Citations**: Tippett 1992.

BAKER, WALTER (act. 1898), Montréal, QC. Painter. Baker was a prolific painter of small watercolours of Québec scenes, habitants and Indians. **Citations**: Harper 1970; McKendry 1988.

BALANCE. Balance is the apparent equilibrium among the various parts of a composition. **Citations**: Pierce 1987.

BALBONI, CARLO (1860-1947), Montréal, QC. Sculptor. He studied in Italy before moving to Montréal at the turn of the century. **Citations**: Laliberté 1986.

BALDWIN, ALMA (1895-1977), Big Bay Point, ON. Sculptor. Baldwin produced a large number of naïve SOFT SCULPTURES caricaturing people she knew or observed. Her sculptures, which are in the form of dressed dolls, vary in size from a few inches high to life size, and are formed from wire, batting, nylon stockings and other clothing, cosmetics and human hair. Several examples of Baldwin`s work are in the CCFCS collections. **Citations**: NMM 1983; Kobayashi 1985(2); McKendry 1988; CCFCS.

BALFOUR, H.L. (act1852), Nova Scotia. Painter. Balfour is known for a TOPOGRAPHICAL painting in watercolour of Halifax, NS, dated 1852. He is thought to be Henry Lowther Balfour who was with the British Army. **Citations**: Allodi 1974; McKendry 1988.

BALFOUR, Miss (act1847), Toronto, ON. Painter. **Citations**: Harper 1970; Tippett 1992.

BALLANTYNE, ROBERT MICHAEL (1825-94), Manitoba, Ontario, Québec. Painter and author. Ballantyne was an amateur artist and author of stories for youths based on Canadian life. He illustrated his books with his own sketches and exhibited watercolour paintings. Ballantyne worked for the Hudson

Bay Company at York Factory, Fort Garry, Norway House, Lachine and Tadoussac. **Citations**: Harper 1970; NGC 1982; McKendry 1988.

BAMFORD, THOMAS (1861-1941), Victoria, BC. Painter. Bamford had some training in art in England before emigrating to America and settling in Victoria. For a time he designed ornamental iron embellishments used in naval architecture but soon began painting TOPOGRAPHICAL landscape views, including studies of ships along the waterfront, and native life scenes. While in Victoria, he studied under RENE EMILE QUENTIN. **Citations**: Harper 1970; NGC 1982; McKendry 1988.

BANFF CENTRE FOR CONTINUING EDUCATION. See BANFF SCHOOL OF FINE ARTS.

BANFF SCHOOL OF FINE ARTS. The Banff School of Fine Arts was founded in 1933 in Banff, AB It was renamed the Banff Centre for Continuing Education in 1978. **Citations**: Buchanan 1950; Reid 1988; Marsh 1988; Tippett 1992.

BANNERMAN, FRANCES M. (née Jones) (1855-1940), Halifax, NS. Painter. At first she painted in Halifax, but after her marriage to the London painter Hamlet Bannerman, she lived in England. **Citations**: Harper 1966, 1970; NGC 1982; Tippett 1992.

BANNISTER, EDWARD M. (1833-1901), New Brunswick. Painter. He lived in the USA. **Citations**: Lumsden 1969; Lerner 1991.

BANTING, Sir FREDERICK GRANT (1891-1941), Toronto, ON. Painter. Banting, who was the co-discoverer of insulin, was a great friend and sketching companion of A.Y. JACKSON. See FRANCES LORING. **Citations**: Robson 1932; Colgate 1943; Jackson 1943, 1958, 1982; MacDonald 1967; Groves 1968; NGC 1982; Marsh 1988; Lerner 1991; Murray 1996(1).

BARBEAU, CHARLES MARIUS (1883-1969), Ottawa, ON. Folklorist. Marius Barbeau founded professional FOLKLORE studies in Canada. He was associated with the National Museum of Canada, now the CANADIAN MUSEUM OF CIVILIZATION, from 1911 and collected a large archive of traditional folk songs and artifacts of Québec, as well as native artifacts of the west coast. Barbeau's work laid the basis for the CANADIAN CENTRE FOR FOLK CULTURE STUDIES. Among his many hundreds of publications are: *Folk Songs of French Canada*, 1925; *The Downfall of Tremlaham*, 1928; *Cornelius Kreighoff: Pioneer Painter of North America*, 1934; *Québec: Where Ancient France Lingers*, 1936; *Maitres artisans de chez-nous*, 1942; *Ceinture Flèchée*, 1945; *Totem Poles*, (2 vols.) 1950; *I have Seen Québec*, 1957; *Haida Carvers in Argillite*, 1957; and *Medicine Men of the North Pacific Coast*, 1958. Barbeau was a scholar with great empathy for Canadian folk. See also FOLK ART, CANADA. **Citations**: Gauvreau 1940; Colgate 1943; McInnes 1950; Palardy 1963; Harper 1966;Story 1967; Mellen 1970; Watson 1974; Lord 1974; Tippett 1979; Aimers 1981; NMM 1983;McKendry 1983; Marsh 1988; Fowke 1988; Reid 1988; Hill 1988 (pp. XVII, XVIII), 1995; Lerner 1991; Murray 1996(1).

BARBEAU, CHRISTIAN MARCEL (b1925), Montréal, QC; Paris; New York. Painter and sculptor. He studied with PAUL-EMILE BORDUAS and was associated with the AUTOMATISTES group 1946-54. Barbeau signed the REFUS GLOBAL in 1948. **Citations**: Harper 1966; Teyssèdre 1968; Duval 1972; Lord 1974; Fenton 1978; Sisler 1980; NGC 1982; Burnett/Schiff 1983; Bringhurst 1983; Hill 1988; Marsh 1988; Reid 1988; Lerner 1991.

BARBIER, Sister MARIE (c1663-1739), Montréal, QC. Painter. A full face, three-quarter length, naïve portrait of the Christ Child is attributed to Sister Marie Barbier. She was a nun who was one of the earliest members of the Sisters of the Congregation of Notre Dame, an order founded in Montréal by Marguerite Bourgeoys in the 17th century. Although the portrait is a flat pattern with rigid outstretched hands, the somewhat mature face has a very appealing look. **Citations**: Harper 1970, 1973; Farr 1976; Kobayashi 1985(2); McKendry 1988; Tippett 1992.

BARBIZON SCHOOL. Théodore Rousseau (1812-67) and other French painters working in the vicinity of the village of Barbizon in the forest of Fontainebleau in the mid 19th century, were concerned with naturalistic rendering of nature and peasant life. Their technique of painting on the spot prepared the way for the IMPRESSIONISTS. In Canada the greatest exponents of the Barbizon tradition were HORATIO WALKER and HOMER WATSON. See also CURTIS WILLIAMSON, WYATT EATON,

WILLIAM BRYMNER. **Citations**: McInnes 1950; Buchanan 1950; Harper 1966; Osborne 1970; Lord 1974; Karel 1987; Miller 1988; Piper 1988; Reid 1988; Chilvers 1988; Lerner 1991.

BARET, JEAN-BAPTISTE (act1823), Québec. Sculptor of religious works in wood. **Citations**: Porter 1986.

BARKER, SYDNEY (SIDNEY) HERBERT (1893-1969), Saskatoon, SK. Painter. Barker's work is in several private and public collections, and was included by the NATIONAL GALLERY OF CANADA in the important early exhibition of folk painting, "Folk Painters of the Canadian West" (see McCullough 1959). At that time Barker said, "I never had any lessons but my father had a natural gift and did some painting. I started painting after 1920 making stage scenery at Oxbow." His work includes naïve landscape paintings in watercolour of local scenes, and studies of birds and animals. Lack of correct scale and perspective in some of his paintings lends a NAÏVE quality, while in others his detailed and rhythmic treatment of trees, rocks and rivers is reminiscent of the work of THOMAS DAVIES. One of Barker's paintings is in the NATIONAL GALLERY OF CANADA. **Citations**: McCullough 1959; NGC 1982; Dunlop Art Gallery; McKendry 1988; Hill 1988; Lerner 1991.

BARNARD, Sir HENRY WILLIAM (1799-1857), Québec; ON. Painter. Barnard, who was a British Army officer, sketched and painted in various parts of Ontario and Québec. Some of his sketches in watercolour have more freedom in choice of subject matter than usually associated with the TOPO-GRAPHICAL work of British army officers and might be classed as GENRE. A large number of Barnard's watercolour paintings are in the collection of the ROYAL ONTARIO MUSEUM, Toronto, ON. **Citations**: Carter 1967; Harper 1970; Allodi 1974; McKendry 1988; Cavell 1988; Béland 1992.

BARNES, ARCHIBALD GEORGE (1887-1972), Toronto, ON. Painter and teacher; RCA 1936. After studying in England, he arrived in Canada in 1929 and was in Toronto by 1931. He taught at the ONTARIO COLLEGE OF ART. His work is represented in the NATIONAL GALLERY OF CANADA. **Citations**: Colgate 1943; Sisler 1980; NGC 1982; Hill 1988; McMann 1997.

BARNES SCHOOL OF ART. See WILFRID MOLSON BARNES.

BARNES, WILFRID MOLSON (1882-1955), Montréal, QC. Painter; RCA 1947. He studied with WILLIAM BRYMNER and EDMOND DYONNET and was the founder of the Barnes School of Art, Montréal 1905-c1936. **Citations**: MacTavish 1925; Robson 1932; Hubbard 1960; Harper 1966; Sisler 1980; NGC 1982; Hill 1988.

BARNSLEY, JAMES MACDONALD (1861-1929), Montréal, QC. Painter and printmaker. He studied in the USA and in Paris. The subject matter of Barnsley's paintings included landscapes in America and in Europe. A large collection of his sketches, watercolours, oils and prints are in the NATIONAL GALLERY OF CANADA. **Citations**: MacTavish 1925; Robson 1932; Colgate 1943; Hubbard 1960; Harper 1966; NGC 1982; Hill 1988; Lerner 1991.

BAROQUE. A style that flourished in the 17th century and, in some areas, into the 18th century. It was the dominant style in Europe between MANNERISM and ROCOCO. Many religious works of the period were in the Baroque style, for example, in Canada, the religious paintings of FRERE LUC (see Harper 1966, pl. 5 to 9). Baroque work is concerned with reality, texture, colour and CHIAROSCURO. In QUEBEC Baroque DECORATIVE ARTS are often referred to as Louis XIV (reigned 1643-1715). See also REVIVALS. **Citations**: Harper 1966; Osborne 1970; Chilvers 1988; Piper 1988; Lerner 1991.

BARR, ROBERT ALLAN (1890-1959), Toronto, ON. Painter, portraitist. Barr, who was born in London, England, moved to Kingston, ON, in 1922, and, by 1923 was in Toronto. He had studied art in London. **Citations**: Hubbard 1960; Sisler 1980; NGC 1982; Hill 1988.

BARR, PATRICK (act. 1860-80), British Columbia. Painter. Barr painted several watercolours of towns and of coastal scenes in British Columbia. **Citations**: Harper 1970; Gilmore 1980; NGC 1982; McKendry 1988; McMann 1997.

BARRE, RAOUL (1874-1932), Montréal, QC. Painter. He studied in Paris. **Citations**: Laliberté 1986; NGC 1982; Duval 1990.

BARRY, FRANCIS LEOPOLD (b1913), Montréal, QC. Painter and sculptor; RCA 1975. He studied

with YVES GAUCHER. **Citations**: Sisler 1980; NGC 1982; Hill 1988

BARTLETT, WILLIAM HENRY (1809-54), London, England. Bartlett is a well-known British painter and illustrator who recorded many Canadian scenes in TOPOGRAPHICAL and ROMANTI-CIZED sepia wash-drawings in 1838. His Canadian work was published in 1842, in London, as STEEL ENGRAVINGS in *Canadian Scenery*, text by N.P. Willis. These engravings were very popular and soon became the source for many copies by Canadian artists who often signed their own names without identifying their debt to Bartlett. One example is REGINALD DRAYTON who went so far as to copy the title page VIGNETTE from Volume One of *Canadian Scenery* without acknowledgement to Bartlett (see McKendry 1983, pl. 135-6; for examples by other artists see pl. 7 and 140). **Citations**: Willis 1842; Morisset 1936; Colgate 1943; McInnes 1950; Hubbard 1967;Harper 1968, 1970; Tyrwhitt 1968; Howat 1972; Ross 1973; Duval 1974; Thibault 1978; Moritz 1982; NGC 1982; McKendry 1983, 1988; Cooke 1983; Farr 1988; Marsh 1988; Hill 1988; Lerner 1991.

BARTOLINI, MARIO (b1930), Montréal, QC. Sculptor and art teacher. **Citations**: NGC 1982; Hill 1988.

BASKETRY. Most baskets made by European settlers have been for utilitarian purposes with little effort made to decorate them. Occasionally form and decoration are combined to produce aesthetically pleasing baskets that may be called FOLK ART. This was often the case in the early baskets made by North American native people (see Patterson 1973, pl. 30 and Feder 1969, pl. 102, 107 and 241). **Citations**: Feder 1969; Patterson 1973; Lerner 1991.

BAS-RELIEF. See RELIEF SCULPTURE.

BASTIN, MICHELE (b1944), Québec. Painter. **Citations**: NGC 1982; Tippett 1992.

BATEMAN, ROBERT McCLELLAN (b1930), Toronto, ON; British Columbia. Painter. He studied with Gordon Payne and CARL SCHAEFER, and is a painter of wild life in a realistic style. See Marsh for a condensed biography and a reading list. **Citations**: NGC 1982; Marsh 1988; Murray 1996(1).

BATES, MAXWELL BENNETT (1906-80), Calgary, AB; Victoria, BC. Painter, printmaker and architect; RCA 1971. He was associated with JOCK MACDONALD and other Calgary artists before moving to Victoria, where he continued to paint landscapes and figure studies. Examples of Bate's work are in the NATIONAL GALLERY OF CANADA. **Citations**: Highlights 1947; McInnes 1950; Hubbard 1960; Eckhardt 1962; Harper 1966; Duval 1972; Bates 1973; Render 1974; Lord 1974; Fenton 1978; Sisler 1980; NGC 1982; Burnett/Schiff 1983; Masters 1987; Reid 1988; Hill 1988; Marsh 1988; Lerner 1991; McMann 1997.

BATES, PATRICIA (PAT) MARTIN (b1927), Victoria, BC. Painter, sculptor and printmaker. She studied in Europe and in the USA. **Citations**: Sisler 1980; NGC 1982; Hill 1988; Lerner 1991; Tippett 1992.

BATIK. A textile printing craft in which a design is produced by a negative dyeing method. The technique was brought from Indonesia to Europe in the 19th century. **Citations**: Osborne 1970; Chilvers 1988.

BAXTER, IAIN and **INGRID**. See N.E.THING COMPANY LTD.

BAYFIELD, FANNY AMELIA WRIGHT (1814-91), Québec and Charlottetown, PE. Painter. She was a painter of flowers, landscapes and MINIATURES, and the wife of HENRY WOLSEY BAY-FIELD. **Citations**: Harper 1970; NGC 1982; Lerner 1991; Tippett 1992.

BAYFIELD, HENRY WOLSEY (1795-1885), Québec and Charlottetown, PE. Painter. He was a TOPOGRAPHICAL painter with the Royal Navy and the husband of FANNY AMELIA WRIGHT BAYFIELD. His Canadian views include sketches of Kingston in 1819. **Citations**: Harper 1970; Tippett 1992.

BEADWORK. In beadwork, decorative effect, or pictorial representation, is formed by arranging and attaching different coloured beads on a foundation such as cloth (see McKendry 1983, pl. 154). The foundation used in the beadwork of North American native people was usually cloth or leather. In some woven beadwork, the beads were strung on threads in a pattern during weaving to produce a band of

beadwork. **Citations**: Feder 1969; Patterson 1973; McKendry 1983; Lerner 1991.

BEAM, CARL (b1943), Manitoulin Island, ON. Painter and printmaker. He is a native Canadian artist. Beam's work is represented in the CANADIAN MUSEUM OF CIVILIZATION. **Citations**: Ojibwa 1981; Houle 1982; NGC 1982; Lerner 1991.

BEAMENT, THOMAS HAROLD (1898-1984), Montréal, QC. Painter and printmaker; RCA 1947. Beament studied with J.W. BEATTY (1922) and travelled widely. He is the father of TIB BEAMENT. **Citations**: McInnes 1950; Hubbard 1960; MacDonald 1967; Beament 1968; Sisler 1980; NGC 1982; Hill 1988; McMann 1997.

BEAMENT, THOMAS HAROLD (TIB) (b1941), Montréal and Ayer's Cliff, QC. Painter and printmaker. He studied with ALBERT DUMOUCHEL and is the son of THOMAS HAROLD BEA-MENT. **Citations**: MacDonald 1967; Watson 1974; Sisler 1980; NGC 1982; Hill 1988; McMann 1997.

BEARDY, JACKSON (1944-84), Winnipeg, MB. Painter. Although Beardy studied art, he maintained a deep interest in native Ojibwa and Cree traditions, myths and legends. His work is graphic with clear references to native legends and nature. For a time he was associated with DAPHNE ODJIG, NORVAL MORRISSEAU, CARL RAY, and ALEX SIMEON JANVIER. **Citations**: Patterson 1973; Hughes 1979; Highwater 1980; NGC 1982; Marsh 1988; McKendry 1988; Lerner 1991.

BEASTALT (BEASTALL), WILLIAM (act. 1795-97), Saint John, NB. Painter. Beastalt is thought to have been an ITINERANT miniaturist who was listed as a Freeman of the City of Saint John in 1797 under the profession of portrait painter. None of his works has been identified. **Citations**: Harper 1966, 1970.

BEATTY, JOHN WILLIAM (BILL) (1869-1941), Toronto, ON. Painter, art teacher and printmaker; RCA 1913. Beatty studied with J.W.L. FORSTER, GEORGE A. REID and WILLIAM CRUIKSHANK. He painted in the Rocky Mountains in 1914 with A.Y. JACKSON and C.W. JEFFERYS. See Farr 1981 for an examination of Beatty's life and work. **Citations**: MacTavish 1925; Housser 1926; Robson 1932; Colgate 1943; Hoover 1948; McInnes 1950; Harper 1955, 1966; Jackson 1958; Hubbard 1960; MacDonald 1967; Groves 1968; Mellen 1970; Lord 1974; Reid 1979, 1988; Laing 1979, 1982; Sisler 1980; Farr 1981; Hill 1988; Lerner 1991 McMann 1997.

BEAU, HENRI (1863-1949), Montréal, QC; Paris, France. Painter. Beau's paintings are mostly small IMPRESSIONISTIC views of the countryside in France, where he was employed as an archivist for the NATIONAL ARCHIVES OF CANADA. **Citations**: Laberge 1938; Harper 1966; NGC 1982; Laliberté 1986; Reid 1988; Hill 1988; Duval 1990; Lerner 1991.

BEAUCHEMIN, MICHELINE (b1930), Grondines, QC. Weaver and stained glass artist. She studied with ALFRED PELLAN and has travelled widely. Her tapestries hang in many important buildings in Montréal, Ottawa, Tokyo and other cities. **Citations**: Sisler 1980; NGC 1982; Hill 1988; Marsh 1988; Lerner 1991.

BEAUCLERK, Lord CHARLES (1818-61), Québec. Painter. Beauclerk was a British Army officer who completed a series of seven military scenes which were LITHOGRAPHED in London in 1840. **Citations**: Robson 1932; Harper 1966, 1970; NGC 1982; McKendry 1988.

BEAUCOURT, FRANCOIS (FRANCOIS MALEPART DE) (1740-94), Laprairie and Québec City, QC. Painter. François Beaucourt, son of PAUL BEAUCOURT, is considered the first native-born Canadian to achieve real recognition as an artist, to have studied extensively in Europe, and to exemplify the Canadian ROCOCO style. In 1792, he advertised in Montréal that he executed portraits, historical, theatrical scenery and landscape paintings, and that he was versed in GEOMETRICAL and AERIAL PERSPECTIVE. Beaucourt also executed religious paintings. For a perceptive analysis of his work with illustrations, see Harper 1966. **Citations**: Robson 1932; Colgate 1943; NGC 1945, 1982; McInnes 1950; Buchanan 1950; Morisset 1959; Hubbard 1960, 1960(1), 1967, 1973; Harper 1966, 1970; MacDonald 1967; Carter 1967; Boggs 1971; Lord 1974; Mellen 1978; NGC 1982; McKendry 1988; Hill 1988; Reid 1988; Lerner 1991.

BEAUCOURT, PAUL MALEPART DE GRAND MAISON (1700-56), Laprairie and Québec City,

QC. Painter. Paul Beaucourt is known for his religious paintings in oil, and he may have executed several EX-VOTO paintings (see Harper 1966, pl. 17 and 18). He was the father of FRANCOIS BEAUCOURT. **Citations**: NGC 1945, 1982; Buchanan 1950; Barbeau (Québec) 1957; Harper 1966, 1970; Hubbard 1967; Lessard 1971; Lord 1974; NGC 1982; McKendry 1988; Reid 1988; Béland 1992.

BEAUDIN, JEAN-PIERRE (b1935), Montréal, QC. Photographer and printmaker. He studied under ALBERT DUMOUCHEL. **Citations**: Sisler 1980; NGC 1982; Hill 1988.

BEAUDOIN, ANNA (act. 1900), Saint-Henri-de-Lévis, QC. Painter. Beaudoin is known for a naïve watercolour drawing of a map of the Parish of Saint-Henri-de-Lévis in which her home was situated. The church and each house is drawn with some attempt at perspective. The parish roads are named, with all enclosed in an attractive running vine border (see Harper 1974, pl. 80). **Citations**: Harper 1973, 1974; Kobayashi 1985(2); McKendry 1988.

BEAUFOY, BENJAMIN (d1879), Québec. TOPOGRAPHICAL painter of Québec scenes. He was with the British army. **Citations**: Spendlove 1958; Harper 1970; Thibault 1978.

BEAULAC, HENRI (b1914), Québec. Artist and designer. He is the husband of SIMONE MARIE YVETTE HUDON-BEAULAC. **Citations**: NGC 1982; Lerner 1991.

BEAULIEU, JOSEPH ALPHONSE (1871-1958), Montréal, QC. Portrait painter. **Citations**: NGC 1982; Laliberté 1986.

BEAULIEU, PAUL VANIER (b1910), St-Sauveur-des-Monts, QC. Painter and printmaker. He studied in Montréal and Paris, and is a brother of LOUIS-JACQUES BEAULIEU JAQUE. **Citations**: Sisler 1980; Beaulieu 1981; NGC 1982; Hill 1988; Lerner 1991.

BEAUPRE, ALFRED (1884-1957), Montréal, QC. Painter. **Citations**: Laliberté 1986.

BEAUPRE, EUGENE (1877-1946), Kingston and Toronto, ON. Printmaker. An ETCHING by this artist is in the NATIONAL GALLERY OF CANADA. After 1936 he lived in California. **Citations**: Hill 1988.

BEAUVAIS, RENE. See SAINT-JAMES dit BEAUVAIS.

BEAVER. The beaver, Canada's largest rodent and a national emblem, is a common theme in Canadian folk art, particularly in Québec Province. It appears on HOOKED MATS, butter and maple sugar moulds, weathervanes, canoe cups, and so on. (See McKendry 1983, pl. 227, 253 and 261.) See also FOLK ART, CANADA. **Citations**: Martin 1892; McKendry 1983; Marsh 1988; Lerner 1991.

BEAVER HALL (HILL) GROUP. This Group of English speaking artists, who had been students of WILLIAM BRYMNER, was formed in 1920 with the encouragement of A.Y. JACKSON. They all had studios on Beaver Hall Square in Montréal. The Group included EDWIN HOLGATE, RANDOLPH HEWTON, PRUDENCE HEWARD, MABEL MAY, SARAH ROBERTSON, ANN SAVAGE and LILIAS TORRANCE NEWTON. **Citations**: McInnes 1950; Jackson 1958; Harper 1966; Lord 1974; Hill 1975; Burnett/Schiff 1983; Reid 1988; Lerner 1991; Tippett 1992.

BEAVER, JAMES (1846-1925), Brantford, ON. Painter. Beaver was an ITINERANT, native artist who worked in several Ontario districts and is known for his naïve, somewhat romantic, landscape paintings. Beaver, a hereditary Chief of the Cayuga Tribe in the Iroquois Confederacy, lived on the Six Nations Reserve. **Citations**: Harper 1970; Kobayashi 1985(1); McKendry 1988.

BECARD DE GRANVILLE, CHARLES (1675-1703), Québec City. Becard prepared maps of the Québec area in 1699 with a cartouche view of Québec City. **Citations**: Harper 1966, 1970; McKendry 1988.

BECKER, JOSEPH (1841-1910), ON. Painter and illustrator. Becker is known for a sketch of Toronto published in 1887 and a naïve oil painting of the first trans-continental CPR train. **Citations**: Harper 1970; McKendry 1988.

BEDWELL, EDWARD PARKER (act1851, d1919), Vancouver Island, BC. Painter. He was a TOPOGRAPHICAL painter of British Columbia scenery and was with the British navy. **Citations**: Harper 1970; Peters 1978; Gilmore 1980; Lerner 1991.

BEECHEY, FREDERICK WILLIAM (1796-1856), Canadian Arctic. Painter. He was the father of

FRANCES ANNE HOPKINS and sketched in the Arctic while with the British navy. **Citations**: Harper 1970; Lerner 1991; Tippett 1992.

BEETON, WILLIAM (b1935), Toronto, ON. Painter and printmaker. A LINOCUT by Beeton is in the NATIONAL GALLERY OF CANADA. **Citations**: NGC 1982; Hill 1988.

BEGIN, CHARLES BENJAMIN (b1874), Mahone Bay, NS. Painter. Decorative free-hand and stencilled paintings on the ceilings, mantelpiece, and fireboard of a house in Mahone Bay are attributed to this man, who was a sailmaker and an artist, and who was living in the house in 1895 (see Greenaway 1986, pl. 29). **Citations**: Greenaway 1986; McKendry 1988.

BEHNAN, MICHAEL (b1947), Gore's Landing, ON. Painter. He is the husband of LYNDA LAPEER. **Citations**: NGC 1982.

BELAND, LUC (b1951), Montréal, QC. Painter and printmaker. He studied art in Montréal. A colour LITHOGRAPH by Béland is in the NATIONAL GALLERY OF CANADA. **Citations**: NGC 1982; Hill 1988; Lerner 1991.

BELANEY, ARCHIBALD (ARCHIE) STANSFELD (GREY OWL), (1888-1938), Ontario and Saskatchewan. Conservationist, author and illustrator. Belaney, born in England, left for northern Ontario at age seventeen. He associated with the Ojibwa and used the name Grey Owl. **Citations**: Marsh 1988.

BELANGER, LOUIS JOSEPH OCTAVE (1886-1972), Montréal, QC. Painter and illustrator. He studied in Montréal and Paris. **Citations**: NGC 1982; Laliberté 1986.

BELBIN, LOUISE (b1896), Burin Peninsula, Grand Bank, NF. Textile artist. Mrs Belbin has made a large number of decorative hooked and poked rugs with geometric or naïve designs of horses, ducks, cats, moose or flowers. Examples of her work are in the collection of Memorial University Art Gallery, St John's, NF. **Citations**: Goodridge 1978; *Artisan'78* 1979; Lynch 1980; McKendry 1988.

BELCHER, EDWARD (1799-1877), Halifax, NS; Newfoundland. Painter of TOPOGRAPHICAL Arctic scenes. Belcher, who was with the Royal Navy, visited the Arctic as a surveyor and later, in 1852-4, as commander of an Arctic expedition. He executed numerous TOPOGRAPHICAL views of the Arctic of which some were published in his book *The Last of the Arctic Voyages*, London, 1855. **Citations**: Harper 1970; McKendry 1988; Lerner 1991.

BELFIELD, W. (act. 1851), Halifax, NS. Painter. This artist, thought to have been a paymaster with the British army in Halifax, is known for a watercolour view of Halifax with a Micmac encampment in the foreground (see Allodi 1974, pl. 139). Other artists who painted similar Micmac encampments are WILLIAM EAGER, JOHN GEORGE TOLER, and JAMES PATTISON COCKBURN. **Citations**: Allodi 1974; McKendry 1988.

BELIVEAU, RENE-CHARLES (1872-1914), Québec. Landscape and portrait painter. He studied in Paris and returned to Canada in 1900. **Citations**: NGC 1982; Laliberté 1986.

BELL. See DE BELL.

BELL, ALISTAIR MACREADY (b1913), Vancouver, BC. Painter and printmaker. He emigrated from England to Toronto in 1922, and moved to British Columbia in 1929. **Citations**: MacDonald 1967; Sisler 1980; NGC 1982; Hill 1988, Lerner 1991; McMann 1997.

BELL, DELOS CLINE. (act. 1867-76), Hamilton and Ottawa, ON. Portrait painter. **Citations**: Harper 1966, 1970; NGC 1982; McKendry 1988.

BELL, JAMES (act. 1827-40), Saint John, NB. Painter. Bell was a ship, sign and ornamental painter who painted historical scenes and possibly some portraits. He died in the Great Fire of Saint John, while attempting to save his paintings. **Citations**: Harper 1970; McKendry 1988.

BELL, LELAND (b1953), Manitoulin Island, ON. Painter. **Citations**: Ojibwa 1981; Lerner 1991.

BELLE. See DE BELLE.

BELL-SMITH, FREDERIC MARLETT (1846-1923), Toronto, Hamilton and London, ON; Montréal, QC. Painter; RCA 1886. Bell-Smith was a well-known painter of landscapes, portraits and historical subjects. He was in Montréal by 1967. See Boulet 1977 for illustrations and detailed information on this

artist. **Citations**: MacTavish 1925; Colgate 1943; McInnes 1950; Duval 1954; Hubbard 1960, 1960(1), 1967; Harper 1966, 1970; Duval 1954; MacDonald 1967; Render 1974; Boulet 1977; Sisler 1980; Baker 1981; NGC 1982; Hill 1988; Marsh 1988; Reid 1979, 1988; Cavell 1988; Lerner 1991.

BELL-SMITH, JOHN (1810-83), Montréal, QC; Hamilton and Toronto, ON. Painter. John Bell-Smith painted portraits including MINIATURES on ivory. In 1867, he was the first president of the SOCIETY OF CANADIAN ARTISTS. **Citations**: MacTavish 1925; Colgate 1943; Hubbard 1960; Harper 1966, 1970; MacDonald 1967; Boulet 1977; London 1978; Reid 1979, 1988; NGC 1982; McKendry 1988; Hill 1988.

BELLE, CHARLES-ERNEST DE. See DE BELLE.

BELLEFLEUR, LEON (b1910), Montréal, QC; Paris, France. Non-figurative painter. Several prints and paintings by Bellefleur are in the NATIONAL GALLERY OF CANADA. **Citations**: Hubbard 1960; MacDonald 1967; Harper 1966; Vie Des Arts 1978; Marteau 1978; NGC 1982; Hill 1988; Reid 1988; Lerner 1991.

BELZILE, LOUIS (b1929), Montréal, QC. Painter. Belzile studied at the ONTARIO COLLEGE OF ART and in France. He was a member of the PLASTICIENS. **Citations**: Harper 1966; NGC 1982; Reid 1988; Lerner 1991.

BENGOUGH, JOHN WILSON (1851-1923), Toronto, ON. CARTOONIST. Bengough was a popular CARTOONIST by 1873, when he founded the satirical journal GRIP in which he published his own work. His line caricatures of political figures included hand-lettered labels and slogans. **Citations**: Colgate 1943; McInnes 1950; Harper 1966, 1970; Mellen 1970; McLeish 1973; Bengough 1974; Lord 1974; Higginson 1975; Desbarats 1979; NGC 1982; McKendry 1988; Marsh 1988.

BENNER, TOM (b1950), London, ON. Sculptor, painter and mixed media artist. Benner uses his work to draw attention to disappearing species of animals and birds. Some of his work is in a deliberately naïve style, for example a group of life-size musk oxen carved from thick wooden planks with flat metal horns and metal outline-strapping. **Citations**: Wilkins 1976(1); NGC 1982; *Whig-Standard*, July 18, 1987; McKendry 1988.

BENNETT, WILLIAM JAMES (1787-1844), USA. Painter. He exhibited paintings and published prints of Niagara Falls. **Citations**: Stokes 1933; Jefferys 1948; Spendlove 1958; Harper 1970.

BENTHAM, DOUGLAS (DOUG) (b1947), Saskatchewan and Alberta. Sculptor. His work includes large steel sculptures. **Citations**: Wilkin 1973(1); Walters 1975; Christie 1976; Heath 1976; NGC 1982; Lerner 1991.

BENY, WILFRED ROY ROLOFF (1924-84), Rome, Italy. Photographer, painter, printmaker and author. He was born in Medicine Hat, AB, but lived in Rome from 1956. He produced several lavishly illustrated books based on his travels. **Citations**: Mendel 1964; MacDonald 1967; Sisler 1980; NGC 1982; Hill 1988; Marsh 1988; Lerner 1991; McMann 1997.

BER. See LE BER.

BERCIER, ETIENNE (1788-1854), Québec. Sculptor of religious subjects in wood. **Citations**: NGC 1982; Porter 1986.

BERCZY, CHARLES ALBERT (1794-1858), Montréal and Québec City, QC; Toronto, ON. Painter. Charles Albert Berczy, son of WILLIAM VON MOLL BERCZY Senior and JEAN-CHARLOTTE BERCZY, was an amateur portrait and landscape painter whose work included sketches of churches and other buildings in Québec City, 1809. **Citations**: Harper 1966, 1970; Andre 1967; McKendry 1988; Tovell 1991.

BERCZY, JEAN-CHARLOTTE (1760-c1833), Toronto, ON; Montréal, QC. Painter. Jean-Charlotte Berczy was the wife of WILLIAM VON MOLL BERCZY Senior. She was a painter of MINIATURES and taught watercolour painting to young ladies in Montréal c1804-1812. **Citations**: Andre 1967; Harper 1970; McKendry 1988; Lerner 1991; Tovell 1991.

BERCZY, LOUISE AMELIE PANET (1789-1862), Amherstburg, ON; Québec City, QC. Painter and art teacher. Louise Amelie Berczy was the wife of WILLIAM BERCZY Junior. **Citations**: Harper

1966, 1970; Andre 1967; McKendry 1988; Tovell 1991; Tippett 1992.

BERCZY, WILLIAM BENT (1791-1873), Toronto and Amherstburg, ON; Montréal and Québec City, QC. Painter. He was a son of WILLIAM VON MOLL BERCZY Senior. **Citations**: Andre 1967; Hill 1988; Lerner 1991; Tovell 1991.

BERCZY, WILLIAM VON MOLL Senior (1744-1813), Toronto, ON; Montréal, QC. Painter and architect. Berczy, born in Saxony and raised in Vienna, was a professional painter known for his portrait, historical, religious and decorative paintings, usually characterized as NEOCLASSICAL in style. His work included group portraits and MINIATURES on ivory. Berczy toured Europe in the 1770s as an ITINERANT miniaturist. Later he became involved in bringing a group of German immigrants to America resulting in the establishment of a German settlement in Markham Township near Toronto in 1794-5. He painted numerous portraits, including three of Joseph Brant (Harper 1966, pl. 59) and the well-known group-portrait, *The Woolsey Family* of 1809, now in the NATIONAL GALLERY OF CANADA. The latter painting may be the first Canadian CONVERSATION PIECE painted in Québec (see Harper 1966, pl. 57 and 58). Harper also refers (p. 75) to some religious work done for the Ursuline nuns. There has been considerable confusion in the attributions of portraits to Berczy Sr, DULONGPRE Sr and GERRITT SCHIPPER. **Citations**: Morisset 1936; Hubbard 1960, 1967; Harper 1966, 1970; Carter 1967; Andre 1967; MacDonald 1967; Boggs 1971; Allodi 1974; Duval 1974; Johnson 1975; Trudel 1976; Burns 1977; Mellen 1978; Boyanoski 1982; NGC 1982; Marsh 1988; McKendry 1988; Hill 1988; Piper 1988; Lerner 1991; Tovell 1991; Béland 1992; Kalman 1994.

BERCZY, WILLIAM VON MOLL Junior (1791-1873), Montréal, QC; Amherstburg, ON; Joliette, QC. Painter. This Berczy was a son of William Senior and husband of LOUISE AMELIE PANET BERCZY. He assisted William Senior with the restoration of an ALTARPIECE for the URSULINE CONVENT Chapel, Québec, and painted in backgrounds for his father`s MINIATURES. If an attribution to William Junior (Harper 1966, pl. 63) is correct, he had some difficulty with scale and perspective resulting in his work having a naïve aspect. **Citations**: Harper 1966, 1970; Andre 1967; Cooke 1983; McKendry 1988; Tovell 1991.

BERGER, JEAN (1682-active 1710), Montréal, QC. Painter. Berger, who came to Canada as a French marine, became a painter in Montréal. He painted the altar frontal for the Church of Sainte-Famille, ILE D'ORLEANS, QC, in 1706. In 1710, he was banished from Canada and may have resumed painting in New England. **Citations**: Harper 1966, 1970; NGC 1982; McKendry 1988.

BERGERON, GASTON (b1922), Laval, QC. Sculptor. The most important work by Bergeron is a miniature circus having a large number of naïve POLYCHROMED sculptures in wood of circus figures and animals. He has made 3000 circus pieces, including 418 horses, which can be arranged in a parade 425 feet long for viewing by the public. He has executed some life-size and over life-size figures as YARD ART. There are 119 pieces by Bergeron in the CCFCS collections. **Citations**: de Grosbois 1978; Kobayashi 1985(2); McKendry 1988; CCFCS.

BERGERON, SUZANNE (b1930), Ile d'Orleans, QC. Painter and printmaker. She studied with JEAN PAUL LEMIEUX and several of her paintings are in the NATIONAL GALLERY OF CANADA. **Citations**: Hubbard 1960; Harper 1966; MacDonald 1967; NGC 1982; Hill 1988; Lerner 1991; Tippett 1992.

BERGMAN, HENRY ERIC (1893-1958), Winnipeg, MB. Painter, printmaker and illustrator. He arrived in Toronto from Germany in 1913 and moved to Winnipeg in 1914. There are several colour WOODCUTS and WOOD ENGRAVINGS by Bergman in the NATIONAL GALLERY OF CANADA. **Citations**: MacDonald 1967; Render 1974; Gilmore 1980(1); Oko 1981; NGC 1982; Hill 1988; Reid 1988; Lerner 1991.

BERKOVITZ, MARTIN (b1944), Toronto, ON. Painter and printmaker. He studied in Toronto, and lived in New York 1964-69. An example of his work is in the NATIONAL GALLERY OF CANADA. **Citations**: NGC 1982; Hill 1988.

BERLIN, EUGENIA (b1905), Toronto, ON. Sculptor and ceramist. She studied in Europe, the USA

and under ELIZABETH WYN WOOD and BOBS COGILL HAWORTH in Toronto. A bronze head of MARIUS BARBEAU by Berlin is in the NATIONAL GALLERY OF CANADA. **Citations**: MacDonald 1967; NGC 1982; Hill 1988.

BERLINQUET, FRANCOIS-XAVIER (b1830), Québec City, QC. Sculptor and contractor. JEAN-BAPTISTE COTE was apprenticed to him. **Citations**: Trudel 1967(sculpture); Porter 1986.

BERLINQUET, LOUIS-THOMAS (1790-1863), Québec City and Montréal, QC. Sculptor. Berlinquet was apprenticed to the sculptor JOSEPH PEPIN for a period of ten years and is known for sculptures in POLYCHROMED wood of religious figures. **Citations**: Vaillancourt 1920; Fried 1920; McInnes 1950; Trudel 1967(sculpture); Simard 1975; Dobson 1982; Béland 1986; Porter 1986; McKendry 1988; Lerner 1991.

BERMAN, MICHAELE (JORDANA), (b1947), Toronto, ON. Painter, photographer, PERFORMANCE ARTIST and art teacher. He studied under KENNETH LOCHHEAD and GEORGE SWINTON. An example of Berman's work is in the NATIONAL GALLERY OF CANADA. **Citations**: NGC 1982; Hill 1988; Lerner 1991.

BERTHON, GEORGE THEODORE (1806-92), Toronto, ON. Portrait painter. Berthon, born in Vienna, arrived in Toronto about 1844. He painted many formal portraits of Upper Canada's business, legal and political establishment. Several portraits by Berthon are in the NATIONAL GALLERY OF CANADA. **Citations**: Hopkins 1898; Morris; Colgate 1943; McInnes 1950; Hubbard 1960(1), 1967; Harper 1964,1966, 1970; MacDonald 1967; Carter 1967; Lord 1974; Mellen 1978; Sisler 1980; NGC 1982; Boyanoski 1982; McKendry 1988; Marsh 1988; Hill 1988; Reid 1988; Lerner 1991; McMann 1997.

BERTRAND, NARCISSE (act1870), Québec. Sculptor of wood. **Citations**: Porter 1986.

BESSAU, OSCAR (OSKAR) (act1849-57), Kingston, ON; USA. Painter of watercolour landscapes and portraits. He did a series of St Lawrence River views, including a view of Kingston, Canada West. He advertised as Bessau de la Garnary, portrait painter, in the *Daily British Whig* newspaper on 30 November 1849. **Citations**: Harper 1970; Allodi 1974; McKendry 1988.

BESSONETT, CECILIA AUGUSTA (act. 1850), Maritime Provinces. Painter. **Citations**: NB Museum 1952; NGC 1982; Lerner 1991.

BEST, R.J. (act. c1860), New Brunswick. Painter. Little is known about this Maritime painter who executed a detailed landscape of the Saint John, NB, area. Best's paintings are similar in style to those of WILLIAM GEORGE RICHARDSON HIND. **Citations**: Duval 1974; McKendry 1988.

BEST, W.R. (act. c1851-60), St John's, NF. Painter, illustrator and architect. Best was an English architect and illustrator who executed a set of views of public buildings in St John's which were published as LITHOGRAPHS in 1851 and 1858. There is a watercolour painting by Best in the ROYAL ONTARIO MUSEUM collections, Toronto, ON (see Allodi 1974, pl. 147.) **Citations**: Harper 1966, 1970; Allodi 1974; McKendry 1988.

BETHUNE, HENRY NORMAN (1890-1939), Toronto, ON; Montréal, QC. Surgeon. He was associated with FRITZ BRANDTNER in setting up in 1936 of a Children's Art Centre for the underprivileged in Montréal. **Citations**: Lord 1974; NGC 1982; Reid 1988; Lerner 1991.

BETTS, AUGUSTA (c1843-1919), Kingston, ON. Painter. This artist is known for a naïve memorial painting in watercolour commemorating the death of her brother in the wreck of a steamship off Newfoundland in 1875 (see McKendry 1983, pl. 175.) **Citations**: McKendry 1979(Photography), 1983, 1988.

BEVERIDGE, KARL JOHN (b1945), Toronto, ON. Sculptor, photographer, printmaker and art teacher. He studied under ARTHUR HANDY and ROBERT HEDRICK. Beveridge lived in New York 1969-77. Examples of his work are in the NATIONAL GALLERY OF CANADA. **Citations**: NGC 1982; Hill 1988; Lerner 1991.

BEYNON, JOHN HUBERT (b1890), Toronto, ON. Painter and commercial artist. He was a nephew of CURTIS WILLIAMSON and studied with WILLIAM CRUIKSHANK. One of Beynon's paintings is

in the NATIONAL GALLERY OF CANADA. **Citations**: NGC 1982; Hill 1988.

BICE, CLARE (1909-76), Ontario and the Maritime Provinces. Painter, illustrator, art teacher and curator; RCA 1966. She studied in Canada and in New York. An oil by Bice is in the NATIONAL GALLERY OF CANADA. **Citations**: MacDonald 1967; Sisler 1980; NGC 1982; Hill 1988; Lerner 1991; McMann 1997.

BIELER, ANDRE CHARLES (1896-1989), Kingston, ON. Painter, printmaker, sculptor and art teacher; RCA 1959. Biéler studied in Paris and in Switzerland, and was in Canada by 1908. He was a very active painter of landscape and GENRE in Québec, including the ILE D'ORLEANS, and Ontario, as well as taking a leading part in art education and art societies. In 1941 Biéler organized the first conference of Canadian artists which resulted in the FEDERATION OF CANADIAN ARTISTS with Biéler as its first president. Also he helped found the AGNES ETHERINGTON ART CENTRE in Kingston in 1957 and was its first director. Paintings by Biéler are in the NATIONAL GALLERY OF CANADA and many other galleries. See also ILE D'ORLEANS. **Citations**: Robson 1932; Trotter 1937; Colgate 1943; Barbeau 1946; McInnes 1950; Duval 1954, 1972; Hubbard 1960, 1963; Ayre 1963, 1977; Harper 1966; MacDonald 1967; Smith 1968, 1980, 1988; Farr 1988; Allen 1970; Duval 1972; Sisler 1980; Aimers 1981; Bringhurst 1983; Burnett/Schiff 1983; Laliberté 1986; Hill 1988; Reid 1988; Marsh 1988; Lerner 1991; Hill 1995; Silcox 1996; McMann 1997.

BIELER, ANDRE CHARLES THEODORE (TED) (b1938), Sculptor. Ted Biéler is a son of ANDRE CHARLES BIELER. **Citations**: MacDonald 1967; Sisler 1980; Smith 1980; NGC 1982; Lerner 1991; McMann 1997.

BIERSTADT, ALBERT (1830-1902), New York. American painter. He was a contemporary of PAUL KANE, CORNELIUS KRIEGHOFF and ALFRED JACOB MILLER. Bierstadt took part in the LUMINIST movement in the United States. He visited Canada c1880-4, and painted in Ottawa and in Québec. THOMAS MOWER MARTIN met Bierstadt while painting in the Rocky Mountains. **Citations**: Harper 1966, 1970; Jones 1968; Mellen 1970; Howat 1972; Ewers 1973; Wilmerding 1980; Baigell 1981; Goetzmann 1986; Lerner 1991.

BIGELOW, ROBERT CLAYTON (BOB) (b1940), British Columbia and Montréal, QC. Printmaker, painter, sculptor and art teacher. He studied in the USA. An example of his work is in the NATIONAL GALLERY OF CANADA. **Citations**: NGC 1982; Hill 1988.

BIGSBY, JOHN JEREMIAH (1792-1881), Ontario and Québec. Painter and author. Bigsby travelled through Ontario, Québec and the lower Hudson's Bay region making TOPOGRAPHICAL sketches of landscape in sepia, and pen and ink. Some of the sketches were published in 1850 in his book *The Shoe and Canoe*. **Citations**: Harper 1970; Baker 1981; McKendry 1988.

BILLET HEAD. See SHIP CARVINGS.

BINGHAM, WILLIAM ST MAUR (act 1858-62), Québec. Painter of family groups in a naïve manner, see Thibault 1978, p. 59, for an example. **Citations**: Harper 1970; Thibault 1978.

BINNING, BERTRAM CHARLES (1909-76), Vancouver, BC. Painter, illustrator, teacher and curator; RCA 1966. He studied with CHARLES H. SCOTT, F.H. VARLEY and JOCK MACDONALD and became known for his drawings. Binning has been referred to as a painter of decorative abstractions. **Citations**: Buchanan 1950; McInnes 1950; Harper 1966; MacDonald 1967; Duval 1972; Sisler 1980; NGC 1982; Bringhurst 1983; Burnett/Schiff 1983; Marsh 1988; Hill 1988; Reid 1988; Lerner 1991; McMann 1997.

BIRDS. Birds, stylistic or realistic, symbolic or decorative, have been a continuous theme in RELIGIOUS ART as well as in naïve paintings and sculpture. The most popular may be the rooster (cock) and the peacock. The rooster is a symbol of watchfulness and vigilance (see McKendry 1983, pl. 123 -6), and is one of the symbols of the PASSION. The peacock is a religious symbol of immortality used in scenes of the NATIVITY, because of a legendary belief that its flesh does not decay. The peacock's strutting and display of feathers has become a symbol of worldly pride and vanity. Other birds, such as the duck and goose have given rise to the craft of DECOY carving. **Citations**: Ferguson 1967;

McKendry 1983; NMM 1983; Fleming 1987; Lerner 1991.

BIRD TREE. Birds are a popular theme in FOLK ART. Some artists go beyond the carving of single bird by executing a small flock of birds arranged in tree branches or other supports mounted on a base. For examples, see McKendry 1983, pl. 85; NMM 1983, pl. 208. **Citations**: McKendry 1983; NMM 1983.

BIRRELL, EBENEZER (1801-88), Pickering, ON. Painter. Birrell, who emigrated to Canada in 1834, was a prominent well-educated farmer who appears to have painted for his own pleasure. His best known painting is *Good Friends* (Harper 1966, pl. 118; Harper 1974, pl. 47; Mellen 1978, pl. 51) now in the Art Gallery of Hamilton. It is an attractive pastoral scene, in oil, with several posed horses and cows. Birrell's work is sometimes compared to that of the American folk artist Edward Hicks (1780-1849). **Citations**: Harper 1966, 1973, 1974; Hubbard 1967; Carter 1967; Lord 1974; Forsey 1975; Mellen 1978; NGC 1982; Kobayashi 1985(2); McKendry 1988.

BISHOP LAVAL. See LAVAL.

BITTAR, ANTOINE (act1990), Montréal, QC. Landscape and figure painter. **Citations**: Kastel.

BJELAJAC, NIKOLA (NICOLA) (b1919), Winnipeg, MB. Painter. He studied in the USA. **Citations**: Swinton 1961; NGC 1982.

BLACKSMITHING. The craft of forging iron has been practiced in Québec since the latter part of the 17th century. From 1738 to 1883 iron was produced near Trois-Rivières at the FORGES SAINT-MAURICE and made into forged products as well as moulded articles such as stoves, pots and pans. Blacksmithing included craftsmen who were gunsmiths, nailsmiths, locksmiths, tool makers, decorative artists, and farriers, and who became essential members of every community across Canada. Work was produced of high aesthetic and technical quality and, because of the durable nature of iron, many early examples survive (see McKendry 1983, pl. 35, 241-3; NMM 1983, pl. 3-9). The first iron mine in Ontario was at Marmora in Hastings County, and it was the subject of a watercolour painting by SUSANNA MOODIE (see Bell 1973, p. 122). For the life story of a second-generation Ontario blacksmith, WALTER CAMERON, see Armstrong 1979. **Citations**: Seguin 1959; D`Allemagne 1968; Shaw 1972; Lessard 1974; Armstrong 1979; *Canadian Collector*, November, 1980; Genest 1982; Marsh 1988; Lerner 1991.

BLACKWOOD, DAVID LLOYD (b1941), Toronto and Port Hope, ON. Printmaker, illustrator and painter. He studied under JOHN ALFSEN, JOCK MACDONALD, CARL SCHAEFER and others. A colour ETCHING by Blackwood is in the NATIONAL GALLERY OF CANADA. **Citations**: Mowat 1973; Sisler 1980; NGC 1982; Hill 1988; Lerner 1991; McMann 1997.

BLAIR, R. JOHN (act. end of 19th century), Manitoba. Painter of prairie scenes. An oil painting of buffaloes on the prairie in the NATIONAL GALLERY OF CANADA is signed by this artist as well as R.B. Blair. **Citations**: Harper 1970; NGC 1982; Hill 1988.

BLAIR, ROBERT BROWN (act1886-1901), Winnipeg, MB. Painter. He is known to have painted an oil landscape of Upper Fort Garry. See R. JOHN BLAIR. **Citations**: Hubbard 1960; Harper 1970; NGC 1982; Hill 1988.

BLAKE, SARA MARY (1864-1933), Pincher Creek, AB Painter. Blake lived on her brother's ranch near Pincher Creek where, in 1889, she painted a naïve watercolour landscape showing the ranch buildings. **Citations**: Render 1970, 1974; NGC 1982; McKendry 1988; Tippett 1992.

BLAKEY, M. (act. 1840), Prescott, ON. Painter. Blakey was a daughter of the Reverend Robert Blakey, first rector of Augusta, Upper Canada. Her only known work is a naïve painting in watercolour of a view of the ruins of Dryburgh Abbey, England. It is thought to be copied from an ENGRAVING. **Citations**: McKendry 1983, 1988.

BLAKSTAD, ROLPH KENNETH (b1929), Ibiza, Spain. Painter and architect. He was born in Vancouver, British Columbia, and studied with B.C. BINNING. He has been an architect in Ibiza since 1956. One of his drawings is in the NATIONAL GALLERY OF CANADA. **Citations**: NGC 1982; Hill 1988.

BLAND, JAMES ALFRED ANTHONY (1865-1928), Pembroke and Ottawa, ON. Painter and art teacher. He painted scenes along the St Lawrence River and made ship models. **Citations**: Harper 1970; NGC 1982.

BLAUVELT, JACOB L. (act. 1915), Tusket, NS. Painter. Blauvelt is listed in McAlpine's *Nova Scotia Directory* for 1914-15 as a professional painter. In 1915, he was commissioned to decorate the chancel of the Ste Anne du Ruisseau Roman Catholic Church, in Yarmouth County, with religious scenes and stencilled symbols. **Citations**: Greenaway 1986; McKendry 1988.

BLOEM, JAN JACQUES (act1718), Québec. Sculptor of religious subjects in wood. **Citations**: Porter 1986.

BLOM, WILLEM (WIM) ADRIAAN (b1927), Ottawa, ON. Painter, printmaker, art teacher and curator. He was born in South Africa, travelled widely and arrived in Canada in 1959. Examples of his paintings are in the NATIONAL GALLERY OF CANADA. **Citations**: NGC 1982; Hill 1988.

BLOORE, RONALD LANGLEY (b1925), Regina, Saskatchewan and Toronto, ON. ABSTRACT painter, MURALIST and sculptor. He was a member of the REGINA FIVE. Several paintings by Bloore are in the NATIONAL GALLERY OF CANADA. **Citations**: Simmins 1961; Harper 1966; Duval 1972; Withrow 1972;Fenton 1978; Osborne 1981; NGC 1982; Burnett/Schiff 1983; Bringhurst 1983; Hill 1988; Marsh 1988; Reid 1988; Heath 1991; Lerner 1991.

BOBAK, BRUNO JOSEPH (BRUNISLAW JACOB) (b1923), Fredericton, NB. Painter, sculptor and printmaker. He is the husband of MOLLY LAMB BOBAK. He studied with ARTHUR LISMER, CHARLES GOLDHAMER, CARL SCHAEFER, ROBERT ROSS, PETER HAWORTH and ELIZA-BETH WYN WOOD. Several paintings and prints by Bobak are in the NATIONAL GALLERY OF CANADA. **Citations**: Hubbard 1960; Harper 1966; Andrus 1966; MacDonald 1967; Duval 1972; Sisler 1980; NGC 1982; Burnett/Schiff 1983; Hill 1988; Marsh 1988; Reid 1988; Lerner 1991; McMann 1997.

BOBAK, MOLLY JOAN LAMB (b1922), Fredericton, NB. Painter, printmaker and writer. Molly Bobak is the wife of BRUNO BOBAK. She studied with JACK SHADBOLT and CHARLES H. SCOTT. Several of her paintings are in the NATIONAL GALLERY OF CANADA. **Citations**: Hubbard 1960; Andrus 1966; Harper 1966; MacDonald 1967; Duval 1972; Sisler 1980; NGC 1982; Burnett/Schiff 1983; Hill 1988; Marsh 1988; Lerner 1991; Tippett 1992; McMann 1997.

BODMER, CHARLES (or KARL) (1809-93), Switzerland and France. Painter, LITHOGRAPHER and ENGRAVER. He painted native people and Niagara Falls in Canada and the USA. **Citations**: Stokes 1933; Rasky 1967; Harper 1970; Davis 1976; Goetzmann 1986; Lerner 1991.

BOHLE, GEORGE DAVID (1831-69), Montréal, QC. Silversmith. He was the son of PETER BOHLE. Sugar tongs by Bohle are in the NATIONAL GALLERY OF CANADA. See also SILVER-SMITHING. **Citations**: Traquair 1940; Langdon 1960, 1966, 1968; Hill 1988.

BOHLE, PETER (PIERRE) (1786-1862), Montréal, QC. Silversmith. He is the father of GEORGE DAVID BOYLE, and was apprenticed to ROBERT CRUICKSHANK 1800-c1807. An example of his work is in the NATIONAL GALLERY OF CANADA. See also SILVERSMITHING. **Citations**: Traquair 1940; Langdon 1960, 1966, 1968; Hill 1988.

BOISVERT, GILLES (b1940), Montréal and Val Morin, QC. Printmaker and painter. He studied with ALBERT DUMOUCHEL 1958-64. Several prints by Boisvert are in the NATIONAL GALLERY OF CANADA. **Citations**: *Vie des Arts* 1978; NGC 1982; Hill 1988; Lerner 1991.

BOLDUC, BLANCHE (b1907), Baie-Saint-Paul, QC. Painter. Bolduc's paintings are detailed, realistic, naïve paintings of everyday life near her home in Baie-Saint-Paul. Her work includes paintings of people gathered in the general store or the barber shop, the parish priest making his rounds, a religious procession from the parish church, and the interiors of farmhouses with people at their everyday tasks. *La Procession de la Fête-Dieu* of 1972 is illustrated in Latour 1975. She started painting in 1966 with the encouragement of her sister of YVONNE BOLDUC; her earlier paintings are signed B.B., but in the 1970s she began to sign them in full. **Citations**: Lessard 1975; Latour 1975; NGC 1982; McKendry 1988; Lerner 1991; Tippett 1992.

BOLDUC, DAVID WAYNE (b1945), Toronto, ON. Painter, printmaker, sculptor and art teacher. He studied with JEAN GOGUEN and ARTHUR LISMER. Several paintings by Bolduc are in the NATIONAL GALLERY OF CANADA. **Citations**: Wilkin 1974(1); Webster 1975; NGC 1982; Bringhurst 1983; Burnett/Schiff 1983; Hill 1988; Carpenter 1981; Reid 1988; Lerner 1991; Murray 1996(1).

BOLDUC, YVONNE (b1905), Baie-Saint-Paul, QC. Sculptor and painter. Yvonne Bolduc is both a woodcarver (see NMM 1983, pl. 184, and Baker 1981, pl. 46), and a painter of detailed, naïve, GENRE scenes similar to those painted by her sister BLANCHE BOLDUC (see Baker 1981, pl. 45-9), as well as more sophisticated themes. As a painter, Yvonne has considerable skill in handling perspective and scale, and is able to introduce rhythmic patterns in her work. She sometimes uses colours obtained from natural sources such as berries, seeds or buds. The sisters live together in the midst of the art colony at Baie-Saint-Paul, CHARLEVOIX COUNTY. **Citations**: Harper 1973; Latour 1975; Baker 1981; NGC 1982; NMM 1983; McKendry 1988; Reid 1988; Tippett 1992.

BOLLIVAR, SAMUEL (b1884), Dayspring, Lunenburg County, NS. Painter. After his retirement from the shipyards in Halifax, Bollivar painted a few colourful, flat-patterned paintings of ships and of landscape, in oil, before his eyesight failed. **Citations**: Elwood 1976; *Canadian Antiques and Art Review*, November, 1979; McKendry 1988; Lerner 1991.

BOLVIN, GILLES (c1711-66), Trois-Rivières, QC. Sculptor. The high altar of the church at Boucherville, QC, is by Bolvin. Several small sculptures, in gilded wood, of saints and other religious figures have survived (see Trudel 1969, pl. 23 -6). The lines of these statuettes are sinuous and fluid, completely avoiding any feeling of stiffness or rigidity. **Citations**: Traquair 1947; Gowans 1955; Trudel 1967(sculpture); Trudel 1969; Gauthier 1974; NGC 1982; Porter 1986; McKendry 1988; Lerner 1991.

BOND, ELEANOR (b1948), Winnipeg, MB. Painter. **Citations**: Lerner 1991; Tippett 1992.

BOND, MARION (act1930), NS. Painter. **Citations**: NGC 1982; Tippett 1992.

BONNYCASTLE, Sir RICHARD HENRY (1791-1847), Toronto, ON; Newfoundland. Amateur painter and TOPOGRAPHER. Bonnycastle was with the British Army in Canada, and served during the war of 1812-14 as well as the Rebellion of 1837. He painted amateur TOPOGRAPHICAL views of Canada and published numerous books. **Citations**: Colgate 1943; McInnes 1950; Harper 1970; Bell 1973; McKendry 1988; Marsh 1988.

BOOGAERTS, PIERRE (b1946), Montréal, QC. Photographer. He studied in Brussels and came to Canada in 1973. Examples of his work are in the NATIONAL GALLERY OF CANADA. **Citations**: NGC 1982; Hill 1988; Lerner 1991.

BORDUAS, PAUL-EMILE (1905-60), Saint-Hilaire and Montréal, QC; Paris, France. Painter. As a student, Borduas worked with OZIAS LEDUC and assisted him in church decoration. Leduc persuaded Borduas to attend the ECOLE DES BEAUX-ARTS in Montréal and to visit Paris. Upon his return to Montréal, Borduas taught school and painted by night. During the late 1930s Borduas was encouraged by JOHN LYMAN who organized exhibitions that included Borduas' work; see CONTEMPORARY ARTS SOCIETY and Duval 1972, p. 83. At first his paintings were figurative but later, after having been influenced by SURREALISM, he became involved in ABSTRACTION and the nonfigurative work for which he is now known. He was the leader of the AUTOMATISTES. Several paintings by Borduas are in the NATIONAL GALLERY OF CANADA. See Harper 1966, pl. 339, 341-3. See Lerner 1991 for an extensive bibliography of Borduas. **Citations**: Borduas 1948, 1978; McInnes 1950; Buchanan 1950; Hubbard 1960,1960(1); Harper 1966; MacDonald 1967; Townsend 1970; Boggs 1971; Ostiguy 1971; Duval 1972; Withrow 1972; Guy 1972,1977; Vachon 1973; Lord 1974; Watson 1974; Gagnon 1978; Borduas 1978; Fenton 1978; Ethier-Blais 1979; Davis 1979; Cloutier-Cournoyer 1979; George 1980; Sisler 1980; Osborne 1981; Burnett/Schiff 1983; Bringhurst 1983; Reid 1988; Marsh 1988; Chilvers 1988; Hill 1988; Piper 1988; Lerner 1991; Tippett 1992; McMann 1997.

BORENSTEIN, SAMUEL (SAM), (1908-69), Montréal, QC. Painter and sculptor. He arrived in

Montréal from Lithuania in 1921, and studied with ELZEAR SOUCY, JOHN Y. JOHNSTONE and ALFRED LALIBERTE. He became devoted to painting in the Laurentians. A painting by Borenstein is in the NATIONAL GALLERY OF CANADA. **Citations**: Ayre 1977; Kuhns 1978; NGC 1982; Hill 1988; Lerner 1991.

BORNSTEIN, ELI (b1922), Saskatoon, SK. Sculptor, painter and printmaker. He studied in the USA and in Paris. An example of his work is in the NATIONAL GALLERY OF CANADA. **Citations**: McInnes 1950; Mendel 1964; Harper 1966; Climer 1967; MacDonald 1967; Townsend 1970; Lord 1974; Heath 1976; NGC 1982; Reid 1988; Hill 1988; Lerner 1991.

BOUCHARD, EDITH MARIE (b1924), Moulin St Césaire, Baie-Saint-Paul, QC. Painter. The naïve paintings of Edith Bouchard are not as well known as those of her sisters SIMONE-MARY BOUCHARD and MARIE-CECILE BOUCHARD. Her work is more orderly, has less unity, and the forms appear rigid (see Baker 1981, pl. 50, for an example). **Citations**: MacDonald 1967; Baker 1981; NGC 1982; McKendry 1988; Lerner 1991; Tippett 1992.

BOUCHARD, LORNE HOLLAND (1913-78), Montréal, QC. Painter and illustrator; RCA 1965. He studied with WILFRED MOLSON BARNES and travelled widely. A painting by Bouchard is in the NATIONAL GALLERY OF CANADA. **Citations**: Bergeron 1946; Watson 1974; Sisler 1980; NGC 1982; Hill 1988; Lerner 1991; McMann 1997.

BOUCHARD, MARIE-CECILE (1920-73), Moulin St Césaire, Baie-Saint-Paul, QC. Painter. Marie-Cécile Bouchard painted naïve landscape, interior and figure paintings in oil (see Baker 1981, pl. 51 and 52). Her work resembles that of her sister EDITH BOUCHARD and shows some influence by her other more accomplished sister, SIMONE-MARY BOUCHARD. **Citations**: MacDonald 1967; Hubbard 1973; Farr 1975; Latour 1975; Lessard 1975; Baker 1981; NGC 1982; Kobayashi 1985(2); McKendry 1988; Lerner 1991.

BOUCHARD, MARIE JOSEPHTE (1854-1950), St-Louis-de-l'Isle-aux-Coudres, QC. Weaver. She wove a boutonné coverlet that is now in the NATIONAL GALLERY OF CANADA. **Citations**: Hill 1988.

BOUCHARD, SIMONE-MARY (1912-45), Moulin St Césaire, Baie-Saint-Paul, QC. Painter. Simone-Mary Bouchard was a sister of EDITH BOUCHARD and MARIE- CECILE BOUCHARD and lived in their ancestral home, a mill called Moulin St Césaire in the Baie-Saint-Paul area. Although the three sisters worked with similar themes, using local subjects, and in the detailed and realistic manner of naïve artists, Simone-Mary's work tends to be more rhythmic, harmonious, and sometimes lyrical (see Baker 1981, pl. 53-5). At first she hooked rugs to sell to tourists, but soon turned to painting and received considerable recognition as a folk artist for her interior, landscape, figure, religious, and still-life paintings. Several of her paintings are in the NATIONAL GALLERY OF CANADA. See also CHARLEVOIX COUNTY. **Citations**: MacDonald 1967; Hubbard 1973; Harper 1973 and 1974; Farr 1975; Latour 1975; Baker 1981; Kobayashi 1985 (2); McKendry 1988; Reid 1988; Hill 1988; Lerner 1991.

BOUCHER, WAYNE (b1943), Nova Scotia. Painter. **Citations**: Laurette 1980(3); NGC 1982; Lerner 1991.

BOUCHETTE, JEAN-FRANCOIS (1803-33), Montréal, QC. Painter. Jean-François Bouchette is a son of Colonel JOSEPH BOUCHETTE. He painted TOPOGRAPHICAL views, some of which were published as coloured LITHOGRAPHS. **Citations**: Harper 1970; McKendry 1988.

BOUCHETTE, Colonel JOSEPH (1774-1841), Montréal, QC. Painter. Colonel Joseph Bouchette studied under FRANCOIS BAILLAIRGE in 1796. He published TOPOGRAPHICAL descriptions of Canada in 1815 and 1832 with illustrations from his own sketches, and prepared surveying plans. A LITHOGRAPHED view of Montréal by Bouchette was published in 1831. One of his watercolour paintings is reproduced in Bell 1973, pl. 43. **Citations**: Hubbard 1967; Harper 1970; de Volpi 1971; Bell 1973; NGC 1982; McKendry 1988.

BOUCHETTE, JOSEPH (1798-1879), Montréal, QC. Painter. This man was the eldest son of Colonel

JOSEPH BOUCHETTE and, like his father, he painted TOPOGRAPHICAL views of Québec scenes in watercolour and prepared surveying plans. **Citations**: Harper 1970; Allodi 1974; McKendry 1988.

BOUCHETTE, ROBERT SHORE MILNES (1805-79), Québec City, QC. Painter. He was the fourth son of Colonel JOSEPH BOUCHETTE. He painted interior (Lord 1974, pl. 32) and TOPOGRAPHI-CAL views (de Volpi 1971, pl. 74) in watercolour, some of which were published. **Citations**: de Volpi 1971; Lord 1974; Allodi 1974; NGC 1982; McKendry 1988.

BOUDREAU, DONALD (act1977), Digby, NS. Sculptor and painter. Boudreau, a retired lumberman, has carved several bathing beauty figures (NMM 1983, pl. 175, 176). His other work includes naïve sculpture in POLYCHROMED wood of human figures, birds (particularly seagulls), whirligigs and some paintings. **Citations**: NMM 1983; *Canadian Art*, Spring, 1985; Kobayashi 1985(2); *Empress*, November/December, 1985; McKendry 1988; CCFCS.

BOUDREAU, PIERRE DE LIGNY (b1923), Ottawa, ON; Paris; Québec City, QC; New York City. Painter. He studied with JEAN PAUL LEMIEUX and travelled extensively in Europe as well as living in Paris for a time. Several paintings by Boudreau are in the NATIONAL GALLERY OF CANADA. **Citations**: Duval 1952; Hubbard 1960; MacDonald 1967; NGC 1982; Hill 1988; Lerner 1991.

BOUKER, Mr. (act. 1807-14), New Brunswick, Québec and Ontario. Silhouettist. Bouker was an ITINERANT SILHOUETTIST who worked in various towns in Eastern Canada as well as in the USA. **Citations**: Harper 1966, 1970; McKendry 1988.

BOULIZON, GUY (act1989), Montréal, QC. Painter of deliberately NAÏVE paintings. **Citations**: Boulizon 1989.

BOULTBEE, ALFRED ERNEST, Jr (1863-1928), Toronto, ON. Boultree was an accomplished artist who, in addition to oil paintings of landscape in Ontario and Québec, completed a large number of watercolour sketches of the Yukon (many now in the National Archives of Canada, two of which are reproduced in Bell 1973, pl. 203-4). **Citations**: Harper 1970; Bell 1973; NGC 1982; Cooke 1983; McKendry 1988; Lerner 1991.

BOULTON, MURIEL CAMERON WELSH (1881-1957), Québec City, QC. Painter. She studied in England and Paris, and was in Québec City 1908-12. One of her paintings is in the NATIONAL GALLERY OF CANADA. **Citations**: Hubbard 1960; MacDonald 1967; NGC 1982; Hill 1988

BOURASSA, NAPOLEON (1827-1916), Montréal, QC. Painter, sculptor, architect and sculptor; RCA 1880-92. He apprenticed with THEOPHILE HAMEL and was a painter of portraits and religious works for church decoration. He also executed architectural plans. Examples of his work are in the NATIONAL GALLERY OF CANADA. **Citations**: Dyonnet 1913; MacTavish 1925; Bellerive 1925; Maurault 1929; Robson 1932; Morisset 1936; Colgate 1943; Miller 1946; McInnes 1950; Trudel 1967(Peinture); Harper 1966; 1970; Hubbard 1960; 1973; MacDonald 1967; Lord 1974; Thibault 1978; *Canadian Collector* January/February, 1979; Sisler 1980; NGC 1982; Laliberté 1986; Reid 1979, 1988; McKendry 1988; Marsh 1988; Hill 1988; Lerner 1991; Béland 1992; McMann 1997.

BOURGAULT, ANDRE (1898-1958), Saint-Jean-Port-Joli, QC. Sculptor. André Bourgault, along with his brothers MEDARD BOURGAULT and JEAN-JULIEN BOURGAULT, are well-known wood carvers of Saint-Jean-Port-Joli. Their work includes both secular and religious sculpture. A good example of André Bourgault`s secular sculpture, *The Checker Game*, is in the CCFCS collections, see NMM 1983, pl. 113. **Citations**: Simard 1975; NGC 1982; NMM 1983; McKendry 1988; CCFCS; Lerner 1991.

BOURGAULT, JEAN-JULIEN (b1910), Saint-Jean-Port-Joli, QC. Sculptor. Jean-Julien is a brother of ANDRE BOURGAULT and MEDARD BOURGAULT and, like them, is a wood carver. **Citations**: Gauvreau 1940; MacDonald 1967; Simard 1975; NGC 1982; Porter 1986; McKendry 1988; Lerner 1991.

BOURGAULT, MEDARD (1897-1967), Saint-Jean-Port-Joli, QC. Sculptor. Médard Bourgault was a skilled carver of religious and secular figures in POLYCHROMED wood (see McKendry 1983, pl. 78). He founded a sculpture school in 1940, and is a brother of ANDRE BOURGAULT and JEAN-JULIEN

BOURGAULT. See Bourgault bibliography in Lerner 1991. **Citations**: Gauvreau 1940; Barbeau (Québec) 1957; Simard 1975; NGC 1982; McKendry 1983, 1988; Porter 1986; Lerner 1991.

BOURGEAU, VICTOR (1809-88), Québec. Sculptor of religious works in wood; architect. He renovated the Church of Notre Dame, Montréal, in the 1870s. **Citations**: Toker 1970; Traquair 1947; Porter 1986.

BOURGEOIS, ALBERIC (1876-1962), Montréal, QC. Painter, caricaturist and illustrator. **Citations**: Laberge 1938; NGC 1982; Laliberté 1986; Lerner 1991.

BOURICHE, HENRI (act1887), Québec. Sculptor of religious works in wood. **Citations**: Porter 1986.

BOUTAL, PAULINE (b1894), Winnipeg, MB. Painter, commercial artist and designer. **Citations**: NGC 1982; Tippett 1992.

BOUTILIER, RALPH (b1906), Milton, NS. Painter and sculptor. After a life at sea, Boutilier started painting in 1936 and only turned to sculpture in 1968. His reputation now rests mainly on sculpture, particularly his bird whirligigs - eagles, gulls, blue jays, kingfishers and hawks. In a Boutilier bird whirligig, rotation of the wind-driven tail, through internal mechanical connections, causes the wings to flap and the beak to open and close (see McKendry 1983, pl. 108, and NMM 1983, pl. 66). Detailed drawings for such a whirligig were published in September 1957 in *Popular Mechanics* magazine and it is likely that is where Boutilier got his inspiration. He has carved life-size figures in POLYCHROMED wood, including a self-portrait, and has painted Nova Scotia scenes. **Citations**: Elwood 1976; NGC 1982; NMM 1983; McKendry 1983, 1988; *Canadian Art*, Spring, 1985; *Equinox*, May/June, 1988; Lerner 1991.

BOWIE, THOMAS TAYLOR (b1905), Toronto, ON. Sculptor and teacher. Bowie, who was born in Scotland, arrived in Toronto in 1953. He taught at the ONTARIO COLLEGE OF ART 1953-70. A bronze by Bowie is in the NATIONAL GALLERY OF CANADA. **Citations**: MacDonald 1967; NGC 1982; Hill 1988.

BOWMANVILLE. See APRIL ANTIQUES AND FOLK ART SHOW.

BOXES. Folk artists have given considerable attention to decorating storage boxes, large and small, by carving and/or painting. A small storage box was carved by OCTAVE MOREL and given to LOUIS JOBIN (see McKendry 1983, pl. 204). It has a sleeping dog resting on the cover and high-relief thistles and roses on the ends and a side panel. In other cases both carving and painting have been used with good effect (see McKendry 1983, pl. 183, 205-12; NMM 1983, pl. 41-3, 47-8.) A large selection of decorative boxes from Nova Scotia is shown in Field 1985, pl. 149-209. See also FOLK ART, CANADA; CHARLES EDENSHAW.

BOYD, ALFRED (1835-1908), Winnipeg, MB. Painter. Boyd was a wealthy Englishman who became a minister in the Manitoba government in 1871, and spent some of his spare time sketching local scenes of prairie life, such as buffalo hunting and fishing through the ice (see Eckhardt 1970, pl. 22). He added descriptive comments to his drawings. **Citations**: Eckhardt 1970; NGC 1982; McKendry 1988.

BOYD, EDWARD FINLAY (1878-1964), Montréal, QC. Painter. He lived part time in New York and in Baie Saint-Paul, Québec. **Citations**: NGC 1982; Laliberté 1986.

BOYD, HENRY N. (act1867-71), Ottawa, ON. Painter. Boyd was an English artist who is known in Canada for a TOPOGRAPHICAL landscape painting in watercolour of a view of Ottawa dated 1867 (collection NATIONAL GALLERY OF CANADA; see Carter 1967, pl. 307). **Citations**: Carter 1967; Harper 1970; McKendry 1988.

BOYD, JAMES HENDERSON (b1928), Ottawa, ON. Printmaker, sculptor, graphic designer and painter. He studied with several artists in New York. Prints by Boyd are in the NATIONAL GALLERY OF CANADA. **Citations**: MacDonald 1967; Sisler 1980; NGC 1982; Hill 1988; Lerner 1991.

BOYER, BOB (b1948), Regina, SK. Painter. His work is represented in the CANADIAN MUSEUM OF CIVILIZATION. **Citations**: NGC 1982; Houle 1982; Zepp 1984.

BOYLE, JOHN BERNARD (b1941), Elsinore, ON. Painter and printmaker. Boyle, who was self-taught, began painting around 1962 with the support of his friends GREG CURNOE and JACK

CHAMBERS. He was a founder-member of the NIHILIST SPASM BAND 1964. Examples of his work are in the NATIONAL GALLERY OF CANADA. **Citations**: Sisler 1980; NGC 1982; Bringhurst 1983; Burnett/Schiff 1983; Hill 1988; Reid 1988; Marsh 1988; Lerner 1991.

BRADETTE, MERENCE (act. 2nd half 19th century), Baie St-Paul, QC. Weaver. A coverlet by her is in the NATIONAL GALLERY OF CANADA. **Citations**: Hill 1988.

BRADFORD, WILLIAM (1823-92), Canadian Arctic and Labrador. Painter. He began his study of art in 1857, and became well known for ship paintings and for studies of the New England and Canadian coast. In 1869 he visited the Arctic, and later exhibited his paintings of that region. **Citations**: Harper 1966, 1970; Render 1970; Fielding 1974; McKendry 1988.

BRADISH, ALVAH (1806-1901), Toronto and Kingston, ON. Portrait painter. He was an American painter who from time to time worked in Canada. **Citations**: Harper 1966, 1970; Fielding 1974.

BRADSHAW, ALICE (b1916), Montréal, QC. Printmaker and painter. She studied with CHARLES GOLDHAMER and PETER HAWORTH. Three WOOD ENGRAVINGS by Bradshaw are in the NATIONAL GALLERY OF CANADA. **Citations**: Hill 1988.

BRADSHAW, EVA THERESA (1873-1938), London, ON. Painter. **Citations**: NGC 1982; Tippett 1992.

BRAINERD, CHARLOTTE BLANCHE MATTISON (b1921), Toronto, ON. Printmaker and painter. She studied with PETER ASPELL and ANDRE BIELER. Two of her prints are in the NATIONAL GALLERY OF CANADA. **Citations**: NGC 1982; Hill 1988.

BRANDL, EVA (b1951), Québec. Sculptor. She exhibited with the VEHICULE ART GALLERY. **Citations**: NGC 1982; Lerner 1991; Tippett 1992.

BRANDTNER, FRITZ (1896-1969), Winnipeg, MB; Montréal, QC. Painter. In 1928, Brandtner arrived in Winnipeg from Danzig with a knowledge of the latest European developments in art, particularly German EXPRESSIONISM and CUBISM. Other than LIONEL LEMOINE FITZGERALD, Brandtner did not find that Winnipeg artists were sympathetic to these new movements in art. In 1934, he moved to the more appreciative environment of Montréal where he felt encouraged to work with experimental art and ABSTRACT ART. Several examples of Brandtner's work are in the NATIONAL GALLERY OF CANADA. **Citations**: Buchanan 1950; Duval 1954, 1972; Harper 1966, 1971(2); MacDonald 1967; Ayre 1977; George 1980; NGC 1982; Duffy 1982; Burnett/Schiff 1983; Reid 1988; Marsh 1988; Hill 1988; Lerner 1991; Tippett 1992.

BREEZE, CLAUDE HERBERT (b1938), Toronto, ON. Painter and printmaker. He studied with ERNEST LIDNER, KENNETH LOCHHEAD and ARTHUR MCKAY. Although at first a west coast painter, he has been in Toronto since 1976. Several paintings by Breeze are in the NATIONAL GALLERY OF CANADA. **Citations**: MacDonald 1967; Withrow 1972; Duval 1972; Lord 1974; Fenton 1978; Sisler 1980; Bringhurst 1983; Burnett/Schiff 1983; Marsh 1988; Hill 1988; Reid 1988; Lerner 1991; McMann 1997.

BREKENMACHER, JEAN-MELCHOIR. See Father FRANCOIS.

BRIAND, DANIEL (b1928), Halifax, NS. Painter. Briand painted two naïve landscape MURALS for the Camp Hill Hospital, Halifax, using latex paint and gold leaf on gypsum board. One is of the Public Gardens and the other is of Grand Pré (see Greenaway 1986, pl. 59). **Citations**: Greenaway 1986; McKendry 1988.

BRIEN dit DESROCHERS, URBAIN (1781-1860), Varennes, QC. Sculptor. Brien, an apprentice of LOUIS QUEVILLON, was a sculptor of religious figures in POLYCHROMED wood. Two examples of his work are in the NATIONAL GALLERY OF CANADA. **Citations**: Traquair 1947; Gowans 1955; Trudel 1969; NGC 1982; Porter 1986; McKendry 1988; Hill 1988; Lerner 1991.

BRIDGMAN (BRIDGEMAN), JOHN WESLEY (1861-1907), Toronto, ON. Painter. He was a portrait painter and a founding member of the ONTARIO SOCIETY OF ARTISTS. J.W.L. FORSTER was apprenticed to Bridgman. **Citations**: Forster 1928; Robson 1932; Colgate 1943; Harper 1966, 1970; Reid 1979; NGC 1982; Hill 1988; Lerner 1991.

BRIDLE, AUGUSTUS (1869-1952), Toronto, ON. Journalist, art critic and editor. He was enthusiastic about the work of the GROUP OF SEVEN. **Citations**: Bridle 1916, 1945; Story 1967; Mellen 1970; Housser 1974; Reid 1988; Hill 1995.

BRIGDEN Sr, FREDERICK (1841-1917), Toronto, ON. ENGRAVER, painter and illustrator. He was the father of FREDERICK HENRY BRIGDEN. In 1876 he founded the Toronto Engraving Company, renamed BRIGDENS LIMITED in 1910. A drawing by Frederick Brigden Sr is in the NATIONAL GALLERY OF CANADA. **Citations**: Middleton 1944; MacDonald 1967; Harper 1970; Nicholson 1970; NGC 1982; Hill 1988; Lerner 1991.

BRIGDEN Jr, FREDERICK HENRY (FRED) (1871-1956), Toronto, ON. Painter; RCA 1939. He was a son of FREDERICK BRIGDEN Sr. F.H. Brigden Jr studied with WILLIAM CRUIKSHANK and GEORGE AGNEW REID, and in New York. Several paintings by Brigden Jr are in the NATIONAL GALLERY OF CANADA. **Citations**: MacTavish 1925; Robson 1932; Colgate 1943; Middleton 1944; Miner 1946; McInnes 1950; Duval 1954; Panabaker 1957; Hubbard 1960; Harper 1966; MacDonald 1967; Lord 1974; Sisler 1980; NGC 1982; Hill 1988; Lerner 1991; McMann 1997.

BRIGDENS OF WINNIPEG LIMITED. See BRIGDENS LIMITED.

BRIGDENS LIMITED. An engraving company founded by FREDERICK HENRY BRIGDEN Jr in Toronto in 1876 as the Toronto Engraving Company, renamed Brigdens Limited in 1910, and whose work included printing techniques from WOOD ENGRAVING to modern LITHOGRAPHIC processes. In 1914, Brigdens of Winnipeg Ltd was established by F.H. BRIGDEN Jr. **Citations**: Middleton 1944; Harper 1966; Nicholson 1970; Duval 1972; Reid 1988; Lerner 1991; McMann 1997.

BRISEBOIS, EPHREM A. (act1875), Alberta. Painter. Brisebois was with the North West Mounted Police, in Québec in 1873, and by 1875 in Alberta, where he helped establish Fort Brisebois, later Fort Calgary, at the confluence of the Bow and Elbow Rivers. He painted naïve landscape paintings in watercolour. **Citations**: Render 1970; NGC 1982; McKendry 1988.

BRITISH COLUMBIA. By at least the European MEDIEVAL period, native tribes and clans along the Northwest coast had a sophisticated culture, and over the following centuries produced many fine examples of textiles and carvings (including house and ceremonial decorations). The HAIDA are particularly well known. The "Golden Age" of native art was 1860-90 (see also TOTEM POLES, POTLACH, SHAMAN, TSIMSHIAN, SALMON, RAVEN, ARGELLITE). Towards the end of the 19th century native ARTIFACTS were being collected for American and Canadian museums (see also NATIVE ART OF CANADA, FOLK ART EXHIBITIONS, MARIUS BARBEAU). In the late 18th century, the coastal regions of British Columbia (BC) provided subjects for many TOPOGRAPHICAL and marine artists who were included in the crews of ships sailing from England on voyages of discovery to the Pacific Ocean. Paintings and sketches were used to illustrate accounts of the voyages published later in London (see De Volpi 1973). One such artist, JOHN WEBBER, accompanied Captain James Cook on a voyage, about which *A Voyage to the Pacific Ocean* was published in 1784 with a number of engravings based on Webber's drawings (see De Volpi 1973, pl. 2-8). These early artists were followed by other artists, some of whom travelled overland, for example PAUL KANE in 1846-7, particularly in the 19th century, and who sketched and painted inland scenes as well as coastal views (see Gilmore 1980). In 1871 British Columbia (this name was given in 1858) entered confederation, and was finally connected to the rest of the country by railway in 1885 — which attracted visiting artists, for example LUCIUS O'BRIEN. The brothers, CHARLES EDWIN FRIPP and THOMAS WILLIAM FRIPP, painted Rocky Mountain and native life scenes around the turn of the century. During the present century, EMILY CARR, through her monumental paintings of the British Columbia forest and of large primitive native sculptures, has directed attention to Northwest coast native art. Other 20th century artists who painted in British Columbia are E.J. HUGHES, TONI ONLEY, LAWREN STEWART HARRIS, FREDERICK H. VARLEY, and J.E.H. MACDONALD. FOLK ART flourished later than in other provinces, but is firmly established by such naïve artists as CHARLES DUDOWARD, BERNIE WREN, CHRISTIAN NORMAN FREY, ELISABETH HOPKINS, RANK KOCEVAR, J.M. NICKER-

SON, and HERMAN OTTO TIEDEMANN. See SCULPTOR'S SOCIETY OF BRITISH COLUMBIA. **Citations**: British Columbia 1909, 1932; McInnes 1950; Northwest 1956; Hume 1958; McNairn 1959; Harper 1966; Skelton 1972;De Volpi 1973; New Era 1974; Tippett 1974, 1977; Annett 1975; BC Sculptors 1976; *Canadian Collector*, May/June, 1976; Balkind 1977; Peters 1978, 1979; Gilmore 1980; BC Art 1981; McKendry 1983;Marsh 1988; Shadbolt 1990; Lerner 1991.

BRITISH COLUMBIA ART LEAGUE. The Art League opened an art school under the direction of CHARLES H. SCOTT and a public gallery in Vancouver, BC, in the early 1920s. **Citations**: McInnes 1950; Harper 1966; Tippett 1979.

BRITISH COLUMBIA COLLEGE OF ART. The College was established in 1933 in Vancouver, BC, and closed in 1936 for financial reasons. It was founded by FRED VARLEY and JOCK MACDONALD. **Citations**: Tippett 1979; Reid 1988.

BRITISH COLUMBIA SOCIETY OF ARTISTS (before 1949, BRITISH COLUMBIA SOCIETY OF FINE ARTS). THOMAS FRIPP served as president, and the Society held its first exhibition in 1909. EMILY CARR was an original member, and her work was in most of their exhibitions, as was that of T. MOWER MARTIN. **Citations**: British Columbia 1909; Harper 1966; Tippett 1979; Shadbolt 1990; Lerner 1991.

BRITISH COLUMBIA SOCIETY OF FINE ARTS. See BRITISH COLUMBIA SOCIETY OF ARTISTS.

BRITTAIN, MILLER GORE (1912-68), Saint John, NB. Painter, mixed media artist and MURALIST. His early paintings depicted life in Saint John (see Lord 1974 Figures 167-170a) but after 1946 his paintings had SURREALISTIC overtones. Several paintings by Brittain are in the NATIONAL GALLERY OF CANADA. **Citations**: Colgate 1943; McInnes 1950; Hubbard 1960; Harper 1966, 1981(1); Andrus 1966, 1968; MacDonald 1967; Duval 1972; Lord 1974; Mogelon 1981; NGC 1982; Bringhurst 1983; Burnett/Schiff 1983; Hill 1988; Reid 1988; Marsh 1988; Lerner 1991.

BRITTON, HARRY (1878-1958), Toronto, ON. Painter; RCA 1934. He studied with F. MCGILLIVRAY KNOWLES and in England. His paintings are represented in the NATIONAL GALLERY OF CANADA. **Citations**: Hubbard 1960; MacDonald 1967; Sisler 1980; NGC 1982; Hill 1988; McMann 1997.

BRITTON, SUSAN KATHLEEN (b1952), Toronto, ON and New York. VIDEO artist and teacher. She studied at the NOVA SCOTIA COLLEGE OF ART AND DESIGN and at the ONTARIO COLLEGE COLLEGE OF ART. Several videotapes by Britton are in the NATIONAL GALLERY OF CANADA. **Citations**: Gale 1977; NGC 1982; Hill 1988; Lerner 1991.

BRODEUR, ALBERT SAMUEL (1862-1933), Montréal, QC. Illustrator and LITHOGRAPHER. He studied under EDMOND DYONNET and WILLIAM BRYMNER. Some of his work resembles that of HENRI JULIEN. **Citations**: Harper 1970; Laliberté 1986.

BRODIE, GEORGE STAUNTON (d1901), BC. TOPOGRAPHICAL painter. He was with the Royal Navy, and painted coastal scenery. **Citations**: Harper 1970; Render 1974; NGC 1982.

BRODIE, JAMES (JIM) DOUGLAS (b1946), Canada and Australia. Printmaker, painter, illustrator, teacher and curator. He studied with YVES GAUCHER, CARL HEYWOOD and others. A print by Brodie is in the NATIONAL GALLERY OF CANADA. **Citations**: NGC 1982; Hill 1988.

BRONSON, A.A. See GENERAL IDEA.

BROOKER, BERTRAM RICHARD (1888-1955), Toronto, ON. Painter. Brooker had a varied career as an advertising executive, musician, poet, novelist, painter, and illustrator. He was an early experimenter with an ABSTRACT approach to painting. Several paintings by Brooker are in the NATIONAL GALLERY OF CANADA. **Citations**: Housser 1929; Robson 1932; McInnes 1950; Harper 1966; MacDonald 1967; Boggs 1971; Duval 1972; Reid 1973, 1988; Lord 1974; NGC 1982; Burnett/Schiff 1983; Bringhurst 1983; Hill 1988; Marsh 1988; Piper 1988; Lerner 1991; Tippett 1992.

BROOKS, FRANK LEONARD (b1911), Canada, USA and Mexico. Painter and printmaker. He studied with FRANZ JOHNSTON. A serigraph by Brooks is in the NATIONAL GALLERY OF

CANADA. See also SILKSCREEN PRINTING. **Citations**: McInnes 1950; Hubbard 1960; MacDonald 1967; Duval 1972; MacDonald 1967; Sisler 1980; Oko 1981; NGC 1982; Hill 1988; Lerner 1991; McMann 1997.

BROOMFIELD, ADOLPHUS GEORGE (b1906), ON. Painter and printmaker. **Citations**: NGC 1982; Lerner 1991.

BROWN, ANDREW Sr or **Jr**, Québec. Painter. It is thought that this painter is Andrew Brown Sr (1766-1835) or Andrew Brown Jr (1806-act. 1857). Brown is best known for an attractive watercolour view of the Tandem Sleigh Club on the St Charles River near Québec City (now in the NATIONAL GALLERY OF CANADA). A nearly identical watercolour by JOHN CRAWFORD YOUNG is also in the NATIONAL GALLERY OF CANADA and another similar watercolour was sold at Sotheby & Co. Toronto, 27 May 1968, lot 70. See Cooke 1983, p. 31 and pl. 64, for detailed information on this artist. **Citations**: Harper 1973; Cooke 1983; Kobayashi 1985(2); McKendry 1988; Hill 1988.

BROWN, ANNORA (b1899), Fort Macleod, AB Painter. She studied at the ONTARIO COLLEGE OF ART. See Tippett 1992, p. 77, for an illustration of one of her paintings in the GLENBOW MUSEUM. **Citations**: Highlights 1947; Render 1970; Brown 1981; NGC 1982; Lerner 1991; Tippett 1992; McMann 1997.

BROWN, DANIEL PRICE ERICKSEN (DP) (b1939), King, ON. Painter and printmaker. He studied with ALEX COLVILLE and, like Colville, Brown is a realist painter. Brown paints exclusively with egg TEMPERA. See Duval 1974 pp. 40-51. **Citations**: Harper 1966; Duval 1972, 1974; Belshaw 1976; NGC 1982; Burnett/Schiff 1983; Marsh 1988; Lerner 1991.

BROWN, ERIC (1877-1939), Ottawa, ON. Curator and gallery director. Brown arrived in Canada from England in 1909 and was the first director of the NATIONAL GALLERY OF CANADA from 1912-39, a period when Brown actively supported Canadian art, including the work of the GROUP OF SEVEN and EMILY CARR. See Boggs 1971 for an account of Brown's work **Citations**: Hubbard 1960; Harper 1966; Brown 1964; Boggs 1971; Watson 1974; Laing 1979; Sisler 1980; Reid 1988; Hill 1988, 1995; Lerner 1991.

BROWN, J. DAVID (1937-95), Kingston, ON. Painter. He studied at the ONTARIO COLLEGE OF ART and graduated in 1962. Many of his landscape paintings include children at play and have a naïve flavour. **Citations**: NGC 1982; Farr 1988.

BROWN, PETER (b1947), ON. Sculptor. **Citations**: Murray 1976; NGC 1982; Lerner 1991.

BROWNE, BELMORE (1880-1954), Banff, AB Painter of the Rocky Mountains. See Render 1974, pl. 159-70. **Citations**: Render 1974; NGC 1982.

BROWNE, JOSEPH ARCHIBALD (1864/1866-1948), Lancaster, ON. Painter; RCA 1919. He studied with WILLIAM CRUIKSHANK in 1888, and was a founding member of the CANADIAN ART CLUB, 1907. Browne was a friend of HORATIO WALKER and HOMER WATSON and exhibited with them. Several paintings by Browne are in the NATIONAL GALLEY OF CANADA. **Citations**: Bridle 1916; MacTavish 1925; Chauvin 1928; Robson 1932; Page 1939; Colgate 1943; Hubbard 1960; MacDonald 1967; Harper 1970; Sisler 1980; NGC 1982; Laliberté 1986; Hill 1988; Reid 1988; Lerner 1991; Murray 1996(1); McMann 1997.

BROWNE, WILLIAM HENRY JAMES (d1872), Canadian Arctic. Painter. He was with the Royal Navy in the Canadian Arctic. **Citations**: Harper 1966, 1970.

BROWNELL, PELEG FRANKLIN (1857-1946), Ottawa, ON. Painter and MURALIST; RCA 1895. Brownell came to Ottawa from the USA in 1886 as head of the Ottawa Art School. He was a founding member of the CANADIAN ART CLUB and many of his paintings are in the NATIONAL GALLERY OF CANADA. **Citations**: MacTavish 1925; Robson 1932; Colgate 1943; Buchanan 1945, 1950; McInnes 1950; Harper 1966, 1970; MacDonald 1967; Duval 1972; Sisler 1980; NGC 1982; Hill 1988; Marsh 1988; Reid 1988; Lerner 1991; McMann 1997.

BRUCE, ROBERT DONALD (b1911), Winnipeg, MB. Painter, illustrator, MURALIST and teacher. He studied with LEMOINE FITZGERALD. **Citations**: Swinton 1961; MacDonald 1967; NGC 1982;

Lerner 1991.

BRUCE, WILLIAM BLAIR (1859-1906), Hamilton, ON; Paris, France; Gotland Island, Sweden. Painter. He is said to be Canada's first IMPRESSIONIST painter. Bruce studied in Canada and in Paris. He travelled widely and died in Stockholm. Several paintings by Bruce are in the NATIONAL GALLERY OF CANADA. **Citations**: MacTavish 1925; Robson 1932; Colgate 1943; Hubbard 1960; Harper 1966, 1970; MacDonald 1967; Lord 1974; Mellen 1978; Bruce 1982; Murray 1982(2); NGC 1982; Hill 1988; Reid 1988; Marsh 1988; Duval 1990; Lerner 1991.

BRUNEAU, MARGUERITE (KITTIE) (b1929), Montréal, QC. Painter, printmaker and sculptor. She studied under MAURICE RAYMOND and GHITTA CAISERMAN-ROTH among others, and in Paris. One of her paintings is in the NATIONAL GALLERY OF CANADA. **Citations**: Harper 1966; MacDonald 1967; NGC 1982; Hill 1988; Lerner 1991; Tippett 1992.

BRUNET, JEAN EMILE (1893/1899-1977), Montréal, QC. Sculptor. He studied with ALFRED LALIBERTE, PHILIPPE HEBERT and EDMOND DYONNET, as well as in Chicago and Paris. One of his well-known works is the statue of Sir Wilfrid Laurier in Dominion Square, Montréal. **Citations**: MacDonald 1967; NGC 1982; Laliberté 1986.

BRUSHWORK. In applying paint with a brush, a painter usually develops a characteristic style that shows in the finished work and is referred to as brushwork. The texture of a painting resulting from brushwork may vary from a smooth finish to broad brush marks, and from a thin wash to a thick coating as in IMPASTO. See also PAINTERLY, LINEAR, POINTILLISM. **Citations**: Lucie-Smith 1984; Piper 1988; Read 1994.

BRYMNER, WILLIAM (1855-1925), Ottawa, ON; Montréal, QC. Painter, illustrator and MURAL-IST; RCA 1886. Brymner studied painting in Paris 1878-85, painted in the BARBIZON area, and then returned to Ottawa. From 1886-1921, he taught at the ART ASSOCIATION OF MONTREAL. In later life, his careful draughtsmanship and ACADEMIC style of painting was influenced by his friend MAURICE CULLEN and others. See Harper 1966, pl. 194-6, for illustrations of Brymner's work. Several paintings by Brymner are in the NATIONAL GALLERY OF CANADA. **Citations**: MacTavish 1925; Robson 1932; Colgate 1943; Buchanan 1945, 1950; Dyonnet 1951; Jackson 1958; Hubbard 1960, 1960(1), 1967; MacDonald 1967; Harper 1966, 1970; Beament 1968; Boggs 1971; Watson 1974; Laurette 1978; Braide 1979; Reid 1979, 1988; Sisler 1980; Farr 1981(1); NGC 1982; Laliberté 1986; Marsh 1988; Piper 1988; Hill 1988; Cavell 1988; Duval 1990; Lerner 1991; Tippett 1992; McMann 1997.

BUCK, WILLIAM (act. 1840), ON. Painter. Buck painted naïve TOPOGRAPHICAL paintings in oil. An example is *View of Penetanguishene* c1840 (see Lord 1974 pl. 64, collection NATIONAL GALLERY OF CANADA). Another painting, *View of St. Andrews, N.B.*, was published as a LITHO-GRAPH. **Citations**: Harper 1964, 1970, 1973; Lord 1974; NGC 1982; Kobayashi 1985(2); McKendry 1988; Hill 1988.

BUDDEN, JOHN SHERRING (1825-1918), Québec City, QC. Auctioneer; patron and friend of CORNELIUS KRIEGHOFF; and publicizer of Krieghoff's work. In 1851 Budden met Krieghoff in Montréal and advised him to paint Québec habitants and native people showing their way of life. Budden persuaded Krieghoff to move to Québec City where his paintings would find a wider audience. **Citations**: Harper 1966, 1979; Jouvancourt 1971; Lord 1974; Reid 1988; Lerner 1991.

BUELL, KATRINA S.D.(act1890-1926), Canada. Painter. **Citations**: Housser 1929; NGC 1982; Lerner 1991.

BUERSCHAPER, PETER (b1940), Toronto, ON. Painter and illustrator of wildlife. He was born in Germany and came to Canada in 1954. **Citations**: Buerschaper 1977; NGC 1982.

BUIST, JOHN (b1929), Kingston, ON. Sculptor and painter. Buist was a guard at the Kingston Penitentiary 1960-87. After his retirement he made many figures of guards and prisoners in clay and in wood, usually painted. Examples of his work are in the Corrections Canada Penitentiary Museum, Kingston, and private collections.

BULLER, CECIL TREMAYNE (MURPHY) (1886-1973), Montréal, QC. Painter, illustrator and printmaker. She studied with WILLIAM BRYMNER, as well as in London, and married New York printmaker John J.A. Murphy. Many WOOD ENGRAVINGS by Buller are in the NATIONAL GALLERY OF CANADA. **Citations:** Hubbard 1960; MacDonald 1967; NGC 1982; Hill 1988.

BUNCE, ALAN (b1951), Ottawa and Toronto, ON. Printmaker. He collaborated with RICHARD RUDNICKI on a LINOCUT now in the NATIONAL GALLERY OF CANADA. **Citations:** NGC 1982; Hill 1988.

BUNNET (BUNNETT), HENRY RICHARD SHARLAND (act. 1881-89), Montréal, QC. Painter. Bunnet painted historic buildings and TOPOGRAPHICAL views of Montréal and Québec City in oil or watercolour (see Allodi 1974 and Cooke 1983). He made copies of earlier prints and painted several watercolour studies of British army uniforms. **Citations:** Harper 1962, 1970; Allodi 1974; NGC 1982; Cooke 1983; McKendry 1988.

BURGOYNE, ST GEORGE (1882-1964), Montréal, QC. Painter and printmaker. He arrived in Montréal from England in 1897. One of his watercolours is in the NATIONAL GALLERY OF CANADA. **Citations:** Hubbard 1960; NGC 1982; Hill 1988.

BURIN. An engraving tool used to cut a furrow in a metal plate. See LINE ENGRAVING; WOOD ENGRAVING. **Citations:** Mayer 1970; Eichenberg 1976; Chilvers 1988; Piper 1988.

BURNSIDE, JOHN THRIFT MELDRUM (1834/35-1900), Toronto, ON. Painter. He arrived in Toronto from Scotland c1855. His paintings are represented in the NATIONAL GALLERY OF CANADA. **Citations:** NGC 1982; Hill 1988.

BURROWS, JOHN (1789-1848), Bytown (Ottawa), ON. Burrows, appointed by Colonel JOHN BY as clerk of the works on the Rideau Canal, remained as superintendent on its completion. He executed many naïve TOPOGRAPHICAL sketches in pencil and watercolour of the Ottawa and Rideau Rivers, and of the Rideau Canal (see Passfield 1982). A number of his sketches are now in the Archives of Ontario, Toronto. **Citations:** Legget 1957; Harper 1970; Allodi 1974; Passfield 1982; McKendry 1988.

BURROWES, THOMAS (b1796), Kingston, ON. Burrowes was on the staff of Colonel JOHN BY during construction of the Rideau Canal and made many naïve TOPOGRAPHICAL sketches in watercolour of the Rideau Canal and district of which a number are now in the Archives of Ontario, Toronto. (see Passfield 1982). **Citations:** Legget 1957; Harper 1970; Passfield 1982; McKendry 1988, Farr 1988.

BURT, LEONARD (b1928), Bonne Bay and St John's, NF. Painter. Since 1974, Burt has been confined to a wheelchair from which he paints from memory areas of Newfoundland that he knew well when he worked on coastal boats. Some of Burt's oil paintings are large detailed PANORAMIC views in good colour, on 4 x 8 foot masonite panels, while others are smaller panels and canvases, all executed in a naïve manner (see Grattan 1977). Examples of his work are in the collection of Memorial University Art Gallery, St John's, NF. **Citations:** Grattan 1976, 1977; Kobayashi 1985(2); McKendry 1988; Lerner 1991.

BURTON, DENNIS EUGENE NORMAN (b1933), Toronto, ON; Vancouver, BC. Painter and sculptor. He studied with JOCK MACDONALD and in the USA. Some of his themes are EROTIC. Several of Burton's paintings, drawings and prints are in the NATIONAL GALLERY OF CANADA. **Citations:** MacDonald 1967; Duval 1972; Lord 1974; Murray 1977; Fenton 1978; Sisler 1980; NGC 1982; Bringhurst 1983; Burnett/Schiff 1983; Marsh 1988; Reid 1988; Hill 1988; Lerner 1991; Murray 1996(1); McMann 1997.

BURTON, RALPH W.(b1905), Ottawa, ON. Painter. He was influenced by his friend A.Y. JACKSON. He studied with Jackson at the BANFF SCHOOL OF FINE ARTS, as well as sketching with him in the Rockies. **Citations:** MacDonald 1967; Jackson 1958; Groves 1968; NGC 1982.

BUSH, (JACK) JOHN HAMILTON (1909-77), Toronto, ON. Painter, MURALIST and printmaker. He studied with ADAM SHERRIFF SCOTT, EDMOND DYONNET, J.W. BEATTY and others. Bush was a founder-member of PAINTERS ELEVEN and a leading Canadian abstract painter. Several

paintings and prints by Bush are in the NATIONAL GALLERY OF CANADA. **Citations**: Harper 1966; MacDonald 1967; Townsend 1970; Boggs 1971; Withrow 1972; Duval 1972; Lord 1974; Fenton 1976, 1978; Mellen 1978; Sisler 1980; Carpenter 1981; NGC 1982; Burnett/Schiff 1983; Bringhurst 1983; Wilkin 1984;Marsh 1988; Reid 1988; Hill 1988; Chilvers 1988; Lerner 1991; Tippett 1992; McMann 1997.

BUST. A bust is a representation of a person depicting only the upper portion of the body. The term is usually used in connection with sculpture, but may be used for a painting, drawing or engraving. **Citations**: Osborne 1970; Pierce 1987; Chilvers 1988; Piper 1988.

BUTLER, KENNETH JOHN (JACK) (b1938), Winnipeg, MB. Painter and printmaker. **Citations**: Fry 1972(1); Heath 1976; NGC 1982; Lerner 1991.

BUTLER, SHEILA M. (b1938), Winnipeg, MB. Painter and printmaker. Sheila and Jack Butler introduced drawing to the Baker Lake Inuit people. **Citations:** Fry 1972(1); Heath 1976; NGC 1982; Lerner 1991.

BY, Colonel JOHN (1781-1836), Bytown (Ottawa), ON. Painter. Colonel By who was in the British Army, was in charge of building the Rideau Canal, an amazing engineering project that connected Bytown with Kingston. He sketched and painted, in watercolour, TOPOGRAPHICAL landscape views and plans of canal locks. He was the founder of Bytown, now Ottawa. **Citations**: Legget 1957; Harper 1962, 1970; Allodi 1974; Passfield 1982; McKendry 1988; Marsh 1988.

BYRON, G.R. (act. 1858-65), Ontario, Québec and Nova Scotia. Painter. Byron was a painter of TOPOGRAPHICAL landscapes in Ontario, Québec and Nova Scotia in watercolour. **Citations**: Allodi 1974; McKendry 1988.

BYZANTINE ART. This is Christian (Greek Orthodox and Roman Catholic) art produced under the influence of the East Roman Empire, evolving from Early Christian Art, and firmly established in Constantinople (now Istanbul), by the Emperor Justinian (527-565). Important examples of ARCHITECTURE, MOSAICS, FRESCOES, manuscripts, and small ivories in RELIEF were also produced in Italy, Greece, and Russia. This was the great era of ICONS, despite the prohibition of creating images of sacred figures by the Iconoclasts from 726 to 843. Byzantine Art is often divided into the First Golden Age (c6th-mid9th centuries), Second Golden Age (late 9th-11th centuries), and Late Byzantine (13th-mid15th centuries). In 1453 Constantinople was conquered by the Turks. See Osborne 1970 for a good discussion of Byzantine Art. **Citations**: Osborne 1970; Janson 1977; Lucie-Smith 1984; Piper 1988; Read 1994.

C

CABANE, E. (act1891-99), Québec. Painter. Cabane painted decorative religious paintings for churches, such as Stations of the Cross. **Citations**: Harper 1970, McKendry 1988.

CABINET PHOTOGRAPH. See PHOTOGRAPHY IN CANADA.

CABOT COMMEMORATIVE STATE SET. See CANADIAN STATE DINNER SERVICE.

CADDY, EDWARD C. (1815-1897), Trent Valley district, ON. Painter. Caddy was a surveyor who executed some naïve landscape paintings in watercolour of the Trent Valley district. One of his paintings of Stoney Lake, with deer in the foreground, is illustrated in Guillet 1957, pl. 50; for a portrait of Caddy, see Guillet 1957, pl. 81. **Citations**: Guillet 1957; Harper 1970; McKendry 1988.

CADDY, Captain JOHN HERBERT (1801-87), London and Hamilton, ON. Painter. Caddy, who was a British army officer, painted TOPOGRAPHICAL landscape and marine scenes, as well as portraits, flower studies and animals. **Citations**: de Volpi 1966; Harper 1966, 1970; Allodi 1974; NGC 1982; Cooke 1983; Smith 1985; McKendry 1988.

CADIEUX, GENEVIEVE (b1955), Montréal, Québec. Painter and photographer. **Citations**: Tippett

1992.

CAHEN, OSCAR (1916-56), King, ON. Painter, illustrator and MURALIST. He arrived in Canada from Copenhagen in 1940 after studying in Paris, Germany and Italy. One of his paintings is in the NATIONAL GALLERY OF CANADA. **Citations**: McInnes 1950; Hubbard 1960; Harper 1966; MacDonald 1967; Duval 1952, 1954, 1972; Lord 1974; NGC 1982; Burnett/Schiff 1983; Bringhurst 1983; Reid 1988; Hill 1988; Lerner 1991.

CAISERMAN-ROTH, GHITTA (b1923), Montréal, QC. Painter, printmaker and MURALIST. She studied with ALEXANDRE BERCOVITCH and ALBERT DUMOUCHEL as well as in New York, and is the wife of ALFRED PINSKY. Several of her paintings are in the NATIONAL GALLERY OF CANADA. **Citations**: Duval 1952, 1954, 1972; MacDonald 1967; Sisler 1980; NGC 1982; Hill 1988; Lerner 1991; Tippett 1992; McMann 1997.

CALDWELL, Lieutenant (act. c1830), Québec. Painter. This artist may be William Bletterman Caldwell (act. 1814-57) who was with the British Army and became the Governor of Assiniboia (Red River colony, MB) 1848-55. He is known for a brown wash drawing of the Falls of Montmorency, QC, now in the ROYAL ONTARIO MUSEUM, Toronto, ON. **Citations**: Allodi 1974; McKendry 1988.

CALLEJA, JOSEPH JOHN (b1924), Toronto, ON. Sculptor, printmaker and painter. He came to Canada in 1958 from Malta after studying art in Malta and England. A MONOTYPE by Calleja is in the NATIONAL GALLERY OF CANADA. **Citations**: MacDonald 1967; NGC 1982; Hill 1988.

CALLIGRAPHY. The art of ornamental penmanship, for example as often seen in FRAKTUR work. **Citations**: Osborne 1970; McKendry 1983; Pierce 1987; Piper 1988; Lerner 1991.

CALOTYPE. See PHOTOGRAPHY IN CANADA.

CALVARY. Calvary refers to the scene of Christ's CRUCIFIXION on the hill of Calvary, or Golgotha, outside Jerusalem. As now used, it may refer to a wayside cross (positioned close to roads for devotional purposes in Québec) or a group of carvings of the PASSION of Christ, and is a theme often used by folk artists, particularly in Québec. See also FOLK ART, CANADA; FRANCOIS GUERON dit BELLEVILLE. **Citations**: Ferguson 1967; Porter 1973; Chilvers 1988; Lerner 1991.

CAMERA LUCIDA. This is a mechanical device— with a prism and lenses — that reflects landscape onto a sheet of paper, where it is traced by the artist, often a TOPOGRAPHER. JAMES PATTISON COCKBURN used this system to record a moving funeral procession. See also BASIL HALL. A simpler device, the camera obscura, was invented in the 16th century. **Citations**: Harper 1970.

CAMERON, A.(act. 1840), Québec City,QC. Painter. Cameron served with the British army and executed naïve caricatures and drawings in watercolour. (See Harper 1974, pl. 100, for an example.) **Citations**: Harper 1970, 1973, 1974; Kobayashi 1985(2); McKendry 1988.

CAMERON, ALEX (b1947), Toronto,ON. Painter and printmaker. **Citations**: Carpenter 1981; NGC 1982; Lerner 1991; Murray 1996(1).

CAMERON, DOROTHY (b1923), Toronto, ON. Sculptor and INSTALLATION artist. **Citations**: NGC 1982; ; Murray 1996(1).

CAMERON, ERIC (b1935), Ontario. Painter and VIDEO artist. **Citations**: Gale 1977; NGC 1982; Lerner 1991.

CAMERON, WALTER GRAHAM (1894-1986), Fallbrook, ON. Sculptor and blacksmith. Cameron was a BLACKSMITH who eventually turned to carving naïve sculpture in wood. He is known for his carvings of farm animals and models of farm implements and vehicles. In his later work he paid much attention to detail and accuracy; however his earlier work is more interesting for freedom of expression. **Citations**: CCFCS; Armstrong 1979; McKendry 1988; Lerner 1991.

CAMPBELL, COLIN (b1942), Toronto, ON. VIDEO artist and sculptor. Several videotapes by Campbell are in the NATIONAL GALLERY OF CANADA. **Citations**: Gale 1977; Ferguson 1980; NGC 1982; Hill 1988; Lerner 1991.

CAM(P)BELL, D. (act. early 20th century), Brockville, ON. Painter. Cambell is known for a naïve oil painting of the battle of Batoche (illustrated in NMM 1983, pl. 116). **Citations**: NMM 1983; Kobayashi

1985(2); McKendry 1988.

CAMPBELL, Sir JOHN (1816-55), Fredericton, NB. Amateur painter. He was a son of Sir Archibald Campbell (1796-1843), Lieutenant Governor of New Brunswick 1831-1837. He is mostly known for his view of the *New Brunswick Fashionables!*, issued in 1834 as a LITHOGRAPH (see Cavell 1988, pl. 20). The scene is a humourous, GENRE, winter-sleighing street-scene of Fredericton showing several houses and other buildings. **Citations**: Harper 1970; McKendry 1988; Cavell 1988.

CAMPBELL, JOHN DOUGLAS SUTHERLAND. See LORNE, MARQUESS OF.

CAMPBELL, M.L. (act. c1850), Eastern Canada. Painter. Campbell made a copy in watercolour of an engraving after WILLIAM HENRY BARTLETT. **Citations**: Allodi 1974; McKendry 1988.

CANADA EAST. See QUEBEC.

CANADA STEAMSHIP LINES. See COVERDALE COLLECTION OF CANADIANA.

CANADA WEST. See ONTARIO.

CANADIAN ACADEMY OF ARTS. See ROYAL CANADIAN ACADEMY OF ARTS.

CANADIAN ART. See ALBERTA, BRITISH COLUMBIA, COLLECTING, FOLK ART, MANI-TOBA, MARITIME PROVINCES, NAÏVE ART, NATIONAL GALLERY OF CANADA, NATIVE ART, NEWFOUNDLAND, ONTARIO, PAINTING IN CANADA, QUEBEC, and SASKATCHEWAN. **Citations**: MacTavish 1925; Robson 1932; Colgate 1943; Buchanan 1945, 1950; McInnes 1950; Hubbard 1960; 1960(1), 1963, 1967, 1973(2); MacDonald 1967; Harper 1962, 1964, 1966, 1970, 1974 1966; Boggs 1971; Lord 1974; Mellen 1978; Laing 1979, 1982; Reid 1979, 1988; Sisler 1980; NGC 1982; McKendry 1983; Hill 1988; Lerner 1991; Tippett 1992; McMann 1997.

CANADIAN ART CLUB. Through the efforts of EDMUND MORRIS and others, the Canadian Art Club was formed in 1907 to promote Canadian art. HOMER WATSON was elected president with CURTIS WILLIAMSON as secretary. Standards for the Club's exhibitions were set by only admitting to membership in the club artists of recognized ability and by restricting invitations issued to nonmembers. The Club was disbanded in 1915. See MacTavish 1925, Chapter VIII; Mellen 1970 pp. 18 and 19 for membership. **Citations**: MacTavish 1925; Robson 1932; Colgate 1943; McInnes 1950; Harper 1966; Mellen 1970; Lord 1974; Laing 1979; Sisler 1980; Reid 1988; Lerner 1991; Tippett 1992; Hill 1995.

CANADIAN ARTISTS' REPRESENTATION (CAR). An organization of Canadian artists formed, in 1967, largely through the efforts of JACK CHAMBERS who became its first president. CAR is concerned with artist's copyright, rental fees, taxation, as well as commission and exhibition contracts. **Citations**: Lord 1974; Reid 1988; Lerner 1991; Tippett 1992.

CANADIAN ARTISTS SERIES. In 1937, the Ryerson Press began to publish small colour-plate, cloth or paper-bound books in the Canadian Artists series. Of these books, six were written by ALBERT H. ROBSON; the series was continued with other authors. **Citations**: Robson 1937(1,2 and 3), 1938(1,2 and 3); Laing 1979.

CANADIAN ARTS COUNCIL. See CANADIAN CONFERENCE OF THE ARTS.

CANADIAN CENTRE FOR FOLK CULTURE STUDIES (CCFCS). The CCFCS is a folklore research division of the CANADIAN MUSEUM OF CIVILIZATION (CMC) (formerly the National Museum of Man) in Hull, QC. It can trace its origin back to the pioneering work of MARIUS BARBEAU, who began fieldwork by collecting FOLKLORE artifacts in 1911. Eventually this led to folk-artifact acquisitions, including the National Museum's first folk art purchase in 1925 that resulted from Barbeau's visit with the Québec sculptor LOUIS JOBIN. As noted in the Introduction of the catalogue (NMM 1983) for the important CCFCS travelling exhibition "From the Heart: Folk Art in Canada": "Barbeau's interest laid the basis for a Canadian Centre of Folk Culture Studies, which supports research not only in folk art, but also into the music, lore and customs of the entire range of Canada's immigrant communities. The emphasis in those early years was on the collection of oral folklore, and it is only in the last decade that the Centre has acquired most of its artifacts, including the collections of several farsighted and dedicated collectors. They include pieces representing traditional art forms that are no longer created as well as ongoing purchases of contemporary works. Following in

Barbeau's path, the Centre acquires objects from working artists and takes special care to discern their meaning." Among the named FOLK ART collections at the CCFCS are: the Gerald Ferguson Collection of Nova Scotia folk art; the Nettie Sharpe Collection of Québec folk art; the Price Collection of Eastern Canadian folk art; and the Ruth McKendry Collection of Quilts. See also FOLK ART, CANADA.

CANADIAN CONFERENCE OF THE ARTS formerly CANADIAN ARTS COUNCIL. In 1961, this conference created a dialogue between representatives of artists and administrators, art educators, writers and art consumers. **Citations**: Sisler 1980; Smith 1980; Lerner 1991.

CANADIAN FEDERATION OF ARTISTS. See FEDERATION OF CANADIAN ARTISTS.

CANADIAN FOLK ART. See FOLK ART, CANADA.

CANADIAN GROUP OF PAINTERS. A group of painters formed in Toronto in 1933 as a successor to the GROUP OF SEVEN. The group included many of the well known painters of the period; the principal members were LAWREN STEWART HARRIS, FREDERICK H. VARLEY, FRANKLIN CARMICHAEL, ALFRED J. CASSON, LIONEL LeMOINE FITZGERALD, EDWIN H. HOLGATE, ARTHUR LISMER and A.Y. JACKSON. It was disbanded in 1969. See Reid 1988, ch. 12; Mellen 1970, p.186; and Duval 1972 which covers the Group and their contemporaries 1930-70. **Citations**: CGP 1933; Colgate 1943; Buchanan 1950; McInnes 1950; McCullough 1966; Harper 1966; Mellen 1970, 1980; Duval 1972; Lord 1974; Hill 1975; Laing 1979; Smith 1980; Osborne 1981; Burnett/Schiff 1983; Bringhurst 1983; Chilvers 1988; Reid 1988; Lerner 1991; Tippett 1992; Murray 1996(1).

CANADIAN HANDICRAFT GUILD. See WOMEN'S ART ASSOCIATION.

CANADIAN MUSEUM OF CIVILIZATION (CMC) (formerly National Museum of Man). The principal activities of the CMC are the collection of artifacts and data, conservation and preservation, scientific research, and exhibition and publication. One of the divisions of the CMC is the CANADIAN CENTRE FOR FOLK CULTURE STUDIES (CCFCS). In 1989, the CMC opened its new museum building, designed by Douglas Cardinal, in Hull, QC. **Citations**: NMM 1983; Marsh 1988.

CANADIAN NATIONAL EXHIBITION (CNE). Following representations by the ONTARIO SOCIETY OF ARTISTS, art exhibitions were held, and catalogues produced, annually by the CNE from 1879-1961, except for the war years 1942-46. **Citations**: CNE Catalogues; MacTavish 1925; Colgate 1943; McInnes 1950; Harper 1966; Lord 1974; Smith 1980; Sisler 1980; Laing 1982; Marsh 1988.

CANADIAN PAINTING. See PAINTING IN CANADA.

CANADIAN SOCIETY OF ARTISTS. See ONTARIO SOCIETY OF ARTISTS.

CANADIAN SOCIETY OF GRAPHIC ART. This Society was organized in 1904 as the Society of Graphic Art and for a time exhibited at the CANADIAN NATIONAL EXHIBITION. In 1976 the Society merged with the SOCIETY OF CANADIAN PAINTER-ETCHERS AND ENGRAVERS to form the PRINT AND DRAWING COUNCIL OF CANADA. **Citations**: CSGA 1924; Smith 1980; Lerner 1991.

CANADIAN SOCIETY OF PAINTERS IN WATERCOLOUR. This Society was formed in 1925 by FRANKLIN CARMICHAEL, ALFRED J. CASSON and FREDERICK H. BRIGDEN to encourage watercolour painting in Canada. There were 24 members by the time of the first exhibition in 1926. Exhibitions were sent across Canada, to Great Britain and to the USA. **Citations**: Colgate 1943; Duval 1954; Casson 1982; Sisler 1980; Lerner 1991; Tippett 1992.

CANADIAN STATE DINNER SERVICE (also known as the CABOT COMMEMORATIVE STATE SET). In 1896 MARY DIGNAM persuaded the Toronto branch of the WOMEN'S ART ASSOCIATION of Canada to sponsor a national competition to decorate a set of sixteen dozen pieces of plain white porcelain dinner ware with historical scenes, harbours and bays, and the flora and fauna of Canada. For example, ALICE HAGEN was one of those selected, and she painted Canada's game birds on her 16 plates. After refusal by the government to purchase the dinner service for Government House, Ottawa, it was purchased through private subscription and presented to the Countess of Aberdeen who was leaving Canada in 1898 with her husband, the governor general. It is now in the CANADIAN MUSEUM OF CIVILIZATION. **Citations**: Elwood 1977; Tippett 1992.

CANADIAN WAR ARTISTS' PROGRAMME. Two years after a recommendation from the CONFERENCE OF CANADIAN ARTISTS (1941), the Canadian government set up this programme to enable artists to record the country's war effort. **Citations**: Robertson 1977; Smith 1980; Tippett 1992.

CANADIAN WOMEN ARTISTS EXHIBITION. An 1947 exhibition by more than seventy Canadian women painters from across Canada at the Riverside Museum in New York City. **Citations**: Tippett 1992.

CANN, ELIZABETH LOVITT (1901-77), Yarmouth, NS. Portraitist. **Citations**: NGC 1982; Tippett 1992.

CANTELON, WILLIAM EAGAR (1866-1950), Simcoe, ON. Painter. Cantelon is thought to have painted more than five thousand local scenes, and portraits of well known citizens, of which several hundred are in the Eva Brook Donly Museum in Simcoe. See Forsey 1975, pl. 14, for a portrait of a horse by Cantelon. **Citations**: Forsey 1975; NGC 1982; McKendry 1988.

CANVAS. Canvas is a textile foundation or SUPPORT for a painting, usually of linen or cotton, sometimes of hemp or jute. The canvas should be prepared with a GROUND to isolate the fabric from the paint and is made taut by a STRETCHER or other means. The term 'canvas' is often used as a synonym for an OIL PAINTING. **Citations**: Mayer 1970; Osborne 1970; Chilvers 1988; Piper 1988.

CANVAS BOARD. Canvas board is pasteboard covered with SIZED and PRIMED cloth. First made commercially in the second half of the 19th century, it is often used by AMATEUR artists. **Citations**: Mayer 1970; Chilvers 1988.

CAPEL, AUDREY. See AUDREY CAPEL DORAY.

CAPPELLO (CAPELLO), LUIGI G. (act. c1874-88), Montréal, QC. Cappello's work was very diversified; he executed portraits, MURALS for churches, signs, banners, ornamental works, glass signs, copies of photographs in oil, embroidery designs, and religious decorative panels for churches. **Citations**: Harper 1966, 1970; McKendry 1988; Lerner 1991.

CAR. See CANADIAN ARTISTS' REPRESENTATION.

CARBONNEAU, Captain P. (act. 1880-92), Lévis, QC. Carbonneau, a St Lawrence River ship captain, executed many naïve watercolour paintings of the ships with which he was familiar (see Harper 1974, pl. 94). **Citations**: Harper 1973, 1974; Kobayashi 1985(2); McKendry 1988.

CARDENAT. See DE CARDENAT.

CARDBOARD. A thin board made from wood pulp, sometimes used as a SUPPORT for paintings by folk artists. **Citations**: Chilvers 1988.

CARDINAL-SCHUBERT, JOANE (act1986), Alberta Painter and sculptor. She is a native artist. For a reproduction of her work see Tippett 1992, p. 180. **Citations**: NGC 1982; Tippett 1992.

CARDINAT. See DE CARDINAT.

CARICATURE. A form of portraiture in which characteristic features of the subject are distorted for comic or grotesque effect. The work of some folk artists can be described as caricatures, for example the carved heads by GEORGE COCKAYNE or some of the political paintings by FRANCIS SILVER. See also CARTOON; FOLK ART, CANADA. **Citations**: AGO 1969; Osborne 1970; Bengough 1974; Riordon 1982; Inglis 1983; Chilvers 1988; Piper 1988.

CARLI, ALEXANDRE (1861-1937), Montréal, QC. Sculptor of religious works. **Citations**: NGC 1982; Laliberté 1986.

CARLI, THOMAS (1838-1906), Montréal, QC. Sculptor of religious works. **Citations**: Lerner 1991.

CARLISLE, WILLIAM OGLE (act. 1870-86), Lévis, QC. Caricaturist and TOPOGRAPHICAL painter. He was with the British army in Canada. **Citations**: Harper 1962, 1966, 1970; NGC 1982.

CARLYLE, FLORENCE (1864-1923), Woodstock, ON. Painter. PAUL PEEL was her friend and patron. She studied in Paris and was noted for her figure paintings. Two of her paintings are in the NATIONAL GALLERY OF CANADA. **Citations**: Jenkins 1925; MacTavish 1925; Robson 1932; McInnes 1950; Hubbard 1960; MacDonald 1967; Harper 1970; Sisler 1980; NGC 1982; Hill 1988;

Lerner 1991; Tippett 1992; McMann 1997.

CARMICHAEL, FRANKLIN (FRANK) (1890-1945), Toronto, ON. Painter, printmaker and illustrator; RCA 1938. Carmichael studied under WILLIAM CRUIKSHANK and GEORGE AGNEW REID, and was a founding member of the GROUP OF SEVEN, of the CANADIAN SOCIETY OF PAINTERS IN WATERCOLOUR, and of the CANADIAN GROUP OF PAINTERS. From 1932 to 1945, he taught at the ONTARIO COLLEGE OF ART. For illustrations of Carmichael's paintings, see Harper 1966, pl. 250, 263. Several of his paintings are in the NATIONAL GALLERY OF CANADA. **Citations**: MacTavish 1925; Robson 1932; NGC 1936; Colgate 1943; McInnes 1950; Buchanan 1950; Duval 1954, 1965, 1972; Jackson 1958; Hubbard 1960, 1967; Harper 1966; MacDonald 1967; Mellen 1970; Reid 1970, 1988; Housser 1974; Lord 1974; Sisler 1980; Thom 1985; Marsh 1988; Lerner 1991; Silcox 1996; Murray 1996(1); McMann 1997.

CARON, PAUL ARCHIBALD (1874-1941), Montréal, QC. Painter, illustrator and printmaker. He studied with WILLIAM BRYMNER, MAURICE CULLEN and EDMOND DYONNET as well as in the USA. Two paintings by Caron are in the NATIONAL GALLERY OF CANADA. **Citations**: Morgan; MacTavish 1925; Robson 1932; Hubbard 1960; MacDonald 1967; Sisler 1980; NGC 1982; Laliberté 1986; Hill 1988; Lerner 1991; McMann 1997.

CARR, M. EMILY (1871-1945), Victoria, BC. Painter and author. Carr was an important painter whose ability to show empathy in her paintings and sketches for the British Columbia forest scenes has never been surpassed. Her paintings of large native sculptures, such as TOTEM POLES, directed attention to what remained standing on original sites of this significant art form. Carr adapted primitive Northwest Coast art as her own, saying "The wild places and primitive people claimed me." She used the skills of an academic artist to preserve the images of primitive sculptures, in their natural settings, before they decayed or were moved to museums. Carr had contact with the GROUP OF SEVEN, and was a member of the CANADIAN GROUP OF PAINTERS. She wrote several books, including her autobiography *Growing Pains* 1946 and her journals *Hundreds and Thousands* 1966. See Shadbolt 1979 for illustrations of Carr's work and Tippett 1979 for a biography. See W. LANGDON KIHN for an American painter of Northwest coast totem poles. Many paintings by Carr are in the NATIONAL GALLERY OF CANADA and the Vancouver Art Gallery. See also ANNA CHENEY. **Citations**: Barbeau 1928, 1973(1); Housser 1929; Robson 1932; IBM 1940; Colgate 1943; Dilworth 1945;Carr 1946, 1953, 1966, 1972; Buchanan 1950; McInnes 1950; Buchanan 1950; Duval 1954, 1972, 1990; Jackson 1958; Hubbard 1960, 1960(1); Mendel 1964; Harper 1966; MacDonald 1967; Groves 1968; Mellen 1970, 1978; Osborne 1970, 1881; Boggs 1971; McLeish 1973; Render 1974; Lord 1974; Tippett 1977, 1974, 1979, 1992; Hembroff-Schleicher 1978; Fenton 1978; Laing 1979, 1982; Shadbolt 1979; Tippett 1979, 1992; NGC 1982; Sisler 1980; Varley 1983; Bringhurst 1983; Burnett/Schiff 1983; McKendry 1983; Thom 1985; Chilvers 1988; Hill 1988; Marsh 1988; Piper 1988; Reid 1988; Shadbolt 1990; Lerner 1991; Silcox 1996; Murray 1996(1).

CARR-HARRIS, IAN (b1941), Toronto, ON. Sculptor and teacher. He studied with THOMAS BOWIE at the ONTARIO COLLEGE OF ART. Carr-Harris' work is represented in the NATIONAL GALLERY OF CANADA. **Citations**: Sisler 1980; NGC 1982; Hill 1988; Lerner 1991; McMann 1997.

CARROLL, BARBARA (b1952), Toronto, ON. Painter and illustrator. Carroll paints deliberately naïve paintings of street scenes of Toronto. **Citations**: *artscanada* 1978; NGC 1982; Market Gallery 1984; Kobayashi 1985(2); McKendry 1988.

CARTE DE VISITE. See PHOTOGRAPHY IN CANADA.

CARTER, ALEXANDER SCOTT (1881-1968), Ontario. Designer, painter and architect; RCA 1928. He studied in England and is considered a master of the art of ILLUMINATION and of interior and exterior architectural design. **Citations**: Sisler 1980; NGC 1982; Lerner 1991; McMann 1997.

CARTMELL, ALBAN (1871-1957), Edmonton, AB Painter. Cartmell came to Canada in 1923 and made his living as a house decorator. He painted delicately coloured winter scenes. **Citations**: Wilkin 1980; McKendry 1988.

CARTOON. A cartoon is either a humourous drawing (parody) or a full-size drawing made for the purpose of transferring a design to a painting, tapestry or other large work. Occasionally a folk artist may produce humorous cartoons, for example FRANCIS SILVER. See Harper 1966, pl. 218, for a cartoon by HENRI JULIEN, and Barbeau 1943 for satirical cartoons by JEAN-BAPTISTE COTE. JOHN WILSON BENGOUGH was a well-known CARTOONIST. See Thom 1985 for cartoons by ARTHUR LISMER. See Desbarats 1979 for a history of political cartooning in Canada. See CARICATURE. **Citations**: Barbeau 1943; AGO 1969; Osborne 1970; Bengough 1974; Bridges 1977; Desbarats 1979; Riordon 1982; Thom 1985; Chilvers 1988; Piper 1988; Marsh 1988.

CARTWRIGHT, HARRIET (1808-87), Kingston, ON. Painter. Harriet Cartwright, née Dobbs, was an amateur landscape painter who executed small attractive watercolour sketches of Kingston and district. She emigrated from Ireland in 1833 to join her husband the Reverend R.D. Cartwright of Kingston. One of their children was Sir Richard Cartwright. Her letterbook is in the Archives of Ontario, Toronto. **Citations**: Harper 1970; Stewart 1973; Bell 1973; Mika 1987; McKendry 1988; Farr 1988; Tippett 1992.

CARTWRIGHT, Miss S.J. (act1858), Kingston, ON. Painter. S.J. Cartwright was an amateur artist known for some drawings in pencil. **Citations**: Harper 1970; McKendry 1988.

CARVING. See MODELING.

CARYATID. A female figure sculpted and acting as a column in architecture. This idea originated in the ancient Greek period: an important model is the Erechtheum, 421-405 B.C. in Athens. **Citations**: Osborne 1970; McKendry 1983; Pierce 1987; Piper 1988; Chilvers 1988.

CAS. See CONTEMPORARY ARTS SOCIETY.

CASSON, ALFRED JOSEPH (1898-1992), Toronto, ON. Painter and printmaker; RCA 1940. He studied with JOHN S. GORDON, HARRY BRITTON and J.W. BEATTY. Casson, a friend of FRANKLIN CARMICHAEL, was at first influenced by Carmichael. Carmichael introduced Casson to the GROUP OF SEVEN, and arranged for Casson to join the Group in 1925. Casson, along with Carmichael and FREDERICK HENRY BRIGDEN, organized the CANADIAN SOCIETY OF PAINTERS IN WATERCOLOUR. See ROUS AND MANN LIMITED. Several paintings by Casson are in the NATIONAL GALLERY OF CANADA. **Citations**: Group of Seven Catalogues; Colgate 1943; NGC 1936,1982; IBM 1940;Duval 1951, 1954, 1965, 1972, 1975, 1980; Jackson 1958; Hubbard 1960, 1967; Harper 1966; MacDonald 1967; Groves 1968; Mellen 1970; Reid 1970, 1988; Murray 1978(2); Sisler 1980; Laing 1982; Casson 1982; Hill 1988; Marsh 1988; Lerner 1991; Silcox 1996; McMann 1997.

CATALOGUE RAISONNE. A complete annotated catalogue of the works of one artist. **Citation**: Lucie-Smith 1984.

CATHEDRAL. A church containing the bishop's throne. **Citations**: Pierce 1987.

CATHOLIC CHURCH. See ROMAN CATHOLIC CHURCH.

CATLIN, GEORGE (1796-1872), USA. Painter, portraitist and miniaturist. Catlin is best known for his paintings of American native peoples and has been compared to PAUL KANE (see Harper 1971). **Citations**: Britannica; Ewers 1955; McCracken 1959; Rasky 1967; Harper 1971(1); Hassrick 1981; Baigell 1981; Tyler 1982; Goetzmann 1986; Lerner 1991.

CAUCHON, ROBERT (1897-1969), Charlevoix County, QC. Painter. Cauchon painted naïve landscape and GENRE paintings in watercolour (see Harper 1974, pl. 48 and 104). **Citations**: Harper 1973, 1974; Baker 1981; NGC 1945, 1982; Kobayashi 1985(2); McKendry 1988; Reid 1988; Lerner 1991.

CAVE ART. See PREHISTORIC ART.

CCFCS. See CANADIAN CENTRE FOR FOLK CULTURE STUDIES.

CEINTURE FLECHEE. A woven sash of 18th and 19th century French Canada, in which the arrow design was inspired by the burden straps and bands of Eastern Woodlands native people. See Dickason 1973, pl. 23, for details of the design. **Citations**: Barbeau 1973; Dickason 1974; Burnham 1981; Lerner 1991.

CELTIC ART. The art of the Celtic peoples of northern Europe during the period from about the 5th

century B.C. to the beginning of MEDIEVAL ART. As the nomadic Celts moved from the east and Russia in the late Roman Empire period into western Europe, they brought intricate metal and wood objects in the "Animal Style." The term "Dark Ages" no longer seems appropriate when considering the brilliantly coloured and skilled examples of Celtic Germanic art. As Celts converted to Christianity in areas such as Ireland, stone crosses and painted manuscripts began to reflect the Animal Style. Some characteristics of Celtic art appear in religious art today, for example in crucifixes by ROBERT A. WYLIE. **Citations:** Osborne 1970; Frere-Cook 1972; Cunliffe 1979; Piper 1988.

CENTRAL TECHNICAL SCHOOL (CENTRAL TECH). Many Canadian artists including KAZUO NAKAMURA, FREDERICK S. CHALLENER and CARL SCHAEFER studied at or taught at Central Tech in Toronto, ON. **Citations:** Gowans 1966; Lord 1974; Reid 1988; Tippett 1992.

CHABERT, Abbé JOSEPH (1832-94), Ottawa, ON; Montréal, QC. Painter and teacher. He arrived in Canada from Paris c1865 and visited France 1878-80. See Harper 1966 for more information on this artist. **Citations:** Harper 1966, 1970; NGC 1982; Lerner 1991.

CHABOILLEZ (CHABOULIE), CHARLES (1654-1708), Montréal, QC. Sculptor. Chaboillez is known to have been in Montréal in 1701 where he executed religious sculpture in wood. See Hubbard 1967, pl. 20, for a Virgin and Child sculpture attributed to him. **Citations:** Traquair 1947; Lessard 1971; Hubbard 1967; Porter 1986; McKendry 1988; Lerner 1991.

CHALK. Chalk is a drawing material made from soft stones or earth. The term is often used interchangeably with CRAYON or PASTEL. **Citations:** Osborne 1970; Mayer 1970; Chilvers 1988; Piper 1988.

CHALLENER, FREDERICK SPROSTON (1869-1959), Toronto, ON. Painter, illustrator and MURALIST; RCA 1899. He was born in England and was in Toronto by 1883 where he studied with G.A. REID. Challener taught at the CENTRAL TECHNICAL SCHOOL 1921-4 and at the ONTARIO COLLEGE OF ART 1927-52. He painted murals in several Canadian cities. See Farr 1981 for J.W. BEATTY'S article about Challener *A Canadian Painter and His Work*. Several of Challener's paintings are in the NATIONAL GALLERY OF CANADA. **Citations:** MacTavish 1925; Robson 1932; Colgate 1943; Miner 1946; Hubbard 1960; Harper 1966; MacDonald 1967; Farr 1981; Hill 1988; Lerner 1991.

CHAMBERLIN, AGNES DUNBAR (MOODIE) FITZGIBBON (1833-1913), Toronto and Ottawa, ON. Painter. Chamberlin executed watercolour paintings of flowers and copied, in oil, landscape and marine paintings. She collaborated with her aunt, CATHARINE PARR TRAILL, in illustrating books of Canadian wild flowers. Agnes Dunbar Chamberlin was a daughter of SUSANNA MOODIE, and is sometimes referred to by her first married name of Fitzgibbon. **Citations:** Harper 1966, 1970; NGC 1982; McKendry 1988; Tippett 1992; Dickenson 1992.

CHAMBERS, JOHN (JACK) RICHARD (1931-78), London, ON. Painter, filmmaker and illustrator. He studied with HERB ARISS and was a founder-member and president of CAR. See Chambers 1978 for an autobiography. Several of his finely detailed paintings, often with photographic realism, are in the NATIONAL GALLERY OF CANADA. **Citations:** Harper 1966; MacDonald 1967; Withrow 1972; Duval 1972, 1974; Lord 1974; Chambers 1978; Mellen 1978; Sisler 1980; Barrio-Garay 1981; NGC 1982; Bringhurst 1983; Burnett/Schiff 1983; Reid 1988; Hill 1988; Marsh 1988; Lerner 1991; Tippett 1992; McMann 1997.

CHAMPLAIN, SAMUEL de (1567-1635), Québec, Nova Scotia and Ontario. Explorer, author, illustrator and painter. Champlain explored many parts of eastern Canada from 1603-29 and made sketches of what he saw, including some TOPOGRAPHICAL landscape paintings in watercolour. In 1609, he sketched a skirmish at Lake Champlain showing himself with arquebus to shoulder aiming at an Iroquois chief (see Lord 1974, pl. 12). This may be the first PORTRAIT made in New France. Champlain left a large body of illustrated writing. **Citations:** Champlain 1911; Traquair 1947; Morisset 1959; Harper 1966, 1970; Lord 1974; Gagnon 1976(1); Reid 1988; McKendry 1988; Marsh 1988; Lerner 1991; Dickenson 1992.

CHANCEL. See CHOIR.

CHANDLER, KENELM (KENEIM) (act. 1784-1804), Québec City, QC. Painter. Chandler was a British army officer who painted landscapes in watercolour. He painted what may be the earliest view of the Talbot settlement (see Allodi 1974, pl. 249). **Citations:** Harper 1970; Allodi 1974; NGC 1982; McKendry 1988.

CHAPEL. A small church, or a part of a large church containing an ALTAR dedicated to one of the saints, but usually named for the DONOR. **Citations:** Pierce 1987.

CHAPLIN, MILLICENT MARY (act. 1838-44), Ottawa, ON; Québec and the Maritimes. Painter. Chaplin was married to a British army officer and executed watercolours). She often made copies of other artist's work and painted GENRE figure groups. Chaplin signed her work "MMC". **Citations:** Barbeau (Québec) 1957; Harper 1970; Bell 1973; Allodi 1974; NGC 1982; McKendry 1988; Lerner 1991; Béland 1992; Tippett 1992.

CHARBONNEAU, MONIQUE (b1928), Québec. Painter, illustrator and printmaker. She studied with ALFRED PELLAN and ALBERT DUMOUCHEL. Three of her prints are in the NATIONAL GALLERY OF CANADA. **Citations:** NGC 1982; Hill 1988; Lerner 1991; Tippett 1992.

CHARCOAL. Charcoal is a stick of wood (willow or vine) reduced to carbon by heat in the absence of air and used for drawing. **Citations:** Mayer 1970; Osborne 1970; Chilvers 1988; Piper 1988.

CHARLEBOIS, JOSEPH CHARLES THEOPHILE (1872-1935), Montréal, QC. Painter, illustrator and caricaturist. He studied in Montréal, Paris and New York. **Citations:** Laberge 1938; NGC 1982; Laliberté 1986; Lerner 1991.

CHARLEVOIX COUNTY. Charlevoix County is on the north shore of the St Lawrence River west of the Saguenay River, QC. In the second half of the 19th century, when roads and steamship travel to the area were established, the region became popular with painters who appreciated the beauty of its rugged landscape. While the area was painted previously by several early TOPOGRAPHERS, including JAMES PEACHEY, GEORGE BULTEEL FISHER, GEORGE HERIOT, and JOHN JEREMIAH BIGSBY, it was not until a tourist industry took root around 1850 that there was an influx of Canadian painters including JAMES D. DUNCAN, OTTO R. JACOBI, WILLIAM RAPHAEL, CHARLES JONES WAY, LUCIUS O'BRIEN, and FREDERICK MARLETT BELL-SMITH. La Malbaie and Baie-Saint-Paul became the centres of artistic activity. Baie-Saint-Paul received increasing attention in the twentieth century largely due to the interest of CLARENCE GAGNON. At about this time, MARIUS BARBEAU was directing attention to the traditional FOLK ART of Charleveoix County and, by the 1930s, a group of self-taught folk artists called the Charlevoix Primitives (Murray Bay Primitives) emerged. This group included SIMONE-MARY BOUCHARD, YVONNE BOLDUC, ROBERT CAU-CHON, ALFRED DESCHENES, PHILIPPE MALTAIS, and GEORGES-EDOUARD TREMBLAY. Many of these artists received personal encouragement from MARIUS BARBEAU, and the collectors and painters from Boston, Maud and Patrick Morgan, as well as JEAN PALARDY and other artists who were working in the area. The Morgans organized a series of annual art exhibitions at Pointe-au-Pic. About this time Palardy was joined by his friend JEAN-PAUL LEMIEUX who returned to Charlevoix County in the summers for many years. In 1940, the work of the Charlevoix Primitives was brought to the attention of the public by the "Exhibition of French-Canadian Primitives" at the ART ASSOCIA-TION OF MONTREAL. In artistic terms, Charlevoix County is an unique region in Canada due to its long and continuing association with Canadian artists. See also COVERLET. **Citations:** Barbeau 1934(1); Morgan 1940; McInnes 1950; Watson 1974; Baker 1981; McKendry 1983; Lerner 1991.

CHARLEVOIX PRIMITIVES. See CHARLEVOIX COUNTY.

CHARMOY. See DE CHARMOY.

CHARPENTIER, HENRI (1888-1967), Montréal, QC. Painter. **Citations:** NGC 1982.

CHARRON, ADELARD EMILE (1878-1945), Ottawa, ON. Portrait painter. He studied in Paris. **Citations:** Harper 1970; Laliberté 1986.

CHARRON, AMABLE (1785-1844), Québec. Sculptor. Charron was a sculptor of religious works, for example the interior of the Church of Saint-Jean-Baptiste at Saint-Jean-Port-Joli, QC. See also JEAN

CHRYSOSTOME PERRAULT. **Citations**: Traquair 1947; Lerner 1991.

CHARTRAND (dit Vincennes), VINCENT (1795-1863), St-Vincent-de-Paul, QC. Painter, and sculptor of religious works in wood. He was apprenticed to LOUIS QUEVILLON. An example of Chartrand's work is in the NATIONAL GALLERY OF CANADA. **Citations**: Vaillancourt 1920; Traquair 1947; NGC 1982; Porter 1986; Hill 1988; Lerner 1991.

CHATIGNY, EDMOND (b1895), Saint-Isidore, QC. Sculptor. Chatigny, a retired farmer, began carving at age seventy-five in an unconventional free style with little concern for realism or craftsmanship. His principal theme is birds and his most interesting carvings are of large bird forms having deck-like areas supporting many small animals and birds (see NMM 1983, pl. 218, and McKendry 1983, pl. 90). The colours used to finish his work are limited to green, white, red and brown. Chatigny's freedom in handling forms and colours has been admired by other artists. **Citations**: de Grosbois 1978; *artscanada* 1979; NGC 1982; NMM 1983; McKendry 1983; Kobayashi 1985(2); *Empress* 1985; McKendry 1988; Lerner 1991.

CHAUCHETIERE, Father CLAUDE (1645-1709), Caughnawaga near Montréal, QC. Painter. Chauchetière was a Jesuit missionary to the Iroquois at Caughnawaga Mission. He executed naïve portraits in oil and religious drawings that he used in teaching the Iroquois. For an illustration of his work, see Harper 1966, pl. 4. **Citations**: Harper 1966, 1970; Gagnon 1975, 1976(1); NGC 1982; McKendry 1988; Lerner 1991.

CHAVIGNAUD, GEORGE (1865-1944), Toronto, ON. Painter. Chavignaud came to Canada in 1884 from France after studying in Paris and Brussels. He painted on ILE D'ORLEANS, QC, and Prince Edward Island. One of his watercolours is in the NATIONAL GALLY OF CANADA. **Citations**: MacTavish 1925; Robson 1932; Colgate 1943; Hubbard 1960; MacDonald 1967; Hill 1988; Lerner 1991.

CHENEY, ANNA (NAN) GERTRUDE LAWSON (1897-1985), Vancouver, BC. Painter, portraitist and illustrator. She studied in the USA, and in Canada with J. W. BEATTY, FRANKLIN BROWNELL and LILIAS TORRANCE NEWTON. Cheney was in Vancouver after 1937. A portrait by Cheney of EMILY CARR is in the NATIONAL GALLERY OF CANADA. **Citations**: NGC 1982; Hill 1988; Lerner 1991.

CHESTER, DONOVAN (DON) T. (b1940), Saskatchewan. Painter and ceramicist. **Citations**: Wilkin 1973(1), 1974(1); Walters 1975; NGC 1982; Lerner 1991.

CHIAROSCURO. Chiaroscuro is an effect obtained by significant gradations between brightness and darkness in paintings, and its dramatic effect was especially appreciated during the BAROQUE and ROMANTIC periods. It is not usually present in FOLK ART. **Citations**: Osborne 1970; Pierce 1987; Piper 1988; Chilvers 1988.

CHILDREN'S ART. The art of young children who have not yet learned to write resembles the PRIMITIVE ART of preliterate peoples who use pictorial signs. Both are concerned with showing only the most important feature of the subject. The child, like more mature NAÏVE artists, at first disregards anatomy, perspective and correct scale. The child progresses and develops greater mental powers at the expense of instinctive powers, resulting in the child's creativity being generally supplanted by deliberate and rational perceptions. For these reasons, children's art is sometimes included in studies of FOLK ART. **Citations**: Osborne 1970; Bihalji-Merin 1971, 1985.

CHILDREN'S ART CENTRE. See HENRY NORMAN BETHUNE.

CHOIR. The part of a church reserved for singers and the clergy, usually from the CROSSING area to the APSE; and sometimes called the chancel. **Citations**: Pierce 1987.

CHOIR SCREEN. A carved screen separating the CHOIR from the NAVE of a church. This feature was revived in 19th-century Gothic REVIVAL churches (especially Anglican and Roman Catholic), modelled on certain MEDIEVAL churches. **Citations**: Pierce 1987.

CHRIST. See GOD THE SON; RELIGIOUS ART.

CHRISTENSEN, DAN (b1942), Canada. Painter. He was interested in the work of JACK BUSH.

Citations: Wilkin 1973(2); Carpenter 1981; NGC 1982; Lerner 1991.

CHRISTIAN ART. See RELIGIOUS ART.

CHRISTIE, ROBERT E. (b1946), Saskatchewan, SK; Alberta Painter. He was influenced by the work of JACK BUSH. **Citations**: Walters 1975; Carpenter 1981; NGC 1982; Lerner 1991.

CHRISTOPHER, KEN (b1942), Calgary, AB Painter. **Citations**: Bingham 1981; NGC 1982; Lerner 1991.

CHROMOLITHOGRAPHY. A colour LITHOGRAPHIC process. **Citations**: Eichenberg 1976.

CHURCH. See ROMAN CATHOLIC CHURCH and RELIGIOUS ART.

CHURCH, H. (act. 1840), Québec. Painter. Little is known about this artist who made a series of copies in oil after engravings of paintings by WILLIAM HENRY BARTLETT published in Willis 1842. Church's work is illustrated in Cooke 1983, pl. 73-9. **Citations**: Willis 1842; Harper 1970; Cooke 1983; McKendry 1988.

CHURCHILL, Miss L. (act. 1873), ON. Painter. This artist is known for a watercolour painting of McKay's Mountain from Fort William (collection ROYAL ONTARIO MUSEUM, Toronto, ON). **Citations**: Allodi 1974; McKendry 1988.

CIBORIUM. A canopy supported by columns over a church altar, that may bear some carved religious decoration. The term also applies to a vessel, usually of silver, used for holding the consecrated Host. See also SILVERSMITHING, RELIGIOUS ART. **Citations**: Traquair 1940; Langdon 1966; Ferguson 1967; Osborne 1970; Trudel 1974; Chilvers 1988.

CICANSKY, FRANK (1900-82), Regina, SK. Sculptor and painter. In 1926 Cicansky emigrated from Roumania to the Dirt Hills area of Saskatchewan where he farmed and worked as a carpenter, a BLACKSMITH and a labourer on a road gang. When he retired in 1967, he made toys, models and windmills for his grandchildren, and painted memory pictures in his naïve, narrative style. Examples of his work are in the DUNLOP ART GALLERY. Frank Cicansky was the father of VICTOR CICAN-SKY. See GRAIN BIN PROJECT. **Citations:** Dunlop Art Gallery; Bringhurst 1983; McKendry 1988.

CICANSKY, VICTOR (act1978), Craven, SK. Sculptor, ceramicist and MURALIST. Victor Cicansky works with ceramic materials and has executed murals for public buildings. He is the son of FRANK CICANSKY and is familiar with the work of the prairie folk artists of his father's generation. This had its influence on the subjects he chooses and on his realistic and detailed manner of presentation. Victor Cicansky collaborated with several folk artists in the GRAIN BIN PROJECT for the 1976 Olympics in Montréal. Another Saskatchewan ceramicist is JOE FAFARD. **Citations**: Ferguson 1976; *artscanada* 1979; Bismanis 1980; Bringhurst 1983; McKendry 1988.

CICCIMARRA, RICHARD MATTHEW (1924-73), Vancouver and Victoria, BC. Painter and printmaker. He arrived in Canada in 1952, after studying art in Vienna and Salzburg. An example of his work is in the NATIONAL GALLERY OF CANADA. **Citations**: NGC 1982; Hill 1988; Lerner 1991.

CIGAR-STORE FIGURES. The use of various figures as tobacconist's trade signs began in the 18th century and was popular through the 19th century in England, the USA and eventually in Canada. Jim Crow and other black figures, Highlanders in kilts, and native people, sometimes holding cigars, appeared inside and in front of most tobacconist shops. By 1860, most of the tobacconist's signs in the USA were cigar-store figures, and this was also the case in Canada (see McKendry 1983, pl. 63; Price 1979, pl. 60 and 61; Harper 1973, pl. 9). Canadian sculptors who carved cigar-store figures include LOUIS JOBIN (see Fried 1920, pl. 140-3), JEAN- BAPTISTE COTE, and CLAUDE COTE. See Fried 1920, pp. 157-70 for an account of Canadian sculptors of cigar-store figures. **Citations**: Fried 1920; Harper 1973; Price 1979; McKendry 1983.

CINQ-MARS, ALONZO (1881-1969), Québec City, QC. Sculptor and journalist. **Citations**: Laberge 1945; NGC 1982; Laliberté 1986; Lerner 1991.

CINQ-MARS, CLEMENT (b1918), Longueuil, QC. Sculptor and painter. After retiring from his trade as a carpenter, Cinq-Mars took up wood carving and produced a number of POLYCHROMED figures such as *Embracing Couple* (shown in NMM 1983, pl. 171). **Citations:** CCFCS; NMM 1983; Kobayashi

1985(2); McKendry 1988.

CLAGUE, JOHN (act1875), Stoney Lake, ON. Painter. After his retirement as a sailor on the Atlantic Ocean and on Lake Ontario, Clague painted naïve oil paintings based on his life as a sailor (see Guillet 1957, pl. 39-41). **Citations**: Guillet 1957; Harper 1970; McKendry 1988.

CLAPP, WILLIAM HENRY (1879-1954), Montréal, QC. Painter. He studied with WILLIAM BRYMNER and in Paris, returning to Canada in 1908. After 1915, he was in Cuba and the USA. Several paintings by Clapp are in the NATIONAL GALLERY OF CANADA. **Citations**: Hubbard 1960; Harper 1966; MacDonald 1967; Sisler 1980; MacTavish 1925; Robson 1932; Colgate 1943; Jackson 1958; NGC 1982; Laliberté 1986; Hill 1988; Reid 1988; Duval 1990; Lerner 1991.

CLARK, KELVIN (KELLY) WILLIAM DAVID (b1935), Winnipeg, MB. Painter, printmaker and folk singer. He studied under GEORGE SWINTON and travelled in the USA and Europe. An example of his work is in the NATIONAL GALLERY OF CANADA. **Citations**: NGC 1982; Hill 1988; Lerner 1991.

CLARK, PARASKEVA (1898-1986), Toronto, ON. Painter; RCA 1966. She studied art in her native Russia and by 1923 was living in Paris. She came to Toronto in 1931. Certain of her works show a strong sense of social-realism. Some of her paintings, including self portraits, are in the NATIONAL GALLEY OF CANADA. **Citations**: McInnes 1950; Buchanan 1950; Duval 1954, 1972; Robertson 1977; Jackson 1958; Hubbard 1960, 1963; Harper 1966; MacDonald 1967; Jarvis 1974; Sisler 1980; NGC 1982; Reid 1988; Marsh 1988; Hill 1988; Lerner 1991; Tippett 1992; McMann 1997.

CLARKE (DARRAH), ANNE (b1944), Alberta. Painter. She came to Canada from England in 1968. **Citations**: Murray 1980(2); Carpenter 1981; NGC 1982; Lerner 1991; Tippett 1992.

CLASSICISM. (or Classical Art) A term used to describe the qualities associated with the art of ancient Greece and Rome, that is from about the 7th century B.C. to the mid 4th century A.D. (or the beginning of the Early Christian Period). Classicism or NEOCLASSICISM is also used to describe works produced from the mid 18th century through the 19th century and has, in the past, been described as the antithesis of ROMANTICISM. See also REVIVALS. The term 'classic' refers to the most representative example of its kind in any field or period. **Citations**: Osborne 1970; Piper 1988; Chilvers 1988.

CLELAND, MARY ALBERTA (1876-1960), Montréal, QC. Painter and sculptor. She studied under WILLIAM BRYMNER and travelled in Italy and the USA. Examples of her work are in the NATIONAL GALLERY OF CANADA. **Citations**: Hubbard 1960; MacDonald 1967; NGC 1982; Hill 1988; Tippett 1992.

CLEMENS, ABRAM S. (1790-1867), Waterloo County, ON. Painter. Clemens, a MENNONITE, emigrated to Canada in 1825 from Pennsylvania and settled near Hespeler, ON. He executed some FRAKTUR drawings with geometric designs, floral motifs and winged figures. **Citations**: Kobayashi 1985(2); McKendry 1988.

CLEMENTI, Reverend VINCENT (1812-99), Lakefield, ON. Painter. Clementi made landscape sketches of the Peterborough area (see Allodi 1974, pl. 263) and studies of Canadian wild flowers. His paintings are sometimes signed "Rev. V.C." He taught CATHARINE PARR TRAILL. **Citations**: Harper 1970; Allodi 1974; NGC 1982; McKendry 1988.

CLENCH (CLENCHE), HARRIET (d1892), Cobourg and Toronto, ON. Painter. She married PAUL KANE in 1853. For illustrations see Guillet 1957, pl. 95 and 96, and Tippett 1992, p. 10. **Citations**: Guillet 1957; Harper 1970; 1971(1); Reid 1988; Tippett 1992.

CLERK, PIERRE JEAN (b1928), Montréal, QC; New York. Painter, printmaker, sculptor, and tapestry designer. He studied under ARTHUR LISMER, GOODRIDGE ROBERTS, JACQUES DE TONNANCOUR, and LOUIS ARCHAMBAULT as well as in Paris and Florence. Examples of his work are in the NATIONAL GALLERY OF CANADA. **Citations**: Henault 1981; NGC 1981; Hill 1988; Lerner 1991.

CLEVELY, JOHN II (1747-86), Arctic. Marine painter. He studied with PAUL SANDBY of the

ROYAL MILITARY ACADEMY, Woolwich. **Citations**: Harper 1964, 1970.

CLEW, CLEPHAM J. See CLOW, CLEPHAM J.

CLOUGH, GIBSON (1738-99), Louisbourg, NS. Painter. Clough, an American, was present at the British capture of Louisbourg in 1758 by General James Wolfe, and made an amateur drawing, with distorted perspective, of *The General's House, Louisbourg* (see Harper 1974, pl. 28). **Citations**: Harper 1973, 1974; Kobayashi 1985(2); McKendry 1988.

CLOUTIER, ALBERT EDWARD (1902-65), Montréal, QC. Painter, MURALIST and illustrator; RCA 1958. He studied under EDMOND DYONNET and JOSEPH SAINT-CHARLES, and sketched with A.Y. JACKSON and EDWIN HOLGATE. Cloutier painted in Newfoundland, Labrador and Ottawa, and as an official war artist 1944-46. Examples of his work are in the NATIONAL GALLERY OF CANADA. **Citations**: McInnes 1950; Jackson 1958; Hubbard 1960; MacDonald 1967; Duval 1972; Sisler 1980; NGC 1982; Hill 1988; Lerner 1991; McMann 1997.

CLOW (CLEW), CLEPHAN JOHN (act c1831-c1850), Halifax, NS. Painter, portraitist, miniaturist and photographer. Clow was an ITINERANT ARTIST who worked in Nova Scotia, New Brunswick and the USA. He painted portraits and landscapes, MINIATURES on ivory, and took DAGUERREO-TYPES. **Citations**: Harper 1966, 1970; NGC 1982; McKendry 1988; Lerner 1991.

CLUTESI, GEORGE C. (b1905), British Columbia. Painter and author. He is a native artist who is a poet, lecturer, and historian of West Coast native people. **Citations**: Clutesi 1969; Barbeau 1973(1); NGC 1982; Lerner 1991.

CMC. See CANADIAN MUSEUM OF CIVILIZATION.

COATES, EDMUND (EDWARD) C. (act. 1836-59), Toronto, ON; Aylmer, QC. Painter. Coates executed landscape and historical paintings including copies, with variations, of engraved views after WILLIAM HENRY BARTLETT from Willis 1842 (see Cooke 1983, pl. 80-1). Two paintings by Coates are in the NATIONAL GALLERY OF CANADA. **Citations**: Willis 1842; Harper 1970; Cooke 1983; McKendry 1988; Hill 1988.

COATES, RICHARD (1778-1868), York (Toronto), ON. Painter. Coates, a portrait and decorative painter, is known for his symbolic and decorative paintings (pre 1828) at the Sharon Temple north of Toronto; see Harper 1974, pl. 17, 18. **Citations**: Harper 1966, 1970, 1973, 1974; NGC 1982; Kobayashi 1985(2); McKendry 1988.

COBURN, FREDERICK SIMPSON (1871-1960), Montréal, QC. Painter, printmaker and illustrator; RCA 1928. Coburn studied in New York, Berlin, Paris, London and Antwerp. He often painted Canadian winter scenes of horses and sleighs with a forest background. Coburn illustrated many books including poetry by the Canadian poet W.H. Drummond. Several paintings by Coburn are in the NATIONAL GALLERY OF CANADA. **Citations**: MacTavish 1925, 1928; Chauvin 1928; Robson 1932; Colgate 1943; Duval 1952; Lee 1956; Stevens 1958; Hubbard 1960; Harper 1966; MacDonald 1967; Watson 1974; Sisler 1980; Antoniou 1982; Laing 1982; NGC 1982; Laliberté 1986; Hill 1988, 1995; Marsh 1988; Lerner 1991; McMann 1997.

COCHAND, PIERRE-HENRI (b1924), Montréal and Ste-Marguerite-Station, QC. Painter. He studied under ADAM SHERRIFF SCOTT and in the USA. Examples of his work are in the NATIONAL GALLERY OF CANADA. **Citations**: Hubbard 1960; NGC 1982; Hill 1988.

COCHRANE, VOLLIE (act1875), Québec. Painter. Little is known about this copyist after COR-NELIUS KRIEGHOFF. His 1875 copy in watercolour of Krieghoff's 1853 *Habitant Farm in Winter* is illustrated in Allodi 1974, pl. 269. See Harper 1979, ch. 5, for other copies of Krieghoff paintings. **Citations**: Harper 1970, 1979; Allodi 1974; McKendry 1988.

COCK. See BIRDS.

COCKAYNE GEORGE (b1906), Hastings County, ON. Sculptor. Cockayne is one of Canada's most interesting folk sculptors because his work is original and often on the borderline between being PRIMITIVE or NAÏVE. At first when he was dependent on others for his livelihood, his work was naïve and subdued. Later when he became independent on his own farm, his work became freer and he

indulged his imagination by producing bold primitive sculpture, sometimes using the naturally occurring shapes in found materials. Mask-like faces and clashing colours characterize some of his work. Although Cockayne has had a one-man show at an art gallery, and his work is represented in public and private collections, his themes are his own and are not influenced by the market. The best reference for this artist is Inglis 1983, which includes a catalogue of his works with comments in the artist's own words. Many examples of his work are in the CCFCS collections. **Citations**: Smith 1975(1); CCFCS; NGC 1982; McKendry 1983, 1988; Inglis 1983; NMM 1983; Kobayashi 1985(2); *Empress* 1985.

COCKBURN, CHARLES FREDERICK (1830-1908), Québec City, QC; Halifax, NS. Painter. A landscape painting in watercolour of Québec City c1851 (see Cooke 1983, pl. 82) is attributed to this man who served with Royal Artillery. He was the son of JOHN HENRY COCKBURN and a grandson of JAMES PATTISON COCKBURN. **Citations**: Cooke 1983; McKendry 1988.

COCKBURN, JAMES PATTISON (PATTERSON) (1779-1847), Québec City, QC. Painter. Cockburn studied TOPOGRAPHICAL painting at the ROYAL MILITARY ACADEMY, Woolwich, under the English watercolour artist PAUL SANDBY (1725/6-1809). He was in Canada with the British Army from 1826-1832, and sketched many scenes in Québec and Ontario and several were published. Some of his paintings are in the NATIONAL GALLERY OF CANADA. See the numerous entries and plates (270-463) in Allodi 1974. See also CAMERA LUCIDA. **Citations**: Duval 1954; Barbeau (Québec) 1957; Spendlove 1958; Harper 1966, 1970; Hubbard 1967; Bell 1973; Allodi 1974; Cameron 1976; Thibault 1978; Nasby 1980; NGC 1982; Cooke 1983; Mika 1987; McKendry 1988; Hill 1988; Farr 1988; Marsh 1988; Reid 1988; Cavell 1988; Lerner 1991; Béland 1992.

COCKBURN, JOHN HENRY (act1817-19), Ontario. Painter. John Henry Cockburn was the elder brother of JAMES PATTISON COCKBURN and was with the British Army in Canada. He executed TOPOGRAPHICAL paintings in watercolour and sketches of Niagara Falls signed "JHC." It is not certain that he is the "H. Cockburn" referred to in Allodi 1974. **Citations**: Harper 1970; Allodi 1974; McKendry 1988.

COFFIN, THOMAS (act1848), Québec. Painter. **Citations**: Béland 1992.

COLBEY, WILLIAM (act1810), Québec. Painter. Little is known about this artist other than his c1810 naïve watercolour view of the Straits of Belle Isle (Cooke 1983, pl. 149). **Citations**: Harper 1970; Cooke 1983; McKendry 1988.

COLE, WILLIAM P. (act. 1884), Eastern Canada. Painter. Cole painted native people figures in landscape in the manner of CORNELIUS KRIEGHOFF. See Harper 1979, ch. 5, for an account of other painters who imitated Krieghoff's work. **Citations**: Harper 1970, 1979; McKendry 1988.

COLEMAN, ARTHUR PHILEMON (1852-1939), Toronto, ON. Painter and geologist. **Citations**: Harper 1970; Render 1974; NGC 1982.

COLIN, FRANCOIS (FRANCIS COLLIN) (c1818-79), Ottawa, ON; Montréal, QC. Painter, portraitist. There is a portrait by this artist in the NATIONAL GALLERY OF CANADA. **Citations**: NGC 1982; Hill 1988.

COLLAGE. A pictorial technique which originated about 1911 with Cubist painters, Pablo Picasso (1881-1974) and Georges Braque (1882-1963), in France as a new way of exploring representation in art. A collage is a combination of various objects such as photographs or news clippings chosen for symbolic purposes and fastened to the painting GROUND, sometimes in combination with painted areas. A collage by Canadian artist JOSEPH CONNOLLY is in the NATIONAL GALLERY OF CANADA. Other Canadian artists who worked with collages are TONY ONLEY, Abbé JOSEPH MIGNAULT and LOUIS DE NIVERVILLE. Some folk artists use the collage technique (see Harper 1973, pl. 27, 128, 161 and Harper 1974, pl. 24). See also FOIL ART. **Citations**: Osborne 1970; Harper 1973, 1974; Pierce 1987; Piper 1988; Chilvers 1988.

COLLECTING. In Canada, as early as the 17th century, the ROMAN CATHOLIC CHURCH in Québec collected RELIGIOUS ART for church decoration. During the 18th century as Québec became more settled, more art was produced and private collections were formed. In 1816, the Abbé

LOUIS-JOSEPH DESJARDINS began to bring about 200 European paintings to Québec of which some were put in churches, while the remainder were bought by the artist JOSEPH LEGARE who used them to establish the first art gallery open to the public in Canada. These paintings, of which many were copies or the work of minor painters, became known as the DESJARDINS COLLECTION. In Montréal, the ART ASSOCIATION OF Montréal was formed in 1860, and this served to increase interest in the collecting of art. Other organizations, such as the ONTARIO SOCIETY OF ARTISTS, were formed in other parts of the country to promote sales and collecting of art. In 1880, the ROYAL CANADIAN ACADEMY OF ARTS (RCA) was formed and this lead to the founding of the NATIONAL GALLERY OF CANADA to collect for the nation (see Hill 1988, pp. XI-XXIX). From that time on, public art gallery collections, corporate collections, and private collections spread throughout the country. After the railway reached the west coast in 1885, native art was collected as ethnology examples by American and Canadian museums. They were not appreciated and collected as art objects until about the 1940s. See also FOLK ART EXHIBITIONS, DECORATIVE ARTS, FURNITURE, SILVERSMITHING. **Citations**: Cox 1960; Harper 1966; Osborne 1970; Boggs 1971; Watson 1974; Laing 1979, 1982; Sisler 1980; Hill 1988; Reid 1988; Marsh 1988; Lerner 1991; Murray 1996(1).

COLLIER, ALAN CASWELL (b1911), Toronto, ON. Painter and MURALIST; RCA 1960. He studied under ROBERT HOLMES, J.E.H. MacDONALD, J.W. BEATTY, FRANK CARMICHAEL, FRED S. HAINES, FREDERICK S. CHALLENER, JOHN ALFSEN, and YVONNE MCKAGUE HOUSSER, and in New York. Two of his paintings are in the NATIONAL GALLERY OF ART. **Citations**: Hubbard 1960; MacDonald 1967; Bennett 1971; Lord 1974; Sisler 1980; Hill 1988; Lerner 1991; McMann 1997.

COLLIN, FRANCIS. See FRANCOIS COLIN.

COLLINGS, CHARLES JOHN (1848-1931), Seymour Arm, BC. Painter. He came to Canada in 1910 and travelled widely throughout British Columbia and other parts of the country. One of his water-colours is in the NATIONAL GALLERY OF CANADA. **Citations**: Carroll 1912; MacTavish 1925; Robson 1932; Colgate 1943; Hubbard 1960; Tippett 1977; Hill 1988; Lerner 1991.

COLLYER, ROBIN JOHN (b1949), Toronto, ON. Sculptor; CONCEPTUAL artist. Collyer arrived in Toronto from London in 1957. He studied at the ONTARIO COLLEGE OF ART and taught there. Several of his sculptures, incorporating various materials, are in the NATIONAL GALLERY OF CANADA. **Citations**: NGC 1982; Hill 1988; Lerner 1991.

COLMAN, ALFRED RUSSELL (1844-1929), Jarvis, ON. Painter. Colman, a veterinary surgeon without formal art training, executed watercolour paintings of animals and pencil sketches of birds. He painted his own professional sign in 1876, in water-colour, showing a group of farm animals in landscape, see Nasby 1980, p. 70. **Citations**: Nasby 1980; McKendry 1988.

COLMAN, Captain W.T. (act1843), Kingston, ON. Painter. Captain Colman is known for a watercolour painting of Kingston from Barriefield executed in 1843, while he was in Kingston with the British Army. **Citations**: Stewart 1973; Mika 1987; McKendry 1988.

COLOUR. See PRIMARY COLOURS.

COLOUR DRYPOINT. See DRYPOINT.

COLOURIST. A term sometimes used in art criticism to denote a painter who puts more emphasis on colour than on line. See also PAINTERLY, LINEAR. **Citations**: Piper 1988.

COLVILLE, DAVID ALEXANDER (ALEX) (b1920), Sackville, NB; Wolfville, NS. Painter, printmaker and MURALIST. Colville is a well-known painter whose work is represented in many public (NATIONAL GALLERY OF CANADA) and private collections. He has been influential in introducing MAGIC REALISM to Canada through his paintings of figures, in suspended animation, looming against a background of inanimate objects. **Citations**: McInnes 1950; Hubbard 1960, 1960(1), 1967; Harper 1966; Andrus 1966; MacDonald 1967; Dow 1972; Duval 1954, 1972, 1974; Boggs 1971; Lord 1974; Wilkin 1976(1); Robertson 1977; Fenton 1978; Mellen 1978; Laurette 1980(2); Osborne 1981; Metson 1981; NGC 1982; Burnett-Schiff 1983; Bringhurst 1983; Burnett 1983; Chilvers 1988; Hill 1988; Piper

1988; Marsh 1988; Reid 1988; Lerner 1991; Tippett 1992.

COLVILLE, CHARLES J. (c1820-1903), Ontario. Painter. Colville, an officer in the British Army, was an Aide-de-camp to Lieutenant-Governor Sir George Arthur in 1840, when he sketched Government House, Toronto, ON (see Allodi 1974, pl. 631). **Citations:** Harper 1970; Allodi 1974; McKendry 1988.

COMBINE-PAINTING. A work of art in which real objects are incorporated into the painted surface. The term is distinguished from COLLAGE, because it applies to works that cause difficulties in deciding whether they are paintings or sculptures. See JUNK ART. **Citations:** Osborne 1981; Piper 1988; Chilvers 1988.

COMFORT, CHARLES FRASER (1900-94), Toronto, ON. Painter, printmaker, illustrator and MURALIST; RCA 1945, RCA president 1957-60. He emigrated in 1912 from Scotland to Winnipeg, MB, where he studied art. Comfort was a friend of the members of the GROUP OF SEVEN. He was director of the NATIONAL ART GALLERY 1960-5, where there are several examples of his work. (see Hill 1988, pp. XXI and XXII). **Citations:** Robson 1932; Colgate 1943; Middleton 1944; McInnes 1950; Buchanan 1050; Duval 1954, 1972; Comfort 1956; Jackson 1958; Hubbard 1960, 1960(1); Harper 1966; MacDonald 1967; Mellen 1970, 1978; Boggs 1971; Lord 1974; Gray 1976; Robertson 1977; Laurette 1978; Sisler 1980; NGC 1982; Laing 1982; Reid 1988; Hill 1988, 1995; Marsh 1988; Piper 1988; Lerner 1991; Silcox 1996; McMann 1997.

COMINGO, JOSEPH BROWN (b1784), Halifax, NS. Painter. Comingo, who was born in Halifax, was painting MINIATURES in that city during the same period as ROBERT FIELD was painting portraits. Comingo's work includes portrait, landscape and miniature paintings on paper, vellum or ivory, in oil or watercolour. **Citations:** Harper 1966, 1970; Field 1985; NGC 1982; McKendry 1988; Lerner 1991.

COMPLEMENTARY COLOURS. See PRIMARY COLOURS.

COMPOSITE PHOTOGRAPH. See MONTAGE.

COMPOSITION. The arrangement of forms in a work of art in relation to each other and to the whole, usually taking into account proportion and harmony. **Citations:** Osborne 1970; Pierce 1987; Piper 1988.

COMPTON, ANNA ROCKWELL (1853-1928), Kingston, ON. Painter, portraitist. She was in Kingston by 1907, and painted three portraits that are now in the Kingston City Hall. She is referred to as an artist in a city directory of 1910.

COMTOIS, ULYSSE (b1931), Montréal, QC. Painter, sculptor and MURALIST. He was married to RITA LETENDRE c1960. Examples of Comtois's work are in the NATIONAL GALLERY OF CANADA. **Citations:** Harper 1966; MacDonald 1967; NGC 1982; Hill 1988; Lerner 1991.

CONCEPTUAL ART. An art movement that emerged in the 1960s and was concerned primarily with idea as opposed to craftsmanship. PERFORMANCE ART and EARTH ART are sometimes called conceptual art. See also N.E.THING COMPANY LTD., ROBIN COLLYER. **Citations:** Hill 1974; Osborne 1981; Lucie-Smith 1984; Piper 1988; Britannica; Read 1994.

CONDON, WANDA (b1951), Manitoba. Painter and film artist. **Citations:** Murray 1980(2); NGC 1982; Lerner 1991.

CONFERENCE OF CANADIAN ARTISTS (1941). This conference, organized by ANDRE BIELER, was held in Kingston, ON. It resulted in the formation of the FEDERATION OF CANADIAN ARTISTS with Biéler as the first president, as well as the CANADIAN WAR ARTS PROGRAMME, initiated in 1943. **Citations:** Biéler 1941; Smith 1980; Bringhurst 1983; Lerner 1991; Tippett 1992.

CONNOISSEUR. A connoisseur is a person who places great emphasis on AESTHETIC appreciation of a work of art and also has expertise in art. **Citations:** Osborne 1970.

CONNOLLY, JOSEPH EMILE REYNALD (b1944), Montréal, QC. Painter, printmaker and illustrator. A COLLAGE by this artist is in the NATIONAL GALLERY OF CANADA. **Citations:** NGC 1982; Hill 1988; Lerner 1991.

CONSCIOUS FOLK ART. See FOLK ART, CONSCIOUS.

CONSERVATION AND RESTORATION. Conservation and restoration of a work of art is a craft that requires a high degree of skill and an intimate knowledge of materials, as well as AESTHETIC sensibility and knowledge of art history. A highly regarded training program in this field is offered at Queen's University, Kingston, ON. A good summary of techniques is given in Osborne 1970.

CONSTRUCTION. A term used for a sculpture in which separate parts are joined together by fastenings rather than by modeling, casting or carving. This is often the case in YARD ART. **Citations:** Pierce 1987.

CONTANT, EDGAR (1883-1944), Montréal, QC. Painter and musician. He was associated with HORNE RUSSELL, LUDGAR LAROSE, CHARLES MAILLARD, and his brother-in-law GEORGES DELFOSSE. **Citations:** Laliberté 1986.

CONTEMPORARY ARTS SOCIETY (CAS). Chiefly through the efforts of JOHN LYMAN, CAS was formed in 1939 to acquaint the public with modern art in Montréal. The founding members included PAUL-EMILE BORDUAS, FRITZ BRANDTNER, STANLEY COSGROVE, LOUIS MUHLSTOCK, GOODRIDGE ROBERTS, JORI SMITH, PHILIP SURREY, and JOHN LYMAN (first president). **Citations:** Bergeron 1946; Buchanan 1950; McInnes 1950; Harper 1966; Duval 1972; Lord 1974; Perreault 1975; Hill 1975; Bingham 1979; Varley 1980; Dompierre 1986; Marsh 1988; Reid 1988; Tippett 1992.

CONTINUOUS NARRATIVE or REPRESENTATION. Depiction within the same work of events which occurred at different times. This was often done in MEDIEVAL ART in MURALS, MOSAICS, RELIEF sculpture, etc., and is still used today by some folk artists, for example CLARENCE WEB-STER. The professional artist JEAN-PAUL LEMIEUX used this technique in his 1941 painting *Lazare* (Harper 1966, pl. 303, collection ART GALLERY OF ONTARIO). See also NARRATIVE ART, FOLK ART. **Citations:** Pierce 1987; Chilvers 1988; Piper 1988.

CONVERSATION PIECE. A group portrait, in which the sitters are in a social setting, often their own parlours, dining rooms, or at tea on the lawns. This was a particularly popular format in 18th-century England with painters such as Arthur Devis (1711-87). A well-known Canadian example is *The Woolsey Family* 1809, by WILLIAM VON MOLL BERCZY (collection NATIONAL GALLERY OF CANADA). This work has been characterized as "an early Canadian conversation piece in an age when the single figure portrait was a general rule." (Harper 1966, p.66). **Citations:** Harper 1966; Osborne 1970; Piper 1988; Chilvers 1988.

COOK (COOKE), NELSON (1817-92), Kingston and Toronto, ON; USA. Painter. Cook and his wife were ITINERANT portraitists who sometimes worked in a naïve style and executed copies of European prints. See Harper 1974, pl. 60, for an illustration of a portrait by Cook. He became well known due to the importance of some of his portrait subjects. **Citations:** Colgate 1943; Harper 1966, 1970, 1973, 1974; NGC 1982; Kobayashi 1985(2); McKendry 1988; Reid 1988; Hill 1988; Lerner 1991.

COOK, THOMAS (act1869), Varna, Huron County, ON. Painter. Cook was at various times a wagon maker, grocer and saloon keeper. He painted a naïve portrait in oil of a child (Harper 1974, pl. 61. **Citations:** Harper 1973, 1974; Kobayashi 1985(2); McKendry 1988.

COOK, WALTER (b1923), Sherbrooke, NS. Sculptor. Cook has carved from wood naïve figures of animals, birds, and people. His figures are usually finished in bright paint. **Citations:** Waddington 1980; AGNS; Kobayashi 1985 (2); McKendry 1988.

COOMBS, EDITH GRACE (Mrs JAMES SHARP LAWSON) (b1890), Guelph, ON. Painter, illustrator, art teacher and MURALIST. She associated with some of the members of the GROUP OF SEVEN and ROBERT HOLMES. Her work has not received the attention that it merits. See Pierce 1949 for the best account of her life and work with many illustrations. **Citations:** Pierce 1949; MacDonald 1967; NGC 1982; Lerner 1991; Tippett 1992.

COONAN, EMILY GERALDINE (1885-1971), Montréal, QC. Painter. She studied under WILLIAM BRYMNER, was associated with the BEAVER HALL GROUP and travelled in Europe. Some of her

paintings are in the NATIONAL GALLERY OF CANADA. **Citations**: Hubbard 1960; NGC 1982; Hill 1988; Tippett 1992.

COOPER, REED TALMAGE (b1931), Toronto, ON. Painter and printmaker. He arrived in Canada in 1945 from Bermuda and studied art in Toronto. One of his paintings is in the NATIONAL GALLERY OF CANADA. **Citations**: NGC 1982; Hill 1988.

CPE. See SOCIETY OF CANADIAN PAINTER-ETCHERS AND ENGRAVERS.

COPSON, PAUL (1884-1916), Québec. Painter. Little is known about this artist who was born in England and killed in the first world war. For a time he worked with MARC-AURELE FORTIN. **Citations**: Laliberté 1986.

COPY. In general, a copy of a work of art is one executed without direct intervention of the original artist. If it comes from the original artist's studio it may be referred to as a VERSION or a REPLICA. See also PROVINCIAL ART; FAKE. **Citations**: Osborne 1970.

CORMIER, ERNEST (1885-1980), Montréal, QC. Painter, sculptor, ceramist and architect; RCA 1932. He studied in Montréal, Paris and Rome. Cormier's architectural works include the Supreme Court of Canada, Ottawa, 1938-50. **Citations**: Chauvin 1928; Hubbard 1960; Sisler 1980; NGC 1982; Laliberté 1986; Hill 1988; Lerner 1991; Kalman 1994; McMann 1997.

CORMIER, MEDARD (b1933), Bertrand, NB. Painter. Cormier is a naïve artist who paints landscapes that include figures. His painting *Pré du Nord* (Northern Meadow), showing the cutting and cocking of hay, is illustrated in Laurette 1980(2). **Citation**: Laurette 1980(2)

COSGROVE, STANLEY MOREL (b1911), Montréal, QC. Painter and MURALIST. He studied under CHARLES MAILLARD, JOSEPH SAINT-CHARLES and EDWIN H. HOLGATE as well as in New York. Several paintings by Cosgrove are in the NATIONAL GALLERY OF CANADA. **Citations**: Buchanan 1950; McInnes 1950; Duval 1952; Hubbard 1960, 1960(1), 1963; MacDonald 1967; Fenton 1978; Bazin 1980; Sisler 1980; Reid 1988; Hill 1988; Marsh 1988; Lerner 1991; McMann 1997.

COSTUME. See CLOTHING.

COTE. See SUZOR-COTE.

COTE, CLAUDE (act1880-1928), Saint-Roch, QC. Sculptor. Claude Côté executed naïve sculpture of people and animals in POLYCHROMED wood, including CIGAR-STORE FIGURES, see Trudel 1967(Sculpture), pl. 84, or Fried 1920, pl. 148. He was a son of JEAN-BAPTISTE COTE and worked in the same shop as his father and his uncle, after whom he was named, leading to some confusion in the attribution of work. **Citations**: Fried 1920; Barbeau 1943; Trudel (Sculpture) 1967; CCFCS; NGC 1982; Porter 1986; McKendry 1988.

COTE, JEAN-BAPTISTE (1832-1907), Québec City and Saint-Roch, QC. Côté was a well known professional wood carver who executed SHIPCARVINGS, signs, tobacconists' native people and black advertising figures, animals, furniture, and religious carvings. For a time he was apprenticed to the architect FRANCOIS-XAVIER BERLINQUET and then turned to wood carving. Côté was carving figureheads for wooden sailing ships at a time when such work became redundant, because sailing ships were being replaced by steamers with steel hulls. He began carving birds, animals, decorative furniture, trade figures (*see back cover*), and trade signs (see Harper 1973, pl. 97), but only felt fulfilled by his work when he became fully occupied with carving wooden statues for churches and religious pictures in high RELIEF (see Hubbard 1967, pl. 130). For a time in the 1860s Côté executed CARTOONS for a satirical periodical *La Scie* (see Barbeau 1943) which he published. Examples of Côté's sculpture are now in many private and public collections including the NATIONAL GALLERY OF CANADA. The best accounts of Côté's life and work are in Fried 1920 and Barbeau 1943. **Citations**: Bridle 1916; Fried 1920; Barbeau 1936, 1943; Barbeau 1957(Québec); Hubbard 1960, 1967; Trudel 1967(Sculpture); Harper 1970, 1973; NGC 1982; CCFCS; McKendry 1983, 1988; Kobayashi 1985(2); Porter 1986; Hill 1988; Lerner 1991.

COTTON, JOHN WESLEY (1869-1931), Toronto, ON. Painter and printmaker. He studied in Toronto, Chicago and London. Several ETCHINGS by Cotton are in the NATIONAL GALLERY OF

CANADA. **Citations**: Robson 1932; Colgate 1943; NGC 1982; Hill 1988; Lerner 1991.

COTTON, W. HENRY (1817-77), Québec City, QC; Ottawa, ON. Painter. After emigrating from Russia to Canada in 1836, it is thought that Cotton executed some landscape sketches in watercolour including four views of Québec City, which were published as LITHOGRAPHS in 1850 by Sarony & Major, New York. He was on the governor general's staff in Québec City and, after 1867, in Ottawa. **Citations**: Harper 1970; Allodi 1974; McKendry 1988.

COUGHTRY, JOHN GRAHAM (b1931), Toronto, ON. Painter and sculptor. He studied under GOODRIDGE ROBERTS, JACQUES DE TONNANCOUR and JOCK MACDONALD, was associated with MICHAEL SNOW, and travelled widely. Coughtry was a member of the ARTISTS' JAZZ BAND. Several of his paintings and prints are in the NATIONAL GALLERY OF CANADA. **Citations**: Hubbard 1960, 1963; Harper 1966; MacDonald 1967; Duval 1972; Lord 1974; Hale 1976; Mellen 1978; Fenton 1978; Sisler 1980; Bringhurst 1983; Burnett/Schiff 1983; Marsh 1988; Reid 1988; Hill 1988; Lerner 1991; Murray 1996(1); McMann 1997.

COURCY, MICHAEL JOHN DE (b1944), Vancouver, BC. Photographer and printmaker. Several of his prints are in the NATIONAL GALLERY OF CANADA. **Citations**: NGC 1982; Hill 1988 (see de Courcy); Lerner 1991.

COURTEMANCHE, ADELARD (1861-1957), Québec. Sculptor of religious works in wood. **Citations**: Porter 1986.

COURTICE, RODY KENNY HAMMOND (Mrs A. Roy Courtice) (1895-1973), Toronto, ON. Painter and printmaker. She studied under Arthur Lismer and was influenced by the GROUP OF SEVEN. **Citations**: McInnes 1950; Jackson 1958; MacDonald 1967; Sisler 1980; NGC 1982; Tippett 1992; McMann 1997.

COVERDALE COLLECTION OF CANADIANA (MANOIR RICHELIEU COLLECTION). The W.H. Coverdale Collection of Canadiana was acquired by the NATIONAL ARCHIVES OF CANADA in 1970 from Canada Steamship Lines. William Hugh Coverdale (1871-1949) who owned a successful engineering firm in New York City, was a descendent of the Coverdale family of Kingston, ON, and acquired a summer home near Kingston in 1917. Of the 2207 works in this important pictorial record of Canada's past, 500 are paintings and drawings. Prints represent about 70 percent of the collection. In 1983 the National Archives issued a catalogue (Cooke 1983) of paintings and prints representing about one-fifth of the collection, and reference should be made to this extensive and illustrated catalogue for further information. **Citations**: Cooke 1983; Lerner 1991.

COVERLET. A decorative bedspread made from yarns of linen, cotton or wool, or combinations of them, woven on a loom. The most distinctively Canadian coverlet designs were those used on the boutonné coverlets of Québec province; see Hubbard 1967, pl. 127, 128, for examples from CHARLEVOIX COUNTY. See also HELENE DESGAGNE; Mme FORTIN. **Citations**: Hubbard 1967; Burnham 1972, 1981, 1986; McKendry 1979.

COWAN, HARVEY (b1935), Toronto, ON. Painter and architect. He was associated with the ARTISTS' JAZZ BAND 1974-76. An OFFSET photo LITHOGRAPH by Cowan is in the NATIONAL GALLERY OF CANADA. **Citations**: NGC 1982; Hill 1988.

COWIN, JACK LEE (b1947), Regina, SK. Painter and printmaker. Cowin who was born in the USA arrived in Regina in 1971. Two examples of his work are in the NATIONAL GALLERY OF CANADA. **Citations**: NGC 1982; Hill 1988; Lerner 1991.

COWLEY, RETA MADELINE (b1910), Moose Jaw, SK. Painter. She studied under A.F. KENDER-DINE, W.J. PHILLIPS and A.Y. JACKSON. **Citations**: MacDonald 1967; Fenton 1971; Dillow 1975; NGC 1982; Lerner 1991; Tippett 1992.

COX, ARTHUR W. (1840-1917), Toronto, ON; Montréal, QC. Painter. He emigrated from England to Canada as a young man and was in Toronto until 1894, then in Montréal until 1897, and from 1902 in Toronto. Cox painted in the Rocky Mountains, in Ontario, and in New England **Citations**: Harper 1970; Sisler 1980; NGC 1982; McMann 1997.

COX, ELFORD BRADLEY (b1914), Toronto, ON. Sculptor. He was influenced by Henry Moore and by native Iroquois sculpture. **Citations:** McInnes 1950; MacDonald 1967; NGC 1982; Lerner 1991.

COX, PALMER (1840-1924), Granby, QC. Illustrator and CARTOONIST. He lived in the USA in mid-life but spent his early and late years in Granby. A large number of his drawings are in the NATIONAL GALLERY OF CANADA. **Citations:** Harper 1970; Fielding 1974; NGC 1982; Hill 1988; Lerner 1991.

COYNE, MICHAEL (b1950), NS. Painter. **Citations:** Laurette 1980(3); NGC 1982; Lerner 1991.

COZIC, YVON (b1942), Montréal, QC. Sculptor and painter. She studied under ALBERT DU-MOUCHEL and JACQUES DE TONNANCOUR and is married to the artist Monic Brassard. Examples of Cozic's work are in the NATIONAL GALLERY OF CANADA. **Citations:** NGC 1982; Hill 1988; Lerner 1991.

COZZENS, FREDERICK SCHILLER (1856-1928), Newfoundland. Painter of Newfoundland scenes. **Citations:** Harper 1970; de Volpi 1972.

CRAFT. See HANDICRAFT.

CRAWFORD, JULIA TILLEY (1896-1968), Saint John, NB. Painter. **Citations:** NGC 1982; Lerner 1991; Tippett 1992.

CRAWLEY, FREDERICK SIDNEY (c1797-c1880), Wolfville, NS. Painter and teacher. He studied in England and France, and taught painting at Acadia University, Wolfville, c1862. **Citations:** Harper 1970; NGC 1982.

CRAYON. Crayons are sticks of colour having an oily or waxy binder. They are often used by folk artists, for example CLARENCE WEBSTER. See also CHALK. **Citations:** Mayer 1970.

CRESSWELL, WILLIAM NICHOL (1822-88), Seaforth, ON. Painter; RCA 1880. Cresswell painted marine views, animal and historical studies, and landscapes, in Eastern Canada. See Cavell 1988, pl. 68 and 72, for illustrations. Several watercolours by Cresswell are in the NATIONAL GALLERY OF CANADA. **Citations:** MacTavish 1925; McInnes 1950; Hubbard 1960; Harper 1966, 1970; Thibault 1978; London 1978; Reid 1979, 1988; Sisler 1980; NGC 1982; Laing 1982; Varley 1986; Cavell 1988; Hill 1988; Fiset 1989; Lerner 1991; McMann 1997.

CRICKMER, the Reverend WILLIAM B. (act. 1859), Derby, BC. Crickmer executed naïve sketches illustrating his daily life in the early settlements around Derby, near Fort Langley. Some of his sketches included information lettered at their edges. For an example, see the illustration on p. 68 of Gilmore 1980. **Citations:** Gilmore 1980; McKendry 1988.

CRISP, ARTHUR WATKINS (1881-1974), Hamilton, On; USA. Muralist and painter. He studied under JOHN S. GORDON, and in New York. Several of Crisp's paintings are in the NATIONAL GALLERY OF CANADA. **Citations:** Hubbard 1960; MacDonald 1967; Fielding 1974; NGC 1982; Hill 1988; Lerner 1991.

CROCKART, JAMES BISSET (1885-1974), Montréal, QC. Painter, printmaker, commercial artist, designer, and architect. In 1911 he arrived in Montréal after studying art in Edinburgh and Glasgow. An ETCHING by Crockart is in the NATIONAL GALLERY OF CANADA. **Citations:** NGC 1982; Hill 1988.

CROSCUP HOUSE. The William Croscup house in the Annapolis Valley area of Nova Scotia had several naïve MURALS (wall-paintings) that are now located in the NATIONAL GALLERY OF CANADA. See Bird 1983, pp. 8-10, for illustrations. **Citations:** Bird 1983; Greenaway 1986.

CROSS. A cross, which is a common emblem of Christ and his Church, is a sign of the sacrifice through which mankind won redemption and salvation. See CRUCIFIXION, CALVARY and RELIGIOUS ART. **Citations:** Ferguson 1967; Porter 1973; Pierce 1987; Lerner 1991.

CROSS, FREDERICK GEORGE (1881-1941), Lethbridge, AB Painter. Cross was a watercolour painter whose painting *Alberta Pool Elevators* is illustrated in Wilkin 1980. He was in Lethbridge by 1917 and, in the 1930s, was with A.Y. JACKSON on a sketching trip through southern Alberta. **Citations:** Colgate 1943 pp. 182-3; Jackson 1958; MacDonald 1967; Wilkin 1980; NGC 1982;

McKendry 1988.

CROSS HATCHING. See HATCHING.

CROSS, JOHN (c1850-1939), Queen Charlotte Islands, BC. Sculptor. His work includes sculpture in argillite or wood based on Haida traditions. **Citations**: Barbeau 1957(Haida); *Canadian Collector* 1976; McKendry 1988.

CROSSING. The area in a church where the TRANSEPT crosses the NAVE. It may be surmounted by a dome or tower. **Citations**: Pierce 1987.

CROUSE, GEORGE (1835-66), Milton, NS. Sculptor. Crouse is known for a 1853 BUST of a child carved in POLYCHROMED wood (Field 1985, pl. 87). This is the only known surviving work by this artist who also carved FIGUREHEADS. **Citations**: MacLaren 1971; Field 1985; McKendry 1988.

CRUCIFIX. A crucifix is any cross, or a CROSS with the figure of Christ crucified upon it. See also CRUCIFIXION, CALVARY. **Citations**: Ferguson 1967; Lerner 1991.

CRUCIFIXION. Crucifixion was used in Roman times as a punishment for criminals. Christ was crucified to ridicule the early Christians. It is a theme in RELIGIOUS ART. See also CALVARY, CRUCIFIX, CROSS. **Citations**: Ferguson 1967; Osborne 1970; Lerner 1991.

CRUIKSHANK, ROBERT (1748-1809), Montréal, QC. Silversmith. He was in Canada from 1773. Two examples of his work are in the NATIONAL GALLERY OF CANADA. See also SILVER-SMITHING. **Citations**: Traquair 1940; Langdon 1960, 1966, 1968; NGC 1982; Hill 1988; Lerner 1991.

CRUIKSHANK, WILLIAM (1848-1922), Toronto, ON. Painter, illustrator and art teacher; RCA 1895. He arrived in Toronto from Scotland in 1857 after studying in Edinburgh, London and Paris. Cruikshank moved to the USA in 1919 and died there. Two of his paintings are in the NATIONAL GALLERY OF CANADA. **Citations**: MacTavish 1925; Robson 1932; Colgate 1943 (p. 45); McInnes 1950; Hubbard 1960; Harper 1966, 1970; MacDonald 1967; Lord 1974; Laurette 1978; Sisler 1980; NGC 1982; Karel 1987; Hill 1988; Lerner 1991; McMann 1997.

CRUISE, STEPHEN PATRICK CHRISTOPHER (b1949), Toronto, ON. Sculptor and VIDEO artist. He studied at the ONTARIO COLLEGE OF ART and travelled widely. An INSTALLATION by Cruise is in the NATIONAL GALLERY OF CANADA. **Citations**: Hill 1988; Lerner 1991.

CUBISM. Cubism was an early 20th century art movement that, in rejecting naturalistic representation, revolutionized painting and sculpture. PABLO PICASSO and Georges Braque (1882-1963), in Paris, started the movement partly inspired by primitive African tribal sculpture as evident from Picasso's 1907 painting *Les Demoiselles d'Avignon*. In Cubism, the subject may be represented from a plurality of viewpoints and appear fragmented into interlocking planes. Canadian artists who were influenced by Cubism include: BERTRAM BINNING, YORK WILSON, FRITZ BRANDTNER, BERTRAM BROOKER, LAWREN HARRIS, LIONEL LEMOINE FITZGERALD, and JAMES W.G. (JOCK) MACDONALD. **Citations**: Harper 1966; Arnason 1968; Chipp 1968; Osborne 1970, 1981; Janson 1974; Clay 1978; Sisler 1980; Rosenblum 1982; Schapiro 1982; McKendry 1983; Reid 1988; Chilvers 1988; Piper 1988; Lerner 1991.

CULLEN, MAURICE GALBRAITH (1866-1934), Montréal, QC. Painter; RCA 1908. Cullen studied sculpture in Montréal under LOUIS-PHILIPPE HEBERT. In 1889, he went to Paris to study painting and came under the influence of IMPRESSIONISM. Cullen returned to Montréal in 1895, and became one of Canada's great painters of Montréal cityscape, of snow covered landscape (see Harper 1966, pl. 230-2, 234), and Newfoundland scenes. Like the later GROUP OF SEVEN, he was much criticized for his new approach to painting. He showed Canadian winter landscape in its true, brilliant and snow-reflected colours. This influenced other painters and helped to prepare the public for acceptance of the expressive approach of the GROUP OF SEVEN. In 1910, Cullen married Barbara Merchand Pilot, mother of ROBERT PILOT. Several of Cullen's paintings are in the NATIONAL GALLERY OF CANADA. **Citations**: MacTavish 1925; Chauvin 1928; Watson 1931, 1974; Robson 1932; Buchanan 1936, 1950; Laberge 1938; McInnes 1950; Dyonnet 1951; Pilot 1956, 1967; Jackson 1958; Stevens

1958; Hubbard 1960, 1960(1), 1963, 1967; Pepper 1966; Harper 1966, 1970; MacDonald 1967; Beament 1968; Osborne 1970; Boggs 1971; Watson 1974; Lord 1974; Ayre 1977; Robertson 1977; Mellen 1978; Thibault 1978; Jouvancourt 1978(2); Laing 1979, 1982, 1984; Sisler 1980; Antoniou 1982; NGC 1982; Rosenblum 1982; McKendry 1983; Laliberté 1986; Piper 1988; Chilvers 1988; Marsh 1988; Reid 1988; Hill 1988; Cavell 1988; Duval 1990; Lerner 1991; Tippett 1992; McMann 1997.

CUMMINS, JANE CATHARINE (1841-93), Montréal, QC. Painter. She studied under OTTO R. JACOBI and in Europe. One of her watercolours is in the NATIONAL GALLERY OF CANADA. **Citations**: Hubbard 1960; MacDonald 1967; NGC 1982; Hill 1988.

CURATOR. A curator is the person in charge of a collection, for example, a museum, art collection, or an art exhibition. See COLLECTING; EXHIBITIONS; NATIONAL GALLERY OF CANADA. **Citations**: Hill 1988; Murray 1996(1).

CURNOE, GREGORY RICHARD (GREG) (1936-92), London, ON. Painter, printmaker and illustrator. Curnoe studied under CARL SCHAEFER, JOHN ALFSEN and others. His work shows influences from CUBISM, DADA and SURREALISM, is often controversial and never dull. He became associated with the NIHILIST SPASM BAND in 1964. See Reid 1988 for commentary on this artist. There are many examples of his work in the NATIONAL GALLERY OF CANADA. **Citations**: Hubbard 1967; Townsend 1970; Boggs 1971; Withrow 1972; Lord 1974; Fenton 1978; Osborne 1981; Bringhurst 1983; Burnett-Schiff 1983; Marsh 1988; Reid 1988; Hill 1988.

CURREN, JOHN D. (1852-1940), Banff, AB Painter. Curren, a prospector and miner, came to Alberta in 1886 and later painted naïve paintings of the Banff area. **Citations**: Render 1974; Wilkin 1980; NGC 1982; McKendry 1988.

CURRELLY, JUDITH (b1946/7), YT. Painter. **Citations**: NGC 1982; Lerner 1991; Tippett 1992.

CURRIER AND IVES PRINTS. Currier and Ives prints are hand coloured LITHOGRAPHS published in large quantities in New York by Nathaniel Currier (1803-87) and James M. Ives (1824-95). These prints, depicting most aspects of contemporary America, were popular in both the USA and Canada. They were cheap in their time and few were saved. **Citations**: Osborne 1970; Eichenberg 1976; Chilvers 1988.

CURRIER, NATHANIEL. See CURRIER AND IVES PRINTS.

CURRY, PEGGY (1885-1966), Halifax, NS. Painter. **Citations**: NGC 1982; Tippett 1992.

CUTHBERTSON, GEORGE ADRIAN (1900-69), Toronto, ON. Painter and illustrator. Cuthbertson, who had studied under WILLIAM BRYMNER, sketched and painted in watercolour many Great Lakes ships of the period from the 18th century to the Second World War. His book, *Freshwater: A History and Narrative of the Great Lakes*, Toronto, 1931, includes illustrations taken from his paintings. **Citations**: Cuthbertson 1931; Allodi 1974; NGC 1982; McKendry 1988.

CUTTING, LORNA (b1933), Saskatchewan. Painter. **Citations**: Mendel 1977; NGC 1982; Lerner 1991.

CUTTS, GERTRUDE ELEANOR SPURR (1858-1941), Port Perry, ON. Painter. She was the wife of WILLIAM MALCOLM CUTTS, and arrived in Toronto c1890 after studying art in London and New York. One of her paintings is in the NATIONAL GALLERY OF CANADA. **Citations**: Colgate 1943 p. 42; Hubbard 1960; MacDonald 1967; Sisler 1980; Hill 1988; McMann 1997.

CUTTS, WILLIAM MALCOLM (1857-1943), Port Perry, ON. Painter. He was the husband of GERTRUDE E.S. CUTTS, and arrived in Canada in 1870. He painted in England, Jamaica and the eastern USA. One of his paintings is in the NATIONAL GALLERY OF CANADA. **Citations**: Hubbard 1960; MacDonald 1967; Hill 1988.

D

DADA. Dada is a nihilistic art movement, which appeared in France in 1915 and was in decline by 1923. It was associated with Marcel Duchamp (1887-1968). Certain of his sculptures were simply FOUND OBJECTS. It was a deliberately anti-rational and anti-aesthetic reaction to World War 1, and helped pave the way to SURREALISM, JUNK ART and POP ART. Dada had a very limited effect on Canadian art, but did influence the work of GREGORY RICHARD CURNOE. See Osborne 1981 for a good account of the Dada movement. **Citations**: Arnason 1968; Osborne 1970, 1981; Lord 1974; Clay 1978; Reid 1988; Chilvers 1988; Piper 1988.

DAGLISH, PETER WILLIAM (b1930), Montréal, QC. Painter, printmaker and sculptor. He came to Canada from England in 1955 and studied with ARMAND FILION, LOUIS ARCHAMBAULT and ALBERT DUMOUCHEL, as well as in New York and London, England, where he now lives. Examples of his work are in the NATIONAL GALLERY OF CANADA. **Citations**: MacDonald 1967; NGC 1982; Hill 1988; Lerner 1991.

DAGUERREOTYPE. A photographic process, invented about 1839 in France by L.J.M. Daguerre (1789-1833), in which an image is produced directly on a silvered copper plate. Each image is unique because there is no negative from which further images could be made. Daguerreotype portraits became cheap compared to painted MINIATURE portraits or SILHOUETTES, and this caused some portrait painters to turn to photography, for example CLEPHAN CLOW and THOMAS HANFORD WENT-WORTH. See PHOTOGRAPHY IN CANADA. **Citations**: Colgate 1943; Greenhill 1965, 1979; Harper 1966; Chilvers 1988; Borcoman 1988.

DAHLSTROM, EUGENE WILHELM (1885-1971), Hardy, SK. Painter. Dahlstrom, who was born in Sweden, immigrated to Canada in 1912 and became a farmer in Saskatchewan. In 1959, after he had been painting for only a few years, ten of his paintings were included in the important exhibition "Folk Painters of the Canadian West,"organized and circulated by the NATIONAL GALLERY OF CANADA. In 1973 he had one painting in another important exhibition, "People's Art: Naïve Art in Canada." Dahlstrom has painted several views of the area around Hardy, portraits and STILL LIFE studies. A self portrait by Dahlstrom is in the NATIONAL GALLERY OF CANADA. See also FOLK ART, PAINTERS OF THE CANADIAN WEST EXHIBITION. **Citations**: McCullough 1959; Harper 1973; Dunlop Art Gallery; NGC 1982; Kobayashi 1985(2); McKendry 1988; Hill 1988; Lerner 1991.

DALLAIRE, JEAN-PHILIPPE (1916-65), Ottawa, ON; Hull, Québec City and Montréal, QC. Painter, illustrator and MURALIST. Dallaire studied with CHARLES GOLDHAMER, PETER HA-WORTH, CHARLES MAILLARD and others, as well as in Paris. His paintings show influence by PABLO PICASSO, ALFRED PELLAN, SURREALISM, and folk imagery; see Harper 1966, pl. 375, and Duval 1972, pp. 113-14. From 1952 to 1957 he illustrated educational films on local history and folklore. Several of his paintings are in the NATIONAL GALLERY OF CANADA. **Citations**: Hubbard 1960, 1967; Mendel 1964; Harper 1966; MacDonald 1967; Ostiguy 1971; Duval 1972; Guy 1980; Burnett-Schiff 1983; Marsh 1988; Reid 1988; Hill 1988; Lerner 1991.

DALLEGRET, FRANCOIS (b1937), Montréal, QC. Designer, printmaker and sculptor; RCA 1973. Born in Morocco, he arrived in Montréal in 1964 after studying architecture in Paris. One of his prints is in the NATIONAL GALLERY OF CANADA. **Citations**: Sisler 1980; NGC 1982; Hill 1988.

D'ALMAINE, GEORGE (d1893), Niagara Falls, ON. Painter, portraitist, SILHOUETTIST and MINIATURIST. D'Almaine was in Niagara Falls in 1834, and painted portraits with the Niagara River or Falls in the background (see Harper 1974, pl. 21-3), as well as a view of Niagara Falls, published as a LITHOGRAPH. After 1855 he was in the USA. **Citations**: Harper 1970, 1973, 1974; Dobson 1982; Kobayashi 1985(1,2); McKendry 1988.

DALY, KATHLEEN FRANCES PEPPER (b1898), Toronto, ON. Painter and printmaker; RCA

1965. She studied with FRED S. HAINES, J.W. BEATTY, J.E.H. MACDONALD and ARTHUR LISMER, and in 1929, married GEORGE DOUGLAS PEPPER in 1929. Two examples of her work are in the NATIONAL GALLERY OF CANADA. **Citations**: Robson 1932; McInnes 1950; Harper 1966; Sisler 1980; NGC 1982; Marsh 1988; Hill 1988; Reid 1988; Tippett 1992; McMann 1997.

DANBY, KENNETH (KEN) EDISON (b1940), Guelph, ON. Painter and printmaker. He studied with J.W.G. (JOCK) MACDONALD. Danby is well known for his studies of sports figures (see Santana 1978). Two examples of his work are in the NATIONAL GALLERY OF CANADA. **Citations**: Duval 1972, 1974, 1976; 1984; Lord 1974; Belshaw 1976; Santana 1978; Sisler 1980; NGC 1982; Burnett/ Schiff 1983; Bringhurst 1983; Hill 1988; Reid 1988; Marsh 1988; Lerner 1991; McMann 1997.

DANYLEWICH, MORRIS JOHN (b1938), Ottawa, ON. Graphic designer and printmaker. He studied with JACQUES de TONNANCOUR, HENRY EVELEIGH and ALBERT DUMOUCHEL. Several prints by Danylewich are in the NATIONAL GALLERY OF CANADA. **Citations**: NGC 1982; Hill 1988.

DAOUST, SYLVIA MARIE EMILIENNE (1902-74), Montréal, QC. Sculptor and printmaker; RCA 1952. She studied with F.C. FRANCHERE, EDMOND DYONNET and EDWIN HOLGATE among others. Two examples of her sculpture are in the NATIONAL GALLERY OF CANADA. **Citations**: Levesque 1936; Colgate 1943; McInnes 1950; Hubbard 1960; MacDonald 1967; Sisler 1980; NGC 1982; Hill 1988; Lerner 1991; Tippett 1992; McMann 1997.

DARRAH. See ANNE CLARKE.

DARTNELL, GEORGE RUSSELL (c.1799-1878), Niagara and London, ON. Painter. Dartnell was a military doctor with the British Army in Canada. He executed TOPOGRAPHICAL sketches in watercolour of Québec and Ontario scenes and, in 1845, had sketches of a shipwreck published as LITHOGRAPHS in London. See de Pencier 1987 for the best account of Dartnell's life and work. **Citations**: Harper 1966, 1970; Bell 1973; Allodi 1974; Thibault 1978; NGC 1982; de Pencier 1987; McKendry 1988.

DAUDELIN, CHARLES (b1920), Kirkland, QC. Sculptor, painter and illustrator. He studied with PAUL-EMILE BORDUAS, as well as in New York and Paris. There is a bronze by this artist in the NATIONAL GALLERY OF CANADA. **Citations**: NGC 1982; Hill 1988; Marsh 1988; Lerner 1991.

DAVID, DAVID-FLEURY (1780-1841), Sault-au-Recollet, QC. Sculptor. David was a sculptor in wood (gilded) of religious subjects. **Citations**: Traquair 1947; Trudel 1967(Sculpture); Trudel 1969; Lessard 1971; McInnes 1950; Porter 1986; McKendry 1988; Lerner 1991.

DAVID, JOSEPH (JOE) (b1946), British Columbia. Painter, sculptor and printmaker. Joe David is a member of the Clayoquot Band of Northwest Coast native people. His work, which includes SERI-GRAPHS and MASKS, reflects the traditional arts of the Clayoquot people. **Citations**: NGC 1982; McKendry 1988; Marsh 1988; Lerner 1991.

DAVID, LOUIS-BASILE (LOUIS-BAZIL) (act1820), Québec. Sculptor of religious works in wood. He collaborated with THOMAS BAILLAIRGE. **Citations**: Traquair 1947; Porter 1986; Lerner 1991.

DAVIES, BLODWEN (1897-1966), Toronto, ON. Author and columnist. She wrote the first biography of TOM THOMSON, *Paddle and Palette, the Story of Tom Thomson* 1935. **Citations**: Jackson 1958; Story 1967; Davies 1935, 1967; Town 1977.

DAVIES, THOMAS (c1737-1812), Nova Scotia and Québec. Painter. Davies was with the British Army in various parts of North America including Canada, where he executed many TOPOGRAPHI-CAL watercolour paintings. He painted scenes in the eastern provinces in such a distinctive, almost naïve style, that modern writers have referred to him as an "eighteenth-century Rousseau." (See HENRI ROUSSEAU.) Many of Davies's paintings are distinguished by a decorative, rhythmic pattern of landscape contours in brilliant colours. It was appropriate that Davies was trained as a topographer to render detail carefully and meticulously, because this fitted his own instincts as an artist. A large number of Davies's paintings are in the NATIONAL GALLERY OF CANADA. See Hubbard 1972(1)(2) for the most complete account of his life and work; see Harper 1966, pl. 33, 42, and

McKendry 1983, pl. 129, 130, 131, for further examples. **Citations**: Robson 1932; Duval 1954; Barbeau (Québec) 1957; Spendlove 1958; Hubbard 1960(1), 1967, 1972(1)(2); Harper 1964, 1966, 1970,1973, 1974; MacDonald 1967; Bell 1973; Lord 1974; Allodi 1974; Mellen 1978; Wight 1980; Cooke 1983; NGC 1982; McKendry 1983, 1988; Kobayashi 1985(2); Reid 1988; Hill 1988; Lerner 1991; Tippett 1992; Béland 1992; Dickenson 1992.

DAVIS, HENRY SAMUEL (1809-51), Nova Scotia and Ontario. Painter. Davis, a British army officer and a TOPOGRAPHER, was in Canada in 1831 and 1845-7. He executed a watercolour view of the Thousand Islands c1846 (see Cooke 1983, pl. 152) and, in 1847, four water-colour views of Niagara Falls which were published in 1848 in London, as LITHOGRAPHS (see Allodi 1974, pl. 664-7). **Citations**: Duval 1954; Spendlove 1958; Harper 1970; Allodi 1974; NGC 1982; Cooke 1983; McKendry 1988; Hill 1988.

DAVIS, LEONARD M.(b1864-act. 1918), Alberta. Painter. Davis, an American artist, was the first painter to be a guest at the E.P. Ranch in Alberta, owned by the Prince of Wales. He made a number of paintings of the Ranch as well as other paintings of Canadian western landscape. **Citations**: Render 1974; Fielding 1974.

DAVIS, THEODORE RUSSELL (1840-94), USA. Painter. He did some painting in western Canada. **Citations**: Ewers 1973; NGC 1982; Lerner 1991.

DAVIS, WILLIAM J. (1876-1956), Toronto, ON. Painter. Some 140 naïve paintings by this artist of historical events relating to Toronto were discovered recently; sixty were used for illustrations in Bennett 1983. **Citations**: Bennett 1983; McKendry 1988.

DAVISON, GERTRUDE ELIZABETH (BETTY) MARY YOUNG (b1909), Ottawa, ON. Printmaker and painter. She studied with LIONEL and ERNEST FOSBERY and ALMA DUNCAN. One of her prints is in the NATIONAL GALLERY OF CANADA. **Citations:** NGC 1982; Hill 1988; Lerner 1991.

DAWSON, RICHARD (act. 1748-58), Newfoundland. Painter. Dawson was an officer with the British Army at Placentia, NF; it is known that he completed a watercolour view of the town (see Allodi 1974, pl. 668). **Citations**: Harper 1970, 1973; Allodi 1974; Kobayashi 1985(2); McKendry 1988.

DAWSON-WATSON, JOHN (b1864), Québec. Painter, printmaker, illustrator and art teacher. He studied in London and Paris, and was in Québec 1900-c1907. **Citations**: Fairchild 1907; Harper 1970; Lerner 1991.

DAY, FORSHAW (1837-1903), Kingston, ON. Painter; RCA 1881. He arrived in Halifax from England in 1862, after studying art in Dublin and London. Day taught art in Halifax and at the Royal Military College in Kingston 1879-97. NICKOLAS HENDERSON studied under Forshaw Day. Two paintings by Day are in the NATIONAL GALLERY OF CANADA. **Citations**: MacTavish 1925; Robson 1932; Colgate 1943; Hubbard 1960; Harper 1966, 1970; Reid 1979; Sisler 1980; Farr 1988; Hill 1988; McMann 1997.

DAY, KATHERINE (1889-1976), Orillia, ON. Printmaker and painter. She studied with FRANZ JOHNSTON, as well as in London and Paris. A WOODCUT by Day is in the NATIONAL GALLERY OF CANADA. **Citations**: NGC 1982; Hill 1988.

DAY, MABEL KILLAM (1884-1961), Nova Scotia. Painter. She studied and worked in the USA for a number of years and then returned to the Maritime Provinces. **Citations**: IBM 1940; NGC 1982; Lerner 1991; Tippett 1992.

DEAN, MAX (b1949), Ottawa, ON; Winnipeg, MB. Sculptor and printmaker. He came to Canada from England in 1952, and taught art at the University of Ottawa after 1979. Two works by Dean are in the NATIONAL GALLERY OF CANADA. **Citations**: NGC 1982; Hill 1988.

DEBASSIGE, BLAKE (b1956), Manitoulin Island, ON. Painter. He is an ALGONQUIN LEGEND PAINTER. **Citations**: Ojibwa 1981; NGC 1982; McLuhan 1984; Lerner 1991.

DE BELLE, CHARLES ERNEST (1873-1939), Montréal, QC. Painter of portraits and figures; illustrator. He came to Canada in 1912. Several of his paintings are in the NATIONAL GALLERY OF

CANADA. **Citations**: Laberge 1938, 1949; Maurault 1940; Hubbard 1960; Harper 1966; Sisler 1980; NGC 1982; Laliberté 1986; Hill 1988; Lerner 1991; McMann 1997.

DE CARDINAT, M. (act. 1675-85), Québec City, QC. Painter. De Cardinat, a painter of religious subjects, was brought to Québec City in 1675 by BISHOP LAVAL. Traces of the name Cardinat appear on an ex-voto painting (see Harper 1966, pl. 15). **Citations**: Harper 1966, 1970.

DE CHAMPLAIN, SAMUEL. See CHAMPLAIN.

DE CHARMOY, COZETTE (b1939), Nova Scotia and Montréal, QC. Painter, author and illustrator. De Charmoy was born in England, visited Nova Scotia 1959-61, lived in Montréal 1962-7 and thereafter in Europe. An example of this artist's work is in the NATIONAL GALLERY OF CANADA. **Citations**: Hill 1988.

DECORATIVE ARTS. This is a general term for work in which decoration is applied to a functional object. Included in Decorative Arts (or APPLIED ARTS) are FURNITURE, glass, ceramics, textiles, metalwork, and woodwork. These are popularly called antiques (usually if over 100 years old). See also LOUIS III, GEORGIAN, REGENCY, EMPIRE, VICTORIAN, BAROQUE, ROCOCO, NEOCLASSICAL, REVIVALS, SILVERSMITHING, BLACKSMITHING, HOOKED RUGS, COVERLETS and FOLKLORE ARTIFACTS. **Citations**: Piper 1988; Chilvers 1988.

DE COURCY, MICHAEL JOHN. See COURCY.

DECOYS. While many working decoys are no more than FOLKLORE ARTIFACTS and many recently carved decoys are no more than craft work, there are some which express the carvers' feelings for birds in such a way that they can be referred to as FOLK ART. For examples of the latter, see Ferguson 1984, which has illustrations of working decoys selected by the artist GERALD FERGUSON. **Citations**: Gates 1982, 1986; Guyette 1983; NMM 1983; McKendry 1983; Ferguson 1984; Field 1985; Fleming 1987.

DE GOULIER. See GOULIER.

DE GRANDMAISON. See GRANDMAISON

DEGUIRE (DEQUIRE), ALPHONSE (1869-1942), Montréal, QC. Portrait painter. He painted numerous portraits of Sir Wilfrid Laurier. **Citations**: NGC 1982; Laliberté 1986.

DE HEER (DE HERR), LOUIS-CHRETIEN, (c1750-c1808), Montréal, QC. Painter, portraitist. De Heer was in Montréal by 1783, opened a studio in Québec City in 1787, and was back in Montréal by 1789. He painted military portraits and portraits of clerics, as well as some landscapes and religious paintings. See Harper 1974, pl. 30, 31 for illustrations of portraits by de Heer. **Citations**: Morisset 1936, 1959; Harper 1966, 1970, 1973, 1974; NGC 1982; Kobayashi 1985(2); McKendry 1988; Reid 1988; Tippett 1992.

DE JONG, SIMON LEENDERT (b1942), Saskatchewan. Painter. **Citations**: Climer 1967; Lerner 1991.

DE KERGOMMEAUX, DUNCAN ROBERT. See KERGOMMEAUX.

DELAGRAVE, FRANCOIS (c1771-1843), Québec City, QC. Silversmith and clockmaker. A tablespoon by Delgrave is in the NATIONAL GALLERY OF CANADA. See also SILVERSMITHING. **Citations**: Traquair 1940; Langdon 1968; Hill 1988.

DE LALL, OSCAR DANIEL. See LALL.

DELAVALLE, JEAN-MARIE (b1944), Montréal, QC. Sculptor and photographer. Two examples of Delavalle's work are in the NATIONAL GALLERY OF CANADA. **Citations**: NGC 1982; Hill 1988; Lerner 1991.

DELFOSSE, MARIE JOSEPH GEORGES (1869-1939), Montréal, QC. Painter of portraits, religious and historical subjects. He studied under WILLIAM BRYMNER and EDMOND DYONNET as well as in Paris. Examples of his work are in the NATIONAL GALLERY OF CANADA. **Citations**: MacTavish 1925; Chauvin 1928; Robson 1932; Maurault 1940; Hubbard 1960; MacDonald 1967; NGC 1982; Laliberté 1986; Hill 1988; Lerner 1991.

DELIBERATELY PRIMITIVE or NAÏVE ART. See FOLK ART, CONSCIOUS.

DELIQUE, CHARLES-FRANCOIS (c1723-80), Montréal, QC. Silversmith. A tablespoon by Delique is in the NATIONAL GALLERY OF CANADA. See also SILVERSMITHING. **Citations**: Traquair 1940; Langdon 1968; Trudel 1974; Hill 1988.

DE LUCCA, YARGO DEITER MUELLER (b1925), Deux-Montagnes, QC. Painter, printmaker and sculptor. He studied art in Germany, arrived in Montréal in 1950 and moved to Switzerland in 1961. Two of De Lucca's paintings are in the NATIONAL GALLERY OF CANADA. **Citations**: MacDonald 1967; NGC 1982; Hill 1988.

DE MONTIGNY-GIGUERE, E. LOUISE (1874-1969), Montréal, QC. Sculptor. She studied with WILLIAM BRYMNER and ALFRED LALIBERTE, and worked with Laliberté in his studio. **Citations**: Laliberté 1986.

DE MONTIGNY-LAFONTAINE, MARGUERITE (1890-1982), Montréal, QC. Sculptor. She studied with ALFRED LALIBERTE and EDMOND DYONNET as well as in the USA. **Citations**: Laliberté 1986.

DENECHAUD, SIMONE (1905-74), Montréal, QC. Painter. **Citations**: Levesque 1936; IBM 1940; NGC 1982; Lerner 1991; Tippett 1992.

DE NIVERVILLE, LOUIS (b1933), Toronto, ON. Painter. De Niverville is a self taught artist who studied the work of artists such as Matisse, Picasso and Rousseau. Much of de Niverville's art appears to be based on fantasies or childhood memories, and to be influenced by FOLK ART. His work includes MURALS and COLLAGES. **Citations**: Kilbourn 1966; MacDonald 1967; Morris 1972; Mellon 1978; Murray 1978(3); *artscanada* October/November 1979; Sisler 1980; Nasby 1980; Murray 1982; NGC 1982; Burnett/Schiff 1983; McKendry 1983, 1988; *City & Country Home* June 1985; Reid 1988; Marsh 1988; Lerner 1991; Murray 1996(1).

DENNIS, EVA A. (b1904), Brownlee, SK. Painter. Eva Dennis is a retired rural-school teacher and the wife of WESLEY C. DENNIS. She is self-taught; her work is mostly naïve narrative paintings about events in or near Brownlee. She is quoted as saying: "Instead of writing some of my memoirs, I'm trying to paint them." **Citations**: Climer 1975; Morgan 1976; Thauberger 1976; *artscanada* October/November 1979; NGC 1982; Dennis 1984; McKendry 1988; Lerner 1991.

DENNIS, JAMES B. (1778-1885), Queenston, ON. Painter. Dennis was a British army officer who is known for an oil painting of the Battle of Queenston Heights that was issued as an ENGRAVING in 1816 (see Harper 1974, pl. 34). **Citations**: Harper 1970, 1973, 1974; Dobson 1982; Kobayashi 1985(2); McKendry 1988.

DENNIS, WESLEY C. (b1899), Brownlee, SK. Painter. Wesley Dennis is a retired farmer and the husband of EVA DENNIS. His work is naïve prairie landscape paintings about which he commented: "Having been a farmer most of my life I take much pleasure in painting the farm scene as I know it from pioneer days to modern times." About his approach to painting, he said: "I use the laws of art as long as they suit me and when they don't suit me, I disregard them." **Citations**: Climer 1975; Thauberger 1976; Morgan 1976; *artscanada* October/November 1979; NGC 1982; NMM 1983; Kobayashi 1985(2); McKendry 1988.

DENNY, WILLIAM (1804-86), Kingston and York (Toronto), ON; Québec City and Montréal, QC. Painter. Denny was a British Army officer who is known for an amateur 1845 pencil drawing of a covered bridge at Trenton, ON. **Citations**: Bell 1973; McKendry 1988.

DE PEDERY-HUNT, DORA. See PEDERY-HUNT.

DEPRESSION. The great Depression of the 1930s caused the market for fine art to almost disappear (see Harper 1966, p. 325). The debilitating effect of this was much greater for professional artists than for folk artists who never had depended on selling their work. The quantity of FOLK ART produced during this period probably increased, because people had more time for it, although no published comment on this has been found. For painting in Canada in the 1930s, see Hill 1975.

DE REPENTIGNY, RODOLPHE (1926-59), Montréal, QC. Painter and critic. He sometimes signed his work "Jauran." **Citations**: Lord 1974; NGC 1982; Reid 1988; Lerner 1991.

DE RICHETERRE. See DESSAILLIANT DE RICHETERRE.

DE RINZY, P.H. (act. 1899), Ottawa, ON. Painter. De Rinzy painted naïve landscape paintings of the Ottawa area. John de Rinzy, who was in Ottawa in 1908, may be the same man. **Citations:** Harper 1970; McKendry 1988.

DE ROS, JOHN FREDERICK FITZGERALD (1804-61), Québec. Painter. De Ros was a British navy officer who toured Canada and the USA in 1826. Some of his landscape sketches were LITHOGRAPHED. He made a pencil drawing of Montréal. **Citations:** Harper 1970; McKendry 1988.

DEROUIN, RENE (b1936), Val-David, QC. Printmaker, painter and filmmaker. He studied in Montréal, Mexico, Calgary and Tokyo. A WOODCUT by Derouin is in the NATIONAL GALLERY OF CANADA. **Citations:** NGC 1982; Hill 1988; Lerner 1991.

DES BARRES, JOSEPH FREDERICK WALLET (1722-1824), Halifax, NS. Painter and surveyor. Des Barres was a TOPOGRAPHICAL artist and surveyor with the British Army in Nova Scotia and Prince Edward Island. His surveys of Nova Scotia resulted in the publication of *The Atlantic Neptune*, 4 vols., London 1777. On retirement, he lived in Halifax. **Citations:** Spendlove 1958; Harper 1966, 1970; Allodi 1974; Armour 1975; NGC 1982; McKendry 1988; Lerner 1991; Dickenson 1992.

DESCHENES, ALFRED (1913-75), Charlevoix County, QC. Painter. Deschênes, a member of the group of self-taught artists called the CHARLEVOIX PRIMITIVES, was a prolific painter who often painted children and other figures in landscape. **Citations:** Harper 1973, 1974; Baker 1981; NGC 1982; McKendry 1988.

DES CLAYES, ALICE (1890-1968), Montréal, QC. Painter. She arrived in Montréal from Scotland in 1914 and was in England after 1938. She was a sister of BERTHE and GERTRUDE DES CLAYES. There is a painting by Alice in the NATIONAL GALLERY OF CANADA. **Citations:** MacTavish 1925; Hubbard 1960; Sisler 1980; NGC 1982; Laliberté 1986; Hill 1988.

DES CLAYES, BERTHE (1877-1968), Montréal, QC. Painter. She was in Canada 1912-1951 and was a sister of ALICE and GERTRUDE DES CLAYES. Three of her paintings are in the NATIONAL GALLERY OF CANADA. **Citations:** Hubbard 1960; Laurette 1978; NGC 1982; Laliberté 1986; Hill 1988; Lerner 1991; McMann 1997.

DES CLAYES, GERTRUDE (1879-1949), Montréal, QC. Portrait and figure painter. She was in Canada 1912-36 and was a sister of ALICE and BERTHE DES CLAYES. One of her paintings is in the NATIONAL GALLERY OF CANADA. **Citations:** MacTavish 1925; Hubbard 1960; Laurette 1978; Sisler 1980; Laliberté 1986; Hill 1988; Lerner 1991; McMann 1997.

DESGAGNE, HELENE (1854-1939), Isle-aux-Coudres, QC. Weaver. Two of her COVERLETS are in the NATIONAL GALLERY OF CANADA. **Citations:** Hill 1988.

DESJARDINS, ABBE PHILIPPE-JEAN-LOUIS. See DESJARDINS COLLECTION.

DESJARDINS COLLECTION. After the French Revolution, there were many confiscated paintings in warehouses in France. In 1803 the Abbé Philippe-Jean-Louis Desjardins (1753-1833) purchased cheaply more than a hundred of these paintings and, by 1820, they had been shipped to Québec City. In 1817 the paintings were exhibited and offered for sale at the Hôtel-Dieu by Desjardin's brother Abbé Louis-Joseph (1766-1848). These European paintings had a strong influence on Québec landscape, still life, religious and historical painting, in particular on the religious work of JOSEPH LEGARE who had bought about thirty of the Desjardins Collection paintings that had religious subjects. Some of the religious works were copied, with variations, by JEAN-BAPTISTE ROY-AUDY. **Citations:** Harper 1966; Cauchon 1971; Lord 1974; Porter 1978; Reid 1988; Lerner 1991.

DESJARDINS-FAUCHER, HUGUETTE (b1938), Montréal, QC. Printmaker and painter. She studied with ALBERT DUMOUCHEL and ANDRE JASMIN. Two of her prints are in the NATIONAL GALLERY OF CANADA. **Citations:** NGC 1982; Hill 1988.

DESJARDINS, LOUIS JOSEPH. See DESJARDINS COLLECTION.

DESNOYERS, CHARLES (1806-1902), Saint-Vincent-de-Paul, QC. Sculptor. Desnoyers was a sculptor of religious figures and decorations, in POLYCHROMED wood, for churches. He executed

several works for the church at Saint-Jean-Baptiste de Rouville. **Citations**: Falardeau 1940; Trudel (Sculpture) 1967; Porter 1986; McKendry 1988; Lerner 1991.

DESROCHERS. See BRIEN dit DESROCHERS.

DESROSIERS, EUGENE (act. 20th century), Richelieu County, QC. Sculptor. Desrosiers is known for naïve sculptures in POLYCHROMED wood of famous strong-men, such as Louis Cyr who toured Europe and America as the "World's Strongest Man." **Citations**: Dunbar 1976; McKendry 1988.

DESROSIERS, MADELEINE (act. 1935), Montréal, QC. Painter. **Citations**: Levesque 1936; NGC 1982; Lerner 1991; Tippett 1992.

DESSAILLIANT de RICHETERRE, MICHEL (act. 1701-10), Québec City and Montréal, QC. Painter of portraits and religious subjects. It is thought that Dessaillant de Richeterre painted some EX VOTO PAINTINGS (see Harper 1966, pl. 16). He was sometimes known as Destaillant de Rissettiere. **Citations**: Morisset 1936; NGC 1945; Barbeau (Québec) 1957; Harper 1966, 1970; Hubbard 1967; Trudel 1967(Peinture); Lord 1974; Gagnon 1976(1); McKendry 1988; Lerner 1991.

DESTAILLANT de RISSETTIERE, MICHEL. See DESSAILLIANT de RICHETERRE, MICHEL.

DE TONNANCOUR. See TONNANCOUR.

DEUTSCH, PETER ANDREW (b1926), Toronto, ON. Painter, printmaker and photographer. He came to Canada in 1954 and now resides in New York. A COLLAGE by this artist is in the NATIONAL GALLERY OF CANADA. **Citations**: NGC 1982; Hill 1988.

DE VISSER, JOHN. See VISSER.

DICKINSON, ANSON (1779-1852), USA. Painter, miniaturist. He began painting MINIATURES c1803, was in New York by 1804 and for the next 20 years travelled widely as an ITINERANT miniature painter. Dickinson visited Montréal. **Citations**: Morisset 1960; Harper 1970; Rosenfeld 1981; Lerner 1991.

DICKSON, JENNIFER (b1936), Ottawa, ON. Painter, sculptor, printmaker and photographer. She arrived in Canada in 1969, after studying in London and Paris. A print by Dickson is in the NATIONAL GALLERY OF CANADA. **Citations**: Sisler 1980; NGC 1982; Hill 1988; Lerner 1991.

DIGNAM, MARY ELLA (1860-1938), London, ON. Landscape and marine painter. She studied under PAUL PEEL and in Paris. Dignam supervised the painting of the CANADIAN STATE DINNER SERVICE. **Citations**: Bull 1934; Elwood 1977; Laing 1982; NGC 1982; Lerner 1991; Tippett 1992.

DINGLE, JOHN ADRIAN DARLEY (1911-74), Toronto, ON. Painter, printmaker and illustrator. He arrived in Canada in 1914 and studied with J.W. BEATTY and in London. One of his paintings is in the NATIONAL GALLERY OF CANADA. **Citations**: NGC 1982; Hill 1988.

DINNER SERVICE. See CANADIAN STATE DINNER SERVICE.

DIONNE, ROSE (act. 1936), Québec. Artist. **Citations**: Levesque 1936; Lerner 1991.

DIORAMA. A diorama is a three-dimensional display, usually using free-standing figures or objects scaled and arranged on or in front of painted surfaces or transparencies to create the illusion of a scene with great depth. Dioramas are often used for museum displays and sometimes are created by folk artists, (see McKendry 1983, pl. 47), for example WILLIAM LONEY. **Citations**: Osborne 1970; McKendry 1983; Chilvers 1988.

DIPLOMA COLLECTION. See ROYAL CANADIAN ACADEMY.

DIPPY, RHOBENA. See CORINNE MAILLET.

DIPTYCH. See TRIPTYCH.

DISTEMPER. A cheap impermanent paint in which the pigment is mixed with water and glue or SIZE. It is mostly used for poster, mural and theatrical scene painting. **Citations**: Mayer 1970; Chilvers 1988; Piper 1988.

DOBELL, SYBIL OCTAVIA (act1946), Montréal, QC. Portrait painter. **Citations**: NGC 1982; Tippett 1992.

DOCTOR'S ISLAND. See Dr JAMES MACCALLUM.

DONLY, EVA MARIE BROOK (1867-1941), Simcoe, ON. Painter. She studied with F.M. BELL-SMITH as well as in New York and Mexico, and founded by bequest the Eva Brook Donly Museum in Simcoe, ON. Two of her watercolours are in the NATIONAL GALLERY OF CANADA. **Citations**: MacTavish 1925; Hubbard 1960; MacDonald 1967; Harper 1970; NGC 1982; Hill 1988.

DONOR. A person who has commissioned a religious work of art, usually an EX VOTO PAINTING, and who may be included in the picture, as was often the case in MEDIEVAL Art. **Citations**: Osborne 1970; Chilvers 1988; Piper 1988.

DORAY, AUDREY CAPEL (b1931), Montréal, QC. Printmaker, sculptor, filmmaker and painter. She studied with JOHN LYMAN, ARTHUR LISMER, JACQUES DE TONNANCOUR and others, as well as in London and Paris. One of her prints is in the NATIONAL GALLERY OF CANADA. **Citations**: NGC 1982; Hill 1988; Lerner 1991.

DORE, CHARLES FRANCIS (1874-1960 or 1966), Ottawa, ON. Painter. Dore executed naïve portrait and landscape paintings in oil or coloured pencil, as well as bas-RELIEF carvings and painted plaster castings. A building contractor and stone mason, he often included houses and people in his paintings. Several examples of his work are in the CCFCS collections. **Citations**: NGC 1982; Kobayashi 1985(2); McKendry 1988; CCFCS.

DOUKHOBOR ART. The Doukhobors are a pacifist sect of Russian dissenters who emigrated to western Canada in 1899. They kept their communities as isolated as possible from other settlements with the result that their traditions and art, mostly FOLK ART, changed very little. Their textiles (see Burnham 1986) are of particular interest. For a fine example of a Doukhobor pile rug with animal, bird and flower motifs, see Burnham 1986, pl. 158. **Citations**: Burnham 1981, 1986; McKendry 1983; Bird 1983; Marsh 1988; Lerner 1991.

DOVE. The dove is used as a symbol for the divine spirit (Holy Ghost) in Christian art. Wood carvings of a dove appear in Québec religious art (see McKendry 1983, pl. 110-11, for examples of carved doves found in Québec churches). **Citations**: Osborne 1970; Ferguson 1967; McKendry 1983; Pierce 1987.

DOYLE, CHARLIE (act. 1907), Nova Scotia. Painter and MURALIST. Doyle was an ITINERANT artist who painted MURALS and other decorations in a house in Port Howe, NS, in 1907. One of the murals, a naïve painting of a ship in full sail is illustrated in Greenaway 1986, p. 27. **Citations**: Greenaway 1986; McKendry 1988.

DRAKE, JOHN POAD (1794-1883), Halifax, NS; Charlottetown, PE; Montréal, QC. Painter. Drake, an Englishman, was in Canada from about 1819 to 1830. He was a professional artist, naval designer and inventor. He painted portraits, ROMANTIC landscapes, marine and religious paintings (including an ALTARPIECE) in oil. His large painting, c1820, of Halifax harbour is a colourful romantic view of ships with their sails spread against a sunset sky (coll. NATIONAL GALLERY OF CANADA; see Harper 1966, pl. 100). **Citations**: Spendlove 1958; Harper 1964, 1966, 1970; Lord 1974; NGC 1982; McKendry 1988; Hill 1988.

DRAKE, WILLIAM ALEXANDER (1891-1979), Toronto, ON, and New York. Printmaker and painter. He studied with GEORGE A. REID, WILLIAM CRUIKSHANK, J.W. BEATTY and others. Two of his prints are in the NATIONAL GALLERY OF CANADA. **Citations**: NGC 1982; Hill 1988.

DRAPELL, JOSEPH (b1940), Toronto, ON; Halifax, NS. Painter, photographer and sculptor. He arrived in Halifax from Bohemia (Czechoslovakia) c1965. From 1968 to 1970 Drapell studied art in the USA, where his ABSTRACT paintings were more popular than in Canada, and where he met JACK BUSH. **Citations**: Carpenter 1981; NGC 1982; Burnett/Schiff 1983; Reid 1988; Lerner 1991.

DRAPERY. Drapery is the depiction of fabric over the body of a figure in a work of sculpture. Drapery is often an important expressive part of the BAROQUE style and of RELIGIOUS ART, as in the cases of figures by LOUIS JOBIN, naïve sculpture by PHILIPPE ROY, and the more sophisticated work by ROBERT A. WYLIE. For examples of draped figures by folk artists, see McKendry 1983, pl. 120, 127-8, 179-82. **Citations**: Osborne 1970; McKendry 1983; Pierce 1987; Piper 1988.

DRAWING. A drawing results when a tool is drawn along a surface and leaves a mark of its path. The

tool is usually CHALK, CRAYON, PENCIL, PEN, CHARCOAL or METAL POINT. Drawings formed of lines and/or shadings, usually on paper, are a basis for many arts and crafts. Some artists, for example TOPOGRAPHICAL artists, regard their drawings as finished work. See Marsh 1988 for an account of drawing in Canada. **Citations**: Harper 1963; Duval 1965; Groves 1968; Town 1969; Osborne 1970; Mayer 1970; Allodi 1974; Bridges 1977; Morris 1980; Fulford 1982; Piper 1988; Marsh 1988; Lerner 1991; Silcox 1996.

DRAYTON, REGINALD (b c1849), Gore's Landing, ON. Painter. Drayton was an amateur artist whose landscape paintings in watercolour of the Rice Lake area included a copy of an engraving after WILLIAM HENRY BARTLETT (see McKendry 1983, pl. 135-6.) **Citations**: McKendry 1983, 1988.

DRENTERS, YOSEF (1929-83), Rockwood, ON. Sculptor and painter. Some of Drenters' sculpture has a naïve religious flavour which may reflect that, although he had been trained for the priesthood, as far as art was concerned, he was self-taught. His work shows a concern for surface texture and PATINA. He is mostly known for his sculpture but at first he did some painting. **Citations**: MacDonald 1967; NGC 1982; McKendry 1988; Lerner 1991.

DROPE, McCLEARY HERBERT (b1931), Winnipeg, MB. Painter, printmaker and sculptor. **Citations**: Harper 1966; NGC 1982; Hill 1988.

DRUE, JUCONDE (1664-1739), Québec City and Lévis, QC. Painter, portraitist and architect. He designed several churches, including the Récollet Church of 1693 in Place d'Armes, Québec City, as well as church furniture. Drué was familiar with the paintings of FRERE LUC and may have been his pupil. **Citations**: Gowans 1955; Harper 1970; McKendry 1988.

DRUICK, DON (b1945), Montréal, QC. VIDEO and performance artist, musician. Several videotapes by Druick are in the NATIONAL GALLERY OF CANADA. **Citations**: Gale 1977; NGC 1982; Hill 1988; Lerner 1991.

DRUMMOND, JEANNE (JANE) REDPATH (act. c1900), Ottawa and Kingston, ON. Painter. She painted many small WATERCOLOURS of Kingston scenes. **Citations**: Harper 1970; Farr 1988.

DRUTZ, JUNE (b1920), Toronto, ON. Painter, printmaker and art teacher; RCA 1974. She studied under CARL SCHAEFER, FREDERICK HAGAN and WILLIAM ROBERTS at the ONTARIO COLLEGE OF ART. A SERIGRAPH by Drutz is in the NATIONAL GALLERY OF ART. **Citations**: Sisler 1980; NGC 1982; Hill 1988; McMann 1997.

DRYPOINT. Drypoint is an engraving technique in which a line is drawn on a metal plate (usually of copper) with a tool having a hard point. The line has a raised burr thrown up beside the groove made by the point, and this burr retains ink for printing. A limited number of prints can be obtained, because the burr becomes crushed by the pressure of printing. A drypoint line has a characteristic rich, furry appearance such as a pen might make when drawn across damp paper. (See Tovell 1980, pp. 237-8.) DAVID MILNE's colour drypoint prints are well known, for example *Painting Place* of 1931. **Citations**: Plowman 1922; Osborne 1970; Mayer 1970; Eichenberg 1976; Tovell 1980; Chilvers 1988; Piper 1988; Silcox 1996.

DUBE, LOUIS THEODORE (THEODULE) (1861-1935), Montréal, QC. Portrait and MINIATURE painter. **Citations**: Harper 1970; NGC 1982; Laliberté 1986.

DUBERGER, JEAN-BAPTISTE dit SANSCHAGRIN (1767-1821 or 1823), Québec City, QC. Surveyor and draughtsman. Duberger helped in the design of fortifications in Québec. He constructed a model of Québec City, approximately 35 feet in length, showing landscape, waterfront and buildings; this model is now in the NATIONAL ARCHIVES OF CANADA. See Barbeau 1957 (Québec) for illustrations of the model. **Citations**: Barbeau 1957(Québec); Harper 1970; NGC 1982; McKendry 1988.

DUBUFFET, JEAN (1901-85), Paris, France. Painter. The French painter Dubuffet, through his work, helped to direct public attention to NAÏVE ART, the art of children, and the art of psychotics. He coined the term ART BRUT (art in the raw) in 1945 for crude pictures by untrained amateurs, children, psychotics and so on. **Citations**: Arnason 1968; Osborne 1970, 1981; Piper 1988; Chilvers 1988.

DUDLEY, ROBERT (act1865-91), Newfoundland. Painter. Dudley was an English painter who visited Newfoundland with the cable-laying ship *Great Eastern*. **Citations**: Harper 1964, 1970.

DUDOWARD, CHARLES (act1873), Port Simpson, BC. Painter. Dudoward was a son of the chieftain of the Eagle Clan at Port Simpson. He executed naïve paintings of Pacific coast scenery including an 1873 view of Port Simpson. **Citations**: Harper 1966, 1970; NGC 1982; McKendry 1988.

DUFF, ANN MACINTOSH (b1925), Toronto, ON. Painter and printmaker; RCA 1974. She studied under PETER HAWORTH, DORIS MCCARTHY, ANDRE BIELER and CAVEN ATKINS. A watercolour by Duff is in the NATIONAL GALLERY OF CANADA. **Citations**: MacDonald 1967; Sisler 1980; NGC 1982; Hill 1988.

DUFF, ANNIE ELEXEY (1873-1955), Carleton Place, ON. Painter, photographer and fashion designer. Two naïve paintings by Duff are in the collection of the NATIONAL GALLERY OF CANADA. One is of Adam and Eve, fully clothed in modern fashionable dress, in the presence of a vision of Christ with cross, and the other is a seaside memorial picture. **Citations**: Hill 1988; Tippett 1992.

DUFF, WALTER RAYMOND (1879-1967), Toronto, ON; Montréal, QC. Painter, printmaker and ceramist. Duff studied in Canada, New York and London. He lived in the USA from 1930 to 1963 when he moved to Toronto. Several ETCHINGS by Duff are in the NATIONAL GALLERY OF CANADA. **Citations**: NGC 1982; Hill 1988.

DUFFERIN, LADY HARRIOT GEORGIANA (1844-1936), Canada. Painter. Lady Dufferin toured Canada with her husband, the governor general from 1872-8, and painted local scenes including native people. She travelled to British Columbia in 1876. **Citations**: Bell 1973; Marsh 1988; Lerner 1991, Tippett 1992.

DUFOUR, ANDRE (b1939), St-Fidèle, QC. Painter, printmaker and illustrator. An ETCHING by Dufour is in the NATIONAL GALLERY OF CANADA. **Citations**: NGC 1982; Hill 1988.

DUFOUR, GILLES (b1941), St-Ours, QC. Sculptor and painter. He studied under JEAN-PAUL LEMIEUX, JEAN SOUCY and others. An example of his work as a sculptor is in the NATIONAL GALLERY OF CANADA. **Citations**: NGC 1982; Hill 1988.

DUGAL, FRANCOIS (act1830), Terrebonne, QC. Sculptor of decorative work for churches. He was an apprentice of LOUIS-AMABLE QUEVILLON. **Citations**: Traquair 1947; Porter 1986.

DUGUAY, RODOLPHE (1891-1973), Nicolet, QC. Painter, printmaker and illustrator. He studied under WILLIAM BRYMNER, MAURICE CULLEN, MARC-AURELE DE FOY SUZOR-COTE and others. Several examples of his work are in the NATIONAL GALLERY OF CANADA. **Citations**: Bergeron 1946; Duguay 1978; Thibault 1978; NGC 1982; Laliberté 1986; Hill 1988; Lerner 1991.

DULONGPRE, LOUIS-JOSEPH Sr (1754 or 1759-1843), Montréal and Saint Hyacinthe, QC. Painter. Dulongpré painted over 3500 portraits and many religious paintings for churches in various parts of Québec, including the Church of Nôtre Dame in Montréal. Many of his portraits were lively and unpretentious. In 1799 he did some decorative painting for FRANCOIS BAILLAIRGE and, in 1802, had JOSEPH MORAND as an apprentice. See WILLIAM VON MOLL BERCZY Sr. Several portraits, including a self portrait, are in the NATIONAL GALLERY OF CANADA. **Citations**: Morisset 1936, 1959; NGC 1945, 1982; Harper 1966, 1970; Andre 1967; Carter 1967; Trudel 1967(Peinture); Hubbard 1967, 1973; Kobayashi 1985(2); McKendry 1988; Hill 1988; Lerner 1991; Tovell 1991; Béland 1992.

DULONGPRE, LOUIS-JOSEPH Jr (1789-1833), Québec. Painter. This artist executed naïve religious paintings and caricatures. He may have been a son of LOUIS-JOSEPH DULONGPRE Sr. **Citations**: Harper 1970; Kobayashi 1985(2); McKendry 1988.

DUMOUCHEL, ALBERT (1916-71), Montréal, QC. Painter, illustrator and printmaker. He studied with ALFRED PELLAN and others. Many prints and drawings by Dumouchel are in the NATIONAL GALLERY OF CANADA. See SURREALISM; GORDON WEBBER. **Citations**: Hubbard 1960; Harper 1966; MacDonald 1967; Guy 1970; Duval 1952, 1972; Ostiguy 1975; Daigneault 1981; NGC 1982; Burnett/Schiff 1983; Hill 1988; Reid 1988; Lerner 1991.

DUNCAN, ALMA MARY (b1917), Montréal, QC. Painter, illustrator, caricaturist and filmmaker. She studied with ADAM SHERRIFF SCOTT and GOODRIDGE ROBERTS. One of her drawings is in the NATIONAL GALLERY OF CANADA. **Citations**: NGC 1982; Hill 1988; Tippett 1992.

DUNCAN, DOUGLAS MOERDYKE (1902-68), Toronto, ON. Art dealer, bookbinder and photographer. Duncan promoted and helped many distinguished artists, in particular DAVID MILNE (see Jarvis 1974). He was instrumental in forming the Picture Loan Society Gallery which showed works by a large number of Canadian artists from 1936 to 1952. See ALAN HEPBURN JARVIS. **Citations**: Jarvis 1974; Lord 1974; Tovell 1980; NGC 1982; Reid 1988; Marsh 1988; Thom 1991; Lerner 1991; Silcox 1996.

DUNCAN, JAMES D. (1806-81), Montréal, QC. Painter. Duncan is thought to have been influenced by CORNELIUS KRIEGHOFF, with whom he collaborated in painting a PANORAMA of Canada. Duncan's work included portrait and TOPOGRAPHICAL paintings as well as MINIATURES and figure groups. In particular, he recorded many Montréal scenes (see Harper 1966, pl. 167). Several paintings by Duncan are in the NATIONAL GALLERY OF CANADA. **Citations**: Jefferys 1948; McInnes 1950; Spendlove 1958; Harper 1966, 1970, 1979; Hubbard 1967, 1973; Thomas 1972; Watson 1974; Allodi 1974; Duval 1974; Lord 1974; Todd 1978; Thibault 1978; Sisler 1980; Baker 1981; NGC 1982; Cooke 1983; Hill 1988; McKendry 1988; Cavell 1988; Reid 1988, 1979; Béland 1992; McMann 1997.

DUNCANSON, ROBERT SCOTT, (1821-72), Montréal, QC. Painter and photographer. He was a black American artist whose Scottish father was from Montréal, and who painted in the USA and around Montréal, the Eastern Townships and Québec City. See Reid 1979, pp. 40-4, for the best account of Duncanson's life and work. Several paintings by Duncanson are in the NATIONAL GALLERY OF CANADA. **Citations**: Harper 1970; Thibault 1978; Hill 1988; Reid 1979, 1988; Lerner 1991.

DUNLOP ART GALLERY. The Dunlop Art Gallery of Regina, SK, has a permanent collection of Saskatchewan art with special emphasis on FOLK ART. Exhibitions with catalogues have originated at this gallery for folk artists FRANK CICANSKY, HAROLD J. TREHERNE, EVA DENNIS, and WILLIAM C. McCARGAR. **Citations**: Morgan 1983; Dennis 1984.

DUNMORE, EARL OF. See CHARLES ADOLPHUS MURRAY.

DUPONT, JEAN-CLAUDE (b1934), Sainte Foy, QC. Painter, illustrator, ethnologist and author. Dupont is self taught and paints naïve-style scenes illustrating Québec legends. **Citations**: Dupont 1988; Boulizon 1989.

DUQUET, GEORGES HENRI (1887-1967), Québec City and Montréal, QC. Painter. He studied with CHARLES HUOT and in Paris. **Citations**: NGC 1982; Laliberté 1986; Lerner 1991.

DUQUET, SUZANNE (b1917), Montréal, QC. Figurative painter. **Citations**: NGC 1982; Lerner 1991; Tippett 1992.

DUVAL, PAUL (b1922), Toronto, ON. Author, editor and art critic. Duval has written many Canadian art books and forewords for catalogues of art exhibitions. **Citations**: Duval 1951, 1952, 1954, 1965, 1967, 1972, 1973, 1974, 1975, 1976, 1977, 1978, 1980, 1984, 1990; Jackson 1958; Lord 1974; Reid 1988; Lerner 1991.

DYNELEY, AMELIA FREDERICA (b1830), Ottawa, ON; Montréal and Québec City, QC. Amateur painter. She copied numerous TOPOGRAPHICAL views of Canada, signed them "AFD" and returned to England with more than 100 such copies. **Citations**: Harper 1970; Cooke 1983; Béland 1992; Tippett 1992.

DYNES, JOSEPH (1825-97), Montréal, QC. Painter of portraits, religious works and landscapes. He sometimes coloured photographic enlargements, in oil or watercolour, and copied other artist's paintings including those of CORNELIUS KRIEGHOFF. **Citations**: Barbeau 1934; Harper 1966, 1970, 1979; NGC 1982; McKendry 1988; Cavell 1988; Lerner 1991.

DYONNET, EDMOND (1859-1954), Montréal, QC. Painter and art teacher; RCA 1903. He arrived in Montréal from France in 1875, studied with various artists and taught art. Dyonnet travelled to the Rocky Mountains and Chicago in 1893. In 1922 he helped found Montréal's ECOLE DES BEAUX-

ARTS. See Dyonnet 1956 for his memoirs. There are three oils by Dyonnet in the NATIONAL GALLERY OF CANADA. **Citations**: Dyonnet 1913, 1951, 1956, 1968; MacTavish 1925; Chauvin 1928; Jones 1934; Colgate 1943; Miner 1946; Rainville 1946;Jackson 1958; Hubbard 1960, 1973; Harper 1966, 1970; MacDonald 1967; NGC 1982; Laliberté 1986; Karel 1987; Hill 1988; Reid 1988; Marsh 1988; Lerner 1991.

E

EAGAR, WILLIAM H. (1796-1839), St Johns, NF; Halifax, NS. Painter. Eagar painted portraits in oil and many views in watercolour of the Maritime Provinces (see Harper 1966, pl. 103, and Allodi 1974, pl. 738-42). He sometimes included Micmac people in the foregrounds of his paintings. Several views by Eagar were published as ENGRAVINGS or LITHOGRAPHS, including one of St Johns published in London 1831. **Citations**: Colgate 1943; McInnes 1950; Spendlove 1958; Hubbard 1967; Harper 1966,1970, 1974; Allodi 1974; NGC 1982; McKendry 1988; Reid 1988; Cavell 1988; Lerner 1991; Tippett 1992.

EARTH ART. Earth art (sometimes referred to as earthworks or CONCEPTUAL ART) is large scale, outdoor sculpture, usually encompassing an area that can be entered by the viewer, such as Stonehenge or some recent work by American sculptor Christo (ChristoJavacheff, b1935). The term includes environmental art and may be applicable to some YARD ART (see *artscanada*, December, 1969). An example of earth art as yard art by folk artist Martin Barter is shown in the centre-fold of Grattan 1983. **Citations**: de Grosbois 1978; Osborne 1981; Grattan 1983; Lucie-Smith 1984; Pierce 1987; Lerner 1991; Read 1994.

EARTH COLOUR. Earth colours are from PIGMENTS found as an earth, for example ochre; or refined from a mineral, for example Indian red from iron oxide. **Citations**: Mayer 1970; Piper 1988.

EARTHWORKS. See EARTH ART.

EASEL. An easel is an adjustable stand, often a tripod, for supporting a painting. Easels are usually used by professional artists but seldom by folk artists who may prefer to work at a table. **Citations**: Osborne 1970; Piper 1988; Chilvers 1988.

EARLE, PAUL BARNARD (1872-1955), Montréal, QC. Painter. He studied with EDMOND DYONNET, WILLIAM BRYMNER and MAURICE CULLEN. An oil by Earle is in the NATIONAL GALLERY OF CANADA. **Citations**: Robson 1932; Colgate 1943; Hubbard 1960; MacDonald 1967; Sisler 1980; NGC 1982; Hill 1988; McMann 1997.

EASTLAKE, CHARLES H. See MARY ALEXANDRA BELL EASTLAKE.

EASTLAKE, MARY ALEXANDRA BELL (1864-1951), Almonte, ON. Painter. She studied with ROBERT HARRIS as well as in New York and Paris, and married the painter Charles H. Eastlake c1897. Her paintings of children were particularly successful. Several of Eastlake's paintings are in the NATIONAL GALLERY OF CANADA. **Citations**: Hubbard 1960; MacDonald 1967; Harper 1970; Sisler 1980; NGC 1982; McKendry 1988; Hill 1988; Tippett 1992; McMann 1997.

EASTMAN, FRANK (act. c1933), Toronto, ON. Painter. A stamp on the back of a portrait of a pigeon identifies this artist as a "Painter of Pigeon and Poultry Portraits".

EATON, WYATT (1849-96), Montréal, QC. Painter, illustrator and printmaker. He was principally a portrait painter. Eaton studied in New York and in France and was a founding member of the SOCIETY OF CANADIAN ARTISTS. He was influenced by Jean-François Millet (1814-75), an important member of the BARBIZON SCHOOL. An oil by Eaton is in the NATIONAL GALLERY OF CANADA. **Citations**: MacTavish 1925; Robson 1932; Colgate 1943; Hubbard 1960; Harper 1966, 1970; MacDonald 1967; Lord 1974; NGC 1982; Marsh 1988; Hill 1988; Reid 1988; Lerner 1991.

ECLECTICISM. Eclecticism in art is the combining of different styles or characteristics from various

artists into the work of one artist. While this may be done to obtain excellence, it is usually thought that lack of originality results. In architecture, however, eclecticism in the second half of the 19th century produced innovative designs. See also REVIVALS. **Citations**: Osborne 1970; Piper 1988; Chilvers 1988.

ECOLE DES BEAUX ARTS. The Ecole des Beaux Arts (School of Fine Arts), which was based on earlier schools, was founded in Québec City in 1921 and in Montréal in 1922 (see Harper 1966, p. 177). **Citations**: Buchanan 1950; McInnes 1950; Harper 1966; Lord 1974; Reid 1988; Tippett 1992.

EDEMA, GERARD VAN (1652-1700), Newfoundland. Painter. He was a Dutch painter who lived in England and travelled to Newfoundland and the American colonies. **Citations**: Harper 1966, 1970; Fielding 1974; NGC 1982.

EDENSHAW, CHARLES (CHARLIE) (1839-1929), Queen Charlotte Islands, BC. Sculptor. Edenshaw, a HAIDA chief, was a sculptor whose art is based on Haida traditions. He worked in gold, silver, ivory, ARGILLITE or wood and created many traditional, decorated totems, dishes, and boxes. For the best account of Edenshaw's life and work, see Barbeau 1957(Haida). **Citations**: Barbeau 1957(Haida); Patterson 1973; *Canadian Collector* 1976; Bringhurst 1983; Marsh 1988; McKendry 1988; Lerner 1988.

EDGAR, PERCIVAL JAMES (1888-1946), Toronto, ON and Winnipeg, MB. Painter. He studied with WILLIAM CRUIKSHANK, GEORGE A. REID and C.M. MANLY. A print by Edgar is in the NATIONAL GALLERY OF CANADA. **Citations**: NGC 1982; Hill 1988.

EDITION. See PRINTS.

EDMOND, PIERRE (1738-1800), Québec. Sculptor in wood of religious objects. **Citations:** Gauthier 1974; NGC 1982; Lerner 1991.

EDMONTON ART CLUB. This club, formed in 1921, in Edmonton, Alberta, held annual exhibitions. **Citations**: Edmonton 1921.

EDSON, AARON ALLAN (1846-88), Montréal, QC. Painter; RCA 1880. He studied under ROBERT DUNCANSON and in Europe. Edson visited the Canadian Rocky Mountains, and was well known for his landscape paintings. He was a charter member of the ONTARIO SOCIETY OF ARTISTS and of the ROYAL CANADIAN ACADEMY. Several of his paintings are in the NATIONAL GALLERY OF CANADA. **Citations**: MacTavish 1925; Robson 1932; Colgate 1943; Hubbard 1960, 1960(1); de Volpi 1962; Harper 1966, 1970; MacDonald 1967; Lumsden 1969; Thibault 1978; Sisler 1980; NGC 1982; Hill 1988; Marsh 1988; Reid 1988; Lerner 1991; McMann 1997.

EDOUART, AUGUSTIN (1789-1861), France. Silhouettist. He cut SILHOUETTES of several Canadians but it is not certain that he visited Canada. **Citations**: Harper 1970.

EEGYVUDLUK RAGEE(1920-83), Cape Dorset, NT. Printmaker. Eegyvudluk Ragee, an Inuit artist, was encouraged by JAMES HOUSTON. A stone, for making prints, by this artist is in the NATIONAL GALLERY OF CANADA. **Citations**: Goetz 1977; NGC 1982; Hill 1988.

EGG TEMPERA. See TEMPERA.

EISENHAUER (EISENER), COLLINS (1898-1979), Union Square, NS. Sculptor in POLY-CHROMED wood. Eisenhauer, or Eisener as he was known locally, began carving at age sixty-five for his own pleasure but soon received attention from collectors, dealers and museums. His most original and best work tends to be EROTIC with more free and expressive qualities than his bland, stiffer, less original images of currently popular mass-media figures such as Colonel Sanders, politicians and the Mounted Police. Eisenhauer's EROTIC work is illustrated in Ellwood 1976 and *artscanada*, October/November, 1979, while his mass-media based work is illustrated in NMM 1983. **Citations**: Elwood 1976; *artscanada*, October/November, 1979; NMM 1983; McKendry 1983, 1987, 1988; Kobayashi 1985(2); *Canadian Art*, Spring, 1985; Lerner 1991.

ELLICE, KATHERINE JANE (1814-64), Montréal and Québec City, QC. Painter. Ellice painted portraits, landscapes, interiors, and figures as well as cock-fighting scenes. See Bell 1973 for illustrations of her work. **Citations**: Harper 1970; Bell 1973; McKendry 1988; Tippett 1992.

ELOUL, KOSSO (1920-95), Toronto, ON. Sculptor. See Marsh 1988 for a photograph of one of his

monumental metallic sculptures. He was the husband of RITA LETENDRE. **Citations**: Sisler 1980; NGC 1982; Marsh 1988; Lerner 1991, McMann 1997.

EMMA LAKE ARTISTS' WORKSHOP. This workshop grew out of a proposal by AUGUSTUS KENDERDINE for Regina College to establish a summer school for the arts at Emma Lake in the wilderness north of Prince Albert, Saskatchewan. With the help of KENNETH LOCHHEAD and ARTHUR MCKAY, it became a workshop for professional Canadian and American artists. **Citations**: Harper 1966; Dillow 1973; Lord 1974; Reid 1988; Lerner 1991; Tippett 1992.

EMOND, PIERRE (1738-1808), Québec City, QC. Sculptor. Emond was a sculptor of religious figures and decorative work for churches in POLYCHROMED or gilded wood. **Citations**: Traquair 1947; Gowans 1955; Barbeau 1957(Québec); Trudel 1967(Sculpture); Trudel 1969; Lessard 1971; NGC 1982; Porter 1986; McKendry 1988; Lerner 1991.

EMPIRE. This term describes the DECORATIVE ARTS of Canada in the period roughly from 1820 to 1850 and overlaps with REGENCY and early VICTORIAN. The name is derived from the rule of Napoleon as Emperor of France from 1804 to 1815, a time when archeological discoveries influenced the arts. The Second Empire refers to the time of Napoleon III, Emperor 1852 to 1870. In ARCHITECTURE Second Empire style, usually associated with mansard roofs (a double sloped roof form) and neo-BAROQUE forms, was popular in Canada during the 1870s. **Citations** : Osborne 1970; Chilvers 1988.

ENGRAVING. The term engraving applies both to the process of cutting a design into a plate of metal or block of wood and to a print taken from the engraved plate or block. See Willis 1842 for examples of engravings taken from metal plates and Grant 1882 for examples of engravings taken from wood blocks. Québec artist JAMES SMILLIE, the first Canadian pictorial ENGRAVER, published his Québec prints in 1823. See MORITZ 1982 and all the DE VOLPI references in the bibliography of the present work for examples of engravings of Canadian pictures. See STEEL ENGRAVING, WOOD ENGRAVING, SOCIETY OF CANADIAN PAINTERS-ETCHERS. **Citations**: Willis 1842; Grant 1882; Burch 1910; Short 1912; Society 1930; Spendlove 1958; Mayer 1970; Harper 1970; Lord 1974; Eichenberg 1976; Allodi 1980, 1989; Moritz 1982; Piper 1988; Chilvers 1988; Lerner 1991.

ENNS, MAUREEN (b1943), Alberta. Sculptor, painter and photographer. **Citations**: Banff 1977; NGC 1982; Lerner 1991.

ENSE, DON (b1953), Manitoulin Island, ON. Native painter. **Citations**: Ojibwa 1981; Lerner 1991.

ENSOR, ARTHUR JOHN (b1905), Ottawa, ON. Painter, designer, printmaker and MURALIST. A watercolour by Ensor is in the NATIONAL GALLERY OF CANADA. **Citations**: Sisler 1980; NGC 1982; Hill 1988; McMann 1997.

ENVIRONMENTAL ART. See EARTH ART.

ERNETTE, VICTOR (or ADOLPHE) (act. 1842, 1844), Montreal and Quebec City, QC. Painter. He painted MINIATURE and THEOREM paintings. **Citations**: Harper 1970; Farr 1988.

EROTIC ART. Sensual and EROTIC themes have been used from the beginnings of art and by most great artists. In Canada, J. RUSSELL HARPER commented that PAUL PEEL, by painting a nude in 1889, "defied the puritanical Canadian taboo against the nude" (Harper 1966, p. 221). Harper said about JOHN RUSSELL that "Russell's skillfully painted sensuous nudes at the Canadian National Exhibition of 1927 were the cause of an unprecedented sensation in Toronto" (p. 253). In 1965, Toronto was still in such moral turmoil that a private art gallery owner who staged an exhibition entitled "Eros" was charged with exposing obscene paintings. The subjects of EROTIC art and the nude in Canadian painting are dealt with at some length in Morris 1972. The best discussion of EROTIC FOLK ART is in *Eros in Naïve Painting* (ch 14) by Bihalji-Merin 1971. Canadian folk sculptors COLLINS EISEN-HAUER and GEORGE COCKAYNE have each included nudes in his work and, in the case of Eisenhauer, some pieces are sexually explicit and display perversions (see *artscanada*, Oct./Nov., 1979, pp. 21-2). **Citations**: Harper 1966; Arnason 1968; Bihalji-Merin 1971; Morris 1972.

ESKIMO ART. See NATIVE ART OF CANADA.

ESLER, JOHN KENNETH (b1933), Calgary, AB Painter and printmaker. He studied with ROBERT BRUCE, GEORGE SWINTON and others. Some of his prints are in the NATIONAL GALLERY OF CANADA. **Citations**: MacDonald 1967; Sisler 1980; NGC 1982; Hill 1988; Lerner 1991; McMann, 1997.

ESTCOURT, Sir JAMES B. BUCKNALL (1802-55), Saint John, NB; Québec City, Montréal, QC; Niagara, ON. TOPOGRAPHICAL painter. He was a British army officer who executed views of Canada. He signed sometimes with the initials JBBE. **Citations**: Harper 1966, 1970; NGC 1982.

ETCHING. The term is used both for a process of ENGRAVING a plate (usually copper or zinc) with acid and for a PRINT made from the plate. In the process, the plate is polished and coated with a substance resistant to acid. A design is drawn on the coated plate with a steel etching needle which cuts through to the metal. Acid is then used to bite into the metal through the lines of the design. The acid-resistant substance is removed, and the plate can then be inked for printing. Many Canadian artists practiced etching, for example HOMER WATSON, HERBERT RAINE and DAVID MILNE. For details of the process and the method of printing, the references given below should be consulted. **Citations**: Hind 1908; Burch 1910; Short 1912; Reed 1914; Pennell 1919; Plowman 1922; Society 1930; Spendlove 1958; Osborne 1970; Mayer 1970; Eichenberg 1976; Tovell 1980; Chilvers 1988; Piper 1988; Allodi 1989; Lerner 1991; Silcox 1996.

ETHERINGTON, AGNES RICHARDSON (1880-1954), Kingston, ON. Painter and patron of the arts. She donated the AGNES ETHERINGTON ART CENTRE. **Citations**: Farr 1988.

ETHNIC ART. Ethnic art is art that by its content or origin can be related to a folk-culture group of people who share a common and distinctive culture. In Canada ethnic art can be identified as originating from native peoples as well as from various peoples of European or Asiatic origins, for example, the UKRAINIANS, the DOUKHOBORS, the Poles, the Chinese, the French, and so on. It is thought that there are some 40 folk-culture groups in Canada. The CANADIAN CENTRE FOR FOLK CULTURE STUDIES is concerned with collecting and studying ethnic folk-culture artifacts whether or not they are considered art. See also FOLK ART, CANADA; NATIVE ART OF CANADA; FOLKLORE, FOLKLORE ARTIFACTS; FOLK ART, ACADIAN; HUTTERITES; GERMANIC INFLUENCE; MENNONITES; HAIDA; TSIMSHIAN. **Citations**: Tilney 1973; McKendry 1983; Marsh 1988; Lerner 1991.

ETROG, SOREL (b1933), Toronto, ON. Sculptor, painter and printmaker. Etrog, after immigrating to Canada in 1963 from Israel, established a reputation as an important sculptor in bronze and in rolled sheet metal. See Marsh 1988 for an illustration of of his work. Examples of his sculpture and prints are in the NATIONAL GALLERY OF CANADA. **Citations**: MacDonald 1967; Sisler 1980; NGC 1982; Hill 1988; Marsh 1988; Lerner 1991; McMann 1997.

EVANS, ANDREW FITZHERBERT (act. 1780-1826), Halifax, NS. Painter. While serving as an officer with the Royal Navy, Evans executed a sketch of the river near Sackville, NS (see Cooke 1983, pl. 199). **Citations**: Harper 1970; Cooke 1983; McKendry 1988.

EVANS, ROGER T. (b1940), Alberta. Painter and printmaker. **Citations**: Banff 1977; NGC 1982; Lerner 1991.

EVELEIGH, HENRY ROWLAND (b1934), Québec. Painter and printmaker. **Citations**: NGC 1982.

EWEN, WILLIAM PATERSON (b1925), Montréal, QC and London, ON. Painter and printmaker. He studied with JOHN LYMAN, ARTHUR LISMER and JACQUES DE TONNANCOUR and others. Several examples of Ewen's work are in the NATIONAL GALLERY OF CANADA. **Citations**: Harper 1966; MacDonald 1967; Sisler 1980; NGC 1982; Hill 1988; McMann 1997.

EXHIBITIONS. Exhibitions seem to be a universal and inevitable consequence of COLLECTING and CONNOISSEURSHIP. In Canada, as early as 1817, there was a public exhibition of the DESJARDINS COLLECTION of European paintings at the Hotel Dieu in Québec City. JOSEPH LEGARE bought about 30 of the Desjardins paintings and acquired some engravings, as well as another 30 paintings from dealers. By 1829, Legaré had his collection on public exhibition in the Union Hotel in Québec City. In

1833, he put his paintings and engravings on display in his house on Saint-Angèle street and invited the public to view them. Five years later, Legaré and his lawyer friend Thomas Amiot opened the Québec Gallery of Painting on the market square in the upper town. In this Gallery, more than 100 paintings were on public exhibition in a large hall with light from a domed ceiling. Meanwhile, in Montréal, artistic activity was increasing. In 1847 the MONTREAL SOCIETY OF ARTISTS was established, followed in 1860 by the formation of the ART ASSOCIATION OF MONTREAL who acquired an art collection and undertook a program of exhibitions. In 1939 the name of the Art Association of Montréal was changed to the MONTREAL MUSEUM OF FINE ARTS. Meanwhile other public galleries were established across the country and many annual agricultural fairs, particularly in Ontario, included exhibitions of art. The ROYAL CANADIAN ACADEMY and the NATIONAL GALLERY OF CANADA were founded in 1880. Paintings from the first exhibition of the Academy became the first items in the National Gallery of Canada collection; the first catalogue was published in 1912. Many National Gallery exhibitions and catalogues followed (see *RACAR* 1984, and Hill 1988, pp. XI-XXIX). See FOLK ART EXHIBITIONS. **Citations**: Hubbard 1957, 1959; Harper 1966; Boggs 1971; Porter 1978; Sisler 1980; Racar 1984; Reid 1988; Hill 1988; Lerner 1991; Murray 1996(1); McMann 1997.

EXPRESSIONISM. The term is used for an early 20th century AESTHETIC movement in reaction to 19th century superficiality based on naturalism and realism. The Expressionist artists, such as Max Beckmann (1884-1950), painted their emotional responses to their subjects and were not adverse to introducing distortions, stylized forms, folk and tribal art images, and violent colour combinations, thus setting the course toward ABSTRACT ART. FRITZ BRANDTNER, who arrived in Winnipeg from Danzig in 1928, played an important part in introducing Expressionism into Canada. The movement became popular in Montréal and spread to other parts of the country. Abstract expressionism dominated the works of the PAINTERS ELEVEN, see Harper 1966, pp. 390-1. **Citations**: Arnason 1968; Harper 1966; Osborne 1970, 1981; Janson 1974; Lord 1974; Clay 1978; Bringhurst 1983; Chilvers 1988; Piper 1988; Murray 1996(1).

EX-VOTO. An ex-voto (votive) is a painting or other work of art which was commissioned by a DONOR to fulfil a religious vow in gratitude to God for a favour, or in the hope of receiving a miraculous benefit. In most ex-voto paintings, the scene is a combination of a real situation and a religious vision. Sometimes explanatory text is included. In Canada, ex-votos occurred mostly in 18th century Québec religious painting, usually by unidentified artists, and were hung in church vestibules for examination and discussion by the worshippers upon entering or leaving.. Known painters who are thought to have executed ex-votos are FRERE LUC, DE CARDENAT, PAUL BEAUCOURT, and MICHEL DESSAILLIANT DE RICHETERRE. See Harper 1966, ch. 2, for a discussion of votive painting in New France. See Schlee 1980, pl. 382-8 for illustrations of German ex-votives. **Citations**: Harper 1966; Hubbard 1967; Lord 1974; Schlee 1980; McKendry 1983, 1987; Chilvers 1988; Marsh 1988 (under Votive Painting).

EYRE, IVAN KENNETH (b1935), Winnipeg, MB. Painter and sculptor. He studied with ERNEST LINDNER, ELI BORNSTEIN, GEORGE SWINTON and others. Three of Eyre's paintings are in the NATIONAL GALLERY OF CANADA. **Citations**: Swinton 1961; Duval 1972; Lord 1974; Heath 1976; Murray 1980; Sisler 1980; Bingham 1981; NGC 1982; Burnett/Schiff 1983; Bringhurst 1983; Marsh 1988; Reid 1988; Hill 1988; Lerner 1991; Murray 1996(1); McMann 1997.

F

FABIEN, HENRI ZOTIQUE (1878-1935), Montréal, QC. Painter. Fabien, after studying with WILLIAM BRYMNER and in Paris, returned to Canada in 1902. **Citations**: NGC 1982; Laliberté 1986.

FAFARD, JOSEPH (JOE) YVON (b1942), Regina and Pense, SK. Sculptor, painter, printmaker and ceramist. Fafard's sculpture is realistic and often satirical. He works in plaster, ceramic, terra cotta or bronze, and uses acrylics or glazes on his work. His portraits of people and animals appear influenced by FOLK ART traditions, but his knowledge and sculptural ability go much beyond that of a folk artist. He does not admit to an influence: "If one is looking for influences as a solution to art problems between myself and the so-called folk artists that I admire, there are none. I admire untutored artists as much as tutored ones." The best published commentary on Fafard and his work is in Teitelbaum 1987. An example of his work is in the NATIONAL GALLERY OF CANADA. **Citations**: Ferguson 1976; 1980; Heath 1976; *artscanada* 1979; Bismanis 1980; NGC 1982; *Canadian Art* 1985; *Century Home* 1985; Susan Whitney Gallery; NGC 1982; Bringhurst 1983; Teitelbaum 1987; Hill 1988; McKendry 1988; Marsh 1988; Lerner 1991.

FAINMEL, CHARLES (b1904), Montréal, QC. Sculptor and printmaker. He is the husband of MARGUERITE FAINMEL. **Citations**: NGC 1982.

FAINMEL, MARGUERITE PAQUETTE (1910-81), Montréal, QC. Painter and MURALIST. She was the wife of CHARLES FAINMEL and lived in New York, Paris and Montréal. One of her paintings is in the NATIONAL GALLERY OF CANADA. **Citations**: NGC 1982; Hill 1988.

FAIRLEY, BARKER (1887-1986), Toronto, ON. Painter, portraitist, German scholar, teacher, poet; literary and art critic. Fairley was one of the foremost German scholars of the century. He was a friend of the GROUP OF SEVEN artists. Upon retirement, Fairley devoted much of his time to painting. **Citations**: Jackson 1958; Mellen 1970; Lord 1974; Sisler 1980; Dault 1980; Fairley 1981; NGC 1982; Reid 1988; Lerner 1991; Tom 1991; Hill 1995; Marsh 1988; Silcox 1996; McMann 1997.

FAKE. A work by an artist is referred to as a fake (or forgery), when it is represented to be the work of another artist. The term does not apply to COPIES of works of art made without any intention or action of deception, as may be the case during the training of an artist. In Canadian art, there have been many discoveries of fakes which were represented as the work of CORNELIUS KRIEGHOFF, WILLIAM HENRY BARTLETT, or members of the GROUP OF SEVEN. Refer to Harper 1979, ch. 5, for a discussion of fakes, particularly with reference to Krieghoff. See McKendry 1983, pl. 133-6, 140, re copies. **Citations**: Harper 1979; McKendry 1983; Piper 1988.

FALARDEAU, ANTOINE-SEBASTIEN (1822-89), Québec City, QC. Painter. Falardeau studied in Italy and painted old master copies, portraits, miniatures and Italian landscapes in 17th century Dutch style. In his younger years he was encouraged by THEOPHILE HAMEL and worked for ROBERT C. TODD as a sign painter. One of his paintings is in the NATIONAL GALLERY OF CANADA. **Citations**: Bellerive 1925; Robson 1932; Falardeau 1936; Morisset 1936; Colgate 1943; Buchanan 1950; Hubbard 1960; Harper 1966, 1970; MacDonald 1967; NGC 1982; Reid 1988; Hill 1988; Lerner 1991; Béland 1992.

FALARDEAU, PIERRE (b1946), Montréal, QC. Filmmaker and VIDEO artist. He has been associated with JULIEN POULIN since 1972. Several examples of Falardeau and Poulin's work are in the NATIONAL GALLERY OF CANADA. **Citations**: Ferguson 1980; Hill 1988.

FALK, AGATHA (GATHIE) (b1928), Vancouver, BC. Sculptor, ceramist and painter. She was associated with J.A.S. MACDONALD, LAWREN P. HARRIS and JACQUES DE TONNANCOUR. Several examples of her work are in the NATIONAL GALLERY OF CANADA. **Citations**: Graham 1975; NGC 1982; Hill 1988;Lerner 1991; Tippett 1992.

FALSE FACE SOCIETY. A society of the Iroquois First Nations people who used carved and painted

wooden MASKS to invoke special powers of healing. The facial features of the masks were greatly distorted or exaggerated (see McKendry 1983, pl. 17, 18) and are examples of Canadian PRIMITIVE ART. **Citations**: Feder 1969; Clark 1970; Patterson 1973; Dickason 1974; McKendry 1983; Marsh 1988.

FANE, FRANCIS A. (active 1853), Québec. Painter of Québec scenes. **Citations**: Thibault 1978.

FANIEL, ALFRED JEAN-JOSEPH (1879-1950), Montréal, QC. Painter. He emigrated from Belgium to Montréal in 1903. Faniel's work included religious subjects. **Citations**: NGC 1982; Laliberté 1986.

FANSHAW, HUBERT VALENTINE (1878-1940), Winnipeg, MB. Painter and printmaker. He studied in Europe and arrived in Winnipeg in 1912. One of his paintings is in the NATIONAL GALLERY OF CANADA. **Citations**: NGC 1982; Hill 1988; Lerner 1991.

FANTASY. About 1910 in Paris, several artists were exploring art with such freedom in imaginative structure that some of their work could be considered Fantasy Art. These artists included PABLO PICASSO, Marc Chagall (1887-1985), Paul Klee (1879-1940), and Joan Miro (1893-1983). In Canada, JAMES W. G. (JOCK) MACDONALD and ALFRED PELLAN, among others, were influenced. ROBERT (SCOTTIE) WILSON seemed to work in a world of fantasy and naïveté. For a discussion of the Fantastic in naïve art, see Bihalji-Merin, ch. XIII. **Citations**: Harper 1966, 1974; Bihalji-Merin 1971; Rosenblum 1982; Makarius 1988; Reid 1988; Lerner 1991.

FARNCOMB, CAROLINE (1859-1951), London, ON. Painter. **Citations**: NGC 1982; Tippett 1992.

FARRAR, the Rev. MICHAEL A. (1813-76), Trent River and Galt districts, ON. Painter. Farrar was an AMATEUR artist. **Citations**: *Canadian Illustrated News* 1871, 1872; Guillet 1957; Harper 1970; McKendry 1988.

FARRELL, SIDNEY BAYNTON (1829-79), Montréal, QC; Ottawa and Kingston, ON. Painter. Farrell was a British army officer with considerable ability in TOPOGRAPHICAL painting and drawing in watercolour or pencil (see Cooke 1983, pl. 200). He worked on the surveys of the Ottawa and Rideau canals. **Citations**: Cooke 1983; McKendry 1988.

FASCIO (FASSIO), GUISEPPE (1789-1851), Montréal, Three Rivers, Québec City, QC; Ottawa, ON. Painter of MINIATURES and portraits. He arrived in Montréal in 1834 and travelled to various points in Québec, as well as to Ottawa and to Italy. A watercolour attributed to Fascio is in the NATIONAL GALLERY OF CANADA. **Citations:** Harper 1970; NGC 1982; Hill 1988.

FASSIO. See FASCIO.

FAUCHER, JEAN-CHARLES (b1907), Montréal,QC. Painter, printmaker and illustrator. He studied with CHARLES MAILLARD and HENRI CHARPENTIER, and travelled to France and Italy. Two of his ETCHINGS are in the NATIONAL GALLERY OF CANADA. **Citations**: NGC 1945, 1982; Barbeau 1946; McInnes 1950; McKendry 1988; Hill 1988.

FAUTEUX, ANDRE LUCIEN (b1946), Toronto, ON. Sculptor, painter and printmaker. He studied at the CENTRAL TECHNICAL SCHOOL and travelled in Europe. A MONOTYPE by Fauteux is in the NATIONAL GALLERY OF CANADA. **Citations**: Hill 1988; Lerner 1991.

FAUTEUX, MARIE CLAIRE CHRISTINE (b1890), Montréal, QC. Painter. She worked with WILLIAM BRYMNER, MAURICE CULLEN, ROBERT PILOT and ARTHUR LISMER at the ART ASSOCIATION OF MONTREAL. Fauteux was in Paris during World War II and returned to Montréal in 1947. **Citations**: NGC 1982; Laliberté 1986; Tippett 1992.

FAUTEUX-MASSE, HENRIETTE (b1924), Montréal, QC. Painter. She lived in New York 1946-9. One of her paintings is in the NATIONAL GALLERY OF CANADA. **Citations**: MacDonald 1967; NGC 1982; Hill 1988; Lerner 1991; Tippett 1992.

FAUVISM. Fauvism was an AESTHETIC movement in early 20th century painting based on the use of pure colour. The term Fauve (wild beasts) was coined at the Paris *Salon d'Automne* in 1905. It was a reaction to IMPRESSIONISM. Fauvism began as a loose association of painters: HENRI MATISSE executed the first paintings in a Fauvist manner about 1899. In Canadian art, DAVID MILNE was

painting in pure interacting colours by 1913. Milne was the only Canadian to exhibit in the New York ARMORY SHOW of 1913, which included paintings by Matisse. Other Canadian painters, including the GROUP OF SEVEN, were influenced to use colour more freely. The work of folk artists, for example GEORGE COCKAYNE who used clashing colours, is sometimes compared to that of Les Fauves. See also FOLK ART. **Citations**: Harper 1966; Arnason 1968; Osborne 1970, 1981; Janson 1974; Lord 1974; Clay 1978; Schapiro 1982; Piper 1988; Reid 1988; Lerner 1991.

FAVRO, MURRAY CARL (b1940), London, ON. Sculptor and painter. Many examples of Favro's ballpoint pen sketches and other works are in the NATIONAL GALLERY OF CANADA. **Citations:** Sisler 1980; NGC 1982; Hill 1988; Lerner 1991; McMann 1997.

FAWCETT, GEORGE (1877-1944), Winnipeg, MB. Painter, printmaker and illustrator. He arrived in Winnipeg c1909, moved to Chicago in 1919 and travelled widely thereafter. Three ETCHINGS by Fawcett are in the NATIONAL GALLERY OF CANADA. **Citations**: Hill 1988; Lerner 1991.

FEDERATION OF CANADIAN ARTISTS. See CONFERENCE OF CANADIAN ARTISTS.

FEINDEL, SUSAN (b1945), Ottawa, ON. Painter. **Citations**: Tippett 1992.

FEIST, HAROLD ELMER (b1945), Québec. Painter. **Citations**: Wilkin 1974(1); Walters 1975; NGC 1982.

FELLOWS, ELEANORE CAROLINE (1831-1926), Victoria, BC. Painter. Fellows was an English AMATEUR artist who visited Victoria 1861-6 and Vancouver c1909. She executed drawings and paintings in pencil or watercolour of landscapes, native people and curiosities. Many are in the Provincial Archives of British Columbia in Victoria. **Citations**: GC 1982; McKendry 1988.

FERGUSON COLLECTION. See CANADIAN CENTRE FOR FOLK CULTURE STUDIES.

FERGUSON, GERALD (b1937), Halifax, NS. Painter, printmaker and mixed media artist. Under the direction of Ferguson and GARRY KENNEDY, the NOVA SCOTIA COLLEGE OF ART AND DESIGN in Halifax was given life and an international reputation. **Citations**: NGC 1982; Burnett/Schiff 1983; Bringhurst 1983; Ferguson 1984, 1987; Lerner 1991.

FERRON, MARCELLE (b1924), Montréal, QC; Paris, France. Painter. Ferron studied in Paris and under JEAN-PAUL LEMIEUX. She was associated with PAUL-EMILE BORDUAS and ALFRED PELLAN in the Les AUTOMATISTES group. Her paintings are characterized by vibrant colours and fluid forms. After 1964, she also worked in stained glass. Examples of her prints and painting are in the NATIONAL GALLERY OF CANADA. **Citations**: Harper 1966; MacDonald 1967; Duval 1972; NGC 1982; Burnett/Schiff 1983; Reid 1988; Marsh 1988; Hill 1988; Lerner 1991.

FERROTYPE. See PHOTOGRAPHY IN CANADA.

FIELD, ROBERT (c1769-1819), Halifax, NS. Painter. Field was an English professional artist and the leading Canadian portrait painter when he was in Halifax from 1808-16. His portraits have been described as elegant and formal. He painted large oil portraits, small watercolours, and MINIATURES on ivory (see Harper 1966, pl. 92-3). **Citations**: Piers 1914; Nutt 1932; Colgate 1943; McInnes 1950; Harper 1966, 1970; Hubbard 1960, 1967; MacDonald 1967; Carter 1967; Lord 1974; Paikowsky 1978; NGC 1982; McKendry 1988; Reid 1988; Hill 1988; Lerner 1991.

FIGURATIVE ART. Recognizable figures or objects are portrayed in figurative (representational) work. **Citations**: Harper 1966; Chilvers 1988; Piper 1988.

FIGUREHEADS. See SHIPCARVINGS.

FILER, MARY HARRIS (b1920), Montréal, QC; Vancouver, BC. Painter, sculptor, printmaker and MURALIST. She studied with GARNET HAZARD, ARTHUR LISMER, GOODRIDGE ROBERTS, JACQUES DE TONNANCOUR, JOHN LYMAN and others, as well as in England and the USA. One of her LINOCUTS is in the NATIONAL GALLERY OF CANADA. **Citations**: NGC 1982; Hill 1988; Lerner 1991.

FILION, ARMAND (b1910), Québec. Sculptor. **Citations**: McInnes 1950; Chicoine 1970; NGC 1982; Lerner 1991.

FILION, PIERETTE (b1935), Québec. Painter. **Citations**: NGC 1982; Tippett 1992.

FINCH, ROBERT DUER CLAYDON (b1900), Toronto, ON. Painter, printmaker and author. He studied in Paris and travelled in Canada, the USA, South America and Europe. Three GOUACHES by Finch are in the NATIONAL GALLERY OF CANADA. **Citations**: NGC 1982; Hill 1988.

FINE ARTS. The term refers to the arts of painting, SCULPTURE and ARCHITECTURE, as opposed to APPLIED or DECORATIVE ARTS. Traditionally, the Fine Arts were held in greater esteem, because they tended to be non-utilitarian and more associated with the intellect than with the mechanical or manual. **Citations**: Osborne 1970; Lucie-Smith 1984; Pierce 1987; Piper 1988; Chilvers 1988.

FINLAY, GEORGE E. (b1819), Fort Garry, MB. Painter. Finlay was a British army officer who was stationed at Lower Fort Garry near Selkirk, MB, from 1846 to 1848, where he executed in pen and ink some naïve TOPOGRAPHICAL landscape drawings and figure studies of native people. **Citations**: Harper 1970; Render 1970; Eckhardt 1970; McKendry 1988.

FINLAYSON, ISOBEL G. (act. 1843), Canadian Northwest. Finlayson was an AMATEUR artist who executed paintings and line drawings of native people, traders, and a view of Upper Fort Garry (Winnipeg, MB) which was issued as a LITHOGRAPH. **Citations**: Harper 1970; Eckhardt 1970; McKendry 1988; Tippett 1992.

FINLEY, FREDERICK (FRED) JAMES (1894-1968), Toronto, ON. Painter, printmaker and illustrator; RCA 1955. He arrived in Canada from Australia in 1925 after studying in Sydney and Paris. In 1930-1 Finley studied in Germany and with A.G. BARNES at the ONTARIO COLLEGE OF ART 1932-4. Examples of his work are in the NATIONAL GALLERY OF CANADA. **Citations**: Duval 1952; Hubbard 1960; MacDonald 1967; Sisler 1980; NGC 1982; Hill 1988; McMann 1997.

FINSTERER, DANIEL (act. 1840), Québec. Sculptor of religious works in wood. **Citations**: Porter 1986.

FISCHL, ERIC (b1948), Halifax, NS; New York City., NY. Painter and sculptor. He arrived in Halifax in 1974 from the USA, where he had studied art. He has lived in New York since 1978. Several examples of his work are in the NATIONAL GALLERY OF CANADA. **Citations**: NGC 1982; Hill 1988; Lerner 1988.

FISH. A fish is a symbol of religious significance in RELIGIOUS ART and in FOLK ART; usually it is a symbol for Christ. The five Greek letters forming the word "fish" are the initial letters of the five words in Greek for: "Jesus Christ God's Son Saviour." An image of a fish has become a traditional theme in Québec folk art and often is seen in hooked rugs, maple sugar moulds, weathervanes, and butter moulds (see McKendry 1983, pl. 225-6). See also SALMON. **Citations**: Ferguson 1967; McKendry 1983.

FISHER, BRIAN RICHARD (b1939), Vancouver, BC. Painter, printmaker and MURALIST. He studied with ROY KIYOOKA, RONALD BLOORE, ARTHUR MCKAY and KENNETH LOCHHEAD. After working in the western provinces, Fisher moved in 1981 to Australia. Examples of his work are in the NATIONAL GALLERY OF CANADA. **Citations**: Sisler 1980; NGC 1982; Hill 1988; Lerner 1991; McMann 1997.

FISHER, GEORGE BULTEEL (1764-1834), Québec. Painter. Fisher who was a British army officer, executed TOPOGRAPHICAL landscape paintings including oil and watercolour views of the Montmorency and Québec City districts that were published as engravings in London in 1796. **Citations**: Harper 1970; Allodi 1974; Baker 1981; McKendry 1988.

FITZGERALD, LIONEL LEMOINE (1890-1956), Winnipeg, MB. Painter and printmaker. FitzGerald was a member of the GROUP OF SEVEN 1932-3 and of the CANADIAN GROUP OF PAINTERS 1933. His characteristic subjects were prairie landscapes, Winnipeg houses and STILL LIFE. He executed many drawings and was a skilled printmaker. FitzGerald used various painting techniques and styles including POINTILLISM and ABSTRACTION. Many examples of his paintings, prints and drawings are in the NATIONAL GALLERY OF CANADA. **Citations**: Winnipeg 1916; Housser 1929; CGP 1933; NGC 1936, 1982; Colgate 1943; Buchanan 1950; Jackson 1958; Hubbard 1960; Eckhardt 1962; Harper 1966; MacDonald 1967; Mellen 1970; Eckhardt 1970; Duval 1972; Bovey 1975; Fenton

1978; Coy 1982; Burnett/Schiff 1983; Reid 1988; Marsh 1988; Hill 1988, 1995; Duval 1990; Lerner 1991; Silcox 1996; McMann 1997.

FITZGIBBON, AGNES DUNBAR. See CHAMBERLIN, AGNES DUNBAR.

FIXATIVE. A fluid for spraying over drawings to prevent smudging. It is most needed for PASTELS, and is usually a transparent resin, such as shellac, dissolved in alcohol. **Citations**: Mayer 1970; Piper 1988; Chilvers 1988.

FLANCER, LUDWIG (1902-80), Montréal, QC. Painter. Flancer painted naïve portraits, religious subjects, animals and landscapes, often based on Montréal or Québec countryside scenes. **Citations**: Kobayashi 1985(2); McKendry 1988.

FLEMING, JOHN (1836-76), Toronto, ON. Painter and photographer. He was a brother of SANDFORD FLEMING and was with HENRY YOULE HIND on his Red, Assiniboine and Saskatchewan River expeditions in 1857 and 1858. His watercolour sketches were used in Hind's report; the paintings are now in the J. Ross Robertson collection in the Toronto Public Library, Toronto, ON. **Citations**: Harper 1970; Eckhardt 1970; McKendry 1988; Lerner 1991.

FLEMING, SANDFORD (1827-1915), Toronto, ON. Fleming was a well known scientist, artist, and a brother of JOHN FLEMING. He designed the first Canadian postage stamp in 1851, and was involved in the surveying of the Canadian Pacific Railway in the 1870s. **Citations**: Harper 1970; NGC 1982; Marsh 1988; McKendry 1988; Lerner 1991.

FOIL ART. Foil art is sometimes called tinsel work or ORIENTAL PAINTING. It is a form of COLLAGE in which a REVERSE PAINTING on glass is accentuated by having certain unpainted areas backed by shiny (usually crinkled) foil. Foil art was popular for a time in the late 19th century, when metallic foil from the packaging of tea from the Orient was readily available. (See McKendry 1983, pl. 159, 160, 162 for illustrations.) See also R.D. LEAVER; FOLK ART, CANADA. **Citations**: Murray 1982; McKendry 1983.

FOLK ART. Folk art is the personal artistic expression of people who are untrained in the principles and techniques of professional ACADEMIC ART. The term is a generic one which includes primitive and naïve art. As can be seen from the bibliographic references, there is considerable disagreement about an exact definition. It is useful to consider Nora McCullough's 1959 comments on folk painters (from the Introduction of McCullough 1959): "The folk painter is carried along by his fervour, his joy in the recreation of familiar things. Even should he believe he is achieving a realistic image, it is actually an inner image of the places and people he knows well that he presents on canvas.... Although he may lack certain knowledge the real folk artist still manages to surmount his technical limitations in a number of ways. With child-like innocence he alters and includes as best suits his purpose. Things far are brought near; light and shade may be disregarded; space may be treated in simple, two-dimensional fashion; rhythms he sees in nature are emphasized. Thus with single-minded devotion he fuses minute details into a total composition. It has been said that a deliberate disregard of perspective and scale is typical of the folk artist, a yardstick which can only measure some examples, and might also very well apply to many works of art." See also NAÏVE ART; PRIMITIVE ART; ART BRUT; YARD ART; FOLK ART, CANADA. Citations: McCullough 1959; Osborne 1970; Bihalji-Merin 1971, 1985; Harper 1974; Lord 1974; Schlee 1980; McKendry 1983, 1987, 1988; Pierce 1987; Piper 1988; Marsh 1988; Chilvers 1988.

FOLK ART, ACADIAN. Acadian folk artists are predominantly French-speaking Roman Catholics who live in parts of New Brunswick and Nova Scotia. Their traditions and themes are similar to those of Québec folk artists but subject to greater English influence. Examples of Acadian folk artists are MEDARD CORMIER, LEO B. LEBLANC and NELSON SURETTE. **Citations**: Laurette 1980(2); Marsh 1988; Boulizon 1989.

FOLK ART, ARTISTS. Canadian folk artists include:

Abbott, J.
Alary, Zenon
Alexander, Hugh
Allard, Emile
Ameen, Sister Anne
Andrews, Billy
Atkinson, Charlie
Audet, Edouard
Baldwin, Alma
Barker, Sydney
Begin, Charles Benjamin
Bergeron, Gaston
Betts, Augusta
Birrell, Ebenezer
Blake, Sara Mary
Bolduc, Blanche
Bolduc, Yvonne
Bollivar, Samuel
Bouchard, Edith Marie
Bouchard, Marie-Cecile
Bouchard, Simone-Mary
Boudreau, Donald
Boulizon, Guy
Boutilier, Ralph
Bradette, Merence
Brisebois, Ephrem A.
Buist, John
Burt, Leonard
Cameron, Walter G.
Carbonneau, Capt. P.
Cauchon, Robert
Chatîgny, Edmond

Cicansky, Frank
Cinq-Mars, Clement
Clogue, John
Clemens, Abram S.
Coates, Richard
Cockayne, George
Cook, Thomas
Cook, Walter
Cormier, Medard
Côté, Claude
Dahlstrom, Eugene
Dennis, Eva
Dennis, Wesley
Dechênes, Alfred
Desrosiers, Eugene
Doyle, Charlie
Eisenhauer, Collins
Flancer, Ludwig
Fortin, Madame
Francis, Mary
Gallant, Art
Garceau, Alfred
Gendron, Ernest
Gibbons, Charles
Greg, Rada
Harbuz, Ann A.
Heon, Oscar
Howard, Sidney
Jasmin, Edouard
Jost, Edward R.
Keevil, Roland
Kocevar, Frank

Kurelek, William
Lacelle, Beatrice
Lacelle, Florence
Lacelle, William
Lanigan, A.R.
Lapeer, Lynda
Latschaw, Abraham
Lavoie, René
Law, Gordon
Law, Ivan
Leblanc, Leo B.
Lawton, Alfred
Leaver, R.D.
Lenhardt, Molly
Lewis, Everett
Lewis, Maud
Litzgus, Hazel
Loney, William
McCargar, William
McCaugherty, Irene
MacDonald, Thomas
McInnes, Harvey
McNeilledge, Alexander
Maka, Jahan
Mandaggio, Edward
Moreland, F.A.
Moulding, Fred
Muyson, Hertha
Norris, Joseph
Panko, William
Pauls, Henry
Pierce, Capt.
Pieroway, Percy

Prevost, E. Nelphas
Racicot, George
Rentz, Ewald
Ringman, A.E.
Robinson, Jonas
Roy, Philippe
Sauvé, Arthur
Shink, Joseph
Silver, Francis
Slack, Crawford
Sleep, Joseph
Sommers, Robert
Spencer, Sam
Stewart, William
Stryjek, Dmytro
Surette, Nelson
Swift, Joseph
Tanner, Charlie
Thomarat, Jeanne
Thorne, Joseph
Tompkins, J. Seton
Trenerne, Harold
Trudeau, Angus
Van Ieperon, Cornelius
Van Lambalgen, Gerald
Villeneuve, Arthur
Weber, Anna
Williams, Arch
Williamson, R. Stanley
Wilson, Scottie
Wren, Bernie
Wyers, Jan
Zeissler, William

FOLK ART, CANADA.

Although folk art was created during prehistoric times in the region that is now Canada, as well as during the period of exploration and settlement by European immigrants, the recorded history of Canadian folk art begins with its rise to popularity with critics, collectors and the public during the 20th century. Around 1900 several prominent artists in Paris directed their attention to the primitive images of African tribal art, as well as to the great naïve paintings of their contemporary, Henri Rousseau (1844-1910). This was the period when Pablo Picasso (1881-1973) used primitive mask-like faces in his well known painting *Les Demoiselles d'Avignon* (1907), when Paul Gauguin (1848-1903) deliberately used naïve characteristics of incorrect perspective and scale, as well as some primitive images from the south sea islands, and when Maurice Utrillo (1885-1955) painted in a purposely naïve style. These great professional academic painters helped critics, collectors and the public appreciate folk art. It was the beginning of the popular taste for aesthetically pleasing folk art. Examples appeared in English Canada early in the twentieth century and continued into the 1970s. During this period no great change appeared in French Canada because folk art, particularly religious folk art, was already established and flourishing among the French people. The Roman Catholic Church had encouraged painters and sculptors to meet the need to decorate and furnish the altars and other parts

of the numerous churches built during, or soon after, the first settlements in the 17th and 18th centuries. Aesthetically pleasing public exhibitions of Canadian folk art occurred in Canada between 1950 and 1975, partly due to the influence of J. RUSSELL HARPER (see FOLK ART EXHIBITIONS). Judging by the exhibitions presented to the Canadian public in the 1980s, a hodgepodge period had commenced. The quality of major folk art exhibitions and collections, at least as far as aesthetic criteria are concerned, had deteriorated to the extent that some contained a miscellaneous mix of paintings, sculpture, craftwork and social artifacts, by artists, amateurs or craftspeople. See also FOLK ART, HODGEPODGE PERIOD. **Citations**: Harper 1966, 1973, 1974; Osborne 1970 (see Canadian Art); Lord 1974; McKendry 1983, 1987; Bihalji-Merin 1985 (p. 649).

FOLK ART, CONSCIOUS. Folk art style work executed by AMATEUR artists or professional ACADEMIC artists may be called 'conscious folk art' to indicate that the artists have deliberately borrowed style and/or images from FOLK ART. In the case of NATIVE ART, PRIMITIVE images usually are used intuitively as opposed to consciously. In the case of NAÏVE ART, naïve images are used intuitively. The French professional painter Jean Dubuffet (1901-85) is an example of an ACADEMIC painter who, for a time, turned his back on conventional fine art and consciously used naïve images. The best reference on this subject is "The Conscious Naïves" in Bihalji-Merin 1971, pp. 273-6.

FOLK ART EXHIBITIONS. In 1927 the NATIONAL GALLERY OF CANADA held a poorly attended exhibition, "Canadian West Coast Art: Native and Modern", (see Tippett 1979 pp. 147-9 and Hill 1988 p. XVII) in Ottawa. EMILY CARR's paintings of primitive sculptures of the Northwest Coast Indians were mixed with painted pottery, hooked rugs, Haida totems, Tsmshian masks, kerfed boxes, cedar-bark capes, and spruce-root hats. By the 1950s folk art was attracting sufficient public attention in English Canada for the National Gallery of Canada to mount the first important aesthetically pleasing exhibition of Canadian folk art painting, "Folk Painters of the Canadian West" 1959. Other folk-art exhibitions followed by curators who were interested in the aesthetic aspects of folk art. In 1968 naïve paintings were exhibited in a show "Les Naifs" by les Jeunes Associés du Musée des Beaux-Arts de Montréal. In 1972, at the same museum, there was an important show of 250 naïve paintings, "Arthur Villeneuve's Québec Chronicles." In 1973 the National Gallery of Canada again presented an aesthetically appealing show "People's Art: Naïve Art in Canada." The paintings and sculpture for this show were carefully selected for quality by J. RUSSELL HARPER who, in the introduction to the catalogue (Harper 1973), gave his criteria for selection of folk art: "Hundreds of paintings and carvings were examined. Many were devoid of artistic merit. Others demonstrated how the artists wished to speak; they wanted to talk so badly that they drew a line around an idea and added colour as best they could. The will and determination behind this effort produced a forceful record of daily life. Such works transcend crude execution, lack of perspective, unorthodox colour harmonies, and imperfect anatomical knowledge. A human vitality permeates the finest of them, and carries with it an innate aesthetic appeal. They are rich in universal meaning, radiate naïveté and charm, and delighted those for whom they were intended. They can still delight us today." That is how to select works for a folk-art exhibition! In 1976 the NORMAN MACKENZIE ART GALLERY mounted an exhibition, "Grassroots Saskatchewan" (Thauberger 1976) by sixteen folk artists whose works were chosen for aesthetic reasons and, in the same year, the ART GALLERY OF NOVA SCOTIA organized a touring exhibition of 20th century folk art, "Folk Art of Nova Scotia" (Elwood 1976), for which the selected works met Harper's standards. Unfortunately, by the 1980s, Harper's criteria were being ignored to a large extent, and the HODGE-PODGE PERIOD in Canadian folk-art exhibitions was in full swing. The quality of major folk-art exhibitions, at least as far as aesthetic criteria are concerned, had deteriorated to the extent that some became miscellaneous collections of paintings, sculpture, craftwork and social artifacts, by artists, amateurs or craftspeople. A large national exhibition, "From The Heart: Folk Art In Canada" (NMM 1983), a regional exhibition, "The Spirit of Nova Scotia: Traditional Decorative Folk Art" (Field 1985), and a regional exhibition"Folk Treasures of Historic Ontario," Kobayashi 1985(1), included aesthetically

pleasing paintings and sculpture, mixed with utilitarian items (butter moulds, storage boxes, wall boxes) and craftwork (carved chains, models). Such exhibitions create the impression that almost anything can be included in folk art, whether art or not. It remains to be seen if the earlier aesthetic criteria, such as Harper's, can be re-established. **Citations**: McCullough 1959; Osborne 1970; Gagnon 1972; Harper 1973, 1974; Thauberger 1976; Elwood 1976; Tippett 1979; NMM 1983; McKendry 1983, 1987; Kobayashi 1985(1); Field 1985; Hill 1988.

FOLK ART, HODGEPODGE PERIOD IN CANADA. In the 1980s the standards for folk-art exhibitions in Canada changed from requiring that exhibited items meet aesthetic considerations to accepting almost any paintings, sculpture, craftwork or social artifacts by artists, amateurs or craftspeople. No longer were items selected "...for their fullness of artistic expression, greater universality of meaning, and innate aesthetic sensibility," (Harper 1974, p. 3), as were the items for many earlier exhibitions such as "Folk Painters of the Canadian West" 1959, "People's Art" 1973, the regional exhibitions "Folk Art of Nova Scotia" 1976 and "Grassroots Saskatchewan" 1976. Later exhibitions such as "From the Heart" 1983, "Spirit of Nova Scotia" 1985, and "Folk Treasures of Historic Ontario" 1985 included items whose utilitarian design outweighed aesthetic qualities. This caused many dealers, collectors and curators to be influenced toward accepting miscellaneous artifacts as folk art - the hodgepodge period was under way. See also ARTS AND CRAFTS MOVEMENT; FOLK ART, CANADA; FOLK ART EXHIBITIONS; FOLK ART, PAINTERS OF THE CANADIAN WEST EXHIBITION. **Citations**: McCullough 1959; Harper 1973, 1974; Thauberger 1976; NMM 1983; Field 1985; Kobayashi 1985(1).

FOLK ART, MISC. See Amateur Art; Animals; April Antique & Art Show; Arctic; Armature; Art; Art Brut; Art Gallery of Nova Scotia; Arthur Villeneuve Quebec Chronicles Exhibition; Artifact; Assemblage; Barbeau, C.M.; Basketry; Beaver; Birds; Bird Tree; Boxes; Calvary; Canadian Centre for Folk Culture Studies; Cardboard; Caricature; Cartoon; Charlevoix County; Children's Art; Cigar Store Figures; Collage; Collecting; Construction; Continuous Narrative; Coverlet; Crayon; Croscup House; Decoys; Depression; Diorama; Doukhobor Art; Drapery; Dubuffet, Jean; Dunlop Art Gallery; Earth Art; Easel; Erotic Art; Ethnic Art; Fafard, J.; Fauvism; Fish; Foil Art; Folklore; Found Object; Fraktur; Furniture; Gameboards; Genre Art; Geometric Designs; Germanic Influence; Graffiti; Grain Bin Project; Gravestones; Grenfell Mats; Harper, J. Russell; Hooked Rugs; Index of American Design; Iron Sculpture; Itinerant Artists; Landscape Painting; Lemieux, J.-P.; Masks; Mennonite; Naïve Art; Primitive Art; Provincial Art; Reverse Painting; Rose; Sand Painting; Sandpaper Painting; Shadow; Shipcarving; Show Towel; Sunday Artist; Thauberger, D.; Theorem Painting; Tramp Art; Ukrainian; Viewpoint; Wood Carving; Yard Art; Yuristy, Russell.

FOLK ART, NAÏVE. See NAÏVE ART; FOLK ART, CONSCIOUS.

FOLK ART OF NOVA SCOTIA EXHIBITION. See FOLK ART EXHIBITIONS.

FOLK ART, PAINTERS OF THE CANADIAN WEST EXHIBITION. This important, aesthetically pleasing, exhibition of Canadian folk-art painting was circulated by the NATIONAL GALLERY OF CANADA in 1959 and 1960. Nora McCullough, who organized the exhibition, said in the introduction to the catalogue (McCullough 1959): "In selecting the paintings for this exhibition, the works have been chosen for their style and decorative charm and for special individual qualities. Knowledge of the art of painting through academic training has not been a consideration." The folk artists represented in the exhibition were: WILLIAM PANKO; JAN GERRIT WYERS; WILLIAM N. STEWART; ROLAND KEEVIL; SYDNEY HERBERT BARKER; and EUGENE WILHELM DAHLSTROM. See also FOLK ART EXHIBITIONS. **Citations**: McCullough 1959; Harper 1974; Lord 1974.

FOLK ART, PRIMITIVE. See PRIMITIVE ART; FOLK ART, CONSCIOUS.

FOLK ART STYLE. See STYLE.

FOLK ART, THE UNITED STATES. Folk art in the part of America that is now the USA had its start with missionaries, explorers, topographers and naturalists in the 16th century. Many were gifted

amateurs at a time when drawings and paintings had to serve many of the same purposes that the camera now serves. During the 18th and 19th centuries, a large number of naïve portraits, TOPOGRAPHICAL landscapes and decorative works were created. Naïve folk sculpture appeared at an early date, the most notable being ship figure-heads. The nature of early folk art in the USA contrasted somewhat with that in the area of America that is now Canada. In Canada, early naïve painting and sculpture got their start at a later date, in the mid 17th century, more through the clerical efforts of the Roman Catholic Church in Québec than through auspices of the laity as was the case, for the most part, in the USA. As a result, the earliest American folk art has more variety and originality than the earliest Canadian folk art which was often based on religious works remembered from France. Nevertheless the religious sculpture of Québec, remains unique in America for its combination of quality and quantity from one region. Later, particularly in the late 19th and 20th centuries, the work done in the two countries became similar in many aspects, although the greater population in the USA produced a larger body of work with a corresponding larger number of varied outstanding works. See also FOLK ART, CANADA;. **Citations**: Harper 1966, 1974; Osborne 1970; Lipman 1974, 1980; Bishop 1974; McKendry 1983, 1987.

FOLK CULTURE ARTIFACTS. See FOLKLORE; FOLKLORE ARTIFACTS.

FOLKLORE. The following definition from Marsh 1988 serves its purpose well: "Folklore ... refers to information, wisdom and human expression that is passed on, usually anonymously, from generation to generation or transmitted and circulated as traditional cultural behaviour." Folklore can be "passed on" verbally through folk songs, tales and sayings, or nonverbally through artifacts, crafts, dances, rituals and customs. Marsh (1988 p. 798 following Folk Music) and Fowke (1988) provide excellent, short discussions of Canadian folklore, noting the early work of CHARLES MARIUS BARBEAU, and referring to the folklore-research centre, the CANADIAN CENTRE FOR FOLK CULTURE STUDIES of the CANADIAN MUSEUM OF CIVILIZATION. There is some overlap between the fields of folklore and folk art leading to confusion in selecting pieces for FOLK ART EXHIBITIONS and in critical discussion. This arises from the fact that all folk-art works can be considered folklore artifacts, but not all folklore artifacts are folk art - some lack the aesthetic qualities necessary to be accepted as art. See also ETHNIC ART. **Citations**: Fowke 1976, 1985, 1988; Marsh 1988.

FOLKLORE ARTIFACTS. Folklore artifacts, sometimes called social-history artifacts or folk-culture artifacts, are artifacts that in some way represent a feature of social (cultural) and/or ethnic behaviour or traditions. See also ARTIFACTS; FOLKLORE; ETHNIC ART. **Citations**: McKendry 1983.

FONES, ROBERT JOHN (b1949), Toronto, ON. Sculptor and printmaker. He studied with HERB ARISS, and an example of his work is in the NATIONAL GALLERY OF CANADA. **Citations**: NGC 1982; Hill 1988.

FORBES, ELIZABETH ADELA STANHOPE (1859-1912), Kingston, ON; London, England. Painter. Although this artist was born in Canada, she studied and worked in England as a painter and etcher. She married the English painter Stanhope A. Forbes in 1889. There are many examples of her work in the NATIONAL GALLERY OF CANADA. **Citations**: Robson 1932; Hubbard 1960; MacDonald 1967; Harper 1970; NGC 1982; Hill 1988.

FORBES, JOHN COLIN (1846-1925), Toronto and Ottawa, ON; Montréal, QC. Painter; RCA 1882. Forbes was a portrait painter whose subjects included many Canadian politicians. He was a charter member of the ROYAL CANADIAN ACADEMY, a member of the ONTARIO SOCIETY OF ARTISTS and the father of KENNETH FORBES. Several portraits by Forbes are in the NATIONAL GALLERY OF CANADA. **Citations**: MacTavish 1925; Robson 1932; Colgate 1943; Hubbard 1960; Harper 1966, 1970; MacDonald 1967; Reid 1979; Sisler 1980; NGC 1982; Hill 1988; Lerner 1991; McMann 1997.

FORBES, KENNETH KEITH (1892-1980), Toronto, ON. Painter; RCA 1933. Kenneth Keith Forbes, a son of JOHN COLIN FORBES, studied painting in England and lived in Toronto after 1924. A painting by Forbes is in the NATIONAL GALLERY OF CANADA. **Citations**: Colgate 1943; McInnes 1950; Hubbard 1960; Harper 1966; MacDonald 1967; Sisler 1980; NGC 1982; Hill 1988;

Lerner 1991; McMann 1997.

FORD, HARRIET MARY (1859-1938), Brockville and Toronto, ON. Painter and MURALIST. She studied in Toronto, London and Paris. Several of her watercolours are in the NATIONAL GALLERY OF CANADA. **Citations**: Miner 1946; Hubbard 1960; MacDonald 1967; NGC 1982; Hill 1988; Tippett 1992.

FORESHORTENING. A technique for showing an object lying at an angle to the picture plane by continuous diminution in size along the length of the receding object. The term is used for a single object and not for PERSPECTIVE in a large space or landscape. **Citations**: Lucie-Smith 1984; Pierce 1987.

FORGERY. See FAKE.

FORGES SAINT-MAURICE. The Saint-Maurice iron forges, located at iron deposits near Trois-Rivières, QC, began iron production in 1738 and continued to the late 19th century. Forged iron and molded products such as pots, pans and stoves, were produced. See BLACKSMITHING. **Citations**: Palardy 1963; Marsh 1988.

FORREST, CHARLES RAMUS (REMUS) (act. 1778-1827), Québec City.QC. Painter and TOPOGRAPHER. Forrest, who was with the British army, painted TOPOGRAPHICAL landscape views in watercolour of Québec scenes and of the French River route from Ottawa to Lake Huron. Several examples of his work are in the NATIONAL GALLERY OF CANADA. **Citations**: Harper 1964; 1970, 1973; Allodi 1974; Wight 1980; NGC 1982; Cooke 1983; Kobayashi 1985(2); McKendry 1988; Hill 1988; Lerner 1991; Béland 1992.

FORRESTALL, THOMAS (TOM) DE VANY (b1936), Nova Scotia; Fredericton, NB Painter and sculptor. He studied under LAWREN PHILLIPS HARRIS and ALEX COLVILLE. **Citations**: Andrus 1966; Harper 1966; MacDonald 1967; Lord 1974; Duval 1974; Sisler 1980; Laurette 1980(3); NGC 1982; Burnett 1983; Reid 1988; Lerner 1991; McMann 1997.

FORSTER, JOHN WYCLIFFE LOWES (1850-1938), Toronto, ON. Painter, portraitist. Forster studied portrait painting under J.W. BRIDGMAN in 1869 and then shared a studio with him. After studying in France, he was back in Toronto by 1883, but made many trips abroad. He was principally a portrait painter. Three portraits by Forster are in the NATIONAL GALLERY OF CANADA. **Citations**: Hopkins 1898; Forster 1928; Robson 1932; Colgate 1943; McInnes 1950; Hubbard 1960; Harper 1966, 1970; MacDonald 1967; Sisler 1980; NGC 1982; Marsh 1988; Hill 1988; Reid 1988; Lerner 1991; McMann 1997.

FORSTER, MICHAEL (b1907), Ottawa, ON. Painter. Michael Forster was an artist with the Royal Canadian Navy during the Second World War, and since then has been active in Canada, Mexico and England. Examples of his work are in the NATIONAL GALLERY OF CANADA. **Citations**: McInnes 1950; Hubbard 1960; Harper 1966; MacDonald 1967; Hill 1988.

FORSTER, TERRY (b1936), Toronto, ON. Printmaker and musician. He was associated with the ARTISTS' JAZZ BAND. A SERIGRAPH by Forster is in the NATIONAL GALLERY OF CANADA. **Citations**: Hill 1988.

FORTIER, MICHEL (b1943), Montréal, QC. Painter and printmaker. He studied with ALBERT DUMOUCHEL and RICHARD LACROIX. An ETCHING and a SERIGRAPH by Fortier are in the NATIONAL GALLERY OF CANADA. **Citations**: Hill 1988, Lerner 1991.

FORTIN, Madame (act. 1873), Saint-Urbain, QC. Madame Fortin is known for a fine decorative COVERLET in wool on homespun. The design of the coverlet includes a house, stylized birds, animals, and trees (see Hubbard 1967, pl. 127). **Citations**: Hubbard 1967; McKendry 1988.

FORTIN, MARC-AURELE (1888-1970), Montréal and Ste-Rose, QC. Painter and printmaker. Fortin studied painting in Montréal with LUDGER LAROSE and EDMOND DYONNET. He painted rural and urban Québec scenery with a personal vision of colour and form. Several of his paintings are in the NATIONAL GALLERY OF CANADA. **Citations**: Chauvin 1928; Bergeron 1946; Barbeau 1946; McInnes 1950; Duval 1954; Hubbard 1960; Harper 1966; MacDonald 1967; Ayre 1977; Thibault 1978;

NGC 1982; Laliberté 1986; Sisler 1980; Marsh 1988; Hill 1988; Duval 1990; Lerner 1991.

FORTON (FORTIN), MICHEL, (1754-1817), Québec City, QC. Silversmith. He was apprenticed to JOSEPH (JONAS?) SCHINDLER. By 1790 he had his own studio in Québec City. A tablespoon by Forton is in the NATIONAL GALLERY OF CANADA. See also SILVERSMITHING. **Citations**: Langdon 1960, 1966, 1968; Hill 1988.

FOSBERY, ERNEST GEORGE (1874-1960), Ottawa, ON; Montréal and Cowansville, QC. Painter, printmaker and illustrator; RCA 1931. Fosbery received early instruction from FRANKLIN BROWNELL as well as in Paris from Fernand Cormon. After 1920 he taught art in Ottawa. He was a brother of the sculptor LIONEL GOOCH FOSBERY. Several prints and paintings by Fosbery are in the NATIONAL GALLERY OF CANADA. **Citations**: Hubbard 1960; Harper 1966; MacDonald 1967; Sisler 1980; NGC 1982; Hill 1988; Lerner 1991; McMann 1997.

FOSBERY, LIONEL GOOCH (1879-1956), Manitoba; Ottawa, ON; Wakefield, QC. Sculptor. After studying in the USA, Fosbery opened a sculpture studio in Ottawa, where he did bronze tablets, busts, trophies, figures and medals. A head by Fosbery is in the NATIONAL GALLERY OF CANADA. **Citations**: MacDonald 1967; NGC 1982; Hill 1988.

FOSTER, FREDERICK LUCAS (1842-99), Toronto, ON. Painter. He painted portraits, landscapes and GENRE, including views of rural Québec, Ontario, Manitoba and Saskatchewan (see Allodi 1974, pl. 754, 763, 767). **Citations**: Eckhardt 1970; Harper 1970; Allodi 1974; McKendry 1988.

FOSTER, ROBERT GIBBONS (1888-1948), Hamilton ON. Printmaker. A LINOCUT by Foster is in the NATIONAL GALLERY OF CANADA. **Citations**: Hill 1988.

FOTHERGILL, CHARLES (1782-1840), Port Hope, ON. Painter, naturalist and journalist. His work included somewhat ROMANTICIZED views of the Port Hope and Rice Lake areas (see Allodi 1974, pl. 768, 769, 770). **Citations**: Guillet 1957; Harper 1966, 1970, 1973; Allodi 1974; NGC 1982; Kobayashi 1985(2); McKendry 1988; Dickenson 1992.

FOULIS, ROBERT (1796-1866), Halifax, NS; Saint John, NB. Painter and DAGUERREOTYPIST. Foulis emigrated from Scotland to Halifax in 1819. He painted portraits and MINIATURES in Halifax and, in 1820, moved to Saint John, where he opened a daguerreotype studio and was active in scientific matters. **Citations**: Harper 1966, 1970; NGC 1982; McKendry 1988; Marsh 1988; Lerner 1991.

FOUND OBJECT. A natural or man-made object selected by an artist as a work of art or used as a part of a work of art, as sometimes occurred in DADA art. When two or more found objects are put together, the work may be called an ASSEMBLAGE. Found objects are often used by folk artists, for example EWALD RENTZ and GEORGE COCKAYNE. **Citations**: Osborne 1970 (see Objet Trouvé); Pierce 1987; Piper 1988.

FOURNELLE, ANDRE (b1939), Montréal, QC. Sculptor, printmaker. He studied with ARMAND VAILLANCOURT and travelled widely. An example of his work is in the NATIONAL GALLERY OF CANADA. **Citations**: Gagnon 1970; NGC 1982; Hill 1988; Lerner 1991.

FOURNIER, FRANCOIS-MARIE (1790-1864), Québec. Sculptor of religious works in wood; architect. A baptistery by Fournier is in the NATIONAL GALLERY OF CANADA . **Citations**: Traquair 1947; Porter 1986; Hill 1988.

FOURNIER, PAUL (b1939), Toronto, ON. Painter and printmaker. Two drawings and an ETCHING by Fournier are in the NATIONAL GALLERY OF CANADA. **Citations**: NGC 1982; Hill 1988; Lerner 1991.

FOURNIER, THOMAS (b.1826), Québec City, QC. Painter and sculptor. Although chiefly a gilder, ornamental carver and picture frame maker, Fournier executed some paintings in watercolour. Fournier was a pupil of FRANCOIS-THOMAS BAILLAIRGE. **Citations**: Harper 1970; McKendry 1988.

FOWLER, DANIEL (1810-94), Amherst Island, ON. Painter; RCA 1880 . After emigrating from England in 1843, Fowler purchased a farm on Amherst Island, near Kingston, where he lived for the remainder of his life. He had sketched and painted in Europe and, in 1857, began painting at his home on Amherst Island. Fowler worked directly from nature, painting flowers, dead birds and landscapes.

He was an accomplished watercolourist and a charter member of the ROYAL CANADIAN ACADEMY. Several watercolours by Fowler and a self portrait are in the NATIONAL GALLERY OF CANADA. The best reference on Fowler is Smith 1979 which includes his *Autobiography or Recollections of an Artist.* **Citations**: Hopkins 1898; MacTavish 1925; Robson 1932; Colgate 1943; McInnes 1950; Duval 1954; Hubbard 1960; Harper 1966, 1970; MacDonald 1967; Lord 1974; Smith 1979; Burleigh 1980; Sisler 1980; NGC 1982; Marsh 1988; Farr 1988; Reid 1988; Hill 1988; Lerner 1991; McMann 1997.

FOX, JOHN RICHARD (b1927), Montréal, QC. Painter. He studied with WILLIAM WALTON ARMSTRONG and GOODRIDGE ROBERTS. Two of his paintings are in the NATIONAL GALLERY OF CANADA. **Citations**: Sisler 1980; NGC 1982; Hill 1988; McMann 1997.

FOY, LEWIS (act. c1793), Niagara, ON. Painter. Little is known about this artist, except that he painted a watercolour view of the Indian Council of 1793 (see Carter 1967, pl. 82). **Citations**: Carter 1967; Harper 1970; McKendry 1988.

FRAKTUR. The term fraktur, in contemporary usage, includes the broken, black-letter (sometimes referred to as Gothic) style of CALLIGRAPHY, as well as the decorative watercolour ILLUMINATION that uses stylized motifs from nature and is often associated with lettering. Fraktur is an established art form in Germanic communities in the USA (for example in Pennsylvania), and in Canada (for example in Waterloo County, ON). ANNA WEBER of the MENNONITE community in Waterloo County is the best known Canadian fraktur artist. **Citations**: Good 1976; Bird 1977, 1981; McKendry 1983; Lerner 1991.

FRAME, STATIRA ELIZABETH (1870-1936), Vancouver, BC. Painter. She was largely self taught. **Citations**: Tippett 1977, 1992; NGC 1982; Lerner 1991.

FRANCHERE, JOSEPH-CHARLES (1866-1921), Montréal, QC. Painter, illustrator and muralist. He studied in Montréal and Paris. Franchère painted portraits, figures, GENRE, landscapes (in Québec and in the Muskoka region of Ontario), and religious paintings. He painted church MURALS in Québec as well as four large paintings for the Notre-Dame du Sacre-Coeur chapel, Church of Notre Dame, Montréal. Several paintings by Franchère are in the NATIONAL GALLERY OF CANADA. **Citations**: Dyonnet 1913; Hubbard 1960, 1973; Harper 1966, 1970; Trudel 1967(Peinture); Morris 1972; Sisler 1980; NGC 1982; Marsh 1988; Laliberté 1986; McKendry 1988; Reid 1988; Hill 1988; Lerner 1991; McMann 1997.

FRANCIS, MARY (1900-79), Picton, ON. Painter. Francis painted naïve, flat landscapes with animals, using repetitive forms, in a decorative but somewhat SURREALIST style. **Citations**: McKendry 1983, 1988; Kobayashi 1985(1)(2).

FRANCOIS, CLAUDE. See FRERE LUC.

FRANCOIS, PERE (act. 1732-56), Montréal, QC. Painter. Father François painted portrait and religious paintings in oil for churches. His portrait of Père Emmanuel Crespel (see Harper 1966, p. 30) is referred to as "a most accomplished portrait." Père François' secular name was François Jean-Melchior Brekenmacher. **Citations**: Harper 1966, 1970; Trudel 1967(Peinture); McKendry 1988.

FRASER, Mr (act. late 19th century), Québec. Painter. The inventory of Works of Art of the Province of Québec of the Ministry of Culture includes a painting in pastel by this artist in imitation of the work of CORNELIUS KRIEGHOFF. **Citations**: Harper 1970; McKendry 1988.

FRASER, A.M. (act. 1856), Hamilton, ON. Painter. This painter may be A. McLeod Fraser, a LITHOGRAPHER for the Hamilton *Spectator*. He is known for a watercolour view of Niagara Falls from the American side. **Citations**: Allodi 1974; McKendry 1988.

FRASER, CAROL LUCILLE HOORN (1930-91), Halifax, NS. Painter and sculptor. She arrived in Halifax from the USA in 1961. Fraser studied in the USA, Canada and Germany. One of her paintings and some of her sketches are in the NATIONAL GALLERY OF CANADA. **Citations**: Andrus 1966; Sisler 1980; NGC 1982; Hill 1988; Lerner 1991; Tippett 1991; McMann 1991.

FRASER, JOHN ARTHUR (1838-98), Montréal, QC; Toronto, ON. Painter, illustrator and photographer; RCA 1880. Fraser was a portrait painter in England before emigrating to Canada c1856. He

became associated with the photographer WILLIAM NOTMAN and painted backdrops for photographs. By 1868 he was a partner in Notman's Toronto branch, known as the Notman-Fraser Studio. In 1886 Fraser painted in the Rocky Mountains for the Canadian Pacific Railway. He taught art and among his pupils were HORATIO WALKER, HENRY SANDHAM, GEORGE AGNEW REID and ERNEST THOMPSON SETON. Fraser was a charter member of the ROYAL CANADIAN ACADEMY and a brother of WILLIAM LEWIS FRASER. Several of his paintings are in the NATIONAL GALLERY OF CANADA. **Citations**: MacTavish 1925; Colgate 1943; McInnes 1950; Hubbard 1960, 1967; Harper 1966, 1967, 1970; MacDonald 1967; Corbeil 1970; Duval 1974; Lord 1974; Mellen 1978; Reid 1979, 1988; Sisler 1980; NGC 1982; Triggs 1985; Marsh 1988; McKendry 1988; Hill 1988; Lerner 1991; McMann 1997.

FRASER, WILLIAM LEWIS (1841-1905), Montréal, QC. Painter. Fraser who emigrated to Canada from England about 1856, painted over photographs for the photographer WILLIAM NOTMAN from 1865-75. He also painted oil portraits and watercolour landscapes of Montréal and district. He was a brother of JOHN ARTHUR FRASER . **Citations**: Colgate 1943; Harper 1966, 1967, 1970; Reid 1979; NGC 1982; Triggs 1985; McKendry 1988.

FREIFELD, ERIC (1919-84), Toronto, ON. Painter and art teacher. A watercolour by Freifeld is in the NATIONAL GALLERY OF CANADA . **Citations**: Macdonald 1967; Duval 1974, 1977(1); Sisler 1980; NGC 1982; Hill 1988; Lerner 1991; McMann 1997.

FREIMAN, LILLIAN (1908-86), Montréal, QC; Toronto, ON. Painter. Freiman was born at Guelph, ON, but spent most of her life studying in Paris and living in New York City. She studied with EDMOND DYONNET and others. She painted street scenes and figures. Several paintings by Freiman are in the NATIONAL GALLERY OF CANADA. **Citations**: Buchanan 1950; McInnes 1950; Duval 1954; Hubbard 1960; MacDonald 1967; Nasby 1978; NGC 1982; Hill 1988; Lerner 1991;Tippett 1992.

FRENCH CANADIAN FOLK ART. See FOLK ART, ACADIAN; FOLK ART, CANADA; QUEBEC.

FRENKEL, VERA (b1938), Toronto, ON. Sculptor, printmaker, film and VIDEO artist. Frenkel arrived in Montréal from Czechoslovakia in 1938. She studied with ARTHUR LISMER, JOHN LYMAN and ALBERT DUMOUCHEL. A colour photo-serigraph by Frenkel is in the NATIONAL GALLERY OF CANADA. **Citations**: NGC 1982; Hill 1988; Lerner 1991.

FRERE LUC. See LUC.

FRESCO. An ancient technique of painting murals using water-based paint on lime plaster. Fresco secco is painted on dry plaster, while buon fresco or true fresco is applied to damp plaster. The artist is guided by his CARTOON. See also LOUIS GADBOIS, CHARLES HUOT. **Citations**: Mayer 1970; Osborne 1970; Lucie-Smith 1984; Piper 1988.

FREY, CHRISTIE NORMAN (b1886), British Columbia; Calgary, AB. Painter and illustrator. In 1912, Frey advertised as a general illustrator and TOPOGRAPHICAL real estate artist in Calgary but, by 1920, was living in BC. For an example of his work, see NMM 1983 pl. 85. **Citations**: NGC 1982; NMM 1983; Kobayashi 1985 (2); McKendry 1988.

FRIEL, JOHN. See N.E. THING COMPANY LTD.

FRIEND, WASHINGTON (c1820-c1886), Ontario and Québec. Painter. Friend was an English painter who, in 1849, toured the USA and Canada making numerous watercolour sketches of scenery preparatory to painting a large PANORAMA that he displayed in Canada, the USA and England. Two of his paintings are in the NATIONAL GALLERY OF CANADA. **Citations**: Harper 1970, 1979; Allodi 1974; NGC 1982; Cooke 1983; Mika 1987; McKendry 1988; Hill 1988; Lerner 1991.

FRIPP, CHARLES EDWIN (1854-1906), British Columbia. Painter. For an illustration of the work of Charles Edwin Fripp, see pl. 319 Harper 1966 (incorrectly attributed to his brother THOMAS WILLIAM FRIPP, but correctly attributed to Charles Edwin Fripp in Harper 1981, pl. 146). Charles Edwin Fripp painted watercolour sketches of scenes in the Northwest often including native people. **Citations**: Harper 1966, 1970, 1981; Hogarth 1972; NGC 1982; McKendry 1988; Lerner 1991.

FRIPP, THOMAS WILLIAM (1864-1931), British Columbia. Painter. Thomas William Fripp painted portraits, Rocky Mountain scenery and Pacific coast views, in oil or watercolour. He was a brother of CHARLES EDWIN FRIPP. A watercolour by Thomas William Fripp is in the NATIONAL GALLERY OF CANADA . **Citations**: Colgate 1943; Hubbard 1960; Harper 1966, 1970; Rendre 1974; NGC 1982; McKendry 1988; Hill 1988; Lerner 1991.

FROM THE HEART: FOLK ART IN CANADA EXHIBITION. See FOLK ART EXHIBITIONS.

FROME, EDWARD CHARLES (1802-90), Bytown (now Ottawa), ON. Painter. Frome who was with the British Army in Canada in 1827, was on the staff of Colonel JOHN BY for six years during the building of the Rideau Canal. He sketched and painted in watercolour many TOPOGRAPHICAL scenes of the Bytown area and of the Rideau Canal. **Citations**: Harper 1970; Passfield 1982; McKendry 1988; Farr 1988.

FROST, GEORGE ALBERT (b1831-act. c1865), British Columbia. Painter. Frost, an American artist who had studied in Europe, made numerous TOPOGRAPHICAL sketches of British Columbia scenes. A large number of his works is in the GLENBOW-ALBERTA INSTITUTE (see illustrations in Gilmore 1980, p. 91, and Render 1974). **Citations**: Render 1974; Gilmore 1980; NGC 1982; McKendry 1988.

FRY, C.N. (act. 1910), Western Ontario. Painter. A well known painting by Fry is a naïve oil painting of a horse against landscape (see Harper 1974, pl. 46). **Citations**: Harper 1973, 1974; McKendry 1988.

FULFORD, ALICE MARY (act. 1850-1922), Montréal, QC. Painter. Fulford painted views of the Bytown (now Ottawa, ON) area in watercolour. Her work shows some influence from the work of WILLIAM HENRY BARTLETT (see Cooke 1983, pl. 211-14). **Citations**: Cooke 1983; McKendry 1988.

FURNITURE. One of the DECORATIVE ARTS. While some furniture is strictly utilitarian, there is other furniture in which the decorative and sculptural qualities far exceed what would be expected in articles intended for everyday use. This applies both to country and formal furniture and, in particular, to church furniture. Some country furniture, through use of paint, carving and form, may be regarded as FOLK ART, while some formal furniture through selection of woods, carving, and use of classical forms and motifs, may be regarded as sculpture - more to be looked at than used. Many QUEBEC churches had elaborately carved furniture in the form of ALTARS, TABERNACLES, candlesticks, canopies, RELIQUARIES, candelabra, and so on (see Traquair 1947). Early French Canadian furniture responded to the international styles of BAROQUE, ROCOCO, and NEOCLASSICAL (see Palardy 1963, Fleming 1994), while Anglo-American and German Canadian furniture, dating from a later starting point, responded mainly to NEOCLASSICISM and the REVIVALS of the 19th century (see Shackleton 1973, Pain 1978, Bird 1994). A good survey of Canadian furniture is included in Marsh 1988, pp. 861-6. See also LOUIS III, GEORGIAN, EMPIRE, REGENCY, VICTORIAN. **Citations**: Traquair 1947; Palardy 1963; Symons 1972; Shackleton 1973; Shakespeare 1975; Pain 1978; Peddle 1983; Marsh 1988; Lerner 1991; Fleming 1994; Bird 1994..

FYLES, FAITH (act. 1925), Ottawa, ON. Painter and botanist. **Citations**: NGC 1982; McMann 1997.

G

GABE, RON. See GENERAL IDEA.

GADBOIS, DENYSE CHAPUT (b1921), Québec. Painter, MURALIST and sculptor. Gadbois studied under GOODRIDGE ROBERTS and in Paris. She is a daughter of MARIE MARGUERITE LOUISE GADBOIS. **Citations**: MacDonald 1967; NGC 1982.

GADBOIS, LOUIS V. (act. 1879-1904), Montréal and Québec City, QC; Ottawa, ON. Painter. He painted signs, landscapes, FRESCOES (see Harper 1970), portraits, and religious paintings including MURALS . **Citations**: Harper 1970; McKendry 1988.

GADBOIS, MARIE MARGUERITE LOUISE (LANDRY) (b1896), Montréal, QC. Painter. Gadbois studied with EDWIN H. HOLGATE and JOHN LYMAN. She is the mother of DENYSE CHAPUT GADBOIS. Her work is represented in the NATIONAL GALLERY OF CANADA. **Citations:** Hubbard 1960; MacDonald 1967; Reid 1988; Lerner 1991; Tippett 1992.

GAGEN, ROBERT FORD (1847-1926), Toronto, ON. Painter; RCA 1914. Gagen studied with WILLIAM NICHOL CRESSWELL and JOHN ARTHUR FRASER. By about 1873 he was working with Fraser at Notman's photographic studio. He was a founding member of the ONTARIO SOCIETY OF ARTISTS. Gagen painted landscapes and seascapes and, in 1890 and thereafter, painted in the Rocky Mountains. Several of his paintings are in the NATIONAL GALLERY OF CANADA. **Citations:** MacTavish 1925; Robson 1932; Colgate 1943; McInnes 1950; Duval 1954; Hubbard 1960; Harper 1966, 1970; MacDonald 1967; London 1978; Reid 1979; Sisler 1980; Farr 1981; NGC 1982; Lerner 1991; McMann 1997.

GAGNON, CHARLES (b1934), Montréal, QC. Painter, filmmaker and photographer. After study in New York, Gagnon returned to Montréal and painted ABSTRACTIONS which appeared in numerous exhibitions. See *Vie des Arts* 1978, pp. 37-46, for the best account of his work . **Citations:** Harper 1966; MacDonald 1967; Duval 1972; Webster 1975; Mellen 1978; *Vie des Arts* 1978; Fenton 1978; Sisler 1980; NGC 1982; Bringhurst 1983; Bunett/Schiff 1983; Marsh 1988; Reid 1988; Lerner 1991; McMann 1997.

GAGNON, CLARENCE ALPHONSE (1881-1942), Montréal, QC. Painter, printmaker and illustrator; RCA 1922. Gagnon studied under WILLIAM BRYMNER at the ART ASSOCIATION OF MONTREAL 1897-1900 and, later in Paris, under the painter Jean-Paul Laurens. After 1900, Gagnon painted scenes of country life in CHARLEVOIX COUNTY and spent some time in Montréal and Paris. He became famous as an illustrator, notably for the illustrations for the 1933 deluxe edition of Louis Hemon's *Maria Chapdelaine*. The original 54 paintings for this book are in the MCMICHAEL CANADIAN COLLECTION, Kleinburg, ON. Several paintings by Gagnon are in the NATIONAL GALLERY OF CANADA. **Citations:** Dyonnet 1913; Chauvin 1928; MacTavish 1925; Robson 1932, 1938; Colgate 1943; Buchanan 1945, 1950; Barbeau 1946; McInnes 1950; Lee 1956; Pilot 1956; Jackson 1958; Hubbard 1960, 1963; Harper 1966; MacDonald 1967; Boggs 1971; Duval 1973, 1990; Lord 1974; Watson 1974; Thibault 1978; Laing 1979, 1982; Sisler 1980; Baker 1981; NGC 1982; Laliberté 1986; McMichael 1986; Reid 1988; Marsh 1988; Lerner 1991; Tippett 1992; McMann 1997.

GALE, DENIS (DENNIS) (1828-1903), Québec City, QC. Painter. Gale, a friend of CORNELIUS KRIEGHOFF, is described by J. RUSSELL HARPER as a mining promoter, painter, picture dealer, amateur natural history student, and man about town (Harper 1979, p. 154). Gale sold paintings by Krieghoff along with his own GENRE paintings in watercolour of habitants and native life. Later some of Gale's paintings had Krieghoff's signature substituted, and were then sold as being by Krieghoff (Harper 1979, p. 177). Examples of Gale's work are illustrated in Cooke 1983, pl. 215-34. **Citations:** Harper 1970, 1979; NGC 1982; Cooke 1983.

GALLANT, ART (d1980), Dieppe, NB. Sculptor. Gallant was a naïve sculptor of people, animals and birds, usually in varnished wood. His carvings tend to be flamboyant statements about contemporary popular culture and often have printed explanatory labels. Examples of his work are in the CCFCS collections. (See McKendry 1983, pl. 61, 62 and 66, for illustrations.) **Citations:** Price 1979; NGC 1982; McKendry 1983, 1988; Kobayashi 1985(2); CCFCS.

GALLERIES. See MUSEUMS AND GALLERIES.

GALLIE, TOMMIE J. (b1946), Edmonton AB. Sculptor and printmaker. He studied at the NOVA SCOTIA COLLEGE OF ART AND DESIGN. **Citations:** Heath 1976; NGC 1982; Lerner 1991.

GALLWEY (GALLWAY), Captain THOMAS LIONEL JOHN (1821-1906), Montréal and Québec City, QC. Gallwey who was in the British army was posted in Canada 1849-58 and 1865-8. He is known for a watercolour painting of Indian Lorette, QC, c1850 (see Cooke 1983, pl. 235.) **Citations:** Harper 1970; Cooke 1983; McKendry 1988.

GAMEBOARDS. Decorative gameboards - checkers, chess, parcheesi, mill games, etc. - usually are considered to be FOLK ART. In most cases the functional elements overwhelm the aesthetic features. The most interesting examples are both painted and carved. The best reference is Field 1981, which includes illustrations and an essay on the history and rules of the games. **Citations**: Field 1981, 1985; NMM 1983; McKendry 1983.

GARANT, ANDRE (b1923), Levis, QC. Painter. He paints large Québec landscapes. **Citations**: Harper 1966; MacDonald 1967; NGC 1982.

GARCEAU, ALFRED (b1888), Grand-Mère, QC. Sculptor. The body of Garceau's work appears to be NAÏVE sculpture, with primitive overtones, of the human figure in wood. He scales his figures with oversized heads and prominent noses and ears, while using the remainder of the bodies as undersized supports. (See De Grosbois 1978 for illustrations.) **Citations**: de Grosbois 1978; Kobayashi 1985(2); McKendry 1988.

GARNARY. See OSCAR BESSAU.

GAUCHER, YVES (b1934), Montréal, QC. Painter, printmaker and musician. During the 1960s he was one of Montréal's important ABSTRACT artists and a respected printmaker. By 1968 Gaucher was producing abstract paintings that received international attention. Music was the greatest influence on Gaucher's art as exemplified in his 1963 series of prints *En Hommage à Webern;* Webern's music became a continuing influence on Gaucher's painting. His work is represented in the NATIONAL GALLEY OF CANADA and many other galleries. **Citations**: Harper 1966; MacDonald 1967; Townsend 1970; Withrow 1972; Duval 1972; Fenton 1978; Vie des Arts 1978; Sisler 1980; NGC 1982; Bringhurst 1983; Burnett/Schiff 1983; Marsh 1988; Reid 1988; Lerner 1991; Silcox 1996; McMann 1997.

GAUGUIN, PAUL. See FOLK ART, CANADA; SYMBOLISM; POST-IMPRESSIONISM.

GAUTHIER, AMABLE (1792-1873), Québec. Sculptor, architect. Gauthier, a pupil of LOUIS-AMABLE QUEVILLON, was a sculptor of church decorative works, for example in the church at Berthierville, where he worked with ALEXIS MILETTE. **Citations**: Vaillancourt 1920; Traquair 1947; NGC 1982; Porter 1986; Lerner 1991.

GAUTHIER-CHARLEBOIS, ALYNE (act. 1932), Québec. Canadian artist. **Citations**: Lévesque 1936; NGC 1982; Lerner 1991.

GAUTHIER, FRANCINE (act. 1930s), Montréal, QC and the USA. Painter. She lived most of her life in the USA, but died in Montréal. Her work is represented in the Musée du Québec, Québec City. **Citations**: Tippett 1992.

GAUVREAU, PIERRE (b1922), Montréal, QC. Painter. He exhibited with the AUTOMATISTES in 1946-7 and signed the manifesto REFUS GLOBAL in 1948. His work is represented in the ART GALLERY OF ONTARIO. See also SURREALISM. **Citations**: Duval 1972; NGC 1982; Fenton 1978; Wilkin 1981(1); Bringhurst 1983; Burnett/Schiff 1983; Reid 1988; Marsh 1988; Lerner 1991.

GAVILLER, MAURICE (1842-1928), Toronto, ON. Sketcher and surveyor. Gaviller was a land surveyor who executed some annotated TOPOGRAPHICAL landscape drawings in pencil. **Citations**: Bell 1973; Orobetz 1977; McKendry 1988.

GENDRON, ERNEST (b1912), Montréal, QC. Painter. In 1950, after a varied life, Gendron began painting icon-like portraits of his heroes such as John Kennedy, Charles de Gaulle, Charlie Chaplin and political figures. He used wooden match sticks to build up layers of enamel producing bright detailed paintings. Gendron has kept most of his work for his own pleasure and possibly with an eye on increasing values. See Bihalji-Merin 1985, p. 256, for an illustration of his work. **Citations**: NGC 1982; Bihalji-Merin 1985; McKendry 1988; Lerner 1991.

GENERAL IDEA (GI). General Idea was a group of PERFORMANCE, INSTALLATION and VIDEO artists formed in 1968 in Toronto and active until 1984 . Three artists were in the group: A.A. Bronson (b1946, Michael Tims), Felix Partz (b1945, Ron Gabe) and Jorge Zontal (b1944, Jorge Saia). **Citations**: Gale 1977; Ferguson 1980; Bringhurst 1983; Burnett/Schiff 1983; Lerner 1991.

GENEREUX, MARIE ARLINE (b1897), Québec. Painter and printmaker. **Citations**: Lévesque 1936; NGC 1982; Lerner 1991.

GENRE ART. Genre art depicts scenes from daily life, and has been popular from at least the 17th century in the Low Countries. Such scenes are often the subjects of FOLK ART, for example, some of the paintings by JAN GERRIT WYERS and sculptures by FRED MOULDING. For academically oriented genre work see CORNELIUS KRIEGHOFF. **Citations**: Harper 1966; Osborne 1970; Lord 1974; Pierce 1987; Chilvers 1988; Piper 1988.

GEOMETRIC DESIGNS. Rectilinear or curvilinear designs, based on forms used in geometry are often found in the borders of FOLK ART paintings and in the patterns of TEXTILES.

GEOMETRIC PERSPECTIVE. Geometric perspective is also known as scientific, RENAISSANCE, optical or linear perspective, and is based upon a fixed, central viewpoint. It creates the impression that parallel lines converge, as they recede towards a VANISHING POINT on a horizontal line level with the viewer's eye with objects becoming smaller and closer together in the distance. See PERSPECTIVE.

GEORGIAN. This term refers to the art, ARCHITECTURE and DECORATIVE ARTS produced during the reigns of British kings George I, II and III (1714-1811) but may also include the REGENCY and reign of George IV (to 1830). It encompasses the styles of late BAROQUE, ROCOCO and NEOCLASSICAL. The United Empire Loyalists moved into Canada in 1783-4 during the reign of George III.

GERALD FERGUSON COLLECTION. See CANADIAN CENTRE FOR FOLK CULTURE STUDIES.

GERMANIC INFLUENCE. In Canada, Germanic influence appears in folk and decorative arts (see Bird 1981), in furniture (see Pain 1978), and in textiles (see McKendry 1979; Burnham 1972, 1981). See also FOLK ART, CANADA; MENNONITE; FURNITURE. **Citations**: Burnham 1972, 1981; Pain 1978; Schlee 1980; Bird 1981; McKendry 1979, 1983; Field 1985; Marsh 1988.

GERVAIS, LISE (b1933), Québec. Painter and sculptor. She studied with STANLEY COSGROVE, JACQUES DE TONNANCOUR and LOUIS ARCHAMBAULT, as well as travelling in Europe. Her work is represented in the MONTREAL MUSEUM OF FINE ARTS. **Citations**: MacDonald 1967; NGC 1982; Lerner 1991; Tippett 1992.

GESSO. A bright white coating of gypsum and glue used on a rigid support as a ground for painting including gilding. It was often used on picture frames and on painted or gilded WOOD CARVINGS. **Citations**: Mayer 1970; Osborne 1970; Lucie-Smith 1984; Piper 1988.

GIBBONS, CHARLES I. (act. 1880-1914), Toronto, ON. Painter. Gibbons executed naïve paintings of Lake Ontario ships in watercolour, pencil, charcoal and crayon. Although his marine compositions were typical of the period, they can be recognized by his use of rippled flags and uniform wave motion. It appears that most of his work was done with coloured crayons and pencil. **Citations**: *Canadian Antiques and Art Review* 1980; *Canadian Collector* 1980; McKendry 1988.

GIBSON, SUSAN (b1947), Nova Scotia. Painter. **Citations**: Laurette 1980(3); NGC 1982; Lerner 1991; Tippett 1992.

GIFFARD (GIFFORD), ALEXANDRE S. (act. 1865-78), Québec City, QC. Painter. Giffard painted portraits, landscapes, historical scenes, marine views and ships in watercolour or oil. He often painted sleighs on country roads, possibly suggested by paintings by CORNELIUS KRIEGHOFF, under whom he may have studied. **Citations**: Carter 1967; Trudel 1967(Peinture); Harper 1966, 1970, 1979; NGC 1982; McKendry 1988.

GIGUERE, ROLAND (b1929), Montréal, QC. Painter, illustrator, printmaker and poet. **Citations**: MacDonald 1967; Marteau 1978; NGC 1982.

GILBERT, GROVE SHELDON (1805-85), Niagara and Toronto, ON. Painter. Gilbert was chiefly a portrait painter. He settled in Rochester, N.Y., in 1834. **Citations**: Harper 1966, 1970; NGC 1982.

GILDING. See GOLD.

GILL, CHARLES IGNACE ADELARD (1871-1918), Montréal, QC. Painter and writer. Gill studied

under WILLIAM RAPHAEL and WILLIAM BRYMNER. He is known for his religious and STILL LIFE paintings (see Harper 1966, pl. 217), as well as for his writings. **Citations**: Laberge 1938; Harper 1966; MacDonald 1967; Hubbard 1973; NGC 1982; Laliberté 1986; Marsh 1988; McKendry 1988; Reid 1988; Lerner 1991.

GILLESPIE, JOHN H. (1793-after 1849), Halifax, NS; Saint John, NB. Painter of MINIATURE portrait paintings and SILHOUETTES. He used mechanical apparatus to draw profiles (see Harper 1966, pl. 108), and is said to have made 30,000 portraits over a twenty year period. (See McKendry 1983, pl. 157, for an illustration). **Citations**: Harper 1966, 1970; NGC 1982; McKendry 1983, 1988; Lerner 1991.

GILLETT, VIOLET AMY (b1898), Saint John and Andover, NB. Painter, illustrator, MURALIST, sculptor and teacher. She studied under ARTHUR LISMER, J.E.H. MACDONALD and others at the ONTARIO COLLEGE OF ART. Gillett made many medical illustrations. **Citations**: MacDonald 1967; NGC 1982; Lerner 1991; Tippett 1992.

GILMOUR, MARY. See MARY E. HALLEN.

GIRARD, CLAUDE (b1938), Montréal, QC. Painter. Girard paints in a lyrical style that is sometimes seen as NON-OBJECTIVE. **Citations**: Harper 1966; Sisler 1980; NGC 1982; Lerner 1991; McMann 1997.

GIROUX, ALFRED (act. 1875), Québec. Sculptor of church decorations. **Citations**: Porter 1986.

GIROUX, ANDRE-RAPHAEL (1815-69), Québec. Architect; sculptor of religious works. **Citations**: Porter 1986; Lerner 1991.

GISSING, ROLAND (1895-1967), Calgary and Cochrane, AB. Painter, illustrator. Gissing, who had had some art instruction in Edinburgh, emigrated to Alberta where he sketched ranch scenes while working as a cowhand. Later he became a professional artist and painted mountain and river landscapes. His work is represented in the Vancouver Art Gallery, Vancouver, BC. **Citations**: Colgate 1943; MacDonald 1967; NGC1982; Masters 1987.

GLASS PAINTING. See STAINED GLASS.

GLAZE. A thin layer of transparent paint applied over another colour or GROUND so that light is reflected back by the under surface and modified by the glaze. In the case of ceramics, a glaze is a vitreous coating which is impervious to water and may also act as decoration. **Citations**: Osborne 1970; Mayer 1970; Lucie-Smith 1984; Piper 1988.

GLENBOW-ALBERTA INSTITUTE. See GLENBOW MUSEUM.

GLENBOW MUSEUM. The Glenbow Museum (Glenbow-Alberta Institute), founded in 1954 in Calgary, AB, now has huge collections of paintings, artifacts, books and documents relating to western Canada. **Citations**: Render 1970, 1974; Marsh 1988.

GLYDE, Henry George (b1906), Calgary, AB. Painter; RCA 1949. Glyde studied art in England and, in 1935, emigrated to Canada. He taught art in Calgary and executed paintings and MURALS depicting urban and prairie life as well as coastal landscape in British Columbia. GERALD TAILFEATHERS studied under Glyde. **Citations**: Hubbard 1960; Harper 1966; MacDonald 1967; Sisler 1980; Wilkin 1980; NGC 1982; Masters 1987; Reid 1988; Marsh 1988; Lerner 1991; McMann 1997.

GO-HOME BAY. See Dr JAMES MACCALLUM.

GOD THE FATHER. Because of the second commandment, representations of God, the father of Christ, were avoided by early European painters, but eventually the hand of God was shown emerging from a cloud. Later His head was portrayed, and finally His whole figure. By the time of the RENAISSANCE, it was common to show images of God the Father. See also RELIGIOUS ART. **Citations**: Ferguson 1967; Osborne 1970; Frere-Cook 1972.

GOD THE SON. Representations of Jesus Christ, the Son of God, appear in scenes of His earthly life and also as the Son of God seated at the right hand of GOD THE FATHER. See also RELIGIOUS ART, CRUCIFIXION, CROSS, PASSION, CALVARY, LAST SUPPER, LAMB, FISH. **Citations**: Ferguson 1967; Frere-Cook 1972.

GODWIN, TED (b1933), Regina, SK. Painter. Godwin studied art in Calgary and went on to work as a television artist and a neon sign designer before becoming recognized as a painter. He was a member of the REGINA FIVE. His work is represented in the NATIONAL GALLERY OF CANADA. **Citations**: Simmins 1961; Eckhardt 1962; Harper 1966; Climer 1967; MacDonald 1967; Duval 1972; Bingham 1981; NGC 1982; Bringhurst 1983; Burnett/Schiff 1983; Reid 1988; Lerner 1991.

GOGUEN, JEAN (b1927), Montréal, QC. Painter. Goguen has been referred to as a lyrical PLASTICIEN. **Citations**: Teyssèdre 1968; NGC 1982; Reid 1988; Lerner 1991.

GOLD. Gold in the form of paint or gold leaf has been used to embellish pictures and their frames, as well as sculpture, from the earliest times. It is much in evidence in Québec RELIGIOUS ART, particularly on wooden and GESSO covered sculptures of religious figures housed in churches. **Citations**: Ferguson 1967; Osborne 1970; Frere-Cook 1972.

GOLDBERG, ERIC (1890-1969), Westmount, QC. Painter. He came from Germany to Montréal in 1928 and is the husband of REGINA SEIDEN GOLDBERG. Some of his paintings are in the NATIONAL GALLERY OF CANADA. **Citations**: Jackson 1958; Hubbard 1960; MacDonald 1967; NGC 1982; Reid 1988.

GOLDBERG, REGINA SEIDEN (b1897), Westmount, QC. Painter. She studied under EDMOND DYONNET, WILLIAM BRYMNER and MAURICE CULLEN, and is known for her portrait and figure paintings; examples are in the NATIONAL GALLERY OF CANADA. She is the wife of ERIC GOLDBERG. **Citations**: Hubbard 1960; MacDonald 1967; NGC 1982; Tippett 1992; McMann 1997 (see Regina Seiden).

GOLDEN DOG (le chien d'or). This term usually refers to a stone bas-RELIEF carving of a dog gnawing a bone on a building in Québec City. The carving dates from 1688, although it is now set in the facade of a much later building. The carving bears the prophetic inscription: (in translation) "I am the dog that gnaws a bone / A-gnawing it, I lay me down / A day shall come, as I foresee, / When I'll bite him who's bitten me." **Citations**: Barbeau 1957; Marsh 1988.

GOLDHAMER, CHARLES (1903-85), Ontario. Painter, war artist, teacher and printmaker. Goldhamer studied under ARTHUR LISMER at the ONTARIO COLLEGE OF ART, and was a friend of FRITZ BRANDTNER. He painted in CHARLEVOIX COUNTY, and his work is represented in the NATIONAL GALLERY OF CANADA. **Citations**: Robson 1932; Colgate 1943; McInnes 1950; Duval 1954; Hubbard 1960; MacDonald 1967; Robertson 1977; NGC 1982; Marsh 1988; Lerner 1991; Tippett 1992.

GOODWIN, BETTY ROODISH (b1923), Montréal, QC. Painter, sculptor and printmaker. **Citations**: MacDonald 1967; NGC 1982; Lerner 1991; Tippett 1992.

GORDON, HORTENSE MATTICE (1887-1961), Hamilton, ON. Painter. Gordon studied under HANS HOFMANN in 1947, and exhibited in the USA and Canada. She was a member of PAINTERS ELEVEN, and the wife of JOHN SLOAN GORDON. **Citations**: Harper 1966; MacDonald 1967; Lord 1974; Sisler 1980; NGC 1982; Lerner 1991; Reid 1988; Tippett 1992; McMann 1997.

GORDON, JOHN SLOAN (1868-1940), Hamilton, ON. Painter, illustrator, writer and art teacher. He studied in Holland and Paris, and was the husband of HORTENSE MATTICE GORDON. John Sloan Gordon, a friend of ARTHUR HEMING, several times visited TOM THOMSON at ALGONQUIN PARK. While in Paris, Gordon admired the works of POINTILLIST French artist Georges Seurat (1859-91). One of Gordon's paintings is in the NATIONAL GALLERY OF CANADA. **Citations**: Guillet 1933; Hubbard 1960; MacDonald 1967; Sisler 1980; NGC 1982; Duval 1990; Lerner 1991; McMann 1997.

GOSSE, PHILIP HENRY (1810-88), Carbonear, NF. Painter and naturalist. He arrived in Newfoundland in 1827, and was known for his paintings of insects. **Citations**: Harper 1970; Dickenson 1992.

GOSSE, WILLIAM (act. c1839-45), St John's, NF. Painter. **Citations**: Harper 1970; De Volpi 1972.

GOTHIC ART. The Gothic style of architecture, sculpture and painting succeeded ROMANESQUE ART in Europe and evolved between the years 1150 to 1400. Gothic is a word now used to refer to all

medieval art from the end of the Romanesque period to the beginning of the RENAISSANCE. In sculpture and painting, Gothic is an expressive, realistic style. In architecture, experiments to achieve ever greater height and expanses of glass were evident in the large cathedrals of Europe. This was the great era of STAINED GLASS. See also REVIVALS. **Citations**: Osborne 1970; Janson 1977; Lucie-Smith 1984; Piper 1988.

GOUACHE. Watercolour paint made opaque by the admixture of white pigment. A gouache painting lacks the luminosity of transparent WATERCOLOUR PAINTING. **Citations**: Osborne 1970; Mayer 1970; Chilvers 1988; Piper 1988.

GOULET, CLAUDE (b1925), Montréal and Three rivers, QC. Painter of ABSTRACT subjects. **Citations**: *Vie des Arts* 1978; Sisler 1980; NGC 1982; Lerner 1991; McMann 1997.

GOULIER, KATE DE (act. 1865), Montréal, QC. Painter. **Citations**: Harper 1970; Tippett 1992.

GOURDEAU, FRANCOIS-XAVIER (act. c1873), Québec. Sculptor. **Citations**: Porter 1986.

GRAFFITI. Graffiti are words, phrases or designs scratched or scribbled on a wall or other surface. In some cases they may be FOLK ART or a record of FOLKLORE. **Citations**: Lucie-Smith 1984; Piper 1988.

GRAHAM, DAN (b1942), Nova Scotia. VIDEO and mixed media artist. **Citations**: Gale 1977; NGC 1982; Lerner 1991.

GRAHAM, JOHN (act. 1827-80), Saint John, NB. Sculptor. Graham was a skilled professional carver in wood of human figures including ship FIGUREHEADS. An example of his work is illustrated in Harper 1973, pl. 8. **Citations**: Harper 1973; Kobayashi 1985(2); McKendry 1988.

GRAHAM, JAMES LILLIE (1873-1965), Montréal, QC. Painter. He studied with WILLIAM BRYMNER, EDMOND DYONNET and in Europe. Graham returned to Canada in 1910. His work is represented in the NATIONAL GALLERY OF CANADA. **Citations**: Hubbard 1960; NGC 1982; Laliberté 1986.

GRAHAM, KATHLEEN (KAY) (KATE) MARGARET HOWITT (b1913), Toronto, ON. Painter. Graham was a friend of JACK BUSH and began serious painting in 1962. She visited Cape Dorset five times before 1977. Many of her paintings are ABSTRACTIONS based on landscape. **Citations**: Wilkin 1974(1); Sisler 1980; Carpenter 1981; NGC 1982; Burnett/Schiff 1983; Wilkin 1984; Reid 1988; Lerner 1991; Tippett 1992; McMann 1997.

GRAIN BIN PROJECT. This was a collaborative project by 15 prairie artists of sculptures and paintings in an INSTALLATION for the 1976 Olympics. The artists included VICTOR CICANSKY, FRED MOULDING, FRANK CICANSKY, RUSS YURISTY, LINDA OLAFSON and JOE FAFARD. (See Bringhurst 1983, p. 131, for an illustration.) **Citations**: Bringhurst 1983.

GRANDMA MOSES. See GRANDMA ANNA ROBERTSON MOSES.

GRANDMAISON, NICHOLAS (NICKOLA) de (1892-1978), Winnipeg, MB; Banff, AB. Painter. Grandmaison, who emigrated to Canada in 1923, was a commercial artist who turned to portraits and became known for his paintings of native people, children and politicians. His work is represented in the NATIONAL GALLERY OF CANADA. **Citations**: MacDonald 1967; Eckhardt 1970; Wilkin 1980; NGC 1982; Masters 1987; McKendry 1988; McMann 1997.

GRANDMAISON, ORESTES NICHOLAS (RICK) de (1932-85), Calgary, AB. Painter. Rick de Grandmaison, son of NICHOLAS de GRANDMAISON, studied abroad and, in Canada, with his father and FREDERICK BOUCHIER TAYLOR. He painted landscapes. **Citations**: MacDonald 1967; NGC 1982; Masters 1987.

GRANVILLE. See BECARD.

GRAPHIC ARTS. See PRINTS.

GRASSROOTS SASKATCHEWAN EXHIBITION. See FOLK ART EXHIBITIONS. **Citations**: Thauberger 1976.

GRATTON, OLINDO (1855-1941), Montréal, QC. Sculptor of religious works and church decoration. He studied with NAPOLEON BOURASSA and PHILIPPE HEBERT. **Citations**: Laliberté 1986;

Porter 1986.

GRAUER, SHERRY (b1939), British Columbia. Mixed media artist, sculptor and printmaker. **Citations**: Graham 1975; HO 1980; NGC 1982; Lerner 1991.

GRAVESTONES. Early gravestones usually were carved of stone by a local craftsman with symbols of death, as well as biographical information about the deceased. In some interesting examples, naïve sculptors cut decorative images relating to the life and times of the person memorialized, and the results may be fine examples of FOLK ART. **Citations**: Hanks 1974; *Canadian Collector* Sept/Oct 1977; Trask 1978; Bird 1981; Lerner 1991; McKendry 1995(2).

GRAY, JOHN WARREN (1824-1912), Nova Scotia and New Brunswick. Painter of marine scenes. **Citations**: Lumsden 1969; NGC 1982; Lerner 1991.

GREEN, WILLIAM (1760-1823), England. Painter and printmaker. Green spent some time in America and is thought to have visited Canada. He made a large number of American drawings which were later engraved. **Citations**: Harper 1964, 1970; NGC 1982.

GREENBERG, CLEMENT (b1909), New York. Art critic. Greenberg was an influential art critic and expounder of the ABSTRACT EXPRESSIONISM of the New York School of painters that became popular by 1955. He wrote an influential book, *Art and Culture: Critical Essays* in 1961. Greenberg visited members of the PAINTERS ELEVEN in Toronto in 1957, and conducted the workshop at EMMA LAKE in 1962. **Citations:** Greenberg 1961; Harper 1966, 1981; Murray 1979, 1996(1); Piper 1981; O'Brian 1986; Reid 1988; Lerner 1991.

GREG, RADA (b1941), Toronto, ON. Painter. Greg, who came to Toronto from Yugoslavia in 1975, has been painting full time since 1978. She is a self-taught artist who seems at home in a naïve style reminiscent of the work of some of the well known naïve artists of her homeland. Her subjects are Toronto streetscape scenes as well as GENRE scenes from across the country. **Citations**: Farr 1982; NGC 1982; McKendry 1983, 1988; Kobayashi 1985(2).

GRENFELL MATS (RUGS). Of the various handcrafts developed and sold during this century by the Grenfell Medical Mission (named after Sir Wilfred T. Grenfell, 1865-1940) in Labrador, finely HOOKED MATS may be the most popular. Designs of local interest were used such as fish, ships, gulls, reindeer, Lapps, dogs, snow and ice landscape, and so on. Sometimes the designs were based on paintings by artists, for example a dog team scene (1939) by the American artist STEPHEN HAMILTON (see Lynch 1980, pl. 8). See also FOLK ART. **Citations**: Kerr 1959; Lynch 1980, 1985; Marsh 1988.

GRENFELL MISSION. See GRENFELL MATS.

GRENIER, ALPHONSE (b1908), Saint-Jean-de-la-Lande, QC. Sculptor. Grenier is a naïve sculptor of birds, animals and people in POLYCHROMED wood and metal, including YARD ART, whirligigs and motor-driven assemblies. Grenier included recorded music in some of his work, for example, a large multi-tiered music box containing fifty figures animated through use of pulleys, belts and an electric motor. Music is supplied from a built-in phonograph. **Citations**: de Grosbois 1978; NMM 1983; Kobayashi 1985(2); McKendry 1988.

GREY OWL. See Archibald Belaney.

GREY, WILLIAM (act. 1849-57), St. John's NF. Painter. He sketched Newfoundland and Labrador scenes. **Citations**: Harper 1970; de Volpi 1972.

GRIER, Sir EDMUND WYLY (1862-1957), Kingston and Toronto, ON. Painter, portraitist; RCA 1895. Grier was born in Australia and came to Canada in 1876. He studied in London, Rome and Paris. Several paintings by Grier are in the NATIONAL GALLERY OF CANADA. **Citations**: Bridle 1916; MacTavish 1925; Colgate 1943; McInnes 1950; Jackson 1958; Hubbard 1960; Harper 1966, 1970; MacDonald 1967; Sisler 1980; NGC 1982; Thom 1985; Lerner 1991; Tippett 1992; Hill 1995; Silcox 1996; McMann 1997.

GRIFFITHS, JAMES (1814-96), London, ON. Painter; RCA 1880. Before emigrating from England to Canada in 1854, Griffiths painted designs on china. After settling in London, ON, he painted

part-time, chiefly flowers and STILL LIFE signed with the monogram "JG." He was a brother of JOHN HOWARD GRIFFITHS. **Citations**: MacTavish 1925; Colgate 1943; Hubbard 1960, 1960(1); Harper 1966, 1970; MacDonald 1967; Sisler 1980; NGC 1982; Reid 1988; Davis 1989; Lerner 1991; McMann 1997.

GRIFFITHS, JOHN HOWARD (1826-97), London, ON. Painter. As in the case of his brother, JAMES GRIFFITHS, John Howard Griffiths was a china painter before emigrating to London, ON, where he opened a photographic studio and later turned to china painting. **Citations**: Harper 1966, 1970; NGC 1982; Davis 1989; Lerner 1991.

GRIP LIMITED (GRIP COMPANY). Grip Limited was a commercial art studio in Toronto which grew out of the publication of a satirical weekly journal called *Grip* (1873-94), founded by the CARTOONIST JOHN WILSON BENGOUGH. About the year 1905, Grip Limited provided employment for five members of the GROUP OF SEVEN and TOM THOMSON. By 1912 all the artists who later became the GROUP OF SEVEN, as well as ALBERT ROBSON who was the art director and manager, had left GRIP LIMITED. Robson went to ROUS AND MANN LIMITED. For a more complete list of the artists employed at Grip, see Robson 1932, p. 136. **Citations**: Robson 1932; Colgate 1943; McInnes 1950; Jackson 1958; Harper 1966; Mellen 1970; McLeish 1973; Lord 1974; Housser 1974; Reid 1988.

GROTESQUE. Grotesque style decoration or art may be considered the antithesis of reality. It is fanciful and often monstrous or abnormal, such as the combining of animal and human characteristics. **Citations**: Osborne 1970; Lucie-Smith 1984; Piper 1988; Chilvers 1988.

GROUND. The ground of a painting is the SUPPORT or prepared surface where colours are laid, for example the paper on which watercolour is painted. **Citations**: Mayer 1970; Osborne 1970; Chilvers 1988.

GROUNDLINE. A single line in a drawing or painting representing the level of the ground, often found in the work of children and some folk artists. More than one groundline may be used to indicate PICTURE SPACE. **Citations**: Pierce 1987.

GROUND PLANE. The ground plane of a picture is the surface which appears to recede into the PICTURE SPACE and upon which people and objects stand. **Citations**: Pierce 1987.

GROUP OF SEVEN. The Group of Seven was founded in 1920 by FRANKLIN CARMICHAEL, LAWREN STEWART HARRIS, ALEXANDER YOUNG JACKSON, FRANZ JOHNSTON, ARTHUR LISMER, JAMES EDWARD HERVEY MacDONALD and FREDERICK HORSMAN VARLEY. Earlier five of the Group and TOM THOMSON were employed as commercial artists by GRIP LIMITED (Jackson and Harris did not work for Grip) and, at that time, they began to make weekend sketching trips to ALGONQUIN PROVINCIAL PARK, which awakened their interest in painting the wild northern Ontario landscape. In 1913 J.E.H. MacDonald and Lawren Harris visited a SCANDINA-VIAN ART SHOW in Buffalo, and were influenced by the bold and vigorous landscape paintings that they saw there. The Group had its first exhibition at the ART GALLERY OF TORONTO in 1920, and they soon became identified as a nationalistic landscape school who had broken the constraints of 19th century naturalism. Although the Group's work was roundly criticized by older painters, particularly members of the ROYAL CANADIAN ACADEMY, the NATIONAL GALLERY OF CANADA was quick to lend its support (see Sisler 1980, pp. 98-9). In 1926 after Franz Johnston's resignation, ALFRED JOSEPH CASSON became a member of the Group. In 1930 EDWIN HOLGATE and in 1932 LIONEL LEMOINE FITZGERALD were admitted. The Group disbanded in 1933, and merged with the CANADIAN GROUP OF PAINTERS. See Hill 1995, for illustrations and a thorough study of the Group of Seven and its association with other painters, including an extensive bibliography. See also HOT MUSH SCHOOL; ALGONQUIN PARK GROUP; ARTS AND LETTERS CLUB; ERIC BROWN; POST-IMPRESSIONISM; PAINTING IN CANADA. **Citations**: Group of Seven Catalogues; MacTavish 1925; Housser 1929, 1974; Robson 1932; Davies 1935, 1967; NGC 1936; Colgate 1943; MacDonald 1944; Bridle 1945; Pierce 1949; Buchanan 1950; McInnes 1950; Jackson 1958; Harris

1964; Duval 1965, 1972; Harper 1966; Reid 1969, 1970, 1971, 1988; Addison 1969; Mellen 1970, 1980; Hunkin 1971; McLeish 1973; Watson 1974; Wilkin 1974, 1981; Lord 1974; Smith 1974; Hill 1975, 1995; Town 1977; Martinsen 1980; Sisler 1980; Chilvers 1988; Piper 1988; Marsh 1988; Sabean 1989; Lerner 1991; Tippett 1992; Murray 1993, 1994, 1996(1); Hill 1995; Silcox 1996.

GROVES, NAOMI JACKSON (b1910), Ottawa and Hamilton, ON. Painter, teacher and author. Her father was HENRY A.C. JACKSON and her uncle was A.Y. JACKSON. She studied under HAROLD BEAMENT and SARAH ROBERTSON as well as in Denmark and Germany. Groves wrote the text of *A.Y.'s Canada* 1968, with pencil drawings by A.Y. Jackson. **Citations:** Jackson 1958 (see Naomi Jackson), 1982; MacDonald 1967; Groves 1968; NGC 1982; McMichael 1986; Lerner 1991 (see Naomi Jackson); Murray 1996(1); McMann 1997.

GRUPPE, CHARLES PAUL (1860-1940), New York. Painter. Gruppe was born in Picton, ON, but lived in the USA since childhood. He was mainly self-taught. One of his paintings is in the NATIONAL GALLERY OF CANADA. **Citations:** Hubbard 1960; NGC 1982.

GUARDIAN FIGURES. Primitive sculptures of the human figure that were used as guardians of territory or graves, such as the huge stone figures of Easter Island or the smaller metal-covered wooden figures used in the Bakota area of Gabon in Equatorial Africa. **Citations:** Janson 1977; Fry 1984, 1988.

GUERARD, LOUIS (act. 1800), Québec. Sculptor of church decoration. **Citations:** Porter 1986.

GUERNON dit BELLEVILLE, FRANÇOIS (c1740-1817), Québec. Sculptor. Guernon is known to have carved a Chandelier Pascal (Easter candlestick), now in the Musée du Québec, as well as the large RELIEF carvings of the CALVARY at Oka, Québec. **Citations:** Trudel 1967(Sculpture); *Canadian Collector* 1975; Porter 1986; McKendry 1988; Lerner 1991.

GUINDON, PIERRE ADOLPHE ARTHUR (1864-1923), Oka and Montréal, QC. Painter and poet. Guindon was ordained to priesthood in 1895. He wrote poetry and painted legends of the Oka area. **Citations:** Harper 1966, 1970; Lord 1974; NGC 1982.

GUITE, SUZANNE (1927-81), Percé, QC. Sculptor, painter and MURALIST. She studied in Chicago, Paris, Mexico, Florence and Greece. In Venice she studied the use of coloured glass in murals and has worked with various materials. **Citations:** MacDonald 1967; Boulanger 1973; Sisler 1980; NGC 1982; Lerner 1991; Tippett 1992; McMann 1997.

GUM. Gum from plants has been used as a painting MEDIUM since ancient times. Gum is the normal medium of WATERCOLOUR paints, PASTEL, and sometimes of TEMPERA. **Citations:** Osborne 1970; Mayer 1970.

GUY, CLOVIS-EDOUARD (1819-1910), Québec. Sculptor of naïve religious works in POLY-CHROMED wood. **Citations:** Latour 1975; Kobayashi 1985(2); Porter 1986; McKendry 1988.

GUYON, JEAN (1659-87), Québec City, QC. Painter. Guyon was a habitant's son who studied at the Québec Seminary and was ordained in 1683. In 1684 he went to France with Bishop LAVAL to study painting, but died shortly after his arrival in Paris. Guyon, Canada's first native-born painter, is known for his naïve portraits in oil and studies of Québec flora in watercolour. (See Harper 1966, pl. 10, for a portrait attributed to Guyon.) **Citations:** Harper 1966, 1970; Hubbard 1967; Lord 1974; Gagnon 1976(1); NGC 1982; McKendry 1988; Reid 1988; Lerner 1991.

H

HABERER, EUGENE (1837-1921), Montréal, QC. Illustrator. Haberer was on the staff of *Canadian Illustrated News*, where some of his sketches were published. **Citations:** De Volpi 1962; Harper 1970; Gilmore 1980; NGC 1982; McKendry 1988.

HAESEKER, ALEXANDRA (SANDY) (b1945), Calgary, AB. Painter and printmaker. Her work involves juxtaposition of realistic figures against ABSTRACT backgrounds. **Citations:** Heath 1976;

Murray 1980(2); NGC 1982; Lerner 1991; Tippett 1992.

HAGAN (HAGEN), ALICE MARY (1872-1972), Mahone Bay, NS. Painter. She studied in Halifax and New York. She is one of the artists who decorated the CANADIAN STATE DINNER SERVICE. **Citations**: MacDonald 1967; NGC 1982; Tippett 1992.

HAGAN, ROBERT FREDERICK (b1918), Painter and printmaker. He studied at the ONTARIO COLLEGE OF ART and in New York. **Citations**: MacDonald 1967; Blackstock 1977; NGC 1982; Lerner 1991.

HAHN, EMANUEL OTTO (1881-1957), Toronto, ON. Sculptor; RCA 1931. For several years he worked as an assistant to WALTER ALLWARD. Hahn, the first president of the SCULPTORS SOCIETY OF CANADA, was the husband of ELIZABETH WYN WOOD. **Citations**: Colgate 1943; McInnes 1950; Hubbard 1960; MacDonald 1967; Sisler 1980; NGC 1982; Lerner 1991; Tippett 1992; Silcox 1996; McMann 1997.

HAHN, GUSTAV (1866-1962), Toronto, ON. Painter, teacher and MURALIST; RCA 1906. After studying art in Germany and Italy, he came to Canada in 1888 and taught at the ONTARIO COLLEGE OF ART. One of his paintings is in the NATIONAL GALLERY OF CANADA. He was a brother of the sculptor EMANUEL HAHN. **Citations**: Miner 1946; Hubbard 1960; Sisler 1980; McMann 1997.

HAIDA PEOPLE. The Haida people have lived along the coastal areas of the Queen Charlotte Islands of British Columbia for several thousands of years. Traditionally the Haida have family crests which, along with symbols representing legendary stories, were carved on TOTEM POLES erected in front of their houses, as well as on war canoes, cedar boxes, MASKS, and utilitarian and decorative objects in ARGILLITE, wood or stone. Contemporary Haida receive much recognition for their sculptural works, for example WILLIAM RONALD (BILL) REID and CHARLES EDENSHAW; see Barbeau 1957(Haida) for others. **Citations**: Jenness 1932; Barbeau 1950, 1957(Haida), 1958; Patterson 1973; Stewart 1973(artifacts); Hodge 1974; King 1979; Marsh 1988; Lerner 1991.

HAINES, FREDERICK STANLEY (1879-1960), Toronto, ON. Painter; RCA 1933. Haines studied under GEORGE AGNEW REID and WILLIAM CRUIKSHANK, and later in Belgium. Examples of his pastoral scenes are in the NATIONAL GALLERY OF CANADA. **Citations**: MacTavish 1925; Colgate 1943; Hubbard 1960; Harper 1966; MacDonald 1967; Sisler 1980; NGC 1982; McMann 1997.

HALE, ELIZABETH AMHERST FRANCES (FRANCIS) (1774-1826), Québec. Painter. Hale, born in England, was in Canada from c1793 as the wife of John Hale who eventually became the Receiver General of Canada. She was a skilled TOPOGRAPHICAL artist whose work included landscape and GENRE paintings in watercolour including views with habitants, native people and buildings; for her view of York (now Toronto, ON) 1804, see Cooke 1983, pl. 238. She worked both in Québec and Ontario. **Citations**: Harper 1970; Bell 1973; NGC 1982; Cooke 1983; McKendry 1988; Tippett 1992.

HALE, WILLIAM (act. 1842-44), Kingston, ON. Painter, portraitist and photographer. Hale was a naïve, ITINERANT painter who was in Kingston in 1842-44, when he painted two known portraits and advertised as a photographer. See Harper 1974, pl. 58-9. **Citations**: Carter 1967; Harper 1970, 1974; Stewart 1973; McKendry 1979(Photography), 1988; NGC 1982; Farr 1988.

HALF TONES. Half tones are those falling between black and white. In half-tone printing the distance between dots is varied to obtain different tones. **Citations**: Burch 1910; Lucie-Smith 1984; Piper 1988.

HALL, BASIL (1788-1844), Canada. Painter. Hall was a British naval officer who visited North America in 1827-28 and sketched scenes including groups of figures showing their costumes. Some of his sketches were published as *Forty Etchings from Sketches Made with the Camera Lucida in North America*, London and Edinburgh 1830. See also CAMERA LUCIDA. **Citations**: Harper 1966, 1970; Allodi 1974; NGC 1982; McKendry 1988.

HALL, MARY G. (act. 1833-5), Saint John, NB. Painter and LITHOGRAPHIC artist. Hall executed TOPOGRAPHIC landscape sketches in watercolour of the Hudson River, Niagara Falls, Saint John, New Brunswick, and Digby, NS. She drew six views of New Brunswick and Nova Scotia on stone,

which were published as *Views of British America* by Pendleton Lithography, Boston 1835. The covers and title page were printed in Saint John. She was one of the earliest lithographic artists in Canada. **Citations**: Harper 1970; De Volpi 1974; Allodi 1974; McKendry 1988; Tippett 1992.

HALL, SYDNEY PRIOR (1842-1922), Ottawa, ON. Painter. Hall accompanied the MARQUIS OF LORNE and Princess LOUISE to Canada in 1878. He sketched scenes showing native people in Western Canada while travelling with Lorne and completed many portraits in pencil. **Citations**: Lorne 1885; Harper 1970; Eckhardt 1970; Hogarth 1972; Bell 1973; McKendry 1988 Lerner 1991.

HALLEN, MARY E.(1819-1907), Penetanguishene, ON. Painter. Hallen was an AMATEUR portrait, marine and landscape painter in watercolour, and is known for views of the Penetanguishene area in the 1850s. Her sister Eleanora made a number of naïve sketches of local scenes. Mary married a Mr Gilmour sometime after 1868 and is also known as Mary Gilmour. **Citations**: Harper 1970; Allodi 1974; Murdoch 1982; McKendry 1988.

HAMEL, JOSEPH ARTHUR EUGENE (1845-1932), Québec City, QC. Painter; RCA 1880. Eugene Hamel painted portrait, religious, STILL LIFE and historical works in oil or watercolour. His portrait of ZACHARIE VINCENT is reproduced in Trudel 1967(Peinture), pl. 23. He was a nephew of THEOPHILE HAMEL and studied under him as well as other artists. He worked as a professional artist until 1892 and then became a SUNDAY ARTIST. A portrait by Hamel is in the NATIONAL GALLERY OF CANADA. **Citations**: MacTavish 1925; Colgate 1943; Hubbard 1960, 1967, 1973; Harper 1966,1970; MacDonald 1967; Trudel (Peinture) 1967; Reid 1979, 1988; Sisler 1980; NGC 1982; Laliberté 1986; McKendry 1988; Lerner 1991; McMann 1997.

HAMEL, THEOPHILE (1817-70), Québec City, QC; Toronto, Kingston and Hamilton, ON. Painter. Theophile Hamel was .apprenticed to ANTOINE PLAMONDON, studied in Europe, and later taught his nephew JOSEPH ARTHUR EUGENE HAMEL. Theophile Hamel is best known for his portraits; many of his patrons were politicians. J. Russell Harper refers to his paintings as cold and official although, in Hamel's time, they were considered an advance over most of his predecessors' work. He was a very popular painter with the ruling classes and the clergy. Several of Hamel's portraits are in the NATIONAL GALLERY OF CANADA. **Citations**: Dyonnet 1913; Bellerive 1925; Morisset 1936; Colgate 1943; Buchanan 1950; Duval 1954, 1974; Barbeau 1957(Québec); Morisset 1959; Harper 1964, 1966, 1970; MacDonald 1967; Trudel 1967(Peinture); Carter 1967; Hubbard 1960, 1970; Osborne 1970; Boggs 1971; Lord 1974; Thibault 1978; Mellen 1978; Reid 1979, 1988; Sisler 1980; NGC 1982; Marsh 1988; McKendry 1988; Chilvers 1988; Piper 1988; Lerner 1991.

HAMELIN, PIERRE (act. early 20th century), Montréal, QC. Sculptor. **Citations**: NGC 1982; Laliberté 1986.

HAMILTON, AUGUSTUS TERRICK (act. 1835-58), Saint John's Montréal and Québec City, QC. Painter. Hamilton was a British army officer who executed TOPOGRAPHICAL landscape paintings in watercolour or charcoal, including views of the Thousand Islands, Montréal and other areas of Québec. See Cooke 1983, pl. 241-67 for illustrations of his work. **Citations**: Harper 1970; Thibault 1978; Cooke 1983; McKendry 1988.

HAMILTON, HENRY (d1796), Québec City, QC. Painter. Hamilton, who was a British army officer, was appointed Lieutenant-Governor of Québec in 1782. He completed several TOPOGRAPHICAL sketches while in Canada. **Citations**: Harper 1966, 1970; NGC 1982; McKendry 1988.

HAMILTON, JAMES (1810-96), Toronto and London, ON. Painter. James Hamilton was an early painter of landscapes in the Toronto and London areas, and a copyist of European prints. He is referred to by J. Russell Harper as having an objective approach with an interest in atmosphere, but remained a SUNDAY PAINTER throughout his lifetime (see Harper 1966, pl. 121). **Citations**: Harper 1966, 1970; NGC 1982; Cooke 1983; McKendry 1988.

HAMILTON, MARY RITER (1873-1954), Victoria, BC; Winnipeg, MB. Painter. She studied under G.A. REID and WYLY GRIER, as well as in Berlin and Paris, and was a member of the WINNIPEG SKETCH CLUB. **Citations**: Winnipeg 1916; MacDonald 1967; NGC 1982; Lerner 1991; Tippett 1992.

HAMILTON, STEPHEN (act. c1940), Labrador; USA. Painter. Hamilton is an American artist who painted in Labrador and was asked to design a rug depicting Eskimos and a dog team to be produced by the GRENFELL Mission. **Citations**: Lynch 1980; McKendry 1988.

HAMMOND, CHARLOTTE WILSON (b1941), Clam Harbour, NS. Painter. She painted Nova Scotia and Prince Edward Island landscapes. **Citations**: NGC 1982; Lerner 1991; Tippett 1992.

HAMMOND, JOHN A. (1843-1939), Montréal, QC; Saint John, NB. Painter; RCA 1893. Hammond painted landscapes and marine scenes. He worked at the NOTMAN photographic studios in Montréal 1877-8. He studied with James Abbot McNeill Whistler (1834-1903, see ART FOR ART'S SAKE) in Holland 1885-6, and this is reflected in his search for tone in his paintings. J. RUSSELL HARPER, in referring to Hammond's paintings of ships in fog, said: "Loving the Saint John fogs, he returned repeatedly to paint fishing boats, their hulls looming out of peasoupers while their sails reflect the yellows, pinks, oranges and reds of the sunset. His canvases are purely studies in subtle variations of tone and colour." (Harper 1966, p. 247). See Harper 1966, pl. 221, for an illustration of his work. A painting by Hammond is in the NATIONAL GALLERY OF CANADA. **Citations**: MacTavish 1925; Nesbitt 1929; Robson 1932; Colgate 1943; Hubbard 1960; Harper 1966, 1970; Rombout 1967; MacDonald 1967; Lumsden 1969; Render 1974; NGC 1982; Sisler 1980; Reid 1988; Lerner 1991; McMann 1997.

HANCE, JAMES B. (1847-1915), Québec. Painter. Hance was an English artist who lived in Québec in 1865 and again in 1910. He painted Québec landscapes and views of the Rocky Mountains. **Citations**: Fairchild 1907; Harper 1970; Lerner 1991.

HANCOCK, HERBERT (1830-80), Montréal, QC; Toronto, ON. Painter and architect. He was a founding member of the ONTARIO SOCIETY OF ARTISTS. **Citations**: Colgate 1943; Harper 1970; Reid 1979; NGC 1982; Sisler 1980; McMann 1997.

HANDICRAFT or HANDIWORK. Handicraft articles are made more through use of manual skill than the personal artistic expression of an artist. See also ARTS AND CRAFTS MOVEMENT. **Citations**: Hulbert 1929; McKendry 1983, 1987.

HANDY, ARTHUR (b1933), Toronto, ON; New York; Montréal, QC. Sculptor, ceramicist and teacher. He came to Canada in 1960 and taught at the ONTARIO COLLEGE OF ART. Examples of his work are in the ROYAL ONTARIO MUSEUM, Toronto, ON. **Citations**: MacDonald 1967; NGC 1982; Lerner 1991.

HANKS (or HANKES), Master JARVIS (or JERVIS) F. (b1799 active1834), Toronto, ON; Halifax NS. Portrait painter and silhouettist. Some of his SILHOUETTES were touched up with bronze paint by an assistant, Reynolds. Hanks is thought to have worked in the USA for a time, where he assumed the title "Master." (See Harper 1966, pl. 106, for a silhouette by Hanks.) **Citations**: Harper 1966, 1970; Rosenfeld 1981; Dobson 1982; NGC 1982; McKendry 1988; Béland 1992; Lerner 1991.

HARBUZ, ANN ALEXANDRA (b1908), North Battleford, SK. Painter. Harbuz who has an UKRAINIAN heritage, is a painter of naïve landscapes, interiors and portraits in oil or acrylic. She began painting in 1967 and used themes based on remembered scenes. She paints in a detailed, narrative style, which she describes by saying: "My style is to do something that is real or I live through or what I love. Sometimes I paint what people want." (See NMM 1983, pl. 79, 203; Kobayashi 1985[2], p. 90; and McKendry 1983, pl. 99, for illustrations.) **Citations**: Climer 1975; Thauberger 1976; *artscanada* 1979; Borsa 1983; NGC 1982; NMM 1983; McKendry 1983, 1988; Kobayashi 1985(2); CCFCS.

HARD EDGE PAINTING. A term is used for a STYLE of ABSTRACT painting, in which forms have sharp edges or contours and are painted in flat colours. This style was in favour with the PLASTICIEN painters and GUIDO MOLINARI in the mid 1950s. (See Withrow 1972, p. 163.) **Citations**: Arnason 1968; Withrow 1972; Hill 1974; Lord 1974; Lucie-Smith 1984; Britannica; Pierce 1987; Chilvers 1988; Piper 1988.

HARDING, NOEL (b1945), Ontario. VIDEO and film artist. **Citations**: Gale 1977; NGC 1982; Lerner 1991.

HARDY, JEAN-BAPTISTE (b1731), Québec. Sculptor of religious works. **Citations**: Traquair 1947; Lavallee 1968; NGC 1982; Lerner 1991.

HAROLD, ALEXANDER (d c1923), NS. Painter. **Citations**: Laurette 1978; NGC 1982; Lerner 1991.

HARPER, JOHN RUSSELL (1914-83). Harper is often referred to as the dean of Canadian art history. He was Curator of Canadian art, NATIONAL GALLERY OF CANADA 1959-63; chief curator, McCord Museum 1965-68; and professor of art history, Concordia University 1965-79. His first important book, *Painting in Canada*, published in 1966 (2nd ed. 1977), is a comprehensive study based on new research, and has been a source book for many later works of other authors. It has not been surpassed as an authoritative history of painting in Canada. This was followed in 1970 by his dictionary of *Early Painters and Engravers in Canada*, a valuable reference for art historians. In 1971 Harper's extensive study of PAUL KANE'S writings, sketches and paintings was published and, in 1979, his definitive study of CORNELIUS KRIEGHOFF. He directed the public's attention to FOLK ART, and set standards, when, in 1973, he collaborated with the National Gallery of Canada in selecting the works for a travelling exhibition, *People's Art: Naïve Art in Canada*. The introduction of the catalogue for this exhibition emphasized Harper's firm opinion that aesthetic considerations apply to folk art as much as to any other style in art. In 1974 his folk art book, *A People's Art: Primitive, Naïve, Provincial, and Folk Painting in Canada*, was published. Harper was a pioneer in the research and study of many aspects of Canadian art history. An example of how he elicited information from primary sources is illustrated by a letter about the artist LAWREN STEWART HARRIS, published in Fulford 1982, pp. 213-16. Harper's major writings are likely to remain for many years as the most important studies of Canadian art history. See Murray 1996(1) for a brief biography of Harper. See also FOLK ART, CANADA; FOLK ART, EXHIBITIONS. **Citations**: Harper 1955, 1964, 1966, 1970, 1971, 1973, 1974, 1979, 1981; Boggs 1971; Lord 1974; Fulford 1982; NGC 1982; Laing 1982; McKendry 1983; Burnett/Schiff 1983; Hill 1988; Marsh 1988; Reid 1988; Lerner 1991; Thom 1991; Murray 1996(1).

HARRIS, BESS LARKIN (BESS HOUSSER) (1890-1969), Vancouver, BC. Painter. Bess Harris was the wife of LAWREN STEWART HARRIS and formerly was married (1914) to FRED HOUSSER, author of *A Canadian Art Movement* (Housser 1974). A painter of landscapes, she sometimes exhibited with the GROUP OF SEVEN. **Citations**: Harper 1955; Jackson 1958; MacDonald 1967; Harris 1969; Adamson 1969; Mellen 1970; Tippett 1979; Laing 1979; NGC 1982; Sabean 1989; Lerner 1991; Hill 1995; Silcox 1996.

HARRIS, LAWREN PHILLIPS Jr (b1910), Toronto, ON; Sackville, NB. Painter and art teacher; RCA 1966. After studying art under his father LAWREN STEWART HARRIS, Lawren Phillips Harris became a professional landscape, mural, abstract and portrait painter. His paintings are represented in the NATIONAL GALLERY OF CANADA. **Citations**: McInnes 1950; Hubbard 1960; Andrus 1966; Harper 1966; MacDonald 1967; Duval 1972; Smith 1972(1); Sisler 1980; NGC 1982; Burnett/Schiff 1983; Reid 1988; McMann 1997.

HARRIS, LAWREN STEWART (1885-1970), Toronto, ON; Vancouver, BC. Painter. Harris, a founding member of the GROUP OF SEVEN, was the first president of the CANADIAN GROUP OF PAINTERS. His work was more ABSTRACT than other members of the Group of Seven, and included paintings of Algoma, Lake Superior, the Rockies, and the Arctic. He used simple but powerful forms for clouds, lakes, trees and mountains. He explored abstraction, but always with an eye on nature. WASSILY KANDINSKY and the spiritualism of Theosophy intrigued him in the 1930s. A concise, interesting and personal biography of Harris is contained in a letter from the artist's wife, BESS HARRIS, to the art historian J. RUSSELL HARPER (see Fulford 1982, pp. 213-16). Many paintings by Harris are in the NATIONAL GALLERY OF CANADA. (See Harris 1969 and Hill 1995 for illustrations.) See also SCANDINAVIAN ART SHOW and STUDIO BUILDING. **Citations**: Mac-Tavish 1925; Robson 1932; Colgate 1943; Buchanan 1945; Jackson 1948(2), 1958; Buchanan 1950; McInnes 1950; Harper 1955, 1966; Hubbard 1960, 1967; McNairn 1963; Mendel 1964; Duval 1965, 1972, 1990; MacDonald 1967; Adamson 1969; Harris 1969; Reid 1969, 1970, 1988; Mellen 1970, 1978;

Boggs 1971; McLeish 1973; Hill 1974, 1975, 1995; Lord 1974; Housser 1974; Fenton 1978; Laing 1979, 1982, 1984; Tippett 1979, 1992; Town 1977; Bingham 1979; Shadbolt 1979; Sisler 1980; Osborne 1981; NGC 1936, 1982; Fulford 1982; Britannica; Burnett/Schiff 1983; Bringhurst 1983; Thom 1985; Piper 1988; Chilvers 1988; Marsh 1988; Lerner 1991; Silcox 1996; Murray 1996(1); McMann 1997.

HARRIS, M. (act. 1749), Halifax, NS. Painter of plants. **Citations:** Tippett 1992.

HARRIS, ROBERT (1849-1919), Charlottetown, PE; Montréal, QC. Painter, illustrator and portraitist; RCA 1880. Harris, born in Wales, immigrated to Prince Edward Island with his family in 1856. He studied art and became a popular illustrator and portrait painter. His historical painting, *The Fathers of Confederation* (1882-4), is well known, although it was destroyed in the fire in the Parliament Buildings in Ottawa in 1916. Harris, a founding member of the ROYAL CANADIAN ACADEMY, became its president in 1893. A selection of his work is illustrated in Hubbard 1960, pp. 115-7, and in Harper 1966, pl. 197-8. Harper comments that "...Harris's paintings vary considerably in quality...many of his portraits throughout the Dominion are uninspired, dull, and repetitious." (Harper 1966, p. 221). Several portraits by Harris are in the NATIONAL GALLERY OF CANADA. **Citations:** MacTavish 1925; Robson 1932; Colgate 1943; McInnes 1950; Hubbard 1960, 1967; MacDonald 1967; Boggs 1971; Lord 1974; Harper 1966, 1970; Williamson 1970, 1973, 1983; Thomas 1972; Harris 1973; Bovey 1976; Mellen 1978; Reid 1979, 1988; Sisler 1980; NGC 1982; Laing 1984; Piper 1988; Marsh 1988; Duval 1990; McMann 1997.

HARRIS, SALMON (b1948), Vancouver, BC. Painter. **Citations:** Heath 1976; NGC 1982; Lerner 1991.

HARRISON, BIRGE LOVELL (1854-1911), Québec. Painter. **Citations:** Fairchild 1907; Lerner 1991.

HARRISON, EDITH ELIZABETH (b1903), Kingston, ON. Painter, portraitist. She assisted ANDRE BIELER during the KINGSTON CONFERENCE OF CANADIAN ART. **Citations:** Colgate 1943; MacDonald 1967; Smith 1980; NGC 1982; Farr 1988.

HARTLEY, MARSDEN (1877-1943), USA; Nova Scotia. Painter. Hartley was an American artist who was active in avant-garde exhibitions, including the famous ARMORY SHOW of 1913 in New York City. He painted in Maine in the 1930s and, in 1935-36, visited Nova Scotia, where he painted some sophisticated but deliberately naïve-style paintings of the province's scenes. For an illustration of Hartley's early modern work see p. 271 of Britannica, and for illustrations of his work from 1935-43 see Ferguson 1987. **Citations:** Burlingame 1954; Hill 1974; Osborne 1981; Britannica; Ferguson 1987; Piper 1988; McKendry 1988; Chilvers 1988.

HARVEY, GEORGE H. (1846-1910), Halifax, NS. Painter. Harvey was in Halifax from c1882-95, and was the principal of the Victoria School of Art and Design, Victoria, BC, 1887-94. **Citations:** Harper 1966, 1970; NGC 1982; Sisler 1980; McMann 1997.

HATCHING. Hatching is a form of SHADING using a series of fine lines close together. When the lines intersect, it is called CROSS-HATCHING. Hatching is often used in pen and ink drawings, as well as in ETCHINGS and ENGRAVINGS. **Citations:** Mayer 1970; Pierce 1987; Lucie-Smith 1984; Chilvers 1988; Piper 1988.

HATTON, W. S. (act. 1855-64), Canada. Painter. Hatton may have been a copyist and illustrator who never visited Canada. He painted views of Toronto 1856-62, of Montréal and district 1855 and 1859, of Québec City 1860, and of British Columbia mountain scenery 1863-4. He signed his paintings "WSH". **Citations:** Harper 1966, 1970; NGC 1982; Cooke 1983; McKendry 1988.

HAWKSETT, SAMUEL C. (1837-1910), Alberta. Painter, portraitist. He was in Montréal in the 1850s and for a time worked with JOSEPH DYNES. **Citations:** Thomas 1972; NGC 1982; Lerner 1991.

HAWORTH, (BOBS) ZEMA BARBARA COGILL (b1904), Toronto, ON. Painter, illustrator, MURALIST; RCA 1963. She came to Canada in 1923, and was the wife of the STAINED GLASS artist PETER HAWORTH. Two of her paintings are in the NATIONAL GALLERY OF CANADA. **Citations:** McInnes 1950; Duval 1954; Jackson 1958; MacDonald 1967; Sisler 1980; NGC 1982; McMann 1997.

HAWORTH, PETER (b1889), Toronto, ON. Painter, illustrator and STAINED GLASS artist; RCA 1954. After studying in England he came to Canada in 1923. He was the husband of BOBS HAWORTH and was the director of the CENTRAL TECHNICAL SCHOOL 1929-55. Haworth's paintings are represented in the NATIONAL GALLERY OF CANADA. **Citations**: Colgate 1943; McInnes 1950; Duval 1954; Jackson 1958; MacDonald 1967; Sisler 1980; NGC 1982; Lerner 1991; McMann 1997.

HAYDEN, MICHAEL (b1943), Ontario. Sculptor. **Citations**: Russell 1970; NGC 1982; Lerner 1991.

HAYNES, DOUGLAS HECTOR (b1936), Alberta. Painter; mixed media artist. He was influenced by JACK BUSH among others. **Citations**: Carpenter 1981; NGC 1982; Lerner 1991.

HAYWARD, ALFRED FREDERICK WILLIAM (1856-1939), Port Hope, ON. Painter. Hayward emigrated to England in 1875, and then made several trips to Canada. He painted portrait, landscape, interior and STILL LIFE (flowers) paintings in oil . For an illustration of one of his flower paintings, see Hubbard 1960. He was a brother of GERALD SINCLAIR HAYWARD, son of CAROLINE HAYWARD and husband of EDITH HAYWARD. **Citations**: Guillet 1957; Hubbard 1960; Harper 1970; NGC 1982; McKendry 1988.

HAYWARD, CAROLINE (act. mid 19th century), Port Hope and Rice Lake, ON. Painter. Caroline Hayward was the mother of ALFRED FREDERICK WILLIAM HAYWARD and GERALD SINCLAIR HAYWARD. She was a landscape painter known for a view of Rice Lake, LITHOGRAPHED in colour c1850. **Citations**: Guillet 1957; Harper 1970; McKendry 1988.

HAYWARD, EDITH (act. late 19th century -1929), Port Hope, ON. Painter. Edith Hayward was the wife of ALFRED FREDERICK WILLIAM HAYWARD. She painted watercolour views in the district of Rice Lake, ON. **Citations**: Guillet 1957; Harper 1970; McKendry 1988.

HAYWARD, GERALD SINCLAIR (1845-1926), Port Hope and Gore's Landing, ON. Painter. Gerald Sinclair Hayward was a brother of ALFRED WILLIAM HAYWARD and a son of CAROLINE HAYWARD. He went to England to study in 1870, and there he painted principally MINIATURES on ivory. In 1904-8 he had a summer home at Gore's Landing, and painted watercolour landscapes of the Rice Lake, ON, area. **Citations**: Guillet 1957; MacDonald 1967; Harper 1970; Allodi 1974; Boyanoski 1982; NGC 1982; McKendry 1988.

HEAD, GEORGE BRUCE (b1931), Winnipeg, MB. Painter, printmaker, mixed media artist, sculptor and MURALIST. **Citations**: Eckhardt 1962; NGC 1982; Lerner 1991.

HEAVISIDE, MARY. See Lady MARY HEAVISIDE LOVE.

HEBERT, ADRIEN (1890-1967), Paris, France; Montréal, QC. Painter; RCA 1942. Hebert was born in Paris but studied in Montréal under EDMOND BRYMNER, EDMOND DYONNET and JOSEPH SAINT-CHARLES. He was a son of the sculptor LOUIS-PHILIPPE HEBERT and a brother of the sculptor HENRI HEBERT. In 1912 he went to Paris to study painting, returned to Montréal in 1914 and was again in Paris about 1923. He painted city and harbour scenes (see Hubbard 1960 for a work in the NATIONAL GALLERY OF CANADA). **Citations**: Chauvin 1928; Robson 1932; Colgate 1943; Bergeron 1946; McInnes 1950; Hubbard 1960; MacDonald 1967; Thibault 1978; Fenton 1978; NGC 1982; Sisler 1980; Laliberté 1986; Reid 1988; Lerner 1991; McMann 1997.

HEBERT, HENRI (1884-1950), Montréal, QC. Sculptor; RCA 1922. Henri Hebert studied art under WILLIAM BRYMNER and EDMOND DYONNET, as well as in Paris. (See Hubbard 1960 for an example in the NATIONAL GALLERY OF CANADA.) Henri was a brother of ADRIEN HEBERT and a son of the sculptor LOUIS-PHILIPPE HEBERT. His work is represented in the ART GALLERY OF ONTARIO and the NATIONAL GALLERY OF CANADA. **Citations**: Dyonnet 1913; MacTavish 1925; Chauvin 1928; Robson 1932; Colgate 1943; McInnes 1950; Hubbard 1960, 1967; MacDonald 1967; Sisler 1980; NGC 1982; Laliberté 1986; Marsh 1988; Lerner 1991; McMann 1997.

HEBERT, LOUIS-PHILIPPE (1850-1917), Montréal, QC. Sculptor; RCA 1886. Monuments by Hébert are in many Canadian cities and at the parliament building in Québec City. In the 1870s he worked with the architect NAPOLEON BOURASSA, and helped him with the decoration of Notre-Dame-de-Lourdes, Montréal. He was the father of ADRIEN and HENRI HEBERT. An example of his

work is in the NATIONAL GALLERY OF CANADA. See also REALISM. **Citations**: Dyonnet 1913; MacTavish 1925; Robson 1932; Colgate 1943; McInnes 1950; Hubbard 1960, 1967; MacDonald 1967; Boggs 1971; Lessard 1971; Hebert 1973; Watson 1974; NGC 1982; Sisler 1980; Porter 1986; Laliberté 1986; Marsh 1988; McKendry 1988; Reid 1988; Lerner 1991; McMann 1997.

HEDRICK, ROBERT BURNS (b1930), Toronto, ON. Sculptor and painter. He studied in Mexico and Spain. Examples of his work are in the ART GALLERY OF ONTARIO and the NATIONAL GALLERY OF CANADA. **Citations**: Harper 1966; MacDonald 1967; Morris 1972; Duval 1972; Sisler 1980; NGC 1982; Burnett/Schiff 1983; Bringhurst 1983; Reid 1988; Lerner 1991; McMann 1997.

HEER, LOUIS-CHRETIEN de. See DE HEER.

HEMING, ARTHUR HENRY HOWARD (1870-1940), Hamilton and Toronto, ON. Painter, illustrator and writer. Much of his work concerns first-hand experiences in northern Canada with wildlife, native peoples, trappers, voyageurs and lumbermen. Prior to c1930 he worked in black, white and yellow and, after that, in various colours. His paintings tend to be bold, simple and decorative, with contrasts of light and shadow. Heming was a friend of Dr JAMES MACCALLUM. (See Robson 1932, pp. 165-7 for illustrations and Hubbard 1960 for his work in the collection of the NATIONAL GALLERY OF CANADA.) **Citations**: Heming 1907, 1921, 1925; Robson 1932; Colgate 1943; Jackson 1958; Hubbard 1960; Harper 1966; MacDonald 1967; Reid 1969; McLeish 1973; Sisler 1980; NGC 1982; Lerner 1991; McMann 1997.

HENDERSHOT, JANET (b1945), Ontario. Painter and printmaker. **Citations**: Murray 1980(2); NGC 1982; Lerner 1991.

HENDERSON, ALEXANDER (1831-1913), Montréal, QC. Photographer. Henderson immigrated to Canada from Scotland c1855 and settled in Montréal, where he made photography his profession. He did portrait and landscape photography and, by 1892, was heading a new photography department for the Canadian Pacific Railway. (See Greenhill 1979, pl. 19-23 and Cavell 1988, pl. 47, 48, 50, 52, 53 and 61, for his work.) **Citations**: Harper 1970; Greenhill 1979; Reid 1979; NGC 1982; Marsh 1988; Cavell 1988; Lerner 1991.

HENDERSON, Sir EDMUND YEAMANS WOLCOTT (1821-96), Halifax, NS; Kingston, ON. Painter. Henderson was with the British army, and was stationed in Canada 1839-45 and 1847-8. He painted the well-known watercolour, *The Insolvent Subalterns Paying Morning Visits*, (see McKendry 1983, pl. 39.) Although Henderson had training in TOPOGRAPHICAL drawing, this painting has naïve overtones. **Citations**: Harper 1966, 1970, 1973, 1974; Stewart 1973; NGC 1982; McKendry 1983, 1987, 1988; Kobayashi 1985(2).

HENDERSON, JAMES (1871-1951), Qu'Appelle Valley and Regina, SK. Painter. Henderson is particularly known for his portraits of native people and western landscapes. Several of his paintings are in the NATIONAL GALLERY OF CANADA. **Citations**: Colgate 1943; McInnes 1950; Hubbard 1960; Harper 1966; MacDonald 1967; Wowk 1969; Render 1974; Laurette 1978; NGC 1982; Reid 1988; Lerner 1991; McMann 1997.

HENDERSON, NICKOLAS (NICHOLAS) (NICK) (1862-1934), Portsmouth Village (Kingston), ON. Painter. Henderson went to sea at age thirteen and eventually received his master's papers for the Great Lakes. He painted portraits of Great Lakes ships and harbour scenes. His early paintings are in watercolour and are lively with naïve characteristics. Later, Henderson studied art in Kingston with FORSHAW DAY, with the result that his oil paintings began to show an influence from British marine painting. Several of Henderson's paintings are in the Marine Museum of the Great Lakes at Kingston. Harper 1970; NGC 1982; McKendry 1983, 1988, 1996; Kobayashi 1985(2); Farr 1988.

HENDERSON, RUTH MILLER (act. 1935), Maritime Provinces. Printmaker. She is known for her WOODCUTS of ice harvesting and milling. **Citations**: Tippett 1992.

HENNEPIN, LOUIS (PERE) (c1640-c1706), Fort Frontenac (now Kingston), ON; Québec City, QC. Painter and explorer. Hennepin was a Récollet missionary who went with René-Robert Cavelier de La Salle on an expedition through the Great Lakes and to the upper Mississippi river. He was back in

Québec City in 1682 and then settled in Holland, where he published narratives of his travels. In 1678 he executed a TOPOGRAPHICAL drawing of Niagara Falls, which was engraved and published in Utrecht in 1697 (see De Volpi 1966, pl. 1, and Dow 1921, pl. facing p. 90.) This may be the earliest known view of Niagara Falls and the first TOPOGRAPHICAL work done in Canada. **Citations**: Dow 1921; Robson 1932; McInnes 1950; De Volpi 1966; Harper 1970; NGC 1982; Marsh 1988.

HENNESSEY, FRANK CHARLES (1894-1941), Ottawa, ON. Painter; RCA 1941. Hennessey painted landscape, animal and bird paintings in pastel or oil. His landscapes include typical Canadian subjects (see Robson 1932, p. 193). Some of his paintings are in the NATIONAL GALLERY OF CANADA. **Citations**: Colgate 1943; Robson 1932; Hubbard 1960; MacDonald 1967; Sisler 1980; Cooke 1983; McKendry 1988; Lerner 1991; McMann 1997.

HEON, OSCAR (1901-76), Cap-de-la-Madeleine, QC. Sculptor. Heon's work includes naïve toys, human figures, animals and religious figures in POLYCHROMED wood. His figures have a smooth, flowing, moulded appearance belying their origin in whittled wood. **Citations**: Price 1979; Mattie 1981; NMM 1983; Latour 1975; Kobayashi 1985(2); McKendry 1988; CCFCS.

HERIOT, GEORGE (1759-1839), Québec City, QC. Painter and writer. After studying at the ROYAL MILITARY COLLEGE, Woolwich, England, with PAUL SANDBY as painting instructor, Heriot arrived in Québec in 1791. He became deputy postmaster-general and travelled extensively throughout British North America in 1800-16. Heriot was a competent painter whose work included landscape, GENRE and figure paintings in watercolour of Canadian subjects and, later, paintings of classical figures in oil. Most of Heriot's paintings were of small size; AQUATINTS from his work were used as illustrations in his book *Travels Through the Canadas*, 1807. (See Harper 1966, pl. 35-6, for illustrations of his work.) See also PICTURESQUE, TOPOGRAPHICAL. **Citations**: Heriot 1807, 1971; Robson 1932; McInnes 1950; Duval 1954; Spendlove 1958; De Volpi 1966, 1971; Harper 1964, 1966, 1970; MacDonald 1967; Hubbard 1967; Bell 1973; MacDonald 1967; Carter 1967; Allodi 1974; Mellen 1978; Thibault 1978; Finley 1979; Nasby 1980; Wight 1980; Baker 1981; NGC 1982; Cooke 1983; Marsh 1988; McKendry 1988; Reid 1988; Lerner 1991; Béland 1992.

HERUE (or HERVE), Mr (act. 1817), Québec City, QC. Painter and SILHOUETTIST. Herue was a British artist who was in Québec in 1817. He was a prolific silhouettist and painter of profile portraits and MINIATURES (see Harper 1966, p. 117). **Citations**: Harper 1966, 1970; McKendry 1988.

HEWARD, EFA PRUDENCE (1896-1947), Montréal, QC; Brockville, ON. Painter. Heward painted figures, landscape and STILL LIFE, and was a founding member of the CANADIAN GROUP OF PAINTERS. She was a pupil of WILLIAM BRYMNER and RANDOLPH HEWTON, and a friend of SARAH ROBERTSON and A.Y. JACKSON. See BEAVER HALL GROUP. Several of her paintings are in the NATIONAL GALLERY OF CANADA. **Citations**: Jackson 1948(1), 1951, 1958; Buchanan 1950; McInnes 1950; Hubbard 1960; Harper 1966; MacDonald 1967; Mellen 1970; Braide 1980; NGC 1982; Reid 1988; Marsh 1988; Lerner 1991; Tippett 1992; Hill 1995; McMann 1997.

HEWTON, RANDOLPH STANLEY (1888-1960), Québec. Painter; RCA 1934. Hewton was a figure, portrait and landscape painter. He studied with WILLIAM BRYMNER but his Québec landscapes resemble those of his friend A.Y. JACKSON. Several of his paintings are in the NATIONAL GALLERY OF CANADA. **Citations**: CGP 1933; Lee 1956; Jackson 1958; Hubbard 1960; Harper 1966; Groves 1968; Mellen 1970; Morris 1972; Housser 1974; Sisler 1980; NGC 1982; Reid 1988; Marsh 1988; Lerner 1991; Hill 1995; McMann 1997.

HEYWOOD, J. CARL (b1941), Kingston, ON. Painter, printmaker and teacher. After graduating from the ONTARIO COLLEGE OF ART, Toronto, ON, he travelled widely to research painting techniques in other countries. **Citations**: MacDonald 1967; NGC 1982.

HICKS, EDWARD (act. 1778-82), Halifax, NS. Painter. Hicks was with the British Army and made TOPOGRAPHICAL sketches of Halifax and district; some were published as ENGRAVINGS. **Citations**: Harper 1964, 1970; NGC 1982.

HIERARCHICAL SCALE. In a painting or RELIEF sculpture, a scale of size of objects or figures

according to which the most important one is rendered much larger than perspective would warrant. This was a common technique in MEDIEVAL ART, as well as NAÏVE art. Hierarchical scale is used by Canadian artists DAVID THAUBERGER and J.-P. LEMIEUX. See also SCALE; STYLE. **Citations**: McKendry 1983; Pierce 1987.

HIESTER, MARY AUGUSTA. See MARY AUGUSTA HIESTER REID.

HIGH REALISM. See MAGIC REALISM.

HILL, GEORGE WILLIAM (1862-1934), Montréal, QC. Sculptor; RCA 1917. He studied in Paris and returned to Canada in 1894. Hill designed several public monuments. His bronze portrait of WILLIAM BRYMNER is in the NATIONAL GALLERY OF CANADA. **Citations**: MacTavish 1925; Colgate 1943; Hubbard 1960; MacDonald 1967; Sisler 1980; NGC 1982; Laliberté 1986; McMann 1997.

HIND, HENRY YOULE (1823-1908), Toronto, ON; Windsor, NS. Painter and explorer. Henry Youle Hind was a geologist, explorer and author, and a brother of WILLIAM GEORGE RICHARDSON HIND. He was an amateur painter who recorded scenes in western Canada. **Citations**: Hind 1863; Colgate 1943; Harper 1966, 1970; Eckhardt 1970; Marsh 1988; McKendry 1988; Reid 1988.

HIND, WILLIAM GEORGE RICHARDSON (1833-89), Toronto, ON; Windsor, NS; Labrador. Painter. Hind, having studied art in Europe, emigrated to Canada in 1852, where he joined his brother HENRY YOULE HIND. He painted in various parts of Canada and, although he was a competent painter, in some cases he ROMANTICIZED the life of native people and the Canadian wilderness, while, in other cases, his work is very detailed, realistic and has a naïve flavour (see PRE-RAPHAELITE). According to J. RUSSELL HARPER: "It would be an understatement to describe his paintings as having a lively air and graphic qualities, for they transcend purely narrative aspects and embody an acute artistic sensibility quite different in nature from that of any other contemporary Canadian painter." (Harper 1976, p. 7). See Harper 1966 pl. 144-6 and Harper 1976 for illustrations of Hind's work. **Citations**: Hind 1863; Colgate 1943; Harper 1964, 1966, 1967(1), 1970, 1976; Hubbard 1967; MacDonald 1967; Eckhardt 1970; De Volpi 1972; Bell 1973; Duval 1974; Lord 1974; Allodi 1974; Mellen 1978; Wilkin 1980; NGC 1982; Marsh 1988; McKendry 1988; Reid 1988; Cavell 1988; Lerner 1991.

HINE, HENRY GEORGE (1811-95), London, England. Painter, illustrator and ENGRAVER. His 1847 landscape of a buffalo hunt on the prairies indicates that he may have visited America. **Citations**: Harper 1964, 1970; NGC 1982.

HISTORICAL DINNER SERVICE. See CANADIAN STATE DINNER SERVICE.

HOCH, JAMES (1827-78), Toronto, ON. Painter. He helped organize the ONTARIO SOCIETY OF ARTISTS 1872. **Citations**: Robson 1932; NGC 1945, 1982; Harper 1966, 1970; Reid 1979.

HOCHSTETTER, J.G.(act. 1791-4), Québec City, QC. Wood ENGRAVER. He engraved illustrations for the *Québec Magazine* including a portrait woodcut in 1792 or 1793, probably the first executed in Canada. Hochstetter was in Saint John, NB, in 1838 and in Halifax. NS, in 1840. **Citations**: Tremaine 1952; Harper 1966, 1970.

HODGEPODGE PERIOD IN FOLK ART IN CANADA. See FOLK ART, HODGEPODGE . . .

HODGSON, THOMAS (TOM) SHERLOCK (b1924), Toronto, ON. Painter; RCA 1970. Hodgson, a member of the PAINTERS ELEVEN GROUP, was for a time a commercial artist but, in the mid 1950s, he turned to ABSTRACT painting. His paintings are represented in the NATIONAL GALLERY OF CANADA. **Citations**: Hubbard 1960; Harper 1966; MacDonald 1967; Duval 1972; Hodgson 1976; Sisler 1980; NGC 1982; Burnett/Schiff 1983; Bringhurst 1983; Lerner 1991; McMann 1997.

HOFMANN, HANS (1880-1966), New York, USA. Painter and art teacher. After founding an art school in Munich, he went to the USA in 1934 and founded an art school in New York and in Provincetown, Mass. He became an American citizen in 1941. Hofmann was part of the ABSTRACT EXPRESSIONISM movement, and taught several Canadian artists including JOCK MACDONALD, JOE PLASKETT and TAKAO TANABE. **Citations**: Osborne 1981; NGC 1982; Reid 1988; Lerner

1991; Murray 1996(1).

HOLDSTOCK, ALFRED WORSLEY (1820-1901), Montréal, QC. Painter. Holdstock was a landscape painter who often included figures and life scenes of native people in his work. He usually used pastels, but also worked in oil or watercolour. Holdstock's work has some relationship to that of CORNELIUS KRIEGHOFF in subject matter and in the brilliant colours used. He was a prolific painter and painted numerous views of the Thousand Islands, Ottawa River, Laurentians, Kenora, Red River and Yukon (see Harper 1966, pl. 170.). **Citations**: NGC 1945, 1982; Harper 1964, 1966, 1970; Corbeil 1970; Render 1970; Allodi 1974; NGC 1982; Cooke 1983; McKendry 1988.

HOLGATE, EDWIN HEADLEY (1892-1977), Montréal, QC. Painter and ENGRAVER; RCA 1954. Holgate studied under WILLIAM BRYMNER and MAURICE CULLEN. He became a member of the GROUP OF SEVEN in 1931, shortly before the Group was disbanded. Holgate was a figure and landscape painter and, during the 1930s, painted a series of female nudes in landscape settings (see Mellen 1970, pl. 190-2, and Harper 1966, pl. 285 and 289.) Several paintings by Holgate are in the NATIONAL GALLERY OF CANADA. **Citations**: Chauvin 1928; Housser 1929, 1974;Robson 1932; NGC 1936, 1982; Colgate 1943; Buchanan 1950; McInnes 1950; Duval 1952, 1965, 1972; Harper 1955, 1966; Lee 1956; Jackson 1958; Hubbard 1960; MacDonald 1967; Mellen 1970; Morris 1972; Barbeau 1973(1); Lord 1974; Reid 1976, 1988; Ayre 1977; Thibault 1978; Fenton 1978; Sisler 1980; Burnett/ Schiff 1983; Laliberté 1986; Marsh 1988; Lerner 1991; Hill 1995; Silcox 1996; McMann 1997.

HOLLOWAY, FREDERICK H. (act. 1840-53), Québec; Brockville, ON. Painter. Holloway, probably of English origin, was in Québec from 1840-53 (possibly from 1830). A series of his Niagara views were reproduced as LITHOGRAPHS c1840. He sketched in Brockville in 1841. **Citations**: Carter 1967: Harper 1970; Allodi 1974; NGC 1982; Mika 1987; McKendry 1988.

HOLMES, DAVID (1936-94), Kingston, ON. Painter and printmaker. He came to Canada from England in 1960 and settled in Kingston in 1964 . After 1971 he had a contract with a New York gallery who sold his work. Holmes' paintings are nostalgic scenes of the Kingston region and often include groups of children at play. **Citations**: NGC 1982; Farr 1988.

HOLMES, ROBERT (1861-1930), Toronto, ON. Painter; RCA 1921. Holmes studied under WILLIAM CRUIKSHANK, and is known chiefly for his watercolours of wild flowers. He was an active founding member of the TORONTO ART STUDENTS LEAGUE. Holmes' work is represented in the NATIONAL GALLERY OF CANADA. **Citations**: MacTavish 1925; Colgate 1943; McInnes 1950; Hubbard 1960; Harper 1966, 1970; MacDonald 1967; Sisler 1980; Lerner 1991; Tippett 1992; McMann 1997.

HOLY FAMILY. See RELIGIOUS ART. **Citations**: Osborne 1970; Ferguson 1967; Lerner 1991.

HOLY SPIRIT. See RELIGIOUS ART. **Citations**: Osborne 1970; Ferguson 1967.

HOLZLHUBER, FRANZ (act. 1856-98), Ontario. Painter and illustrator. Holzlhhuber was an Austrian who travelled and sketched through eastern Canada on his way to the USA. Some of his sketches were published in periodicals (an example is shown in Render 1970, p. 20.) **Citations**: Render 1970; McKendry 1988.

HOOD, ROBERT (1796-1821), Canadian Arctic. Painter and illustrator. Hood executed TOPO-GRAPHICAL landscape paintings of Arctic scenes in watercolour, drawings of birds, and illustrations while with the Sir John Franklin expedition of 1819-21. He was killed by native people during the expedition. **Citations**: NGC 1945; Eckhardt 1970; Harper 1966, 1970; Bell 1973; Hood 1974; NGC 1982; Cooke 1983; McKendry 1988; Lerner 1991.

HOOKED RUGS (MATS). Hooked rugs are thought to have appeared in the North American continent around the middle of the 19th century. There is some dispute as to whether they were first made in the Maritime provinces, in Québec, in Ontario, or in the USA; few early surviving rugs are dated (see Ruth McKendry, "Hooked Rugs in Canada" *Upper Canadian* May/June 1982, pp. 12-13). A hooked rug consists of a foundation cloth, such as burlap, through which loops of cloth or yarn are pulled by a metal hook to a more or less uniform height and, usually, through use of colour, a design is formed.

Hooked rugs are considered to be FOLK ART, when they have original naïve designs (see McKendry 1983, pl. 10, 192-203, 255, 257-61.) See also GRENFELL RUGS. **Citations**: Pocius 1978; Young; Lynch 1980, 1985; McKendry 1983; Lerner 1991.

HOOKER, MARION HOPE NELSON (1866-1946), Selkirk, MB; St Catharines, ON. Painter. Hooker studied art in the USA and in Europe. She painted landscapes, GENRE, and portraits which included a series of native chieftains. She was a member of the ONTARIO SOCIETY OF ARTISTS . **Citations**: Harper 1966, 1970; Eckhardt 1970; NGC 1982; Lerner 1991; McMann 1997.

HOPE (later HOPE-WALLACE), Sir JAMES ARCHIBALD (1807-54), Québec and Ontario. Painter. Hope was a British army officer in Lower Canada 1838-47, where he completed TOPO-GRAPHICAL watercolour views of landscape, GENRE and figures, including some of military costumes. (See Allodi 1974, pl. 882, 897-8, 933-5.) **Citations**: Duval 1954; Harper 1970; Bell 1973; Allodi 1974; NGC 1982; Cooke 1983; McKendry 1988; Béland 1992.

HOPE, WILLIAM R.(1863-1931), Montréal, QC. Painter. RCA 1902. He studied in Holland and Italy. Hope's paintings are represented in the NATIONAL GALLERY OF CANADA. He was a member of the CANADIAN ART CLUB. **Citations**: Hubbard 1960; MacDonald 1967; Sisler 1980; NGC 1982; Lerner 1991; McMann 1997.

HOPKINS, ELISABETH MARGARET (1894-1991), Galiano Island, BC. Painter and illustrator. FRANCIS ANNE HOPKINS was her great-grandmother. Elisabeth Hopkins is known chiefly for her naïve garden and woodland scenes of children and animals. **Citations**: NGC 1982; Tippett 1992; Lerner 1991; Tippett 1992.

HOPKINS, FRANCES ANNE BEECHY (1838-1918), Montréal, QC. Painter and illustrator. Hopkins' subjects included landscapes, and GENRE studies of voyageurs, habitants and children. She married the private secretary to Sir George Simpson, the governor of the Hudson's Bay Company, and travelled with them in the fur trade canoes during the 1860s and 1870s. She recorded what she saw in sketches and in large illustrative canvases. (See Allodi 1974, pl. 937, 939-41, 943-5, 949, 955, 958, 961, 975.) **Citations**: MacDonald 1967; Eckhardt 1970; Harper 1964, 1966, 1970; Allodi 1974; Roberts 1983; McKendry 1988; Lerner 1991; Tippett 1992.

HORETZKY, CHARLES GEORGE (1838-1900), Toronto, ON. Photographer. Horetzky was with the Hudson's Bay Company at Fort Garry, MB, in 1869 and, in 1871-9, made survey photographs for the Canadian Pacific Railway Company. (See Greenhill 1979, pl. 42, and Cavell 1988, pl. 42-3 for illustrations.) **Citations**: Greenhill 1979; Cavell 1988; Marsh 1988; Lerner 1991.

HORNE, ARTHUR EDWARD CLEEVE (b1912), Toronto, ON. Sculptor and portrait painter; RCA 1951. A BUST by Horne is in the NATIONAL GALLERY OF CANADA. **Citations**: Colgate 1943; Hubbard 1960; Harper 1966; MacDonald 1967; Sisler 1980; NGC 1982; Lerner 1991; McMann 1997.

HORWOOD, HAROLD A. (act. 1876-85), Prescott, ON. STAINED GLASS artist. Horwood worked with STAINED GLASS as well as painting memorial windows and supplying geometrical designs in crayon. Some of his painted windows show livestock and local views (see Harper 1974, pl. 78), while one of his designs included portraits of political leaders. **Citations**: Harper 1970, 1973, 1974; *Canadian Collector* 1968, 1980; Kobayashi 1985(2); McKendry 1988; Lerner 1991.

HOT MUSH SCHOOL. A derogatory name applied to the GROUP OF SEVEN by Henry Franklin Gadsby in the *Toronto Star*, 12 December 1913, and that became a rallying cry for the Group of Seven. (See Hill 1995, p. 58.) **Citations**: Davies 1967; Reid 1970; Mellen 1970; Housser 1974; Hill 1995.

HOUSE, HARLAN (b1944), Alberta and Ontario. Ceramist and mixed media artist. **Citations**: Render 1974; NGC 1982.

HOUSSER, BESS See BESS LARKIN HARRIS.

HOUSSER, FREDERICK (FRED) BROUGHTON (1889-1936), Toronto, ON. Writer and art critic. In 1926 Housser published a classic in the history of Canadian art, *A Canadian Art Movement: The Story of the Group of Seven* (rpt 1974). In his book, Housser defended the GROUP OF SEVEN against critics who, along with other derogatory remarks, referred to the Group as the HOT MUSH SCHOOL. Housser

records his insights into the work of the individual artists in the Group. He married MURIEL YVONNE MCKAGUE HOUSSER. **Citations**: Colgate 1943; Jackson 1958; Mellen 1970; Housser 1974; Lord 1974; Smith 1974; Laing 1979; Tippett 1979; Thom 1985; Reid 1988; Sabean 1989; Lerner 1991; Hill 1995.

HOUSSER, MURIEL YVONNE MCKAGUE (b1898), Toronto, ON. Painter and art teacher; RCA 1951. Housser taught art at the ONTARIO COLLEGE OF ART, and was the wife of FRED HOUSSER. A founding member of the CANADIAN GROUP OF PAINTERS in 1933, she was an associate of the GROUP OF SEVEN painters. Several paintings by Housser are in the NATIONAL GALLERY OF CANADA. **Citations**: Carr 1946; McInnes 1950; Harper 1955, 1966; Jackson 1958; Hubbard 1960; MacDonald 1967; Mellen 1970; Duval 1972; Laing 1979, 1982; Sisler 1980; NGC 1982; Reid 1988; Lerner 1991; Tippett 1992; Hill 1995; McMann 1997.

HOUSTON, JAMES ARCHIBALD (b1921), Canadian Arctic; New York. Artist, printmaker, author, illustrator and filmmaker. Houston spent many years in the Arctic teaching the Inuit the techniques of printmaking and helping to market Inuit prints and stone sculptures in southern Canada and in the USA. He has written and illustrated several books based on native cultures. **Citations**: Houston 1967; MacDonald 1967; Swinton 1972; Patterson 1973; NGC 1982; Marsh 1988; Lerner 1991.

HOWARD, ALFRED HAROLD (1854-1916), Toronto, ON. Painter, illustrator, illuminator and designer; RCA 1883. He came to Canada from England in 1876. An example of his work is in the NATIONAL GALLERY OF CANADA. **Citations**: MacDonald 1967; Sisler 1980; NGC 1982; McMann 1997.

HOWARD, BARBARA (b1926), Ontario. Painter. **Citations**: Outram 1978; NGC 1982; Lerner 1991.

HOWARD, JEMIMA FRANCES MEIKLE (1802-77), Toronto, ON. Painter. She was an amateur painter and was married to JOHN GEORGE HOWARD. **Citations**: Harper 1970; Lerner 1991; Tippett 1992.

HOWARD, JOHN GEORGE (1803-90), Toronto, ON. Architect and painter; RCA 1881. Howard emigrated from England in 1832. As an architect he was responsible for many private and public buildings including the Provincial Lunatic Asylum, Toronto, (1845-9, demolished 1976). Howard painted many fine watercolours . **Citations**: Guillet 1933; Colgate 1943; McInnes 1950; Harper 1966, 1970; Lord 1974; Sisler 1980; NGC 1982; Reid 1988; Marsh 1988; Lerner 1991; Kalman 1994; McMann 1997.

HOWARD, SIDNEY (b1913), Albert Bridge, NS. Sculptor. Howard is a prolific carver of naïve works in POLYCHROMED wood. His subjects are varied and include people, birds, animals and fish. Some of his work is life size and is YARD ART. **Citations**: Elwood 1976; Kobayashi 1985 (2); *Canadian Art* (Spring) 1985; McKendry 1988; Lerner 1991.

HOWARTH, GLENN (b1946), Victoria, BC. Painter. **Citations**: Heath 1976; NGC 1982; Lerner 1991.

HUBBARD, ROBERT HAMILTON (1916-89), Ottawa, ON. Art curator and writer. Hubbard was appointed Curator of Canadian Art at the NATIONAL GALLERY OF CANADA in 1947 and, in 1954, he became the Gallery's Chief Curator. He was the Cultural Adviser to the Governor General of Canada in the 1970s, and an authority on the history of Rideau Hall, Ottawa. **Citations**: Hubbard 1954, 1957, 1959, 1960, 1960(1), 1963, 1967, 1970, 1972(1)(2), 1973, 1973(2), 1977, 1989; Boggs 1971; Laing 1979; Hill 1988; Silcox 1996.

HUDON-BEAULAC, SIMONE MARIE YVETTE (b1905), Québec City, QC. Painter, art teacher and printmaker. She is the wife of HENRI BEAULAC. **Citations**: Levesque 1936; MacDonald 1967; NGC 1982; Lerner 1991.

HUDSON RIVER SCHOOL. The term applies to American landscape painters, active c1825-c1875 and who painted Hudson River Valley and Catskill Mountains scenes for their natural beauty and ROMANTICISM. The group included Thomas Cole (1801-48), Thomas Doughty (1793-1856), George Inness (1825-94), and Asher B. Durand (1796-1886). Canadian artists HOMER WATSON, ROBERT

WHALE, OWEN STAPLES, HENRI PERRE and others were influenced to some degree. **Citations**: Harper 1966; Jones 1968; Mellen 1970; Howat 1972; Lord 1974; Wilmerding 1980; Chilvers 1988; Reid 1988.

HUE. The property of a colour from which it is named - orange, yellow, blue and so on. **Citations**: Mayer 1970; Pierce 1987.

HUGHES, EDWARD JOHN (b1913), Vancouver, Victoria and Shawnigan, BC. Painter, MURALIST and illustrator; RCA 1969. Hughes is a painter of landscapes and portraits who has a personal, realistic, colourful, detailed style. His work includes coastal views with ships. He studied under FREDERICK HORSMAN VARLEY and JOCK MacDONALD and, as a war artist, worked with CHARLES COMFORT . Hughes was familiar with the work of the French naïve artist HENRI ROUSSEAU, and this influence appears to have resulted in a naïve quality in Hughes' paintings. (See Harper 1966, pl. 306; Adamson 1969, pl. 54; and Sisler 1980, p. 252, for illustrations.) **Citations**: McInnes 1950; Hubbard 1960, 1967; MacDonald 1967; Harper 1966; Adamson 1969; Duval 1972, 1974; Lord 1974; Forsey 1975; Sisler 1980; NGC 1982; Marsh 1988; Reid 1988; McKendry 1988; Lerner 1991; McMann 1997.

HUGHES, GEORGE H. (act. 1861-78), Montréal, QC. Painter. Hughes painted landscape and GENRE scenes in oil in the manner of CORNELIUS KRIEGHOFF, particularly winter scenes. He made many copies of Krieghoff's paintings of a native hunter and of a native woman with moccasins in hand (see Harper 1979, pp. 165-6, for a discussion of these copies). **Citations**: Harper 1966, 1970, 1979; NGC 1982; Cooke 1983; McKendry 1988.

HUGHES, LYNN (b1951), Montréal, QC. Painter. Hughes paints still life and portraits in a consciously naïve style. She admires FOLK ART and sometimes looks to it for inspiration. See also FOLK ART, CONSCIOUS. **Citations**: NGC 1982; *Canadian Art* 1985; McKendry 1988.

HUMME, JOSEPH JULIUS (1825-89), Orillia and Toronto, ON. Painter. Hümme's work included landscape, portrait and historical paintings. An emigrant from Germany, he settled in 1864 in the District of Muskoka near Sparrow Lake, ON. Hümme opened a studio in Toronto c1883, but was back in the Muskoka area by the time of his death in 1891. (*See front cover*) **Citations**: Harper 1970; French 1981; NGC 1982; McKendry 1983, 1988; Lerner 1991; McMann 1997.

HUMPHREY, JACK WELDON (1901-67), Saint John, NB. Painter. Humphrey studied in the USA and in Europe, and was a member of the CANADIAN GROUP OF PAINTERS. He painted portraits, harbour and street scenes, as well as abstract work (see Harper 1966, pl. 296-298). Several paintings by Humphrey are in the NATIONAL GALLERY OF CANADA. **Citations**: Colgate 1943; McInnes 1950; Buchanan 1950; Hubbard 1960; Harper 1966; Andrus 1966; MacDonald 1967; Duval 1954, 1972; Lord 1974; Fenton 1978; NGC 1982; Burnett/Schiff 1983; Bringhurst1983; Reid 1988; Marsh 1988; Lerner 1991; McMann 1997.

HUNT, DORA DE PEDERY. See DORA DE PEDERY-HUNT.

HUNT, HENRY (b1923), Victoria, BC. Sculptor and printmaker. Hunt, a Kwakiutl artist, is a son-in-law of MUNGO MARTIN and was apprenticed to him, as well as to ARTHUR SHAUNNESY. Hunt continues Mungo Martin's work in wood sculpture of totem poles, masks, ceremonial screens, as well as executing SERIGRAPHS. He is the father of TONY HUNT. **Citations**: *Canadian Collector* 1976; NGC 1982; Marsh 1988; McKendry 1988; Lerner 1991.

HUNT, TONY (b1942), Alert Bay, BC. Sculptor. Tony Hunt is a Kwakiutl artist who works with wood or stone in a traditional style. His works include totem poles and other sculptures portraying native legends. He studied with his grandfather MUNGO MARTIN as well as with his father HENRY HUNT. **Citations**: MacDonald 1967; NGC 1982; Marsh 1988; McKendry 1988.

HUNT, WILLIAM EDWARD (1891-1955), Québec. Painter, journalist and botanist. **Citations**: NGC 1982; Laliberté 1986; Lerner 1991.

HUNTER, JAMES (act. 1776-99), Québec City, QC. TOPOGRAPHICAL painter. Hunter was with the British army in Canada. He executed watercolour drawings of the Québec City area (see Bell 1973, pp. 51 and 90 for illustrations.) **Citations**: Harper 1970; Bell 1973; McKendry 1988.

HUNTER, WILLIAM STEWART Jr (1823-94), Stanstead, QC. Painter and illustrator. Hunter painted portraits and TOPOGRAPHICAL landscapes as well as making illustrations for travel guides. Some of his views of the Ottawa, Niagara Falls and Eastern Townships districts were published as LITHOGRAPHS. **Citations**: Hunter 1855, 1857, 1860; Spendlove 1958; Harper 1970; NGC 1982; Boyanoski 1982; McKendry 1988.

HUOT, CHARLES-EDOUARD-MASSON (1855-1930), Québec City, QC. Painter, illustrator and MURALIST. Huot's work includes portrait, figure, landscape, GENRE, interior, religious and historical paintings, as well as FRESCO decorations in churches (1886-90 Church of St Sauveur, QC - see Harper 1970), illustrations and MURALS. According to Harper 1979 (p. 168), Huot painted at least one painting based directly on paintings by CORNELIUS KRIEGHOFF. See Harper 1966, pl. 216, for an illustration of Huot's *La Bataille des Plaines d'Abraham*. A painting by Huot is in the NATIONAL GALLERY OF CANADA. **Citations**: Fairchild 1907; Dyonnet 1913; MacTavish 1925; Chauvin 1928; Morisset 1936; Colgate 1943; Barbeau 1957(Québec); Hubbard 1960, 1967, 1973; MacDonald 1967; Harper 1966, 1970, 1979; Trudel 1967(Peinture); Thibault 1978; NGC 1982; Laliberté 1986; Marsh 1988; McKendry 1988; Reid 1988; Lerner 1991; McMann 1997.

HURLEY, ROBERT NEWTON (1894-1980), Saskatchewan and Victoria, BC. Painter. Hurley is mostly known for his landscape paintings in watercolour of western prairie scenes. He had some training but retained a personal style with some naïve characteristics. **Citations**: MacDonald 1967; Dunlop Art Gallery; Fenton 1970, 1971; Dillow 1975; NGC 1982; Moppett 1986; McKendry 1988; Lerner 1991.

HURTUBISE, JACQUES (b1939), Montréal and Riviere-des-Prairies, QC; Ottawa, ON. Painter. Hurtubise is an ABSTRACT painter who is active in the Montréal art scene. His work is represented in the NATIONAL GALLERY OF CANADA. **Citations**: Harper 1966; MacDonald 1967; Teyssedre 1968; Duval 1972; Vie des Arts 1978; Sisler 1980; NGC 1982; Burnett/Schiff 1983; Bringhurst 1983; Reid 1988; Marsh 1988; Lerner 1991; McMann 1997.

HUSBAND, DELLA (c1900-41), Winnipeg, MB. Painter. **Citations**: NGC 1982; Tippett 1992.

HUTCHINS, ERNEST J. (act. 1900-12), Winnipeg, MB. Painter. Hutchins executed naïve landscape paintings in watercolour, ink and pencil of scenes near Fort Garry and Winnipeg, and in Alberta and British Columbia. **Citations**: Eckhardt 1970; Allodi 1974; NGC 1982; McKendry 1988.

HUTCHISON, FREDERICK WILLIAM (1871-1953), Montréal, QC. Painter; RCA 1941. He studied under WILLIAM BRYMNER as well as in New York and Paris. An example of his work is in the NATIONAL GALLERY OF CANADA. **Citations**: Jackson 1958; Hubbard 1960; MacDonald 1967; Watson 1974; Sisler 1980; NGC 1982; McMann 1997.

HUTCHINSON, LEONARD (1896-1980), Hamilton, ON. Painter and printmaker. After emigrating from England in 1912, he became well known for his WOODBLOCK colour prints. Examples are in the NATIONAL GALLERY OF CANADA. **Citations**: Colgate 1943; McInnes 1950; Duval 1952; MacDonald 1967; Lord 1974; Brown 1975; NGC 1982; Lerner 1991.

HUTNER, PAUL (b1948), Toronto, ON. Painter. **Citations**: Wilkin 1974(1); NGC 1982; Lerner 1991.

HUTTERITES. The Hutterites who originated as an Anabaptist German-speaking sect in Switzerland in the 1520s, established a colony in Alberta after World War One. See Bird 1981 for Hutterite DECORATIVE ARTS. **Citations**: Bird 1981; McKendry 1983; Marsh 1988; Lerner 1991.

HYDE, LAURENCE (1914-87), Ottawa, ON and Montréal, QC. Painter, wood ENGRAVER and printmaker. He studied under CHARLES GOLDHAMER and CARL SCHAEFER. Hyde's work is represented in the NATIONAL GALLERY OF CANADA. **Citations**: McInnes 1950; Duval 1952; MacDonald 1967; NGC 1982; Ainslie 1986; Lerner 1991.

I

ICON. An image of a holy personage which may be regarded by the viewer as sacred in itself, as well as a medium in contacting the personage portrayed. Icons are particularly important in the Greek Orthodox Church. See also RELIGIOUS ART. **Citations**: Osborne 1970; Pierce 1987; Chilvers 1988; Piper 1988.

ICONOGRAPHY. An understanding of the meanings behind pictorial images, for example a LAMB may represent Jesus Christ. See also RELIGIOUS ART; ICON. **Citations**: Chilvers 1988, Piper 1988.

IDEAL ART. This term is often associated with CLASSICAL or RENAISSANCE art. It may transform reality (that which actually exists) through a mental process or an idea into a perfect image. PROPORTION is an important component of Ideal Art. **Citations**: Osborne 1970; Lucie-Smith 1984; Piper 1988.

IEPEREN. See VAN IEPEREN.

ILE D'ORLEANS. This is a large island, just downstream from Québec City in the St Lawrence River, and which was valued as a painting site, particularly in the 19th and early 20th centuries. It was given its name by Jacques Cartier in 1536. After 1660 it was farmed by settlers, some of whose descendants still live there. There are fine examples of early stone houses and churches. Its picturesque qualities attracted such artists as HORATIO WALKER, HOMER WATSON and ANDRE BIELER, who noted in 1926 that "many artists have stayed there." **Citations**: Jackson 1958; Smith 1980; March 1988.

ILLUMINATION. Manuscripts written by hand and decorated with paintings and ornaments are called illuminated manuscripts. They were particularly important during the MEDIEVAL era in Europe. See FRAKTUR, CALLIGRAPHY. **Citations**: Osborne 1970; Chilvers 1988; Piper 1988.

IMPASTO. The thick opaque paint used to create various textural effects in a painting. **Citations**: Osborne 1970; Pierce 1987; Piper 1988.

IMPRESSION. See PRINTS.

IMPRESSIONISM. The first Impressionism Exhibition was held in Paris in 1874 with such now famous exhibitors as Pierre Renoir (1841-1919) and Claude Monet (1840-1926). Careful attention was paid to light and colour (for example an object's shadow casts a complementary colour). Impressionists rejected the traditional use of line around an object in their search to portray how light plays on the surface of an object. The greatest period of Impressionism was from 1870 to 1880, but it continued to influence many later artists. The work of some Canadian artists who studied in Paris around the turn of the century shows the influence of impressionism, for example that of MAURICE CULLEN, JAMES WILSON MORRICE, and some members of the GROUP OF SEVEN. (See Duval 1990.) **Citations**: Buchanan 1936; Hunter 1940; Jackson 1958; Harper 1966; Arnason 1968; Osborne 1970; Mellen 1970; Rewald 1973; Murray 1973; Watson 1974; Lord 1974; Courthion; Janson 1977; Callen 1982; Laing 1984; Piper 1988; Chilvers 1988; Reid 1988; Duval 1990; Lerner 1991; Silcox 1996.

INDEX OF AMERICAN DESIGN. An American government project during the 1930s to record FOLK ART and crafts from early Colonial times to the end of the 19th century. The Index contains coloured drawings and photographs, by hundreds of artists, and is housed in the National Gallery of Art, Washington, DC. **Citations**: Cahill 1950; Osborne 1970; Hornung 1976; Chilvers 1988.

INDIAN ART OF CANADA. See NATIVE ART OF CANADA; PRIMITIVE ART; FOLK ART EXHIBITIONS; MARIUS BARBEAU; EMILY CARR; LINEAR; SHAMAN; MASKS, FALSE FACE SOCIETY; POTLACH; ALGONQUIN LEGEND PAINTERS; BRITISH COLUMBIA; ARGILLITE; HAIDA, TSIMSHIAN; TOTEM POLES; and individual artists such as NORVAL MORRISSEAU, CHARLES EDENSHAW.

INGLEFIELD, Sir EDWARD AUGUSTUS (1820-94), Canadian Arctic; Halifax, NS. Marine artist and TOPOGRAPHER. Inglefield was in the Royal Navy and commanded ships during the searches for

Sir John Franklin (see Harper 1966, pl. 151.) **Citations**: Harper 1966, 1970; NGC 1982.

INNES, JOHN (JACK) I. (1863-1941), Calgary, AB; Toronto, ON; Vancouver, BC. Painter, illustrator, CARTOONIST and ENGRAVER. He studied under WILLIAM CRUIKSHANK and was familiar with western scenes. His western paintings resemble those of the American western artist FREDERIC REMINGTON. **Citations**: Colgate 1943; Harper 1966, 1970; MacDonald 1967; Render 1974; NGC 1982; Masters 1987; McKendry 1988; Lerner 1991; McMann 1997.

INSTALLATION. A term that came into use in the 1970s for an ASSEMBLAGE constructed in a gallery. A list of Canadian installation artists is provided in Lerner 1991. See also GRAIN BIN PROJECT. **Citations**: Osborne 1981; Lerner 1991; Read 1994.

INTAGLIO. A printing technique, in which an engraved or etched plate is inked, the surface wiped clean, and the ink in the recesses then transferred to the paper by pressure. **Citations**: Burch 1910; Mayer 1970; Eichenberg 1976; Piper 1988.

INTUITIVE NAÏVISM or PRIMITIVISM. See FOLK ART, CONSCIOUS.

INUIT ART OF CANADA. See NATIVE ART OF CANADA; JAMES HOUSTON; GEORGE SWINTON; SOAPSTONE; SHAMAN; SCRIMSHAW; and individual artists such as JESSIE OONARK.

IRON SCULPTURE. In most cases iron is unsuitable for casting works of art because of the difficulty with molten iron contracting as it cools. Wrought iron is used in modern abstract sculpture, and has a longer history of use in FOLK ART, mostly in weathervanes, weathercocks, and iron utensils (see McKendry 1983 pl. 35, 123-6, 226, 227, 241-3.) See also BLACKSMITHING. **Citations**: Osborne 1970; McKendry 1983; Lerner 1991.

IROQUOIS FALSE FACE SOCIETY. See FALSE FACE SOCIETY.

IRVINE, ROBERT (act. 1814-20), Saint John, NB and Toronto, ON. Painter. Irvine painted naïve landscape and marine paintings in watercolour or oil. Known works include views of the Toronto waterfront, the Niagara area, and a view of the Battle of Lake Erie. **Citations**: Harper 1966, 1970; NGC 1982; Dobson 1982; McKendry 1988.

IRWIN, de la CHEROIS THOMAS (1843-1928), Ottawa, ON and Vancouver Island, BC. Painter. Irwin came to Canada with the British army and retired from active service in 1882. He thought of himself as an AMATEUR painter of landscapes and is known to have painted some views of Québec and Alberta and British Columbia. (See Allodi 1974, pl. 987 and 989.) **Citations**: Harper 1970; Allodi 1974; Gilmore 1980; McKendry 1988.

ISAACS GALLERY. See ARTISTS' JAZZ BAND.

ISKOWITZ, GERSHON (b1921), Toronto, ON. Painter. He studied in Poland, Munich, France and Italy. Iskowitz came to Canada in 1949. **Citations**: MacDonald 1967; Smith 1972; Duval 1972; Lord 1974; Fenton 1978; Sisler 1980; NGC 1982; Burnett/Schiff 1983; Bringhurst 1983; Reid 1988; Lerner 1991; McMann 1997.

ITINERANT ARTISTS. In the 19th century many portrait artists in eastern Canada and the USA travelled widely in search of clients who would pay for PORTRAITS, MINIATURES or SILHOUETTES. These itinerant artists advertised their talents and set up temporary studios in towns they visited. In most cases their work was NAÏVE, and was in much demand before there was competition from photography. In Canada, itinerant work was almost a full-time occupation for JEAN-BAPTISTE ROY-AUDY, WILLIAM KING, Mr BOUKER, JARVIS F. HANKS, JOHN RAMAGE, and G. SCHROEDER. (See Harper 1966, pp. 115-19.) **Citations**: Harper 1966; McKendry 1983; Farr 1988.

IVES, JAMES M. See CURRIER AND IVES PRINTS.

IVESON, ROBERT (BOB) (b1951), Edmonton, AB. Sculptor. **Citations**: Heath 1976; NGC 1982; Lerner 1991.

IVORIES. See SCRIMSHAW.

J

JACKMAN, HARRY (H.R.) and MARY. The Jackmans are art collectors and were friends of A.Y. JACKSON. Having purchased Dr JAMES MACCALLUM's island (now known as West Wind Island) and cottage in 1945, the Jackmans carried on Dr MacCallum's hospitality to the members of the GROUP OF SEVEN. TOM THOMSON, J.E.H. MACDONALD and ARTHUR LISMER had worked on some MURALS for the cottage, commissioned by the doctor in 1915, that were later completed by A.Y. JACKSON. These murals were a gift by the Jackmans to the NATIONAL GALLERY OF CANADA in 1967 (see illustrations in Reid 1969). **Citations**: Jackson 1958; Reid 1969.

JACKSON, ALEXANDER YOUNG (A.Y.) (1882-1974), Montréal, QC; Toronto, Ottawa and Kleinburg, ON. Painter; RCA 1954. A.Y. Jackson was a landscape painter whose presence has been felt in Canadian art for many years, both for his numerous striking canvases and his work as a founding member and promoter of the GROUP OF SEVEN. In 1907 after study with EDMOND DYONNET and WILLIAM BRYMNER, Jackson went to Paris where he became familiar with IMPRESSIONISM. By 1913 Jackson was sharing a studio in Toronto with TOM THOMSON, and painting in the Algoma area with LAWREN HARRIS. In the 1920s Jackson painted near the St Lawrence shores in Québec, where he developed his style of simple rolling contours and combinations of muted and vivid colours (see Harper 1966, pl. 272). Many of his paintings are in the NATIONAL GALLERY OF CANADA. **Citations**: MacTavish 1925; Housser 1929, 1974; Robson 1932, 1938(3); NGC 1936, 1982; Colgate 1943; Buchanan 1945, 1950; Jackson 1948(1)(2), 1951, 1958, 1982; Pierce 1949; McInnes 1950; Lismer 1953; Pilot 1956; Lee 1956; Stevens 1958; Hubbard 1960; Mendel 1964; Harper 1966; Pepper 1966; MacDonald 1967; Davies 1967; Groves 1968; Reid 1969, 1988; Addison 1969; Mellen 1970, 1978; Boggs 1971; Murray 1971; Duval 1965, 1972, 1990; Barbeau 1973(1); Lord 1974; Watson 1974, 1982; Town 1977; Fenton 1978; Thibault 1978; Laing 1979, 1982, 1984; Firestone 1979; Tippett 1979, 1992; Smith 1980; Sisler 1980; Darroch 1981; Osborne 1981; Bringhurst 1983; Thom 1985; McMichael 1986; Reid 1988; Marsh 1988; Piper 1988; Chilvers 1988; Sabean 1989; Thom 1991; Lerner 1991; Hill 1995; Silcox 1996; Murray 1996(1); McMann 1997.

JACKSON, HENRY (HARRY) ALEXANDER CARMICHAEL (1877-1961), Manotick, ON. Painter, illustrator, LITHOGRAPHER and commercial artist. He is a brother of A.Y. JACKSON and is considered an expert painter of mushrooms. Many of his watercolour paintings of mushrooms are in the NATIONAL GALLERY OF CANADA. **Citations**: Lismer 1953; Jackson 1958, 1979; MacDonald 1967; NGC 1982.

JACKSON, NAOMI. See NAOMI JACKSON GROVES.

JACOBI, OTTO REINHOLD (1812-1901), Montréal, QC; Toronto, ON. Painter; RCA 1883. Jacobi, who was born in Prussia and studied in Germany, was a respected painter by the time he came to Canada in 1860. Jacobi's watercolours and oils were mostly ROMANTIC compositions of foliage, trees and waterfalls and, occasionally, portraits and buildings (see Harper 1966, pl. 171 and 176). He worked in watercolour and oil. His work is represented in the NATIONAL GALLERY OF CANADA. **Citations**: MacTavish 1925; Robson 1932; Colgate 1943; McInnes 1950; Duval 1954; Hubbard 1960; Harper 1964, 1966, 1970; MacDonald 1967; Watson 1974; Reid 1979, 1988; Sisler 1980; Baker 1981; NGC 1982; Silcox 1996; McMann 1997.

JACQUARD. See COVERLET.

JACQUIER (JACQUIES) dit LEBLOND, JEAN (1688-c1734), Trois-Rivieres, QC. Painter and sculptor of religious works in gilded wood. He helped JOSEPH QUINTAL found the Trois-Rivières school of wood carving c1715. **Citations**: Trudel 1967(Sculpture); Harper 1970; Lessard 1971; McKendry 1988; Lerner 1991.

JAMESON, ANNA BROWNELL (1794-1860), Toronto, ON. Painter, illustrator and writer. Mrs

Jameson completed numerous amateur landscape, GENRE and native-life sketches in ink or pencil, and some were used to illustrate her writings. By 1836 she was in Canada and made many sketches during travels through the Great Lakes region that were published in 1838 in her book, *Winter Studies and Summer Rambles in Canada.* She spent eight months in Canada while the wife of ROBERT SYMPSON JAMESON, from whom she legally separated upon her return to England. **Citations**: Needler 1958; Harper 1966, 1970; NGC 1982; Kobayashi 1985(2); Marsh 1988; McKendry 1988; Lerner 1991; Tippett 1992.

JAMESON, ROBERT SYMPSON (d1854), Toronto, ON. Painter. Jameson executed some amateur landscape paintings; some may be copies of European paintings. In 1836 he was appointed Attorney-General of Upper Canada. He was the husband of ANNA BROWNELL JAMESON. **Citations**: Needler 1958; Harper 1970; McKendry 1988.

JANVIER, ALEX SIMEON (b1935), Edmonton, AB; Winnipeg, MB. Painter and MURALIST. Janvier paints Chipewyan life and has completed many MURALS. For a time, he was associated with DAPHNE ODJIG, NORVAL MORRISSEAU, CARL RAY and JACKSON BEARDY. **Citations**: MacDonald 1967; Render 1970; Patterson 1973; Marsh 1988; McKendry 1988.

JAPANNING. A treatment of metal, in the decoration of articles, with a varnish mixed with paint, usually black. It was also a term used in 17th century England to describe oriental or domestic lacquer furniture. A Canadian working in lacquer is CALEB KEENE. **Citations**: Mayer 1970; Lucie-Smith 1984.

JAQUE, LOUIS-JACQUES BEAULIEU (b1919), Montréal, QC. Painter. He studied with JEAN-PAUL LEMIEUX and PAUL-EMILE BORDUAS and is a brother of PAUL VANIER BEAULIEU. **Citations**: MacDonald 1967; Vie des Arts 1978; Sisler 1980; NGC 1982; Lerner 1991; McMann 1997.

JARVIS, ALAN HEPBURN (1915-72), Ottawa and Toronto, ON. Sculptor and author. He was the director of the NATIONAL GALLERY OF CANADA 1955-59. Jarvis was a friend of DOUGLAS DUNCAN and DAVID MILNE. **Citations**: MacDonald 1967; Boggs 1971; Lord 1974; Jarvis 1974; Laing 1979, 1982; Tovell 1980; Burnett/Schiff 1983; Hill 1988; Marsh 1988; Reid 1988; Thom 1991; Lerner 1991.

JARVIS, DONALD (DON) ALVIN (b1923), Vancouver, BC. Painter; RCA 1967. Jarvis studied under BERTRAM C. BINNING and JACK L. SHADBOLT. His paintings are chiefly abstractions based on landscape. An example of his work is in the NATIONAL GALLERY OF CANADA. **Citations**: McInnes 1950; McNairn 1959; Hubbard 1960; Harper 1966; MacDonald 1967; Duval 1972; Sisler 1980; NGC 1982; Bringhurst 1983; Hill 1988; Reid 1988; Lerner 1991; McMann 1997.

JARVIS, LUCY MARY HOPE (1896-1989), Yarmouth, NS. Painter and art teacher. She studied in Boston. One of her paintings is in the Hart House Collection, University of Toronto, Toronto, ON. **Citations**: Harper 1955; MacDonald 1967; Adamson 1969; NGC 1982; Tippett 1992.

JASMIN, ANDRE (b1922), Québec. Painter and printmaker. He was a student of PAUL-EMILE BORDUAS. **Citations**: NGC 1982; Lerner 1991.

JASMIN, EDOUARD (b1905-act. 1960), Montréal, QC. Sculptor. Jasmin executes naïve sculptures in clay of religious and GENRE scenes, sometimes including lettered commentary. He has been referred to as a folk ceramicist. **Citations**: NGC 1982; Kobayashi 1985(2); McKendry 1988.

JAURAN. See RODOLPHE DE REPENTIGNY.

JAZZ BAND. See ARTISTS' JAZZ BAND.

JBBE. See Sir JAMES B. BUCKNALL ESTCOURT.

JEBB, Sir JOSHUA (act. c1820), Ontario. Painter. Jebb is known for AMATEUR paintings in watercolour of native people at Michilimackinac. He worked on the construction of the Rideau Canal as an engineer. **Citations**: Harper 1970; McKendry 1988.

JEFFERY, ALICIA ANNE (b1808), Nova Scotia. Painter. She painted Nova Scotia scenery. **Citations**: Lerner 1991; Tippett 1992.

JEFFERYS, CHARLES WILLIAM (1869-1951), York Mills, ON. Painter and illustrator; RCA 1927.

Jefferys executed historical, landscape, portrait and figure paintings and drawings in oil, watercolour, ink or pencil. Jefferys' work varied greatly in quality from perceptive interpretations of Canadian landscape to rather mundane historical sketches for illustrative purposes. **Citations**: Stevenson 1927; Bull 1934; Jefferys 1942; Jackson 1958; Hubbard 1960; Harper 1966; MacDonald 1967; Mellen 1970; Eckhardt 1970; Stacey 1976; Reid 1979, 1988; Sisler 1980; NGC 1982; Boyanoski 1982; Cooke 1983; Marsh 1988; McKendry 1988; Hill 1995; McMann 1997.

JEMMETT, MARY ELLA MAUD MARTINEAU (1892-1986), Kingston, ON. Painter. She studied with ANDRE BIELER and CARL SCHAEFER, and began painting in 1940. **Citations**: NGC 1982; Farr 1988.

JEROME, JEAN-PAUL (b1928), Montréal, QC. Painter. Jerome studied under STANLEY COS-GROVE and in Europe. He was one of a group of Montréal artists concerned with a plastic style of painting and who referred to themselves as Les PLASTICIENS. **Citations**: Harper 1966; MacDonald 1967; Marteau 1978; Sisler 1980; NGC 1982; Burnett/Schiff 1983; Bringhurst 1983; Reid 1988; Lerner 1991; McMann 1997.

JOBIN, IVAN (YVAN) (b1886), Québec. Painter, sculptor and MURALIST. **Citations**: NGC 1982; Laliberté 1986.

JOBIN, LOUIS (1845-1928), Montréal, Québec City and Sainte-Anne-de-Beaupré, QC. Sculptor. After a short apprenticeship c1855 with the contractor and sculptor FRANCOIS-XAVIER BERLIN-QUET, and a further two years in New York where he carved CIGAR-STORE FIGURES of native people (see Fried 1970 pp. 157-64), Jobin had a studio in Montréal 1870-5, and carved ship FIGURE-HEADS, signs and furniture. In 1875, when he began carving religious subjects, he moved to Québec City and, in 1896, to Sainte-Anne-de-Beaupré. Jobin was brought to the attention of museums and art galleries by MARIUS BARBEAU who visited him in 1925 accompanied by ARTHUR LISMER and A.Y. JACKSON. Jobin is known mostly for religious figures (examples are in the collection of the NATIONAL GALLERY OF CANADA). **Citations**: Barbeau 1934(1); 1957(Québec), 1968; Colgate 1943; Traquair 1947; McInnes 1950; Jackson 1958; Hubbard 1960, 1967, 1982; MacDonald 1967; Trudel 1967(Sculpture); Trudel 1969; Fried 1970; Harper 1973; Dobson 1982; McKendry 1983, 1988; Béland 1986; Porter 1986; Laliberté 1986; Marsh 1988; Lerner 1991.

JOBIN, NARCISSE (act. 1871), Québec. Sculptor. **Citations**: Porter 1986.

JOE, MENDELSON (b1944), Toronto, ON. Painter. Although Joe has an academic background, he paints naïve GENRE paintings of Toronto scenes and has exhibited in a show of naïve paintings. **Citations**: NGC 1982; Market Gallery 1984; McKendry 1988.

JOHNSON, ARTHUR (b1918), Kingston, ON and Montréal, QC. Sculptor and painter. **Citations**: NGC 1982; Farr 1988.

JOHNSTON, FRANCIS HANS (FRANZ) (FRANK) (1888-1949), Toronto, ON. Painter, illustrator and art teacher. Johnston studied under WILLIAM CRUIKSHANK and GEORGE A. REID. He worked for GRIP LIMITED in 1908. He became a member of the ONTARIO SOCIETY OF ARTISTS in 1917 and a founding member of the GROUP OF SEVEN in 1920. Johnston's paintings were more conventional than those of other members of the Group of Seven; he participated only in the Group's first exhibition in 1920. Johnston taught at the Winnipeg School of Art and at the ONTARIO COLLEGE OF ART. Several of his paintings are in the NATIONAL GALLERY OF CANADA. **Citations**: MacTavish 1925; Colgate 1943; Buchanan 1945; McInnes 1950; Jackson 1958; Hubbard 1960; Duval 1965, 1990; Harper 1966; MacDonald 1967; Mellen 1970; Housser 1974; Lord 1974; Fenton 1978; Sisler 1980; NGC1982; Thom 1985; Reid 1988; Marsh 1988; Sabean 1989; Lerner 1991; Hill 1995; McMann 1997.

JOHNSTONE, JOHN YOUNG (1887-1930), Montréal, QC. Painter. He studied with WILLIAM BRYMNER and in Paris. His work is represented in the NATIONAL GALLERY OF CANADA. **Citations**: MacTavish 1925; Hubbard 1960; MacDonald 1967; Sisler 1980; Laliberté 1986; McMann 1997.

JONASSEN, OLE (b c1898), Kingston, ON. Painter and MURALIST. Jonassen became established in

Kingston as a MURAL painter, in the late 1940s, after a career in Europe as a commercial artist and a mural painter. He has decorated the walls of many Kingston restaurants and other public places with colourful romantic landscapes. **Citations**: NGC 1982; Whig-Standard 1987; McKendry 1988.

JONES, WILLIAM (BILL) (b1946), Vancouver, BC. Photographer, painter and mixed media artist. **Citations**: Heath 1976.

JONES, DAVID (act. 1823-35), Fort Garry, MB. Painter. It is thought that David Jones is the H. Jones who is attributed as the creator of a series of LITHOGRAPHS copied from some of PETER RINDIS-BACHER'S views of the Red River Colony. **Citations**: Spendlove 1958; Hubbard 1967; Harper 1970; McKendry 1988.

JONES, ELIZABETH FIELD (1805-90), Brantford, ON. Painter. Elizabeth Jones was the wife of the native Wesleyan Methodist minister, Peter Jones. She is known to have exhibited MINIATURE watercolour paintings in the Upper Canada Provincial Exhibition of 1854. **Citations**: Orobetz 1977; Kobayashi 1985(2); Smith 1987; McKendry 1988; Tippett 1992.

JONES, H. See DAVID JONES.

JONES, PHYLLIS JACOBINE (1898-1976), Toronto and Niagara-on-the-Lake, ON. Sculptor; RCA 1951. After study in Europe, she came to Canada from England in 1932. Many large sculptures by Jones are in Toronto (see MacDonald 1967). An example of her work is in the NATIONAL GALLERY OF CANADA. **Citations**: Colgate 1943; McInnes 1950; Hubbard 1960; MacDonald 1967; Sisler 1980; NGC 1982; Lerner 1991; Tippett 1992; McMann 1997.

JONES, WILLIAM HARRIS (d1839), Halifax, NS. Painter. Jones was an American artist who taught and influenced art in Halifax. One of his students was MARIA (MORRIS) MILLER. **Citations**: Harper 1970; Lerner 1991; Tippett 1992.

JONG. See DE JONG.

JONGERS, ALPHONSE (1872-1945), Montréal, QC. Painter; RCA 1940. Jongers studied in Paris, travelled in Spain and came to Montréal in 1896. He was mainly a portrait painter. An example of his work is in the NATIONAL GALLERY OF CANADA. **Citations**: Chauvin 1928; Colgate 1943; Hubbard 1960; MacDonald 1967; Sisler 1980; NGC 1982; Laliberté 1986; Lerner 1991; McMann 1997.

JOST, EDWARD R. (act. 1864), Halifax, NS. Painter and cabinet-maker. Jost is known for a naïve painting of a Greek mythological tale about Ulysses (pl. 113 Harper 1974). **Citations**: Harper 1970, 1973, 1974; Kobayashi 1985(2); McKendry 1988.

JOYCE-GAGNON, THERESE (b1921), Montréal, QC. Painter. **Citations**: Tippett 1992.

JOURDAIN dit LABROSSE, PAUL (1697-1769), Montréal, QC. Sculptor. Jourdain executed sculpture in wood of religious figures. **Citations**: Gowans 1955; Trudel 1967(Sculpture); Porter 1986; McKendry 1988; Lerner 1991.

JUDAH, DORIS MINETTE (1887-1965), Montréal, QC. Sculptor. She studied under EDMOND DYONNET, ALFRED LALIBERTE and WILLIAM BRYMNER. **Citations**: MacDonald 1967; MacLachlan 1980; NGC 1982; Laliberté 1986; Lerner 1991.

JULIEN, OCTAVE-HENRI (1852-1908), Montréal and Québec City, QC. Painter, illustrator and CARTOONIST. Julien's work included landscape, GENRE, portrait and figure paintings, as well as drawings for illustrations and political CARTOONS. His drawings were very popular, particularly his political sketches and French Canadian habitant scenes. (See Julien 1916 and Harper 1966.) Julien's work is represented in the Musée du Québec. **Citations**: Julien 1916; MacTavish 1925(p64); Robson 1932; Morisset 1936; Morris; Barbeau 1938, 1941, 1957(Québec); Colgate 1943; McInnes 1950; Duval 1952; Jackson 1958; Harper 1966,1970; MacDonald 1967; Trudel 1967(Peinture); Eckhardt 1970; Hubbard 1973; Allodi 1974; *Canadian Collector* 1974; Lord 1974; Dunbar 1976; Guilbault 1980; NGC 1982; Laliberté 1986; Marsh 1988; McKendry 1988; Lerner 1991.

JUNEAU, DENIS (b1925), Montréal, QC. Sculptor, painter and MURALIST. Juneau studied under ALFRED PELLAN among others. His work is represented in the NATIONAL GALLERY OF CANADA. **Citations**: Harper 1966; MacDonald 1967; Teyssedre 1968; Sisler 1980; NGC 1982;

Burnett/Schiff 1983; Lerner 1991; McMann 19997.

JUNK ART. This term is used for a 20th century art form, in which junk (worthless materials, rubbish) is used for aesthetic purposes, usually as sculptural ASSEMBLAGES or COMBINE-PAINTINGS. **Citations**: Osborne 1981; Chilvers 1988; Piper 1988.

JUTRAS, JOSEPH (1894-1972), Montréal, QC. Painter. He belonged to the group of painters known as the PEINTRES DE LA MONTEE SAINT-MICHEL. **Citations**: MacDonald 1967; NGC 1982; Laliberté 1986; Lerner 1991.

K

KAGVIK, DAVIDEE (b1915), Great Whale River, Canadian Arctic. Sculptor. Kagvik is an Inuit artist. **Citations**: MacDonald 1967; Inuit 1971; Swinton 1972; NGC 1982.

KAHANE, ANNE (b1924), Montréal, QC. Sculptor, painter and printmaker. Kahane studied at the Cooper Union Art School in New York 1945-7. Many of her sculptures are in wood. Examples of her work are in the NATIONAL GALLERY OF CANADA. **Citations**: Ross 1958; Hubbard 1960; MacDonald 1967; Sisler 1980; Antoniou 1981; NGC 1982; Lerner 1991; Tippett 1992; McMann 1997.

KAKEGAMIC, GOYCE (b1948), Red Lake, ON. Painter and printmaker. Kakegamic is a native Canadian artist and brother-in-law of NORVAL MORRISSEAU. **Citations**: McLuhan 1977; Sinclair 1979; Highwater 1980; NGC 1982; Lerner 1991.

KAKEGAMIC, JOSHIM (b1952), Sandy Lake Reserve, ON. Painter and printmaker. Kakegamic is a native Canadian artist and brother-in-law of NORVAL MORRISSEAU. **Citations**: McLuhan 1977, 1984; Sinclair 1979; Highwater 1980; NGC 1982; Lerner 1991.

KAKINUMA, THOMAS (b1908), Burnaby, BC. Sculptor; ceramicist. Kakinuma studied at the ONTARIO COLLEGE OF ART and in New York. His ceramic sculpture and pottery were well received and won many awards. **Citations**: MacDonald 1967; NGC 1982; Lerner 1991.

KALLMEYER, MINNIE (1882-1947), Toronto, ON. Painter. Kallmeyer studied under F. MCGILLIVRAY KNOWLES and J.W. BEATTY as well as in Europe. Her work is represented in the NATIONAL GALLERY OF CANADA. **Citations**: MacTavish 1925; Hubbard 1960; MacDonald 1967; NGC 1982; McMann 1997.

KALVAK, HELEN (b1901), Holman, Canadian Arctic. Printmaker. Kalvak is an Inuit artist. **Citations**: MacDonald 1967; Goetz 1977; NGC 1982.

KAMIENSKI, JAN (b1923), Winnipeg, MB. CARTOONIST and illustrator. On the staff of the *Winnipeg Tribune* since about 1958, he has exhibited award-winning cartoons. **Citations**: MacDonald 1967; NGC 1982.

KAMPMANN, DURTEN (b1941), Winnipeg, MB; San Francisco, Cal. Sculptor. Kampmann came to Canada from Germany in 1956. He uses a variety of media including wood and stone. **Citations**: MacDonald 1967; NGC 1982.

KANANGINAK (b1935), Cape Dorset, Canadian Arctic. Sculptor and printmaker. Kananginak is an Inuit artist. **Citations**: MacDonald 1967; Inuit 1971; Swinton 1972; Goetz 1977; Sisler 1980; NGC 1982; McMann 1997.

KANDINSKY, WASSILY (1866-1944), Moscow, Russia; Munich, Germany. Painter. Russian painter Kandinsky was in the forefront of NON-FIGURATIVE, ABSTRACT painting. He had a wide influence on art and on Canadian artists including BERTRAM RICHARD BROOKER, GUIDO MOLINARI, LAWREN PHILLIPS HARRIS and LAWREN STEWART HARRIS. **Citations**: Harper 1966; Osborne 1970; Mellen 1970; Duval 1972; Smith 1972(1); Lord 1974; Bringhurst 1983; Reid 1988; Chilvers 1988; Lerner 1991.

KANE, HARRIET CLENCH (CLENCHE). See HARRIET CLENCH.

KANE, PAUL (1810-71), Cobourg and Toronto, ON. Painter. Prior to 1845, Irish-born Kane travelled widely in the USA and Europe painting portraits and copying old masters. He was in Toronto in 1845 and then travelled the North American West, including the fur-trade routes to the west coast, and sketched native people and the native way of life. He married HARRIET CLENCH in 1853. Kane's account of his travels, *Wanderings of an Artist Among the Indians of North America*, was published in 1859 (reprinted in Harper 1971[1]). The large canvases that Kane painted from his sketches are usually thought to have a ROMANTIC flavour with European overtones. Many of his paintings are in the NATIONAL GALLERY OF CANADA, Ottawa, and the ROYAL ONTARIO MUSEUM, Toronto. Watercolours, oil and pencil sketches and some oil paintings by Kane are in the Amon Carter Museum, Fort Worth, Texas (see Harper 1971[1]). **Citations**: Kane 1859, 1969; Hopkins 1898; MacTavish 1925; Lismer 1926; Robson 1932, 1938(2); Bushnell 1940; Colgate 1943; Buchanan 1950; McInnes 1950; Jackson 1958; Hubbard 1960, 1967; Harper 1964, 1966, 1970, 1971(1), 1972(3); MacDonald 1967; Carter 1967; Davies 1967; Rasky 1967; Eckhardt 1970; Mellen 1970; Osborne 1970; Boggs 1971; Wilkin 1973; Watson 1974; Render 1974; Allodi 1974; Lord 1974; Benham 1977; Mellen 1978; Reid 1979, 1988; Laing 1979, 1982; Wilkin 1980; NGC 1982; Goetzmann 1986; Marsh 1988; McKendry 1988; Chilvers 1988; Cavell 1988; Piper 1988; Lerner 1991; Tippett 1992.

KANTAROFF, MARYON (b1933), Toronto, ON. Sculptor and painter. She studied in Toronto and in England. Kantaroff's sculptures vary from monumental to jewelry. **Citations**: MacDonald 1967; NGC 1982; Lerner 1991.

KARDOS, LADISLAS (b1909), Vancouver, BC. Painter. He came to Canada in 1951 after living in Vienna and Paris. Kardos' paintings are in many collections including that of the University of British Columbia, Vancouver. **Citations**: McNairn 1963(1); MacDonald 1967; NGC 1982; Lerner 1991.

KARLIK, PIERRE (b c1931), Rankin Inlet, Canadian Arctic. Sculptor. Karlic, an Inuit carver of stone, has had commissions to carve very large sculptures. **Citations**: MacDonald 1967; NGC 1982.

KARMAN, ROBERT (b1933), Scarborough, ON. Painter and commercial artist. **Citations**: MacDonald 1967; NGC 1982.

KARSH, YOUSUF (b1908), Ottawa, ON. Photographer, portraitist. Karsh who emigrated from Armenia in 1924, has photographed many famous people and his portraits have received much praise. **Citations**: Karsh 1946, 1976, 1978; Sisler 1980; NGC 1982; Marsh 1988; Lerner 1991; McMann 1997.

KARVONEN, MIRJA LYDIA (b1918), Vancouver, BC. Textile artist and weaver. She studied in Finland and Sweden. **Citations**: MacDonald 1967; NGC 1982.

KASHETSKY, JOSEPH (1941-74), Saint John, NB. Painter and commercial artist. Kashetsky explores ABSTRACT forms in his paintings. **Citations**: Andrus 1966; MacDonald 1967; Lumsden 1973; NGC 1982; Lerner 1991.

KAUFMANIS, RUSINS (b1925), Ottawa, ON. CARTOONIST and illustrator. His satirical cartoons appeared in the *Ottawa Citizen*. **Citations**: MacDonald 1967; NGC 1982.

KAY, LOUIS (b1919), Toronto, ON. Painter, portraitist. **Citations**: MacDonald 1967; NGC 1982.

KEARNS, MURRAY WILLIAM (b1929), Toronto, ON. Painter and printmaker (etcher). Kearns studied under J.W.G. MACDONALD, CARL SCHAEFFER and GEORGE PEPPER. **Citations**: MacDonald 1967; NGC 1982.

KEATING, FRANK (1892-1970), St John's, NF. Painter of marine scenes, MURALIST, illustrator and mixed media artist. **Citations**: MacDonald 1967; NGC 1982.

KEENE, CALEB (1862-1954), Oakville, ON. Painter and lacquer worker. Keene's skill in lacquer work has been widely recognized in Canada and abroad. He produced highly decorated furniture with oriental and MEDIEVAL designs in lacquer. See also JAPANNING. **Citations**: MacDonald 1967; NGC 1982; Lerner 1991.

KEEVIL, ROLAND (1886-1963), Saskatoon, SK. Painter. Keevil painted naïve landscapes using vivid colouring with strong horizontal lines. Seven of his paintings were included in the 1959 NATIONAL GALLERY OF CANADA show, " Folk Painters of the Canadian West." See also FOLK

ART, PAINTERS OF THE CANADIAN WEST. **Citations**: McCullough 1959; MacDonald 1967; NGC 1982; McKendry 1988; Lerner 1991.

KEIRSTEAD, JAMES LORIMER (b1932), Kingston, ON. Painter. Keirstead is known chiefly for his portraits of rural homes and mills. He studied under ANDRE BIELER and RALPH ALLEN. **Citations**: MacDonald 1967; Keirstead 1979, 1991; NGC 1982; Lerner 1991.

KELLY, JOHN DAVID (1862-1958), Toronto, ON. Painter, illustrator and printmaker. Kelly studied under MARMADUKE MATTHEWS and JOHN FRASER. He was with GRIP LIMITED c1883, and joined the staff at the Toronto Lithographing Company in 1884 . Kelly's work included many paintings of historical subjects. **Citations**: Colgate 1943; MacDonald 1967; NGC 1982.

KENDALL, EDWARD NICHOLAS (1800-45), Canadian Arctic. Painter and illustrator. Kendall was with the Royal Navy and was an accomplished TOPOGRAPHICAL artist. He accompanied Sir John Franklin (1786-1847) on his second land expedition to the Arctic 1825-7. He is thought to be the same man as Harry P. Kendall who made a series of New Brunswick sketches c1835. **Citations**: Spendlove 1958; Harper 1964, 1970.

KENDALL, HARRY P. See EDWARD NICHOLAS KENDALL.

KENDERDINE, AUGUSTUS (GUS) FREDERICK (1870-1947), Lashburn and Saskatoon, SK. Painter. Kenderdine studied in Europe and emigrated to Canada in 1907. In 1935 he was appointed Director of Fine Art at the University of Saskatchewan. He painted prairie life and portraits particularly of native people. Harper 1966 reproduces a self-portrait (pl. 315). Kenderdine proposed the establishment of the EMMA LAKE ARTISTS' WORKSHOP. His work is represented in the NATIONAL GALLERY OF CANADA. **Citations**: Robson 1932; IBM 1940; Colgate 1943; Hubbard 1960; Harper 1966, 1981; MacDonald 1967; Render 1974; NGC 1982; Marsh 1988; Reid 1988; Lerner 1991; McMann 1997.

KENMURE, ADAM GORDON (1792-1847), Lake Huron, ON. TOPOGRAPHICAL artist. Kenmure was with the Royal Navy and painted TOPOGRAPHICAL marine scenes in watercolour, including a naval view of the War of 1812 on Lake Huron. **Citations**: Harper 1970; Allodi 1974; McKendry 1988.

KENNEDY, DAVID JOHNSTON (1816-98), Kingston and Guelph, ON. Painter. Kennedy painted about 750 views of Guelph and district showing many details of buildings and landscape. He sometimes made copies from his earlier work. Several examples are now in the collection of the University of Guelph. **Citations**: *Canadian Collector* 1976; Nasby 1980; McKendry 1988; Lerner 1991.

KENNEDY, GARRY NEILL (b1935), Halifax, NS. Painter and mixed media artist. Kennedy was appointed president of the NOVA SCOTIA COLLEGE OF ART AND DESIGN, Halifax, in 1967. Under the direction of Garry Kennedy and GERALD FERGUSON, the COLLEGE was given new life. **Citations**: MacDonald 1967; Nasgaard 1978; NGC 1982; Burnett/Schiff 1983; Bringhurst 1983; Lerner 1991.

KENNEDY, SYBIL (b1899), Montréal, QC; New York. Sculptor; RCA 1975. Kennedy studied in Montréal under WILLIAM BRYMNER, and in New York with abstract sculptor Alexander Archipenko (1887-1964) for four years. She exhibited in New York and Montréal. A sculpture by Kennedy is in the NATIONAL GALLERY OF CANADA. **Citations**: Ross 1958; Hubbard 1960; MacDonald 1967; Sisler 1980; NGC 1982; Lerner 1991; Tippett 1992; McMann 1997.

KENOJUAK (b1927), Cape Dorset, NT. Printmaker. Kenojuak Ashevak, an Inuit, is well known as a graphic artist, particularly for her print *The Enchanted Owl*. **Citations**: Houston 1967; MacDonald 1967; Larmour 1972; Lord 1974; Goetz 1977; Sisler 1980; NGC 1982; Marsh 1988; Lerner 1991; Tippett 1992; McMann 1997.

KENYON, J.J. (1862-1937), Blair, ON. Painter and photographer. Some of Kenyon's naïve paintings of farm animals and horse portraits were likely made from photographs. **Citations**: Harper 1973; *Canadian Collector* 1980; NGC 1982; *Upper Canadian* 1985; McKendry 1988; Lerner 1991.

KERGOMMEAUX, DUNCAN ROBERT CHASSIN DE (b1927), London, ON. Painter and MURALIST. He studied with JAN ZACH, JOCK MACDONALD and HANS HOFMANN. An example of

his work is in the NATIONAL GALLERY OF CANADA. **Citations**: Hubbard 1960; MacDonald 1967; Sisler 1980; NGC 1982; Hill 1988; McMann 1997.

KERR, ESTELLE MURIEL (1879-1971), Toronto, ON. Painter and illustrator. Kerr studied under MARY ELLA DIGNNAM and LAURA MUNTZ in Toronto, as well as in New York and Paris. **Citations**: MacTavish 1932; MacDonald 1967; NGC 1982; Lerner 1991; Tippett 1992; McMann 1997.

KERR, ILLINGWORTH HOLEY (b1905), Toronto, ON; Lumsden, SK; Vancouver, BC; Calgary, AB. Painter. Kerr studied under ARTHUR LISMER, J.E.H. MacDONALD, F.H. VARLEY and J.W. BEATTY. By 1928 he was in the western provinces painting, illustrating, trapping and sign-painting. One of his prairie paintings is illustrated in Harper 1966, pl. 299. An example of his work is in the NATIONAL GALLERY OF CANADA. **Citations**: Highlights 1947; Hubbard 1960; Harper 1966, 1981; MacDonald 1967; Render 1974; Sisler 1980; NGC 1982; Masters 1987; Marsh 1988; Reid 1988; Lerner 1991; McMann 1997.

KERR-LAWSON, JAMES (1864-1939), Hamilton and Toronto, ON. Painter. Kerr-Lawson (also known as Lawson) emigrated with his parents from Scotland to Hamilton in 1865. He painted portraits, GENRE and landscapes. **Citations**: Colgate 1943; Harper 1966, 1970, 1981; Sisler 1980; NGC 1982; Reid 1988; Lerner 1991; McMann 1997.

KERWIN, CLAIRE (b1921), Ontario. Painter and printmaker. **Citations**: Sisler 1980; NGC 1982; McMann 1997.

KEY. Key is an averaging of the TONAL VALUES in a painting. High-key is nearly white and low-key is nearly black. **Citations**: Lucie-Smith 1984; Read 1994.

KEYS. One or two large keys are sometimes used to identify St Peter in works of art According to biblical reference, Christ gave St Peter the keys of the kingdom of heaven. **Citations**: Ferguson 1967; Lucie-Smith 1984.

KEYSTONE. Keystone is an architectural term for the upper cental wedge-shaped stone of an ARCH or VAULT. **Citations**: Osborne 1970; Lucie-Smith 1984.

KIHN, WILFRED LANGDON (1898-1957), New York. Painter. Kihn painted native people scenes, native people portraits and totem poles along the Northwest coast (see Barbeau 1973[1]). **Citations**: Jackson 1958; Barbeau 1973(1); Fielding 1974; Tippett 1979; NGC 1982; Lerner 1991.

KILBOURN, ROSEMARY ELIZABETH (b1931), Ontario. Painter, printmaker and MURALIST. **Citations**: Sisler 1980; NGC 1982; Lerner 1991; McMann 1997.

KILGOUR, ANDREW WILKIE (1868-1930), Montréal, QC. Painter. Kilgour, born in Scotland, came to Montréal in 1910. He studied under WILLIAM BRYMNER and MAURICE CULLEN. A painting by Kilgour is in the NATIONAL GALLERY OF CANADA. **Citations**: Robson 1932; Hubbard 1960; MacDonald 1967; NGC 1982; Laliberté 1986; McMann 1997.

KILLALY, ALICIA (1836-1916), London, ON. Painter. Killaly painted small studies similar in subject to paintings by CORNELIUS KRIEGHOFF, with whom she may have studied. Her work is sometimes anecdotal and includes views of Québec City (see Allodi 1974, pl. 1351), Toronto and Niagara areas. A series of six LITHOGRAPHS, *A Picnic to Montmorency*, published in 1868 and signed "A.K.," is attributed to her (see Spendlove 1958, pl. 73-8). **Citations**: Spendlove 1958; Harper 1970; Allodi 1974; Farr 1975; Cooke 1983; McKendry 1988; Cavell 1988; Tippett 1992.

KILPIN, LEIGH MULHALL (1853-1919), Montréal, QC. Painter and sculptor. Kilpin who studied art in Europe, was in Montréal by 1906, where he painted portraits, landscapes, GENRE and MINIATURES, as well as doing some sculpture. Examples of his paintings are in the NATIONAL GALLERY OF CANADA. **Citations**: MacTavish 1925; Hubbard 1960; MacDonald 1967; Harper 1970; NGC 1982; Dobson 1982; McKendry 1988; Lerner 1991; McMann 1997.

KINETIC ART. Kinetic art incorporates real or apparent movement, for example MOBILES, WHIRLIGIGS. A music box by ALPHONSE GRENIER, in which various figures move in time to the music (see NMM 1983, pl. 204), can be considered Kinetic Art. See also OP ART. **Citations**: Arnason 1968; Osborne 1981; NMM 1983; Lucie-Smith 1984; Chilvers 1988; Piper 1988.

KING, WILLIAM (act. c1785-1809), Halifax, NS; Saint John, NB; Newfoundland. Silhouettist. King was an American ITINERANT artist who may have been the first silhouettist to visit the Canadian Atlantic provinces. He used a mechanical device in taking the profiles for his SILHOUETTES and could complete one in six minutes. His work is signed "King" or "W.K." **Citations:** Harper 1966, 1970; NGC 1982; McKendry 1988.

KINGAN, EDWARD (TED) NATHAN (b1927), British Columbia. Painter. **Citations:** Sisler 1980; NGC 1982; McMann 1997.

KINGSTON CONFERENCE OF CANADIAN ART (1941). See CONFERENCE OF CANADIAN ARTISTS (1941).

KIPLING, BARBARA ANN EPP (b1934), Burrard Inlet, BC. Painter and portraitist. She studied under JAN ZACH and others. **Citations:** MacDonald 1967; Sisler 1980; NGC 1982; Lerner 1991; Tippett 1992; McMann 1997.

KITCAT. Kitcat is a standard size of canvas, 36 x 28 inches (91.5 x 71 cm). A kitcat PORTRAIT usually shows the head, shoulders and one hand. It became popular in England during the early 18th century, and is often associated with Godfrey Kneller (c1646-1723). **Citations:** Osborne 1970 (see Kitcat Club); Lucie-Smith 1984; Piper 1988.

KITSCH. A German word for a design style of the 1930s and '40s that followed ART DECO. Kitsch vulgarizes other styles and is sometimes mass produced as tourist souvenirs. **Citations:** Osborne 1970; Lesieutre 1978; Osborne 1981; Piper 1988; Chilvers 1988; Lerner 1991.

KIYOOKA, HARRY MITSUO (b1928), Alberta. Painter and printmaker. **Citations:** Sisler 1980; NGC 1982; Lerner 1991; McMann 1997.

KIYOOKA, ROY KENZIE (b1926), Montréal, QC. Painter, teacher and poet. Kiyooka studied under J.W.G. MACDONALD and ILLINGWORTH H. KERR. See Withrow 1972, pp. 89-96. His work is represented in the NATIONAL GALLERY OF CANADA. **Citations:** Hubbard 1960; Harper 1966, 1981; MacDonald 1967; Teyssedre 1968; Townsend 1970; Duval 1972; Withrow 1972; Mellen 1978; Sisler 1980; NGC 1982; Burnett/Schiff 1983; Bringhurst 1983; Marsh 1988; Reid 1988; Lerner 1991; McMann 1997.

KNOWLES, DOROTHY ELSIE (b1927), Saskatoon, SK. Painter. Knowles interest in landscapes was encouraged at the EMMA LAKE ARTISTS' WORKSHOPS, and she has become well known for her paintings of Saskatchewan landscape. She is the wife of WILLIAM PEREHUDOFF. **Citations:** Climer 1967; MacDonald 1967; Fenton 1971, 1978; Duval 1972; Render 1974; Lord 1974; Walters 1975; Bingham 1981; NGC 1982; Bringhurst 1983; Burnett/Schiff 1983; Reid 1988; Marsh 1988; Lerner 1991; Tippett 1992.

KNOWLES, ELIZABETH ANNIE (BEACH) McGILLIVRAY (1866-1928), Toronto, ON. Painter. She was a niece of F.M. BELL-SMITH and wife of F. McGILLIVRAY KNOWLES. She moved to New York c1915. One of her paintings is in the NATIONAL GALLERY OF CANADA. **Citations:** MacTavish 1925; Robson 1932; Hubbard 1960; MacDonald 1967; Sisler 1980; NGC 1982; Lerner 1991; Hill 1995; McMann 1997.

KNOWLES, FARQUHAR McGILLIVRAY STRACHAN STEWART (1859-1932),Toronto, ON. Painter, portraitist; RCA 1898. Knowles first worked at the photographic studios of WILLIAM NOTMAN and JOHN A. FRASER in Toronto, where he took his first painting lessons from Fraser. In 1885 he went to London and Paris to study. He and his wife ELIZABETH MCGILLIVRAY KNOWLES moved to New York c1915. Several of Knowles' paintings are in the NATIONAL GALLERY OF CANADA. **Citations:** MacTavish 1925; Robson 1932; Colgate 1943; McInnes 1950; Hubbard 1960; Harper 1966, 1970, 1981; MacDonald 1967; Sisler 1980; Laing 1982; NGC 1982; Hill 1995; McMann 1997.

KOCEVAR, FRANK J.(1899-1982), Kelowna, BC. Painter. Kocevar who was born in Austria, came to Canada in 1924. He began painting landscape, religious and interior paintings after a visit to the 1967 World's Fair in Montréal. His paintings are naïve and are often based on memories. In some cases, he

painted a second or a third variation of the same subject. Several of his paintings are in the collection of the British Columbia Department of Public Works, Victoria, BC. **Citations**: Mattie 1981; Farr 1982; NGC 1982; NMM 1983; McKendry 1983, 1988; Kobayashi 1985(2).

KOLISNYK, PETER HENRY (b1934), Ontario. Sculptor and painter. Kolisnyk is known for his white-on-white paintings and sculptures. **Citations**: Nasgaard 1977; Sisler 1980; NGC 1982; Lerner 1991; McMann 1997.

KÖLLNER, AUGUST (b1813-act. 1870), Philadelphia, USA. Painter, LITHOGRAPHER and ENGRAVER. He emigrated from Germany in 1839 or 1840 to the USA, where he produced military prints and painted watercolour views of cities and landscapes. He visited Montréal, Québec City, Kingston and Toronto in 1848. **Citations**: Stokes 1933; Jefferys 1948; Spendlove 1958; De Volpi 1965; Harper 1970; Béland 1992.

KOOCHIN, WILLIAM (BILL) (b1927), British Columbia. Sculptor. Koochin was influenced by Russian woodcarvings, and turned his attention to carving Canadian wildlife in wood. **Citations**: Sisler 1980; NGC 1982; Lerner 1991; McMann 1997.

KOOP, WANDA (b1951), Winnipeg, MB. Painter. **Citations**: Tippett 1992.

KOPMANIS, AUGUST ARNOLD (1910-76), Ontario. Sculptor. Kopmanis's work included sculpture. of medals. **Citations**: Sisler 1980; NGC 1982; Lerner 1991; McMann 1997.

KORNER (KOERNER), JOHN MICHAEL ANTHONY (b1913), Vancouver, BC. Painter and MURALIST. Korner was born in Czechoslovakia, studied art in Europe, and moved to Vancouver in 1939, where he taught painting at the Vancouver School of Art. Examples of his work are in the NATIONAL GALLERY OF CANADA. **Citations**: McNairn 1959; Hubbard 1960; Harper 1966, 1981; Sisler 1980; NGC 1982; Lerner 1991; McMann 1997.

KOSTYNIUK, RONALD (RON) PETER (b1941), Alberta. Sculptor. Kostyniuk's work includes coloured RELIEF structures. **Citations**: Greenwood 1973; Sisler 1980; NGC 1982; Lerner 1991; McMann 1997.

KRAMER, BURTON (b1932), Ottawa, ON. Painter, printmaker and graphic designer. **Citations**: Sisler 1980; NGC 1982; Lerner 1991; McMann 1997.

KREYES, MARIE-LOUISE (b1935), Winnipeg, MB. Painter. She came to Canada from Germany in 1951. **Citations**: MacDonald 1967; Heath 1976; Lerner 1991.

KRIEGHOFF, CORNELIUS DAVID (1815-72), Montréal and Québec City, QC. Painter. Dutch born Krieghoff was in the USA by 1837 and moved to Canada c1840. He was a prolific painter of Québec habitants and native people in bright colours and often with humour. In general, his landscapes are ROMANTICIZED, and the quality of his work varies considerably from pot-boilers and anecdotal scenes to highly finished canvases. Krieghoff had his Montréal studio in the same building as MARTIN SOMERVILLE, and they had a joint exhibition in 1847. Krieghoff and Somerville did similar studies of native people, such as moccasin and basket sellers in winter landscapes. In 1853, on the advice of his friend and patron JOHN BUDDEN, Krieghoff moved to Québec City where he painted Lorette native people, the countryside and habitants. It is thought that Krieghoff painted over 2000 canvases, and many copies and forgeries have been made by other artists (see Harper 1979, pp. 165-79). Much has been written about this artist, but the most authoritative is by J. RUSSELL HARPER. Krieghoff died in 1872, one year after moving to Chicago. Krieghoff's paintings are included in the collection of the NATIONAL GALLERY OF CANADA, as well as many other public and private collections. **Citations**: Fairchild 1907, 1908; Morisset 1936; MacTavish 1925; Lismer 1926; Robson 1932; Barbeau 1934, 1936, 1948, 1957, 1962; Morisset 1936; Robson 1937(1); Colgate 1943; Buchanan 1950; McInnes 1950; Barbeau 1957(Québec); Jackson 1958; Spendlove 1958; MacDonald 1967; Davies 1967; Hubbard 1960, 1967, 1973; Mendel 1964; Harper 1964, 1966, 1970, 1972, 1972(2), 1977, 1979; Trudel 1967(Peinture); Carter 1967; Guttenberg 1969; Osborne 1970; Mellen 1970; Boggs 1971; Jouvancourt 1971; Vezina 1972; Morris 1972; Hill 1974; Watson 1974; Allodi 1974; Lord 1974; Duval 1974; Mellen 1978; Thibault 1978; Reid 1979, 1988; Sisler 1980; NGC 1982; Marsh 1988; McKendry 1988; Piper 1988;

Cavell 1988; Lerner 1991; Béland 1992; Tippett 1992; Hill 1995; Silcox 1996; McMann 1997.

KRÜGER, AUGUSTUS (act. mid 19th century), Fenelon Falls, Lindsay and Kingston, ON. Painter. Krüger emigrated from Russia in 1866 and was in Kingston Penitentiary for attempted murder by 1871. He was in Rockwood Insane Asylum (now Kingston Psychiatric Hospital) in 1874. He made a large oil painting (collection Corrections Canada) of a penitentiary guard and dog overlooking Portsmouth Village. **Citations**: McKendry 1996 (see front cover for colour reproduction).

KUBOTA, NABVO (b1932), Toronto, ON. Sculptor. He was a member of the ARTISTS' JAZZ BAND. **Citations**: Sisler 1980; NGC 1982; Burnett/Schiff 1983; Reid 1988; Lerner 1991; McMann 1997.

KURELEK, WILLIAM (1927-77), Toronto, ON. Painter. Kurelek was born in Canada of UKRAINIAN parents and, after a difficult childhood, had long bouts of mental illness. While in a mental hospital in England for treatment, he began painting nightmarish scenes, and later got some help from electroshock treatments. He converted to Roman Catholicism and thought he had a mission to spread the word of God. While his paintings often reflect his religious outlook, many are rather somber, realistic, detailed accounts of farm, labour and family scenes with naïve overtones (see Mellen 1978, pl. 111). Kurelek died of cancer at age fifty. **Citations**: Harper 1966; Hubbard 1967; MacDonald 1967; Duval 1972; Kurelek 1973, 1980, 1983; Lord 1974; Mellen 1978; Sisler 1980; Nasby 1980; Murray 1982(3), 1996(1); NGC 1982; Bringhurst 1983; Burnett/Schiff 1983; Marsh 1988; Morley 1986; McKendry 1983, 1988; Reid 1988; Dedora 1989; Lerner 1991; McMann 1997.

KUZELA, MIROSLAV (act. 1969), Toronto, ON. Painter. After being in Toronto for a few years, Kuzela returned to his native Czechoslovakia. He left behind some colourful and decorative paintings of Toronto scenes (see Harper 1974, pl. 83). **Citations**: Harper 1973, 1974; Kobayashi 1985(2); McKendry 1988.

L

LABELLE, JOSEPH A. P. (1857-1939), Montréal, QC. Illustrator and LITHOGRAPHER. **Citations**: Harper 1970; Laliberté 1986.

LABROSSE, dit PAUL-RAYMOND JOURDAIN (1697-1769), Montréal, QC. Sculptor. Labrosse was the leading Montréal wood sculptor from 1730 to1760. He created many religious works for churches, including figures and furnishings, in POLYCHROMED or gilded wood. One of his richly ornamented TABERNACLES is in the NATIONAL GALLERY OF CANADA. **Citations**: Traquair 1947; McInnes 1950; Barbeau (Québec) 1957; MacDonald 1967; Hubbard 1967; Trudel 1969; NGC 1982; Marsh 1988; McKendry 1988.

LABRADOR. See NEWFOUNDLAND .

LACELLE, BEATRICE (active 1969), Spanish, ON. Painter. Lacelle is a naïve painter who was discovered by FREDERICK HOWARD OWEN in 1969. She is a sister of WILLIAM and FLORENCE LACELLE. **Citations**: MacDonald 1967; NGC 1982; McKendry 1988.

LACELLE, FLORENCE (active 1969), Spanish, ON. Florence Lacelle is a naïve painter who was discovered by FREDERICK HOWARD OWEN in 1969. She is a sister of WILLIAM and BEATRICE LACELLE. **Citations**: MacDonald 1967; NGC 1982; McKendry 1988.

LACELLE, WILLIAM (active 1946-69), Spanish, ON. William Lacelle is a naïve painter who was discovered by FREDERICK HOWARD OWEN in 1969. He is a brother of FLORENCE and BEAT-RICE LACELLE. **Citations**: MacDonald 1967; McKendry 1988.

LACROIX, JOSEPH SAMUEL RICHARD (b1939), Montréal, QC. Printmaker, ENGRAVER and sculptor. He studied under ALBERT DUMOUCHEL and others. **Citations**: Roussan 1967; MacDonald 1967; Hubbard 1967; NGC 1982; Lerner 1991.

LADDS, ELIZABETH S. (1837-1922), Dartmouth, NS. Painter. Ladds painted naïve studies in oil or watercolour of the life of Micmac native people, see Farr 1975, pl. 10, or Field 1985, pl. 133, for an illustration. **Citations**: Hubbard 1967; Harper 1970; Farr 1975; NGC 1982; Field 1985; McKendry 1988.

LAFORD, JOHN (b1955), Manitoulin Island, ON. Painter. **Citations**: Ojibwa 1981; NGC 1982; Lerner 1991.

LAGACE, JEAN-BAPTISTE (1868-1946), Montréal, QC. Illustrator. Lagace studied with EDMOND DYONNET. **Citations**: Laliberté 1986.

LALIBERTE, ALFRED (1878-1953), Montréal, QC. Sculptor, painter and author; RCA 1922. Laliberté, who studied in Montréal and Paris, is best known for his sculptures of figures and of monuments, and as a teacher of younger artists. Several of his works are in the NATIONAL GALLERY OF CANADA, see Hubbard 1960. Laliberté was a founding member of the SCULPTORS' SOCIETY OF CANADA. See Laliberté 1986 for a short autobiography. **Citations**: Dyonnet 1913, 1951;Chauvin 1928; Laliberté 1934, 1978(1)(2), 1986; Laberge 1938; Colgate 1943; McInnes 1950; Hubbard 1960; MacDonald 1967; Musée du Québec 1978; Sisler 1980; NGC 1982; Marsh 1988; Lerner 1991; McMann 1997.

LALIBERTE, MADELINE (b1922), Québec. Painter of rural Québec scenes. One of her paintings is in the NATIONAL GALLERY OF CANADA. **Citations**: Hubbard 1960; MacDonald 1967; NGC 1982; Lerner 1992; Tippett 1992.

LALL, OSCAR DANIEL DE (1903-71), Montréal, QC. Painter, portraitist; RCA 1959. He came to Canada from Russia in 1926 and studied under EDMOND DYONNET. One of his paintings is in the NATIONAL GALLERY OF CANADA. **Citations**: (see de Lall) MacDonald 1967; Sisler 1980; NGC 1982; Hill 1988; McMann 1997.

LAMARCHE, E. ULRIC (1867-1921), Montréal, QC. Painter, portraitist and CARTOONIST. He studied in Paris and visited France periodically. **Citations**: Laberge 1938; MacDonald 1967; Harper 1970; NGC 1982; Laliberté 1986; Lerner 1991; McMann 1997.

LAMBALGEN. See VAN LAMBALGEN.

LAMB. The lamb is frequently used in religious works as a symbol of Christ based on such scriptural passages as John I:29: "The next day John seeth Jesus coming unto him, and saith, Behold the Lamb of God." See RELIGIOUS ART. **Citations**: Osborne 1970; Ferguson 1967; Pierce 1987.

LANDSCAPE FORMAT. A painting, drawing, print or photograph, which is wider than it is high, is in a landscape format (opposite of PORTRAIT FORMAT). **Citations**: Lucie-Smith 1984.

LANDSCAPE PAINTING. The word landscape as a painter's term originally was used to describe the painting of natural scenery. As modern art departed from reality, however, it was chiefly folk artists such as HENRI ROUSSEAU who continued to paint landscapes with the intention to record nature faithfully. J. RUSSELL HARPER (Harper 1966, p. 81) says that JOSEPH LEGARE "is virtually the founder of Canadian Landscape painting." Respected Canadian landscape painters include THOMAS DAVIES, GEORGE HERIOT, PAUL KANE, CORNELIUS KRIEGHOFF, DANIEL FOWLER, JOHN FRASER, LUCIUS O'BRIEN, OTTO JACOBI, HORATIO WALKER, MAURICE CULLEN, GOODRIDGE ROBERTS, and TONI ONLEY. See also TOPOGRAPHICAL, PAINTING IN CANADA, GROUP OF SEVEN, CANADIAN GROUP OF PAINTERS, BARBIZON SCHOOL, HUDSON RIVER SCHOOL, PICTURESQUE, ROMANTICISM. **Citations**: Harper 1966; Osborne 1970; Lord 1974; Porter 1978; Piper 1988; Lerner 1991.

LANDSLEY, PATRICK ALFRED (b1926), Québec. Painter. **Citations**: Ayre 1977; NGC 1982; Lerner 1991.

LANGTON, ANNE (1804-93), Fenelon Falls and Toronto, ON. Painter. Langton was educated in Europe and studied MINIATURE painting in Italy. She was a painter of landscapes and miniatures in watercolour, mixed media or pencil. Her work included sketches of Fenelon Falls, Québec, Toronto and Ottawa areas showing pioneer scenes, as well as paintings on china. See Farr 1975, pl. 6-8, for reproductions of sketches now in the Ontario Archives. **Citations**: Langton 1904; Guillet 1933; Harper

1970; Farr 1975; NGC 1982; McKendry 1988; Tippett 1992.

LANIGAN, A.R. (active 1885), Québec. Painter. Lanigan's paintings are naïve, and include Québec landscapes and rural scenes. He sometimes signed his paintings "ARL". See McKendry 1983, pl. 74, for a reproduction of one of his winter scenes. **Citations**: McKendry 1983, 1988.

LANSDOWNE, JAMES FENWICK (b1937), Victoria, BC. Painter. Lansdowne ranks among the best painters of birds and has gained world recognition for his work. His watercolours and prints have been exhibited widely, and his work has been published in several books such as *Birds of the Northern Forest* 1966, *Birds of the Eastern Forest* 1968, *Birds of the West Coast* 1976, and *Rails of the World* 1977. **Citations**: Livingston 1966, 1968; MacDonald 1967; Render 1970; Ripley 1977; Sisler 1980; Danzker 1981; NGC 1982; Lerner 1991; McMann 1997.

LAPEER, LYNDA (LINDA) (b1949), Gore's Landing, ON. Painter. When Lapeer became paralyzed with Guillaine-Barre syndrome, she was encouraged to begin painting by her husband, painter MICHAEL BEHNAN. Another influence was the American naïve painter Ralph Fasanella (b 1914), about whom she read in a book. Lapeer's paintings have the usual characteristics of naïve art such as lack of correct perspective, bold use of colour, absence of shadows, realism, full of details and use of nearby subject matter. Her work has been in several public exhibitions, see Farr 1982, pl. 3. **Citations**: Murray 1981; NGC 1982; Farr 1982; *Century Home* 1983; Kobayashi 1985(2); McKendry 1988.

LAPERLE, PHILIPPE (1860-1934), Montréal, QC. Painter and sculptor of religious works. He was a pupil of PHILIPPE HEBERT and worked with OLINDO GRATTON. **Citations**: Harper 1970; Laliberté 1986.

LAPINE, ANDREAS (ANDRE) CHRISTIAN GOTTFRIED (1866-1952), Manitoba; Toronto and Minden, ON. Painter. Lapine, born in Russia, studied art there before coming to Canada in 1907. He was a portrait, animal and landscape painter, and is well known for his studies of horses. Lapine's work is represented in the NATIONAL GALLERY OF CANADA. **Citations**: MacTavish 1925; Robson 1932; Hubbard 1960; MacDonald 1967; Smith 1968; Eckhardt 1970; Harper 1970; Sisler 1980; NGC 1982; McKendry 1988; McMann 1997.

LAPOINTE, ESTHER (b1947), Montréal, QC. Painter and sculptor. **Citations**: Lerner 1991; Tippett 1992.

LAROSE, LUDGER (1868-1915), Montréal, QC. Painter. Larose studied in Paris and, on his return to Montréal, taught art, painted landscapes, and did some church decoration. **Citations**: Harper 1966; MacDonald 1967; Thibault 1978; NGC 1982; Laliberté 1986; Reid 1988; McMann 1997.

LAST SUPPER. The Last Supper, part of the PASSION, is a continuing theme in RELIGIOUS ART and refers to the occasion of Christ's announcement of his betrayal. In Canadian art, a well known work having this theme is JEAN-BAPTISTE COTE's *Last Supper*, see Barbeau 1943, p. 5 and p. 7, and Hubbard 1960, p. 345. **Citations**: Barbeau 1943; Hubbard 1960; Osborne 1970; Ferguson 1967; Lerner 1991.

LATOUR, GEORGES (1877-1946), Montréal and Québec City, QC. Illustrator and painter. **Citations**: NGC 1982; Laliberté 1986; McMann 1997.

LATOUR, JACQUES. See LEBLOND dit LATOUR.

LATSCHAW, ABRAHAM (1799-1870), Waterloo County, ON. Painter, furniture maker, and designer. Latschaw, of Pennsylvanian German origins, was a folk artist whose work included decorative FRAKTUR paintings in watercolour, calligraphy, and furniture inlaid with tulips, trees and geometric designs. **Citations**: Bird 1977; Kobayashi 1985(2); McKendry 1988.

LAURE, PIERRE (1686-1738), Chicoutimi, QC. Painter. Laure, born in France, emigrated to Canada in 1711. He was a Jesuit Father and an amateur painter of religious works. In 1720 he was in charge of the mission of Saguenay, and built a chapel at Chicoutimi which he decorated with his own paintings. **Citations**: Barbeau 1957(Tresor); Harper 1966, 1970; NGC 1982; McKendry 1988.

LAVAL, BISHOP FRANCOIS de (1623-1708), Québec City, QC. In 1659 Laval was posted from France to Québec City as the first resident bishop, at a time when the Catholic Church was active in

artistic as well as educational and other cultural affairs. This was the BAROQUE era during the reign of Louis XIV, 1643-1715. He ordered the building of elaborately decorated churches, and encouraged religious painters such as HUGUES POMMIER, FRERE LUC, JEAN PIERRON, JEAN GUYON, and CLAUDE CHAUCHETIERE. Laval apparently founded an arts and crafts school in 1668 at Saint-Joachim near Sainte-Anne de Beaupré where, among other studies, sculpture, painting, gilding and church decoration was taught. JACQUES LEBLOND dit LATOUR is often associated with this institution. See Kalman 1994 (vol .1, p. 67 and note 110). Laval encouraged Jacques Leblond dit Latour to teach sculpture at the Séminaire de Québec. Laval retired in 1685, and died in Québec City in 1708. He had set a course to be followed for many years by the Catholic Church in promoting the arts, particularly painting, sculpture and church decoration. See Harper 1966, pp. 3-15 about painting in the age of Laval. **Citations**: Barbeau 1934(1), 1936; Traquair 1947; McInnes 1950; Gowans 1955; Palardy 1963; Harper 1966; Lord 1974; Marsh 1988; Reid 1988; Lerner 1991; Kalman 1994.

LAVALLEE, ANDRE. See ANDRE PAQUET.

LAVOIE, RENE (active early 20th century), Château-Richer, QC. Sculptor. Lavoie is a wood carver who is known for his naïve sculpture in POLYCHROMED wood of human figures, animals, shadow boxes and models. Sometimes his carved figures are arranged in pictures illustrating the daily lives of habitants, see NMM 1983, pl. 91 and 111. **Citations**: *Canadian Collector* 1979; NMM 1983; McKendry 1988.

LAW, GORDON (b1914), Oshawa, ON. Sculptor. Gordon Law is a folk artist whose naïve sculpture in POLYCHROMED wood includes people, animals, a circus, a Noah's ark, a carousel, figures from mythology and models. He is a son of IVAN LAW. **Citations**: CCFCS; Murray 1981; Kobayashi 1985(2); McKendry 1988.

LAW, IVAN (1885-1979), Oshawa, ON. Sculptor. After Ivan Law retired from farming, he carved over 600 naïve works in POLYCHROMED wood , most relating to rural scenes and including people, animals and models of farm vehicles. He was the father of GORDON LAW. **Citations**: Murray 1978; Price 1979; Kobayashi 1985(2); McKendry 1988; Lerner 1991.

LAWSON, ERNEST (1873-1939), Ontario; Halifax, NS; Newfoundland. Painter. Lawson was born in Nova Scotia but lived most of his life in the USA and France. He was a landscape painter and a member of the CANADIAN ART CLUB. **Citations**: MacTavish 1925; Price 1930; Robson 1932; Colgate 1943; Hubbard 1960, 1963, 1967; MacDonald 1967; Berry-Hill 1968; NGC 1982; Reid 1988; Duval 1990; Lerner 1991; McMann 1997.

LAWSON, JAMES KERR. See KERR-LAWSON, JAMES.

LAWSON, (Mrs) JAMES SHARP. See GRACE COOMBS.

LAWTON, ALFRED V. (1848-1929), Eganville, ON. Painter. Lawton, who emigrated from England, taught school in Eganville, gave violin lessons, and painted in his spare time. His most interesting paintings are naïve, detailed, narrative studies of logging scenes such as felling trees, squaring timbers, and preparing for the spring drive on the rivers - activities he had seen first hand in the Eganville area. He completed some large canvases such as the logging scene (64x100 cm) illustrated in McKendry 1983, pl. 45. Two of his paintings are in the collection of the NATIONAL GALLERY OF CANADA. **Citations**: NGC 1982; McKendry 1983, 1988.

LEAVER, R.D. (active 1877), Lanark County, ON. Painter and tinsel artist. Leaver is known for a naïve REVERSE PAINTING on glass which includes tinsel or FOIL work, and which he signed and dated (see Murray 1982, pl. 2, or McKendry 1983, pl. 159). **Citations**: Murray 1982; McKendry 1983, 1988.

LEBEL, MAURICE (1898-1963), Montréal, QC. Painter and wood ENGRAVER. Lebel studied with EDMOND DYONNET and WILLIAM BRYMNER, and in New York. His work is represented in the NATIONAL GALLERY OF CANADA. **Citations**: Laberge 1938; Bergeron 1946; MacDonald 1967; NGC 1982; Laliberté 1986; Lerner 1991; McMann 1997.

LE BER, JEANNE (1662-1724), Montréal, QC. Embroiderer. Le Ber lived as a recluse with the Sisters

of the Congregation, Montréal, but was known throughout New France for her decorative religious embroidery. She was a sister of PIERRE LE BER. **Citations**: De Brumath 1912; Barbeau 1942; Harper 1966; Hubbard 1967; McKendry 1988; Lerner 1991; Tippett 1992.

LE BER, PIERRE (1669-1707), Montréal, QC. Painter. In 1697, Pierre Le Ber, one of the earliest Canadian born painters, designed the Chapel of Sainte-Anne near Montréal and decorated it with his own paintings. He is best known for his portrait of Marguerite Bourgeoys, the foundress of the Congrégation of Notre Dame, Montréal, completed after her death in January 1700. It is an austere portrait, conceived in a flat pattern of whites, ochres and blacks. J. RUSSELL HARPER refers to this portrait as having an emotional impact that is timeless, and as being a MASTERPIECE of early Canadian painting. **Citations**: Harper 1966, 1970, 1973; Lord 1974; Gagnon 1976(1); Mellen 1978; NGC 1982; Kobayashi 1985(2); McKendry 1988; Reid 1988; Marsh 1988; Tippett 1992.

LEBLANC, LEO B. (b1914), Nôtre Dame, NB. Painter. Leblanc paints naïve views of houses, mills and other buildings. **Citations**: Laurette 1980 (2); NGC 1982; Vie des Arts 1984; Lerner 1991.

LEBLOND dit LATOUR, JACQUES (1670-1715), Baie-Saint-Paul, QC. Painter and sculptor. Leblond was brought from France to Québec by BISHOP LAVAL in 1695 to teach sculpture, perhaps at the SAINT-JOACHIM SCHOOL of Arts and Crafts. In 1706 he was ordained to priesthood by Bishop Laval and eventually was appointed priest at the new parish of Baie-Saint-Paul. He executed many portraits and religious paintings, as well as religious, decorative and figure sculptures in wood for churches. **Citations**: Barbeau 1934(1), 1957(Québec); Traquair 1947; Gowans 1955; Harper 1966, 1970; Hubbard 1967; NGC 1945, 1982; NGC 1982; Porter 1986; McKendry 1988.

LEDUC, FERNAND (b1916), Montréal, QC; Paris, France. Painter. Leduc studied in Montréal and in Paris. A member of the AUTOMATISTES, he signed the REFUS GLOBAL in 1948. His work is included in the collections of the NATIONAL GALLERY OF CANADA. See also SURREALISM. **Citations**: Hubbard 1960; Harper 1966; MacDonald 1967; Vie des Arts 1978; George 1980; Duquette 1980; NGC 1982; Burnett/Schiff 1983; Bringhurst 1983; Reid 1988; Marsh 1988; Lerner 1991.

LEE-NOVA, GARY (b1943), Vancouver, BC. Sculptor, film artist and painter. His work is represented in the NATIONAL GALLERY OF CANADA. **Citations:** MacDonald 1967; Heath 1976; NGC 1982; Lerner 1991.

LEDUC, OZIAS (1864-1955), Saint-Hilaire and Saint-Hyacinthe, QC. Painter and MURALIST. Leduc's paintings show great sensitivity to nature combined with an unusual ability to interpret the effect of light on his subject matter. See Ostiguy 1974 for illustrations of many examples of his work and an account of his life. He remained active throughout his long life and, at the age of ninety, was engaged in overseeing the decoration of a church. Several paintings by Leduc are in the NATIONAL GALLERY OF CANADA. See also SYMBOLISM. **Citations**: MacTavish 1925; Chauvin 1928; Maurault 1929; Robson 1932; Colgate 1943; Rainville 1946; Bergeron 1946; McInnes 1950; Hubbard 1960, 1967, 1973; MacDonald 1967; Harper 1966, 1970; Boggs 1971; Reid 1973; Vachon 1973; Ostiguy 1974, 1974(1); Duval 1974; Mellen 1978; Thibault 1978; Lacroix 1978; Sisler 1980; NGC 1982; Burnett/Schiff 1983; Laliberté 1986; Greenaway 1986; McKendry 1988; Marsh 1988; Lerner 1991; McMann 1997.

LEFORT, MARIE AGNES (1891-1973), Montréal, QC. Painter and art dealer. **Citations**: MacDonald 1967; NGC 1982; Lerner 1991; Tippett 1992; McMann 1997.

LEGARE, JOSEPH (1795-1855), Québec City, QC. Painter. Légaré was a self-taught painter, art collector, politician and, in 1833, the founder of Canada's first art gallery. Légaré's lack of formal training is evident in certain naïve characteristics in some of his work. He was involved in the restoration and copying of some thirty European academic paintings of the DESJARDINS COLLECTION, which had been brought to Québec from France during the French Revolution. This appears to have influenced the style of his religious paintings toward the styles and tastes of France. Légaré's paintings of historical subjects, landscapes and scenes of the life of native people are in a ROMANTIC style, but nevertheless have considerable Realistic NARRATIVE content. J. RUSSELL HARPER has said that: "Légaré is virtually the founder of Canadian landscape painting." (Harper 1966, p. 81). See

Porter 1978 for an illustrated CATALOGUE RAISONNE. Légaré's work is represented in the NATIONAL GALLERY OF CANADA. **Citations**: Bellerive 1925; Robson 1932; Colgate 1943; Morisset 1959; Hubbard 1960, 1967, 1973; Harper 1966, 1970, 1973; Carter 1967; MacDonald 1967; Lord 1974; Thibault 1978; Mellen 1978; Porter 1986; 1978; NGC 1982; McKendry 1983, 1988; Kobayashi 1985(2); Marsh 1988; Reid 1988; Béland 1992; Tippett 1992.

LEGAULT, JEAN (JOSEPH) ONESIME (1882-1944), Montée Saint-Michel, QC. Painter. He was one of the group of painters of MONTEE SAINT-MICHEL. **Citations**: NGC 1982; Laliberté 1986; Lerner 1991.

LEGENDRE, IRENE (b1904), Montréal, QC. Painter. **Citations**: NGC 1982; Tippett 1992; McMann 1997.

LEGER, ONESIME AIME (ANDRE) (1881-1924), Montréal, QC. Painter, illustrator and sculptor. **Citations**: Laberge 1938; Laliberté 1986; Lerner 1991; McMann 1997.

LEIGHTON, ALFRED CROCKER (1901-1965), Calgary, AB. Painter. Leighton emigrated from England in 1929, after studying painting in London and Paris. He painted landscapes, chiefly of the Rocky Mountains. He was the husband of BARBARA LEIGHTON. His work is represented in the NATIONAL GALLERY OF CANADA. **Citations**: Alberta 1931; IBM 1940; Hubbard 1960; Harper 1966; MacDonald 1967; Render 1971, 1974; Sisler 1980; NGC 1982; Burnett/Schiff 1983; Masters 1987; Lerner 1991; Tippett 1992; McMann 1997.

LEIGHTON, BARBARA HARVEY (b1911), Calgary, AB. Painter and printmaker. She was the wife of ALFRED CROCKER LEIGHTON. **Citations**: Render 1971; NGC 1982; Lerner 1991.

LEMIEUX, EMILE (1889-1967), Montréal, QC. Painter. Lemieux studied in New York and Paris. He was the artistic director of the T. Eaton Company for several years. **Citations**: MacDonald 1967; NGC 1982; Laliberté 1986; McMann 1997.

LEMIEUX, JEAN-PAUL (b1904), Montréal and Québec City, QC. Painter; RCA 1966. Lemieux studied with CHARLES MAILLARD, EDWIN H. HOLGATE and others, as well as in Paris. Lemieux's paintings reflect his love of Québec landscape and, in particular, of that of CHARLEVOIX COUNTY. Of the various influences which have affected Lemieux's art, one that can be identified is that of FOLK ART images. Marius Barbeau, when referring to the relation between Lemieux's work and primitive or folk-art imagery, wrote: "The spirit and naïveté of those images (folk art) furnish a clue to much of Lemieux's later work as a painter." (Barbeau 1946, p. 36). This applies particularly to his detailed, NARRATIVE paintings. He sometimes omitted parts of the roofs and walls of buildings in order to show simultaneously interior and exterior scenes, as is often done in naïve folk art (see Harper 1966, pl. 303). Lemieux collects early Québec folk art, and is active as a painter in the Québec City and Charlevoix County areas. His paintings of stylized figures looming large against rather barren Québec landscape recall a folk-art tradition. He has been commissioned to paint portraits of important public figures. Several paintings by Lemieux are in the NATIONAL GALLERY OF CANADA. See also HIERARCHICAL SCALE. **Citations**: Barbeau 1946, 1957(Québec); Buchanan 1950; McInnes 1950; Harper 1966; Hubbard 1960, 1967; Mendel 1964; D'Iberville 1967; MacDonald 1967; Robert 1968, 1978; Boggs 1971; Ostiguy 1971; Duval 1972; Lord 1974; Guy 1978(2); Marteau 1978; Vie des Arts 1978; Thibault 1978; Fenton 1978; Mellen 1978; Robert 1978; Sisler 1980; Baker 1981; NGC 1982; Bringhurst 1983; Burnett/Schiff 1983; Marsh 1988; McKendry 1988; Reid 1988; Lerner 1991; Tippett 1992; McMann 1997.

LEMIEUX, LISETTE (b1934), QC. Sculptor. **Citations**: NGC 1982; Lerner 1991.

LEMIEUX, LYSE (b1956), BC. Sculptor. **Citations**: NGC 1982; Lerner 1991.

LEMIEUX, MARGUERITE (1899-1971), Montréal, QC. Painter and sculptor. Lemieux studied with ALFRED LALIBERTE and EDMOND DYONNET, as well as in Paris. **Citations**: Levesque 1936; Laberge 1938; MacDonald 1967; NGC 1982; Laliberté 1986; Lerner 1991; McMann 1997.

LEMIEUX, MAURICE (b1932), Valleyfield, QC. Sculptor. **Citations**: MacDonald 1967; NGC 1982; Lerner 1991.

LEMOINE, EDMOND (EDMUND) (1877-1922), Québec City, QC. Painter. Lemoine studied under CHARLES HUOT and in Europe. He painted landscapes, portraits, habitant interiors and still lifes. An example of his work is in the NATIONAL GALLERY OF CANADA. **Citations**: Hubbard 1960; MacDonald 1967; NGC 1982; Laliberté 1986; McMann 1997.

LEMOYNE, BERTHE (1884-1958), Montréal, QC. Painter and illustrator. Lemoyne studied under WILLIAM BRYMNER, MAURICE CULLEN and ROBERT PILOT. **Citations**: Laliberté 1986; Tippett 1992.

LENHARDT, MOLLY (b1920), Melville, SK. Painter. Lenhardt's work is naïve and includes portrait paintings which are direct, flat, brightly coloured, frontal views of remembered Ukrainian women and men. She paints many local scenes and landscapes. **Citations**: Thauberger 1976; *artscanada* 1979; NGC 1982; Borsa 1983; NMM 1983; McKendry 1983, 1988; *Century Home* 1985; Kobayashi 1985(2); Lerner 1991; Tippett 1992.

LENNIE, EDITH BEATRICE CATHARINE (1904-87), Vancouver, BC. Sculptor, painter, MURALIST and teacher of art. She studied with F.H. VARLEY and J.W.G. MACDONALD. **Citations**: MacDonald 1967; NGC 1982; Lerner 1991; Tippett 1992; McMann 1997.

LEPAGE, FRANCOIS (act. 1800), Québec. Sculptor of church decorative carvings. **Citations**: Porter 1986.

LEPREVOST, PIERRE-GABRIEL (act. 1716), Québec. Sculptor of religious works in wood. **Citations**: Porter 1986.

LEPROPHON, JULES (1877-1949), Montréal, QC. Sculptor. **Citations**: Laliberté 1986.

LEROUX, ANTONIO (1880-1940), Montréal, QC. Sculptor. Leroux worked with ARTHUR VINCENT. **Citations**: Laliberté 1986.

LETENDRE, RITA (b1929), Montréal, QC. Painter, printmaker and MURALIST. Letendre was influenced by PAUL-EMILE BORDUAS and the AUTOMATISTES. She is well known for her large interior and exterior MURALS. Her husband is the sculptor KOSSO ELOUL. See ULYSSE COMTOIS. **Citations**: Harper 1966; MacDonald 1967; Vie des Arts 1978; Sisler 1980; NGC 1982; Burnett/Schiff 1983; Reid 1988; Marsh 1988; Lerner 1991; Tippett 1992; McMann 1997.

LEVASSEUR FAMILY. See NOEL LEVASSEUR.

LEVASSEUR, NOEL (1680-1740), Montréal and Québec City, QC. Sculptor. Noël Levasseur was the father of François-Noël Levasseur and Jean-Baptiste-Antoine Levasseur who, along with their cousin Pierre-Noël Levasseur, worked in Noël Levasseur's shop carving religious figures and ALTARPIECES. The Levasseurs were involved in the ornamentation of the chapel of the URSULINE CONVENT of Québec City with its magnificent altarpiece and pulpit. **Citations**: Traquair 1947; McInnes 1950; Gowans 1955; Barbeau 1957(Québec); Hubbard 1967; MacDonald 1967; Lavallée 1968; Trudel 1969; Boggs 1971; Gauthier 1974; Mellen 1978; Porter 1986; McKendry 1988; Marsh 1988; Lerner 1991.

LEVINE, LESLIE (LES) LEOPOLD (b1936), Toronto, ON; New York. Sculptor, mixed media artist, photographer and printmaker. **Citations**: Hubbard 1967; MacDonald 1967; Russell 1970; Townsend 1970; NGC 1982; Burnett/Schiff 1983; Lerner 1991.

LEVINGE, Sir RICHARD GEORGE AUGUSTUS (1811-1884), Ontario, Québec and the maritime provinces. Painter. Levinge was with the British army and made TOPOGRAPHICAL landscape, GENRE and native people paintings, as well as writing about his experiences in Canada. Some of his sketches were engraved and published in his books. **Citations**: Spendlove 1958; Carter 1967; Harper 1964, 1966, 1970; Bell 1973; Allodi 1974; NGC 1982; McKendry 1988; Cavell 1988.

LEWIS, EVERETT (1893-1980), Marshalltown, NS. Painter. Lewis painted naïve landscapes, animals and maritime scenes in acrylic. He was the husband of MAUD LEWIS. **Citations**: Elwood 1976; Kobayashi 1985(2); McKendry 1988.

LEWIS, HERBERT B. (active 1886), Rocky Mountain area, Canada. Painter. Lewis, born in South Wales, came to Canada and for a time worked for the Canadian Pacific Railway; then he moved to California. Some of his Rocky Mountain paintings are illustrated in Render 1974. **Citations**: Render

1974; McMann 1997.

LEWIS, MAUD (1903-70), Marshalltown, NS. Painter. When Maud Lewis was a child, her arms were crippled and her hands deformed by polio. At eighteen she married EVERETT LEWIS. They were very poor and made daily rounds peddling fish. Maud painted Christmas cards which she sold for a few cents each. Later she began painting brightly coloured flowers, birds and butterflies on various parts of their small house. Everett bought oil paints for her and, with his encouragement, she began painting small, decorative, brightly coloured paintings that sold for a few dollars. Maud's compositions are quite sophisticated and are executed with much charm in flat patterns of colour taken directly from the tube. Her work can be seen at the ART GALLERY OF NOVA SCOTIA . **Citations**: Elwood 1976; NGC 1982; Kobayashi 1985 (2); Greenaway 1986; McKendry 1988; Lerner 1991; Woolaver 1996.

LIEBERT (LEBER), PHILLIPPE (1732 or 1734-1804), Montréal, QC. Sculptor and painter. Liebert painted naïve portraits and carved religious figures in wood (gilded), as well as making ALTARS for churches. **Citations**: Morisset 1943; Traquair 1947; Hubbard 1967; Trudel 1967(Sculpture); MacDonald 1967; Lavallée 1968; Trudel 1969; Harper 1970; Lessard 1971; Porter 1986; McKendry 1988; Lerner 1991.

LILY. The lily is a symbol of purity and chastity. **Citations**: Ferguson 1967; Pierce 1987.

LIMNER. This term is derived from "luminer" which was used in the Middle Ages for an illuminator of manuscripts. It came to mean a painter of MINIATURE PORTRAITS and, sometimes, painters generally. The term is seldom used today. See Bihalji-Merin 1971, p. 42, for an account of the American limners. See JOHN RAMPAGE. **Citations**: Osborne 1970; Bihalji-Merin 1971; Hill 1974; Piper 1988; Chilvers 1988.

LIMNERS (THE). A group of artists formed in 1972 in Victoria, BC, called "The Limners". Among the members were MAXWELL BATES, RICHARD CICCIMARRA and ROBERT DE CASTRO. **Citations**: Skelton 1972; Lerner 1991.

LINDNER, ERNEST (1897-1988), Saskatoon, SK. Painter, printmaker and MURALIST. Lindner emigrated from Austria to Canada in 1926, and settled in Saskatchewan as a farm labourer. By 1931 he had won recognition as an artist and is known for his watercolours, as well as LINOCUT and WOODCUT prints. Lindner's work is represented in the ART GALLERY OF ONTARIO. **Citations**: Colgate 1943; Duval 1952, 1972, 1974; Mendel 1964; Harper 1966; Climer 1967; MacDonald 1967; Fenton 1971; Render 1974; Lord 1974; Walters 1975; Dillow 1975; Heath 1976; Fenton 1978; Mellen 1978; Morris 1980; Christie 1980; Sisler 1980; NGC 1982; Burnett/Schiff 1983; Bringhurst 1983; Reid 1988; Marsh 1988; Lerner 1991; McMann 1997.

LINDSTROM, MATT (1890-1975), Edmonton and Calgary, AB. Painter. Lindstrom emigrated from Sweden in 1929 and settled near Edmonton. After 1945 he received some instruction and began painting full time. **Citations**: NGC 1982; MacDonald 1967; Masters 1987.

LINE. A mark or stroke which is long in proportion to its breadth. See also LINEAR. **Citations**: Pierce 1987.

LINEAR. A term often associated with NEOCLASSICISM and sometimes used to describe a work of art in which forms and rhythms are represented chiefly in terms of LINE. Linear may be used as an opposite to PAINTERLY. Northwest coast native artists often used curvilinear black or coloured lines in their designs. This is also important for NORVAL MORRISSEAU

LINEAR PERSPECTIVE. See GEOMETRIC PERSPECTIVE.

LINE ENGRAVING. An INTAGLIO method of engraving with a BURIN for the purpose of making PRINTS. **Citations**: Osborne 1970; Lucie-Smith 1984; Chilvers 1988; Lerner 1991.

LINNEN (LINEN), JOHN (c1800-c1863), Toronto, ON. Painter. Linnen was a portrait and figure painter who was in Toronto by 1834 and later in the USA. **Citations**: Harper 1966, 1970; NGC 1982; Reid 1988.

LINOCUT. A 20th-century relief printing process, similar to WOODCUT. One uses linoleum and tools such as a BURIN, and the resulting print is called a linocut. See also ERNEST LINDNER.

Citations: Osborne 1970; Piper 1988.

LINSEED OIL. A drying oil, from the seeds of flax, used in OIL PAINTING; usually diluted with TURPENTINE. **Citations**: Osborne 1970; Mayer 1970; Piper 1988.

LISMER, ARTHUR (1885-1969), Halifax, NS; Toronto, ON; Montréal, QC. Painter; RCA 1947. Lismer came to Toronto from England in 1911 and, in 1920, became one of the original members of the GROUP OF SEVEN. He taught art in Toronto, Ottawa and Montréal, and had a particular interest in teaching children. Lismer painted the landscape of various parts of Canada. **Citations**: MacTavish 1925; Lismer 1926, 1953; Robson 1932; NGC 1936,1982; Colgate 1943; MacDonald 1944, 1967; Buchanan 1945, 1950; McInnes 1950; Harper 1955, 1966; Pilot 1956; Jackson 1958; Hubbard 1960, 1973; Mendel 1964; Davies 1967; Adamson 1969; Reid 1969, 1970, 1988; Mellen 1970, 1978; Boggs 1971; McLeish 1973; Duval 1965,1972, 1973, 1990; Housser 1974; Lord 1974; Watson 1974; Hill 1974, 1995; Town 1977; Bridges 1977; Thibault 1978; Fenton 1978; Laing 1979, 1982; Sisler 1980; Darroch 1981; Burnett/Schiff 1983; Thom 1985; Piper 1988; Marsh 1988; Lerner 1991; Tippett 1992; Silcox 1996; McMann 1997.

LITHOGRAPH. See LITHOGRAPHY.

LITHOGRAPHY. Lithography was invented in 1798 by the Bavarian writer Aloy Senefelder (1771-1834) as a way of reproducing his plays. When practiced by artists, it is a method of surface printing from stone in which the design is drawn on the flat surface of a special lithographic stone and, by making use of the antipathy of grease and water, the design is transferred to paper to form PRINTS. Modern commercial applications of the process include colour lithography (chromolithography). See also OFFSET. **Citations**: Plowman 1922; Spendlove 1958; Mayer 1970; Osborne 1970; Harper 1970; Hill 1974; Tovell 1974; Eichenberg 1978; Chilvers 1988; Piper 1988; Lerner 1991.

LITZGUS, HAZEL (b1927), Lloydminster, AB. Painter. Litzgus painted naïve landscape scenes in watercolour of her memories of farm life. **Citations**: Harper 1973, 1974; NGC 1982; Kobayashi 1985(2); McKendry 1988.

LMS. See LIONEL MCDONALD STEPHENSON.

LOATES, MARTIN GLEN (b1946), Toronto and Maple, ON. Painter. Loates is a well known nature artist. In his early years, he received instruction and encouragement from FREDERICK HENRY BRIGDEN. Loates' work is detailed and accurate in depicting many aspects of wild life. He usually works in watercolours. **Citations**: MacDonald 1967; Duval 1977; Sisler 1980; NGC 1982; Warner 1984; Lerner 1991; McMann 1997.

LOCHHEAD, KENNETH CAMPBELL (b1926), Regina, SK; Ottawa, ON. Painter. Lochhead was one of the REGINA FIVE artists and was involved with the establishment of the EMMA LAKE ARTISTS' WORKSHOP. For some years his paintings were nonfigurative and abstract; in the 1970s he introduced recognizable subject matter into his work. See Withrow 1972 for illustrations and an account of Lochhead's pre-1971 work. Lochhead's paintings are represented in the NATIONAL GALLERY OF CANADA. **Citations**: Hubbard 1960; Simmins 1961; Eckhardt 1962; Mendel 1964; Harper 1966; MacDonald 1967; Townsend 1970; Duval 1972; Withrow 1972; Lord 1974; Fenton 1978; Mellen 1978; NGC 1982; Brinhurst 1983; Burnett/Schiff 1983; Marsh 1988; Reid 1988; Lerner 1991; McMann 1997.

LOCK, FREDERICK W. (active 1843-60), Montréal, QC; Brockville, ON. Painter. Lock painted views of Niagara Falls, the Thousand Islands, Chaudiere Falls and the Brockville area. One of his works, *Niagara Falls, Winter View* 1856, is the subject of a LITHOGRAPH, illustrated on p. 23 of Cavell 1988. **Citations**: Harper 1964, 1970; Allodi 1974; NGC 1982; Cavell 1988; McKendry 1988.

LOCKERBY, MABEL IRENE (1887-1976), Montréal, QC. Painter. She studied under WILLIAM BRYMNER and MAURICE CULLEN, and was a member of the BEAVER HALL HILL group. Paintings by Lockerby are in the NATIONAL GALLERY OF CANADA. **Citations**: Robson 1932; Hubbard 1960; MacDonald 1967; NGC 1982; Reid 1988; Tippett 1992; Hill 1995; McMann 1997.

LOCKWOOD, WILLIAM (c1803-c1866), Toronto, ON; Montréal and Québec City, QC. Painter. In 1833 in Québec City, Lockwood was associated with JOHN POPPLEWELL in teaching POONAH

painting, MEZZOTINTING, JAPANNING, Chinese painting, painting on velvet and satin, painting MINIATURES on ivory or bristol board, and cutting profiles in black or bronze. It appears that he worked periodically as an ITINERANT ARTIST. **Citations**: Carter 1967; Harper 1970; NGC 1982; McKendry 1988; Farr 1988.

LONEY, WILLIAM GLENWORTH (1878-1956), South Bay, Prince Edward County, ON. Sculptor and painter. After his wife's death in 1943, Loney retired from his labours as a blacksmith and filled his time with carving, painting and exhibiting his work at country fairs. An auction sale was held in 1956 shortly after his death, and it was discovered that he left many sculptures and paintings. Loney's subject matter included local scenes translated into naïve DIORAMAS, decorative bird houses, flowers, animals, birds and people. His work was executed with accuracy and style. **Citations**: Harper 1974; NMM 1983; *Upper Canadian* 1983; McKendry 1983, 1988; Kobayashi 1985(2); *Canadian Art* Spring 1985.

LONG, MARION (1892-1970), Toronto, ON. Portrait painter; RCA 1933. She studied under G.A. REID, LAURA MUNTZ LYALL and in New York. A portrait by Long is in the NATIONAL GALLERY OF CANADA. **Citations**: Colgate 1943; Jackson 1958; Hubbard 1960; Sisler 1980; NGC 1982; Lerner 1991; Tippett 1992; Hill 1995; McMann 1997.

LONG, VICTOR ALBERT (1866-1939), Winnipeg, MB; Vancouver, BC. Portrait painter. He studied in Paris, Munich and Italy. **Citations**: MacDonald 1967; Eckhardt 1970; Harper 1970; NGC 1982.

LORING, FRANCES NORMA (1887-1968), Toronto, ON. Sculptor; RCA 1947. She studied in Geneva, Munich, Paris and the USA. Several sculptures by Loring are in the NATIONAL GALLERY OF CANADA, and include a head of SIR FREDERICK BANTING. See PEDERY-HUNT. **Citations**: Jackson 1958; MacDonald 1967; Sisler 1972, 1980; Tippett 1992; Hill 1995; McMann 1997.

LORNE, MARQUESS OF (John Douglas Sutherland Campbell) (1845-1914), Ottawa, ON. Painter, illustrator and sculptor. The Marquess of Lorne was Governor General of Canada 1878-83, and travelled to many parts of the country during that time. A number of his sketches, which included some native people scenes, were reproduced in his publications. He was instrumental in forming the ROYAL CANADIAN ACADEMY. Lorne was married to the PRINCESS LOUISE. **Citations**: Lorne 1885; Colgate 1943; Buchanan 1950; McInnes 1950; Eckhardt 1970; Harper 1966, 1970; Boggs 1971; Lord 1974; Watson 1974; Reid 1979; Sisler 1980; Gilmore 1980; NGC 1982; McKendry 1988; Marsh 1988; Lerner 1991; Tippett 1992; Hill 1995.

LOUIS III. King of France 1610-43. In QUEBEC DECORATIVE ARTS there were aspects of the RENAISSANCE style combined with MEDIEVAL. This style was influential in the 17th and early 18th centuries. **Citations**: Palardy 1963; Fleming 1994.

LOUIS XIV. See BAROQUE, LAVAL.

LOUIS XV. See ROCOCO.

LOUIS XVI. See NEOCLASSICAL.

LOUISE, Princess (1848-1939), Ottawa, ON. Painter, illustrator and sculptor. Princess Louise, Queen Victoria's fourth daughter and an amateur artist, was born and lived most of her life in England. She came to Canada in 1878 as the wife of the MARQUESS OF LORNE and some of her work was published in his publications. Lorne was governor general of Canada 1878-83. **Citations**: Withrow 1889; McInnes 1950; Harper 1966, 1970; Boggs 1971; Watson 1974; Reid 1979; Sisler 1980; McKendry 1988; Tippett 1992.

LOVE, Lady MARY HEAVISIDE(active 1806-86), Saint John, NB. Painter, illustrator and LITHOGRAPHER. She made many sketches of scenery in New Brunswick and Québec - some were published as LITHOGRAPHS. **Citations**: MacDonald 1967; Harper 1970; NGC 1982; Lerner 1991; Tippett 1992.

LOWE, FREDERIC C. (active 1843-56), Toronto, ON. ENGRAVER. Lowe was a predecessor of the firm of Rolph-Clark-Stone of Toronto. He engraved portraits of many Torontonians, and exhibited drawings of cattle in crayon and WOOD ENGRAVINGS. He was a member of the TORONTO SOCIETY OF ARTS. **Citations**: De Volpi 1965; Harper 1970; McKendry 1988; Lerner 1991.

LOWER CANADA. See Québec.

LUC, FRERE (CLAUDE FRANCOIS) (1614-85), Québec City, QC. Painter. Claude François studied in Paris and Rome, and copied many religious paintings. He became a member of the Order of Recollets and assumed the religious name Frère Luc. From August 1670 to October 1671, he was in Québec designing the chapel for the rebuilt Recollet monastery, now the oldest chapel in Canada and part of the Hôpital-Général. While in Québec, Frère Luc executed many religious paintings and a few portraits. He returned to France in 1671, but continued to paint pictures for Canadian churches. Frère Luc borrowed heavily from other artists and painted in the BAROQUE style; it has been said that his figures are sometimes wooden and his groupings uninspired (Harper 1966, p. 11). Nevertheless, because his canvases were a good deal more sophisticated than any seen previously in New France, he influenced public taste as well as the style of artists who followed. For illustrations of Frère Luc's work, see Harper 1966, pl. 1, 5-9. **Citations**: Robson 1932; Morisset 1936, 1944; NGC 1945, 1982;McInnes 1950; Gowans 1955; Barbeau 1957(Québec); Harper 1966, 1970; Hubbard 1960(1), 1967; MacDonald 1967; Trudel 1967(Peinture); Lord 1974; Gagnon 1976(1); Mellen 1978; McKendry 1983, 1988; Marsh 1988; Reid 1988; Lerner 1991; Tippett 1992.

LUCCA. See DE LUCCA, YARGO DEITER MUELLER.

LUKE, ALEXANDRA (MARGARET ALEXANDRA LUKE MCLAUGHLIN) (1901-67), Oshawa, ON. Painter. Luke was principally self-taught but worked for a time with A.Y. JACKSON and JOCK MACDONALD at the BANFF SCHOOL OF FINE ARTS, and later with HANS HOFMANN. She was a member of the group PAINTERS ELEVEN. **Citations**: CGP 1933; Harper 1966; MacDonald 1967; Duval 1972; NGC 1982; Bringhurst 1983; Burnett/Schiff 1983; Reid 1988; Lerner 1991; Tippett 1992.

LUMINISTS (LUMINIST MOVEMENT; LUMINISM). A group of American landscape painters of the mid-19th century who were concerned with light and atmospheric effects. The group included J.F. Kensett (1816-72), F.E. Church (1826-1900), S.R. Gifford (1823-80), F.H. Lane (1804-65), Thomas Cole (1801-48), A.B. Durand (1796-1886), George Innes (1825-94), David Johnson (1827-1908), Thomas Eakins (1844-1916), and many others. A Canadian painter influenced by luminism was LUCIUS O'BRIEN. See also HUDSON RIVER SCHOOL. **Citations**: Wilmerding 1980; Piper 1988; Chilvers 1988; Read 1994.

LYALL (MUNTZ), LAURA ADELINE (1860-1930), Toronto, ON. Painter. Lyall studied with J.W.L. FORSTER and in Paris. She painted mothers and children, as well as portraits and landscapes. Her paintings are represented in the NATIONAL GALLERY OF CANADA. **Citations**: MacTavish 1925; Robson 1932; Colgate 1943; Hubbard 1960; Harper 1966, 1970; MacDonald 1967; Sisler 1980; McMann 1997; NGC 1982; Duval 1990; Lerner 1991; Tippett 1992; McMann 1997.

LYMAN, JOHN GOODWIN (1886-1967), Montréal, QC. Painter and author. Lyman studied in Paris with HENRI MATISSE, and later founded the CONTEMPORARY ARTS SOCIETY. He travelled widely and painted in several countries. Although Lyman's paintings were not well received by the public, he did have considerable influence on other painters. See Dompierre 1986 for the most complete account of Lyman's work with numerous illustrations. Several paintings by Lyman are in the NATIONAL GALLERY OF CANADA. **Citations**: Dumas 1944; McInnes 1950; Buchanan 1950; McInnes 1950; Hubbard 1960, 1967; Harper 1966; MacDonald 1967; Duval 1972; Watson 1974; Lord 1974; Ayre 1977; Mellen 1978; Thibault 1978; Fenton 1978; Varley 1980; NGC 1982; Burnett/Schiff 1983; Bringhurst 1983; Dompierre 1986; Marsh 1988; Reid 1988; Lerner 1991; McMann 1997.

LYNN, WASHINGTON FRANK (1836-1906), Winnipeg, MB. Painter. Lynn, who had studied art in England, is thought to be the first professionally trained artist to reside in Winnipeg. Eckhardt writes that Lynn's paintings "show certain human qualities blended with naïveté and primitiveness." (Eckhardt 1970, p. 11). Lynn's work included portraits, landscapes and TOPOGRAPHICAL views with figures including native people. **Citations**: Harper 1966, 1970; *Canadian Collector* 1970; Eckhardt 1970; NGC 1982; McKendry 1988; Lerner 1991.

LYRICAL ABSTRACTION. A vague term sometimes used for a lush and sumptuous use of colour in an ABSTRACT painting. See JEAN ALBERT MCEWAN; RALPH ALLEN. **Citations**: Guy 1964;

Chilvers 1988.
LYTTLETON, WESTCOTT WITCHURCH LEWIS (1818-79), Halifax, NS. Painter. Lyttleton was a TOPOGRAPHER with the British Army stationed in Halifax 1840-3 and 1849-66. At least two of his views of Halifax were LITHOGRAPHED. **Citations**: Harper 1966, 1970; Allodi 1974; Carter 1975; NGC 1982; McKendry 1988; Lerner 1991.

M

MCCALLUM, DON (b1919), Kingston, ON. Painter, musician and photographer. McCallum studied under GOODRIDGE ROBERTS and ANDRE BIELER. He began serious work as a painter in the early 1960s, and has painted many watercolours of the Kingston area. **Citations**: NGC 1982; Farr 1988.

MACCALLUM, Dr JAMES METCALFE (1860-1943), Toronto, ON. Art collector and physician. In 1913-14 Dr MacCallum and LAWREN HARRIS financed and arranged the building of the STUDIO BUILDING on Severn Street near the Rosedale Ravine in Toronto. The building had six large studios with northern light and eighteen foot ceilings. It was used by members of the GROUP OF SEVEN and others. Dr MacCallum invited several of the artists to paint in the Georgian Bay area, where he had a summer home on an island (now known as West Wind Island) in Go-Home Bay. He was president of the ARTS AND LETTERS CLUB 1916-18. Dr MacCallum's bequest to the NATIONAL GALLERY OF CANADA included eighty-five sketches and canvases by TOM THOMSON, see Reid 1969. See also HARRY and MARY JACKMAN. **Citations**: MacTavish 1925; Mellors 1937; Colgate 1943; McInnes 1950; Buchanan 1950; Jackson 1958; Davies 1967; Groves 1968; Reid 1969, 1988; Addison 1969; Reid 1969; Mellen 1970; Murray 1971, 1994; Boggs 1971; Housser 1974; Lord 1974; Town 1977; Duval 1978; Laing 1979, 1982; Darroch 1981; Fulford 1982; McMichael 1986; Lerner 1991; Hill 1995.

MCCARGAR, WILLIAM C. (1906-80), Regina, SK. Painter. McCargar worked for the Canadian Pacific Railway until he retired and started painting in 1958. The artist KENNETH LOCHHEAD, who was a neighbour, advised McCargar to throw away a paint-by-number set and follow his own intuition. McCargar's naïve compositions often include a railway line vanishing into the distance, showing a sense of perspective developed during his daily contact with the railway. He had a few basic compositions which, with small variations, he repeated several times, as well as making numerous postcard-size versions. A retrospective exhibition on McCargar was held in 1987 at the DUNLOP ART GALLERY. **Citations**: Thauberger 1976; *artscanada* 1979; NGC 1982; Borsa 1983; *Canadian Art*, Fall 1987; McKendry 1988.

MACCARTHY, COEUR-DE-LION (1881-1979), Ottawa, ON; Montréal, QC. Sculptor. MacCarthy, was a son of the sculptor HAMILTON PLANTAGENET MACCARTHY. He worked with his father in Ottawa prior to moving to Montréal about 1918 and establishing his own studio. **Citations**: MacDonald 1967; NGC 1982; Laliberté 1986; McMann 1997.

MCCARTHY, DORIS JEAN (b1910), Toronto, ON. Painter; RCA 1974. McCarthy studied under ARTHUR LISMER, J.E.H. MACDONALD, J.W. BEATTY and EMANUEL HAHN. **Citations**: MacDonald 1967; Sisler 1980; NGC 1982; Masters 1987; Lerner 1991; Tippett 1992; McMann 1997.

MACCARTHY, HAMILTON THOMAS CARLETON PLANTAGENET (1846-1939), Ottawa, ON. Sculptor; RCA 1892. MacCarthy was the sculptor of a number of monuments including the head of a child, now in the NATIONAL GALLERY OF CANADA. He was the father of COEUR-DE-LION MACCARTHY. **Citations**: Colgate 1943; Hubbard 1960; MacDonald 1967; Sisler 1980; NGC 1982; Laliberté 1986; Lerner 1991; McMann 1997.

MCCAUGHERTY, IRENE (b1914), Lethbridge, AB. Painter. McCaugherty's naïve watercolour paintings depict scenes of rural Alberta such as a rodeo, a shingling bee, a round-up, or an auction sale. **Citations**: NGC 1982; Stebbins 1982; Tippett 1992.

MACAULEY, S.S. (active 1861-69), Trois-Rivieres, QC. Painter Macauley painted figure studies as well as autumn and winter landscapes in the manner of CORNELIUS KRIEGHOFF. He was the local member of Parliament. **Citations**: Harper 1970, 1979; McKendry 1988.

MACCRAE, GEORGE (active 1783-1802), Halifax, NS. Portrait painter. MacCrae was in Halifax from 1783-1802. He returned to Scotland in 1802. **Citations**: Harper 1966, 1970; NGC 1982.

MACDONALD, GRANT KENNETH (1909-87), Kingston, ON. Painter, portraitist, illustrator and theatre set designer; RCA 1966. He studied in Toronto, ON; London, England; and in New York. MacDonald is well known for his theatrical and military portraits. His work is represented in the collections of the ART GALLERY OF ONTARIO , Toronto, and the AGNES ETHERINGTON ART CENTRE, Kingston, ON. **Citations**: McInnes 1950; Duval 1952; MacDonald 1967; Smith 1968; Adamson 1969; Bradfield 1970; Sisler 1980; NGC 1982; Farr 1988; Lerner 1991; McMann 1997.

MACDONALD, J. See THOMAS MACDONALD.

MACDONALD, JAMES ALEXANDER STIRLING (b1921), Vancouver, BC. Painter, sculptor and art teacher. He studied in Switzerland and under B.C. BINNING, JACK SHADBOLT, C.H. SCOTT and others. His work is represented in the NATIONAL GALLERY OF CANADA and the Vancouver Art Gallery. **Citations**: Hubbard 1960; MacDonald 1967; NGC 1982; Lerner 1991.

MACDONALD, JAMES EDWARD HERVEY (J.E.H.) (1873-1932), Hamilton, Toronto and Thornhill, ON. Painter; RCA 1932. J.E.H. MacDonald studied under WILLIAM CRUIKSHANK and GEORGE A. REID, and in London, England. He was one of the founders of the GROUP OF SEVEN and the CANADIAN GROUP OF PAINTERS. MacDonald's best works are colourful and elegant stylizations of Canadian landscape, in particular of Algoma, north of Lake Superior, which he visited in the company of LAWREN HARRIS. For the most complete account of his life and work, see Duval 1978. He was the father of THOREAU MACDONALD. See also SCANDINAVIAN ART SHOW. **Citations**: MacTavish 1925; Robson 1932, 1937(2); NGC 1936, 1982; Hunter 1940; Pierce 1940, 1949; Colgate 1943; Buchanan 1945, 1950; McInnes 1950; Jackson 1958; Hubbard 1960; Mendel 1964; Harper 1966; MacDonald 1967,1979; Groves 1968; Reid 1969, 1970, 1988; Mellen 1970, 1978; Boggs 1971; Duval 1972, 1973, 1978, 1990; McLeish 1973; Lord 1974; Housser 1974; Town 1977; Fenton 1978; Laing 1979, 1982; Sisler 1980; Osborne 1981; Thom 1985; McMichael 1986; Marsh 1988; Chilvers 1988; Sabean 1989; Lerner 1991; Tippett 1992; Hill 1995; Silcox 1996; McMann 1997.

MACDONALD, JAMES WILLIAMSON GALLOWAY (JOCK) (1897-1960), Vancouver, BC; Toronto, ON. Painter. Jock Macdonald studied under HANS HOFFMAN. He accompanied FREDERICK VARLEY on sketching trips and was influenced by the GROUP OF SEVEN. Although he was basically a landscape painter, much of his work is ABSTRACT. He was a founding member of the CANADIAN GROUP OF PAINTERS and a member of PAINTERS ELEVEN. **Citations**: CGP 1933; Duval 1954, 1972; Hubbard 1960; Harper 1966; Mellen 1970; Withrow 1972; Lord 1974; Mellen 1978; Fenton 1978; Laurette 1978; Sisler 1980; Zemans 1981; Murray 1981(4); Osborne 1981; NGC 1982; Bringhurst 1983; Burnett/Schiff 1983; Varley 1983; Piper 1988; Marsh 1988; Chilvers 1988; Lerner 1991; Tippett 1992; Silcox 1996; McMann 1997.

MACDONALD, THOMAS (active 1825-37), Gagetown and Fredericton, NB. Painter. Thomas MacDonald painted naïve portraits using, in the background, flat, decorative, detailed patterns and bright colours. One example of his work is illustrated in Harper 1966, pl. 97, where it is incorrectly attributed to J. MacDonald. Other examples are shown in Harper 1974, pl. 37 and 57. Several examples of Thomas MacDonald's work have survived. **Citations**: Hubbard 1967; Harper 1966, 1973, 1974; *Canadian Collector* 1974; Dobson 1982; NGC 1982; Kobayashi 1985(2); McKendry 1988.

MACDONALD, THOMAS REID (1908-78), Hamilton, ON. Painter, portraitist, curator; RCA 1960. He studied under ADAM SHERRIFF SCOTT and EDMOND DYONNET, and in Europe. MacDonald was the director and curator of the Art Gallery of Hamilton 1947-73 and a prolific painter. His work is represented in the NATIONAL GALLERY OF CANADA. **Citations**: Hubbard 1960; MacDonald 1967; Beament 1968; Oko 1980; Sisler 1980; NGC 1982; Lerner 1991; McMann 1997.

MACDONALD, THOREAU (b1901), Thornhill, ON. Illustrator and painter. Thoreau MacDonald is a son of J.E.H. MACDONALD, from whom he took lessons. He suffered from colour blindness causing him to work mainly in black and white. He was a founding member of the CANADIAN GROUP OF PAINTERS. **Citations**: Robson 1932; Hunter 1942; Colgate 1943; McInnes 1950; Duval 1952, 1972; 1973; Harper 1955; Hubbard 1960; MacDonald 1944; 1967, 1980; FitzGerald 1964; Addison 1969; Adamson 1969; Mellen 1970; Edison 1973; Duval 1978; NGC 1982; Marsh 1988; Reid 1988; Sabean 1989; Lerner 1991; McMann 1997.

MCDOUGALL, CLARK HOLMES (1921-80), St Thomas, ON. Painter. McDougall was largely self-taught and painted scenes in the St Thomas and London area. He used saturated colours with forms separated by heavy lines. **Citations**: MacDonald 1967; Woodman 1977; NGC 1982; Reid 1988; Lerner 1991.

MCEWAN, JEAN ALBERT (b1923), Montréal, QC. Painter; RCA 1968. Although mainly self-taught, McEwan studied in Paris, where he knew JEAN-PAUL RIOPELLE, and later was influenced by the work of PAUL-EMILE BORDUAS. He has been referred to as a LYRICAL ABSTRACTIONIST. **Citations**: Harper 1966; MacDonald 1967; Duval 1972; Fenton 1978; Sisler 1980; NGC 1982; Bringhurst 1983; Burnett/Schiff 1983; Reid 1988; Marsh 1988; Lerner 1991; McMann 1997.

MCGILLIVRAY, FLORENCE HELENA (1864-1938), Whitby and Ottawa, ON. Painter and teacher at the Ontario Ladies College in Whitby. She studied under WILLIAM CRUIKSHANK and others, as well as in Paris. **Citations**: Robson 1932; Hubbard 1960; Harper 1970; Bradfield 1970; MacDonald 1967; Sisler 1980; NGC 1982; McMann 1997.

MCGREGOR, EDWARD (EDWIN) (active 1847-72), Toronto, ON. Painter. McGregor was an ITINERANT painter of portraits who was in Toronto in 1847 in partnership with THOMAS H. STEVENSON. McGregor was a member of the TORONTO SOCIETY OF ARTS. **Citations**: Harper 1966, 1970; NGC 1982; Lerner 1991.

MCINNES, HARVEY A. (b1904), Zealandia, SK. Naïve painter. McInnes has commented extensively on his own work: "I've been more or less retired (from farming) since 1972. Most of my art work has been done in the last ten or twelve years a lot of my pictures are made up just from scenery and things I remember from away back. Some of them I make entirely just using my imagination I save small animal pictures sometimes and use them with my own makeup of scenery for a picture." In 1981, he said: "I didn't do anything more (painting) until about 1965, when I started doing a little oil painting as a winter pastime and and experimenting with pastels. For some time now, I've been working with a combination of pastels, coloured pencil and lead pencil. I like detail in pictures I like the outdoors and things of nature, especially animals, and try to portray them as naturally as possible in my pictures." **Citations**: Thauberger 1976; *artscanada* 1979; NGC 1982; NMM 1983; Borsa 1983; McKendry 1988; Lerner 1991.

MCKAY, ARTHUR FORTESCUE (b1926), Regina, SK. Painter. Many of McKay's paintings are non-objective complex patterns such as that illustrated in Reid 1988, p. 282. He was one of the REGINA FIVE. **Citations**: Simmins 1961; Mendel 1964; Harper 1966; Climer 1967; MacDonald 1967; Duval 1972; Fenton 1978; Murray 1979(4); NGC 1982; Bringhurst 1983; Burnett/Schiff 1983; Reid 1988; Marsh 1988; Lerner 1991.

MCKECHNIE, NEIL K. (active 1913), Toronto, ON. Painter. He was associated with the members of the GROUP OF SEVEN at GRIP LIMITED and knew TOM THOMSON. McKechnie painted in ALGONQUIN PARK and was drowned in that area. See also ALBERT HENRY ROBSON. **Citations**: Jackson 1958; Mellen 1970; Housser 1974; NGC 1982; Hill 1995.

MCKEE, JOHN (b1941), Calgary, AB. Painter. **Citations**: Bingham 1981; NGC 1982; Lerner 1991.

MCKENDRY COLLECTION. See CANADIAN CENTRE FOR FOLK CULTURE STUDIES. **Citations**: McKendry 1979(Quilts), Lerner 1991.

MCKENDRY, JENNIFER MARGARET (b1946), Kingston, ON. Architectural historian, photographer and author. McKendry who is now researching Ontario cemeteries and graveyards, received a PhD

in art history from the University of Toronto in 1991. **Citations**: McKendry 1979, 1980, 1993, 1995(1)(2), 1996.

MCKENDRY, RUTH (b1920), Kingston, ON. Author and collector. An expert on early Canadian textiles, McKendry is the author of articles and books on Canadian quilts. See also CANADIAN CENTRE FOR FOLK CULTURE STUDIES. **Citations**: NGC 1982; McKendry 1979 (Quilts), 1997; Lerner 1991.

MACKENZIE, HUGH SEAFORTH (b1928), London and Toronto, ON. Painter. He studied at the ONTARIO COLLEGE OF ART, and under ALEX COLVILLE and LAWREN P. HARRIS at Mount Allison University. See Duval 1974 for comments on MacKenzie's work and for illustrations. **Citations**: Morris 1965, 1969, 1972; MacDonald 1967; NGC 1982; Duval 1972, 1974; Lerner 1991; McMann 1997.

MCKENZIE, ROBERT TAIT (1867-1938), Montréal, QC; Almonte, ON. Sculptor, educator and surgeon. McKenzie was a sculptor of athletes. He designed a number of monuments in Canada and in the USA, as well as medallions and war memorials. McKenzie's work is represented in the NATIONAL GALLERY OF CANADA. **Citations**: Stevenson 1927; Colgate 1943; Hubbard 1960; MacDonald 1967; Kozar 1975; Santana 1978; Sisler 1980; McGill 1980; Laliberté 1986; Marsh 1988; Lerner 1991; McMann 1997.

MACKEY, J.R. (active 1862-4), Vancouver Island, BC. TOPOGRAPHICAL painter. He was with the British Navy. It is likely that this is the same man as J.R. Mackay whose paintings are listed on p. 145 of Gilmore 1980. **Citations**: Harper 1964, 1970; Gilmore 1980; NGC 1982.

MCKIE, MARY R. (active 1840-62), Halifax, NS. Painter. McKie painted the portraits of a Micmac girl and a black youth (illustrated in Bell 1973, p. 41). **Citations**: Harper 1970; Bell 1973; McKendry 1988; Tippett 1992.

MCKIM, IRENE (active 1965 and later), Kingston, ON. Painter, sculptor and mixed media artist. She studied under ANDRE BIELER, RALPH ALLEN, GRANT MACDONALD and DAVID PARTRIDGE. **Citations**: MacDonald 1967; NGC 1982; Farr 1988; McMann 1997.

MCLAUGHLIN, AGNES (b c1920), Saint John, NB. Painter. McLaughlin's paintings are naïve landscape, still-life, GENRE and religious paintings, and include scenes in Saint John. **Citations**: Kobayashi 1985(2); McKendry 1988.

MCLAUGHLIN, ISABEL GRACE (b1903), Oshawa and Toronto, ON. Painter. She was a founding member of the CANADIAN GROUP OF PAINTERS. McLaughlin associated with members of the GROUP OF SEVEN and was a supporter of the group. Her work is represented in the NATIONAL GALLERY OF CANADA. **Citations**: Housser 1929; Jackson 1958; Hubbard 1960; MacDonald 1967; Bradfield 1970; NGC 1982; McMichael 1986; Lerner 1991; Tippett 1992; Hill 1995; McMann 1997.

MCLEAN, THOMAS (TOM) WESLEY(1881-1951), Toronto, ON. Painter and printmaker. His work is often compared to that of the GROUP OF SEVEN. **Citations**: MacDonald 1967; NGC 1982; Lerner 1991; McMann 1997.

MACLEOD, PEGI NICOL (MARGARET KATHLEEN NICHOL) (1904-49), Toronto, ON; Fredericton, NB; New York City. Painter. Pegi Nicol MacLeod (often referred to as Pegi Nicol) was a pupil of FRANKLIN BROWNELL in Ottawa, and then studied in Montréal. She painted GENRE, figures and landscape. Several of her paintings are in the NATIONAL GALLERY OF CANADA. **Citations**: Colgate 1943; NGC 1945, 1982; McInnes 1950; Buchanan 1950; Hubbard 1960; Harper 1966; MacDonald 1967; Duval 1954, 1972; Laing 1979; Murray 1984; Marsh 1988; Reid 1988; Lerner 1991; Tippett 1992; McMann 1997.

MCMICHAEL CANADIAN COLLECTION. The McMichael collection is housed in a gallery at Kleinburg, ON. It was formed by Robert and Signe McMichael who collected a large number of paintings by members of the GROUP OF SEVEN. The collection now includes works by other artists, INUIT ART, and the original paintings for CLARENCE A. GAGNON's illustrations for Louis Hemon's Canadian classic *MARIA CHAPDELAINE*, published in Paris in 1933 with Gagnon's illustrations.

Citations: Duval 1967, 1972; 1973; Laing 1979; McMichael 1986; Lerner 1991; Silcox 1996; Murray 1996(1).

MCNAUGHT, EUPHEMIA (b1910), Peace River, AB. Painter. She studied under ARTHUR LISMER and J.E.H. MACDONALD. **Citations**: NGC 1982; Tippett 1992.

MCNEILLEDGE, ALEXANDER (1791-1874), Port Dover, ON. Painter. McNeilledge was a retired sea captain who settled in Port Dover and painted naïve marine, ship and patriotic-symbol paintings in watercolour or ink, including a box decorated with flags, beavers and inscriptions. See Harper 1974, pl. 90, and Kobayashi 1985(2), p. 146, for illustrations of his work. **Citations**: Harper 1973, 1974; Dobson 1982; Kobayashi 1985(1)(2); McKendry 1988.

MCNICOLL, HELEN GALLOWAY (1879-1915), Montréal, QC. Painter. McNicoll studied painting under WILLIAM BRYMNER and in England. Her work is represented in the NATIONAL GALLERY OF CANADA. **Citations**: Hubbard 1960; MacDonald 1967; Murray 1974; Sisler 1980; NGC 1982; Duval 1990; Lerner 1991; Tippett 1992; McMann 1997.

MADAHBEE, MEL (b1956), Manitoulin Island, ON. Ojibwa artist. **Citations**: Ojibwa 1981; Lerner 1991.

MADDEN, ORVAL CLINTON (1892-1971), Napanee and Toronto, ON. Painter. Madden studied with WILLIAM CRUIKSHANK, GEORGE A. REID and others. His work includes landscape, historical, animal and local rural-life paintings. **Citations**: Bull 1934; MacDonald 1967; NGC 1982; McKendry 1988; McMann 1997.

MAGIC (HIGH) REALISM. Magic realism is a sharply focussed style, in which objects are depicted with photographic detail but arranged to convey a feeling of unreality. Many of the paintings of ALEX COLVILLE are examples of this style. See Duval 1974 for a history of magic realism in Canada and for illustrations. See also REALISM. **Citations**: Harper 1966; Duval 1972, 1974; Lord 1974; Hill 1974; Arnason 1968; Silcox 1982; Burnett 1983; Chilvers 1988; Piper 1988; Reid 1988; Lerner 1991.

MAGOR, ELIZABETH (LIZ) (b1948), Vancouver, BC. Sculptor. Manual work is the chief subject matter of her art. **Citations**: Snider 1979; NGC 1982; Lerner 1991; Tippett 1992.

MAGRILL, CYRIL (born c1908), Toronto, ON. Painter. Magrill, born in Dublin, Ireland,went to sea at the age of 14. He has been living in Toronto since 1952, and began painting naïve landscapes and interiors in 1973. **Citations**: North Shore Art Gallery; McKendry 1988.

MAILLARD, CHARLES (1887-1973), Montréal, QC. Painter. Maillard studied in Paris and came to Canada in 1910. From 1925 to 1945 he was the director of the ECOLE DES BEAUX-ARTS in Montréal. He was a portrait and landscape painter. **Citations**: MacDonald 1967; Duval 1972; NGC 1982; Burnett/Schiff 1983; Laliberté 1986; Reid 1988; Lerner 1991; Tippett 1992.

MAILLARD, Mgr CHARLES (1873-1939), Gravelbourg, SK; Montréal, QC. Painter and priest. Maillard was a portrait painter and church decorator. **Citations**: Chauvin 1928; MacDonald 1967; Eckhardt 1970; NGC 1982.

MAILLET, CORINNE DUPUIS (RHOBENA DIPPY) (COLIN MARTEL) (b1900), Montréal, QC. Painter. She studied under WILLIAM BRYMNER. Maillet sometimes used pseudonyms as noted. **Citations**: MacDonald 1967; Tippett 1992.

MAKA, JAHAN (1900-87), Flin Flon, MB. Painter. Maka emigrated from Lithuania in 1927, and eventually worked in the mines in Flin Flon until he retired in 1965. He started painting in 1970 and produced a number of flat, brightly coloured, graphic pictures which are narratives of his memories and experiences. His paintings are typical of naïve work: he disregards correct perspective and scale, fills all space with details, and deals with his subject matter in a direct and uninhibited manner. Maka's work has been compared to that of Marc Chagall in respect to using floating figures in a narrative setting. See Hall 1988 for the best account of Maka's life and work. **Citations**: NGC 1982; McKendry 1983, 1988; NMM 1983; Kobayashi 1985(2); *Empress* 1985; Hall 1988.

MALEPART DE BEAUCOURT. See FRANCOIS BEAUCOURT.

MALEPART DE GRAND MAISON. See PAUL BEAUCOURT.

MALTAIS, MARCELLE (MARCELLA) (b1933), Montréal, QC. Painter. Maltais studied painting under JEAN DALLAIRE, JEAN-PAUL LEMIEUX and JEAN SOUCY, as well as in Paris. **Citations**: Harper 1966; MacDonald 1967; NGC 1982; Lerner 1991.

MALTBY, MARY (act. 1880-90), Carrington Manor, NT. Painter. **Citations**: Tippett 1992.

MANDAGGIO, EDWARD (EDDIE) (b1927), Bridgewater, NS. Sculptor and painter. Mandaggio began carving around 1974 and painting around 1976, after a life as a trapper and as a guide. His work is naïve and his subjects are usually animals and birds. **Citations**: *Canadian Art*, Spring 1985; Kobayashi 1985(2); *Empress* 1985; McKendry 1988; *Equinox*, May/June 1988.

MANIFESTO. See REFUS GLOBAL.

MANITOBA. The province of Manitoba (MB) was established in 1870, but its present boundaries were not defined until early in the 20th century. Ethnic groups in MB, include UKRAINIANS and native people. Among the later better-known artists of MB are the painters LIONEL LEMOINE FITZGERALD, WALTER PHILLIPS, ALEXANDER JOHNSTON MUSGROVE, IVAN EYRE, and KENNETH LOCHHEAD. The earlier resident artists include PETER RINDISBACHER, W. FRANK LYNN, CONSTANTIN TAUFFENBACH, MARION NELSON HOOKER, and VICTOR ALBERT LONG. Among the important early artists who painted in MB are PAUL KANE, WILLIAM ARM-STRONG, Sir GEORGE BACK, FREDERIC MARLETT BELL-SMITH, WILLIAM GEORGE RICHARDSON HIND, FRANCIS ANN HOPKINS, THOMAS MOWER MARTIN, and FREDERICK ARTHUR VERNER. See Eckhardt 1970 for a history of art in Manitoba. **Citations**: Winnipeg 1916; Harper 1964, 1966; Eckhardt 1962, 1970; Perry 1970; Fry 1972; Ewers 1973; Bingham 1981; Bringhurst 1983; Marsh 1988; Lerner 1991.

MANLY, CHARLES MACDONALD (1855-1924), Toronto, ON. Painter and graphic artist. Manly had emigrated from England to Toronto by 1876. He taught at the ONTARIO COLLEGE OF ART. His work is represented in the NATIONAL GALLERY OF ART. **Citations**: MacTavish 1925; Robson 1932; Colgate 1943; Middleton 1944; Miner 1946; McInnes 1950; Hubbard 1960; Harper 1966, 1970; MacDonald 1967; Bradfield 1970; Sisler 1980; NGC 1982; Lerner 1991; McMann 1997.

MANNERISM. The term mannerism implies exaggerated NATURALISM such as elongated and over-muscular figures in unusual poses. Generally the term is used to denote the period in European art between High RENAISSANCE and BAROQUE from about 1520 to about 1600. **Citations**: Osborne 1970; Janson 1977; Chilvers 1988; Piper 1988.

MANNY, NICOLAS (1812-83), Québec. Sculptor of religious works in wood. **Citations**: NGC 1982; Porter 1986.

MANOIR RICHELIEU COLLECTION. See COVERDALE COLLECTION.

MAQUETTE. A maquette is a small preliminary model, usually of clay or wax, for a work of sculpture. **Citations**: Osborne 1970; Piper 1988; Chilvers 1988;

MARACLE, THOMAS B. (active 1994), Deseronto, ON. Sculptor. Maracle is a native Mohawk stone sculptor.

MARIE-DE-L'INCARNATION, Mere (MARIE GUYART) (1599-1672), Québec City, QC. Embroiderer. Mother Marie-de-l'Incarnation came to Québec City in 1639 to establish the first Ursuline convent there and to become its Superior. She was renowned for decorative embroidery of altar clothes and may have done some painting. **Citations**: McInnes 1950; Barbeau (Québec) 1957; Harper 1966, 1970; McKendry 1988; Reid 1988; Marsh 1988; Lerner 1991.

MARION, SALOMON (1782-1832), Montréal, QC. Silversmith. According to Traquair 1940, p.19, Marion was probably the best silversmith in Montreal in his day. An elegant silver Madonna by Marion is in the NATIONAL GALLERY OF CANADA (see Boggs 1971, pl. 104). **Citations**: Traquair 1940; Langdon 1960, 1966, 1968; Boggs 1971.

MARITIME PROVINCES. Prince Edward Island (PE) ,Nova Scotia (NS) and New Brunswick (NB) have had their share of early travelling and ITINERANT artists including British army officers and illustrators. THOMAS DAVIES was posted to Halifax for a time, Sir RICHARD LEVINGE to Saint

John, and ALEXANDER CAVALIE MERCER sketched in PE. ROBERT FIELD, JOHN HAMMOND, WILLIAM HENRY BARTLETT, WILLIAM VALENTINE and JOHN O'BRIEN are among the early artists who worked in the Maritimes. Later artists include ROBERT HARRIS in PE; ALEX COLVILLE in NB and in NS; ROBERT ANNAND and MARSDEN HARTLEY in NS; GEORGE HORNE RUSSELL, MILLER BRITTAIN, LAWREN PHILLIPS HARRIS and JACK HUMPHREY in NB. A great many naïve artists have been discovered in NS, for example JOE NORRIS, MAUD LEWIS, COLLINS EISENHAUER, JOSEPH SLEEP, RALPH BOUTILIER, and SAMUEL BOLLIVAR. **Citations**: NB Museum 1952; Harper 1964; Andrus 1966; Tweedie 1967; Hashey 1967; Ryder 1967; Lumsden 1969, 1973, 1975; Duval 1972; Lord 1974; De Volpi 1974; Parsons 1976; Elwood 1976; Lord 1979; Hachey 1980; Laurette 1980(2); Marsh 1988; Lerner 1991; Woolaver 1996.

MARKELL, JACK HAROLD (b1919), Winnipeg, MB; Vancouver, BC. Painter. Markell studied under ALEX MUSGROVE and in New York. An example of his work is in the NATIONAL GALLERY OF CANADA. **Citations**: Hubbard 1960; Eckhardt 1962; Harper 1966; MacDonald 1967; NGC 1982; Lerner 1991.

MARKLE, ROBERT NELSON (b1936), Toronto, ON. Painter and MURALIST. He studied at the ONTARIO COLLEGE OF ART. **Citations**: MacDonald 1967; Townsend 1970; Bradfield 1970; Morris 1972, 1980; NGC 1982; Bringhurst 1983; Burnett/Schiff 1983; Lerner 1991.

MARSH, CHARLES (b1948), Saskatchewan. Painter and printmaker. **Citations**: Mendell 1977; NGC 1982; Lerner 1991.

MARTEL, COLIN. See CORINNE MAILLET.

MARQUESS OF LORNE. See LORNE.

MARSEILLE, JEAN. See NATTE dit MARSEILLE.

MARSHALL (MARS), TANYA. See TANYA ROSENBERG.

MARTIN, JOHN (JACK) (1904-65), ON. Painter, printmaker and illustrator. He was a member of the CANADIAN GROUP OF PAINTERS. **Citations**: CGP 1933; NGC 1982; Lerner 1991.

MARTIN, MUNGO (c1880-1962), Fort Rupert and Victoria, BC. Sculptor and painter. Martin was a skilled carver of totem poles and an authority on Northwest Coast culture. He was an uncle (or father-in-law) of HENRY HUNT and, for a time, they worked together. **Citations**: MacDonald 1967; Patterson 1973; *Canadian Collector* 1976; NGC 1982; Marsh 1988; McKendry 1988; Lerner 1991.

MARTIN, S.W. (active 1842), Charlottetown, PE. Painter. Martin was an English artist who advertised in a Charlottetown newspaper, and is known for a naïve ROMANTICIZED figure painting illustrated in Harper 1974, pl. 110. **Citations**: Harper 1973, 1974; Kobayashi 1985(2); McKendry 1988.

MARTIN, THOMAS MOWER (1838-1934), Muskoka and Toronto, ON. Painter; RCA 1880. Martin emigrated from England to Muskoka in 1862, but soon moved to the Toronto area and opened a studio in that city. He taught art and painted landscapes in many parts of Canada including the Rocky Mountains, as well as STILL LIFE and some portraits. See McMann 1997, pp. 271-3, for an extensive, dated list of Martin's paintings. Examples of his work are in the NATIONAL GALLERY OF CANADA. **Citations**: Campbell 1907; MacTavish 1925; Robson 1932; Colgate 1943; McInnes 1950; Hubbard 1960; Harper 1966, 1970; MacDonald 1967; Render 1974; Reid 1979, 1988; Sisler 1980; NGC 1982; Lerner 1991; McMann 1997.

MASKS. Masks are an important aspect of PRIMITIVE ART. In prehistoric times, throughout North America, masks were worn for religious or social purposes. In historic times, native people throughout Canada continued to construct and use masks for their magical powers over the spirits and lives of ordinary people. The Iroquois FALSE FACE SOCIETY used masks to invoke special powers of healing and for ceremonial purposes (see McKendry 1983, pl. 17, 18). The Tsimshian native people of the Northwest coast used a mask of a sea monster to depict some of their hunters being carried out to sea by a monster (see McKendry 1983, pl. 19). Primitive masks have been used in modern art ever since PABLO PICASSO used the primitive and savage features of African tribal masks in the painting *Les Demoiselles d'Avignon* 1907, see McKendry 1983, pl. 1. In Canada, masks have been used to good

effect in recent paintings by JEAN DALLAIRE and ALFRED PELLAN. See also BRITISH COLUMBIA, NATIVE ART OF CANADA, SHAMAN. **Citations**: Jenness 1932; Feder 1969; Osborne 1970; Pellan 1972, 1973; Patterson 1973; Hodge 1974; Janson 1977; King 1979; McKendry 1983; *Upper Canadian* January/February 1984; Lerner 1991.

MASSICOTTE, EDMOND JOSEPH (1875-1929), Montréal, QC. Painter and illustrator. Massicotte was a painter and illustrator of popular customs and traditions of Québec. **Citations**: MacDonald 1967; Dunbar 1976; Genest 1979; NGC 1982; Laliberté 1986; Marsh 1988; McKendry 1988; Lerner 1991.

MASSON, HENRI LEOPOLD (b1907), Ottawa, ON. Painter and ENGRAVER. Masson emigrated from Belgium to Ottawa in 1921. His early work is described and illustrated in Barbeau 1946. According to Barbeau ,"Masson's approach to pictorial art so far has been of the imagery of naïve medieval kind, with a bent for mild irony and caricature. He is the antithesis of complacency and pedantry." Masson has a fluid vigorous style that easily conveys movement in his GENRE scenes. Several paintings by Masson are in the NATIONAL GALLERY OF CANADA and in the AGNES ETHERINGTON ART CENTRE. **Citations**: NGC 1945, 1982; Barbeau 1946; McInnes 1950; Duval 1052; 1954, 1972; Hubbard 1960, 1963; MacDonald 1967; Smith 1968; Thibault 1978; Bouchard 1979; Gingras 1981; Laing 1982; Reid 1988; Marsh 1988; Lerner 1991; McMann 1997.

MASSON, RAYMOND (1860-1944), Terrebonne, QC. Sculptor. Masson studied in Boston and in Paris. **Citations**: Laliberté 1986.

MASTERPIECE. Masterpiece is an overused term for the finest work by a particular artist, or for any work of acknowledged greatness. Originally it applied to the work by which a craftsman, upon finishing his training, was granted the rank of master in his guild. In Canadian art, an approach to the selecting of Canadian masterpieces was made in Mellen 1978, although they were referred to as landmarks. See also PIERRE LE BER. **Citations**: Osborne 1970; Mellen 1978; Chilvers 1988; Piper 1988.

MATHEY, JEAN (act. 1824), Red River, MB. Painter. Mathey is known for two naïve portraits, 1824, in ink and watercolour, illustrated on p. 23 of Eckhardt 1970. **Citations**: Eckhardt 1970; NGC 1982; McKendry 1988.

MATISSE, HENRI (1869-1954), France. Painter. The use of pure colour in decorative abstraction by the great French painter Henri Matisse influenced many Canadian artists including JAMES WILSON MORRICE, FREDERICK VARLEY, DAVID MILNE, JOHN LYMAN, ALFRED PELLAN, LOUIS DE NIVERVILLE, BERTRAM BROOKER, JACQUES DE TONNANCOUR and others. See also FAUVISM. **Citations**: Harper 1966; Arnason 1968; Osborne 1970; Duval 1972; Lord 1974; Laing 1982, 1984; Bringhurst 1983; Burnett/Schiff 1983; McKendry 1983; Varley 1983; Chilvers 1988; Thom 1991; Silcox 1996.

MATTHEWS, MARMADUKE M. (1837-1913), Toronto, ON. Painter; RCA 1883. Matthews emigrated from England in 1860, and was a landscape and portrait painter. His work is represented in the NATIONAL GALLERY OF CANADA. See McMann 1997, pp. 276-8, for an extensive, dated list of Matthews's paintings. **Citations**: MacTavish 1925; Robson 1932; McInnes 1950; Colgate 1943; Hubbard 1960; Harper 1966, 1970; MacDonald 1967; Render 1974; Reid 1979, 1988; Sisler 1980; NGC 1982; Laing 1982; Lerner 1991; McMann 1997.

MAUFILS DE SAINT-LOUIS, MARIE-MADELEINE (1670-1702), Québec City, QC. Painter. She is said to have painted local landscapes. **Citations**: Harper 1966, 1970.

MAUPAS, EMILE (1874-1948), Montréal, QC. Sculptor and painter. Maupas studied in Paris. **Citations**: Laliberté 1986.

MAY, HENRIETTA MABEL (1884-1971), Ottawa, ON; Montréal, QC; Vancouver, BC. Painter. Mabel May studied under WILLIAM BRYMNER and in Paris. She painted with A.Y. JACKSON for a time and was a founding member of the CANADIAN GROUP OF PAINTERS. Several paintings by May are in the NATIONAL GALLERY OF CANADA. See McMann 1997, pp. 280-1, for an extensive, dated list of May's paintings. **Citations**: MacTavish 1925; Robson 1932; Tate 1938; Colgate 1943; Jackson 1958; Hubbard 1960; Harper 1966; MacDonald 1967; Mellen 1970; Bradfield 1970; Duval

1972; Housser 1974; Sisler 1980; NGC 1982; Lerner 1991; Tippett 1992; Hill 1995; McMann 1997.

MAYHEW, ELZA EDITH LOVITT (b1916), British Columbia. Sculptor. **Citations**: Sisler 1980; NGC 1982; Tippett 1992; McMann 1997.

MAYNE, RICHARD C. (1835-92), British Columbia. Painter. Mayne was with the Royal Navy and sketched along the coasts of British Columbia. There is some doubt whether his or other artists sketches were used for the illustrations in his 1862 book *Four Years in British Columbia and Vancouver Island* (see Gilmore 1980, pp. 39-40). **Citations**: Harper 1966, 1970; Gilmore 1980; NGC 1982.

MEAD, RAY JOHN (b1921), Montréal, QC. Painter. Mead, English born, came to Canada in 1946, first to Toronto and, in 1957, to Montréal, when he became a member of the PAINTERS ELEVEN of Toronto. **Citations**: Duval 1952, 1954, 1972; Harper 1966; MacDonald 1967; Lord 1974; NGC 1982; Bringhurst 1983; Burnett/Schiff 1983; Reid 1988.

MEAGHER, AILEEN ALETHEA (b1910), Halifax, NS. Painter and teacher. She studied at the NOVA SCOTIA COLLEGE OF ART AND DESIGN and in Toronto, ON. Her work is represented in the Dalhousie University Art Gallery, NS. **Citations**: Harper 1966; MacDonald 1967; NGC 1982; Tippett 1992.

MEDIEVAL ART. This term often refers to the art of Europe after the fall of the Roman Empire in the 4th century AD until the RENAISSANCE about 1400. It may include the Early Christian, BYZAN-TINE, early Middle Ages, ROMANESQUE, and GOTHIC periods. See also CELTIC; CONTINUOUS NARRATIVE; STYLE; REVIVALS. **Citations**: Janson 1977; Huyghe 1981; Piper 1988.

MEDIUM. The liquid into which pigment is ground to make paint. The term is also used for the actual material used by a painter or a sculptor such as oil paint, watercolours, clay, marble, wood, etc. In mixed media works, more than one medium is used at different times during the completion of a work. See PAINT; GUM. **Citations**: Osborne 1970; Mayer 1970; Pierce 1987; Piper 1988; Chilvers 1988.

MEISTER, ALFRED ERNEST. See Paul Alfred.

MELAINOTYPE. See PHOTOGRAPHY IN CANADA.

MELANCON. (act. 1846), Québec. Painter. Melançon is known only for a naïve 1846 portrait of a child (Harper 1974, pl. 65). **Citations**: Harper 1970, 1973, 1974; Kobayashi 1985(2); McKendry 1988.

MELOCHE, FRANCOIS XAVIER EDOUARD (EDMOND) (1855-1917), Montréal, QC. Decorative painter; architect. Meloche studied under NAPOLEON BOURASSA, as well as in Paris and in Italy. He worked on numerous churches, particularly in the Montréal region (see Harper 1970 for a list of the churches). **Citations**: Gowans 1955; Harper 1970; Laliberté 1986.

MELOCHE, SUZANNE (b1926), Montréal, QC. Painter. Meloche studied with PAUL-EMILE BORDUAS, as well as in Paris and London. She is a non-figurative painter and a member of PAINTERS ELEVEN. **Citations**: Harper 1966; MacDonald 1967; NGC 1982; Tippett 1992.

MENDAGGIO. See MANDAGGIO.

MENDEL, EVA. See EVA MENDEL MILLER.

MENNONITES. The Mennonites, a Protestant religious-cultural group, first arrived in Canada from the USA in 1786 and, later, were joined by groups from other countries who settled in parts of what is now Ontario and in the Prairie Provinces. Many spoke Germanic dialects. A group of Amish Mennonites from Pennsylvania settled in Ontario's Waterloo County. This latter group included many naïve decorative and FRAKTUR artists (see Bird 1977): ANNA WEBER is a well known Mennonite artist. See also ABRAM S. CLEMENS. **Citations**: Good 1976; Bird 1977, 1981; McKendry 1983; Marsh 1988; Lerner 1991.

MENTALLY ILL - ART OF. See PSYCHIATRIC ART.

MERCER, ALEXANDER CAVALIE (1783-c1868), Lake Huron, ON; Halifax, NS. Topographical painter. Mercer, a TOPOGRAPHICAL artist with the British army, executed watercolour sketches in the Atlantic Provinces. **Citations**: Harper 1964, 1966, 1970; NGC 1982; McKendry 1988.

MEREDITH JOHN (JOHN MEREDITH SMITH) (b1933), Brampton and Toronto, ON. Painter. John Meredith (professional name since 1951) is a brother of WILLIAM RONALD. Meredith is known

for large scale abstract paintings with a pronounced interaction of colour. See Withrow 1972 for a discussion of Meredith's work and for illustrations. His work is represented in the ART GALLERY OF ONTARIO and the NATIONAL GALLERY OF CANADA. **Citations**: Harper 1966; Kilbourn 1966; MacDonald 1967; Smith 1968; Bradfield 1970; Duval 1972; Withrow 1972, 1974; Fleming 1974; Lord 1974; Fenton 1978; Mellen 1978; Sisler 1980; Thom 1980; Sisler 1980; Osborne 1981; NGC 1982; Bringhurst 1983; Burnett/Schiff 1983; Marsh 1988; Reid 1988; Lerner 1991; McMann 1997.

MERES, JAMES S. (active 1786-1835), Newfoundland and Nova Scotia. Topographical painter. Meres was with the Royal Navy and added TOPOGRAPHICAL watercolour sketches of Newfoundland and Nova Scotia scenes to the log book of the H.M.S.Pegasus (see Bell 1973 for illustrations). **Citations**: Bell 1973; McKendry 1988.

METAL CUT. An engraving made on a metal plate for relief printing. **Citations**: Osborne 1970; Eichenberg 1976; Lucie-Smith 1984; Chilvers 1988.

METAL POINT. A drawing instrument made from a metal rod pointed at one end. It may be of lead, copper, silver, or gold; a silver point is the most commonly used. An abrasive drawing surface is required. **Citations**: Osborne 1970; Lucie-Smith 1984; Piper 1988; Chilvers 1988.

METCALF, ELIAB (1785-1834), Québec City, QC; Halifax, NS. Silhouettist and painter. Metcalf was an ITINERANT SILHOUETTE cutter and MINIATURE painter who visited Québec City in 1809 and Halifax in 1810, but made his headquarters in New York City. **Citations**: Harper 1966, 1970; Rosenfeld 1981; McKendry 1988; Lerner 1991.

MEYER, HOPPNER FRANCIS (act. 1832-60), Québec City, QC; Toronto, ON. Portrait painter, miniaturist and ENGRAVER. He was in Québec City 1832-33 and in Toronto 1840-62. **Citations**: Colgate 1943; Harper 1966, 1970; Lord 1974; NGC 1982; McKendry 1988; Reid 1988; Lerner 1991.

MEZZOTINT. The term refers to a process or a print dependent on a tonal engraving method using a copper or steel plate worked all over with a serrated rocker-tool to raise a burr. Tones are then obtained by scraping and burnishing to vary the amount of ink held by the plate. Mezzotint engraving was invented in 1642 by Ludwig von Siegen (1609-after 1676) of Utrecht. It was much used in the 17th, 18th and early 19th centuries to reproduce paintings. **Citations**: Osborne 1970; Eichenberg 1976; Chilvers 1988; Piper 1988.

MIDDLE AGES. See MEDIEVAL ART.

MIGNAULT, Abbé JOSEPH (active 1936), Québec. Mixed media and COLLAGE artist. Mignault is known for a collage of feathers and plants featuring an owl (illustrated in Harper 1974, pl. 122), and other studies of birds. **Citations**: Harper 1973, 1974; Kobayashi 1985(2); McKendry 1988.

MILBURN (active c1862), Western Ontario. Painter. Milburn painted a naïve portrait (1862) of the wood-burning locomotive "Saxon" illustrated in Harper 1974, pl. 77. It is thought that the artist's name may have been John Milburn. **Citations**: Harper 1973; Forsey 1975; Kobayashi 1985(2); McKendry 1988.

MILES, FREDERICK (FRED) H.C. (1863-1918), Saint John, NB. Painter of landscapes and marines. He was a son of JOHN CHRISTOPHER MILES. **Citations**: Lumsden 1969; Harper 1970; NGC 1982; McMann 1997.

MILES, JOHN CHRISTOPHER (1832-1911), Saint John, NB. Painter, portraitist and illustrator. He studied in the USA and had a studio in Saint John from 1878. **Citations**: Lumsden 1969; Harper 1970; Sisler 1980; NGC 1982; Lerner 1991; McMann 1997.

MILETTE, ALEXIS (1793-1869), Québec. Sculptor of religious works and architect. Milette was influenced by the BAILLAIRGES and, along with AMABLE GAUTHIER, carved decorations for the church at Berthierville, QC. **Citations**: Vaillancourt 1920; Traquair 1947; Lerner 1991.

MILLER, ALFRED JACOB (1810-74), Baltimore, MD, USA. Painter. Miller was an American artist who travelled and painted in western USA and Canada. He was the first artist to travel to the Rocky Mountains (1837) and to portray native people in Oregon which was then British territory. He painted portraits of chiefs and braves. See Miller 1973 for the 41 Miller watercolours in the collections of the

NATIONAL ARCHIVES OF CANADA. **Citations**: Brunet 1951; Rasky 1967; Carter 1967; Harper 1970; Miller 1973; Ewers 1973; Fielding 1974; Baigell 1981; Tyler 1982; NGC 1982; Goetzmann 1986; McKendry 1988; Lerner 1991.

MILLER, EVA MENDEL (b1919), Saskatchewan. Painter. **Citations**: Mendel 1964; NGC 1982.

MILLER, HERBERT MCRAE (1895-1981), Montréal, QC. Painter and sculptor; RCA 1955. Miller studied in New York and under EDMOND DYONNET and ALFRED LALIBERTE . A bust by Miller is in the NATIONAL GALLERY OF CANADA. **Citations**: Hubbard 1960; MacDonald 1967; Sisler 1980; Laliberté 1986; McMann 1997.

MILLER (MORRIS), MARIA FRANCES ANNE. (1813-75), Halifax, NS. Painter. Maria Morris, later Maria Miller, studied under WILLIAM HARRIS JONES. She taught art and was well-known for her flower paintings and prints. She may have been the first professional woman painter in Nova Scotia. **Citations**: Nutt 1932; Colgate 1943; NB Museum 1952; Harper 1966, 1970; MacDonald 1967; NGC 1982; Reid 1988; Lerner 1991; Tippett 1992; Dickenson 1992.

MILLS, DORIS HUESTIS. See DORIS HUESTIS MILLS SPEIRS.

MILNE, DAVID BROWN (1882-1953), Montréal, QC; Ottawa and Toronto, ON. Painter and printmaker. At first Milne received more attention in the USA, where he lived for a time, than in Canada, where the GROUP OF SEVEN had become popular. Milne's work was avant-garde and was influenced by the IMPRESSIONIST artists and by FAUVISM, in particular by HENRI MATISSE. Milne was the only Canadian to exhibit in the New York ARMORY SHOW. There are many paintings by Milne in the NATIONAL GALLERY OF CANADA. **Citations**: Colgate 1943; Buchanan 1950; McInnes 1950; Duval 1952; 1954, 1972, 1973; Harper 1955, 1966; Jackson 1958; Hubbard 1960, 1963, 1967; Jarvis 1962, 1974; Mendel 1964; Kilbourn 1966; Silcox 1967, 1996; Adamson 1969; Osborne 1970, 1981; Mellen 1970, 1978; Townsend 1970; Boggs 1971; Lord 1974; Hill 1975, 1995; Tovell 1976, 1980; Robertson 1977; Town 1977; Fenton 1978; Mellen 1978; Laing 1979, 1982; Tovell 1980; Sisler 1980; NGC 1982; Bringhurst 1983; Burnett/Schiff 1983; Reid 1988; Marsh 1988; Chilvers 1988; Thom 1991; Lerner 1991.

MINIATURE. A miniature is a very small painting, particularly a portrait. After c1850, when photography became popular, the demand for miniatures lessened. The first miniaturist in Canada is thought to be JOHN RAMAGE who was in Halifax, NS, 1772-4. He was followed by many ITINERANT miniaturists who came to Québec City, the prosperous seat of government. WILLIAM VON MOLL BERCZY was a skilled miniature painter. See Harper 1966, pp. 115-19. **Citations**: NB Museum 1952; Harper 1966; Osborne 1970; Pierce 1987; Piper 1988; Chilvers 1988; Lerner 1991.

MITCHELL, JANET (b1915), Calgary, AB. Painter. Mitchell is mainly self-taught and her paintings have some naïve characteristics. Examples of her paintings are in the NATIONAL GALLERY OF CANADA. **Citations**: Hubbard 1960; NGC 1982; Kobayashi 1985 (2); Masters 1987; McKendry 1988; Lerner 1991; Tippett 1992; McMann 1997;.

MIXED MEDIA. See MEDIUM.

MOBILE. A kinetic sculpture having elements suspended and balanced to respond to movement of the surrounding air, or sometimes to respond to a motor. **Citations**: Osborne 1970, 1981; Chilvers 1988; Piper 1988; Lerner 1991.

MODEL. A term used in connection with painting or sculpture for a figure, usually human, posed for the artist. The term 'model' also is used for a three dimensional representation of a proposed structure designed by an architect. **Citations**: Osborne 1970; Morris 1972; Janson 1977; Piper 1988; Lerner 1991.

MODELING. Modeling is the creating three-dimensional forms from a soft material such as clay. Modeling includes adding or subtracting material, whereas CARVING is entirely a subtractive process. In painting, modeling effect is achieved by controlling the VALUE of colours and by SHADING. **Citations**: Osborne 1970; Mayer 1970; Hill 1974; Pierce 1987; Lerner 1991.

MODERN ART; MODERNISM. There is no definite date for the beginning of modern art. Some historians argue that the date is 1863, the year of the Salon des Refusés in Paris when Edouard Manet

(1832-83) exhibited his *Déjeuner sur l'herbe*, but later or earlier dates are also proposed. The ARMORY SHOW in New York in 1913 introduced modern art to North America, and had a large influence on American and Canadian artists. Modern art movements include Les NABIS, SYMBOLISM, EXPRESSIONISM, FAUVISM, ABSTRACTION, CUBISM, SURREALISM, and DADA. **Citations**: Ozenfant 1952; Chipp 1968; Arnason 1968; Clay 1978; Huyghe 1980; Schapiro 1982; Lerner 1991; Silcox 1996.

MOISAN, LAURENT (act. 1910), Québec. Sculptor of religious works in wood. **Citations**: Porter 1986.

MOLINARI, GUIDO (b1933), Montréal, QC. Painter; RCA 1969. Molinari is a disciplined painter of colour ABSTRACTION who uses brilliant colours, often in HARD EDGE stripes, to create an interaction of colours. See Withrow 1972 for a discussion and illustrations of Molinari's work. His paintings are in the NATIONAL GALLERY OF CANADA and the ART GALLERY OF ONTARIO. **Citations**: Kilbourn 1966; Harper 1966; Hubbard 1967; MacDonald 1967; Teyssedre 1968; Adamson 1969; Duval 1972; Withrow 1972, 1974; Bengle 1974; Lord 1974; Webster 1975; Theberge 1976; Mellen 1978; Fenton 1978; Vie des Arts 1978; George 1980; Sisler 1980; Osborne 1981; NGC 1982; Burnett/Schiff 1983; Bringhurst 1983; Reid 1988; Marsh 1988; Lerner 1991; McMann 1997.

MONGEAU, JEAN GUY (b1931), Montréal, QC. Painter. Mongeau's semi-abstract paintings are powerful and colourful works, which have received considerable attention in local exhibitions and in the press (see MacDonald 1967). **Citations**: Harper 1966; MacDonald 1967; NGC 1982; Lerner 1991.

MONOCHROME. See POLYCHROME.

MONOTYPE. In monotype printing the artist paints his design directly on a plate and, to obtain a print, presses paper on the plate before the paint dries. Only one strong impression can be obtained, unless more paint is added to the plate, but then each impression will differ. **Citations**: Osborne 1970; Eichenberg 1976; Piper 1988; Chilvers 1988.

MONRO (MUNROE), WILLIAM (1815-act. 1854), Québec City, QC. Painter. Monro, enrolled in the British army, was in Canada from 1849-51. He was a sketching companion of AMELIA FREDERICA DYNELEY, and was influenced by CORNELIUS KRIEGHOFF. The only known work by Monro is in the COVERDALE COLLECTION, see Cooke 1983, p. 154 and pl. 348. **Citations**: Harper 1970 (under Munroe); Cooke 1983; McKendry 1988.

MONSTRANCE. A vessel in which the consecrated Host is exposed for the adoration of the faithful. See also SILVERSMITHING. **Citation**: Marsh 1988.

MONTAGE. A picture formed of previously made images such as newsprint or photographic images (photomontage or composite photograph). The photographer WILLIAM NOTMAN executed several well-known photomontages, see Harper 1967 and Triggs 1985. See also PHOTOGRAPHY. **Citations**: Harper 1967; Osborne 1970; Thomas 1972, 1979; Triggs 1985; Chilvers 1988; Piper 1988.

MONTEE SAINT-MICHEL, LES PEINTRES DE LA. A group of Québec painters who had in common their friendship, a love of painting, and the area where they worked, - La Montée Saint-Michel. The group included ERNEST AUBIN, JOSEPH JUTRAS, JEAN ONESIME LEGAULT, ONESIME-AIME LEGER, ELISEE MARTEL, JEAN-PAUL PEPIN, NARCISSE POIRIER, and JEAN OCTAVE PROULX. **Citations**: Laliberté 1986; Lerner 1991.

MONTREAL MUSEUM OF FINE ARTS. Montréal, QC. The Art Association of Montréal was formed in 1860 as an outgrowth of an earlier group, the Montréal Society of Artists, which was founded in 1847. In 1948 the Association changed its name to the Montréal Museum of Fine Arts and it now has its own building, an internationally respected collection of paintings and sculpture, an active program, and a major art school. **Citations**: McInnes 1950; Turner 1960; Harper 1966; Mellen 1970; Lord 1974; Watson 1974; Sisler 1980; George 1980; Reid 1979, 1988; Lerner 1991; Tippett 1992; Silcox 1996.

MONTREAL SOCIETY OF ARTISTS. See MONTREAL MUSEUM OF FINE ARTS.

MOODIE, AGNES DUNBAR. See AGNES DUNBAR CHAMBERLIN.

MOODIE, SUSANNA (1803-85), Cobourg, Peterborough, Belleville and Toronto, ON. Author and painter. Mrs Moodie with her husband and child emigrated to the Cobourg area of Upper Canada (now

Ontario) in 1832. She wrote about pioneer life in Upper Canada and her best known work is the book *Roughing it in the Bush*, published in England in 1852. It is less known that she was a competent watercolour painter of local scenes (see Bell 1973, p. 122) and wild flowers (see Allodi 1974, pl. 1404). She was a sister of CATHARINE PARR TRAILL and the mother of AGNES DUNBAR CHAMBER-LIN. See also Mrs WALTER. **Citations**: Harper 1970; Bell 1973; Allodi 1974; Farr 1975; NGC 1982; McKendry 1983, 1988; Marsh 1988; Tippett 1992.

MOODY, HAMPDEN CLEMENT BLAMIRE (c1813-69), Fort Garry, MB; British Columbia. Painter. Moody, a British army officer, served in Canada c1838-48 and in the 1860s. He made some naïve landscape sketches, sometimes with figures, in ink, pencil or watercolour, and occasionally made copies of other artists' work. **Citations**: Eckhardt 1970; Bell 1973; Allodi 1974; McKendry 1988.

MOPPETT, RONALD (RON) BENJAMIN (b1945), Calgary, AB. Painter. His work is represented in the NATIONAL GALLERY OF CANADA. **Citations**: MacDonald 1967; Heath 1976; NGC 1982.

MOREL, OCTAVE (b1837), Québec City, QC. Sculptor of animals, religious works and decorative sculpture in wood. **Citations**: Barbeau 1957(Québec); Lessard 1971; NGC 1982; McKendry 1983, 1988; Porter 1986; Lerner 1991.

MORELAND, F.A. (act. 1915), Eastern Canada. Painter. Moreland is known for a naïve lumbering scene that he painted in 1915 (illustrated in McKendry 1983, pl. 93). **Citations**: McKendry 1983, 1988.

MORENCY, ANDRE (b1910), Québec. Painter. **Citations**: Bergeron 1946; NGC 1982; Lerner 1991.

MORGAN, PATRICK and MAUD. See CHARLEVOIX COUNTY.

MORRICE, JAMES WILSON (1865-1924), Québec City, QC; Paris, France. Painter. Although born in Montréal and studying in Toronto, Morrice went abroad in 1890 to study art and never returned to live in Canada. He visited Québec regularly and some of his finest paintings are of Québec scenes. He was elected honorary member of the ROYAL CANADIAN ACADEMY in 1913. Morrice painted in Paris, Brittany, Normandy, Holland, Belgium, England, Provence, Venice, Spain, Corsica, North Africa, Cuba, Jamaica, and Trinidad. He was widely appreciated outside Canada before his death and, since then, has been recognized by Canadians as one of their great painters. See Laing 1984 for an account of Morrice's life and for ninety colour plates of his work. There are many paintings by Morrice in the NATIONAL GALLERY OF CANADA. See also ART FOR ART'S SAKE. **Citations**: MacTavish 1925; Stevenson 1927; Robson 1932; Buchanan 1936, 1945; 1947, 1950; Colgate 1943; Lyman 1945; NGC 1945, 1982; McInnes 1950; Jackson 1958; Turner 1960; Hubbard 1960, 1963, 1967, 1973(2); Mendel 1964; Johnston 1965; Pepper 1966; Kilbourn 1966; Harper 1955, 1966, 1970; Jackson 1958; MacDonald 1967; Sutton 1968; Guttenberg 1969; Adamson 1969; Mellen 1970; Osborne 1970, 1981; Boggs 1971; Duval 1972, 1973, 1990; Withrow 1974; Watson 1974; Lord 1974; Mellen 1978; Tippett 1979, 1992; Laing 1979, 1982, 1984; Sisler 1980; Burnett/Schiff 1983; Laliberté 1986; Karel 1987; Reid 1988; Piper 1988; Cavell 1988; Marsh 1988; Thom 1991; Lerner 1991; Hill 1995; Silcox 1996; McMann 1997.

MORRIS, ANDREW (act. 1844-52), Montréal, QC. Painter. Morris painted portraits, historical subjects and decorative paintings. For a time (1848-52) he painted portraits in New York. In 1847 he was president of the Montréal SOCIETY OF ARTISTS. **Citations**: Harper 1964; NGC 1982.

MORRIS, EDMUND MONTAGUE (1871-1913), Toronto, ON. Painter. Morris studied painting under WILLIAM CRUIKSHANK, as well as in New York and Paris. He was a landscape and portrait painter, particularly portraits of native people. Several paintings by Morris are in the NATIONAL GALLERY OF CANADA, ROYAL ONTARIO MUSEUM, and GLENBOW MUSEUM. **Citations**: MacTavish 1925; Robson 1932; Colgate 1943; McInnes 1950; Hubbard 1960; Harper 1966; MacDonald 1967; Eckhardt 1970; Render 1970; Sisler 1980; NGC 1982; McGill 1984; Simmins 1984; Karel 1987; Reid 1988; Lerner 1991; Hill 1995; McMann 1997.

MORRIS, KATHLEEN MOIR (b1893), Ottawa, ON; Montréal, QC. Painter. Morris, a landscape and GENRE painter, studied under WILLIAM BRYMNER and sketched with MAURICE CULLEN. Several of her paintings are in the NATIONAL GALLERY OF CANADA. See McMann 1997 for a dated list of a selection of her paintings. **Citations**: MacTavish 1925; Robson 1932; McInnes 1950;

Hubbard 1960; Harper 1955, 1966; MacDonald 1967; Sisler 1980; NGC 1982; Reid 1988; Tippett 1992; McMann 1997.

MORRIS, MARIA. See MARIA E. MILLER

MORRISSEAU, NORVAL (b1932), Beardmore, ON. Painter. Morrisseau is a self-taught Ojibway artist who is well versed in his ancestors' rituals, ceremonies and magic. He uses bold designs and striking colours. For a time, he was associated with DAPHNE ODJIG, ALEX SIMEON JANVIER, JACKSON BEARDY, and CARL RAY. Morrisseau's work is represented in the ART GALLERY OF ONTARIO. See also SERIGRAPH. **Citations**: MacDonald 1967; Hubbard 1967; Schwarz 1969; Bradfield 1970; Patterson 1973; Dickason 1974; Lord 1974; McLuhan 1977, 1984; Mellen 1978; Radulovich 1978; Sinclair 1979; Highwater 1980; NGC 1982; Bringhurst 1983; McKendry 1983, 1988; Marsh 1988; Reid 1988; Lerner 1991; Tippett 1992.

MORTON, DOUGLAS GIBB (b1926), Regina, SK. Painter. Morton studied under LEMOINE FITZGERALD as well as in the USA and in Europe. He is a member of the REGINA FIVE. His work is represented in the NATIONAL GALLERY OF CANADA. **Citations**: Simmins 1961; Hubbard 1967; MacDonald 1967; Climer 1967; Townsend 1970; Duval 1972; Lord 1974; Sisler 1980; NGC 1982; Reid 1988; Lerner 1991; McMann 1997.

MOSAIC. An ancient technique, mosaic is a picture or pattern composed of small distinct patches of colour which may be formed by fragments of glass, marble, or ceramic set into a bed of cement. See Osborne 1970 for a detailed discussion of early mosaics. **Citations**: Osborne 1970; Janson 1977; Piper 1988; Chilvers 1988.

MOSES, ANNA MARY ROBERTSON (GRANDMA) (1860-1961), USA. Painter. Grandma Moses was a well-known American naïve artist who started painting when she was in her 60s and received widespread recognition during her remaining years. A naïve artist who takes up painting late in life is often called a "Grandma Moses." **Citations**: Osborne 1970; Black 1966; Bishop 1979; Piper 1988; Chilvers 1988.

MOULDING, FRED (b1894), Regina, SK. Sculptor. Moulding started carving around 1960 with the intention of leaving a material legacy of information about the farm activities with which he was familiar. His work, which is naïve, has received much attention in the press and is in several public and private collections. See GRAIN BIN PROJECT. **Citations**: Thauberger 1976; *artscanada* 1979; Borsa 1983; Bringhurst 1983; NMM 1983; Kobayashi 1985(2); McKendry 1983, 1988; Lerner 1991.

MOULTON, DONN (b1929), Winnipeg, MB. Painter. **Citations**: Swinton 1961; NGC 1982.

MOUNT, RITA (1888-1967), Montréal, QC. Painter and illustrator. Mount studied under WILLIAM BRYMNER, as well as in Paris and New York. Her work is represented in the NATIONAL GALLERY OF CANADA. See McMann 1997 for a dated list of a selection of her paintings. **Citations**: Hubbard 1960; MacDonald 1967; Sisler 1980; NGC 1982; Laliberté 1986; Tippett 1992; McMann 1997.

MOUSSEAU, JEAN-PAUL ARMAND (b1927), Montréal, QC. Painter. Mousseau who studied under PAUL EMILE BORDUAS was a member of the AUTOMATISTES. After 1960 he became involved with large innovative MURALS using new technologies and nontraditional media. His work is represented in the NATIONAL GALLERY OF CANADA. **Citations**: Hubbard 1960; Harper 1966, 1967; MacDonald 1967; Duval 1972; Robillard 1973; Fenton 1978; Burnett/Schiff 1983; Bringhurst 1983; Reid 1988; Marsh 1988; Lerner 1991.

MUHLSTOCK, LOUIS (b1904), Montréal, QC. Painter. Muhlstock was born in Poland and came to Montréal in 1911. He studied art in Montréal and in Paris. His work includes paintings of Montréal scenes and drawings of figures and animals, but by 1986 became abstract. His paintings are represented in the NATIONAL GALLERY OF CANADA. **Citations**: McInnes 1950; Buchanan 1950; Duval 1952, 1972; Harper 1955; Hubbard 1960, 1963; MacDonald 1967; Adamson 1969; Bradfield 1970; Morris 1972; Lord 1974; Hill 1976; Ayre 1977; Fenton 1978; NGC 1982; Marsh 1988; Reid 1988; Lerner 1991; McMann 1997.

MULCASTER, WYNONA CROFT (b1915), Saskatchewan. Painter and teacher. She studied under

ERNEST LINDER and ARTHUR LISMER, as well as in Europe. She taught ALLEN SAPP. **Citations**: MacDonald 1967; Mulcaster 1969; Render 1974; Walters 1975; NGC 1982; Lerner 1991; Tippett 1992.

MUNN, KATHLEEN JEAN (1887-1974), Toronto, ON. Painter. Munn studied under F. MCGILLIVRAY KNOWLES and in the USA. Her work included religious drawings and CUBIST influenced paintings - see Hill 1995, pl. 166. Munn's paintings are represented in the ART GALLERY OF ONTARIO. **Citations**: Housser 1929; Robson 1932; Duval 1952; Harper 1966; MacDonald 1967; Bradfield 1970; NGC 1982; Lerner 1991; Tippett 1992; Hill 1995; McMann 1997.

MUNROE, WILLIAM. See WILLIAM MONRO.

MUNTZ, LAURA ADELINE. See LAURA ADELINE MUNTZ LYALL.

MURAL. A large work of art in any MEDIUM covering a great part of the surface of a wall. Murals were particularly popular in civic buildings for historical and propaganda purposes and in churches for teaching religious stories. For a description of GEORGE REID's interest in painting murals for the old Toronto City Hall in the mid 1890s see Reid 1988, p.102. See Bird 1983, pp. 8-10, for illustrations of the murals from the CROSCUP HOUSE, now in the NATIONAL GALLERY OF CANADA. The Winter Garden Theatre, Yonge Street, Toronto, has a fantasy English garden on its walls painted in 1914. Mural painters include OZIAS LEDUC, ALEX COLVILLE, CHARLES COMFORT, VICTOR CICAN-SKY, LUIGI CAPPELLO, JACK BUSH, JOSEPH-CHARLES FRANCHER and OSCAR CAHEN. See also HARRY and MARY JACKMAN. **Citations**: Lord 1974; Bird 1983; Riordon 1982; Greenaway 1986; Lerner 1991.

MURPHY, CECIL TREMAYNE. See CECIL TREMAYNE BULLER.

MURRAY BAY PRIMITIVES. See CHARLEVOIS COUNTY.

MURRAY, CHARLES ADOLPHUS (Earl of Dunmore) (1814-1907), England. Amateur painter. He travelled widely and visited western Canada. See Render 1974, pl. 7 and 8. **Citations**: Harper 1970; Render 1974.

MURRAY, JOAN (b1943). Joan Murray is the director of the Robert McLaughlin Art Gallery in Oshawa, ON. She is a widely known art historian, author of numerous Canadian art books and the curator of many Canadian catalogued art exhibitions. **Citations**: Murray 1971, 1972, 1973, 1978, 1978(2), 1978(3), 1979, 1979(2), 1980, 1981, 1981(2), 1982, 1982(2), 1984, 1984(2), 1988, 1994; Price 1979; Laing 1982; Morley 1986; Lerner 1991.

MUSEE DES BEAUX-ARTS DE MONTREAL. See MONTREAL MUSEUM OF FINE ARTS.

MUSEUMS AND GALLERIES. See COLLECTING; EXHIBITIONS.

MUSGROVE, ALEXANDER JOHNSTON (1890-1952), Winnipeg, MB. Painter. After studying art in Scotland and Europe, Musgrove came to Winnipeg in 1923 to establish an art school and gallery. He was a landscape painter. **Citations**: Robson 1932; IBM 1940; Harper 1966; MacDonald 1967; Eckhardt 1970; NGC 1982; Lerner 1991.

MUYSSON, HERTHA (1898-1984), Guelph, ON. Painter. Although Hertha Muysson did not start painting until she was in her 70s, she has painted sensitive, revealing portraits and self-portraits, which have received considerable attention from collectors and galleries. Her work is naïve and includes some local scenes. She is the mother of WILLIAM J. MUYSSON. **Citations**: MacGregor 1974; Farr 1975, 1982; NGC 1982; McKendry 1983, 1988; Kobayashi 1985(1)(2).

MUYSSON, WILLIAM J. (BILL) (b1940), Kingston, ON. Painter. Bill Muysson studied art and has worked as an art teacher and curator. For the most part his work is ABSTRACT. He is a son of HERTHA MUYSSON. **Citations**: MacDonald 1967; NGC 1982.

MYREN, RONALD L. (b1937), Edmonton, AB. Painter. **Citations**: Bingham 1981; NGC 1982; Lerner 1991.

N

NABIS, LES. At the end of the 19th century, a small number of French painters, such as Pierre Bonnard (1867-1947), were attracted to exloring the use of pure colours, while downplaying the importance of subject matter and as a reaction against NATURALISM. Canadian artist, PAUL-EMILE BORDUAS had contact early in his career with Nabis painter Maurice Denis (1870-1943). See also SYMBOLISM. **Citations:** Osborne 1970; Lucie-Smith 1984; Piper 1988; Read 1994.

NAÏVE ART. The term naïve art can apply to sculptures and paintings produced by artists who lack the conventional expertise of ACADEMIC artists. Usually a piece of naïve art is detailed, without showing much regard to scale, perspective or harmony of colours, yet displaying the intuitive ability of the artist to create images based on personal visions. The French artist HENRI ROUSSEAU is an outstanding example of a naïve artist. Some important Canadian naïve artists are: HERTHA MUYSSON, GEORGE COCKAYNE, MAUD LEWIS, JOSEPH SWIFT, WILLIAM PANKO, JAN WYERS, ARTHUR VIL-LENEUVE, WILLIAM LONEY, ANNA WEBER, CAPTAIN CARBONNEAU, MARIE BOUCHARD, A. DESCHENES, JAMES B. DENNIS, ARCH WILLIAMS, JOSEPH NORRIS, ALFRED V. LAW-TON, and BERNIE WREN. See also FOLK ART; FOLK ART, CONSCIOUS; NARRATIVE ART; PRIMITIVE ART; PROVINCIAL ART. **Citations**: Bihalji-Merin 1971, 1985; Harper 1973, 1974; Osborne 1981; McKendry 1983, 1987, 1988; Chilvers 1988; Piper 1988.

NAKAMURA, KAZUO (b1926), Toronto, ON. Painter. Nakmura studied at the CENTRAL TECHNI-CAL SCHOOL in Toronto. He exhibited with the PAINTERS ELEVEN Group of Toronto after turning from figurative painting to ABSTRACT EXPRESSIONISM. Several paintings by Nakamura are in the NATIONAL GALLERY OF CANADA. **Citations**: Hubbard 1960, 1963; Harper 1966; MacDonald 1967; Duval 1972; Lord 1974; Sisler 1980; NGC 1982; Bringhurst 1983; Burnett/Schiff 1983; Marsh 1988; Reid 1988; Lerner 1991; McMann 1997.

NAPIER, WILLIAM HENRY EDWARD (1829-94), Québec. Painter. Napier accompanied HENRY YOULE HIND on his Canadian Red River exploring expedition in 1858, and visited Fort Garry and Norway House. In 1868-70 he worked as a civil engineer with the Intercolonial Railway. Napier's paintings include views of the various places he visited in the west and throughout Québec. His sketches form the basis for some of WILLIAM ARMSTRONG's paintings. **Citations**: Eckhardt 1970; Render 1970; Harper 1970; Bell 1973; Allodi 1974; Nasby 1980; NGC 1982; McKendry 1988; Cavell 1988.

NARRATIVE ART. Narrative paintings and sculpture tell a story. It was popular in Victorian England and in NAÏVE ART, see McKendry 1983, pl. 45. Canadian sculptor ART GALLANT and painter ALFRED LAWTON used narrative in their works. See also CONTINUOUS NARRATIVE. **Citations**: McKendry 1983; Lucie-Smith 1984.

NATIONAL ARCHIVES OF CANADA. The National Archives in Ottawa, ON, is the keeper of Canada's documentary unpublished records and also houses many works of art of historical value; see ALFRED JACOB MILLER. **Citations**: Smith 1972(1); Miller 1973; Vachon 1985; Marsh 1988.

NATIONAL GALLERY OF CANADA (NGC). The National Gallery of Canada in Ottawa, ON, has grown from an inauspicious start in 1880 through troubled teen-age years to a respected maturity with a distinguished collection of art housed and displayed in a new world-class gallery designed by the architect Moshe Safdie (b1938) and opened in 1988. Its collection of Canadian Art, both historical and contemporary, is the largest and most important collection of Canadian work due largely to the first director, ERIC BROWN, and a succession of dedicated curators including ROBERT H. HUBBARD, J. RUSSELL HARPER, Jean-Réné Ostiguy, Jean Trudel, DENNIS REID, and Charles Hill. See COL-LECTING; EXHIBITIONS; ROYAL CANADIAN ACADEMY. **Citations**: Colgate 1943; McInnes 1950; Hubbard 1957; Cox 1960; Harper 1966; Mellen 1970; Boggs 1971; Watson 1974; Lord 1974; Sisler 1980; Reid 1979; 1988; Marsh 1988; Hill 1988, 1995; Lerner 1991; Tippett 1992; Kalman 1994;

Silcox 1996; McMann 1997.

NATIONAL MUSEUM OF CIVILIZATION. See CANADIAN MUSEUM OF CIVILIZATION.

NATIONAL MUSEUM OF MAN. See CANADIAN MUSEUM OF CIVILIZATION.

NATIVE ART OF CANADA. It is only recently that native art has been distinguished from HANDICRAFTS, and even yet the 'reserve' mentality applies to the art of Canada's first peoples. The five-page. entry in *The Canadian Encyclopedia* (Marsh 1988) on painting in Canada does not discuss native painting or refer to such respected native painters as NORVAL MORRISSEAU, DAPHNE ODJIG, BLAKE DEBASSIGE, and CARL RAY, although there are individual entries for these artists. Studies of native painting such as *The Art of Norval Morrisseau* (Sinclair 1979) and *The Image Makers* (McLuhan 1984), as well as many exhibitions of native work, should ensure that native painters are not overlooked when the next definitive history of painting in Canada is written (native painting is not included in *Painting in Canada*, Harper 1966, 1981, and is very briefly dealt with in the *Concise History of Canadian Painting*, Reid 1988 p. 360). Early native sculptors have received much more attention from anthropological museums than from art galleries. MARIUS BARBEAU studied west coast native sculpture (see Barbeau 1950, 1957) and GEORGE SWINTON (Swinton 1972) has dealt with the sculpture of the Inuit people in a definitive manner. See Houston 1967 and Goetz 1977 for Inuit prints. See also PRIMITIVE ART; FOLK ART EXHIBITIONS; MARIUS BARBEAU; EMILY CARR; LINEAR; MASKS, FALSE FACE SOCIETY; POTLACH; ALGONQUIN LEGEND PAINTERS; BRITISH COLUMBIA; ARGILLITE; HAIDA, TSIMSHIAN; TOTEM POLES; SOAPSTONE; SHAMAN; SCRIMSHAW; and individual artists such as JESSIE OONARK and CHARLES EDEN-SHAW. **Citations**: Newcombe 1930; Jenness 1932; Ravenhill 1944; Inverarity 1947; Barbeau 1950, 1957, 1960, 1961, 1973(1); Hawthorn 1956; Siebert 1967; Houston 1967; Clutesi 1969; Feder 1969; Osborne 1970 (see Indian Arts); MacEwan 1971; Swinton 1965; Inuit 1971; Swinton 1972; Patterson 1973; Dickason 1974; Goetz 1977; Hassrick 1977; Radulovich 1978; King 1979; Sinclair 1979; Halpin 1981; Ojibwa 1981; Bringhurst 1983 (pages 150-5); McKendry 1983 (see Indians, Inuit); McLuhan 1984; Wright 1987; Marsh 1988 (see Indian Art, Inuit Art, Northwest Coast Indian Art, Native People, totem pole); Lerner 1991(Indian artists).

NATIVITY. See RELIGIOUS ART.

NATTE dit MARSEILLE, JEAN (act. 1772-92), Québec City, QC. Painter. Natte made marionettes and painted religious scenes in churches. **Citations**: Harper 1966; NGC 1982.

NATURALISM. A stylistic term used for a type of art which shows natural objects as they appear and not stylized. The mature works of DANIEL FOWLER have a strong sense of naturalism. See also REALISM. **Citations**: Osborne 1970; Piper 1988; Chilvers 1988.

NAVE. The nave is usually for the congregation and is the largest interior space on the main floor of a church, chapel or cathedral. It may extend from the narthex (interior entrance porch) or entrance wall to the APSE or to the CROSSING or the CHOIR. For illustrations of an early Canadian example, see Kalman 1994, v.1, pp. 73-4. **Citations**: Pierce 1987; Kalman 1994.

NEAVITT, RICHARD BARRINGTON (1850-1928), Calgary, AB. Painter. Neavitt was with the Royal Canadian Mounted Police at Fort MacLeod and Fort Calgary, AB. He painted lively watercolours of landscape and GENRE scenes. Examples of his work are in the GLENBOW MUSEUM. **Citations**: Harper 1970; Wilkin 1980; McKendry 1988.

NEILSON, HENRY IVAN (1865-1931), Québec City, QC. Painter and printmaker. Neilson studied art in Europe and taught art in Québec City. A member of the CANADIAN ART CLUB , he was best known for his paintings of Québec scenes. Examples of his paintings are in the NATIONAL GALLERY OF CANADA. **Citations**: MacTavish 1925; Robson 1932; Colgate 1943; McInnes 1950; Hubbard 1960; Harper 1970; MacDonald 1967; Sisler 1980; NGC 1982; Laliberté 1986; Reid 1988; Lerner 1991; McMann 1997.

NELSON, MARION HOPE. See MARION HOPE NELSON HOOKER.

NEOCLASSICISM. Neoclassicism, stimulated by excavations at the Roman towns of Herculaneum and Pompeii during the 18th century, was an art movement that affected decorative arts, architecture, painting, and sculpture from about the mid 18th to the early 19th centuries. Certain Roman and Renaissance classical forms were studied and drawn by British gentlemen during their Grand Tours of Italy. This style spread quickly to North America through the tastes of emigrants, as well as printed theory and illustrations. WILLIAM BERCZY SR is an example of a Canadian artist and architect influenced by this style. LAURENT AMIOT was a Québec silversmith working in this style. In architecture and interior design, it may be referred to as the Adam or Adamesque style, after the Scottish architect Robert Adam (1728-92) and his brothers James and John Adam. Province House (1811-19) in Halifax, NS, has very fine Adamesque interior detailing. **Citations**: Harper 1966; Arnason 1968; Osborne 1970; Lord 1974; Janson 1977; Chilvers 1988; Piper 1988; Kalman 1994.

NEO-IMPRESSIONISM. Neo-impressionism was a movement in French painting that developed out of IMPRESSIONISM and in reaction to it, and that originated with an exhibition in 1886 when Georges Seurat (1859-91), Paul Signac(1863-1935) and Camille Pissarro (1830-1903) included works in the POINTILLIST technique. **Citations**: Arnason 1968; Osborne 1970; Janson 1977; Bringhurst 1983; Piper 1988; Chilvers 1988.

N.E.THING COMPANY LTD. A company formed in Vancouver, BC, between 1966 and 1969, by IAIN and INGRID BAXTER, and JOHN FRIEL to create CONCEPTUAL ART as a commodity. See Burnett/Schiff 1983, pp. 183-7, and Bringhurst 1983, pp. 194-5, for an illustration and discussion of the company's work. **Citations**: Townsend 1970; Wilkin 1976(1) (see Iain Baxter); Mellen 1978; Burnett/ Schiff 1983; Bringhurst 1983; Reid 1988; Hill 1988(see Iain Baxter).

NETTIE SHARPE COLLECTION. See CANADIAN CENTRE FOR FOLK CULTURE STUDIES.

NEUFELD, WOLDEMAR (b1909), Waterloo County, ON. Painter. Although Neufeld now lives in the USA, he continues to paint many scenes in Waterloo County, where he lived after leaving Russia in 1923. **Citations**: Blain 1982; NGC 1982; McKendry 1988.

NEVITT, RICHARD BARRINGTON (1850-1928), Alberta, Western Canada. Painter. Nevitt was a doctor with the North West Mounted Police 1874-78. For a discussion of his paintings with illustrations, see Render 1974, pp. 36-45. After 1878 Nevitt was in Toronto, ON. **Citations**: Render 1974; NGC 1982.

NEW BRUNSWICK. See MARITIME PROVINCES.

NEWFOUNDLAND and LABRADOR. Newfoundland (NF), of which Labrador is a part, joined the Canadian Confederation in 1949. The area which is now the Province of NF was visited by early travelers who sometimes sketched or painted views. These artists included THOMAS SKINNER, PETER RINDISBACHER, NICHOLAS POCOCK, WILLIAM EAGAR, WILLIAM GEORGE RICHARDSON HIND, and ROBERT DUDLEY. Later artists include FREDERICK SCHILLER COZZENS, JOHN W. HAYWARD, WILLIAM GREY, WILLIAM GOSSE, DAVID BLACKWOOD, MARY and CHRISTOPHER PRATT, ARCH WILLIAMS, LEONARD BURT, CARL BARBOUR, THOMAS HUDSON, and PERCY PIEROWAY. **Citations**: Whiteway 1952; Harper 1964; Smallwood 1967; De Volpi 1972; Goodridge 1975; Gratton 1976, 1977; McKendry 1983; Marsh 1988; Lerner 1991.

NEWFOUNDLAND ACADEMY OF ART. Founded in 1949 by REGINALD and HELEN SHEP-HERD, after they had studied at the ONTARIO COLLEGE OF ART. Instruction was provided in painting and sculpture. **Citations**: Smallwood 1967; Lerner 1991.

NEW FRANCE. See Québec.

NEWTON, LILIAS TORRANCE (1896-1980), Montréal, QC. Portrait painter; RCA 1937. Newton joined the BEAVER HALL GROUP in 1920, and was a founding member of the CANADIAN GROUP OF PAINTERS (1933). She painted portraits of A.Y. JACKSON, LAWREN HARRIS, EDWIN HOLGATE and ARTHUR LISMER (now in the NATIONAL GALLERY OF CANADA). **Citations**: Colgate 1943; McInnes 1950; Harper 1955; Jackson 1958; MacDonald 1967; Mellen 1970; Duval 1972; Hill 1975, 1995; Farr 1981(1); NGC 1982; Burnett/Schiff 1983; Marsh 1988; Reid 1988; Lerner 1991;

Tippett 1992; McMann 1997.

NGC. See NATIONAL GALLERY OF CANADA.

NICHE. A recess in a wall for a statue, BUST, vase, etc. is called a niche. It is often curved with a round arch at the top. **Citations:** Pierce 1987.

NICHOLS, JACK (b1921), Toronto, ON. Painter, printmaker and teacher. He studied under LOUIS MULSTOCK. Nichols's work is represented in the NATIONAL GALLERY OF CANADA. **Citations:** Buchanan 1950; McInnes 1950; Duval 1952, 1954, 1972; Ross 1958; Jackson 1958; Hubbard 1960; 1963; Harper 1966, 1967; MacDonald 1967; Bradfield 1970; Sisler 1980; Reid 1988; Lerner 1991; McMann 1997.

NICKERSON, J.M. (act. 1912), British Columbia. Painter. Nickerson is known for an oil painting of a shipwreck illustrated in Harper 1974, pl. 95. **Citations:** Harper 1973, 1974; Kobayashi 1985(2); McKendry 1988.

NICOL (NICHOL), PEGI. See PEGI NICOL MACLEOD.

NICOLL, JAMES (JIM) MCLAREN (1892-1986), Calgary, AB. Painter and illustrator. Nicoll was largely self taught, although he did study in New York in 1958-9. He began painting in 1935, and was married to MARION NICOLL. James Nicoll was the founding editor of the magazine, *Highlights* published by the ALBERTA SOCIETY OF ARTISTS. See Render 1974, pl. 186-7 for illustrations. **Citations:** Highlights 1947; MacDonald 1967, Render 1974; Wilkin 1980; Bingham 1980; NGC 1982; Burnett/Schiff 1983; Masters 1987; Tippett 1992; Lerner 1991; McMann 1997.

NICOLL, MARION FLORENCE S. MACKAY (1909-85), Calgary, AB. Painter. Nicoll studied under J.E.H. MACDONALD and A.C. LEIGHTON, as well as in England and New York. Her work includes abstractions (see Harper 1966, pl. 355). She is married to the painter JAMES NICOLL. **Citations:** Harper 1966; MacDonald 1967; Lord 1974; Barnet 1975; Sisler 1980; Wilkin 1980; NGC 1982; Burnett/Schiff 1983; Masters 1987; Reid 1988; Lerner 1991; Tippett 1992; McMann 1997.

NIHILIST SPASM BAND. A kazoo music group founded by GREG CURNOE and his friends c1962-4. **Citations:** Lord 1974; Reid 1988.

NIVERVILLE. See DE NIVERVILLE, LOUIS.

NMM. See NATIONAL MUSEUM OF MAN.

NOKONY, DENIS (b1951), Saskatchewan. Painter and poet. **Citations:** Mendell 1977; Enright 1981; NGC 1982.

NOLIN, ALICE (1896-1967), Montréal, QC. Sculptor. Nolin studied under CHARLES MAILLARD and ALFRED LALIBERTE. **Citations:** Levesque 1936; NGC 1982; Laliberté 1986; Lerner 1991.

NON-FIGURATIVE ARTISTS' ASSOCIATION OF MONTREAL (1956-61). The Association was founded in 1956 with FERNAND LEDUC as president (followed by JEAN ALBERT MCEWEN) and RODOLPHE DE REPENTIGNY as secretary. Its membership included the PLASTICIENS and many of the artists working in the AUTOMATISTE tradition. **Citations:** Leblanc 1979; Reid 1988; Lerner 1991; Tippett 1992.

NON-FIGURATIVE PAINTING. See EXPRESSIONISM; ABSTRACT.

NON-OBJECTIVE ART. See ABSTRACT ART.

NORMAND, FRANCOIS (1779-1854), Québec. Sculptor of religious works in wood. **Citations:** Traquair 1947; Gowans 1955; NGC 1982; Porter 1986.

NORRIS, JOSEPH (JOE) (b1924), Lower Prospect, NS. Painter. At age forty-nine, as a result of a heart attack, Norris was forced to retire from commercial fishing. As he recovered, he began painting and became so involved in his art that he worked ten or twelve hours a day. Norris's work is naïve and shows a strong feeling for decorative design based on bold colouring, some sense of perspective and scale, and repetitive patterns. His subjects include landscape, marine scenes, birds (particularly seagulls), animals, ships and coastal scenes, as well as decorative paintings on furniture. **Citations:** Elwood 1976; Huntington 1978; NGC 1982; NMM 1983; McKendry 1983, 1988; Kobayashi 1985(2); Lerner 1991.

NORTHWEST COAST ART. See BRITISH COLUMBIA; NATIVE ART OF CANADA; PRIMI-TIVE ART; FOLK ART EXHIBITIONS; MARIUS BARBEAU; EMILY CARR; LINEAR; SHAMAN; MASKS, POTLACH; ARGILLITE; HAIDA, TSIMSHIAN; TOTEM POLES; and individual artists such as CHARLES EDENSHAW..

NORWELL, GRAHAM NOBLE (1901-67), Ottawa, ON; Montréal, QC. Painter. Norwell left Scotland and came to Canada in 1914. He studied art under ARTHUR LISMER, G.A. REID, J.W. BEATTY, and ROBERT HOLMES at the Ontario College of Art, as well as in London and Paris. He was a landscape painter with a love of Laurentian scenes. His paintings are included in the collections of the NATIONAL GALLERY OF CANADA. **Citations**: MacTavish 1925; Harper 1955; Hubbard 1960; MacDonald 1967; Adamson 1969; Laurette 1978; NGC 1982; Lerner 1991; Hill 1995; Silcox 1996; McMann 1997.

NOTMAN, WILLIAM (1826-91), Montréal, QC; Halifax, NS; Ottawa and Toronto, ON. Photographer. Notman, who had learned the DAGUERREOTYPE photographic process in Scotland, immigrated to Canada in 1856 and set up a photographic studio in Montréal. Notman established many branch studios and provided employment for artists, among whom were JOHN HAMMOND, OTTO JACOBI, FREDERICK ARTHUR VERNER, JOHN ARTHUR FRASER, HENRY SANDHAM, CHARLES JONES WAY, ADOLPHE VOGT, ROBERT FORD GAGEN, FARQUAR MCGILLIVRAY KNOWLES, HOMER WATSON and HORATIO WALKER. Notman made many large COMPOSITE PHOTOGRAPHS by cutting out and pasting as many as 300 individual portraits on a painted background, which would then be photographed and prints issued, for examples see Harper 1967 or Triggs 1985, pp. 158-61. A very large Notman collection, containing among other documents over 400,000 photographs, is housed in the Notman Photographic Archives of the McCord Museum of McGill University in Montréal, QC. **Citations**: Robson 1932; Colgate 1943; Harper 1966, 1970, 1967, 1979; Mellen 1970; Lord 1974; Duval 1974; Greenhill 1965, 1979; Thomas 1972, 1979; Bovey 1976; Reid 1979, 1988; Sisler 1980; NGC 1982; Triggs 1985; Cavell 1988; Marsh 1988; McKendry 1988; Hill 1988(p. 400); Lerner 1991.

NOVA SCOTIA. See MARITIME PROVINCES.

NOVA SCOTIA COLLEGE OF ART AND DESIGN. The College was established in Halifax, NS, in 1887 and obtained university status in 1969. Bachelor's and master's degrees are offered in fine arts and art education. See GERALD FERGUSON and GARRY KENNEDY. **Citations**: Lord 1974; Laing 1979; Bringhurst 1983; Marsh 1988; Reid 1988; Tippett 1992; Soucy 1993.

NOVA SCOTIA SOCIETY OF ARTISTS (NSA). The Society was founded in 1922 by eleven artists including EDITH SMITH and ELIZABETH NUTT. Incorporated in 1938, it became inactive in 1972. **Citations**: NSA 1923; Lerner 1991.

NUDE. See EROTIC ART.

NULF, FRANK ALLEN (b1933), Saskatchewan. Painter and printmaker. **Citations**: Dillow 1976(1); Mendell 1977; NGC 1982; Lerner 1991.

NUTT, ELIZABETH STYRING (1870-1946), Nova Scotia. Painter and art teacher. She studied art in England, Paris and Italy, and was active in the NOVA SCOTIA SOCIETY OF ARTISTS. Her work is represented in the NATIONAL GALLERY OF CANADA. **Citations**: NSA 1923; Robson 1932; Colgate 1943; Hubbard 1960; MacDonald 1967; Hill 1975; Sisler 1980; Kelly 1980; NGC 1982; Lerner 1991; Tippett 1992; McMann 1997.

NUTTING, ELLEN (act. 1842-46), Eastern Canada. Painter. She is known for the portrait of a native woman. **Citations**: Tippett 1992.

O

OAD, JAN (b1889), Toronto, ON. Painter. Oad is an Estonian seaman turned artist who retired to Toronto. Many of his paintings relate to ships and to his native island of Kihnu near the Estonian coast. See Bihalji-Merin 1985 for an illustration and a further account of his life. **Citations**: Bihalji-Merin 1985; McKendry 1988.

OBERHEIDE, HEIDI (b1943), Newfoundland. Printmaker, sculptor and mixed media artist. **Citations**: NGC 1982; Lerner 1991; Tippett 1992.

O'BRIEN, JOHN (1831 or 1832-91), Halifax, NS. Painter. O'Brien is noted for his marine, ship and portrait paintings in oil. O'Brien's earlier marine paintings showed much promise (see Mellen 1978, pl. 52, and Harper 1966, pl. 104-5) but, in later years, the quality deteriorated and he began painting local views on a mass production basis (Harper 1966, p. 114). His work is represented in the NATIONAL GALLERY OF CANADA. **Citations**: Colgate 1943; Hubbard 1960, 1967; Harper 1964, 1966, 1970; Carter 1967; Lord 1974; Armour 1975; Mellen 1978; NGC 1982; Laurette 1984; McKendry 1988; Reid 1988.

O'BRIEN, LUCIUS RICHARD (1832-99), Toronto, ON. Painter, RCA 1880. After about 1872, O'Brien turned from civil engineering to professional landscape painting. He was the first president of the ROYAL CANADIAN ACADEMY, and supervised the illustrations in *Picturesque Canada* (Grant 1882). His 1880 painting *Sunrise on the Saguenay* (see Mellen 1978, pl. 62), now in the NATIONAL GALLERY OF CANADA, is much admired for the manner in which the artist used light in the picture. See Reid 1990 for the best account and illustrations of O'Brien's work. Several paintings by O'Brien are in the NATIONAL GALLERY OF CANADA. See McMann 1997, pp. 307-10, for a dated list of O'Brien's paintings. See also LUMINISM. **Citations**: Grant 1882; MacTavish 1925; Robson 1932; Colgate 1943; NGC 1945; McInnes 1950; Duval 1954; Hubbard 1960, 1967; Kilbourn 1966; Harper 1966, 1970; MacDonald 1967; Mellen 1970, 1978; Bradfield 1970; Boggs 1971; Render 1974; Lord 1974; Forsey 1975; Reid 1979, 1988, 1990; Sisler 1980; Baker 1981; Piper 1988; Marsh 1988; Lerner 1991; Hill 1995 McMann 1997.

ODJIG, DAPHNE (b1919), New Westminster, BC; Winnipeg, MB; Manitoulin Island, ON. Painter. Odjig's paintings have many primitive overtones based on native traditions (see Bringhurst 1983, pp. 152-3). For a time, she was associated with NORVAL MORRISSEAU, CARL RAY, ALEX SIMEON JANVIER and JACKSON BEARDY. **Citations**: MacDonald 1967; Farr 1975; Ojibwa 1981; NGC 1982; Bringhurst 1983; Marsh 1988; McKendry 1988; Reid 1988; Lerner 1991; Tippett 1992.

OEUVRE. This term describes all the work of an artist. **Citation**: Lucie-Smith 1984.

OFFSET. A method of LITHOGRAPHIC printing, in which ink is transferred from a plate or stone to a rubber surface and from there to paper. This double reverse of the image results in the print having the correct orientation when compared to the original. **Citation**: Osborne 1970.

OGILVIE, WILLIAM (WILL) ABERNETHY (b1901), Palgrave, ON. Painter, MURALIST. Ogilvie came to Canada from South Africa in 1925, and then studied painting in New York. He is a landscape and figure painter. Several of his paintings are in the NATIONAL GALLERY OF CANADA. **Citations**: Robson 1932; Tate 1938; Colgate 1943; Buchanan 1950;McInnes 1950; Duval 1952, 1954, 1972; Harper 1955, 1966; Jackson 1958; Hubbard 1960, 1963; Kilbourn 1966; MacDonald 1967; Adamson 1969; Bradfield 1970; Morris 1972; Jarvis 1974; Robertson 1977; Sisler 1980; NGC 1982; Reid 1988; Marsh 1988; Lerner 1991; Silcox 1996; McMann 1997.

OIL PAINTING. Any painting is an oil painting if a substantial amount of drying oils are used in the MEDIUM. In recent times ACRYLIC PAINT has rivalled oils in popularity. **Citations**: Osborne 1970; Mayer 1970; Pierce 1987; Chilvers 1988; Silcox 1996.

OLAFSON, LINDA (b1922), Saskatchewan. Ceramicist. She was involved in the GRAIN BIN

PROJECT. **Citations**: NGC 1982; Bringhurst 1983.

OLIVER, BOBBIE (b1943), Ontario. Painter. **Citations**: Murray 1980(2); NGC 1982; Lerner 1991.

ONDAATJE, KIM (Betty Jane Kimbark Jones Ondaatje) (b1928), Bellrock, ON. Painter and printmaker. She studied under JOHN LYMAN, and her work is represented in the MONTREAL MUSEUM OF FINE ARTS. She was married to the writer Michael Ondaatje. **Citations**: MacDonald 1967; Ondaatje 1974; NGC 1982; Farr 1988; Lerner 1991; Tippett 1992.

ONLEY, NORMAN ANTONIO (TONI) (b1928), Vancouver and Victoria, BC. Painter, COLLAGE maker and printmaker. Onley studied in Mexico and in England. He is a landscape painter who travels widely throughout Canada working in watercolour, on location, using broad washes. His studio work is usually oil paintings or SILK-SCREEN prints based on his watercolours. Onley's art is represented in many private and public collections including the NATIONAL GALLERY OF CANADA. **Citations**: Harper 1966; MacDonald 1967; Bradfield 1970; Duval 1972; Lord 1974; Heath 1976; Fenton 1978; Lindberg 1978; Sisler 1980; Boulet 1981; NGC 1982; Bringhurst 1983; Burnett/Schiff 1983; Reid 1988; Marsh 1988; Lerner 1991; McMann 1997.

ONTARIO. Ontario (ON), the second-largest province, has the largest population and numerous artists. Upper Canada, settled by United Empire Loyalists in 1784, came into existence by an act of the British parliament in 1791, was known after 1841 as Canada West, and entered Confederation as Ontario on 1 July 1 1867. Among the early artists were many British army officers, travelers, and some settlers, for example THOMAS DAVIES, EDWARD WALSH, WILLIAM GREEN, GEORGE BACK, THOMAS YOUNG, GEORGE THEODORE BERTHON, WILLIAM BUCK, ROBERT WHALE, FREDERICK W. LOCK, ALFRED WORSLEY HOLDSTOCK, FRANCES ANN BEECHEY HOPKINS, OTTO REINHOLD JACOBI, HOMER WATSON, and DANIEL FOWLER. Of the more recent artists, the GROUP OF SEVEN is best known and their paintings are the most sought after for the highest prices. The nation's art collection is in the NATIONAL GALLERY OF CANADA, Ottawa., ON Another important public collection is in the ART GALLERY OF ONTARIO, Toronto, ON. The MCMICHAEL CANADIAN COLLECTION, in Kleinburg, ON, has a large number of paintings by the Group of Seven. See ONTARIO SOCIETY OF ARTISTS; ONTARIO COLLEGE OF ART; PAINTERS ELEVEN; and CANADIAN GROUP OF PAINTERS. **Citations**: OSA 1873; de Volpi 1964, 1965, 1966; Harper 1964, 1966; Groves 1968; Murray 1972; Reid 1972, 1979, 1988; Housser 1974; Lord 1974; Forsey 1975; Bird 1977, 1981; Wolff 1978; Reid 1979, 1988; Sisler 1980; Kobayashi 1985(1); Marsh 1988; Lerner 1991; Hill 1995; Silcox 1996.

ONTARIO COLLEGE OF ART (OCA). In 1876, the ONTARIO SOCIETY OF ARTISTS founded the Ontario School of Art in Toronto that became the Ontario College of Art and is now Canada's best known art school. Many well-known Canadian artists have studied at and/or taught at the OCA. **Citations**: Colgate 1943; McInnes 1950; Jackson 1958; Harper 1966; Mellen 1970; Duval 1972, 1974; Lord 1974; Reid 1979, 1988; Sisler 1980; Bringhurst 1983; Marsh 1988; Lerner 1991; Tippett 1992; Hill 1995.

ONTARIO SCHOOL OF ART. See ONTARIO COLLEGE OF ART.

ONTARIO SOCIETY OF ARTISTS (OSA). The OSA was formed in Toronto in 1872 by JOHN A. FRASER, ROBERT F. GAGEN, MARMADUKE MATTHEWS, THOMAS MOWER MARTIN, JAMES HOCH, CHARLES S. MILLARD, and J.W. BRIDGMAN. The first annual exhibition of the OSA was held in 1873 with great success. In 1876, the OSA started a school which eventually became the ONTARIO COLLEGE OF ART and, in 1900, the OSA assisted in the founding of the art museum that is now the ART GALLERY OF ONTARIO. **Citations**: OSA 1873; MacTavish 1925; Robson 1932; Colgate 1943; McInnes 1950; Jackson 1958; Harper 1966; Mellen 1970; Murray 1972; Duval 1972, 1974; Lord 1974; Reid 1979, 1988; Withrow 1974; Sisler 1980; Burnett/Schiff 1983; Lerner 1991; Tippett 1992; Hill 1995; Silcox 1996.

OONARK, JESSIE (1906-85), Baker Lake, Canadian Arctic. Printmaker. Oonark was an Inuit artist who is known for her drawings and wall hangings. **Citations**: Goetz 1977; Sisler 1980; NGC 1982;

Marsh 1988; Lerner 1991; Tippett 1992; McMann 1997.

OP (OPTICAL) ART. Op art is ABSTRACT ART in which optical effects (visual illusions) are created by a pattern. Such a pattern may appear to vibrate or change shape while being viewed. Canadian artists who used these effects include CLAUDE TOUSIGNANT, MARCEL BARBEAU, GUIDO MOLINARI, YVES GAUCHER, RALPH ALLEN and RAY MEAD. See also KINETIC ART. **Citations**: Harper 1966; Duval 1972; Lord 1974; Osborne 1981; Piper 1988; Reid 1988.

OPTICAL PERSPECTIVE. See GEOMETRIC PERSPECTIVE.

ORIENTAL PAINTING. See FOIL ART.

ORNAMENTAL ART. See DECORATIVE ART.

OSA. See ONTARIO SOCIETY OF ARTISTS.

OVERSHOT. See COVERLETS.

OWEN, FREDERICK HOWARD (b1934), New Westminster, BC. Sculptor, ceramicist and teacher. His art is represented in the ROYAL ONTARIO MUSEUM, Toronto, ON. **Citations**: MacDonald 1967; NGC 1982.

P

PAGE, J.R. (act. 1864-65), eastern Ontario. Painter, illustrator. Page is known for some naïve paintings of farm scenes and farm animals. He sketched livestock for reproduction in the *Canada Farmer* (Toronto) 1864-65. **Citations**: Harper 1970, 1973; *Canadian Collector* 1967, 1980; Kobayashi 1985(2); McKendry 1988; Lerner 1991.

PAINT. Paint comprises very fine solid particles of PIGMENT dispersed in a MEDIUM. See FRESCO; GOUACHE; OIL PAINTING; SECCO; TEMPERA; WATERCOLOUR; ACRYLIC. **Citations**: Osborne 1970; Mayer 1970.

PAINTERLY. Painterly artistssuch as Titian (c1487/90-1576), Peter Paul Rubens (1577-1640), and Eugène Delacroix (1798-1863), depict forms with patches of coloured light and shade or by merging the form's edges into adjacent areas in a manner opposite to LINEAR. The term painterly was first used by the Swiss art historian heinrich Wölfflin in his *Principles of Art History* 1915. The work of Canadian artiss MAURICE CULLEN can be said to be painterly. **Citations**: Piper 1988.

PAINTERS ELEVEN. A group of Toronto, ON, abstract artists who were active from 1953 to 1960 and included WILLIAM RONALD, KAZUO NAKAMURA, ALEXANDRA LUKE, RAY MEAD, OSCAR CAHEN, JACK BUSH, TOM HODGSON, JOCK MACDONALD, HORTENSE GORDON, WALTER YARWOOD, and HAROLD TOWN. **Citations**: NGC 1958; Harper 1966; Woods 1970, 1972; Withrow 1972; Duval 1972; Lord 1974; Murray 1979; Sisler 1980; Burnett/Schiff 1983; Bringhurst 1983; Marsh 1988; Reid 1988; Chilvers 1988; Lerner 1991; Tippett 1992.

PAINTING IN CANADA. In the 17th century, paintings and ENGRAVINGS were sent from France and were mostly of religious subjects. Some priests in New France (now Québec) were painters, for example JEAN PIERRON and CLAUDE CHAUCHETIERE, but little of their work remains. The latter part of the 17th century was the age of BISHOP LAVAL (see Harper 1966, pp. 3-15); he had artists and craftsmen sent from France to decorate the churches being built in New France. Harper refers to the Abbé POMMIER, who was one of Laval's protégés, as "probably the first real painter to work in Canada." (Harper 1966, p. 3). The British conquest in 1759-60 introduced TOPOGRAPHICAL painting to Canada by members of the British army, among whom were THOMAS DAVIES, JOSEPH FREDERICK WALLET DES BARRES, JAMES PEACHEY, GEORGE HERIOT, EDWARD WALSH, JAMES PATTISON COCKBURN, RICHARD G. A. LEVINGE, J.B. ESTCOURT, and E.Y.W. HENDERSON. During the period of prosperity which followed the conquest, the middle class began to replace the church as patrons of the arts, and the demand for portraits and decorative paintings increased. Artists

who flourished in this period were LOUIS DULONGPRE, FRANCOIS BEAUCOURT, FRANCOIS BAILLAIRGE, WILLIAM BERCZY, ROBERT FIELD, JEAN ANTOINE AIDE-CREQUY, JOSEPH LEGARE, ANTOINE PLAMONDON, THEOPHILE HAMEL, and GEORGE THEODORE BERTHON. Prior to the mid 19th century, Canadian painting reflected European taste but, by 1841, CORNELIUS KRIEGHOFF was painting local Québec GENRE scenes, sometimes showing native life. PETER RINDISBACHER painted local views around Fort Garry in what is now Manitoba, followed by PAUL KANE who painted western scenes and native people, as well as FREDERICK VERNER, and WILLIAM G.R. HIND. In the latter part of the 19th century, photography was popular and the demand for painted portraits faded. The portrait, landscape and GENRE work of the photographer WILLIAM NOTMAN was in demand, and he employed many artists who painted in their spare time, for example JOHN A. FRASER, HENRY SANDHAM, ALLAN EDSON, and OTTO JACOBI. Respect for Canadian art increased to the extent that in 1880 the ROYAL CANADIAN ACADEMY and the NATIONAL GALLERY OF CANADA were founded. Prominent painters during the early years of the Academy and of the Gallery were LUCIUS O'BRIEN, WILLIAM BRYMNER, ROBERT HARRIS, PAUL PEEL, GEORGE REID, HOMER WATSON, OZIAS LEDUC, HORATIO WALKER, MORRICE CULLEN, JAMES WILSON MORRICE, and MARC-AURELE DE FOY SUZOR-COTE. Early in the 20th century, a group of Toronto landscape painters changed the nature of Canadian painting. They were TOM THOMSON, FRANK CARMICHAEL, LAWREN HARRIS, A.Y. JACKSON, FRANZ JOHNSTON, ARTHUR LISMER, J.E.H. MACDONALD, and F.H. VARLEY. Tom Thomson died in 1917, but the remaining members of the group became the GROUP OF SEVEN and held their first exhibition in 1920. Their bold, colourful, POST-IMPRESSIONIST style of painting Canadian landscape influenced Canadian painting for many years. The group disbanded in 1933 and was followed by other groups who were broader based. Other artists working at the time of the Group of Seven tended to be ignored until after the group disbanded; these included EMILY CARR, DAVID MILNE, LIONEL LEMOINE FITZGERALD, CHARLES COMFORT, MILLER BRITTAIN, JACK HUMPHREY, and BERTRAM BROOKER. After the last World War, the number of professional artists, modern movements in art, exhibitions and galleries increased sharply, at first in Montréal and then spreading across the country. Painters who appeared in this scene include JOHN LYMAN, ALFRED ELLAN, PRUDENCE HEWARD, FRITZ BRANDTNER, GOODRIDGE ROBERTS, LOUIS MUHLSTOCK, PAUL-EMILE BORDUAS, FERNAND LEDUC, PIERRE GAUVREAU, JEAN-PAUL RIOPELLE, MARCEL BARBEAU, GUIDO MOLINARI, PARASKEVA CLARK, JOCK MACDONALD, JACK BUSH, HAROLD TOWN, WILLIAM RONALD, KAZUO NAKAMURA, MICHAEL SNOW, BRUNO BOBAK, MOLLY LAMB BOBAK, LAWREN P. HARRIS, ALEX COLVILLE, CHRISTOPHER PRATT, MARY PRATT, TOM FORRESTALL, B.C. BINNING, JACK SHADBOLT, TONI ONLEY, ROY KIYOOKA, GORDON SMITH, and JOE PLASKETT. See also NATIVE ART; MARITIME PROVINCES; QUEBEC; ONTARIO; MANITOBA; SASKATCHEWAN; ALBERTA; BRITISH COLUMBIA; FOLK ART, CANADA. **Citations**: MacTavish 1925; Robson 1932; Trotter 1937; Colgate 1943; Buchanan 1945, 1950; McInnes 1950; Duval 1952, 1954, 1965, 1967; 1972, 1974, 1990; Jackson 1958; Hubbard 1960, 1960(1), 1967, 1973(2); Harper 1966, 1970, 1974; MacDonald 1967; Groves 1968; Mellen 1970, 1978; Eckhardt 1970; Boggs 1971; Thomas 1972; Bell 1973; Watson 1974; Render 1974; Lord 1974; Housser 1974; Robertson 1977; Mellen 1978; Reid 1979, 1988; Laing 1979, 1982; Wilkin 1980; Gilmore 1980; Sisler 1980; NGC 1981, 1982; Bringhurst 1983; McKendry 1983; Burnett/Schiff 1983; Marsh 1988; Hill 1988, 1995; Boulizon 1989; Lerner 1991; Tippett 1992; Silcox 1996; McMann 1997.

PALARDY, JOSEPH JEAN ALBERT (JEAN) (1905-91), Montréal, QC. Painter, collector and author. Palardy was a film director and expert in folk traditions of French Canada. For a time he took an active part in the art colony in CHARLEVOIX COUNTY, QC, and painted landscapes. He was the husband of JORI SMITH and is well known as the author of *The Early Furniture of French Canada* (Palardy 1963). **Citations**: Palardy 1963; MacDonald 1967; Smith 1980; Baker 1981; NGC 1982; Reid

1988; McKendry 1983.

PALARDY, MARJORIE E. See JORI SMITH.

PALETTE. The term palette is used both for the shaped board on which a painter mixes his colours and for the range of colours used by an artist. **Citations**: Osborne 1970; Mayer 1970; Chilvers 1988; Piper 1988.

PALETTE KNIFE. A palette knife has a flexible spatulate blade which is used for mixing paint on the PALETTE and for applying it to the painting. **Citations**: Osborne 1970; Mayer 1970; Lord 1974; Chilvers 1988; Piper 1988.

PALMER, HERBERT FRANKLIN (FRANK) (b1921), Calgary, AB. Painter; RCA 1966. Frank Palmer is known for his fine watercolour paintings. His art is represented in the NATIONAL GALLERY OF CANADA. **Citations**: Duval 1954; Eckhardt 1962; MacDonald 1967; Sisler 1980; NGC 1982; Lerner 1991; McMann 1997.

PALMER, HERBERT SIDNEY (SYDNEY) (1881-1970), Toronto, ON. Painter; RCA 1934. Palmer studied under F.S. CHALLENER and J.W. BEATTY. He was a landscape and animal painter. Several of Palmer's paintings are in the NATIONAL GALLERY OF CANADA. **Citations**: MacTavish 1925; Robson 1932; Tate 1938; Hubbard 1960; Harper 1955, 1966; MacDonald 1967; Adamson 1969; Bradfield 1970; Sisler 1980; NGC 1982; Laing 1982; Lerner 1991; Hill 1995; McMann 1997.

PALMER, SAMUEL (act. 1834-45), Saint John, NB; Québec City and Montréal, QC. Painter. Palmer was a portrait and MINIATURE painter who sometimes took likenesses from corpses. **Citations**: Harper 1966, 1970; MacDonald 1967; NGC 1982; Farr 1988.

PANABAKER, FRANK SHIRLEY (b1904), Hespeler and Ancaster, ON. Painter. Panabaker studied at the ONTARIO COLLEGE OF ART and in the USA. His art is represented in the ART GALLERY OF ONTARIO. **Citations**: Robson 1932; Colgate 1943; Panabaker 1957; MacDonald 1967; Sisler 1980; NGC 1982; Lerner 1991; McMann 1997.

PANAMICK, MARTIN (1956-77), Manitoulin Island, ON. Painter. **Citations**: Ojibwa 1981; NGC 1982; Lerner 1991.

PANEL. A panel is a rigid SUPPORT for a painting. It may be of wood, metal or any board material. **Citations**: Osborne 1970; Mayer 1970; Chilvers 1988.

PANET, LOUISE-AMELIE. See LOUISE-AMELIE BERCZY.

PANKO, WILLIAM (1892-1948), Drumheller, AB. Painter. In 1911 Panko emigrated from Austria and worked in the mines at Drumheller until 1937, when he was admitted to a hospital with tuberculosis. About 1945 with the encouragement of the artist MARION FLORENCE NICOLL but without any instruction, he took up painting and completed enough paintings for a one-man show by the time he left the hospital in 1947. Mrs. Nicoll commented that "I didn't teach him anything other than how to mix watercolours. The biggest trouble I had was to protect him from the well-meaning people who wanted to teach him perspective or some such horror." In all, Panko completed about 30 naïve paintings before his death. His work often includes people, birds or animals, and shows a sensitivity to lyrical design and colour. **Citations**: McCullough 1959; Harper 1966, 1973, 1974; MacDonald 1967; Lord 1974; Wilkin 1980; NGC 1982; McKendry 1983, 1988; Kobayashi 1985(2); McKendry 1988; Lerner 1991.

PANORAMA. A large painting arranged cylindrically around the viewer, or made to pass before the viewer, to show various parts in succession. In modern art the term is used for any very wide view of a scene. **Citations**: Osborne 1970; Harper 1979; Chilvers 1988; Lerner 1991.

PANTER-DOWNES, EDWARD D. (act. 1857-9), Vancouver Island, BC. TOPOGRAPHICAL painter. He was a British naval officer. **Citations**: Harper 1964, 1970.

PANTOGRAPH. An instrument for mechanically copying a drawing to any desired scale. It was sometimes used by silhouettists to reduce in size a tracing of the shadow of a sitter. See also SILHOUETTES.

PANTON, LAWRENCE ARTHUR COLLEY (1894-1954), Toronto, ON. Painter and printmaker; RCA 1943. Panton, born in England, came to Toronto about 1911. He was the Principal of the

ONTARIO COLLEGE OF ART 1951-4. His paintings are represented in the NATIONAL GALLERY OF CANADA. **Citations**: Robson 1932; Colgate 1943; McInnes 1950; Duval 1952, 1954, 1972; Harper 1955; Hubbard 1960; MacDonald 1967; Bradfield 1970; McLeish 1973; Sisler 1980; NGC 1982; Lerner 1991; McMann 1997.

PAPER. Paper is the usual SUPPORT for a WATERCOLOUR PAINTING and for a PRINT. **Citations**: Osborne 1970; Mayer 1970; Chilvers 1988; Lerner 1991.

PAQUET (dit LAVALLEE), ANDRE (1799-1860), Québec. Sculptor of religious works and church decorations. **Citations**: Traquair 1947; NGC 1982; Porter 1986; Lerner 1991.

PAQUET, JEAN-BAPTISTE (1828-1912), Québec. Painter and sculptor of works for churches. He served an apprenticeship with his uncle ANDRE PAQUET. **Citations**: Harper 1970.

PARADIS, JOBSON EMILIAN HENRI (1871-1926), Montréal, QC. Painter. Paradis studied in Paris. **Citations**: Laberge 1938; Laliberté 1986.

PARENT, LEANDRE (1809-89), Québec. Carver of church decorations. **Citations**: NGC 1982; Porter 1986.

PARENT, MIMI (b1924), Montréal, QC; Paris, France. Painter, printmaker, poet. She studied under ALFRED PELLAN and after 1948 moved to Paris, where she took part in the SURREALIST movement. **Citations**: McInnes 1950; MacDonald 1967; Robert 1973; Tippett 1992.

PARKYNS, GEORGE ISHAM (1750-1820), Halifax, NS. Painter. Parkyns was an English painter who visited Halifax, where he painted a series of watercolour views - some were reproduced as AQUATINTS in 1801. **Citations**: Spendlove 1958; Hubbard 1967; Harper 1970; *Canadian Antiques and Art Review* 1980; *Canadian Collector* 1980; McKendry 1988.

PARSONS, WILLIAM BRUCE (b1937), Halifax, NS. Painter, printmaker and teacher. He studied under JOCK MACDONALD, and taught painting at the NOVA SCOTIA COLLEGE OF ART AND DESIGN. **Citations**: Climer 1967; MacDonald 1967; Townsend 1970; NGC 1982; Lerner 1991.

PARTRIDGE, DAVID GERRY (b1919), Ottawa and Toronto, ON. Painter, printmaker, mixed media artist and MURALIST; RCA 1979. He studied under CARL SCHAEFER, CAVIN ATKINS, ANDRE BIELER and WILL OGILVIE. Partridge's work included sculptures formed of nails partly driven into a wood SUPPORT. His art is represented in the NATIONAL GALLERY OF CANADA and in the ART GALLERY OF ONTARIO. **Citations**: MacDonald 1967; Bradfield 1970; Townsend 1970; Sisler 1980; NGC 1982; Lerner 1991; McMann 1997.

PARTRIDGE, JOSEPH E. (1792-c1833), Halifax, NS. Painter of landscapes and MINIATURES. Partridge was an English artist who visited Halifax 1817-21. For his 1819 self-portrait see pl. 108, Field 1985. **Citations**: Harper 1970; Field 1985; McKendry 1988.

PARTZ, FELIX. See GENERAL IDEA.

PASTEL PAINTING. A method of painting with dry colours in the form of sticks. Pastel work may resemble an OIL PAINTING, but the colours are paler and have a dusty appearance. Some artists who worked in Canada and used pastel are ALFRED HOLDSTOCK, EDMOND MORRIS, GERRIT SCHIPPER, WILLIAM BERCZY and HARVEY MCINNES. See also GUM. **Citations**: Osborne 1970; Mayer 1970; Pierce 1987; Chilvers 1988.

PASSION. The Passion refers to the sufferings of Christ during the last days of his life on earth. Such scenes are often depicted in RELIGIOUS ART. **Citations**: Ferguson 1967; Osborne 1970; Lucie-Smith 1984; Pierce 1987.

PATINA. Patina is a surface coat, usually a result of aging or chemical action, affecting the appearance of a sculpture or other object. Patina can have an attractive, mellowing effect. **Citations**: Mayer 1970; Osborne 1970; Chilvers 1988.

PATTERSON, ANDREW DICKSON (1854-1930), Montreal, QC; Toronto, ON. Portrait painter, teacher, illustrator; RCA 1887. He studied art in London, England. See McMann 1997 for a dated list of his paintings. **Citations**: Colgate 1943; Hubbard 1960; Sisler 1980; NGC 1982; McKendry 1988; Lerner 1991; McMann 1997.

PATTERSON, DANIEL (DAN) (1884-1968), St Thomas, ON. Sculptor. Patterson is known for a large naïve CONSTRUCTION-sculpture composed of several hundred Carnation milk cans that is now in the NATIONAL GALLERY OF CANADA. **Citations**: MacDonald 1967; *artscanada* 1969; NGC 1982; Kobayashi 1985(2); McKendry 1983, 1988.

PATTERSON, FREEMAN WILFORD (b1937), New Brunswick. Photographer and author. Patterson is mainly a landscape photographer who makes good use of the effects of natural light. **Citations**: Patterson 1977, 1979 (3); Sisler 1980; NGC 1982; Marsh 1988; McMann 1997.

PAULMIERS, HUGUES. See POMMIER.

PAUMMIES, HUGUES. See POMMIER.

PAULS, HENRY (b1904), Blythewood, ON. Painter. After leaving a Mennonite community in southern Russia in 1923, Pauls lived in Saskatchewan , then moved to Ontario and, in the 1970s, began painting naïve memory paintings in oil of life in Russia, Saskatchewan and Ontario. **Citations**: CCFCS; Kobayashi 1985(2); McKendry 1988.

PAWLYK, KOST (b1905), Elk Point, AB. Sculptor. Pawlyk who has a UKRAINIAN background, worked with POLYCHROMED wood and produced naïve YARD ART, whirligigs, weathervanes, and garden ornaments with bright colours and geometric designs. **Citations**: NMM 1983; Kobayashi 1985 (2); McKendry 1988.

PAYZANT, Mr (act. late 19th century), Yarmouth, NS. Painter. Payzant is known for a naïve portrait of an unknown ship owner, illustrated in Harper 1974, pl. 92. **Citations**: Harper 1973, 1974; Kobayashi 1985(2); McKendry 1988.

PEACEABLE KINGDOM THEME. The Peaceable Kingdom theme is derived from the Bible, Isaiah XI:6-9, "The wolf also shall dwell with the lamb, and the leopard shall lie down with the kid; and the calf and the young lion and the fatling together; and a little child shall lead them ..." The American naïve artist, Edward Hicks (1780-1849), made this theme his own and painted many variations. **Citations**: Mather 1973; McKendry 1983.

PEACHEY (PEACHY), JAMES (WILLIAM) (act. 1774-97), Québec and Ontario. TOPOGRAPHI-CAL painter. Peachey, a surveyor in the British army, prepared maps, plans and views of Upper Canada (now Ontario) and Lower Canada (now Québec). He was appointed Deputy-Surveyor General of the Province of Canada in 1784. His work included TOPOGRAPHICAL landscape paintings in watercolour or ink, book illustrations and engravings. **Citations**: Robson 1932; Guillet 1933; Spendlove 1958; Harper 1966, 1970; Carter 1967; Bell 1973; Allodi 1974; Wight 1980; Baker 1981; NGC 1982; Cooke 1983; Farr 1988; McKendry 1988; Cavell 1988; Marsh 1988; Lerner 1991.

PEACOCK, GRAHAM (b1945), Edmonton, AB. Painter and sculptor. **Citations**: MacDonald 1967; Wilkin 1974(1); NGC 1982; Lerner 1991.

PEARRON, JEAN. See PIERRON.

PEDERY-HUNT, DORA DE (b1913), Toronto, ON. Sculptor. She studied in Budapest and came to Canada in 1948. A portrait head of FRANCES LORING by Pedery-Hunt is in the NATIONAL GALLERY OF CANADA, along with several medallions by her. **Citations**: Hubbard 1960; MacDonald 1967; Bradfield 1970; De Pedery-Hunt 1978; Hill 1988 (see de Pedery-Hunt); Lerner 1991.

PEEL, PAUL (1860-92), London, ON; Paris, France. Painter; RCA 1891. Peel studied in the USA and England, as well as in Paris, where he spent the latter part of his short life. He painted GENRE, landscapes and portraits. His painting *After the Bath* (1890, Art Gallery of Ontario) is well known (see Mellen 1978, pl. 2.) **Citations**: MacTavish 1925; Macdonald 1925; Stevenson 1927; Robson 1932; Colgate 1943; McInnes 1950; Hubbard 1960, 1967; Harper 1966, 1970; MacDonald 1967; Boggs 1971; Morris 1972; Thomas 1972; Martin 1974; Duval 1974, 1990; Lord 1974; Forsey 1975; Mellen 1978; London 1978; Laing 1979, 1982; Reid 1979, 1988; Sisler 1980; NGC 1982; Marsh 1988; Lerner 1991; McMann 1997.

PEINTRES de la MONTEE SAINT-MICHEL. See MONTEE SAINT-MICHEL.

PELLAN (PELLAND), ALFRED (1906-88), Montréal and Laval, QC. Painter, MURALIST and

illustrator. Pellan studied in Paris and for a time lived there. His earliest work was based on nature, but later his paintings became more stylized, abstract, decorative and SURREAL. He used bright colours and many symbolic images, including some borrowed from NAÏVE ART. Several canvases by Pellan are in the NATIONAL GALLERY OF CANADA. **Citations**: Barbeau 1945; Buchanan 1950, 1960, 1962; McInnes 1950; Hubbard 1960, 1967, 1973; Guy 1963, 1964; Kilbourn 1966; Harper 1966; MacDonald 1967; Ostiguy 1971; Boggs 1971; Morris 1972; Duval 1972; Lefebvre 1972, 1973; Lord 1974; Forsey 1975; Fenton 1978; Mellen 1978; Vie des Arts 1978; Laing 1979, 1982; George 1980; Sisler 1980; Greenberg 1980; Baker 1981; NGC 1982; Burnett/Schiff 1983; Bringhurst 1983; McKendry 1983, 1988; Marsh 1988; Reid 1988; Lerner 1991; Tippett 1992; McMann 1997.

PEMBERTON, SOPHIE (SOPHIA) THERESA PEMBERTON (1869-1959), Victoria, BC; London, England. Painter. Pemberton studied in London, England and in Paris. One of her portraits, *Little Boy Blue*, 1899, is illustrated in Harper 1966, pl. 202. **Citations**: Harper 1966; MacDonald 1967; Tuele 1978; Tippett 1979, 1992; Sisler 1980; NGC 1982; Reid 1988; Lerner 1991; McMann 1997.

PEOPLE'S ART: NAÏVE ART IN CANADA EXHIBITION. This 1974 exhibition of naïve paintings and sculptures, which was a collaborative effort by the NATIONAL GALLERY OF CANADA and J. RUSSELL HARPER, traveled to Toronto and Vancouver. It was one of the few exhibitions of naïve art since 1970 for which the works exhibited were selected for purely aesthetic reasons (see Harper 1973, p. 13). See also FOLK ART EXHIBITIONS. **Citations**: Harper 1973, 1974; McKendry 1987.

PEPIN, JEAN PAUL (1894/97-1983), Montée Saint-Michel, QC. Painter and sculptor. Pepin studied painting and sculpture under several artists in Montréal and became a very active landscape painter. He completed many views of Montréal, QC. See MONTEE SAINT-MICHEL. **Citations**: MacDonald 1967; Laliberté 1986; NGC 1982; Lerner 1991.

PEPIN, JOSEPH (1770-1842), Montréal, QC. Sculptor of religious works for churches. See BERLINQUET. **Citations**: Vaillancourt 1920; Traquair 1947; McInnes 1950; Trudel 1967(sculpture); Lessard 1971; NGC 1982; Porter 1986; McKendry 1988.

PEPPER, GEORGE DOUGLAS (1903-62), Toronto, ON. Painter and illustrator; RCA 1957. Pepper studied under J.E.H. MACDONALD and J.W. BEATTY, and in Paris. He was influenced by the GROUP OF SEVEN. Pepper was a founding member of the CANADIAN GROUP OF PAINTERS (1933). He was the husband of KATHLEEN FRANCES PEPPER DALY. Examples of his paintings are in the NATIONAL GALLERY OF CANADA. **Citations**: Robson 1932; CGP 1933; Duval 1952, 1972; Harper 1955, 1966; Jackson 1958; Adamson 1969; Hubbard 1960; MacDonald 1967; Hill 1975, 1995; Robertson 1977; Laing 1979, 1982; Sisler 1980; NGC 1982; Marsh 1988; Reid 1988; Lerner 1991; McMann 1997.

PEPPER, KATHLEEN DALY. See KATHLEEN FRANCES DALY.

PERCIVAL, ROBERT (b1924), New Brunswick. Painter, writer and curator. **Citations**: NGC 1982; Lerner 1991.

PEREHUDOFF, WILLIAM (BILL) (b1919), Saskatoon, SK. Painter and commercial artist. Perehudoff who studied in the USA is known for his large abstract paintings. He is the husband of DOROTHY KNOWLES. Perehudoff's work is represented in many collections including the Mendel Art Gallery in Saskatoon. **Citations**: Mendel 1964; Climer 1967; MacDonald 1967; Duval 1972; Walters 1975; Fenton 1978; Sisler 1980; Carpenter 1981; NGC 1982; Bringhurst 1983; Burnett/Schiff 1983; Reid 1988; Marsh 1988; Lerner 1991; McMann 1997.

PERFORMANCE ART. Performance art combines elements of theatre, music and the visual arts. Canadian artists who were involved in performance art include MICHAELE BERMAN, MAX DEAN, GENERAL IDEA, KIM TOMCZAK and TIM ZUCK **Citations**: Bringhurst 1983; Chilvers 1988; Lerner 1991.

PERRAULT, JEAN CHRYSOSTOME (1793-1829), Saint-Jean-Port-Joli, QC. Sculptor of religious works and church decorator. Perrault was closely associated with AMABLE CHARRON and worked

with Charron on the interior of the Church of Saint-Jean-Baptiste at Saint-Jean-Port-Joli. **Citations**: Traquair 1947; Porter 1986; Lerner 1991.

PERRE (PERE), HENRI (1821/28-90), Toronto, ON. Painter; RCA 1882. Perre was in Toronto from 1863. He was a member of the ONTARIO SOCIETY OF ARTISTS and charter member of the ROYAL CANADIAN ACADEMY. Perre is chiefly known for his paintings of woodland subjects; some of his paintings are in the manner of the HUDSON RIVER SCHOOL. His paintings are represented in the NATIONAL GALLERY OF CANADA. **Citations**: MacTavish 1925; Robson 1932; Colgate 1943; Hubbard 1960; Harper 1966, 1970; MacDonald 1967; Bradfield 1970; Reid 1979; Laing 1979, 1982; Sisler 1980; NGC 1982; McMann 1997.

PERRIGARD, HAL ROSS (1891-1960), Montréal, QC. Painter, illustrator and MURALIST. Perrigard studied under WILLIAM BRYMNER and MAURICE CULLEN, but was mostly self-taught. His work is represented in the NATIONAL GALLERY OF CANADA. **Citations**: MacTavish 1925; Chauvin 1928; Robson 1932; Laberge 1938; Colgate 1943; Hubbard 1960; MacDonald 1967; Sisler 1980; NGC 1982; Laliberté 1986; Lerner 1991; McMann 1997.

PERRON, ANGELE (act. c1885), Les Eboulements-en-Haut, QC. Weaver. Perron is known for decorative boutonné coverlets with geometric designs and figures. **Citations**: Hubbard 1963, 1967; Burnham 1972; Lessard 1975; McKendry 1988.

PERROTT, JAMES STANFORD (b1917), Calgary, AB. Painter and art teacher. He studied art in the USA. See Render 1974, pl. 200 and 201 for illustrations of his work. **Citations**: MacDonald 1967; Render 1974; NGC 1982.

PERSPECTIVE. The term perspective refers to any graphic method of conveying an impression of spatial depth greater than that of a surface on which art is being created, often by diminution in size of objects at a distance and convergence of parallel lines. Perspective is usually ignored in naïve work. See GEOMETRIC PERSPECTIVE; AERIAL PERSPECTIVE; FORESHORTENING. **Citations**: Mayer 1970; Osborne 1970; Hill 1974; Pierce 1987; Chilvers 1988; Piper 1988.

PETERS, BARRY (b1938), Red Lake, ON. Painter and printmaker. Peters is a native artist. **Citations**: McLuhan 1977; Lerner 1991.

PETERS, PADDY (b1956), Red Lake ON. Painter and printmaker. Peters is a native artist. **Citations**: McLuhan 1977; Lerner 1991.

PETERS, KENNETH M. (b1939), Regina, SK. Painter and art teacher. His work is represented in the Norman Mackenzie Art Gallery, Regina. **Citations**: Climer 1967; MacDonald 1967; Fenton 1978; NGC 1982; Lerner 1991.

PETERSON, MARGARET (b1902), Victoria, BC. Painter and MURALIST. She studied under HANS HOFMANN. Peterson's work is mostly abstract paintings in TEMPERA based on primitive images suggested by Northwest Coast native people or African tribal sculptures (see Harper 1966, pl. 372). She uses harsh, bright colours. Her work is represented in the NATIONAL GALLERY OF CANADA. **Citations**: Harper 1966; MacDonald 1967; NGC 1982; McKendry 1988; Lerner 1991.

PETERSON, WARREN H. (b1935), Saskatoon, SK. Painter, printmaker and art teacher. **Citations**: MacDonald 1967; Mendel 1977; NGC 1982; Lerner 1991.

PETITOT (PETETOT), EMILE (1838-1917), Northwest Territories. Painter, MURALIST, author and illustrator. Petitot, a missionary priest in the Mackenzie River area , decorated the walls of his mission chapels with his own naïve murals and religious paintings. His TOPOGRAPHICAL view of Fort Edmonton, AB, 1870s (Alberta Legislative Library, Edmonton) is well known (Harper 1974, pl. 74). **Citations**: Harper 1966, 1970, 1973, 1974; MacDonald 1967; Wilkin 1980; NGC 1982; McKendry 1988.

PETLEY, ROBERT (1812-69), Halifax, NS; Fredericton, NB. TOPOGRAPHICAL artist. Petley was with the British army, and was in Canada 1831-6. His works include landscape paintings and figure studies in watercolour or ink, sepia sketches and LITHOGRAPHS of Nova Scotia scenery, sometimes including Micmac people. **Citations**: Colgate 1943; Spendlove 1958; Harper 1970; Allodi 1974; NGC

1982; Cooke 1983; McKendry 1988; Lerner 1991.

PFEIFER, BODO (b1939), Vancouver, BC. Painter, printmaker, MURALIST and sculptor. He studied in Montréal, in Germany and in Vancouver under ROY KIYOOKA and JACK SHADBOLDT. His work is represented in the NATIONAL GALLERY OF CANADA. **Citations**: MacDonald 1967; Townsend 1970; NGC 1982; Burnett/Schiff 1983; Lerner 1991; McMann 1997.

PFEIFFER, GORDON EDWARD (b1899), Montréal, QC. Painter. Pfeiffer was mostly self-taught but had an association with HORATIO WALKER, ANDRE BIELER and ROBERT PILOT. He is a brother of HAROLD SAMSON PFEIFFER. **Citations**: Barbeau 1936(1); MacDonald 1967; Smith 1980; Aimers 1981; NGC 1982; Lerner 1991; McMann 1997.

PFEIFFER, HAROLD SAMSON (b1908), Ottawa, ON. Sculptor. He studied in Montréal and in New York. Pfeiffer's sculpture is in many collections including that of the MONTREAL MUSEUM OF FINE ARTS and of the GLENBOW MUSEUM in Calgary, AB. He is a brother of GORDON EDWARD PFEIFFER. **Citations**: MacDonald 1967; Wolff 1978; NGC 1982; McKendry 1983 (Preface); McMann 1997.

PFLUG, CHRISTIANE SYBILLE (1936-72), Toronto, ON. Painter. Christine Pflug was born in Germany, met her husband MICHAEL PFLUG in Paris, lived in Tunis, and then Toronto in 1959. In 1962 Christine had a sell-out show at the Isaacs Gallery, Toronto, and subsequent shows followed. She suffered from severe depression from time to time and on 4 April 1972 brought an end to her life at a favourite painting place on the beach at Hanlan's Point, Toronto Island. Her work is represented in the NATIONAL GALLERY OF CANADA. **Citations**: Eckhardt 1966; MacDonald 1967; Adamson 1969; Duval 1974; Davis 1974, 1979; Sisler 1980; NGC 1982; Burnett/Schiff 1983; Reid 1988; Lerner 1991; Tippett 1992; McMann 1997.

PFLUG, MICHAEL (b1929), Toronto, ON. Painter and doctor of medicine. Michael Pflug was born in Germany, where he studied art as well as in Paris, where he met his wife CHRISTINE PFLUG. After living in Tunisia, he emigrated to Canada in 1960 after his wife Christine and children had gone ahead to Toronto in 1959. **Citations**: MacDonald 1967; Davis 1974; NGC 1982; Tippett 1992.

PHILLIPS, WALTER JOSEPH (1884-1963), Winnipeg, MB; Calgary, AB. Painter, illustrator and printmaker; RCA 1934. Phillips emigrated from England to Winnipeg in 1913. He was a skilled watercolour painter and printmaker who was widely known for his colour WOODCUTS. Several paintings by Phillips are in the NATIONAL GALLERY OF CANADA. See McMann 1997 for a dated list of some of his works. **Citations**: Phillips 1926, 1930, 1954; Salaman 1930; Robson 1932; Gibbon 1938; Leacock 1941; Colgate 1943; Scott 1947; Duval 1952, 1954; Harper 1955, 1966; Hubbard 1960; Bradfield 1970; Eckhardt 1970; Render 1974; Tippett 1977, 1992; Gribbon 1978; Sisler 1980; Boulet 1981(1); NGC 1982; Burnett/Schiff 1983; Masters 1987; Marsh 1988; Reid 1988; Lerner 1991; McMann 1997.

PHILLIPPS, FREDERICK (born c1860), Arden and Winnipeg, MB. Painter. Phillipps is known for some naïve sketches illustrating pioneer life in watercolour or ink. **Citations**: Eckhardt 1970; McKendry 1988.

PHOTOGRAPHY IN CANADA. The DAGUERREOTYPE, a shimmering image on silvered copper, usually protected in a case, was invented in France by L.J.M. Daguerre, and made public in 1839. In that same year the *Quebec Gazette* reported on this process which was to remain popular in Canada until about 1860. By then daguerreotypes began to decline in popularity, as tintypes (also called ferrotypes or melainotypes) were introduced. They remained popular in Canada until about 1900, while ambrotypes (an image on glass, usually in a case) came and went in fashion from about 1855 to about 1870. Images printed on paper, such as the calotype (or talbotype which were rare in Canada and were invented as early as 1841 in England) and the carte de visite (popular in Canada 1860-75) or cabinet photograph (popular 1863 to 1900) lead the way to modern photography, largely due to the use of negatives. The latter permitted multiple copies unlike the unique nature of daguerreotypes. At first negatives were on glass, sometimes as large as 8 x 10 inches to provide contact prints of scenery and portraits by

professional photographers and then increasing numbers of amateur photographers. This reduced demand for artists to work in these fields. Photography has not yet been accepted unreservedly as an art form in Canada. See Greenhill 1979 for a history of Canadian photography 1839-1920, and Marsh 1988 for a history of modern Canadian photography. See also MONTAGE, WILLIAM NOTMAN, POR-TRAITURE. **Citations**: Harper 1966, 1967, 1977(Donovan); Lord 1974; Birrell 1978; Greenhill 1965, 1979; Patterson 1977, 1979 (3); Thomas 1972, 1979; Bell 1978; McKendry 1979; Bringhurst 1983; Triggs 1985; Marsh 1988.

PHOTOMONTAGE. See MONTAGE.

PICASSO, PABLO. See FOLK ART, CANADA.

PICHER, CLAUDE (b1927), Ile d'Orléans, QC. Painter. Picher studied painting under JEAN PAUL LEMIEUX as well as in Montréal, Paris and New York. His work includes many forceful and original landscape paintings. His work is represented in the NATIONAL GALLERY OF CANADA. **Citations**: Hubbard 1960, 1967; Harper 1966; MacDonald 1967; Viau 1967; Groves 1968; Bradfield 1970; Duval 1972; Robert 1973; Lemieux 1974; Lord 1974; Sisler 1980; Dumas 1981; NGC 1982; Lerner 1991; McMann 1997.

PICHET, ROLAND (b1936), Québec. Painter and printmaker. **Citations**: Ayre 1977; NGC 1982; Lerner 1991.

PICKET, SARAH T. (act. 1848), Kingston, NB. Painter. A school exercise book contains all Picket's known work including the flat-patterned, decorative and colourful painting of her namesake ship in full sail and under steam (pl. 89 of Harper 1974). **Citations**: Harper 1973, 1974; Bihalji-Merin 1985; Kobayashi 1985(2); McKendry 1983, 1988.

PICTURE LOAN SOCIETY. See DOUGLAS MOERDYKE DUNCAN.

PICTURE PLANE. The surface upon which a painting is painted. **Citations**: Pierce 1987; Piper 1988; Chilvers 1988.

PICTURE SPACE. Picture space is the illusion of space extending back beyond the PICTURE PLANE through such devices as FORESHORTENING, linear PERSPECTIVE, and AERIAL PERSPECTIVE. The GROUND PLANE, which extends into the picture space, may be considered as divided into foreground, middle ground, and background. **Citations**: Lucie-Smith 1984; Pierce 1987.

PICTURESQUE. This term was accepted in Britain as an AESTHETIC category in respect to LANDSCAPES — the idea of beauty was transformed by qualities of roughness, variety and irregularity, as formulated by William Gilpin in his writings from 1782 to 1809. A Canadian lanscape artist influenced by these ideas was GEORGE HERIOT. See also HUDSON RIVER SCHOOL. **Citations**: Osborne 1970; Finley 1978, 1979; Pierce 1987; Piper 1988.

PIDDINGTON, HELEN VIVIAN (b1931), Victoria, BC. Painter and printmaker. She studied in London and Paris as well as with B.C. BINNING. Her work is represented in many private and public collections including that of the MONTREAL MUSEUM OF FINE ARTS. **Citations**: MacDonald 1967; Bradfield 1970; NGC 1982; Tippett 1992.

PIERCE, CAPTAIN (act 1900), Portsmouth Village (Kingston), ON. Pierce is known for a pleasing and competent painting of the Portsmouth Town Hall (see back cover, McKendry 1996). **Citations**: McKendry 1996.

PIEROWAY, PERCY (b1921), Stephenville, NF. Painter. Pieroway started painting in his spare time about 1972, and has taken some art lessons. His work, while naïve, shows some ability to handle perspective and to deal with abstract patterns in the landscape. **Citations**: CCFCS; Grattan 1976, 1977; Kobayashi 1985(2); McKendry 1983, 1988.

PIERRON (PEARRON), JEAN (1631-1700), Québec City, QC. Painter. Pierron was a Jesuit Father who worked as a missionary among the Iroquois people. He wrote that he "preached by day and painted by night." Father Pierron used his MINIATURE paintings in teaching the native people about Christianity. **Citations**: Harper 1966, 1970; Gagnon 1975, 1976(1); NGC 1982; McKendry 1988; Lerner 1991.

PIGMENT. A finely ground colouring substance which is held in suspension in a MEDIUM to form PAINT. **Citations**: Osborne 1970; Mayer 1970; Pierce 1987; Piper 1988; Lerner 1991.

PILKINGTON, ROBERT (1765-1834), Québec and Ontario. TOPOGRAPHICAL artist. Pilkington was with the British army and was on the staff of John Graves Simcoe 1793-6. He sketched several views in Upper Canada (now Ontario). Some of his sketches were copied by ELIZABETH POSTUMA SIMCOE. **Citations**: Harper 1970; Tippett 1992.

PILOT, ROBERT WAKEHAM (1898-1967), Montréal, QC. Painter; RCA 1934. Pilot studied under WILLIAM BRYMNER and his stepfather MAURICE CULLEN, as well as in Paris. He painted views of Montréal street scenes, the St Lawrence River, east-coast seascapes, and the snow-covered Rockies. Several paintings by Pilot are in the NATIONAL GALLERY OF CANADA. **Citations**: Group of Seven Catalogues; Chauvin 1928; Robson 1932; Colgate 1943; Pilot 1956, 1967; Lee 1956; Jackson 1958; Hubbard 1960; Harper 1966; MacDonald 1967; Carter 1968; Duval 1952, 1972, 1990; Beament 1968; Mellen 1970; Bradfield 1970; Watson 1974; Ayre 1977; Thibault 1978; Laing 1979, 1982; Sisler 1980; Laliberté 1986; NGC 1982; Antoniou 1982; Marsh 1988; Lerner 1991; Hill 1995; McMann 1997.

PINHEY, JOHN CHARLES (1860-1912), Ottawa, ON; Montréal, QC. Painter; RCA 1897. Pinhey who was mainly a portraitist, studied in Toronto, ON, and in Paris, France. **Citations**:MacTavish 1925; Harper 1970;,Sisler 1980; NGC 1982; McMann 1997.

PINPRICKT PICTURES. Pinprickt pictures (designs) were pricked into paper with pins or wheels with sharp points. Pinprickt pictures were more common in 18th and early 19th centuries England than in Canada. **Citations**: Osborne 1970.

PINSKY, ALFRED (b1921), Montréal, QC. Painter. Pinsky studied with GOODRIDGE ROBERTS and ARTHUR LISMER. He is the husband of RHITTA CAISERMAN-ROTH. **Citations**: Tweedie 1967; MacDonald 1967; NGC 1982; Tippett 1992; McMann 1997.

PINSKY, GHITTA CAISERMAN-ROTH. See GHITTA CAISERMAN-ROTH.

PITSEOLAK, MARY (born c1900), Baffin Island. Printmaker, embroiderer, textile designer and sculptor. Pitseolak is an Inuit artist who was encouraged by JAMES HOUSTON. She married her childhood friend Ashoona, and bore five surviving children. Four of her sons are sculptors living at Cape Dorset. Her work is represented in the NATIONAL GALLERY OF CANADA. **Citations**: MacDonald 1967; Houston 1967; Eber 1971; Goetz 1977; Sisler 1980; NGC 1982; Lerner 1991; Tippett 1992; McMann 1997.

PLAINWOMAN, PERCY (Two Gun) (act. c1935), Alberta. Painter. Plainwoman painted naïve landscape paintings including buffalo hunting scenes and mountains, as well as portraits of native people. He was a Blood Indian and an uncle of GERALD TAILFEATHERS. **Citations**: *Canadian Collector* 1976; McKendry 1988.

PLAMONDON, ANTOINE-SEBASTIEN (1804-95), Québec City and Neuville, QC. Painter; RCA 1880. Plamondon studied with JOSEPH LEGARE, and assisted in restoring and repainting the DESJARDINS COLLECTION of European paintings. After studying in Paris, Plamondon returned to Québec in 1830 to paint portraits of leading citizens and to copy religious works. Among his most noteworthy works are his early voluptuous portraits of Québec society women and a series of portraits of nuns at the Hôpital Général. In later years, his work became uneven and he copied portraits from photographs. THEOPHILE HAMEL studied with Plamondon. Several paintings by Plamondon are in the NATIONAL GALLERY OF CANADA. **Citations**: MacTavish 1925; Bellerive 1925; Robson 1932; Morisset 1936; Colgate 1943; NGC 1945, 1982; Buchanan 1950; McInnes 1950; Barbeau 1957(Québec); Morisset 1959; Hubbard 1960, 1967; Harper 1966, 1970; MacDonald 1967; Trudel 1967(Peinture);Hubbard 1960, 1967, 1970, 1973; Carter 1967; Osborne 1970; Boggs 1971; Duval 1974; Lord 1974; Hill 1974; Mellen 1978; Thibault 1978; Reid 1979, 1988; Sisler 1980; Marsh 1988; Piper 1988; Chilvers 1988; McKendry 1988; Lerner 1991; Béland 1992; McMann 1997.

PLASKETT, JOSEPH FRANCIS (JOE) (b1918), Vancouver, BC; Winnipeg, MB; Paris, France. Painter. Plaskett studied under B.C. BINNING, A.Y. JACKSON and J.L. SHADBOLT, as well as in the

USA under HANS HOFMANN and in London. He painted many landscape, interior and figurative works in various parts of Canada and Europe. Several of his paintings are in the NATIONAL GALLERY OF CANADA. **Citations**: Hubbard 1960; Harper 1966; MacDonald 1967; Eckhardt 1970; Balkind 1971; Duval 1972; Render 1974; Forsey 1976; Sisler 1980; NGC 1982; Burnett/Schiff 1983; Reid 1988; Lerner 1991; Tippett 1992; McMann 1997.

PLASTICIEN MOVEMENT. This movement originated with four young Montréal painters who, in 1955, issued a manifesto in connection with an exhibition of their paintings declaring that their work was based on 'plastic' characteristics including unity of tone, texture, form and line. The four young painters were LOUIS BELZILE, RODOLPHE DE REPENTIGNY, JEAN-PAUL JEROME, and FERNAND TOUPIN. **Citations**: Guy 1964; Harper 1966; Townsend 1970; Lord 1974; Davis 1979; George 1980; Burnett/Schiff 1983; Bringhurst 1983; Reid 1988; Marsh 1988; Lerner 1991; Tippett 1992.

PLASTICITY. In a sculptural context, plasticity refers to the ease of manipulation of materials such as clay or wet plaster; in connection with paintings, the term refers to sculptural, three-dimensional qualities. **Citations**: Piper 1988; Read 1994.

PLEIN AIR. This is the French term for "open air" and is applied to paintings that have been executed outdoors, rather than in a studio; it has come to be used in connection with paintings that create the impression of spontaneity and naturalness. The early paintings of J.E.H. MACDONALD of southern Ontario scenes have a *plein air* naturalism., see Hunter 1940. **Citations**: Hunter 1940; Lucie-Smith 1984; Piper 1988.

POCOCK, NICHOLAS (1741-1821), Newfoundland. Painter. Pocock was a marine painter with the Royal Navy. He visited Newfoundland and made many coastal drawings, including a view of St. John's harbour published in London in 1811. **Citations**: Harper 1966, 1970; De Volpi 1972.

POINTILLISM. Pointillism is a method of painting, adopted by the NEO-IMPRESSIONISTS, in which tiny juxtaposed dots of pure colour are placed to reflect chromatic light beams which are additively mixed by the eye to form one solid colour. The method was developed by the French artist Georges Seurat (1859-91) and, in Canada, has been used by W.H. CLAPP, JOHN S. GORDON, and ALEX COLVILLE. **Citations**: Harper 1966; Osborne 1970; Janson 1977; Chilvers 1988; Piper 1988.

POIRIER, NARCISSE (1883-1983), Montréal, QC. Painter. Poirier studied under EDMOND DYONNET, MAURICE CULLEN and others. He worked with MARC-AURELE SUZOR-COTE painting religious pictures and decorating churches. He was a founding member of the MONTEE SAINT-MICHEL group of painters. **Citations**: MacDonald 1967; NGC 1982; Laliberté 1986; Lerner 1991; McMann 1997.

POISSON, JOSEPH (1876-1951), Montréal, QC. Sculptor. **Citations**: Laliberté 1986.

POITRAS, EDWARD (b1953), Regina, SK. Sculptor. Poitras is a native sculptor whose work includes, but is not limited to, native people themes. **Citations**: Zepp 1984.

POITRAS, JANE ASH (b1951), Edmonton, AB. Native artist. **Citations**: Tippett 1992.

POLKEN, JEFFREY ERVIN (b1934), New Brunswick. Mixed media artist. **Citations**: NGC 1982; Andrus 1966; Lerner 1991.

POLYCHROME SCULPTURE. This is sculpture with more than one colour visible, as in the case of many naïve or RELIGIOUS sculptures in wood. **Citations**: Osborne 1970; McKendry 1983; NMM 1983; Chilvers 1988.

POLYPTYCH. See TRIPTYCH.

POMMIER (or PAUMIES, PAULMIERS), Abbé HUGUES (1637-86), Québec City, QC. Painter of portraits and religious works. Pommier, a missionary who arrived in Québec in 1664, may be the first painter to work in Canada. There is difficulty, however, in attributing paintings to him with certainty. **Citations**: Robson 1932; Morisset 1936; NGC 1945; Harper 1966, 1970; Hubbard 1967; Gagnon 1976(1); NGC 1982; McKendry 1988; Lerner 1991.

POOLEY, HENRY (act. c1845), Ottawa, ON. TOPOGRAPHICAL artist. Pooley was with the British army and was stationed in Upper Canada in connection with the building of the Rideau Canal. Some of

his drawings show New Brunswick scenes. **Citations:** Harper 1970; McKendry 1988.

POONAH (POOMAH) PAINTING. One definition is: "poonah painting referred to colour stamped on white silk through a stencil (Murray 1982, p.8)." Poonah painting was taught in Canada, according to Harper 1974, (p. 173, note 9 for chapter 9, referring to the *New Brunswick Courier*, Saint John, February 1839). It was taught as well in Québec City by JOHN POPPLEWELL and WILLIAM LOCKWOOD. **Citations:** Harper 1974; Murray 1982.

POP ART. Pop art is a movement which originated in England and flourished from in the late 1950s to the early 1970s. It was based on popular imagery applied to figurative art. Andy Warhol (1930-87) was a well known American pop artist. In Canada the influence of pop art appeared in the work of GREG CURNOE, GUIDO MOLINARI, MICHAEL SNOW, PIERRE AYOT and ROBERT PERCIVAL. **Citations:** Harper 1966; Arnason 1968; Osborne 1970; 1981; Janson 1977; Piper 1988; Chilvers 1988; Lerner 1991.

POPE, WILLIAM (1811-1902), Long Point ON. Painter and naturalist. Pope painted birds and insects. Many of his watercolours are in the Toronto Public Library, Toronto, ON. **Citations:** NGC 1982; Barrett 1976; Lerner 1991; Dickenson 1992.

POPPLEWELL, JOHN (act, 1833-41), Québec City, QC; Toronto, ON. Painter. Popplewell settled first in Québec where, with WILLIAM LOCKWOOD, he taught POONAH PAINTING, MINIATURE PAINTING, and the cutting of SILHOUETTES. In Toronto, he exhibited fruit and flower paintings. **Citations:** Harper 1970; McKendry 1988.

PORCHER, ALEXIS (act. 1752), Québec. Sculptor of religious works in wood. **Citations:** Porter 1986.

PORTRAIT FORMAT. Portrait format refers to a painting, print, photograph or drawing which is higher than it is wide. It is the opposite to LANDSCAPE FORMAT. **Citations:** Lucie-Smith 1984.

PORTRAITURE. Portraiture is the art of painting, drawing, photographing or sculpting the likeness of a person; although the meaning is sometimes extended to include the likeness of an animal, ship, house and so on. One of the finest 19th century Québec portraitists was THEOPHILE HAMEL. In Ontario GEORGE BERTHON was an accomplished portraitist, while ROBERT FIELD's sophisticated works set a high standard in the Maritimes. In Canada, after the introduction of PHOTOGRAPHY in the 1840s, the demand for painted portraits lessened, particularly by the 1880s, when photographic portraits from WILLIAM NOTMAN's photographic studios became very popular. A few painters, for example WILLIAM SAWYER and JOHN ARTHUR FRASER, sometimes worked from photographic images. For an account and illustrations of early portraiture in Canada, see Harper 1966, pp. 53-78; Morisset 1959, Introduction; and Duval 1974, p. 7. Twentieth-century Canadian portrait painters include ROBERT HARRIS, JOHN C. FORBES, J.W.L. FORSTER, ERNEST FOSBERY, EDMOND DYON-NET, CHARLES W. SIMPSON, KENNETH FORBES, LILIAS TORRANCE NEWTON, CLEEVE HORNE, OZIAS LEDUC, ALFRED PELLAN, and PAUL-EMILE BORDUAS. For a discussion of portraiture and self-portraits by naïve painters, see Bilhalji-Merin 1971, pp. 219-36; and MacGregor 1974. See SAMUEL de CHAMPLAIN for the earliest Canadian portrait. See also KITCAT. **Citations:** MacDonald 1925; Kenney 1925; Morisset 1959; Harper 1966, 1967, 1977(Donovan); Hubbard 1970; Bilhalji-Merin 1971; Morris 1972; Duval 1974; MacGregor 1974; Janson 1977; Bell 1978; Thomas 1979; Allodi 1980; Fisher 1981; Boyanoski 1982; McKendry 1983; Triggs 1985; Piper 1988; Borcoman 1988; Lerner 1991.

POST-IMPRESSIONISM. This term was coined in 1910 in connection with an exhibition in London, England, in which the works of French artists Paul Cézanne (1836-1906) and Paul Gauguin (1848-1903) and Dutch artist Vincent van Gogh (1853-90) dominated the show; in essence this rather vague term was used to express reactions against IMPRESSIONISM. To some extent post-Impressionist painters rejected NATURALISM, and they renewed interest in colour as well as in religious and symbolic themes. The work of the Canadian GROUP OF SEVEN has been referred to as a modified form of post-impressionism. See also Les NABIS, SYMBOLISM. **Citations:** Buchanan 1936; Hunter 1940;

Harper 1966; Arnason 1968; Mellen 1970; Osborne 1970, 1981; Lord 1974; Janson 1977; Laing 1984; Reid 1988; Piper 1988; Chilvers 1988; Lerner 1991; Silcox 1996.

POTHIER, ARMAND (1873-1943), Wedgeport, NS. Painter and maker of ship models. Pothier painted oils of ships including five known versions of the *S.S. Castilian on Gannet Ledge*, 1889. **Citations:** information from the owner of a S.S. Castilian painting.

POTLATCH. The word potlatch is derived from a word meaning gift as used by natives of the Northwest coast of North America. At a potlatch ceremony, possessions, including works of art, were displayed and given away, sometimes competitively. This was a strong incentive to produce carvings and other forms of art. The potlatch was banned by the intolerant Canadian governments from 1884 to 1951. See also BRITISH COLUMBIA, NATIVE ART OF CANADA. **Citations:** Jenness 1932; Inverarity 1947; Hawthorn 1956; Clutesi 1969; Patterson 1973; Lord 1974; Hodge 1974; Lucie-Smith 1984; Marsh 1988; Lerner 1991.

POULIN, JULIEN. See PIERRE FALARDEAU.

POWERHOUSE. A women artists' cultural cooperative established in Montréal in 1973. **Citations:** Bringhurst 1983; Tippett 1992.

PRAT, ANNIE LOUISA (1860 or 1861-1960), Halifax, NS. Painter. **Citations:** NGC 1982; Tippett 1992.

PRATT, JOHN CHRISTOPHER (b1935), St Mary's Bay, NF. Painter and printmaker. Christopher Pratt finds his starkly realistic images in Newfoundland landscape, architecture and figures. For a while he worked with ALEX COLVILLE. He is married to the artist MARY PRATT. His art is represented in the NATIONAL GALLERY OF CANADA and in the ART GALLERY OF ONTARIO. **Citations:** Harper 1966; Andruss 1966; MacDonald 1967; Townsend 1970; Duval 1972, 1974; Lord 1974; Mellen 1978; Fenton 1978; Sisler 1980; NGC 1982; Silcox 1982; Burnett/Schiff 1983; Bringhurst 1983; Reid 1988; Lerner 1991; Tippett 1992; Murray 1997; McMann 1997.

PRATT, MARY FRANCES WEST (b1935), St Mary's Bay, NF. Painter. Mary Pratt paints domestic objects and scenes, particularly food and objects found in a kitchen. She studied with ALEX COLVILLE and LAWREN PHILLIPS HARRIS. She is married to the artist CHRISTOPHER PRATT. **Citations:** MacDonald 1967; Duval 1974; Graham 1975; Murray 1980(2), 1981(2); NGC 1982; Sisler 1980; Burnett/Schiff 1983; Marsh 1988; Reid 1988; Moray 1989; Lerner 1991; Tippett 1992; McMann 1997.

PREHISTORIC ART. Prehistoric (preliterate) art precedes written records. Sometime during the period of the last ice age (80,000 to 12,000 years ago), a land bridge was created between Siberia and Alaska, and thus animals and humans were able to cross to North America. Some of the functional prehistoric artifacts created by these first inhabitants of Canada are considered to have artistic merit and qualify as prehistoric art. A large quantity of later artifacts, including stone and wood carvings, created before the arrival of literate white men, also are works of prehistoric art. **Citations:** Jenness 1932; Miles 1963; Patterson 1973; Stewart 1973; Lord 1974; Duff 1975; Janson 1977; McKendry 1983; Marsh 1988; Lerner 1991.

PRELITERATE ART. See PREHISTORIC ART.

PRE-RAPHAELITES. The initials "P.R.B." (Pre-Raphaelite Brotherhood) appeared on a painting by Daniel Rossetti (1828-82) in 1849. He was one of a group of English painters who declared an affinity with the art produced previous to the High RENAISSANCE. Their work is characterized by stylized PERSPECTIVE, bright colours, minute detailing, and serious subjects. The work of Canadian artist WILLIAM HIND is said to show some Pre-Raphaelite aspects. **Citations:** Osborne 1970; Lucie-Smith 1984; Piper 1988; Read 1994.

PREVOST, E. NELPHAS (b1904), Fassett, QC. Sculptor of naïve works in wood. Prevost executed naïve sculpture in painted or varnished wood, sometimes using found shapes. His work includes animals, birds, as well as decorated and carved violins and their cases. **Citations:** NMM 1983; *Empress* 1985; McKendry 1988; CCFCS.

PRICE, ADDISON WINCHELL (b1907), Port Credit, ON. Painter. He studied under J.W. BEATTY and G.A. REID. **Citations**: MacDonald 1967; Sisler 1980; NGC 1982; Laing 1982; Lerner 1991; McMann 1997.

PRICE, ARTHUR (ART) DONALD (b1918), Ottawa, ON. Sculptor, illustrator, designer and painter; RCA 1973. Price is a son-in-law of MARIUS BARBEAU. His work shows influences from Canadian native art. **Citations**: Barbeau 1955, 1957, 1960, 1961; MacDonald 1967; Price 1973; Sisler 1980; Lerner 1991; McMann 1997.

PRICE COLLECTION. See CANADIAN CENTRE FOR FOLK CULTURE STUDIES.

PRIESTLEY, GLENN (b1955), Toronto, ON. Painter. **Citations**: Stacey 1989.

PRIMARY COLOURS. The primary colours in painting are red, yellow and blue. They cannot be created by mixing other colours, but are the bases of other colours: red and yellow mixed make orange, red and blue make purple, and blue and yellow make green. Mixtures of primary colours are called secondary colours. **Citations**: Mayer 1970; Piper 1988; Chilvers 1988.

PRIMING. Priming is a thin layer applied on top of the GROUND to make it more suitable to receive paint. It may make the ground less absorbent, or may supply a tint. **Citations**: Mayer 1970; Osborne 1970; Chilvers 1988.

PRIMITIVE ART. Primitive art includes the art of preliterate peoples and characteristically combines symbolism, boldness, directness, clashing colours and clarity with exaggeration of the most expressive features. These characteristics may be seen in the NATIVE ART OF CANADA, and in African tribal art, as well as the aboriginal art of other parts of the world. In modern art some of these characteristics may be used as 'conscious primitivism' by professional artists, or may appear as 'intuitive primitivism' in the work of native artists or naïve artists. Very little modern FOLK ART is primitive, although isolated primitive characteristics are sometimes seen in naïve work, for example in the sculptures of GEORGE COCKAYNE. **Citations**: Osborne 1970; Clark 1970; Bihalji-Merin 1971; Patterson 1973; Dickason 1974; Lord 1974; Wilkinson 1981; McKendry 1983, 1987, 1988; Rubin 1984; Goldwater 1986; Piper 1988; Lerner 1991.

PRIMITIVISM. See PRIMITIVE ART.

PRINCE EDWARD ISLAND. See MARITIME PROVINCES.

PRINCE, RICHARD EDMUND (b1949), Vancouver, BC. Sculptor and mixed media artist. His work is represented in the NATIONAL GALLERY OF CANADA. **Citations**: MacDonald 1967; Heath 1976; Sisler 1980; NGC 1982; McMann 1997.

PRINCESS LOUISE. See LOUISE, PRINCESS.

PRINT AND DRAWING COUNCIL OF CANADA. See CANADIAN SOCIETY OF GRAPHIC ART.

PRINTS. The many processes for making prints fall into four main groups: relief methods (ENGRAVING), INTAGLIO methods, surface or planographic methods (LITHOGRAPHY), and stencil methods (SILK-SCREEN PRINTING or SERIGRAPHY). Each print made is referred to as an impression and the total number of prints taken from a printing plate or stencil is referred to as an edition. In restricted editions each print is signed and numbered, for example '3/25' indicating the 3rd print of an edition of 25 copies. A distinction can be made between artists who work directly in the studio with plates and inks as a creative expression, such as DAVID MILNE, JESSIE OONARK, WALTER PHILLIPS, KENOJUAK, CARL HEYWOOD, GWYNETH-MABEL TRAVERS, and RITA LETENDRE, and artists whose drawings and paintings are made into prints by professional print-makers. The latter catagory includes RICHARD SHORT, COKE SMYTH, JAMES SMILLIE, JAMES DUNCAN, FREDERICK COBURN, and CORNELIUS KRIEGHOFF. See also WILLIAM BARTLETT; STEEL ENGRAVING; WOOD ENGRAVING; WOODCUT. See Marsh 1988 under PRINTMAKING for an account of printmaking in Canada. **Citations**: Burch 1910; Plowman 1922; Stokes 1933; Spendlove 1958;De Volpi 1962, 1963, 1964, 1965, 1966, 1971, 1972, 1973, 1974; Houston 1967; Harper 1970; Osborne 1970; Mayer 1970; Lord 1974; Eichenberg 1976; Goetz 1977; Tovell 1980;

Daigneault 1981; Oko 1981; Allodi 1980, 1989; Hachey 1980; Coy 1982; Moritz 1982; Marsh 1988; Lerner 1991.

PRISME D'YEUX (1948), Montréal, QC. Prisme d'yeux was a short-lived group of painters who were associated with ALFRED PELLAN, opposed to non-objective art and offering an alternative to the AUTOMATISTES. The group included, among others, GOODRIDGE ROBERTS, JACQUES de TONNANCOUR, GORDON WEBBER and ALBERT DUMOUCHEL. **Citations**: Buchanan 1962; Guy 1963; Wilkin 1976; Davis 1979; Burnett/Schiff 1983; Lerner 1991; Tippett 1992.

PROCH, DONALD (DON) (b1944), Winnipeg, MB. Painter, MURALIST and sculptor. Proch sometimes combines painted landscape and sculpture in one work as in his *Rainbow Mask* (pl. 125 Mellen 1978). Proch is concerned with prairie landscape and man's relation to it. **Citations**: Heath 1976; MacDonald 1967; Mellen 1978; Phillips 1978; NGC 1982; McKendry 1988; Lerner 1991.

PROCTOR, ALEXANDER PHIMISTER (1862-1950), New York, USA. Sculptor. Proctor was born in Ontario, but by 1903 he was in the USA, where he sculpted a number of monuments. Several bronzes by Proctor are in the NATIONAL GALLERY OF CANADA. **Citations**: Colgate 1943; Hubbard 1960; MacDonald 1967; NGC 1982; Lerner 1991.

PROCTOR, EDWARD D'ARCY (b1919), Pontypool, ON. Painter. Proctor started painting after retirement in 1968. He sometimes paints in a deliberate, flat, decorative naïve style, without perspective, using solid, bright colours. **Citations**: NGC 1982; *Century Home* 1985; McKendry 1988.

PROPORTION. Proportion is the measure of relative quantity and, in art, usually refers to a harmonic relationship among parts, and between any part and the whole object, whether a building or the human body. Western art has been strongly influenced by the proportional theories of classical art, especially as interpreted during the RENAISSANCE. **Citations**: Osborne 1970; Pierce 1987.

PROULX, JEAN OCTAVE (1890-1970), Montée Saint-Michel, QC. Painter. See MONTEE SAINT-MICHEL, LES PEINTRES DE LA. **Citations**: Laliberté 1986; Lerner 1991.

PROVENANCE. The history of previous owners and locations of a work of art. **Citations**: Chilvers 1988; Piper 1988.

PROVINCIAL ART. Provincial art is a subclassification of NAÏVE ART which includes naïve characteristics but has less original themes drawn from fashionable subjects or other works of art. **Citations**: McKendry 1983, 1987, 1988.

PSYCHIATRIC ART. Psychiatric art refers to art created by people who are considered atypical and who may be suffering from mental illness. See Bihalj-Merin 1971 pp. 24-30 for a discussion and illustrations of paintings by mentally ill patients. See WILLIAM KURELEK. **Citations**: Osborne 1970; Bihalj-Merin 1971.

PUBLIC ARCHIVES OF CANADA. See NATIONAL ARCHIVES OF CANADA.

PUGH, DAVID (b1947), Canmore, AB. Painter. Pugh is a mostly self-taught painter of landscapes. **Citations**: Godin 1984.

Q

QUEBEC (NEW FRANCE). While "Québec," an Algonquian word, has been in use since at least the 17th century by the French, the province was called Lower Canada in 1791 and Canada East from 1841 to 1867. In 1759 the British took over Québec City and in 1760 Montréal. Canada's largest province, is the birth-place of non-native Canadian painting and sculpture. In the 17th and 18th centuries Québec was closely tied to France and, through the Roman Catholic Church, RELIGIOUS ART was encouraged for the purpose of furnishing the many new churches. BISHOP LAVAL, who founded a school of arts and crafts, had great influence in bringing painters and sculptors from France, who in turn influenced and taught others. From this period, paintings by FRERE LUC, HUGUES POMMIER, CLAUDE

CHAUCHETIERE, JEAN GUYON, and PIERRE LE BER have survived. The international styles of BAROQUE and ROCOCO were well represented in Québec by painters, sculptors, silversmiths and furniture makers. It was not until after the English conquest of 1759-60 that influences other than that of France began to be felt in Québec. Painting in the French colony 1665-1759 is discussed in detail and illustrated in Harper 1966, pp. 3-30. After 1759, British army TOPOGRAPHERS appeared throughout Eastern Canada, and "the golden age of native painting was dawning in Québec, Montréal, and other villages and towns along the St Lawrence River." (Harper 1966, p. 53). During this period many fine portraits and landscapes were created by such well-known artists as FRANCOIS MALEPART DE BEAUCOURT, LOUIS DULONGPRE, FRANCOIS BAILLAIRGE, WILLIAM VON MOLL BERCZY, LOUIS-CHRETIEN DE HEER, JOSEPH LEGARE, ANTOINE PLAMONDON, ZACHARIE VINCENT, THEOPHILE HAMEL, and JEAN-BAPTISTE ROY-AUDY. In the mid 19th century, GENRE paintings by CORNELIUS KRIEGHOFF became popular and overshadowed contemporary painters such as ROBERT C. TODD. By the mid 20th century, there was a revival of painting in Québec centered in Montréal and promoted by painters such as JOHN LYMAN, ALFRED PELLAN, PAUL-EMILE BORDUAS, JEAN-PAUL RIOPELLE, HENRY CLAPP, A.Y. JACKSON, JACQUES DE TONNANCOUR, EDMUND ALLEYN, ALBERT DUMOUCHEL, and JEAN MCEWEN. Throughout the long history of art in Québec, there have been many noteworthy sculptors, although less has been written about them than about painters. Among Québec sculptors are LOUIS ARCHAMBAULT, JEAN-BAPTISTE COTE, SYLVI DAOUST, HENRI HEBERT, PHILLIPPE HEBERT, LOUIS JOBIN, ANNE KAHANE, SYBIL KENNEDY, ALFRED LALIBERTE, LOUIS-AMABLE QUEVILLON, and AURELE DE FOY SUZOR-COTE. An important legacy of the early establishment of the Roman Catholic Church is a large quantity of ecclesiastical silver. See also SILVERSMITHING; BLACKSMITHING; FOLK ART, CANADA; RELIGIOUS ART; NAÏVE ART. See Lerner 1991 vol. 1, pp. 150-203 for an extensive bibliography of Québec art. **Citations**: Lemoine 1876, 1882; Fairchild 1907, 1908; Dyonnet 1913; Morisset 1936, 1941, 1952, 1959; Barbeau 1934(1), 1936, 1936(1), 1946, 1957, 1957(Tresor), 1973; Traquair 1940, 1947; Colgate 1943; Traquair 1940, 1947; Laberge 1945; McInnes 1950; Gowans 1955; Jackson 1958; Hubbard 1960, 1967, 1973; de Volpi 1962, 1963, 1971; Harper 1964, 1966; NGC 1965; Trudel 1967(Peinture), 1967(Sculpture), 1969, 1974; Guy 1973, 1978; Watson 1974; Lord 1974; Roy 1974; Institut 1975; Lessard 1975; Ayre 1977; *Vie des Arts* 1978; Marteau 1978; Thibault 1978; de Grosbois 1978; Gagnon 1979; Reid 1979, 1988; George 1980; Daigneault 1981; Baker 1981; Ostiguy 1982; McKendry 1983; Laliberté 1986; Marsh 1988; Boulizon 1989; Lerner 1991; Béland 1991, 1992.

QUENTIN, RENE EMILE (1860-1914),Montréal, QC; Victoria, BC; Boston, USA. Painter of Canadian life, scenery, historical paintings and portraits. **Citations**: Harper 1970.

QUEVILLON, LOUIS-AMABLE (1749-1823), Montréal, QC. Sculptor of religious works in gilded, silvered or POLYCHROMED wood. In 1818 he had 14 sculptors and apprentices working in his studio. One of Quevillon's altarpieces is still in the church at Vercheres, QC. **Citations**: Vaillancourt 1920; Barbeau 1934(1); Traquair 1947; Gowans 1955; Lavallee 1968; Trudel 1969; Lessard 1971; Gauthier 1974; NGC 1982; Porter 1986; Marsh 1988; McKendry 1988; Lerner 1991.

QUINTAL, JOSEPH dit FRERE AUGUSTIN (1683-1776), Québec. Church architect; sculptor and painter of religious works. Quintal was a pupil of JUCONDE DRUE. **Citations**: Gowans 1955; Harper 1970; Lerner 1991.

R

R., D.B. (act. c1877), Western Canada. Painter. D.B.R. is known for some naïve portraits in watercolour of native people Chiefs. These works are now in the GLENBOW MUSEUM, Calgary, AB. **Citations**: Render 1970; McKendry 1988.

RACICOT, GEORGE (b.1937), Calumet, QC. Sculptor. Racicot's work includes naïve carvings of heads and relief panels in POLYCHROMED wood. His carved heads have primitive exaggerated features such as large protruding eyes, elongated noses and protruding lips. He uses bright solid colours. **Citations**: CCFCS; McKendry 1983, 1988.

RAGEE. See EEGYVUDLUK.

RAINE, HERBERT (1875-1951), Montréal, QC. Painter, printmaker and architect; RCA 1925. Raine was born in England, where he studied art before coming to Montréal in 1907. He painted Québec scenes, and became well known for his ETCHINGS. His work is represented in the NATIONAL GALLERY OF CANADA. **Citations**: Hubbard 1960; MacDonald 1967; Bradfield 1970; Thibault 1978; Sisler 1980; NGC 1982; Lerner 1991; McMann 1997.

RAMAGE, JOHN (c1748-1802), Halifax, NS and Montréal, QC. Painter. Ramage was an itinerant painter of life-size and miniature portraits. He worked in both Canada and the USA . In his obituary he was referred to as a "Limner being a wandering Portraitist." See LIMNER. **Citations**: Harper 1966, 1970; Rosenfeld 1981; McKendry 1988; Lerner 1991.

RANDLE, CHARLES (act. 1775-1813), Québec and the Maritime Provinces. Painter. Randle was with the British navy. His work included naïve TOPOGRAPHICAL landscape and marine paintings in watercolour, sketches and drawings of the St Lawrence River and Lake Champlain regions, and of Charlottetown, PE, as well as a map of Halifax, NS, 1778. **Citations**: Harper 1970; Bell 1973; Allodi 1974; Field 1985; McKendry 1988.

RAPHAEL, WILLIAM (1833-1914), Montréal, QC. Painter; RCA 1880. Raphael was born in Prussia and came to Canada via New York in 1857. He painted portraits, sleighing scenes, studies of habitants and other GENRE works similar in subject matter to that in some paintings by CORNELIUS KRIEGHOFF. **Citations**: Grant 1882; MacTavish 1925; Robson 1932; Hubbard 1960, 1963, 1967; Kilbourn 1966; Harper 1966, 1970; MacDonald 1967; Boggs 1971; Thomas 1972; Duval 1974; Lord 1974; Mellen 1978; Reid 1979, 1988; Morris 1980; Sisler 1980; Nasby 1980; Boyanoski 1982; Marsh 1988; McKendry 1988; Cavell 1988; Lerner 1991; McMann 1997.

RAPIN, FRANCOIS-XAVIER-ALDERIC (1868-1901), Marieville, QC. Painter. Rapin studied painting in Paris and returned to Québec to paint religious works and church decorations. **Citations**: Falardeau 1943; MacDonald 1967; Harper 1970; NGC 1982; Laliberté 1986; Lerner 1991.

RAVEN. This large black bird was a complex symbol for natives of the Northwest coast. The raven may be portrayed on carvings as the mediator between the ordinary and spiritual worlds. It also brought light into the world. See also BRITISH COLUMBIA.

RAY, CARL (1943-78), Sandy Lake and Sioux Lookout, ON. Painter. Ray's paintings are based on Ojibwa traditions, myths and legends. For a time, he was associated with NORVAL MORRISSEAU, DAPHNE ODJIG, ALEX SIMEON JANVIER and JACKSON BEARDY. Ray's work is in the Winnipeg Art Gallery, MB and the ROYAL ONTARIO MUSEUM, Toronto, ON. **Citations**: MacDonald 1967; Patterson 1973; Highwater 1980; McLuhan 1984; Marsh 1988; McKendry 1988.

RAYNER, GORDON (b1935), Toronto, ON. Painter, MURALIST, sculptor and CONSTRUCTIONIST. Rayner was mostly self-taught but for a time, he was apprenticed to JACK BUSH. His art is represented in the NATIONAL GALLERY OF CANADA and the ART GALLERY OF ONTARIO. **Citations**: MacDonald 1967; Townsend 1970; Bradfield 1970; Duval 1972; Withrow 1972; Lord 1974; Mellen 1978; Fenton 1978; Murray 1979(2); Morris 1980; NGC 1982; Burnett/Schiff 1983; Bringhurst

1983; Reid 1988; Lerner 1991; McMann 1997.

RCA. See ROYAL CANADIAN ACADEMY OF ARTS.

READE, JOHN (act. c1850), Western Canada. Painter. Reade is known for some naïve paintings in watercolour and/or ink of native people scenes, portraits and GENRE. He may have copied other artist's work. **Citations**: Allodi 1974; McKendry 1988.

REALISM. Realism is a term used to describe objective representation. As an art movement, Realism arrived in France with Gustave Courbet's (1819-77) *Stone Breakers* of 1849. Here was "the heroism of modern life" with this objective depiction of peasant labour. The work of LOUIS-PHILIPPE HEBERT has been described as "Québec realism" (Marsh 1988). See also BARBIZON SCHOOL; NATURAL-ISM; MAGIC REALISM. **Citations**: Osborne 1970; Piper 1988; Chilvers 1988; Lerner 1991.

REDINGER, WALTER (b1940), West Lorne, ON. Sculptor. Redinger works with massive totemic forms mostly constructed by a casting process. He has shared a studio with EDWARD ZELENAK. **Citations**: MacDonald 1967; Russell 1970; Smith 1972; Wolff 1978; Sisler 1980; NGC 1982; Lerner 1991; McMann 1997.

REFUS GLOBAL. In 1948 the painters PAUL-EMILE BORDUAS and FERNAND LEDUC, and some other members of the artistic community in Montréal, including the AUTOMATISTES, published a manifesto entitled *Refus Global* challenging the traditional values of Québec society. Although largely condemned by the press, the *Refus Global* had an impact on the public. **Citations**: Duval 1972; Lord 1974; *Vie des Arts* 1978; Osborne 1981; Bringhurst 1983; Burnett/Schiff 1983; Marsh 1988; Reid 1988.

REGENCY. This term refers to the art, ARCHITECTURE and DECORATIVE ARTS produced about the time the future King George IV of Britain was Prince Regent, 1811-20, during his father's illness. It was preceded by the GEORGIAN period and followed by the VICTORIAN period. See also EMPIRE. **Citations**: Chilvers 1988; Lerner 1991.

REGINA FIVE. This is a name given to five artists in the 1961 exhibition by the NATIONAL GALLERY OF CANADA *Five Painters from Regina.* The five painters were KENNETH LOCHHEAD, ARTHUR MCKAY, DOUGLAS MORTON, TED GODWIN and RONALD BLOORE. **Citations**: Borduas 1948, 1978; Simmins 1961; Townsend 1970; Dillow 1971; Duval 1972; Davis 1979; Osborne 1981; Bringhurst 1983; Burnett/Schiff 1983; Reid 1988; Marsh 1988; Lerner 1991.

REID, DENNIS. At present Reid is the senior curator of Canadian art at the ART GALLERY OF ONTARIO, Toronto, ON, and professor, history of art, at the University of Toronto; previously he was the curator of post-confederation art at the NATIONAL GALLERY OF CANADA. He has completed several important published studies of Canadian art: *A Concise History of Canadian Painting* 1973 (second edition 1988); *Bertram Brooker* 1973; *Edwin Holgate 1976; Our Own Country Canada: Being an Account of the National Aspirations of the Principal Landscape Artists in Montreal and Toronto 1860-1890* 1979; with Edward Cavall, *When Winter Was King: the Image of Winter in 19th Century Canada* 1988; *Lucius R. O'Brien: Visions of Victorian Canada* 1990; *Exploring Plane and Contour: The Drawing, Painting, Collage, Foldage, Photo-work, Sculpture and Film of Michael Snow from 1951 to 1967* 1994, and has organized important exhibitions of Canadian art for the NATIONAL GALLERY OF CANADA and the ART GALLERY OF ONTARIO. **Citations**: Reid 1970, 1973, 1976, 1979, 1988, 1990, 1994; Duval 1972; Laing 1979; Bringhurst 1983; Burnett/Schiff 1983; Cavell 1988.

REID, GEORGE AGNEW (1860-1947), Toronto, ON. Painter, MURALIST and art teacher; OSA 1885; RCA 1890. Reid studied under ROBERT HARRIS and JOHN A. FRASER, and in the USA and Europe. He painted murals and portraits, as well as GENRE, historical, and landscape subjects. In 1885 Reid married MARY AUGUSTA HIESTER REID and, in 1922, he married MARY EVELYN WRINCH REID. Reid taught at the ONTARIO COLLEGE OF ART 1890-1928. Several paintings by Reid are in the NATIONAL GALLERY OF CANADA. See McMann, pp. 340-3, for a dated list of paintings by Reid. **Citations**: MacTavish 1925; Robson 1932; Colgate 1943; Miner 1946; McInnes 1950; McLeish 1955; Jackson 1958; Hubbard 1960; Harper 1966, 1970; MacDonald 1967; Mellen 1970, 1978; Boggs 1971; Thomas 1972; Lord 1974; Forsey 1976; London 1978; Reid 1979, 1988; Sisler 1980; Laing 1982;

NGC 1982; Miller 1987; Marsh 1988; Duval 1990; Hill 1995; Silcox 1996; McMann 1997.

REID, IRENE HOFFER (b1908), Vancouver, BC. Painter, portrait painter. **Citations**: NGC 1982; Tippett 1992.

REID, JACK (b1925), Rockwood, ON. Painter; watercolorist. **Citations**: MacDonald 1967; Wolff 1978; NGC 1982.

REID, LESLIE MARY MARGARET (b1947), Ottawa, ON. Painter, printmaker and teacher. She studied under RALPH ALLEN and in England. Her work is represented in the NATIONAL GALLERY OF CANADA. **Citations**: MacDonald 1967; Graham 1975; Sisler 1980; NGC 1982; Burnett/Schiff 1983; Lerner 1991; Tippett 1992; McMann 1997.

REID, LORNA FYFE (b1887), London and Toronto, ON. Painter. She studied with F. MCGILLIVRAY KNOWLES and in New York. Her work is represented in the NATIONAL GALLERY OF CANADA. **Citations**: Hubbard 1960; NGC 1982; McMann 1997.

REID, MARY EVELYN WRINCH (1877-1969), Toronto, ON. Painter. Mary Wrinch studied under GEORGE REID and in England. As early as 1908, before she married GEORGE AGNEW REID in 1922 and before the formation of the GROUP OF SEVEN, she painted the Ontario northland. For reproductions of her work see Duval 1990, pp. 106-9. **Citations**: Miner 1946; Sisler 1980; NGC 1982; Miller 1987; Duval 1990; Lerner 1991; Tippett 1992; McMann 1997.

REID, MARY AUGUSTA HIESTER (1854-1921), Toronto, ON. Painter. Reid, who studied in the USA and in Europe, is known for her paintings of interiors, gardens and flower arrangements. She married GEORGE AGNEW REID in 1885. Several of her paintings are in the NATIONAL GALLERY OF CANADA. See McMann 1997, pp. 343-5, for a dated list of paintings by Reid. **Citations**: Reid 1922; MacTavish 1925; Robson 1932; Miner 1946; Hubbard 1960; MacDonald 1967; Bradfield 1970; Harper 1970; Farr 1975; Sisler 1980; NGC 1982; Miller 1987; Lerner 1991; Tippett 1992; McMann 1997.

REID, WILLIAM RONALD (BILL) (b1920), Vancouver, BC. Sculptor in wood and metal. Reid's work is based on Haida traditions, myths and legends. He was influenced by MUNGO MARTIN and CHARLES EDENSHAW, but is an authority in his own right on Haida art. **Citations**: *Canadian Collector* 1976; Mellen 1978; NGC 1982; Bringhurst 1983; Marsh 1988; McKendry 1988.

RELIEF SCULPTURE. Relief sculpture is carved or cast so that it rises from a surface of which it is part. The degree of projection is described as high, medium, or low. In bas-relief the projection from the surrounding surface is slight, and no part of the modeled form is undercut. Canadian sculptors who have worked in relief include JEAN-BAPTISTE COTE, ELIZABETH WYN WOOD, and MARC-AURELE DE FOY SUZOR-COTE. About 1880 traditional wood sculpture in Canada gave way to plaster and bronze. **Citations**: Osborne 1970; Pierce 1987; Piper 1988; Chilvers 1988.

RELIGIOUS ART. The term religious art usually refers to art having a theme based on Christianity such as the TRINITY (Father, Son and Holy Ghost), the VIRGIN of the Immaculate Conception, the Nativity, the Angels, the Saints, the Prophets, and so on. For a discussion of naïve religious art, see Bihalji-Merin 1971, pp. 237-52, and Schlee 1980, pp. 210-15. For a discussion of early religious art in Canada, see Harper 1966, pp. 3-30. See also ALTARPIECE, RETABLE, WOOD CARVING, FRERE LUC, BISHOP LAVAL, OZIAS LEDUC, SISTER ANNE AMEEN, JEAN-BAPTISTE COTE, LOUIS JOBIN, SILVERSMITHING, CHOIR, CIBORIUM, RELIQUARY, MONSTRANCE. **Citations**: Traquair 1947; Morisset 1952; Barbeau 1957(Tresor); Harper 1966; Ferguson 1967; Osborne 1970 (under Early Christian Art); Bihalji-Merin 1971; Frere-Cook 1972; Porter 1973; Schlee 1980; McKendry 1983, 1988; Lerner 1991.

RELINING. This is the process of mounting a painting, while still on its original canvas, on a new supporting canvas. **Citations**: Lucie-Smith 1984.

RELIQUARY. A reliquary is a container for storing or exhibiting one or more religious relics. See RELIGIOUS ART. **Citations**: Ferguson 1967.

REMINGTON, FREDERIC (1861-1908), USA Painter, sculptor, writer and illustrator. Remington's

subjects were mostly western scenes that included cowboys, horses and native people. Some of his illustrations were of Canadian subject matter, see Ralph 1892. A museum in Ogdensburg, New York State, the Remington Art Memorial, has a large collection of his work. **Citations**: Ralph 1892; McCracken 1947; Harper 1970; Hasrick 1975; Goetzmann 1986; McKendry 1988; Chilvers 1988; Piper 1988; Read 1994.

RENAISSANCE. The Renaissance is usually interpreted as the revival or rebirth of art and architecture in imitation of Roman (and indirectly Greek) models from about 1400 to about 1520 in Italy (including the Early and High Renaissance but excluding MANNERISM). The Northern Renaissance, about 1500 to about 1600, was preceded by "Late Gothic" in Flanders, Germany and France, and followed by the BAROQUE. The term Renaissance is usually applied to English art and architecture in the 15th and 16th centuries. There is, however, considerable MEDIEVAL influence, with important exceptions, throughout these centuries. **Citations**: Huyghe 1964; Hay 1967; Osborne 1970; Lord 1974; Janson 1977; McKendry 1983; Chilvers 1988; Piper 1988; Lerner 1991.

RENAISSANCE PERSPECTIVE. See GEOMETRIC PERSPECTIVE.

RENAUD, TOUSSAINT-XENOPHON (1860-1946), Montréal, QC. Painter and church decorator. **Citations**: Harper 1970; Laliberté 1986.

RENTZ, EWALD (born c1901), Beardmore, ON. Sculptor. Rentz is a naïve artist who accumulates natural objects that suggest sculptural shapes and uses them to form whimsical and humorous figures of people, animals and birds. His work includes religious subjects such as a crucifixion scene. **Citations**: Mattie 1981; NMM 1983; McKendry 1983, 1988; Kobayashi 1985(2).

REPLICA. See COPY.

REPRESENTATIONAL ART. See FIGURATIVE ART.

REPRODUCTION. A reproduction is a copy of a work of art. See PRINTS; ENGRAVING; FAKE; ETCHING; WOODCUT; LITHOGRAPHY. For a history of reproduction see Osborne 1970.

REREDOS. See RETABLE.

RESTORATION. See CONSERVATION.

RESTOULE, TIM (b1960), Manitoulin Island, ON. Painter. Restoule is a native artist. **Citations**: Ojibwa 1981; Lerner 1991.

RESURRECTION. The Resurrection of Christ is a continuing theme in RELIGIOUS ART. **Citations**: Osborne 1970; Ferguson 1967; Pierce 1987.

RETABLE. A decorative wall treatment or screen (also known as a reredos) behind the altar of a church. See also WOOD CARVING. **Citation**: Kalman 1994.

REVERSE SCALE. The relative size or SCALE of objects, in a painting, usually decreases with distance. If the size of objects, in a painting, increases with distance, the painting is said to be in reverse scale. Reverse scale is most likely to be found in MEDIEVAL ART and in NAÏVE ART.

REVERSE PAINTING. A painting in which the paint has been applied to the back of the glass through which it is viewed. R.D. LEAVER painted tinsel reverse-glass paintings in Lanark County, ON. See also FOIL ART; FOLK ART, CANADA. **Citation**: Britannica.

REVIVALS. During the 19th century there were numerous Revivals of earlier styles, such as CLASSICAL, MEDIEVAL, ROMANESQUE, GOTHIC and BAROQUE, which affected in particular DECORATIVE ARTS and ARCHITECTURE. This period is sometimes referred to as VICTORIAN, and one or more of these revival styles may be combined into an ECLECTIC style. See also NEOCLASSICAL.

REYNOLDS, CATHERINE MARGARET (1784-1864), Amherstburg, ON. Painter. Reynolds's existing paintings are naïve landscapes of Essex County, Niagara Falls, and Montréal, (see Harper 1974, pl. 35). **Citations**: Robinson 1967; Harper 1970, 1973, 1974; Farr 1975; NGC 1982; McKendry 1988; Lerner 1991.

RHEAU. See RHO.

RHO (RHEAU), JOSEPH-ADOLPHE (1835-1905), Québec City and Becancourt, QC. Sculptor of

religious objects in wood; painter; portraitist. He was a friend of CHARLES HUOT and father of AUGUSTE RHO. See Harper 1970 for a list of some of his works. **Citations:** Bellerive 1925; Morisset 1936; Colgate 1943; MacDonald 1967; Harper 1970; NGC 1982; Laliberté 1986; Porter 1986; Reid 1988; Lerner 1991.

RHO, AUGUSTE (1867-1947), Becancour and Montréal, QC. Sculptor and painter. Auguste Rho was apprenticed to his father JOSEPH-ADOLPHE RHO. **Citations:** Laliberté 1986.

RHEAUME, JEANNE LEBLANC (b1915), Montréal, QC. Painter. Rheaume studied under LILIAS TORRANCE NEWTON, HAROLD BEAMENT and GOODRIDGE ROBERTS. She was influenced by ALFRED PELLAN and was a member of the PRISME D'YEUX. An example of her work is in the NATIONAL GALLERY OF CANADA. **Citations:** Hubbard 1960; Viau 1967; MacDonald 1967; Robert 1978; NGC 1982; Lerner 1991; Tippett 1992.

RICHARD, HENRI (1879-1938), Montréal, QC. Photographer and painter of Laurentian landscape. Richard worked for some years in the studio of GEORGES DELFOSSE. **Citations:** MacDonald 1967; NGC 1982; Laliberté 1986.

RICHARD, RENE-JEAN (1895-1982), Baie St Paul, QC. Painter. Richard was influenced by CLARENCE GAGNON and JAMES WILSON MORRICE. After working and traveling in the western provinces and the Arctic, he settled at Baie St Paul and married one of Québec's finest weavers, Blanche Simon. His work is represented in the NATIONAL GALLERY OF CANADA. **Citations:** Bergeron 1946; MacDonald 1967; Bouchard 1978; Jouvancourt 1978(3); NGC 1982; Lerner 1991.

RICHARDS, CECIL CLARENCE (b1907), MB. Sculptor. **Citations:** Outram 1978; NGC 1982; Lerner 1991.

RICHARDS, WILLIAM (1786-1811), Moose Factory, ON. Painter. Richards, born in the James Bay area, was raised by his mother's people who were Cree. He taught himself to paint and, before his early death from tuberculosis, sketched several trading-post scenes, including a view of the fur-trading post of Albany Factory (see Harper 1974, pl. 8). **Citations:** Harper 1970, 1973, 1974; *Canadian Collector* 1974; NGC 1982; McKendry 1988; Lerner 1991.

RICHARDSON, EDWARD M. (act 1863-4), Victoria, BC. Painter and scuptor. He was an artist with a Cariboo exploration expedition in 1864. See Harper 1966, pl. 141, for an example of his work. **Citations:** Harper 1964, 1970, 1966; NGC 1982.

RICHARDSON, THEODORE J. (1855-1914), British Columbia. Painter. Richardson was an American who painted scenes in Alaska and BC. **Citations:** Fielding 1974; Render 1974.

RICHETERRE. See DESSAILLIANT de RICHETERRE.

RICHMOND, JOHN RUSSELL (b1926), Toronto, ON. Painter and sculptor. Richmond is a witty and versatile artist who interprets contemporary society in paintings, drawings and sculpture, using many forms derived from naïve-art traditions. **Citations:** Murray 1982; NGC 1982; McKendry 1988; McMann 1997.

RINDISBACHER, PETER (1806-34), Red River Colony, MB. Painter. In 1821 the Rindisbacher family immigrated to the Red River Colony from Switzerland. Peter Rindisbacher, a capable draughts-man, sketched many scenes on the voyage, including at least 40 (now in the NATIONAL ARCHIVES OF CANADA) between Hudson Strait and the Red River Colony. He became a clerk in the fur trade, and gained the intimate knowledge of native people and buffalo hunts that formed a basis for many of his paintings. In 1826, the Rindisbacher family moved to the USA and, by 1829, Rindisbacher was established with a studio in St. Louis, Mo. See Josephy 1970, Harper 1966, pl. 131, and Marsh 1988, p. 1872, for illustrations of Rindisbacher's work. **Citations:** Spendlove 1958; Harper 1962, 1964, 1966, 1970; Hubbard 1967; Carter 1967; MacDonald 1967; *Canadian Collector* 1969; Josephy 1970; Render 1970; Eckhardt 1970; Bell 1973; Ewers 1973; Lord 1974; Allodi 1974; Bovay 1976; Mellen 1978; NGC 1982; Marsh 1988; McKendry 1988; Cavell 1988; Lerner 1991; Dickenson 1992.

RINGMAN, A.E. (active 1917), Lunenburg, NS. Painter. Ringman is known for a ship portrait of a five-mast barque *Potosi* (Field 1985, pl. 128). **Citations:** Field 1985; McKendry 1988.

RIOPELLE, JEAN-PAUL (b1923), Montréal, QC; Paris, France. Painter and sculptor. Riopelle, an internationally acclaimed ABSTRACT painter, is an original member of the AUTOMATISTES and a signer of the REFUS GLOBAL. He studied with PAUL-EMILE BORDUAS and exhibited with him. Riopelle is known for personal improvisations and spontaneity in his work. There have been numerous exhibitions and publications of his work in Canada and in Europe, see Lerner 1991. Several of his paintings are in the NATIONAL GALLERY OF CANADA. **Citations**: Hubbard 1960; Harper 1962(2), 1966; Mendel 1964; MacDonald 1967; Viau 1967; Robert 1970; Boggs 1971; Withrow 1972; Duval 1972; Lord 1974; Ayre 1977; Robert 1978(2), 1981; Fenton 1978; Mellen 1978; Marteau 1978; Vie des Arts 1978; Sisler 1980; Osborne 1981; NGC 1982; Bringhurst 1983; Burnett/Schiff 1983; Marsh 1988; Reid 1988; Lerner 1991; Murray 1996(1); McMann 1997.

RISTVEDT-HANDEREK, MILLY (b1942), Toronto, ON. Painter and art teacher. She studied under ROY KIYOOKA 1960-64 at the Vancouver School of Art and then moved to Ontario. **Citations**: MacDonald 1967; Wilkin 1974(1), 1979; NGC 1982; Burnett/Schiff 1983; Lerner 1991; Tippett 1992.

RIVARD, SUZANNE LEMOYNE (b1928), Montréal, QC and Paris, France. Painter. She studied under JEAN-PAUL LEMIEUX 1946-50. **Citations**: MacDonald 1967; Robert 1973; NGC 1982; Tippett 1992.

ROBERT, LOUISE (b1941), Montréal, QC. Self-taught painter of abstract subjects and graphic artist. Her work is represented in the Musée du Québec, Québec City. **Citations**: MacDonald 1967; Murray 1980(2); NGC 1982; Lerner 1991; Tippett 1992.

ROBERTS, GOODRIDGE. See WILLIAM GOODRIDGE ROBERTS.

ROBERTS, H. TOMTU (1859-1938), Toronto, ON; Vancouver, BC. Painter. Roberts emigrated from Wales to Canada. He studied portraiture in Toronto with J.W. BRIDGMAN and J.W.L. FORSTER. In 1885 Roberts moved to Vancouver, where he painted numerous small oil landscapes of that city and the surrounding area (see Harper 1966, pl. 182, for an example). **Citations**: Harper 1966, 1970; Petrov 1980; NGC 1982; Lerner 1991.

ROBERTS, THOMAS (TOM) KEITH (b1909), Port Credit, ON. Painter, commercial artist and illustrator. Roberts studied under PETER HAWORTH, CARL SCHAEFFER, J.W. BEATTY and others. **Citations**: MacDonald 1967; Wolff 1978; Nasby 1980; Sisler 1980; NGC 1982; McMann 1997.

ROBERTS, WILLIAM GOODRIDGE (1904-74), Ottawa and Kingston, ON; Montréal, QC. Painter of landscapes, figures and still life; art teacher; RCA 1957. In Montréal, Roberts was associated with JOHN LYMAN, taught JACQUES DE TONNANCOUR and was a founding member of the CONTEMPORARY ARTS SOCIETY. He studied art in Montréal and New York. Roberts was a contemporary of the GROUP OF SEVEN. Several of Roberts' paintings are in the NATIONAL GALLERY OF CANADA. **Citations**: Tonnancour 1944; McInnes 1950; Buchanan 1950; Duval 1952, 1954, 1972; Harper 1955, 1966; Mendel 1964; Adamson 1969; Hubbard 1960, 1963, 1967; Borcoman 1969; Mellen 1970; Boggs 1971; Morris 1972; Render 1974; Lord 1974; Bell 1976; Ayre 1977; Fenton 1978; Thibault 1978; Mellen 1978; Bingham 1979; Varley 1980; Sisler 1980; Wilkin 1981; NGC 1982; Burnett/Schiff 1983; Farr 1988; Reid 1988; Marsh 1988; Lerner 1991; Hill 1995; McMann 1997.

ROBERTS, WILLIAM GRIFFITH (b1921), Toronto, ON; St Mary's Bay, NS. Painter. He is mainly self-taught. One of his paintings is in the NATIONAL GALLERY OF CANADA. **Citations**: Hubbard 1960; MacDonald 1967; Sisler 1980; NGC 1982; McMann 1997.

ROBERTSON, CLIVE (b1946), Québec. Sculptor; VIDEO and film artist. **Citations**: Gale 1977; NGC 1982; Lerner 1991.

ROBERTSON, SARAH MARGARET ARMOUR (1891-1948), Toronto, ON. Painter. She studied under WILLIAM BRYMNER and MAURICE CULLEN. Robertson was a friend of PRUDENCE HEWARD and A.Y. JACKSON, and was a founding member of the CANADIAN GROUP OF PAINTERS. See BEAVER HALL GROUP . Several of her paintings are in the NATIONAL GALLERY OF CANADA. **Citations**: Jackson 1951, 1958; Hubbard 1960; McCullough 1966; Harper 1966; MacDonald 1967; Bradfield 1970; Duval 1972; Housser 1974; Hill 1975, 1995; Farr 1975; Laing

1979; Ostiguy 1982; NGC 1982; Burnett/Schiff 1983; Lerner 1991; Tippett 1992; McMann 1997.

ROBINSON, ALBERT HENRY (1881-1956), Hamilton, ON; Montréal, QC. Painter; RCA 1921. After studying in Paris and in the USA , Robinson returned to Hamilton in 1905. About 1908 he began to paint Québec landscape and moved to Montréal. Robinson was a friend of A.Y. JACKSON and often painted with him. Robinson was a founding member of the CANADIAN GROUP OF PAINTERS. See Harper 1966, pl. 288, for a colour illustration of Robinson's work, and Watson 1982 for an illustrated account of his mature years. There are many paintings by Robinson in the NATIONAL GALLERY OF CANADA. **Citations**: MacTavish 1925; Robson 1932; Colgate 1943; Buchanan 1950; McInnes 1950; MacDonald 1955, 1967; Lee 1956; Jackson 1958; Hubbard 1960, 1960(1); Harper 1966; Duval 1967, 1973, 1990; Wodehouse 1968; Groves 1968; Mellen 1970; Bradfield 1970; Murray 1973; Housser 1974; Lord 1974; Watson 1974, 1982; Laing 1979, 1982; Sisler 1980; NGC 1982; Burnett/Schiff 1983; Laliberté 1986; McMichael 1986; Reid 1988; Lerner 1991; Tippett 1992; Hill 1995; McMann 1997.

ROBINSON, CLIFFORD FEARD (b1916), Banff, AB; Vancouver, BC. Painter. Clifford Robinson studied painting under W.J. PHILLIPS, H.G. GLYDE and others at the BANFF SCHOOL OF FINE ARTS, and worked with A.Y. JACKSON. **Citations**: NGC 1982; Masters 1987.

ROBINSON, DOROTHY (act. 1978), Saskatchewan. Painter. **Citations**: Dunlop Art Gallery; NGC 1982; McKendry 1988.

ROBINSON, JONAS (1901-88), Merrickville, ON. Painter. Upon retirement from farming in 1947, Robinson moved to Merrickville and had time to paint many remembered farm scenes, as well as views of historic buildings in Merrickville. His paintings are flat, brightly coloured and detailed. There are several examples of his work in the collections of CCFCS. **Citations**: CCFCS; McKendry 1983, 1988; Kobayashi 1985(2).

ROBINSON, MARIA S. (d1884), Kingston, ON. Painter. Robinson painted views of Upper Canada (now Ontario) . Some are illustrated in Allodi 1974, pl. 467-9. **Citations**: Allodi 1974; McKendry 1988.

ROBSON, ALBERT HENRY (1882-1939), Toronto, ON. Art critic, writer, graphic artist and painter. He became the art director of GRIP LIMITED, and in 1912 moved to ROUS AND MANN LIMITED. While at Grip he supervised J.E.H. MACDONALD, TOM THOMSON, FRANK JOHNSTON, ARTHUR LISMER, FRANK CARMICHAEL, F.H. VARLEY, TOM MCLEAN, NEIL MCKECHNIE and others. Five of these artists became members of the GROUP OF SEVEN. Robson was the author of six books in the CANADIAN ARTISTS SERIES and of *Canadian Landscape Painters* 1932 - the first Canadian art book to have a large number of colour illustrations. **Citations**: Robson 1932, 1937(1)(2)(3), 1938, 1938(2)(3); Colgate 1943; Miner 1946; McInnes 1950; Jackson 1958; Harper 1966; MacDonald 1967; Mellen 1970; McLeish 1973; Lord 1974; Housser 1974; Laing 1979; Darroch 1981; Thom 1988; Lerner 1991; Hill 1995; McMann 1997.

ROCKWELL, CLEVELAND (1837-1907), Alberta and British Columbia. Painter. Rockwell was an American artist. (See Render 1974, pl. 67-70.) **Citations**: Render 1974.

ROCOCO. Rococo is a style in the fine and decorative arts that originated in France and superseded the BAROQUE style in the early 18th century in the reign of Louis XV (1715-74). It is characterized by extravagant decoration including scrolls, rock and plant motifs. It fell out of fashion as NEOCLASSI-CISM became popular in the mid to late 18th century. In Canada, the Rococo style had its greatest influence in Québec, particularly on silversmiths, furniture makers, sculptors and painters. A talented artist in Montréal was FRANCOIS MALEPART DE BEAUCOURT. For examples of furniture, see Palardy 1963, figs. 25-7, 83, 115, 430-40. See also REVIVALS. **Citations**: Palardy 1963; Harper 1966; Osborne 1970; Lord 1974; Janson 1977; Piper 1988.

ROEBUCK, JOHN ARTHUR (1801-79), Augusta, ON; Côteau-du-Lac, QC. Painter. John Arthur Roebuck, an English emigrant, took part in Canadian politics. He was an amateur painter of views of Upper and Lower Canada and a brother of WILLIAM ROEBUCK. **Citations**: Harper 1970; Allodi 1974; McKendry 1988.

ROEBUCK, WILLIAM (c1795-1847), Augusta, ON; Côteau-du-Lac, QC. William Roebuck painted

TOPOGRAPHICAL views of Upper Canada and Lower Canada (now Ontario and Québec) including sketches of the construction of the Citadel in Québec City. He was a brother of JOHN ARTHUR ROEBUCK, and was with the British Army. **Citations:** Morisset 1960; Harper 1970; Bell 1973; Stewart 1973; Allodi 1974; NGC 1982; Cooke 1983; McKendry 1988.

ROGERS, OTTO DONALD (b1935), Regina, SK. Painter and sculptor. His paintings are AB-SRACT, with figurative overtones, influenced by prairie landscape and religion. **Citations:** Harper 1966; Climer 1967; MacDonald 1967; Render 1974; Walters 1975; Fenton 1978; Sisler 1980; NGC 1982; Burnett/Schiff 1983; Bringhurst 1983; Reid 1988; Marsh 1988; Lerner 1991; McMann 1997.

ROGERSON, JOHN (1837-1925), Saint John, NB. Sculptor. Rogerson was a professional sculptor in POLYCHROMED or gilded wood of ship carvings including figureheads, busts, relief carvings, furniture and church decorations. Examples of his work are in the New Brunswick Museum, Saint John. **Citations:** MacDonald 1967; Ryder 1967; Harper 1973; *Canadian Collector* 1975; *Maine Antique Digest* 1983; Kobayashi 1985(2); McKendry 1988; Lerner 1991.

ROLLIN, PAUL (act. 1812-30), Montréal, QC. Sculptor. He was an apprentice to LOUIS QUEVIL-LON and later Quevillon's associate. **Citations:** Vaillancourt 1920; Traquair 1947; Lerner 1991.

ROM. See ROYAL ONTARIO MUSEUM.

ROMAN CATHOLIC CHURCH. The Catholic clergy in Québec, in particular BISHOP LAVAL, through its patronage of the arts and the active participation of many of its members, introduced painting, sculpture and church architecture to NEW FRANCE. For the best account of this period, see Harper 1966, pp. 3-30. **Citations:** Traquair 1947; Gowans 1955; Harper 1966; Lord 1974 (chapter II); McKendry 1983; Reid 1988 (chapter 1).

ROMANESQUE. Romanesque is a style of art which was popular in Europe during the 11th and 12th centuries. The dominant art form in this period was architecture, which was massive, round arched, powerful, and - on churches - featured religious carvings. Manuscripts were the most significant form of painting. See also REVIVALS. **Citations:** Osborne 1970; Janson 1977; Piper 1988; Lerner 1991.

ROMANTICISM. Romanticism developed in the late 18th and into the 19th century as a reaction to CLASSICISM and in response to the romantic literature of the period. This movement in art involved freedom of the imagination combined with emotional response and interest in nature in its untamed state. It was to be expected that Romanticism would affect painting in Canada, where raw nature was ever present in the 18th and 19th centuries, and this was the case in some of the paintings of JOSEPH LEGARE (Harper 1966, pl. 73), ADOLPHE VOGT (Harper 1966, pl. 153), WILLIAM HENRY BARTLETT, and others. **Citations:** Harper 1966; Osborne 1970; Lord 1974; Chilvers 1988; Piper 1988; Lerner 1991.

RONALD, WILLIAM (WILLIAM RONALD SMITH) (b1926), Toronto, ON; New York City, NY. Painter. Ronald's ABSTRACT paintings have influenced the direction of Canadian art. In 1953 he was involved in the formation of PAINTERS ELEVEN, the first abstract painting group in Ontario. **Citations:** Hubbard 1960; MacDonald 1967; Duval 1972; Withrow 1972; Lord 1974; Callaghan 1975; Fenton 1978; Mellen 1978; Sisler 1980; Osborne 1981; NGC 1982; Ronald 1983; Burnett/Schiff 1983; Bringhurst 1983; Piper 1988; Marsh 1988; Reid 1988; Lerner 1991; Murray 1996(1); McMann 1997.

ROPER, EDWARD (1857-91), England. Painter. Roper made several visits to Canada and traveled across the country painting scenery. He exhibited his paintings of western Canada in England and issued a series of LITHOGRAPHS of Muskoka, ON. (See Render 1974, pl. 66 and Harper 1966, pl. 147.) **Citations:** Render 1974; Harper 1966, 1970; Bovey 1976; NGC 1982; Marsh 1988; Lerner 1991.

ROSAIRE. See ROZAIRE.

ROSE. In Christian symbolism, a red rose is a symbol of martyrdom and the white rose is a symbol of purity. The Virgin Mary is especially associated with the rose. Folk artists sometimes use a rose in a simple decorative way, but in one case (see McKendry 1983, pl. 119) roses were carved on the extremities of a crucifix symbolizing Christ's suffering on the cross. **Citations:** Ferguson 1967; McKendry 1983; Pierce 1987.

ROSENBERG, TANYA (TANYA MARSHALL {MARS}) (b1948), Québec. Sculptor. **Citations**: NGC 1982; Lerner 1991; Tippett 1992.

ROSS, FREDERICK (FRED) JOSEPH (b1927), Saint John, NB. Painter, portraitist, MURALIST and printmaker. He studied in the USA and Mexico. His work is represented in the New Brunswick Museum, Saint John. **Citations**: Harper 1966; Hashey 1967; Tweedie 1967; MacDonald 1967; Duval 1972, 1974; NGC 1982; Lerner 1991; McMann 1997.

ROSS, ROBERT (b1902), Toronto, ON. Painter, portraitist and printmaker. He studied under G.A. REID, ARTHUR LISMER, FREDERICK VARLEY, J.W. BEATTY and EMANUEL HAHN. His work is represented in the ART GALLERY OF ONTARIO. **Citations**: Duval 1952; MacDonald 1967; Bradfield 1970; NGC 1982; McMann 1997.

ROTH, EVELYN (b1936), Vancouver, BC. Mixed-media and textile artist. **Citations**:Murray 1980(2); NGC 1982; Lerner 1991; Tippett 1992.

ROUS AND MANN LIMITED. In 1912 ALBERT ROBSON left GRIP LIMITED and went as manager to the Toronto commercial art and print house Rous and Mann Limited. He took with him FRANKLIN CARMICHAEL, FRANK JOHNSTON, ARTHUR LISMER, FREDERICK VARLEY, and TOM THOMSON. J.E.H. MACDONALD had already left Grip. Grip was, therefore, no longer important for the formation of the GROUP OF SEVEN in 1920. ALFRED CASSON later joined the other members of the Group at Rous and Mann and, at about the same time, EDWIN HOLGATE joined the Group. **Citations**: Robson 1932; Mellen 1970; Laing 1979; Hill 1995; McMann 1997.

ROUSSEAU, ALBERT (1908-82), Québec. Painter, illustrator, teacher and printmaker. His work is represented in the MONTREAL MUSEUM OF FINE ARTS. **Citations**: Bergeron 1946; MacDonald 1967; Guy 1979; NGC 1982; Lerner 1991.

ROUSSEAU, HENRI (1844-1910), Paris, France. Painter. Rousseau is a well-known French naïve artist, to whom THOMAS DAVIES has been compared and who influenced Canadian artists MAURICE CULLEN, EDWARD JOHN HUGHES, CAROL FRASER, HOMER WATSON and others. **Citations**: Hamilton 1936; Harper 1966; Hubbard 1972(1); Lord 1974; Pichon 1982; McKendry 1983; Lerner 1991.

ROWAN, FREDERICK JAMES (act. c1855), Ontario. Painter. Rowan painted views of Rice Lake, ON, and of the St Lawrence River. He was associated with WILLIAM ARMSTRONG. **Citations**: Harper 1970; Allodi 1974; NGC 1982; McKendry 1988.

ROY, PHILIPPE (1899-1982), Saint-Philemon, QC. Sculptor. Roy is known for his naïve sculpture in POLYCHROMED wood of religious figures, crucifixion scenes, the Holy Family, and animals. Roy's simple faith is evident in his many appealing and symbolic religious carvings which convey Biblical stories. He painted his sculptures in bright decorative colours, see McKendry 1983, pl. 128. **Citations**: Harper 1973; Dunbar 1976; NMM 1983; McKendry 1983, 1988; Kobayashi 1985(2); CCFCS.

ROYAL CANADIAN ACADEMY OF ARTS (RCA). The Royal Canadian Academy is a national organization of professional Canadian artists and architects founded in 1880 through collaboration of the ONTARIO ASSOCIATION OF ARTISTS and the ART ASSOCIATION OF MONTREAL under the active patronage of the Governor General the MARQUESS OF LORNE and his wife the PRINCESS LOUISE. LUCIUS O'BRIEN was the first president. Before 1973 artists and architects first became associate members (ARCA) and then were elected to full membership (RCA) upon presenting a diploma work for deposit in the diploma collection at the NATIONAL GALLERY OF CANADA. For many years annual open juried exhibitions were held. The RCA follows a long tradition in western art: the Academy of Fine Arts was established in 1563 in Florence, Italy, by Vasari; the French Academy in 1648; the French Academy in Rome in 1666; and the Royal Academy in London, England in 1768. See Sisler 1980 and McMann 1997 for full accounts of the formation of the RCA and for lists of its members and exhibitions. **Citations**: MacTavish 1925; Jones 1934; Colgate 1943; Buchanan 1950; McInnes 1950; Jackson 1958; Harper 1966, 1979; Mellen 1970; Watson 1974; Lord 1974; Housser 1974; Reid 1979, 1988; Laing 1979; Tippett 1979, 1992; Sisler 1980; Karel 1987; Marsh 1988; Hill 1988, 1995; Lerner 1991; Silcox 1996; McMann 1997.

ROYAL MILITARY ACADEMY (WOOLWICH MILITARY ACADEMY). The Royal Military Academy at Woolwich, England, trained artillery and engineer officers for the British Army of whom many were posted to Canada in the 18th and 19th centuries. Some of these officers were taught TOPOGRAPHICAL drawing and watercolour painting by the important English watercolourist PAUL SANDBY who was the Chief Drawing Master 1768-96. Notable among the officers taught by Sandby and who later were posted to Canada, were GEORGE HERIOT, JAMES PATTISON COCKBURN, and THOMAS DAVIES. (See Harper 1966, pp. 41-52, re British army TOPOGRAPHERS in Eastern Canada.) **Citations**: Harper 1966; Hubbard 1972(1); Lord 1974; Cameron 1976; Finley 1978, 1979; Laing 1982; Reid 1988.

ROYAL ONTARIO MUSEUM (ROM), est. 1912. This large institution in Toronto holds an international collection of artifacts, as well as an important collection of Canadian art and DECORATIVE ARTS in the Sigmund Samuel Building. Citations: Jefferys 1948; Spendlove 1958; Harper 1966; Harper 1971(1); Kane 1969; Allodi 1974; Marsh 1988; Reid 1988.

ROY-AUDY, JEAN-BAPTISTE (1778-1848), Québec City and Montréal, QC. Painter. Although Roy-Audy studied drawing with FRANCOIS BAILLAIRGE in 1796, his work remained naïve in character, possibly because in his early years he worked as an ITINERANT artist, and was not single-minded about any particular branch of painting. At first, he divided his time between wood carving, carpentry, painting and gilding. An advertisement in 1831 described him as painting historical paintings, portraits, armoires, carriages, transparencies on silk, cloth for sideboards, and fantastic signs. Roy-Audy signed few paintings, and there has been much difficulty in attributing work to him. His portrait paintings are detailed, smoothly finished with the sharpness and clarity of a steel engraving, while retaining charming naïveté (see McKendry 1983, pl. 137, and Harper 1966, p. 94-7). **Citations**: Morisset 1959; Hubbard 1960, 1967, 1973; Harper 1966, 1970, 1973, 1974; Carter 1967; Trudel 1967(Peinture); Cauchon 1971; NGC 1982; McKendry 1983, 1988; Farr 1988; Marsh 1988; Lerner 1991; Béland 1992.

ROYLE, STANLEY (1886-1961), New Brunswick; Halifax, NS. Painter and art teacher; RCA 1942. Royle came to Halifax from England in 1930 and returned to England by 1948. An example of his work is in the NATIONAL GALLERY OF CANADA. **Citations**: Colgate 1943; Hubbard 1960; MacDonald 1967; Sisler 1980; NGC 1982; Lerner 1991; Tippett 1992; McMann 1997.

ROZAIRE (ROSAIRE), ARTHUR DOMINIQUE (1879-1922), Montréal, QC; Los Angeles, Cal. Painter. Rozaire studied under EDMOND DYONNET, WILLIAM BRYMNER, and MAURICE CULLEN. He moved to Los Angeles in 1917. Several of his paintings are in the NATIONAL GALLERY OF CANADA. **Citations**: MacTavish 1925; Robson 1932; Laberge 1938; Hubbard 1960; MacDonald 1967; Murray 1973; Sisler 1980; NGC 1982; Laliberté 1986; Lerner 1991; McMann 1997.

RUDNICKI, RICHARD (b1951), Ottawa, ON; Halifax, NS. Printmaker. He collaborated with ALAN BUNCE on a LINOCUT, now in the NATIONAL GALLERY OF CANADA. **Citations**: Hill 1988 (see BUNCE).

RUELLAND, GEORGES (1869-1915), Levis, QC. Painter, portraitist. He was a son of LUDGER RUELLAND and a brother of WILHELMINE RUELLAND. Georges and Wilhelmine worked in the same studio. **Citations**: Harper 1970; McKendry 1988.

RUELLAND, LUDGER (1827-96), Levis, QC. Painter, portraitist. Although Ruelland studied painting with THEOPHILE HAMEL, he painted in a naïve style. His portraits include middle-class society, country bourgeois, clerics and merchants. He was the father of GEORGES and WILHELMINE RUELLAND. **Citations**: Morisset 1959; Trudel (Peinture) 1967; Harper 1970; NGC 1982; McKendry 1988; Lerner 1991.

RUELLAND, WILHELMINE (c1865-1932), Levis, QC. Painter, portraitist. She was a daughter of LUDGER RUELLAND and a sister of GEORGES RUELLAND. Wilhelmine and Georges worked in the same studio. **Citations**: Harper 1970; McKendry 1988.

RUNGIUS, CARL CLEMENS MORITZ (1869-1959), Banff, AB. Painter. Rungius is known for his

portrayal of wild animals in Rocky Mountain settings. He was an American artist who established a studio in Banff but sold most of his paintings in the USA. Many paintings by Rungius are in the collection of the GLENBOW MUSEUM in Calgary, AB. **Citations**: MacDonald 1967; Render 1970, 1974; *Canadian Collector* 1976, 1985; Wilkin 1980; NGC 1982; Hart 1985; McKendry 1988; Lerner 1991.

RUSSELL, ARNOLD M. (1900-76), Prince Albert, SK. Painter. Russell painted naïve landscape paintings including remembered rural scenes. His daughter has commented: "My father started painting in 1964, after his retirement, and for personal pleasure." His work is represented in the Mendel Art Gallery, Saskatoon, SK. **Citations**: MacDonald 1967; Thauberger 1976; Borsa 1983; McKendry 1988.

RUSSELL, EDWARD JOHN (1832-1906), Saint John and Fredericton, NB. Painter, illustrator and CARTOONIST. Russell, who was born on the Isle of Wight, England, emigrated to Saint John in 1851. He is best known for his many paintings of sailing ships and marine scenes in watercolour. He published political cartoons and some coloured LITHOGRAPHS. **Citations**:*Canadian Illustrated News* 1871, 1872, 1873; Ryder 1953; Harper 1966, 1970; MacDonald 1967; *Canadian Collector* 1970; Armour 1975; NGC 1982; McKendry 1988; Lerner 1991.

RUSSELL, GEORGE HORNE (1861-1933), Montréal, QC; St Andrews and St Stephen, NB. Painter; RCA 1918. Russell was in Montréal by 1889 and until 1906 was employed by WILLIAM NOTMAN. He painted portraits, flower studies and landscapes including some in the Canadian Rockies. Some of his paintings are in the NATIONAL GALLERY OF CANADA. **Citations**: MacTavish 1925; Colgate 1943; Jackson 1958; Hubbard 1960; Harper 1966, 1970; MacDonald 1967; Bradfield 1970; Thomas 1972; Render 1974; Laurette 1978; Sisler 1980; NGC 1982; Lerner 1991; McMann 1997.

RUSSELL, GYRTH (1892-1970), Halifax, NS; England. Painter and etcher. He studied in Halifax, Boston and Paris. His work is represented in the NATIONAL GALLERY OF CANADA. **Citations**: MacTavish 1925; Colgate 1943; Hubbard 1960; MacDonald 1967; Wodehouse 1968; Lerner 1991; McMann 1997.

RUSSELL, JOHN WENTWORTH (1879-1959), Paris, France; Toronto, ON. Painter. John Wentworth Russell is chiefly known for his paintings of figures and portraits, including nudes. He went to Paris in 1906 and lived there for some years. Examples of his work are in the NATIONAL GALLERY OF CANADA. **Citations**: MacTavish 1925; Colgate 1943; Jackson 1958; Hubbard 1960; Harper 1966; MacDonald 1967; Bradfield 1970; Morris 1972; Sisler 1980; NGC 1982; Miller 1983; Bayer 1984; Duval 1990; Lerner 1991; McMann 1997.

RYLEY, Miss (act. 1847), Ontario. Painter. She exhibited at the inaugural exhibition of the TORONTO SOCIETY OF ARTISTS. **Citations**: Tippett 1992.

S

S., H. (act. 1849), Ontario. Painter. This unidentified artist painted naïve landscape paintings in watercolour, including a view of the Long Sault rapids on the St Lawrence River showing a timber raft and other shipping. **Citations**: Bell 1973; Cooke 1983; McKendry 1988.

SADD, WILLIAM HARVEY (1864-1954), Toronto, Ottawa and Manotick, ON. Painter and LITHOGRAPHER. Sadd studied under FREDERIC BELL-SMITH and L.R. O'BRIEN. For the most part he is known for his views of Ottawa, and Gatineau, Québec, scenery. He painted many autumn landscapes. **Citations**: MacDonald 1967; Harper 1970; NGC 1982; McKendry 1988.

SAIA, JORGE. See GENERAL IDEA.

SAINT-CHARLES (ST CHARLES), JOSEPH A. (1868-1956), Montréal, QC. Painter, portraitist. He studied in Paris and, by 1890, was in Montréal working on three pictures for the chapel of the Sacré-Cœur of the church of Notre Dame. **Citations**: Dyonnet 1913; Chauvin 1928; Rainville 1946;

Harper 1966; NGC 1982; Laliberté 1986; Lerner 1991; McMann 1997.

ST CLAIR, BRUCE (b1945), Ontario. Painter. **Citations**: Belshaw 1976; NGC 1982; Lerner 1991.

SAINT-HILAIRE, LOUIS (1860-1922), l'Ile-aux-Noix, Saint-Jean and Montréal, QC. Painter of religious subjects. Saint-Hilaire studied abroad and returned to Canada in 1895. **Citations**: Harper 1970; Laliberté 1986.

SAINT-JAMES dit BEAUVAIS, RENE (1785-1837), Québec. Sculptor of religious subjects in wood. **Citations**: Vaillancourt 1920; Traquair 1947; NGC 1982; Porter 1986; Lerner 1991.

SAINT-JOACHIM SCHOOL. It is said that there was an arts and craft school founded by BISHOP LAVAL in 1668 at Saint-Joachim near Saint-Anne de Beaupré, QC (see Harper 1966, pp. 11-14). Some historians believe JACQUES LEBLOND dit LATOUR directed the sculpture-atelier at this school. **Citations**: Barbeau 1934, 1957(Québec); Traquair 1947; Gowans 1955; Harper 1966; Gagnon 1976(1); Lerner 1991; Kalman 1994.

SAINT-MEMIN, CHARLES BALTHAZAR JULIEN FEURET de (1770-1852), Halifax, NS; Québec City and Montréal, QC. Painter, portraitist. Saint-Memin's work included life-size and MINIATURE portraits, and engravings. He used physionatrace apparatus (see Harper 1970) to take accurate profiles of his sitters. **Citations**: Harper 1962, 1970; Cooke 1983; McKendry 1988.

SAINT-MICHEL. See MONTEE SAINT-MICHEL.

SALMON. This fish often represents the cyclical flow of life and death in the art of the native peoples of the Northwest coast. See also BRITISH COLUMBIA.

SALOMON, MARION (1782-1830), Québec. Silversmith. **Citations**: Langdon 1966; NGC 1982.

SAMSON, OLIVIER (act. 1854), Québec. Sculptor of religious subjects for churches. **Citations**: Traquair 1947; Porter 1986; Lerner 1991.

SANDBY, PAUL (1730-1809), Woolwich, England. Painter. The English watercolourist Paul Sandby was the Chief Drawing Master at the ROYAL MILITARY ACADEMY, Woolwich, 1768-1796. He influenced many of the military TOPOGRAPHICAL painters who worked in Canada, for example GEORGE HERIOT, THOMAS DAVIES, and JAMES PATTISON COCKBURN. **Citations**: Harper 1966; Osborne 1970; Hubbard 1972; Lord 1974; Allodi 1974; Cameron 1976; Finley 1978, 1979; McKendry 1983, 1988; Chilvers 1988; Lerner 1991.

SANDHAM, J. HENRY (1842-1910), Montréal, QC; Saint John, NB. Painter, illustrator and por-traitist; RCA 1880. Sandham worked in the NOTMAN Studios in Montréal and in Saint John, NB. This work put him in contact with the prominent artists of the time. After some study, he became successful as an illustrator, portrait painter, and painter of historical scenes. Sandham spent his final years in England. Several of his paintings are in the NATIONAL GALLERY OF CANADA. **Citations**: *Canadian Illustrated News* 1870-72, 1879; Willson 1911; MacTavish 1925; Robson 1932; Colgate 1943; McInnes 1950; Duval 1954; Hubbard 1960; Harper 1966, 1970; Carter 1967; Thomas 1972; Reid 1973, 1988; Thibault 1978; Sisler 1980; NGC 1982; Cooke 1983; Cavell 1988; McKendry 1988; Lerner 1991; McMann 1997.

SAND-PAINTING. Sand-painting has been practised in the south-western USA by various native tribes, as well as in other parts of the world by aboriginal peoples. The designs, which are drawn with coloured sand in a flat layer of yellow-white sand, have ceremonial significance and are thought to have healing powers. Each sand-painting is destroyed after the ceremony. See also FOLK ART. **Citations**: Osborne 1970.

SANDPAPER PAINTING. Sandpaper paintings have a surface texture provided by application of sand. The technique had some popularity in the USA around 1850 and to a lesser extent in Canada. (See McKendry 1983, pl. 176, for an example.) See also FOLK ART. **Citations**: McKendry 1983.

SAPP, ALLEN (b1929), North Battleford, SK. Painter. Sapp, a native Cree, studied under WYNONA MULCASTER and paints the life and legends of his people. He has studied art and is considered one of the foremost native painters. **Citations**: Mulcaster 1969; MacEwan 1971; Sapp 1977; Highwater 1980; Sisler 1980; NGC 1982; Marsh 1988; Lerner 1991; Sapp 1996; McMann 1997.

SASKATCHEWAN. Saskatchewan was created out of the Northwest Territories in 1905. Among the earlier painters in Saskatchewan are JAMES HENDERSON, INGLIS SHELDON-WILLIAMS and AUGUSTUS KENDERDINE (see Harper 1966, pp. 344-8). Some later painters are ROBERT SYMONS, ROBERT HURLEY, ERNEST LINDNER, RETA COWLEY, DOROTHY KNOWLES, ALLEN SAPP, DAVID THAUBERGER, WILLIAM PEREHHUDOFF, and OTTO DONALD ROGERS (see Reid 1988, pp. 348-52 for this later period). See also REGINA FIVE; EMMA LAKE ARTIST'S WORKSHOP. **Citations**: Simmins 1961; Mendel 1964; Harper 1964, 1966; Climer 1967, 1975; Fenton 1967, 1969, 1971; Dillow 1971, 1973; Walters 1975; Thauberger 1976; Mendel 1977; Bell 1980; Christie 1980; Bingham 1981; Borsa 1983; Reid 1988; Marsh 1988; Lerner 1991.

SASSEVILLE, FRANCOIS (1797-1864), Québec City, QC. Silversmith. Sasseville succeeded LAURENT AMIOT, to whom he had been apprenticed. **Citations**: Traquair 1940; Langdon 1960, 1966, 1968; NGC 1982; Lerner 1991.

SASSEVILLE, JOSEPH (1776-1831), Québec City, QC. Silversmith. **Citations**: Traquair 1940; Langdon 1960, 1966, 1968; Lerner 1991.

SAUVE, ARTHUR (1896-1973), Maxville, ON. Sculptor. Sauvé returned from World War 1 in poor health, and had to supplement his small pension by carving picture frames and handles for axes and hammers. This resulted in rapid growth of his skill in carving wood at a much earlier age than most naïve artists, and he soon advanced to carving musical instruments, such as guitars, violins and mandolins. Sauve's whirligigs include wind-driven motorcycles and bicycles with jointed-limb riders. He made several expressive crucifixes for members of his family. J. Russell Harper commented: "Arthur Sauvé's figures of musicians at the Highland Games recall the carefree outpourings of the bagpipes with all the country and ethnic qualities analogous to FOLK ART." **Citations**: *Upper Canadian* 1983; CCFCS; McKendry 1983, 1984, 1988; Kobayashi 1985(2).

SAVAGE, ANNE (ANNIE) DOUGLAS (1896-1971), Montréal, QC. Painter and teacher. She studied under WILLIAM BRYMNER and MAURICE CULLEN and was a friend of A.Y. JACKSON. Savage was a member of the BEAVER HALL GROUP and a founding member of the CANADIAN GROUP OF PAINTERS. Her work is represented in the NATIONAL GALLERY OF CANADA. **Citations**: CGP 1933; Colgate 1943; McInnes 1950; Jackson 1958; Hubbard 1960; Harper 1966; Mellen 1970; Duval 1972; Barbeau 1973(1); Andrus 1974; Housser 1974; Ayre 1977; McDougall 1977; Firestone 1979; NGC 1982; Burnett/Schiff 1983; Marsh 1988; Reid 1988; Lerner 1991; Tippett 1992; Hill 1995; McMann 1997.

SAVARD, NAPOLEON (1870-1962), Montréal, QC. Illustrator for newspapers. **Citations**: Laliberté 1986.

SAWYER, WILLIAM (1820-89), Montréal, QC; Kingston, ON. Portrait painter and photographer. Sawyer sometimes based his work on photographs. His paintings became detailed and meticulous as photography began to be used more widely for portraits. He found it necessary to advise the public that "Mr. Sawyer desires it to be particularly understood that his portraits are veritable oil paintings, painted by the hand directly on to the canvas and not a photograph of the person faintly taken on the canvas and then painted thinly over as is so frequently done by inferior artists and palmed off as genuine oil portraits." (see Montréal *Gazette*, 24 January 1872.) He was, on the other hand, a talented and innovative photographer. A portrait by Sawyer is in the NATIONAL GALLERY OF CANADA. **Citations**: *Canadian Illustrated News* 1872; Hubbard 1960; Harper 1964, 1966 1970; Thomas 1972, 1979; Stewart 1973; Bell 1978; Reid 1979, 1988; McKendry 1979(Photography), 1988; NGC 1982; Farr 1988; Lerner 1991; McMann 1997.

SCALE. Scale means literally a graduated series of values. With reference to paintings, the term is usually used to refer to the relative size of one object shown in a painting to that of another. See HIERARCHICAL SCALE; REVERSE SCALE. **Citations**: Pierce 1987.

SCANDINAVIAN ART SHOW. This was a show held in Buffalo, N.Y., in 1913 of 163 paintings by artists from Scandinavian countries. J.E.H. MACDONALD and LAWREN HARRIS went to see the

show and were so impressed with the way the Scandinavians painted the rugged landscape of their countries, that the Canadian artists were reinforced in their resolve to paint the Canadian landscape in the bold and vigorous manner later used by the GROUP OF SEVEN. (See Mellen 1970 pl. 1-5 for illustrations of some of the Scandinavian paintings.) **Citations**: Osborne 1970; Mellen 1970; Lord 1974; Housser 1974; Murray 1996(1).

SCHAEFER, CARL FELLMAN (b1903), Hanover and Toronto, ON. Painter, watercolourist and teacher; RCA 1965. He studied with ARTHUR LISMER and J.E.H. MACDONALD. For a time Schaefer taught art at the CENTRAL TECHNICAL SCHOOL and the ONTARIO COLLEGE OF ART in Toronto. Some of his best work is of the countryside around Hanover in Grey County and of neighbouring counties. Several of his paintings are in the NATIONAL GALLERY OF CANADA. **Citations**: Robson 1932; Colgate 1943; McInnes 1950; Buchanan 1950; Duval 1954, 1972; Jackson 1958; Hubbard 1960, 1960(1); Harper 1966, 1969; Johnston 1969; Lord 1974; Gray 1977; Robertson 1977; Tovell 1980; Sisler 1980; NGC 1982;Burnett/Schiff 1983; Reid 1988; Marsh 1988; Farr 1988; Lerner 1991; Tippett 1992; Hill 1995; Silcox 1996; McMann 1997.

SCHINDLER, JOSEPH (JONAS) (act. 1730-92), Québec City, QC. Silversmith. MICHEL FORTON was apprenticed to Schindler. **Citations**: Traquair 1940; Langdon 1960, 1966, 1968; Lerner 1991.

SCHIPPER, GERRITT (1770-1825), USA and Québec. Painter; portraitist. Schipper, who was born in Amsterdam, studied painting in Paris and went to the USA in 1803. He was in Québec in 1807 and 1810, and in Montréal in 1809-11. Schipper is known mostly for his pastel miniatures. There has been some confusion between profile portraits painted by Schipper and those painted by WILLIAM BERCZY Senior, when both artists were in Montréal 1809-11 (see Andre 1967). **Citations**: Andre 1967; Harper 1970; Tovell 1991.

SCHONBERGER, FRED (b1930), Kingston, ON. Painter, printmaker and sculptor. Schonberger , an emigrant from Holland in 1957, settled in Kingston in 1962. **Citations**: NGC 1982; Farr 1988.

SCHOOL. Artists who work in a similar STYLE may be said to belong to the same school of art. The term is sometimes applied to artists working in the same city or country. **Citations**: Pierce 1987; Piper 1988.

SCHREIBER, CHARLOTTE MOUNT BROCK MORRELL (1834-1922), Toronto, ON. Painter and illustrator; OSA 1876; RCA 1880. Schreiber emigrated to Canada from England in 1875 and returned to her homeland in 1899. Schreiber was the first woman painter to be a member of the ROYAL CANADIAN ACADEMY. Her work is represented in the NATIONAL GALLERY OF CANADA. **Citations**: MacTavish 1925; Robson 1932; Colgate 1943; Hubbard 1960; Sisler 1980; NGC 1982; Marsh 1988; Lerner 1991;Tippett 1992; Hill 1995; McMann 1997.

SCHRODER, C. (SCHROEDER G.) (act. 1811-31), New York; Québec City and Montréal, QC. Painter; portraitist. Schroder was an ITINERANT painter of MINIATURES who visited Québec City and Montréal in 1819 and 1830-1. **Citations**: Harper 1966, 1970; McKendry 1988.

SCIENTIFIC PERSPECTIVE. See GEOMETRIC PERSPECTIVE.

SCOTT, ADAM SHERRIFF (1887-1980), Montréal, QC. Painter; portraitist; MURALIST; teacher; RCA 1942. Scott studied in Scotland and England. In 1911 or 1912, he went to western Canada and later moved to Montréal, where he established his own art school. Examples of his work are in the NATIONAL GALLERY OF CANADA. **Citations**: MacTavish 1925; Hubbard 1960; Laurette 1978; Sisler 1980; NGC 1982; Laliberté 1986; Reid 1988; Lerner 1991; Hill 1995; McMann 1997.

SCOTT, CHARLES HEPBURN (1886-1964), Calgary, AB; Vancouver, BC. Painter and teacher. Scott was in Calgary 1912-14 and, after 1919, was in Vancouver as director of the Vancouver School of Art. He painted powerful landscapes in the mountains and along the coast (see Render 1974, pl. 83-86). **Citations**: Robson 1932; Colgate 1943; Harper 1966; Render 1974; Sisler 1980; NGC 1982; Reid 1988; Lerner 1991; Hill 1995; McMann 1997.

SCOTT, LOUISE (b1937), Montréal, QC. Painter. **Citations**: NGC 1982; Tippett 1992.

SCOTT, MARIAN MILDRED DALE (b1906), Montréal, QC. Painter and MURALIST; RCA 1975.

Scott exhibited in exhibitions organized by JOHN LYMAN. She was a contemporary of the GROUP OF SEVEN artists but her attention was directed to city themes and abstraction. She joined the CONTEMPORARY ARTS SOCIETY in 1939. Examples of her work are in the NATIONAL GALLERY OF CANADA. **Citations**: Jackson 1958; Hubbard 1960; Duval 1972; Sisler 1980; NGC 1982; Burnett/Schiff 1983; Marsh 1988; Lerner 1991; Tippett 1992; McMann 1997.

SCRIMSHAW. Scrimshaw is an art of carving or engraving, usually on the surface of bone or ivory. It was popular among the crews of whaling ships and the Inuit people in the Arctic. **Citations**: Patterson 1973; Lerner 1991.

SCULPTORS' SOCIETY OF BRITISH COLUMBIA. The society was founded in 1974 and had 22 members. **Citations**: BC Sculptors 1976; Lerner 1991.

SCULPTORS' SOCIETY OF CANADA. The society, founded in 1928, was effective in improving the quality of Canadian sculpture. ALFRED LALIBERTE and EMANUEL HAHN were among the founding members. **Citations**: Colgate 1943; McInnes 1950; Sculptors 1978; Lerner 1991; Tippett 1992.

SCULPTURE. Sculpture is the art of creating figures or objects in relief or in the round, or it refers to the object created. (For an overview of sculpture in Canada, see Marsh 1988, Burnett/Schiff 1983, pp. 141-58, 213-46; McInnes 1950, ch. XII; and Colgate 1943, ch. 13.) Canadian sculptors include: LOUIS-PHILIPPE HEBERT, JEAN and PIERRE LEVASSEUR, NOEL LEVASSEUR, FRANCOIS BAILLAIRGE, LOUIS QUEVILLON, JEAN-BAPTISTE COTE, LOUIS JOBIN, NAPOLEON BOURASSA, EMANUEL OTTO HAHN, ELIZABETH WYN WOOD, FRANCES NORMA LORING, R.TAIT MCKENZIE, ALFRED LALIBERTE, MARC-AURELE de FOY SUZOR-COTE, FLORENCE WYLE, KOSSO ELOUL, WALTER REDINGER, MICHAEL SNOW, YVES TRUDEAU, ELI BORNSTEIN, DOUGLAS BENTHAM, TED BIELER, SOREL ETROG, and many more. (See ASSEMBLAGE; CONSTRUCTION; BUST; EARTH ART; FOUND OBJECTS; RELIEF SCULPTURE; SOFT SCULPTURE; SCULPTORS' SOCIETY OF CANADA; SCULPTORS' SOCIETY OF BRITISH COLUMBIA.) **Citations**: Colgate 1943; McRae 1944; McInnes 1950; Hubbard 1960, 1960(1); BC Sculptors 1976; Mellen 1978; Sculptors 1978; Bringhurst 1983; Burnett/Schiff 1983; NMM 1983; McKendry 1983; Pierce 1987, Murray 1988; Piper 1988; Marsh 1988; Lerner 1991.

SEATH, ETHEL (1878-1963), Montréal, QC. Painter, illustrator and art teacher. Seath studied with EDMOND DYONNET, WILLIAM BRYMNER and MAURICE CULLEN, as well as in the USA. She was a member of the CANADIAN GROUP OF PAINTERS, and a friend of ANNE SAVAGE. Seath's work is represented in the NATIONAL GALLERY OF CANADA. **Citations**: CGP 1933; Hubbard 1960; 1960; Duval 1972; NGC 1982; Lerner 1991; Tippett 1992; Hill 1995; McMann 1997.

SEAVEY, JULIEN RUGGLES (1857-1940), Hamilton, ON. Painter, illustrator and art teacher. Seavey's work included landscape, TROMPE L'OEIL, historical and flower paintings. **Citations**: Seavey 1897; Harper 1966, 1970; Allodi 1974; Duval 1974; Orobetz 1977; NGC 1982; McKendry 1988; Lerner 1991.

SECOND EMPIRE. See EMPIRE.

SECONDARY COLOURS. See PRIMARY COLOURS.

SECCO. An Italian term meaning dry, secco describes a technique of wall-painting, in which TEMPERA or casein colours are applied to dry lime plaster. **Citations**: Osborne 1970; Mayer 1970; Piper 1988.

SEIDEN, REGINA. See REGINA SEIDEN GOLDBERG.

SELF-PORTRAIT. Self-portraits became particularly important from the RENAISSANCE on; sometimes the artist's work, or the artist-at-work, is shown. In Canada, in 1609, a drawing made by SAMUEL DE CHAMPLAIN shows himself firing his arquebus at an Iroquois chief. A native painter, ZACHARIE VINCENT, painted several self-portraits (see Harper 1966, pl. 80). See McKendry 1983, pl. 141, for a self-portrait by a naïve artist, and pl. 58 for one by LOUIS JOBIN. See PORTRAITURE. **Citations**: Morisset 1959; Osborne 1970; McKendry 1983; Lerner 1991.

SENECAL, IRENE (1901-78), Montréal, QC. Painter and professor at the ECOLE DES BEAUX ARTS, Montréal. **Citations**: Levesque 1936; NGC 1982; Lerner 1991; Tippett 1992.

SEPIA. Sepia is a brown pigment of semi-transparent quality used for LINE and WASH drawings. **Citations**: Mayer 1970; Piper 1988.

SERIGRAPHY. Silk-screen printing, also called serigraphy, is a method of colour printing in which separate stencils are used for each colour. Each screen is made of fine-mesh fabric and includes a stencil, around which ink or paint is forced onto a printing surface, usually paper. The area covered by the stencil is left blank. Canadian artists NORVAL MORRISSEAU, JOE DAVID, JANE DRUTZ, MICHAEL FORSTER and FRANK BROOKS have used this technique. **Citations**: Osborne 1970; Mika 1970; Dow 1972; Eichenberg 1976; Piper 1988; Lerner 1991.

SERPENT. A serpent or a dragon was used by early painters, and is still used by naïve artists, to symbolize Satan or evil. (See NMM 1983, pl. 277; Field 1985, pl. 248.) **Citations**: Ferguson 1967; NMM 1983; Field 1985; Pierce 1987.

SETON, ERNEST THOMPSON (1860-1946), Toronto, ON; Manitoba; New Mexico. Writer, painter, illustrator and naturalist. **Citations**: Harper 1970; Redekop 1979; NGC 1982; Marsh 1988; Lerner 1991; McMann 1997.

SHADBOLT, JACK LEONARD (b1909), Vancouver, BC. Painter, author, and teacher. He was influenced by EMILY CARR at an early age and later studied in London, Paris and New York. Shadbolt is a prolific artist who uses colour and abstraction to depict natural subjects and emotional feelings. Some of his paintings are in the NATIONAL GALLERY OF CANADA. **Citations**: Colgate 1943; McInnes 1950; Duval 1954, 1972; McNairn 1959; Hubbard 1960, 1960(1); Harper 1966; Shadbolt 1968, 1973, 1981; Emery 1969; Withrow 1972; Lord 1974; Webster 1975; Heath 1976; Robertson 1977; Fenton 1978; Mellen 1978; Tippett 1979; Thom 1980; NGC 1982; Bringhurst 1983; Burnett/Schiff 1983; Reid 1988; Lerner 1991; McMann 1997.

SHADE. See COLOUR.

SHADING. Shading is the darkening of an area in a painting or drawing to suggest the effect of light. This is not usually done by naïve artists. See SHADOW. **Citations**: Pierce 1987.

SHADOW. Use of shadows in a painting creates a spatial effect and to some degree avoids flatness. Naïve artists rarely include shadows in their compositions thus accentuating the flat effect which may be present through lack of, or inept use of, perspective (see McKendry 1983, pl. 57). ACADEMIC artists traditionally added black or gray to shadows, but the IMPRESSIONISTS challenged this by the use of COMPLEMENTARY colours. **Citations**: McKendry 1983; Pierce 1987.

SHADOW BOX. A shadow box is a box which is open, or glazed, at the front, and in which a work of art or craft is displayed and protected. If the box is deep and contains sculptural forms, the light entering only from the front may cast shadows of the forms thereby adding interest to the work. Folk artists are fond of this format.

SHAMAN. This person who needed carvings and costumes for ceremonies, helped native people to understand the transformations and journies of the spirit. The Shaman had many associated symbols, for example on the Northwest coast the mountain goat could leap across chasms just as the Shaman could leap from human form to nonhuman. Male and female Shamans were important to the Inuit of the Canadian Arctic, and often wore MASKS during rites. See also NATIVE ART OF CANADA.

SHANLY, CHARLES DAWSON (1811-75), Montréal, QC. Painter. Shanly's work included TOPOGRAPHICAL landscape paintings in watercolour, naïve drawings with figures, winter scenes, views of Kingston and of Montréal. He was the grandfather of CHARLES DAWSON SHANLY (1871-87), CUTHBERT WILLIAM SHANLY and FRANCIS JAMES SHANLY. **Citations**: Harper 1970; Allodi 1974; *Canadian Antiques and Art Review* 1979; McKendry 1988; Lerner 1991.

SHANLY, CHARLES DAWSON (1871-87), Toronto, ON. Painter. Shanly is known for sketches relating to horse racing in England and Ontario. He was a grandson of CHARLES DAWSON SHANLY (1811-75). **Citations**: Allodi 1974; McKendry 1988.

187

SHANLY, CUTHBERT WILLIAM (1859-82), Toronto, ON. Painter. His work includes naïve landscape paintings in water-colour as well as portrait and figure drawings in pencil. He was a grandson of CHARLES DAWSON SHANLY (1811-75). **Citations**: Allodi 1974; McKendry 1988.

SHANLY, FRANCIS JAMES (1857-77), Toronto, ON. Painter. His work includes sketches in watercolour, ink or pencil relating to hunting and horse racing. He was a grandson of CHARLES DAWSON SHANLY (1811-75). **Citations**: Allodi 1974; McKendry 1988.

SHARON TEMPLE. See RICHARD COATES.

SHARPE COLLECTION. See CANADIAN CENTRE FOR FOLK CULTURE STUDIES.

SHARPE, EDWARD (act. 1870), Montréal, QC. Painter. For a time, Sharpe worked with the photographer WILLIAM NOTMAN. **Citations**: Harper 1967, 1970; NGC 1982; Cavell 1988; McKendry 1988.

SHAUGHNESSY, ARTHUR (1884-1945), Victoria, BC. Sculptor in wood. Shaughnessy was a sculptor of totem poles and other work based on Northwest Coast native legends. He was a native Kwakiutl artist and, for a time, taught HENRY HUNT. **Citations**: McKendry 1988, Lerner 1991.

SHELDON-WILLIAMS, INGLIS (1870-1940), Regina, SK. Painter. Sheldon-Williams emigrated from England to Saskatchewan at age 16. See Harper 1966, pl. 317, for an illustration of his work. **Citations**: Harper 1966; Hogarth 1972; Christie 1980; NGC 1982; Reid 1988; Lerner 1991; McMann 1997.

SHELTON, MARGARET DOROTHY (1915-84), Calgary, AB. Painter. Shelton studied painting under H.G. GLYDE and W.J. PHILLIPS. **Citations**: NGC 1982; Masters 1987; Tippett 1992.

SHEPHERD, HELEN PARSONS (b1923), St John's, NF. Painter and art teacher. Shepherd is a portraitist and co-founder with her husband REGINALD SHEPHERD of the NEWFOUNDLAND ACADEMY OF ART in St John's. **Citations**: Smallwood 1967; Sisler 1980; NGC 1982; Lerner 1991; Tippett 1992; McMann 1997.

SHEPHERD, REGINALD SHIRLEY MOORE (b1924), St John's, NF. Painter and art teacher. He and his wife HELEN PARSONS founded the NEWFOUNDLAND ACADEMY OF ART in St John's. **Citations**: Smallwood 1967; Sisler 1980; NGC 1982; McMann 1997.

SHERMAN, TOM (b1947), Ontario. Sculptor and VIDEO artist. **Citations**: Gale 1977; Ferguson 1980; NGC 1982; Lerner 1991.

SHINK, JOSEPH (1884-1963), Beaumont, QC. Sculptor. Shink sculpted naïve human figures, birds, animals, and religious figures in POLYCHROMED wood. His human figure carvings have strong features with protruding, staring eyes (see McKendry 1983, pl. 33). **Citations**: Lessard 1975; Latour 1975; McKendry 1983, 1988.

SHIPCARVINGS. In the 18th and 19th centuries, the building of sailing ships with wooden hulls flourished in Québec and the eastern Maritime Provinces. This created a demand for shipcarvings such as figureheads and billetheads to be mounted below the bowsprits, as well as for decorative and symbolic carvings for the stern, and decorative nameboards. This work became redundant when sailing ships were replaced by steamers with steel hulls in the late 1800s. The few shipcarvings that have survived show that Canadian woodcarvers filled the need with distinction. Among the Canadian artists who executed shipcarvings are LOUIS JOBIN, JEAN-BAPTISTE COTE, and JOHN ROGERSON. For examples of shipcarvings see Harper 1973, pl. 41, 110; Armour 1975, p. 71; McKendry 1983, pl. 55; and Field 1985, pl. VII, VIII, 102, 104, 105, 106. For a brief history of shipbuilding in Canada, see Marsh 1988. See also FOLK ART. **Citations**: Fried 1920; Harper 1973; Armour 1975; McKendry 1983; Field 1985; Béland 1986; Marsh 1988; Lerner 1991.

SHIP FIGUREHEADS. See SHIPCARVINGS.

SHORE, HENRIETTA MARY (1880-1963), Toronto, ON. Painter and printmaker. After teaching in Toronto, she moved to the USA in the early 1900s. **Citations**: Armitage 1933; NGC 1982; Lerner 1991; Tippett 1992; McMann 1997.

SHORT, RICHARD (act. 1759-61), Québec City, QC; Halifax, NS. Painter. Short was with the Royal

Navy and made TOPOGRAPHICAL landscape views of Québec City and Halifax. These were published in London as ENGRAVINGS in 1761. Short sketched many buildings in Québec City and Halifax. **Citations:**Robson 1932; Colgate 1943; McInnes 1950; Spendlove 1958; Harper 1966, 1970; de Volpi 1971, 1974; Cooke 1983; McKendry 1988; Reid 1988; Lerner 1991.

SHOW TOWEL. Show towels are a form of naïve MENNONITE art or craft made by embroidering textiles, usually linen, in cross or chain-stitch in traditional FOLK ART designs. See McKendry 1983, pl. 147, for an illustration of a show towel. **Citations:** Bird 1981; McKendry 1983.

SHRAPNEL, EDWARD SCROPE (act. 1876, d1920), Orillia and Toronto, ON; Victoria, BC. Painter. Shrapnel painted landscapes, GENRE and still-life. His work includes views of the Muskoka region, ON, and of British Columbia. Shrapnel often included animals or native people in his paintings and sometimes painted winter landscapes in the manner of CORNELIUS KRIEGHOFF. He was a son of HENRY NEEDHAM SHRAPNEL. **Citations:** Harper 1970; Allodi 1974; Sisler 1980; Gilmore 1980; NGC 1982; McKendry 1988; McMann 1997.

SHRAPNEL, HENRY NEEDHAM (1812-96), Orillia, ON. Artist. He was the father of EDWARD SCROPE SHRAPNEL, and was thought to have artistic talent. After serving with the British army, Shrapnel returned to Canada about 1860 and lived near Orillia. **Citations:** Harper 1970; McKendry 1988.

SICOTTE, ROLANDE (act. 1936), Québec. Artist. **Citations:** Levesque 1936; Lerner 1991.

SIGMUND SAMUEL COLLECTION. See ROYAL ONTARIO MUSEUM.

SILHOUETTES. Silhouettes were popular in the 19th century, and many portrait artists provided them at a reasonable price. Usually silhouettes were black profiles of the upper body and head, cut from paper, sometimes touched up with gold. Some were cut from black paper with scissors, while others were produced by mechanical means in a darkened room using a candle to cast a shadow of the sitter on a transparent screen. A tracing of the shadow could then be reduced in size using a PANTOGRAPH (see Harper 1966, pp. 115-19). **Citations:** Harper 1966; Osborne 1970; McKendry 1983; Lerner 1991.

SILK-SCREEN PRINTING. See SERIGRAPHY.

SILVER, FRANCIS (FRANCIE) (1841-1920), Hantsport, NS. Painter, MURALIST and CARTOON-IST. Silver (originally da Silva) emigrated from Portugal to Nova Scotia in 1861 and, after some years spent at sea, he became caretaker of the Churchill estate at Hantsport. In his spare time, he painted his impressions of religion, local scenery, and politics, both local and international, on canvas (sail cloth), wooden panels, and the walls of the Churchill basement and carriage house. Many of Silver's pictures, caricatures and cartoons include captions, in large lettering, to make certain the viewer understands the artist's opinions. Silver lacked ability to handle perspective and scale, but did leave many detailed, graphic paintings that, like all good FOLK ART, communicate the artist's views, and even his daydreams. **Citations:** Riordon 1982; Greenaway 1986; McKendry 1988.

SILVER POINT. See METAL POINT.

SILVERSMITHING. A highly appreciated category of the DECORATIVE ARTS, silversmithing in QUEBEC responded to various French styles such as BAROQUE, ROCOCO, and NEOCLASSICAL, as well as the REVIVALS of the 19th century. Ecclesiastical pieces and domestic tableware were in demand from such smiths as LAURENT AMIOT, PETER and GEORGE BOHLE, SALOMON MAR-ION, MICHEL FORTON, Paul Lambert (1691-1749), Jean-François Landron (1686-1744), Jacques Pagé (1686-1742), Roland Paradis (1696-1754), Ignace-François Delezenne (1717-90), Ignace François Ranvoyzé (1739-1819), FRANCOIS and JOSEPH SASSEVILLE. See also CIBORIUM, RELIQUARY, MONSTRANCE, ALTAR, TABERNACLE. **Citations:** Traquair 1940; Langdon 1960, 1966, 1968; NGC 1982.

SIMCOE, ELIZABETH POSTHUMA GWILLIM (1766-1850), England; Toronto, ON. Painter and diarist. Elizabeth Posthuma Gwillim Simcoe was the wife of John Graves Simcoe, the first Lieutenant Governor of Upper Canada, 1792-96. She was an amateur artist who made many TOPOGRAPHICAL landscape and GENRE watercolour paintings and line drawings of Ontario and Québec scenes. Ninety

sketches by Mrs Simcoe were published in Robertson's 1911 edition of *The Diary of Mrs. John Graves Simcoe* (Toronto: William Briggs). **Citations**: Robertson 1911; Harper 1970; Orobetz 1977; *Canadian Antiques and Art Review* 1980; NGC 1982; McKendry 1988; Marsh 1988; Lerner 1991.

SIMON, BLANCHE. See RENE-JEAN RICHARD.

SIMPSON, CHARLES WALTER (1878-1942), Montréal, QC; Halifax, NS. Painter and illustrator; RCA 1920. Simpson studied under WILLIAM BRYMNER, EDMOND DYONNET and MAURICE CULLEN, and was encouraged by HENRI JULIEN. Several paintings by Simpson are in the NATIONAL GALLERY OF CANADA. **Citations**: Smith 1928; Chauvin 1928; Hale 1933; Colgate 1943; Hubbard 1960; Harper 1966; Sisler 1980; NGC 1982; Laliberté 1986; Lerner 1991; McMann 1997.

SINCLAIR, ROBERT WILLIAM (b1939), Alberta. Painter, sculptor and art teacher. Sinclair minimizes the elements in his western landscape paintings and sculptures leaving blank areas to the viewer's imagination (see Render 1974, pl. 194-8). **Citations**: Render 1974; Swain 1976; Sisler 1980; NGC 1982; Marsh 1988; Lerner 1991. McMann 1997.

SINGER, JUDY (b1951), Toronto, ON. Painter. **Citations**: Carpenter 1981; NGC 1982

SISLER, REBECCA JEAN (b1932), Ontario. Sculptor and author; RCA 1979. **Citations**: Outram 1978; Sisler 1972, 1980; NGC 1982; Lerner 1991; McMann 1997.

SIZE. Size is a painting term for gelatine or glue used for filling the porous surface of panels or canvases to provide a foundation for PRIMING or PAINT. **Citations**: Osborne 1970; Mayer 1970; Chilvers 1988; Piper 1988.

SKETCH (SKETCHBOOK). A sketch is a rough drawing usually intended as a basis for a finished drawing or painting; sometimes called a STUDY. Traditional ACADEMIC ART stressed the need for careful studies before applying paint to canvas in the studio. This was challenged by artists who worked in PLEIN AIR such as the IMPRESSIONISTS. **Citations**: Osborne 1970; Chilvers 1988; Piper 1988; Lerner 1991.

SKINNER, SI ANGELO (act. 1940s), Newfoundland. Painter. **Citations**: IBM 1940; NGC 1982; Lerner 1991.

SKINNER, THOMAS (act. 1792), Newfoundland. Painter. In 1792 Skinner painted a watercolour of an iceberg off St John's, NF. **Citations**: Harper 1964.

SKULL. A skull may be used in art to symbolize the transitory nature of life on earth. **Citations**: Ferguson 1967; Pierce 1987.

SLACK, CRAWFORD CHELSON (act. c1900), Athens, ON. Painter. Slack was a carriage maker who wrote music and painted rural scenes in his spare time. Untrained as a painter, his work is naïve. He completed many attractive paintings: some are in the town hall in Athens. **Citations**: Harper 1970; McKendry 1983, 1988.

SLEEP, JOSEPH (1914-78), Halifax, NS. Painter. Sleep produced many naïve decorative paintings in acrylic, latex or ink, of fish, animals, birds, flowers and ships. In 1973, while in the Halifax Infirmary, he started painting: "They gave me posters to colour and I started drawing my own and I aint stopped since. Done about 500 pictures this year [1977-8]." He used flat patterns of bright colour, usually filling all available space, while enclosing the design in a decorative border of fish or flowers. In many cases, he used stencils or templates for drawing the numerous repeated forms in his compositions. **Citations**: Elwood 1976; Ferguson 1981; NGC 1982; NMM 1983; McKendry 1983, 1988; Kobayashi 1985(2); Bihalji-Merin 1985; Lerner 1991.

SLOAN, JOHN (1890-1970), Hamilton, ON. Painter and sculptor. He taught at the Hamilton Technical Institute. **Citations**: Sisler 1980; NGC 1982; McMann 1997.

SMILLIE, JAMES (1807-85), Québec City, QC. ENGRAVER. Smillie apprenticed in his birthplace, Edinburgh, Scotland, and emigrated to Canada in 1821. After 1830 he worked in the USA but visited Montréal and Québec City from time to time. In 1882 he completed his autobiography *A Pilgrimage* (published in Allodi 1989, along with illustrations of many examples of his work.) He was the first ENGRAVER in Québec City. **Citations**: Spendlove 1958; Harper 1970; Porter 1978; Allodi 1980,

1989; Moritz 1982; Cooke 1983; Béland 1992.

SMITH, EDITH AGNES (1867-1954), Halifax, NS. Painter, portraitist and art teacher. Smith taught art at the Halifax Ladies College, and was active. in the NOVA SCOTIA SOCIETY OF ARTISTS. **Citations**: NSA 1923; Harper 1970; NGC 1982; Lerner 1991; Tippett 1992; McMann 1997.

SMITH, G. (act. c1840), Saint John, NB. Painter. Smith is known for a well executed drawing , engraved c1840, of a steam mill, wharfs and shipping at Saint John (see Armour 1975, p. 46). **Citations**: Armour 1975; McKendry 1988.

SMITH, GORDON APPELBE (b1919), Vancouver, BC. Painter, printmaker, MURALIST and teacher; RCA 1967. Smith studied painting in Winnipeg under LEMOINE FITZGERALD and later moved to Vancouver. He paints ABSTRACT landscapes: examples are in the NATIONAL GALLERY OF CANADA. **Citations**: McNairn 1959; Hubbard 1960; Harper 1966; Duval 1972; Lord 1974; Rombout 1976; Sisler 1980; NGC 1982; Burnett/Schiff 1983; Bringhurst 1983; Reid 1988; Marsh 1988; Lerner 1991; McMann 1997.

SMITH, GORDON (GORD) HAMMOND (b1937), Montréal, QC. Sculptor. **Citations**: Waddington 1972; Sisler 1980; NGC 1982; Lerner 1991; McMann 1997.

SMITH, HENRY WALTER (b1917), Hamilton and Toronto, ON. Painter and MURALIST. Smith has painted landscapes in the Hamilton and Laurentian areas. He studied under HORTENSE M. GORDON and JOHN SLOAN, and his work is represented in the NATIONAL GALLERY OF CANADA. **Citations**: Hubbard 1960; NGC 1982; McMann 1997.

SMITH, JAMES AVON (1832-1918), Painter and architect; RCA 1880. Smith emigrated from Scotland to Canada in 1851, and studied architecture in Toronto. In 1875 Smith and Gemmell designed Knox College, Spadina Crescent, Toronto. **Citations**: MacTavish 1925; Robson 1932; Colgate 1943; Harper 1970; Sisler 1980; NGC 1982; McMann 1997.

SMITH, JEREMY (b1946), Ontario. Painter. His work is realistic and is described in Duval 1974, pp. 160-9. **Citations**: Duval 1974; NGC 1982; Lerner 1991.

SMITH, JOHN MEREDITH. See JOHN MEREDITH.

SMITH, M. (act1807), Halifax, NS. Artist and art teacher. **Citations**: Tippett 1992.

SMITH, MARJORIE (JORI) THURSTON (b1907), Montréal, QC. Painter. Smith studied painting under RANDOLPH HEWTON and others, as well as in England and France. She is the wife of JEAN PALARDY. **Citations**: McInnes 1950; Hubbard 1960; Duval 1972; Fenton 1978; Baker 1981; NGC 1982; Reid 1988; Lerner 1991; Tippett 1992.

SMITH, WILLIAM (ST THOMAS) (1862-1947), St Thomas, ON. Painter. Smith was a landscape and marine painter. He emigrated to Canada from Scotland in 1869, and was in St Thomas from 1887. He was given the name St Thomas to distinguish him from another William Smith. His work is represented in the NATIONAL GALLERY OF CANADA. **Citations**: MacTavish 1925; Robson 1932; Colgate 1943; Hubbard 1960; London 1978; Sisler 1980; NGC 1982; Lerner 1991; McMann 1997.

SMITH, WILLIAM RONALD. See WILLIAM RONALD.

SMYTH (SMITH), HERVEY (1734-1811), England; Québec. Painter. Smyth fought at Louisbourg in 1758, and served as a captain and aide-de-camp to General James Wolfe, leader of the British expedition against Québec in 1759. He painted a portrait of Wolfe and a series of drawings and paintings of Canadian views, six of which were engraved and published. **Citations**: Stokes 1933; Jefferys 1948; Spendlove 1958; Hubbard 1960; Harper 1964, 1966, 1970; Thibault 1978; NGC 1982; Lerner 1991.

SMYTH, JOHN RICHARD COKE (1808-82), Québec City, QC. Painter. In 1838 Smyth was a member of the staff of Canada's newly appointed Governor General, the Earl of Durham, and toured Upper and Lower Canada with Durham. Smyth returned to England and, in 1840, published 23 LITHOGRAPHS in an album *Sketches in the Canadas*. Some of his pencil sketches have had the signature "W.H. Bartlett" or "WHB" added to them, see WILLIAM HENRY BARTLETT. **Citations**: Smyth 1840; Jefferys 1948; Spendlove 1958; Harper 1970; Allodi 1974; NGC 1982; Cooke 1983; McKendry 1988; Lerner 1991; Béland 1992.

SNAKE. See SERPENT.

SNIDER, GREGORY (GREG) (b1945), Victoria, BC. Sculptor. **Citations**: Heath 1976; NGC 1982; Lerner 1991.

SNOW, MICHAEL JAMES ALECK (b1929), Toronto, ON. Painter, sculptor, photographer, musician and filmmaker. Snow studied at the ONTARIO COLLEGE OF ART 1948-52, and traveled in Europe 1953-54. He lived in New York 1964-72 and then returned to Toronto. His experimental films have received a good deal of international attention, as did his 1961-67 work in all media based on the silhouette of a young woman, known as the *Walking Woman Works*. Snow was a member of the ARTISTS' JAZZ BAND and is married to JOYCE WIELAND. **Citations**: Boggs 1971; Duval 1972; Withrow 1972; Mellen 1978; Fenton 1978; Theberge 1979; Sisler 1980; Osborne 1981; Guest 1981; NGC 1982; Burnett/Schiff 1983; Bringhurst 1983; Reid 1988, 1994; Marsh 1988; Lerner 1991; Tippett 1992; Murray 1996(1); McMann 1997.

SNOWIE, ALLAN (b1922), Edmonton, AB. Sculptor. Snowie carved naïve sculptures of birds, toys and a full scale bicycle. **Citations**: Kobayashi 1985 (2); McKendry 1988.

SOAPSTONE. Soapstone, sometimes called steatite, is a smooth soft stone superficially resembling marble but with a soapy texture. It is easily worked with a knife, file or saw, and may be greenish, bluish gray or brown in colour. soapstone has been, and is still being, used for sculpture by Canadian native people, particularly the INUIT. JAMES A. HOUSTON encouraged Inuits to produce soapstone carving in 1948-49 and arranged for its sale in Southern Canada. **Citations**: Swinton 1968; Osborne 1970; Inuit 1971; Patterson 1973; Wight 1987; Chilvers 1988.

SOCIAL-HISTORY ARTIFACTS. See FOLK-LORE ARTIFACTS.

SOCIETE DES ARTS. This Society was founded in Montréal in 1955 to publish the French-language art magazine *Vie des Arts*. **Citations**: Lerner 1991.

SOCIETY OF ARTISTS AND AMATEURS OF TORONTO. This was Ontario's first official art society. In 1834, this Society of artists mounted an exhibition of 196 works at the Parliament Buildings in Toronto. PAUL KANE was included, along with seventeen other artists. By 1847 the artists regrouped as the Toronto Society of Arts. **Citations**: SAA 1834; TSA 1847; Hopkins 1898; Colgate 1943; McInnes 1950; Reid 1979, 1988; Sisler 1980; Lerner 1991; Tippett 1992.

SOCIETY OF ARTS. This was a 19th century Montréal society of artists that was in existence as early as 1826. **Citations**: Colgate 1943; McInnes 1950.

SOCIETY OF CANADIAN ARTISTS. The Society was founded in Montréal in 1867 with the support of CORNELIUS KRIEGHOFF; the first president was JOHN BELL-SMITH. The charter members included OTTO JACOBI, WILLIAM RAPHAEL, and ADOLPHE VOGT. The Society held its last exhibition in 1872. **Citations**: Colgate 1943; Harper 1966; Lord 1974; Reid 1979, 1988; Sisler 1980; Lerner 1991.

SOCIETY OF CANADIAN PAINTERS-ETCHERS AND ENGRAVERS. This society of artists was founded in 1916 in Toronto. The first president was WILLIAM JAMES THOMSON. In 1976 the Society merged with the CANADIAN SOCIETY OF GRAPHIC ART to form the PRINT AND DRAWING COUNCIL OF CANADA. **Citations**: Society 1930; Colgate 1943; Oko 1981; Lerner 1991; Tippett 1992.

SOCIETY OF GRAPHIC ART. See SOCIETY OF CANADIAN PAINTERS-ETCHERS, and CANADIAN SOCIETY OF GRAPHIC ART.

SOFT SCULPTURE. Soft sculpture is formed of non-rigid materials such as cloth, rubber or batting rather than traditional hard materials such as wood. The folk artist ALMA BALDWIN used wire, batting, nylon stockings and other clothing, cosmetics and human hair to form large, naïve, soft sculptures caricaturing people she knew or observed. **Citations**: Pierce 1987; Chilvers 1988.

SOLOMON, DANIEL (b1945), Toronto, ON. Painter and MURALIST. **Citations**: Wilkin 1974; Webster 1977; NGC 1982; Lerner 1991.

SOMERVILLE, MARTIN (act. 1839-56), Montréal, QC. Painter. In 1847, Somerville and COR-

NELIUS KRIEGHOFF had studios in the same building in Montréal and sometimes had joint exhibitions. Krieghoff imitated some of Somerville's work such as Indian moccasin or basket sellers in winter landscapes. **Citations**: Harper 1966, 1970, 1979; Carter 1967; Allodi 1974; McKendry 1988.

SOMMERS (SOMMES or SOMMS), ROBERT KARL (1908-87), Sunbury, ON. Painter. Sommers painted many naïve portrait, landscape, interior and figure paintings. His most interesting work may be a series of masks, 1961-2, RELIEF-carved on wooden panels, and painted in bright colours with the addition of many small found objects such as tacks, buttons, ceramic tiles and marbles (see article by Blake McKendry, *Upper Canadian*, Jan/Feb 1984, pp.21-3). **Citations**: *Upper Canadian;* McKendry 1988.

SOUCY, JOSEPH ALFRED ELZEAR (1876-1970), Montréal, QC. Sculptor. Soucy studied with ARTHUR VINCENT and worked with GEORGE HILL. **Citations**: Rainville 1946; NGC 1982; Laliberté 1986; Porter 1986; McMann 1997.

SOUCY, JEAN (b1934), Québec City, QC. Painter. Jean Soucy is mentioned by Harper for experimenting with rigidly controlled shapes to create space (p. 412). **Citation**: Harper 1966.

SPEIRS, DORIS HUESTIS MILLS (b1894), Toronto, ON. Painter. She was a long-time friend of J.E.H. MACDONALD and of BESS and FRED HOUSSER. **Citations**: NGC 1982; Sabean 1989; Lerner 1991; Tippett 1992; Hill 1995.

SPENCER, JAMES BURTON (b1940), Toronto, ON. Painter, printmaker and MURALIST. **Citations**: Tovell 1974; Laurette 1980; NGC 1982; Lerner 1991.

SPENCER, R.B. (act 1813), Ontario. Painter. Spencer is known for a painting of the Battle of Lake Erie in the War of 1812. **Citations**: Harper 1964.

SPENCER, SAM (ARTHUR B.) (b1898), Saskatoon, SK. Painter and sculptor. Spencer began carving picture frames in 1927 and soon was working on a series of carved pictures with integral frames, each picture and its frame carved from a single plank of wood and carefully painted in bright colours. Most of his later work is in the CCFCS collections of the CANADIAN MUSEUM OF CIVILIZATION and includes naïve sculpture in POLYCHROMED wood, high-relief plaques painted in bright colours portraying religious subjects, sports figures in action, birds and animals. **Citations**: Climer 1975; Thauberger 1976; *artscanada* 1979; NMM 1983; McKendry 1983, 1988; Bihalji-Merin 1985; CCFCS; Lerner 1991.

SPICKETT, RONALD JOHN (b1926), Alberta. Painter and sculptor; RCA 1968. **Citations**: Eckhardt 1962; Sisler 1980; NGC 1982; Lerner 1991; McMann 1997.

SPIRIT OF NOVA SCOTIA EXHIBITION. See FOLK ART EXHIBITIONS.

SPRINGER, JUDY (act. 1995), Camden East, ON. Sculptor and ceramicist. **Citations**: NGC 1982.

SPROULE, ROBERT AUCHMETY (1799-1845), Montréal, QC. Painter, illustrator and miniaturist. Sproule painted landscapes in watercolour and MINIATURES on ivory. His work includes views of Québec City and Montréal of which some were published as LITHOGRAPHS and illustrations. It is thought that four of Sproule's black and white LITHOGRAPHS of 1832 were painted in colour by JAMES DUNCAN for re-issue as CHROMOLITHOGRAPHS in 1874, with a fifth Québec City view by Duncan added to the set. In at least one case, JOSEPH LEGARE in his painting, *Cholera Plague, Quebéc,* c1837, used the architectural setting from one of Sproule's works. **Citations**: Spendlove 1958; Hubbard 1967; Harper 1970; Reid 1973; Allodi 1974; Lord 1974; Porter 1978; NGC 1982; Cooke 1983; McKendry 1988; Cavell 1988; Marsh 1988; Lerner 1991.

STAINED GLASS. Stained glass is used in windows to create glass-paintings. The glass is either dyed or surface-coloured. Although stained glass windows in churches can be traced back to the GOTHIC period, they only became popular in Canada in the late 19th century. See also REVIVALS. **Citations**: Osborne 1970; Chilvers 1988; Lerner 1991.

STADELBAUER, HELEN (b1910), Alberta. Printmaker. **Citations**: NGC 1982; Tippett 1992.

STAPLES, OWEN B. (1866-1949), Toronto, ON. Painter, CARTOONIST, illustrator and printmaker. Staples studied with HORATIO WALKER and GEORGE AGNEW REID. After 1885 he was in

Toronto where he made large historical paintings for Toronto city hall. His work is represented in the NATIONAL GALLERY OF CANADA. **Citations**: MacTavish 1925; Robson 1932; Bull 1934; Colgate 1943; Hubbard 1960; Harper 1966, 1970; NGC 1982; Lerner 1991; McMann 1997.

STATE. This is a term used in printmaking to indicate a particular condition of the plate or block. See PRINTS. **Citations**: Piper 1988.

STATE DINNER SERVICE OF CANADA. See CANADIAN STATE DINNER SERVICE.

STEATITE. See SOAPSTONE.

STEEL ENGRAVING. Steel engraving refers either to the process of cutting a design into a steel plate, or the print made from such a plate. Extremely fine lines and subtle tones are possible. Steel engraving was popular in the first half of the 19th century (see Willis 1842 for examples). See also ENGRAVING; LINE ENGRAVING. **Citations**: Willis 1842; Hind 1908; Burch 1910; Short 1912; Plowman 1922; Harper 1970; Allodi 1980, 1989; Moritz 1982; Lerner 1991.

STEELE, LISA (b1947), Toronto, ON. Painter and VIDEO artist. **Citations**: Gale 1977; Ferguson 1980; NGC 1982; Lerner 1991; Tippett 1992.

STEEN, LOIS (b1934), Toronto, ON. Painter. She studied painting with JOCK MACDONALD. **Citations**: NGC 1982; Tippett 1992.

STEINHOUSE, TOBIE THELMA DAVIS (b1925), Québec. Painter and printmaker. **Citations**: Sisler 1980; NGC 1982; Lerner 1991; Tippett 1992; McMann 1997.

STENCIL WORK. In stencil work, a thin sheet of material is perforated with a design or lettering, and this can then be reproduced on other material by brushing colouring through the openings. **Citations**: Osborne 1970; Chilvers 1988.

STEPHENSON, LIONEL McDONALD (1854-1907), Winnipeg, MB. Painter. Stephenson made NAÏVE landscape paintings in oil of Winnipeg and Fort Garry, MB, as well as copies of earlier paintings by other artists. He supplied hundreds of paintings to the soldiers from eastern Canada during the Riel Rebellion of 1885. His work is usually signed "LMS." **Citations**: Harper 1966, 1970; Eckhardt 1970; NGC 1982; Cooke 1983; McKendry 1988.

STEVENS, DOROTHY (1888-1966), Toronto, ON. Painter, portraitist, etcher, printmaker, illustrator and art teacher; RCA 1949. She studied in London and Paris. **Citations**: MacTavish 1925; Robson 1932; Hale 1933, 1952; Colgate 1943; McInnes 1950; Hubbard 1960; Sisler 1980; NGC 1982; Marsh 1988; Lerner 1991; Tippett 1992; McMann 1997.

STEVENSON, THOMAS H. (act. 1841-58), Toronto and Hamilton, ON. Painter of landscape and of miniatures. He spent some time in the USA. **Citations**: Harper 1970; Lerner 1991.

STEVENSON, WILLIAM LEWY LEROY (1905-66), Calgary, AB. Painter and art teacher. **Citations**: Render 1970, 1974; Fenton 1978; NGC 1982.

STEWART, WILLIAM N. (b1888), Vancouver, BC. Painter. In 1948 Stewart retired from his law practice and, in the early 1950s, started painting. He has painted landscapes in California, New Mexico and Arizona , where he wintered in his retirement years, and in Prince Edward Island and Nova Scotia, where he had lived as a young man. He was included in the National Gallery of Canada exhibition, "Folk Painters of the Canadian West," in 1958-9. **Citations**: McCullough 1959; NGC 1982; Bihalji-Merin 1985; McKendry 1988; Lerner 1991.

STILL LIFE. A painting or drawing of inanimate objects, sometimes including dead game such as birds, hares or fish, is called a still life. This category of GENRE painting was developed to a high level in the Low Countries during the 17th century. The VANITAS type of still life reminds the viewer of the passage of time and life through its ICONOGRAPHY. For Canadian examples, see the work of DANIEL FOWLER or ANTOINE PLAMONDON (Harper 1966, pl. 88, 163). **Citations**: Harper 1966; Osborne 1970; Piper 1988.

STODDARD, S.P. (act. 1843), Nova Scotia. Painter. Stoddard is known for a NAÏVE copy of a view of Windsor, NS, after a print of a painting by WILLIAM HENRY BARTLETT. **Citations**: Harper 1966, 1970; Allodi 1974; NGC 1982; Cooke 1983; McKendry 1988; Lerner 1991.

STONE AGE ART. See PREHISTORIC ART.

STONE SCULPTURE. The most common stones for carving are SOAPSTONE, marble, sandstone, limestone and granite. In Canada, NATIVE ART includes many examples of stone sculpture (see McKendry 1983, pl. 11, 15, 184 and 205). **Citations:** Osborne 1970; Swinton 1972; Patterson 1973; McKendry 1983; Piper 1988.

STRETCHER. A wooden frame on which the CANVAS for a painting is stretched taut is known as a stretcher.

STRETTON, SEMPRONIUS (1781-1824), Toronto, ON; Québec City, QC. Painter. Sempronius Stretton's work included TOPOGRAPHICAL landscape, GENRE, costume and figure paintings in watercolour and ink, as well as sketches of natural history specimens. He was a brother of SEVERUS WILLIAM LYMAN STRETTON, and served in the British Army. **Citations:** Harper 1970; Bell 1973; Allodi 1974; McKendry 1988.

STRETTON, SEVERUS WILLIAM LYNAM (b1793), Québec City, QC. Painter. Severus Stretton painted TOPOGRAPHICAL landscapes in watercolour, including a view of Québec City. He was a brother of SEMPRONIUS STRETTON and served in the British Army. **Citations:** Harper 1970; Bell 1973; Allodi 1974; Cooke 1983; McKendry 1988.

STRICKLAND, SUSANNA. See, SUSANNA MOODIE.

STRYJEK, DMYTRO (b1899), Saskatoon, SK. Painter. In 1923 Stryjek emigrated to Canada from the Ukraine and for 34 years worked as a section hand for the Canadian National Railways in the Hafford area, SK. By the mid 1950s he was making wallet-size portraits using pen, pencil and crayon. After his retirement and move to Saskatoon in 1967, he began recording remembered images of historical events, religious themes, political figures and movie stars. **Citations:** Climer 1975; Bell 1982; Farr 1982; Borsa 1983; Millard 1988; McKendry 1983, 1988; Lerner 1991.

STUDIO. An artist's work-place is usually called a studio. **Citations:** Osborne 1970; Lerner 1991.

STUDIO BUILDING. A building containing six studios at 25 Severn Street, Toronto, ON, built in 1914 and used by members of the GROUP OF SEVEN. THOMSON'S SHACK was located on the Studio Building property. LAWREN S. HARRIS and Dr JAMES MACCALLUM provided the financial support for the building. It was the first building in Canada designed and constructed specifically for artists' studios. For a picture of the Studio Building, see Mellen 1970, pl. 51, and Reid 1970, p. 35.. **Citations:** Colgate 1943; McInnes 1950; Buchanan 1950; Jackson 1958; Harper 1966; Reid 1969, 1970, 1988; Mellen 1970; Murray 1971; Housser 1974; Lord 1974; Town 1977; Laing 1979; Darroch 1981; Fulford 1982; Hill 1995.

STUDY. See SKETCH.

STYLE. The distinctive and characteristic features of a work of art by which the artist can be recognized, the place of origin be resolved, or the period be determined. When distinctive and characteristic features are common to the work of a large group of artists, their style may be named, for example "folk-art style" as in the case of artists who are not familiar with the principles and techniques of professional academic art and whose work is characterized by flat forms, little or no perspective, undiluted colour, and continuance of MEDIEVAL traditions such as HIERARCHICAL SCALE. See also SCHOOL. **Citations:** McKendry 1983, 1987; Pierce 1987.

STYLIZATION (STYLIZED). These are terms applied to art or ornament in which established non-realistic conventions are used. See McKendry 1983, p. 263, for an illustration. **Citations:** Osborne 1970; Piper 1988.

STYLUS. A pointed metal instrument for drawing impressed lines on a GROUND. **Citations:** Osborne 1970; Piper 1988.

SULLIVAN, FRANCOISE (b1928), Montréal, QC. Sculptor. She was one of the signatories of the AUTOMATISTS' 1948 manifesto. **Citations:** Gosselin 1981; NGC 1982; Lerner 1991; Tippett 1992.

SUNDAY ARTIST. Part-time, AMATEUR or FOLK artists are sometimes referred to as Sunday artists.

SUPPORT. The support for a painting is the solid material on which the paint is placed, for example canvas, wooden panel or paper. **Citations**: Osborne 1970; Mayer 1970; Chilvers 1988.

SURREALISM. an outgrowth of the DADA, Surrealism was proclaimed in 1924 by French critic and poet André Breton (who visited Canada in 1944). Surreal paintings may be intuitive and automatic in technqiue with bizarre subject matter. Canadian artist JEAN-PAUL RIOPELLE moved in Breton's circle in Paris after World War Two. Others interested in the movement in the 1940s were ALFRED PELLAN, PAUL-EMILE BORDUAS, ALBERT DUMOUCHEL and JOCK MACDONALD. The Québec AUTOMATISTES were allied in spirit with the Surrealists of Europe (see Reid 1988, pp.226-39). See also MARY FRANCIS. **Citations**: Buchanan 1950; Guy 1964; London 1964; Harper 1966; Osborne 1970; Lord 1974; Wilkin 1976; Janson 1977; Luckyj 1978; Sisler 1980; Lucie-Smith 1984; Piper 1988; Chilvers 1988; Reid 1988; Lerner 1991; Silcox 1996.

SURRETTE, NELSON (b1920), Yarmouth, NS. Painter and sculptor. Surrette made naïve paintings of landscape and people, as well as some portrait sculpture in papier mâché. **Citations**: Laurette 1980(2).

SURREY, PHILIP HENRY (b1910), Québec. Painter. He studied with FRED VARLEY and LEMOINE FITZGERALD as well as in New York. Surrey shared a studio with ALFRED PELLAN. Some of Surrey's work has a naïve quality and reflects city life. His work is represented in the NATIONAL GALLERY OF CANADA. **Citations**: McInnes 1950; Buchanan 1950; Hubbard 1960; Harper 1966; Roussan 1968; Viau 1971; Duval 1972; Fenton 1978; Sisler 1980; NGC 1982; Burnett/Schiff 1983; Reid 1988; Lerner 1991; McMann 1997.

SUTTON, CAROL (b1945), Toronto, ON. Painter and sculptor. Her work is noted for naturalistic colour paintings. **Citations**: Carpenter 1981; NGC 1982; Burnett/Schiff 1983; Lerner 1991; Tippett 1992.

SUZOR-COTE, MARC-AURELE de FOY (1869-1937), Arthabaska and Montréal, QC. Painter, church decorator and sculptor; RCA 1916. Many of his works are of rural subjects which he executed with great skill and feeling. Several of his paintings and sculptures are in the NATIONAL GALLERY OF CANADA. See McMann 1997, pp. 392-5, for a dated list of paintings and sculpture. **Citations**: Sibley 1913; Dyonnet 1913; Bridle 1916; MacTavish 1925; Stevenson 1927; Chauvin 1928; Robson 1932; Colgate 1943; Barbeau 1946; Gour 1950; Buchanan 1950; McInnes 1950; Jackson 1958; Hubbard 1960(1), 1960; Harper 1966; Falardeau 1969; Lord 1974; Watson 1974; Thibault 1978; Jouvancourt 1978(1); Sisler 1980; Osborne 1981; NGC 1982; Laliberté 1986; Reid 1988; Marsh 1988; Duval 1990; Lerner 1991; McMann 1997.

SWAG. An ornamental festoon of flowers or drapery appearing in sculpture, painting or decoration, particularly important in the era of NEOCLASSICISM. **Citations**: Osborne 1970; Piper 1988.

SWEETMAN, HARRIET (act. 1830), Prince Edward County, ON. Painter. Sweetman is known for a view of the lighthouse on False Duck Island, Lake Ontario. **Citations**: Harper 1973, 1974; McKendry 1988.

SWIFT, JOSEPH (d1889), Toronto, ON. Painter. Swift painted many prize-winning farm animals including several magnificent horses which tend to fill the pictures and overshadow the landscape backgrounds. He used stencils to paint the bodies of animals in a THEOREM technique, similar to that used by amateur Victorian ladies to paint decorative still-life pictures. In this way, he attained clean lines and a halo effect around each animal. Details of each animal and the landscape backgrounds were painted freehand. **Citations**: Harper 1973, 1974; Allodi 1974; *Canadian Collector* 1980; Dobson 1982; McKendry 1988; Lerner 1991.

SWINTON, GEORGE (b1917), Winnipeg, MB. Painter and author. Swinton is an expert on Inuit art. He came to Canada from Austria in 1939. **Citations**: Swinton 1961, 1972; Eckhardt 1962; NGC 1982; Lerner 1991.

SYMBOLISM. In the late 19th century French painters, such as Odilon Redon (1840-1916) and Paul Gauguin (1848-1903), transformed, through emotions, the ojective aspects found in IMPRESSIONISM and REALISM. Certain works by Québec artist OZIAS LEDUC have Symbolist aspects. See also Les

NABIS, POST-IMPRESSIONISM. **Citations**: Ferguson 1967; Osborne 1970; Janson 1977; Clay 1978; McKendry 1983; Lucie-Smith 1984; Chilvers 1988; Piper 1988.

SYMONS, ROBERT DAVID (1898-1973), Silton, SK. Painter, MURALIST, dioramist and author. **Citations**: Fenton 1971; NGC 1982; Lerner 1991.

T

TABERNACLE. A space, usually having ornamental framing, containing the consecrated host or, in classical architecture, a statue. **Citations**: Ferguson 1967; Pierce 1987.

TACON, EDNA JEANETTE (1905-80), Hamilton, ON. Non-representational painter and musician. **Citations**: NGC 1982; Lerner 1991; Tippett 1992.

TACTILE VALUES. A phrase denoting the qualities of a painting which give the impression of three dimensions. **Citations**: Osborne 1970; Piper 1988.

TAILFEATHERS, GERALD (1925-75), Alberta. Painter, illustrator and sculptor. Many of Tailfeathers' paintings are romantic views of his Blood Indian people's life in the late nineteenth century and of cowboy activities. In his early years, he was influenced by his uncle PERCY PLAINWOMAN and other artists. **Citations**: MacEwan 1971; Patterson 1973; *Canadian Collector* 1976; Dempsey 1978; NGC 1982; Marsh 1985; McKendry 1988; Lerner 1991.

TALBOTYPE. See PHOTOGRAPHY IN CANADA.

TANABE, TAKAO (b1926), Vancouver, BC. Painter, MURALIST and printmaker. He studied with HANS HOFMANN. His work is represented in the NATIONAL GALLERY OF CANADA. **Citations**: McNairn 1959; Hubbard 1960; Duval 1972; Lord 1974; Dillow 1976; Sisler 1980; NGC 1982; Burnett/Schiff 1983; Bringhurst 1983; Lerner 1991; McMann 1997.

TANNER, CHARLES ENOS (CHARLIE) (1904-1982), Eagle's Head, NS. Sculptor. In 1973, Tanner, retired from a life at sea on fishing schooners, began carving small animal and human figures in addition to the decoys which he had carved from time to time throughout his life. It is thought that he may have made about 3000 carvings during his last eight years. **Citations**: Elwood 1976; Huntington 1984; McKendry 1983, 1988.

TASSEOR, LUCY (TUTSWEETOK) (b1934), Eskimo Point, NT. Sculptor. She is a native Inuit sculptor in stone. **Citations**: Inuit 1971; Swinton 1972; Tippett 1992 (see Tutsweetok).

TAUFFENBACH, CONSTANTIN NICOLAS (1829-90), Ste Anne des Chênes, MB. Painter and church decorator. An emigrant from Europe to Montréal, Tauffenbach then moved to Manitoba in 1881. **Citations**: Eckhardt 1970; NGC 1982.

TAYLOR, Sir ANDREW THOMAS (1850-1937), Montréal, QC. Painter and architect; RCA 1890. After studies in Edinburgh, Scotland, in London, England, and in Italy, Taylor emigrated to Montréal in 1883. He designed the Redpath Library, McGill University, in 1891. **Citations**: Harper 1970; Sisler 1980; NGC 1982; McMann 1997

TAYLOR, ERNIE (act. 1980), Collingwood, ON. Painter. Taylor painted portraits, GENRE, and marine paintings in acrylic, including ship portraits. Some of Taylor's marine paintings are in a NAÏVE, narrative style. **Citations**: Marine Museum 1987; McKendry 1988.

TAYLOR, FREDERICK BOURCHIER (1906-87), Montréal, QC. Painter, printmaker and art teacher; RCA 1967. Taylor painted Québec rural and city scenes. Examples of his paintings are in the NATIONAL GALLERY OF CANADA. **Citations**: Hubbard 1960; Lord 1974; Sisler 1980; NGC 1982; Lerner 1991; McMann 1997.

TAYLOR, G.L. (1874-1962), Calgary, AB. Painter. Taylor painted landscape, historical and theatre-scenery paintings, including western scenes and a view of Upper Fort Garry and the Governor's House, Winnipeg, MB. He came to Montréal, QC, from England in 1896. He soon left for western Canada and,

by 1898, was living in Calgary, where he founded the Taylor Sign Works. **Citations**: Herald 1958; NGC 1982; McKendry 1988.

TAYLOR, JOHN (JACK) BENJAMIN (1917-70), Prince Edward Island. Painter. **Citations**: IBM 1940; Forbes 1973; NGC 1982; Lerner 1991; McMann 1997.

TEHARIOLIN, ZACHARIE VINCENT dit. See ZACHARIE VINCENT.

TEMPERA. A MEDIUM used in painting in which the binder is white or yolk of egg mixed with water. It is suitable for fine work and retains a bright surface. See also DANIEL P.E. BROWN and MARGARET PETERSON. **Citations**: Osborne 1970; Mayer 1970; Pierce 1987; Piper 1988; Chilvers 1988.

TEMPEST, JOHN SUGDEN (1864-1941), Alberta. Painter. Tempest came to Canada from England in 1896 and became active as a painter in the western provinces in 1928. **Citations**: NGC 1982; Masters 1987; McMann 1997.

TERRACOTTA. Terracotta is clay baked until it is hard and compact. It has been used since early times for architectural ornaments and by artists for figures. The Canadian sculptor JOE FAFARD uses terracotta to good effect for his human and animal figures. **Citations**: Osborne 1970; Pierce 1987; Chilvers 1988.

TESSIER, YVES (1800-47), Montréal, QC. Painter. Tessier served an apprenticeship with JEAN-BAPTISTE ROY-AUDY, and worked extensively in Québec churches. In some cases he imitated paintings by other artists such as FRANCOIS MALEPART de BEAUCOURT and JOSEPH LEGARE. **Citations**: Harper 1970; McKendry 1988.

THAUBERGER, DAVID ALLAN (b1948), Regina, SK. Painter and ceramicist. In his paintings and ceramics, Thauberger combines sophisticated techniques with folk-art techniques, such as going directly to the heart of a theme by using HIERARCHICAL SCALE. **Citations**: Ferguson 1967(1); *artscanada* 1979; Bismanis 1980; NGC 1982; McKendry 1988; White 1988; Lerner 1991.

THEOLARIOLIN. See ZACHARIE VINCENT.

THEOREM PAINTING. Theorem painting, introduced about 1830, was based on using stencils for certain portions of the work such as leaves, flowers, and birds. These could be arranged in a desirable pattern, painted, and then connected by freehand painting to achieve a decorative effect. Sometimes the compositions came from the popular prints published by CURRIER AND IVES. For examples of theorem painting see: Harper 1974, pl. 107; McKendry 1983, pl. 177. See also FOLK ART.

THIBAULT, SABAS (act. 1875), Québec. Sculptor of religious works in wood. **Citations**: Porter 1986.

THIELCKE, HENRY DANIEL (act. 1843), Montréal and Québec City, QC. Painter, portraitist, miniaturist and art teacher. He studied art in London and arrived in Québec City in 1832. **Citations**: Fairchild 1907; Morisset 1936, 1960; Harper 1970; NGC 1982; Béland 1992.

THIFAULT, FERNAND (act. 1977), Saint-Adelphe, QC. Painter. Thifault painted portrait, landscape and legend subjects including a painting of the Québec legend La Chasse-Galerie, a subject also painted by OCTAVE HENRI JULIEN. **Citations**: NMM 1983; McKendry 1988.

THOMARAT, JEANNE ALINE (b1893), Duck Lake, SK. Painter. When she was fourteen years old, Thomarat emigrated from France to Canada and, in 1952, began painting her memories of the peaceful countryside that she knew as a child. Her paintings are flat, lyrical and naïve, with rhythmic patterns of colour (see McKendry 1983, pl. 40). In her view "when you paint you can make it as nice as you want." Several examples of Thomarat's work are in the CCFCS collections. **Citations**: Thauberger 1976; *artscanada* 1979; Mattie 1981; NMM 1983; McKendry 1983, 1988.

THOMAS, CHUT (act. 1842), Niagara, ON. Painter. Chut painted portrait and landscape paintings in watercolour, including views of Niagara Falls. **Citations**: Dobson 1982; McKendry 1988.

THOMAS, ROY (b1949), Ontario. Painter. Thomas is a native artist whose work has been referred to as contemporary Algonkian legend painting. **Citations**: NGC 1982; McLuhan 1984; Lerner 1991.

THOMSON, JOHN (act1809), Halifax, NS. Painter and art teacher. Thomson was an ITINERANT

artist whose work included MINIATURES and portraits. He visited Montréal in 1805 and Québec City in 1806. See Harper 1970 for the prices he charged. **Citations**: Morisset 1941; Harper 1970; Tippett 1992.

THOMSON, THOMAS (TOM) JOHN (1877-1917), Toronto, ON. Painter. Tom Thomson grew up in Ontario and, after working in the USA at photo-engraving and advertising design, moved to Toronto in 1905, where he worked for several photo-engraving houses including GRIP LIMITED. There he was associated with J.E.H. MACDONALD, ARTHUR LISMER, F.H. VARLEY and FRANKLIN CARMICHAEL. In 1913 Dr JAMES MACCALLUM and LAWREN HARRIS became his patrons. From 1914-1917 Thomson painted in ALGONQUIN PARK, usually with A.Y. JACKSON, ARTHUR LISMER or F.H. VARLEY, and returned in the winters to paint in his studio (THOMSON'S SHACK) in Toronto. In 1917 Thomson was drowned in Canoe Lake in Algonquin Park. Thomson's paintings of the Canadian landscape are brilliant intensely colourful visions of water, rock, trees and sky that lived on in the works of the GROUP OF SEVEN (Thomson died before the Group was formed.) Dr James MacCallum's bequest to the NATIONAL GALLERY OF CANADA included 85 sketches and canvases by Thomson. **Citations**: MacTavish 1925; Stevenson 1927, 1930; Davies 1935, 1967; Robson 1932, 1937(3); Mellors 1937; Colgate 1943; Saunders 1947; Buchanan 1950; McLeish 1955; Harper 1955, 1966; Jackson 1958; Hubbard 1960, 1960(1); Harris 1964; Groves 1968; Reid 1969, 1970, 1988; Addison 1969; Osborne 1970, 1981; Little 1970; Mellen 1970; Boggs 1971; Murray 1971, 1994; Duval 1973, 1990; Lord 1974; Housser 1974; Town 1977; Fenton 1978; Hembroff-Schleicher 1978; Laing 1979, 1982; Tippet 1979, 1992; Sisler 1980; Smith 1980; Darroch 1981; NGC 1982; Varley 1983; Burnett/Schiff 1983; Thom 1985; McMichael 1986; Chilvers 1988; Marsh 1988; Piper 1988; Lerner 1991; Thom 1991; Hill 1995; Silcox 1996; McMann 1997.

THOMSON, WILLIAM JAMES (1858-1927), Toronto, ON. Painter, graphic artist and ENGRAVER. Thomson studied under JOHN A. FRASER and WILLIAM CRUIKSHANK. He became the first president of the SOCIETY OF CANADIAN PAINTER-ETCHERS. **Citations**: Society 1930; Colgate 1943; Harper 1970; NGC 1982; Lerner 1991; McMann 1997.

THOMSON'S SHACK. After the STUDIO BUILDING was built, and when he was in Toronto, TOM THOMSON lived and worked on the Studio Building property in an old cabinet maker's shop that was fixed up like a northern shack. **Citations**: Jackson 1958; Davies 1967; Groves 1968; Addison 1969; Murray 1971; Housser 1974; Town 1977.

THORNE, JOSEPH BRADSHAW (1869-1963), Toronto, ON. Painter. Thorne emigrated from England to Canada, where he worked as a labourer and painted in his spare time. His paintings sometimes include captions. **Citations**: Cumming 1981; Kobayashi 1985(1); McKendry 1988; Lerner 1991.

THORNSBURY, JAMES (b1941), Saskatchewan. Ceramicist. **Citations**: Walters 1975; NGC 1982; Lerner 1991.

THORNTON, MILDRED VALLEY STINSON (1896-1967), British Columbia. Painter. Thornton painted western Canadian native people and their way of life. **Citations**: Thornton 1966; NGC 1982; Lerner 1991; McMann 1997.

THRESHER, ELIZA W. MORRISON (act. 1816-43), Montréal, QC; Halifax, NS; Charlottetown, PE. Painter and art teacher. She was the wife of GEORGE GODSELL THRESHER. **Citations**: Harper 1970; Lerner 1991; Tippett 1992.

THRESHER, GEORGE GODSELL (1779-1859), Montréal, QC; Halifax, NS; Charlottetown, PE. Painter and art teacher. He was the husband of ELIZA W. MORRISON THRESHER. **Citations**: Harper 1970; NGC 1982; Lerner 1991.

TIEDEMANN, HERMANN OTTO, (1821-91), Victoria, BC. TOPOGRAPHICAL painter and architect. Tiedemann emigrated to British Columbia in 1858. He accompanied exploration parties into the interior and completed TOPOGRAPHICAL views. Tiedemann designed several public buildings in BC. **Citations**: Harper 1970, 1973, 1974; Gilmore 1980; NGC 1982; Kobayashi 1985(2); McKendry

1988; Lerner 1991.

TIESSEN, GEORGE (b1935), Atlantic Canada. Painter, sculptor and printmaker. **Citations**: Andrus 1966; NGC 1982; Lerner 1991.

TIMS, MICHAEL. See GENERAL IDEA.

TINSEL ART. See FOIL ART.

TINSLEY, W. (act. 1841-57), Kingston, ON. Painter. Very little is known about this artist who painted a portrait of the Hon. John Kirby of Kingston in 1841 and a portrait of a child in 1857 in Kingston. **Citations**: Harper 1966, 1970; Stewart 1973; McKendry 1988.

TOBIN, GEORGE (1768-1838), Halifax, NS. Painter. Tobin is known for a TOPOGRAPHICAL view of Halifax harbour painted in 1797. **Citations**: Cooke 1983; McKendry 1988.

TOD, JOANNE (b1953), Toronto, ON. Painter. **Citations**: Tippett 1992.

TODD, ROBERT CLOW (1809-66), Québec City, QC; Toronto, ON. Painter, MURALIST and art teacher. In 1834 Todd emigrated from England to Québec City, and started a business of house, carriage and decorative painting, as well as carving and gilding. Todd's subjects for paintings included landscape and GENRE scenes, lively winter scenes with horses and sleighs - sometimes with the Montmorency ice cone as a background, as well as other Québec views, and horse portraits. He employed ANTOINE-SEBASTIEN FALARDEAU. From about 1854 to 1865, Todd was in Toronto, where he advertised as an "artist, herald and ornamental painter;" he taught art, and painted at least one mural in a Toronto civic building. In 1861, however, he wrote that "Toronto is too new and too poor to support an ornamental artist." The relationship between Todd's subject matter and that of CORNELIUS KRIEGHOFF is discussed at some length in Harper 1966. **Citations**: Hubbard 1960, 1967; Harper 1966, 1970, 1973, 1974, 1979; Boggs 1971; Lord 1974; Mellen 1978; NGC 1982; Dobson 1982; Marsh 1988; McKendry 1988; Lerner 1991; Béland 1992.

TOLER, JOHN GEORGE (act. 1808-29), Halifax, NS. Painter. Toler painted portraits and native people scenes in watercolour, including Micmac encampments and a plan of Halifax engraved in 1817. JOSEPH TOLER may have been his son. Other artists who painted Micmac encampments include W. BELFIELD and JAMES COCKBURN. **Citations**: Harper 1970; Bell 1973; NGC 1982; Cooke 1983; McKendry 1988.

TOLER, JOSEPH (act. 1831-42), Halifax, NS; Saint John, NB. Painter. Joseph Toler painted portraits, landscapes, and MINIATURES on ivory or paper. He was a goldsmith and silversmith, and may have been a son of JOHN GEORGE TOLER. **Citations**: Harper 1970; NGC 1982; McKendry 1988.

TOLMIE, KENNETH (b1941), Nova Scotia. Painter. **Citations**: Laurette 1980(3); NGC 1982; Lerner 1991.

TOMCZAK, KIM (b1953), Toronto, ON. PERFORMANCE artist. **Citations**: NGC 1982; Tippett 1992.

TOMPKINS, J. SETON (1899-1986), Singhampton, ON. Sculptor. Tompkins started carving in 1967 shortly after retirement from working at a service station. He finished his work with glossy surfaces, similar to those he was familiar with on automobiles at his service station. His work includes naïve sculpture in POLYCHROMED wood of people, animals, religious subjects, and pictures illustrating humourous or anecdotal incidents. Several examples of his work are in the CCFCS collections. **Citations**: Price 1979; NMM 1983; McKendry 1983, 1988; *Empress* 1985.

TONAL VALUES (TONE). The relative lightness or darkness of areas in a painting. See CHIAROSCURO. **Citations**: Lucie-Smith 1984; Pierce 1987.

TONNANCOUR, JACQUES GODEFROY DE (b1917), Montréal, QC. Painter and art teacher. Tonnancour studied painting with GOODRIDGE ROBERTS, and was influenced by ALFRED PELLAN and the GROUP OF SEVEN. His later work approached pure abstraction. Several of his paintings are in the NATIONAL GALLERY OF CANADA. **Citations**: Tonnancour 1944; McInnes 1950; Buchanan 1950; Hubbard 1960, 1960(1); Harper 1966; Ostiguy 1971; Folch-Ribas 1971; Ayre 1977; Vie des Arts

1978; Sisler 1980; NGC 1982; Bringhurst 1983; Marsh 1988; Lerner 1991; McMann 1997.

TOPHAM, WILLIAM THURSTON (1888-1966), Montréal, QC. Painter. **Citations**: Sisler 1980; NGC 1982; Lerner 1991; McMann 1997

TOPOGRAPHICAL ART. Topographical art merges with LANDSCAPE, but is more concerned with accuracy in supplying information about features of the landscape, towns and buildings. The British Army introduced topographical drawing and watercolour painting to Eastern Canada in the 18th century but PERE LOUIS HENNEPIN is thought to be the first topographer to make drawings of Canadian views, including one of Niagara in 1678. Many officers who had been trained in topographical drawing at the WOOLWICH MILITARY ACADEMY, came to Canada and produced numerous watercolours of Canadian scenes, for example THOMAS DAVIES, RICHARD SHORT, HERVEY SMYTH, GEORGE HERIOT, and J.P. COCKBURN. (See Harper 1966, pp. 40-51 for more information and illustrations; Reid 1988, pp. 18-37; and McInnes 1950, ch. IV.) **Citations**: McInnes 1950; Harper 1966, 1970; Osborne 1970; Heriot 1971; Bell 1973; Lord 1974; McKendry 1983, 1987; Reid 1988; Marsh 1988; Lerner 1991.

TORBETT, CHARLES W. (act. 1812-34), Halifax, NS. ENGRAVER and copper plate printer. He engraved plans and portraits from drawings by JOHN G. TOLER. **Citations**: Harper 1970; Allodi 1989; Lerner 1991.

TORONTO ART GALLERY. See ART GALLERY OF ONTARIO.

TORONTO ART STUDENTS LEAGUE. This society originated as a sketching club in 1866. One of the active founding members was ROBERT HOLMES. In 1904 it became part of the CANADIAN SOCIETY OF GRAPHIC ART. **Citations**: CSGA 1924; Harper 1966; Tippett 1992; Lerner 1991.

TORONTO ENGRAVING COMPANY. See BRIGDENS LIMITED.

TORONTO SOCIETY OF ARTS. See SOCIETY OF ARTISTS AND AMATEURS OF TORONTO.

TORSO. A portrayal of the nude human trunk without the head and limbs. **Citations**: Osborne 1970; Piper 1988.

TOTEM POLES. Totem poles were carved and erected by Northwest Coast native tribes. The principal types of poles are heraldic, grave memorials, house posts or portal posts, welcoming poles, and mortuary poles. The carvings represented animals and birds and were painted. Some modern native artists continue the tradition. See also NATIVE ART OF CANADA. Totem poles were a favourite subject of Canadian artist EMILY CARR. **Citations**: Newcombe 1930; Ravenhill 1944; McInnes 1950; Barbeau 1950; Osborne 1970; Patterson 1973; Lord 1974; Mellen 1978; Shadbolt 1979; Halpin 1981; McKendry 1983; Marsh 1988; Lerner 1991.

TOUPIN, FERNAND (b1930), Montréal, QC. Painter. Toupin took part in the PLASTICIEN MOVEMENT. **Citations**: Harper 1966; Marteau 1978; Sisler 1980; NGC 1982; Burnett/Schiff 1983; Harper 1966; Barras 1970; Bringhurst 1983; Reid 1988; Lerner 1991; McMann 1997.

TOUSIGNANT, CLAUDE (b1932), Montréal, QC. Painter. Tousignant studied under ARTHUR LISMER and JACQUES DE TONNANCOUR. His paintings are ABSTRACT, often using circular forms with colours producing an emphasized optical effect. See OP ART. His work is represented in the NATIONAL GALLERY OF CANADA. **Citations**: Harper 1966; Teysedre 1968; Boggs 1971; Duval 1972; Corbeil 1973; Lord 1974; Fenton 1978; Vie des Arts 1978; Sisler 1980; Osborne 1981; Burnett/Schiff 1983; Bringhurst 1983; Marsh 1988; Lerner 1991; McMann 1997.

TOWN, HAROLD BARLING (1924-90), Toronto, ON. Painter, sculptor, MURALIST and print-maker. Town was a diversely talented artist who painted MURALS and portraits, and produced COLLAGES, prints, drawings, illustrations, and sculpture. He wrote books and articles on art and artists, and was active in the PAINTERS ELEVEN group. Several of his paintings are in the NATIONAL GALLERY OF CANADA. **Citations**: Duval 1954, 1972; Hubbard 1960, 1960(1); Town 1964, 1969, 1977; Harper 1966; Fulford 1969; Townsend 1970; Boggs 1971; Hirsh 1971; Withrow 1972; Silcox 1973, 1996; Lord 1974; Webster 1975; Fenton 1978; Mellen 1978; Sisler 1980; Osborne 1981; NGC 1982; Bringhurst 1983; Burnett/Schiff 1983; Burnett 1986; Marsh 1988; Reid 1988; Piper

1988; Lerner 1991; McMann 1997.

TOWNSHEND, GEORGE (act. 1759). Officer and painter. The Marquis of Townshend is known for his portrait of General James Wolfe who led the British expedition against Québec in 1759. **Citation:** Harper, 1966.

TOZER, MARJORIE HUGHSON (1900-59), Halifax, NS. Painter and art teacher. **Citations:** NGC 1982; Tippett 1992; McMann 1997.

TRAILL, CATHARINE PARR (1802-99), Lakefield, ON. Painter, illustrator and author. Mrs. Traill received instruction in painting botanical subjects from VINCENT CLEMENTI, but she is best known for her writings, in particular *The Backwoods of Canada*, London 1836. She collaborated with her niece AGNES DUNBAR CHAMBERLIN in illustrating books on Canadian wildflowers. Mrs Traill was a sister of SUSANNA MOODIE. **Citations:** Colgate 1943; Story 1967; NGC 1982; Marsh 1988; McKendry 1988; Tippett 1992; Dickenson 1992.

TRAMP ART. A style of FOLK ART sculpture, usually made by ITINERANT crafts-people, characterized by chip-carving and use of discarded materials. **Citations:** McKendry 1983.

TRANSEPT. In church architecture, there may be two transepts or arms set at right angles to the NAVE. This may result in a Latin cross plan. **Citations:** Pierce 1987.

TRAQUAIR, RAMSAY (1874-1952), Montréal, QC. Architect, author, painter, printmaker and professor of architecture at McGill University. Among his important writings are *The Old Silver of Québec* 1940 and *The Old Architecture of Québec* 1947. **Citations:** Traquair 1940, 1947; McInnes 1950; Gowans 1955; NGC 1982; Marsh 1988; McMann 1997.

TRAVERS, GWYNETH-MABEL (1911-82), Kingston, ON. Painter and printmaker. She studied under ANDRE BIELER, GEORGE SWINTON and RALPH ALLEN. Travers developed her own individual style of colour WOODBLOCK printing. **Citations:** Oko 1981; NGC 1982; Farr 1988.

TREHERNE, HAROLD J. (1899-1975), Saskatchewan. Painter. **Citations:** Mendel 1977; NGC 1982; Lerner 1991.

TREMBLAY, GEORGES (1878-1939), Iberville, QC. Sculptor. Tremblay was a sculptor and stone cutter who collaborated with ALFRED LALIBERTE. **Citations:** NGC 1982; Laliberté 1986.

TREMBLAY, GEORGES-EDOUARD (1907-87), Charlevoix County, QC. Painter and textile artist. Georges-Edouard Tremblay painted landscapes and GENRE scenes, and is well known for his decorative tapestries and hooked rugs with Québec scenes. **Citations:** Gauvreau 1940; Simard 1975; Baker 1981; NGC 1982; Laliberté 1986; McKendry 1988; Lerner 1991.

TREMBLAY, GERARD (b1908), Montréal, QC. Painter and printmaker. **Citations:** Marteau 1978; NGC 1982; Lerner 1991.

TRIAUD, LOUIS-HUBERT (1794-1836), Québec City, QC. Painter and art teacher. Triaud was a painter of religious subjects who taught painting and drawing at the URSULINE CONVENT in Québec City. In 1823 he assisted ANTOINE PLAMONDON in restoring some paintings in the DESJARDIN COLLECTION. He was a friend of JOSEPH LEGARE. (See Hubbard 1960[1] pl. 20 or Harper 1966 pl. 75 for a colour reproduction.) **Citations:** Hubbard 1960(1); Harper 1966,1970,1974; NGC 1982; Lerner 1991; Béland 1992.

TRINITY. The usual symbols for the Trinity are: God the Father symbolized by the Hand from above usually among clouds, Christ by the Lamb, and the Holy Spirit by the Dove. These symbols often appear singly in RELIGIOUS ART. **Citations:** Osborne 1970; Ferguson 1967.

TRIPTYCH. Three panels forming an ALTARPIECE of a church. The two outer panels may be hinged to close to cover the central panel. In painting, a triptych consists of three parts, panels or canvases; a diptych has two parts and a polyptych has more than three parts. **Citations:** Pierce 1987; Piper 1988.

TROMPE L'OEIL. A painting in which illusionistic skill has been used to make the painted object appear as a real one. Canadian artists, OZIAS LEDUC and JULIAN R. SEAVEY have used this technique. **Citations:** Harper 1966; Osborne 1970; Lord 1974; Piper 1988; Lerner 1991.

TRUDEAU, ANGUS (1905-84), Manitoulin Island, ON. Painter. Trudeau, an Odawa native person,

worked as a pulpwood cutter and a cook in lumber camps, and on lake ships. He began to make paintings of ships and construct models after he retired. **Citations**: Ojibwa 1981; Farr 1982; CCFCS; NGC 1982; Kobayashi 1985(1); McKendry 1988.

TRUDEAU, RANDY (b1954), Manitoulin Island, ON. Painter. Trudeau is a native artist. **Citations**: Ojibwa 1981; NGC 1982; Lerner 1991.

TRUDEAU, YVES (b1930), Québec. Sculptor. **Citations**: Guy 1970(1); Sisler 1980; NGC 1982; Lerner 1991; McMann 1997.

TRUDELLE, J. GEORGES (act. 1930), Québec. Sculptor of religious subjects. **Citations**: Porter 1986.

TSIMSHIAN. The term refers to northern British Columbia native people living in the Skeena River area. Numerous TOTEM POLES were carved by the Tsimshian. **Citations**: Barbeau 1950; Barbeau (Haida)1957; Patterson 1973; Hodge 1974; Marsh 1988; Lerner 1991.

TULLEY, CHARLES (1885-1950), Ontario. Painter. Tulley emigrated to Canada from England in 1907. He studied painting with FREDERICK COBURN and SHERRIFF SCOTT. **Citations**: NGC 1982; Laliberté 1986.

TURPENTINE. In its distilled form, turpentine is a thinner for OIL PAINT. **Citations**: Mayer 1970; Chilvers 1988; Piper 1988.

'TWAS EVER THUS EXHIBITION. This was a FOLK ART EXHIBITION from a private collection (the PRICE COLLECTION), held in 1979 at the Robert McLaughlin Gallery, Oshawa, ON. **Citations**: Price 1979; McKendry 1983, 1987.

TUTSWEETOK, LUCY TASSEOR. See LUCY TASSEOR.

U

UHTHOFF, INA D.D. (1889-1971), Victoria, BC. Painter and art teacher. Uhthoff who had studied in Scotland, came to Victoria in 1926. Painting in the manner of the GROUP OF SEVEN, she minimized the elements of the landscape and emphasized its basic structures (see Render 1974, pl. 87-8). Her work is represented in the collection of the GLENBOW-ALBERTA INSTITUTE of Calgary. **Citations**: Graham 1972; Render 1974; NGC 1982; Lerner 1991.

UKRAINIANS. As a result of political difficulties with Russia many Ukrainians emigrated to Canada, mostly between 1891 and 1914. Their architecture, art, embroidery, FOLK ART and crafts are much in evidence throughout Canada. See also ANN HARBUZ, WILLIAM KURELEK. **Citations**: Ukrainian 1951; Marsh 1988; Lerner 1991.

ULRICH, JAMES (JIM) (b1944), Alberta. Painter and sculptor. **Citations**: Banff 1977; NGC 1982; Lerner 1991; McMann 1997.

UMHOLTZ, DAVID (b1943), Winnipeg, MB. Painter and printmaker. **Citations**: NGC 1982; Lerner 1991; McMann 1997.

UNDERPAINTING. Preliminary layers of paint which are subsequently covered by the final surface of paint. **Citations**: Osborne 1970; Pierce 1987; Chilvers 1988.

UPPER CANADA. See ONTARIO.

URQUHART, ANTHONY (TONY) MORSE (b1934), Niagara Falls and London, ON. Painter and sculptor. Urquhart joined a group of London painters that included GREG CURNOE and JACK CHAMBERS. Urquhart's paintings are represented in the NATIONAL GALLERY OF CANADA. **Citations**: Hubbard 1960; Harper 1966; Lord 1974; Ihrig 1978; Sisler 1980; NGC 1982; Bringhurst 1983; Burnett/Schiff 1983; Reid 1988; Marsh 1988; Lerner 1991; McMann 1997.

URSULINE CONVENT. The Ursuline convent in Québec City, QC, was established by 1642, and soon housed many fine examples of early Québec religious sculpture and paintings (see Harper 1966, pp.

3-15). **Citations**: Morisset 1936; Traquair 1947; Gowans 1955; Harper 1966; Marsh 1988; Lerner 1991.
UU, DAVID (b1948), British Columbia. Painter, film and mixed media artist. **Citations**: NGC 1982; Lerner 1991.

V

VAILLANCOURT, ARMAND (b1932), Québec. Sculptor. **Citations**: Robillard 1973; NGC 1982; Lerner 1991.

VALENTINE, WILLIAM (1798-1849), Halifax, NS. Painter and photographer. During his earlier years, Valentine was a house painter and decorator. By 1830 he was travelling throughout the maritime provinces as an itinerant artist and, in 1844, he opened the first photographic studio in Halifax and introduced DAGUERREOTYPES to that city. **Citations**: Piers 1914; Nutt 1932; Morris; Harper 1964, 1966, 1970; Hubbard 1967; NGC 1982; Field 1985; McKendry 1988; Reid 1988; Lerner 1991; McMann 1997.

VALIN, JEAN (1691-1759), Québec. Sculptor in wood of religious subjects. **Citations**: Gauthier 1974; NGC 1982; Porter 1986; Lerner 1991.

VALLIERE, LAUREAT (1888-1973), Québec. Sculptor in wood of religious subjects. **Citations**: NGC 1982; Porter 1986; Lerner 1991.

VALLIERE(S), PHILIPPE (act. 1886), Québec. Sculptor in wood and maker of carved furniture. **Citations**: Porter 1986; Lerner 1991.

VAN IEPEREN, CORNELIUS (b1899), Consul, SK. Painter. Van Ieperen started painting in 1967, when he had to reduce other activities due to illness. A recurring theme in his work is the wide expanse of the prairies and the isolation of such an environment. **Citations**: Thauberger 1976; NGC 1982; NMM 1983; McKendry 1988.

VAN LAMBALGEN, GERALD (b1910), Saskatoon, SK. Painter. Van Lambalgen is a naïve painter who came to Canada in 1955. A painter from childhood, he soon developed some ability to handle perspective and scale appropriate to the prairie landscape. **Citations**: CCFCS; Thauberger 1976; McKendry 1988.

VANISHING POINT. A vanishing point as used in GEOMETRIC PERSPECTIVE (linear perspective) is the point at which lines forming an angle with the PICTURE PLANE converge. It is not usually used in FOLK ART. **Citations**: Pierce 1987; Piper 1988.

VARLEY, FREDERICK (FRED) HORSMAN (1881-1969), Toronto and Ottawa, ON; Vancouver, BC. Painter, portraitist and art teacher. Varley came from England to Toronto in 1912 and for a short time worked at GRIP LIMITED. He accompanied ARTHUR LISMER and A.Y. JACKSON on painting trips to ALGONQUIN PARK, and was an original member of the GROUP OF SEVEN. Varley painted portraits and landscapes, taught at the ONTARIO COLLEGE OF ART 1925-6, and was a founding member of the CANADIAN GROUP OF PAINTERS. Several of his paintings are in the NATIONAL GALLERY OF CANADA. **Citations**: MacTavish 1925; Robson 1932; NGC 1936, 1982; Colgate 1943; Buchanan 1945, 1950; McInnes 1950; Duval 1954, 1965, 1972; Jackson 1958; Hubbard 1960, 1960(1); Harper 1966; Groves 1968; Mellen 1970, 1978; Boggs 1971; Housser 1974; Lord 1974; Fenton 1978; Laing 1979, 1982; Tippett 1979; Laing 1979, 1982; Sisler 1980; Smith 1980; Osborne 1981; Varley 1981, 1983; Fairley 1981; Burnett/Schiff 1983; Bringhurst 1983; Thom 1985; McMichael 1986; Reid 1988; Piper 1988; Marsh 1988; Farr 1988; Lerner 1991; Hill 1995; Silcox 1996; McMann 1997.

VARNISH. Varnish is often used as a protective coating over a finished OIL PAINTING. In time such a coating may darken the painting and be difficult to remove. **Citations**: Osborne 1970; Mayer 1970; Chilvers 1988; Piper 1988.

VAULT. An architectural term for a roof (as viewed from the interior) based on the structural principle

of the ARCH. Early church ceilings are often vaulted. **Citations**: Osborne 1970; Lucie-Smith 1984.

VEHICLE. The liquid in which pigment is suspended. For example, in OIL PAINTING, it may be linseed oil or TURPENTINE, or both together. See also PAINT. **Citations**: Osborne 1970; Mayer 1970; Chilvers 1988.

VEHICULE ART GALLERY. Vehicule was founded in Montréal in 1972 as an artist-run gallery to foster alternatives to traditional art. The sculptor EVA BRANDL exhibited at this gallery. **Citations**: Bringhurst 1983; Reid 1988.

VERNACULAR ART. See FOLK ART.

VERNER, FREDERICK ARTHUR (1836-1928), Toronto, ON. Painter. Verner traveled extensively in the Canadian Northwest painting native people and animal life on the prairies, including a series of portraits of First Nations chieftains. He painted a portrait of his friend PAUL KANE, and occasionally tinted photographs. The best commentary on Verner's work is in Harper 1966,pp.151-5, and Murray 1984(2). Several paintings by Verner are in the NATIONAL GALLERY OF CANADA. See McMann 1997 for a dated list of paintings. **Citations**: Colgate 1943; Hubbard 1960, 1967; Eckhardt 1970; Render 1970; Harper 1966, 1970; Eckhardt 1970; Corbeil 1970; Watson 1974; Annett 1976; Sisler 1980; NGC 1982; Murray 1984(2); Marsh 1988; McKendry 1988; Lerner 1991; McMann 1997.

VERSION. See COPY.

VEZINA, CHARLES (1685-1755), Québec. Sculptor of decorations for churches. **Citations**: Traquair 1947; NGC 1982; Porter 1986; Lerner 1991.

VEZINA, EMILE (1876-1942), Montréal, QC. Painter. Vezina studied in Chicago but was back in Montréal c1900. He was a painter of landscapes and portraits. **Citations**: Laberge 1945; NGC 1982; Laliberté 1986; Lerner 1991; McMann 1997.

VICTORIAN. This term describes the art, ARCHITECTURE, and DECORATIVE ARTS produced during Queen Victoria's reign in Britain 1837-1901. It was preceded by REGENCY and GEORGIAN, and followed by Edwardian. See also REVIVALS, ECLECTICISM. **Citation**: Lerner 1991.

VIDAL, EMERIC ESSEX (1791-1861), Québec and Ontario. Painter. Vidal painted TOPOGRAPHICAL landscape paintings of various places from Halifax, NS, to Niagara Falls, ON, including sleighing scenes. **Citations**: Harper 1970; *Canadian Collector* 1975; Cooke 1983; McKendry 1988.

VIDEO ART. Video art is artistic expression through videotape displayed by television. See Marsh 1988 for a concise history of Video art in Canada. See also DAN GRAHAM, DON DRUICK, GENERAL IDEA, NOEL HARDING, TOM SHERMAN, and RODNEY WERDEN. **Citations**: Gale 1976, 1977; Ferguson 1980; Marsh 1988; Lerner 1991.

VIEW PAINTING. See TOPOGRAPHICAL PAINTING.

VIEWPOINT. A point selected by the artist as the point from which a viewer is to look at his work. It was particularly important for traditional ACADEMIC artists. Some artists, for example PICASSO, may use more than one viewpoint, and this is also the case for many folk artists. Selection of a viewpoint determines what parts of objects can be seen and which cannot. **Citations**: Pierce 1987.

VILLENEUVE, ARTHUR (b1910), Chicoutimi, QC. Painter. Villeneuve is a Chicoutimi barber who closed his shop and painted over 2000 works, because he believes he is complying with a divine mission to paint. He paints brightly coloured, dream-like visions in abstract patterns, based on the landscape of the region from Chicoutimi to Québec City, sometimes filling them with a ghostly multitude of strange creatures (see McKendry 1983, pl. 14). In 1972, the Montréal Museum of Fine Arts gave him a one-man show, *Arthur Villeneuve's Québec Chronicles*, that, in the words of J. Russell Harper, was at the time "Canada's most ambitious effort in recognition of Canadian primitives." (Harper 1974, p. 6). **Citations**: *artscanada* 1969; Gagnon 1972, 1979; Harper 1973 1974; Lord 1974; Wilkin 1976(1); NGC 1982; Bringhurst 1983; McKendry 1983, 1987, 1988; Kobayashi 1985(2); Lerner 1991.

VILLENEUVE, FERDINAND (1831-1909), Québec. Sculptor of religious works in wood. **Citations**: NGC 1982; Porter 1986.

VINCENT, ARTHUR (1852-1903), Montréal, QC. Sculptor of monuments and religious works.

Citations: NGC 1982; Laliberté 1986.

VINCENT, BERNICE (b1934), London, ON. Painter. **Citations**: NGC 1982; Tippett 1992.

VINCENT, ROBERT (b1905), Saskatoon, SK. Painter of naïve landscape and GENRE paintings. **Citations**: Thauberger 1976; NGC 1982; Millard 1984; McKendry 1988.

VINCENT, ZACHARIE dit TEHARIOLIN (1812-86), Lorette, QC. Painter. Vincent was the Chief of the Huron Tribe at Lorette, QC, and was taught rudiments of painting by ANTOINE SEBASTIEN PLAMONDON. Some of Vincent's landscapes appear to be free renditions of paintings by COR-NELIUS KRIEGHOFF. He painted numerous, vividly coloured, strong SELF-PORTRAITS with many details of costume and ornaments (see Harper 1966, pl. 80). For a portrait of Zacharie Vincent by EUGENE HAMEL, see Trudel 1967(peinture), pl. 23. **Citations**: Morisset 1959; NGC 1965, 1982; Trudel 1967(Peinture); Carter 1967; Harper 1966, 1970, 1973, 1974; McKendry 1988; Lerner 1991.

VIRGIN. See RELIGIOUS ART.

VIRGIN AND CHILD. See RELIGIOUS ART.

VISSER, JOHN DE (b1930), Port Hope, ON. Photographer and illustrator; RCA 1976. **Citations**: Symons 1971; Sisler 1980; NGC 1982; Hill 1988; Lerner 1991; McMann 1997.

VOGT, ADOLPHE (1843-71), Montréal, QC. Painter. After studying in Europe, Vogt was in Montréal by 1865 where he worked for WILLIAM NOTMAN'S studios with JOHN A. FRASER, HENRY SANDHAM and others. He specialized in painting horses and cattle, and made some copies of paintings by the French artist Rosa Bonheur (1822-99). He was a founding member of the SOCIETY OF CANADIAN ARTISTS. His work is represented in the NATIONAL GALLERY OF CANADA. **Citations**: Stevenson 1927; Colgate 1943; Hubbard 1960; Harper 1966, 1970; Sisler 1980; NGC 1982; Reid 1979, 1988; Lerner 1991; McMann 1997.

VON BAICH, PAUL (act. 1980), Ontario. Photographer. He studied photography at the Vienna Institute of Arts before coming to Canada in 1960. **Citations**: McKendry 1980; NGC 1982; Lerner 1991.

VOTIVE PAINTINGS. See EX-VOTO.

VOYER, MONIQUE (b1928), Québec. Painter. **Citations**: NGC 1982; Tippett 1992.

W

WAGSCHAL, MARION (b1943), Montréal, QC. Painter. **Citations**: NGC 1982; Tippett 1992.

WAINWRIGHT, RUTH (1902-84), Halifax, NS. Painter and textile artist. **Citations**: Lerner 1991; Lerner 1991; Tippett 1992.

WALKER, HORATIO (1858-1938), Ile d'Orléans, QC. Painter; RCA 1917. Walker sketched and painted many farm scenes in Québec including people with their domestic animals and poultry, such as oxen, horses, pigs and turkeys. In his own words: "I have passed the greatest part of my life in trying to paint ... the hard daily work of rural life, the sylvan beauty in which is spent the peaceable life of the habitant, the gesture of the wood cutter and the ploughman ..." The artist HOMER WATSON was a friend and they sketched together on the ILE D'ORLEANS in 1896. Several of Walker's paintings are in the NATIONAL GALLERY OF CANADA. See also BARBIZON SCHOOL. **Citations**: Britannica; Fairchild 1907; MacTavish 1925; Stevenson 1927; Price 1928; Chauvin 1928; NGC 1945; Buchanan 1945, 1950; Duval 1954; Jackson 1958; Hubbard 1960, 1960(1), 1967; Harper 1966, 1970; Osborne 1970; Mellen 1970; Boggs 1971; Watson 1974; Lord 1974; Farr 1977; Thibault 1978; London 1978; Mellen 1978; Laing 1979, 1982; Reid 1979, 1988; Sisler 1980; NGC 1982; McGill 1984; Laliberté 1986; Karel 1987; McKendry 1988; Marsh 1988; Lerner 1991; Hill 1995, Silcox 1996; McMann 1997.

WALKER, JOY (b1942), Ontario. Painter and printmaker. **Citations**: Murray 1980(2); NGC 1982; Lerner 1991

WALL ART. See MURAL.

WALLACE, WILLIAM (act. 1826), Québec. Painter. Wallace was a TOPOGRAPHICAL artist with the British Army. **Citations**: Harper 1970; Cooke 1983; Clavell 1988; McKendry 1988.

WALLIS, KATHERINE ELIZABETH (1861-1957), Ontario. Sculptor. Wallis's subjects included children and animals. Examples of her sculptures are in the NATIONAL GALLERY OF CANADA. **Citations**: Hubbard 1960; NGC 1982; Lerner 1991; Tippett 1992; McMann 1997.

WALSH, EDWARD (c1766-1832), Montréal, QC; Niagara, ON. Painter and illustrator. Walsh who was with the British Army, painted naïve TOPOGRAPHICAL landscape paintings in watercolour. He traveled extensively among the native people as far as the head of Lake Huron, sometimes in the company of SEMPRONIUS STRETTON. **Citations**: Spendlove 1958; Carter 1967; Harper 1964; 1966, 1970, 1973; Allodi 1974; Cooke 1983; McKendry 1988; Tippett 1991.

WALTER, Mrs (act. 1872), Ontario. Painter. Mrs Walter is known for a view of gold mines at Marmora, ON, (a subject also painted by SUSANNA MOODIE in 1870.) **Citations**: Tippett 1992.

WANDESFORD (WANDERSFORDE, WANDERFORD), JAMES (JUAN, IVAN) BUCKING-HAM (1817-1902), Ontario. Painter. Wandesford was an ITINERANT artist who painted portraits, landscapes, GENRE and flower paintings in watercolour, as well as MINIATURES on ivory. He was in Ontario from 1847-57. Some of his earlier portraits have naïve characteristics. **Citations**: Harper 1966, 1970; NGC 1982; McKendry 1988.

WARD, CHARLES CALEB (c1831-96), Saint John and Rothesay, NB. Painter and writer. Ward was in New Brunswick in 1856 and from 1882. He painted portraits and GENRE scenes that often included native people. **Citations**: Lumsden 1969; Harper 1970; NGC 1982; Lerner 1991.

WARKOV, ESTHER (b1941), Winnipeg, MB. Painter and sculptor. Warkov's figure paintings sometimes have deliberately naïve characteristics. **Citations**: Hubbard 1967; Lumsden 1970; Eckhardt 1970; Morris 1972; Harper 1976; Heath 1976; NGC 1982; McKendry 1988; Lerner 1991; Tippett 1992; McMann 1997.

WARRE, HENRY JAMES (1819-98), Eastern and Western Canada. Painter. Warre served in the British Army in Canada and traveled across the country to the Oregon Territory and to British Columbia. His work included TOPOGRAPHICAL landscape paintings and GENRE scenes with native people and other figures. **Citations**: NGC 1945, 1982; Spendlove 1958; Harper 1964, 1970; Eckhardt 1970; Bell 1973; Allodi 1974; Orobetz 1977; Peters 1978; Wight 1980; NGC 1982; Cooke 1983; Cavell 1988; McKendry 1988; Lerner 1991; Dickenson 1992.

WARTERS, WINIFRED M. (1898-1963), Winnipeg, MB. Painter. She executed a colourful winter street scene in Winnipeg with people and a teepee (Harper 1974, pl. 81). Warters, born in England, came in 1900 to Winnipeg, where she was a teacher until her retirement in 1940. She started painting in 1950 in a naïve folk style. **Citations**: Eckhardt 1970; Harper 1973, 1974; NGC 1982; McKendry 1988.

WASH. A Wash is diluted ink, or transparent watercolour, applied to paper, as in the case of a drawing, which would then be called a wash-drawing. **Citations**: Pierce 1987; Piper 1988; Chilvers 1988.

WATERCOLOUR. Watercolour painting is done with PIGMENTS bound with a MEDIUM (GUM arabic) which is soluble in water. Watercolour was widely used in Canada by the TOPOGRAPHICAL artists of the 19th century, as well as by other artists such as DANIEL FOWLER, HARLOW WHITE, OTTO JACOBI, ALAN EDSON, TONI ONLEY and many others. (See Harper 1966, pp. 193-206 and Duval 1954 for illustrations and comments on Canadian watercolour painting.) See also GOUACHE and CANADIAN SOCIETY OF PAINTERS IN WATERCOLOUR. **Citations**: Duval 1954; Harper 1966; Osborne 1970; Mayer 1970; Bell 1973; Allodi 1974; Boulet 1981(1),1981(2); Pierce 1987; Piper 1988; Chilvers 1988; Lerner 1991; Silcox 1996.

WATERCOLOUR SOCIETY. See CANADIAN SOCIETY OF PAINTERS IN WATER-COLOUR.

WATERLOO COUNTY. See MENNONITES.

WATSON, HOMER RANSFORD (1855-1936), Doon, ON. Painter and illustrator; RCA 1882. In 1874 Watson worked in the NOTMAN Photographic Studios in Toronto and by 1877 he was working as

an illustrator in Doon. After visiting England and Scotland and meeting artists there, he returned to Canada but continued to visit London, England. In Canada he sketched with HORATIO WALKER on the ILE D'ORLEANS, QC, in 1896. Watson was influenced by the BARBIZON SCHOOL of painting in his work of rural Ontario countryside. In 1907 Watson and EDMUND MORRIS founded the CANADIAN ART CLUB, and Watson was president of the ROYAL CANADIAN ACADEMY 1918-21. Several of Watson's paintings are in the NATIONAL GALLERY OF CANADA. See McMann 1997, pp. 417-20, for a dated list of paintings. **Citations**: Bridle 1916; MacTavish 1925; Stevenson 1927; Robson 1932; Hamilton 1936; Miller 1938, 1988; Page 1939; Colgate 1943; Buchanan 1945, 1950; McInnes 1950; Harper 1955, 1963, 1966, 1970; Hubbard 1960, 1960(1); VanEvery 1967; Adamson 1969; Osborne 1970; Mellen 1970, 1978; Boggs 1971; Lord 1974; London 1978; Laing 1979, 1982; Reid 1979, 1988; Sisler 1980; NGC 1982; Thom 1985; Karel 1987; Marsh 1988; Piper 1988; Chilvers 1988; Lerner 1991; McMann 1997.

WATSON, WILLIAM R. (1887-1973), Montréal, QC. Art dealer. Watson arrived in Montréal from England in 1908, and from that time until 1958 operated the Watson Art Galleries. He was instrumental in changing the taste of Canadian collectors from European paintings to Canadian paintings including those of the GROUP OF SEVEN. Watson was a friend of JAMES W. MORRICE, MAURICE CULLEN, CLARENCE GAGNON, ROBERT PILOT, A.Y. JACKSON and ARTHUR LISMER. For Watson's recollections as an art dealer, see Watson 1974. **Citations**: Jackson 1958; Watson 1974; Laing 1979, 1982; Lerner 1991; Hill 1995.

WAY, CHARLES JONES (1835-1919), Montréal, QC. Painter. Way emigrated from England to Montréal c1858 and painted landscapes in a romantic style (see ROMANTICISM). He painted in the Canadian Rocky Mountains c1898 for the Canadian Pacific Railway. Some of Way's paintings were photographed by WILLIAM NOTMAN and published in book form in 1863-4, and his paintings are represented in the NATIONAL GALLERY OF CANADA. **Citations**: Way 1863; Fairchild 1907; MacTavish 1925; Robson 1932; Colgate 1943; Dyonnet 1951, 1968; Hubbard 1960; Harper 1966, 1970; Thibault 1978; Sisler 1980; NGC 1982; McMann 1997.

WAYSIDE CROSS. See CALVARY.

WEATHERBIE, VERA OLIVIA (1909-77), Vancouver, BC. Painter and art teacher. **Citations**: NGC 1982; Tippett 1992.

WEAVER, JOHN (act. 1798), Halifax, NS. Painter. Weaver is said to be the first portrait painter in Halifax. **Citations**: Harper 1970; Dobson 1982; McKendry 1988.

WEBBER, GORDON MCKINLEY (1909-65), Montréal, QC. Painter. He was associated with the PRISME D'YEUX, but had a more conservative approach to painting than an artist such as ALBERT DUMOUCHEL. GUIDO MOLINARI studied under Webber at the MONTREAL MUSEUM OF FINE ARTS. **Citations**: CGP 1933; Duval 1972; NGC 1982; Burnett/Schiff 1983; Lerner 1991; McMann 1997.

WEBBER (WEBER, WABER), JOHN (JOHANN) (c1750-93), British Columbia. Painter. Webber was an English artist who accompanied Captain Cook in 1776 on his third voyage around the world, including a visit to Canada's west coast. Webber made drawings of west-coast scenes for the official account of the expedition published in 1784. See BRITISH COLUMBIA. **Citations**: Carter 1967; Harper 1964, 1970; Bell 1973; De Volpi 1973; NGC 1982; McKendry 1988; Lerner 1991.

WEBER, ANNA (1814-88), Waterloo County, ON. Painter. Weber, a MENNONITE, is known for her naïve decorative paintings in watercolour or ink of birds, animals and flowers with geometric borders, usually referred to as FRAKTUR art. Weber's work is whimsical and stylized, but sometimes includes identifiable turkeys, doves, peafowl, ducks, horses, foxes or tulips. She used bright colours with more freedom than usually found in fraktur work. **Citations**: Harper 1973, 1974; Good 1976; Bird 1977, 1981, 1983; McKendry 1983; Kobayashi 1985(2); McKendry 1988; Marsh 1988; Lerner 1991.

WEBSTER, CLARENCE (born c1900), Toronto, ON. Painter. Webster's work is mainly naïve anecdotal and narrative drawings in crayon, felt marker or pencil, of people in groups, enclosed in

decorative borders. Webster started to draw when confined to a nursing home, first working on the walls of his room and then on paper. His drawings usually have groups of figures arranged in colourful, flat and detailed linear patterns. About his work, Webster says: "It just comes natural to me, I just draw what I see in my head." Several examples of his work are in the CCFCS collections. **Citations**: CCFCS; NGC 1982; McKendry 1983, 1988; Kobayashi 1985(1).

WENTWORTH, THOMAS HANFORD (1781-1849), Saint John, NB. Painter and DAGUERREO-TYPIST. Wentworth was an itinerant artist who did portraits and MINIATURES. It has been said that he took more than 3000 pencil likenesses before 1824. (See Harper 1966, pl. 101, for Wentworth's *View of the Great Conflagration ... City of Saint John*, engraving 1839.) He was the father of WILLIAM HENRY WENTWORTH. **Citations**: Harper 1966, 1970; NGC 1982; McKendry 1988; Farr 1988; Lerner 1991.

WENTWORTH, WILLIAM HENRY (b1813, act. 1859), Oswego, New York. Painter. William Henry Wentworth, the son of THOMAS HANFORD WENTWORTH, worked with his father on the painting of the fire at Saint John, NB, 1839. **Citations**: Harper 1970.

WERDEN, RODNEY (b1946), Ontario. VIDEO artist. **Citations**: Gale 1977; NGC 1982; Bringhurst 1983; Lerner 1991.

WERTHEIMER, ESTHER (b1926), Québec. Painter and sculptor. **Citations**: Giannattasio 1977; NGC 1982; Lerner 1991; Tippett 1992.

WEST, JOHN (1778-1845), Fort Garry, MB. Painter. Some of West's paintings are similar to those of PETER RINDISBACHER. **Citations**: Harper 1970; McKendry 1988.

WEST WIND ISLAND. See Dr JAMES MACCALLUM.

WESTON, JAMES L. (c1815-96), Montréal, QC. Painter and illustrator. Weston, thought to have been in Montréal by 1840, was employed by the WILLIAM NOTMAN photographic firm 1870-82 (see Cavell 1988, pl. 74 and Guillet 1933, p. 276). **Citations**: Guillet 1933; de Volpi 1962; Harper 1970; Sisler 1980; NGC 1982; Cavell 1988; McKendry 1988; McMann 1997.

WESTON, WILLIAM PERCIVAL (PERCY) (1879-1967), Vancouver, BC. Painter. He arrived in Vancouver from England in 1909. **Citations**: British Columbia 1909; Thom 1980(3); NGC 1982; Lerner 1991.

WHALE, JOHN CLAUDE (1852-1905), Brantford, ON. Portrait and landscape painter. He was a son of ROBERT REGINALD WHALE. **Citations**: Robson 1932; Harper 1970; NGC 1982.

WHALE, JOHN HICKS (1829-1905), Brantford, ON. Portrait, landscape, decorative and mural painter. He was a nephew of ROBERT REGINALD WHALE. **Citations**: Harper 1970.

WHALE, ROBERT HEARD (1857-1906), Guelph and Brantford, ON. Landscape painter and art teacher. He was a son of ROBERT REGINALD WHALE. **Citations**: Harper 1970; NGC 1982.

WHALE, ROBERT REGINALD (1805-87), Brantford, ON. Portrait and landscape painter. After studying art in England and being influenced by the OEUVRE and ideas of Sir Joshua Reynolds (1723-92), Whale emigrated to Canada in 1852. He lived in Burford, ON, until 1864 when he moved to Brantford. He was the father of ROBERT HEARD WHALE and JOHN CLAUDE WHALE, and uncle of JOHN HICKS WHALE. See Harper 1966, pp. 142-4, for interesting comments on Whale and for illustrations of his work. Several of Whale's paintings are in the NATIONAL GALLERY OF CANADA. **Citations**: MacTavish 1925; Robson 1932; Hubbard 1960, 1960(1); Harper 1964; 1966, 1970; Lord 1974; London 1978; Mellen 1978; Sisler 1980; NGC 1982; Reid 1988; Lerner 1991; McMann 1997.

WHEELER, ORSON SHOREY (b1902), Montréal, QC. Sculptor; RCA 1954. Wheeler studied under EDMOND DYONNET and ELZEAR SOUCY, and in the USA. His work is represented in the NATIONAL GALLERY OF CANADA. **Citations**: Sisler 1980; NGC 1982; Laliberté 1986; Lerner 1991; McMann 1997.

WHITE, GEORGE HARLOW (1817-88), Oro Township and Toronto, ON. Painter. White emigrated from England to Canada c1870 and returned to England in 1877. He painted Ontario pioneer

scenes and sketched in the Rocky Mountains. White visited British Columbia in 1876. See Smith 1975(2) for the best information about this artist and for illustrations of his work. His paintings are represented in the NATIONAL GALLERY OF CANADA and the ART GALLERY OF ONTARIO. **Citations**: MacTavish 1925; Hammond 1930; Robson 1932; Colgate 1943; Hubbard 1960; Harper 1966, 1970; Smith 1975(2); Sisler 1980; Gilmore 1980; Lerner 1991; McMann 1997.

WHITE, JOHN CLAYTON (1835-1907), British Columbia. Painter and architect. White, a British army officer, was posted to British Columbia in 1859, and remained there as an architect after his discharge from the army. **Citations**: Harper 1970; Peters 1978, 1979; Gilmore 1980; NGC 1982; Lerner 1991.

WHITE, NORMAN (b1938), Vancouver, BC. Sculptor, painter and mixed media artist. **Citations**: Heath 1976; NGC 1982; Lerner 1991.

WHITEFIELD, EDWIN (1816-92), Dedham, Mass., USA. Painter, LITHOGRAPHER and author. Whitefield was an American artist who visited Canada in 1854 to make drawings and paintings of Canadian scenes, including cities from Niagara Falls, ON, to Tadoussac, QC. Many of his detailed drawings of Canadian cities were published as prints. **Citations**: Stokes 1933; Spendlove 1958; Morisset 1960; De Volpi 1964, 1965, 1966, 1971; Harper 1970; Allodi 1974; Norton 1977; NGC 1982; Lerner 1991.

WHITEN, COLETTE (b1945), Toronto, ON. Sculptor and instructor at the ONTARIO COLLEGE OF ART. **Citations**: Graham 1975; Monk 1978; NGC 1982; Marsh 1988; Lerner 1991; Tippett 1992.

WHITLOCK, AN (b1944), Ontario. Sculptor and artist of wall-hangings. **Citations**: Graham 1975; NGC 1982; Lerner 1991.

WHITTOME, IRENE F. (b1942), Québec. Sculptor. **Citations**: Fry 1980; NGC 1982; Lerner 1991; Tippett 1992; McMann 1997.

WHYTE, CATHARINE ROBB (1906-79), Alberta. Painter. She was the wife of PETER WHYTE. **Citations**: NGC 1982; Lerner 1991.

WHYTE, PETER (1905-66), Alberta. Painter. He was the husband of CATHARINE ROBB WHYTE. **Citations**: Wilkin 1980; NGC 1982; Lerner 1991.

WHYMPER, FREDERICK (1838-1908), British Columbia. TOPOGRAPHICAL painter and illustrator. Whymper, a British army officer, was on Vancouver Island 1863-5. (See De Volpi 1973, pl. 94-98, 129, 130.) **Citations**: Harper 1966, 1970; De Volpi 1973; Peters 1978, 1979; Gilmore 1980; NGC 1982; Lerner 1991.

WICKENDEN, ROBERT J. (1861-1931), Montréal, QC. Painter, writer and art critic. He studied in France and had a portrait studio in Montréal 1900-06. His work is represented in the NATIONAL GALLERY OF CANADA. **Citations**: Fairchild 1907; Laberge 1938; Hubbard 1960; Harper 1970; NGC 1982; Laliberté 1986; Lerner 1991; McMann 1997.

WIELAND, JOYCE (b1931), Toronto, ON; New York. Painter, filmmaker and sculptor. Wieland studied at the CENTRAL TECHNICAL SCHOOL, Toronto, and lived in New York with her husband MICHAEL SNOW 1962-70. Her work is represented in the NATIONAL GALLERY OF CANADA and the ART GALLERY OF ONTARIO. **Citations**: Wieland 1971; Withrow 1972; Fenton 1978; Sisler 1980; Osborne 1981; NGC 1982; Burnett/Schiff 1983; Bringhurst 1983; Marsh 1988; Reid 1988; Lerner 1991; Tippett 1992; McMann 1997.

WIITASALO, SHIRLEY (b1949), Ontario. Painter. **Citations**: Graham 1975; NGC 1982; Lerner 1991; Tippett 1992.

WILBER (WILBUR), A. RUTHERFORD (1869-1949), New Brunswick. Painter. **Citations**: Lumsden 1969; NGC 1982.

WILKINSON, JOHN B. (act. 1865-c1915), Québec. Painter and art teacher. In 1865 Wilkinson was teaching painting in Québec City and painting local Québec scenes. By 1874 he was living in Philadelphia, USA. **Citations**: Fairchild 1907; Harper 1970; Allodi 1974; NGC 1982; Cooke 1983.

WILLIAMS, ARCH (b1909), Ferryland, NF. Painter. Williams' paintings usually are naïve views of

the white houses and fences of Newfoundland communities, set against a background of rugged terrain and sea. Public interest in his work has been shown at exhibitions and through reproductions in publications. **Citations**: Grattan 1976, 1977, 1980; NGC 1982; NMM 1983; McKendry 1983, 1988; Lerner 1991.

WILLIAMS, EVA BROOK (DONLY). See EVA MARIE BROOK DONLY.

WILLIAMS, SAUL (b1954), Weagamow Lake, ON. Painter. Williams is a native artist who was influenced by NORVAL MORRISSEAU. **Citations**: McLuhan 1977, 1984; NGC 1982; Lerner 1991.

WILLIAMSON, ALBERT CURTIS (1867-1944), Toronto, ON. Painter; RCA 1907. Williamson painted portraits, GENRE scenes, interiors and landscapes, usually in a dark tonal style learned in Holland. In the early 1890s he painted in the vicinity of the village of BARBIZON, France. He was a friend of Dr JAMES MACCALLUM whose portrait he painted. (See Hubbard 1960, pp.333-4, for illustrations.) Several paintings by Williamson are in the NATIONAL GALLERY OF CANADA. **Citations**: MacTavish 1925; Robson 1932; Colgate 1943; McInnes 1950; Hubbard 1960; Harper 1966; Reid 1969, 1988; Sisler 1980; NGC 1982; McGill 1984; Marsh 1988; Lerner 1991; McMann 1997.

WILLIAMSON, R. STANLEY (1877-1968), Gananoque, ON. Sculptor and painter. Williamson, a stone-monument maker by trade, exhibited and sold his naïve paintings, carvings and models at country fairs and in a local hardware store. His most ambitious project may have been *Mountain City* which included models of many houses, business premises and working mills. **Citations**: CCFCS; NMM 1983; McKendry 1988.

WILSON, Sir DANIEL (1816-92), Toronto, ON. Painter. Wilson is known for amateur landscape paintings in watercolour of scenes in the areas of Muskoka, ON, and Lake Nipigon, ON, 1865-7, and in Québec. **Citations**: Robson 1932; Barbeau 1957(Québec); Harper 1970; Corbeil 1970; NGC 1982; Cooke 1983; McKendry 1988; Lerner 1991.

WILSON, JOHN FRANCIS (1865-c1941), Manitoba. Painter and illustrator. Wilson emigrated from England to Canada in 1888. His humorous paintings and sketches of farm life in Manitoba were published in *The Story of the Migration of Skivens and His First Year in Western Canada*, Toronto (prepared by Wilson for publication in 1900, but not published until 1962). **Citations**: Wilson 1962; NGC 1982; Harper 1970.

WILSON, ROBERT (SCOTTIE) (1889-1972), Toronto, ON. Painter. Wilson lived in Canada from the mid 1930s to 1945, when he returned to London, England. He began to draw about 1942 while in Canada. For the most part Wilson's work is naïve decorative designs and fantasies (see FANTASY ART) in watercolour, pencil, pen and ink, or crayon. See Marzolf 1989 for the best commentary on and illustrations of Wilson's work. **Citations**: Hubbard 1960; Bihalji-Merin 1971, 1985; Harper 1973, 1974; Barwick 1975; Osborne 1981; NGC 1982; Melly 1986; Chilvers 1988; McKendry 1983, 1988; Reid 1988; Marzolf 1989.

WINNIPEG SKETCH CLUB. The club was formed in 1914 and held exhibitions annually from 1916 to 1981. Among the early members were LIONEL LEMOINE FITZGERALD and MARY RITER HAMILTON. **Citations**: Winnipeg 1916; Perry 1970.

WISELBERG, ROSE (1908-92), Montréal, QC. Painter. Wiselberg was mainly a self-taught painter of views of Montréal and still-lifes. **Citations**: Kastel; NGC 1982.

WOMEN'S ART ASSOCIATION. The Women's Art Club, Toronto, was formed in 1887 by MARY E. DIGMAN. In 1890, the Club changed its name to Women's Art Association, and became the first national women's art organization. Annual exhibitions were held 1889-1901. The Association proposed the creation of the CANADIAN STATE DINNER SERVICE. The Montréal branch of the Association established the Canadian Handicraft Guild in 1906. **Citations**: CNE Catalogues; WAS 1889; Hopkins 1898; Hulbert 1929; Elwood 1977; Lerner 1991; Tippett 1992.

WOOD CARVING. Still important for sculptors, wood has been used for many centuries as a MEDIUM for RELIEF SCULPTURE and free-standing sculpture. Wood is a favoured medium for naïve and FOLK ART sculptors such as, ROBERT WYLIE, LOUIS JOBIN, FRED MOULDING, RENE

LAVOIE, GORDON LAW, IVAN LAW, WILLIAM LONEY, and ALFRED GARCEAU. Most of the early RELIGIOUS sculpture of Québec is wood, often covered in GESSO, decorated with gold leaf and/or painted. Important carvers include such family dynasties as BAILLAIRGE, PAQUET, LEVASSEUR, and BOURGAULT. Other carvers are JACQUES LEBLOND, GILLES BOLVIN, LOUIS-AMABLE QUEVILLON, AMABLE GAUTHIER, ALEXIS MILETTE, LABROSSE, NICOLAS MANNY, and PHILIPPE LIEBERT. Wood was the medium of choice for Northwest coast native MASKS and TOTEM POLES. See also BISHOP LAVAL; SAINT-JOACHIM SCHOOL; RETABLE; WOODCUT; WOOD ENGRAVING; CIGAR-STORE FIGURES; SHIPCARVINGS. **Citations**: Osborne 1970; Lerner 1991.

WOOD, ELIZABETH WYN (1903-66), Ontario. Sculptor; RCA 1948. She studied with EMANUEL HAHN and became his wife in 1926. Examples of her work are in the NATIONAL GALLERY OF CANADA. **Citations**: Colgate 1943; McInnes 1950; Hubbard 1960; Sisler 1980; NGC 1982; Marsh 1988; Lerner 1991; Tippett 1992; McMann 1997.

WOOD ENGRAVING. Wood engraving is a method of relief printing from a block of hardwood sawn across the grain and engraved with a BURIN. The incised areas print white. Wood engraving was developed in the 18th century and became a popular means of book illustration, see Moritz 1982. See STEEL ENGRAVING, and HENRY ERIC BERGMAN. **Citations**: Grant 1882; Hind 1908; Burch 1910; Short 1912; Plowman 1922; Spendlove 1958; Mayer 1970; Harper 1970; Eichenberg 1976; Allodi 1980; Moritz 1982; Chilvers 1988; Piper 1988; Lerner 1991.

WOOD, WILLIAM (BILL) JOHN (1877-1954), Midland, ON. Painter and printmaker. See Jackson 1958, pp.147-8 for comments on Wood's life and art. **Citations**: Housser 1929; Harper 1955; Jackson 1958; Adamson 1969; NGC 1982; Lerner 1991; McMann 1997.

WOODBLOCK. See WOODCUT

WOODCUT. Woodcut is the term for a technique of making a print from a block of wood, which has been sawn along the grain. Areas of design requiring no colour are cut away from the block. If there is to be more than one colour in the print, a separate block is used for each colour. The term is used both for the technique and the print. See also WALTER JOSEPH PHILLIPS. **Citations**: Burch 1910; Phillips 1926, 1930; Salaman 1930; Spendlove 1958; Mayer 1970; Eichenberg 1976; Allodi 1980; Chilvers 1988; Piper 1988; Lerner 1991.

WOOLFORD, JOHN ELLIOTT (1778-1866), Halifax, NS. Painter and architect. Woolford worked as an architect for the British army. He sketched along the French River in Ontario in the 1820s and visited Québec during the same period. **Citations**: Harper 1966, 1970; Allodi 1974; Armour 1975; *Canadian Collector* 1980; Wight 1980; NGC 1982; Lerner 1991; Kalman 1994.

WOOLNOUGH, HILDA MARY (b1934), Prince Edward Island. Painter. Woolnough studied in England and in Mexico. **Citations**: NGC 1982; Lerner 1991; Tippett 1992.

WOOLWICH MILITARY ACADEMY. See ROYAL MILITARY ACADEMY.

WREN, BERNIE (b1917), Langley, BC. Painter and sculptor. Wren's work includes naïve high-relief sculptures in POLYCHROMED wood of coastal landscape and views of logging scenes (see McKendry 1983, pl. 42-3). He began carving and painting in 1975, at a time when he was able to retire from a life of logging and carpentry, and soon received attention from the public through exhibitions and publication of his work. His own view is that: "I don't have a leg to stand on really. I'm not trained, I'm not nothin'. I'm not even young. I just tried it and found I was good at it." **Citations**: Mattie 1981; NGC 1982; NMM 1983; McKendry 1983, 1988; *Empress* 1985; Kobayashi 1985(2); CCFCS.

WRENSHALL, CHARLES E. (1838-1928), Kingston, ON. Painter. He emigrated from England about 1862. Wrenshall became principal of an art school (established in 1884) in Kingston from 1887 to 1903, when the school closed. His three daughters, Hattie, Edith and Anna, were painters. **Citations**: Harper 1970; Rollason 1982; Farr 1988.

WRIGHT, CHARLES (act1837), Québec. Painter. **Citations**: Béland 1992.

WRIGHT, GEORGE HAND (1872-1951), Westport, Conn., USA. Painter and illustrator. Wright was

an American artist who painted some scenes in Québec. **Citations**: Fielding 1974; Cooke 1983.

WRINCH, MARY E. See MARY E.WRINCH REID.

WYERS, JAN GERRIT (1888-1973), Windhorst, SK. Painter. Wyers , born in Holland, came in 1916 to Canada, where he became a night watchman at an Ontario camp for German prisoners of war. He started painting during the day with some help from one of the prisoners. He again took up painting about 1930 at the onset of the depression and after he was farming in Saskatchewan. Wyers has said: "I paint things I remember and sometimes paint from photographs. I have some books - one on horses, one on colours and one on drawing. I used to sketch with watercolours for small things but now I work straight-ahead with oil colours. Any kind of colour I can get." His work has received a great deal of attention through exhibitions and publications (see Harper 1966, p. 349; McKendry 1983, pl. 38; and Bringhurst 1983, p. 132). **Citations**: McCullough 1959; *Canadian Art* 1960; Harper 1966, 1973, 1974; Fenton 1970; Lord 1974; *artscanada* 1979; NGC 1982; Bringhurst 1983; McKendry 1983, 1988; Bihalji-Merin 1985; Lerner 1991.

WYLE, FLORENCE (1881-1968), Toronto, ON. Sculptor; RCA 1938. Wyle was born and studied in the USA. She moved to Toronto in 1913. Wyle was a founding member of the SCULPTORS' SOCIETY OF CANADA. She shared studio with FRANCES LORING. Several sculptures by Wyle are in the NATIONAL GALLERY OF CANADA. **Citations**: Colgate 1943; McInnes 1950; Hubbard 1960; Sisler 1972, 1980; NGC 1882; Marsh 1988; Lerner 1991; Tippett 1992; McMann 1997.

WYLIE, ROBERT A. (b1932), Thomasburg, ON. Sculptor. Wylie's work includes naïve religious, bird and animal sculptures in POLYCHROMED or monochromed wood, or in bronze. His sculptures are distinguished by clean lines, smooth polished surfaces, and abstract qualities. He has carved several crucifixes with Celtic crosses. Some of his figure carvings are stylized, for example, one of a horse with classical lines, of which copies have been cast in bronze. (See McKendry 1983, p. 263, pl. 81, 120.) **Citations**: McKendry 1983, 1988; Kobayashi 1985(1).

X Y Z

X-RAY STYLE. A style often found in aboriginal work in which the internal organs or bone structures of animals are indicated (see Janson 1977, pl. 8, and Sinclair 1979, p. 57). **Citations**: Patterson 1973; Janson 1977; Sinclair 1979.

XYLOGRAPHY. A seldom used term for any kind of printing from a wooden block. See WOODCUT; WOOD ENGRAVING. **Citations**: Piper 1988; Chilvers 1988.

YARD ART. This term is usually used for work by naïve artists intended to be placed outside, that is in the yard. See also EARTH ART. **Citations**: de Grosbois 1978; Grattan 1983.

YARWOOD, WALTER HAWLEY (b1917), Toronto, ON. Sculptor and painter. He was a member of PAINTERS ELEVEN. **Citations**: Harper 1966; Murray 1979; Sisler 1980; NGC 1982; Bringhurst 1983; Burnett/Schiff 1983; Lerner 1991; McMann 1997.

YATES, EDWARD NORMAN (b1923), Alberta. Painter, MURALIST and printmaker. **Citations**: Wilkin 1980; NGC 1982; Lerner 1991.

YORKE, W.H. (act. 1887), Québec City, QC. Painter. He is known for naïve paintings of ships. **Citations**: Harper 1970; Armour 1975; McKendry 1988.

YOUNG, JOHN CRAWFORD (1778-c1859), Québec Painter. Young was with the British Army and arrived in Québec in 1825. He was later posted to Montréal, Kingston and Toronto. He designed the 1828 Wolfe-Montcalm monument in Québec City and made sketches of costume and scenes in Québec. **Citations**: Roy 1923; Harper 1962, 1970; Allodi 1974; Cooke 1983.

YOUNG, THOMAS (1810-60), Toronto, ON. Painter and architect. He made a series of Toronto views that were LITHOGRAPHED by NATHANIEL CURRIER 1835-6, as well as a series of oil views

of Toronto. **Citations**: TSA 1847; Spendlove 1958; Harper 1964, 1970; Lerner 1991; Kalman 1994.

YURISTY, RUSSELL (RUSS) (b1936), Silton, SK. Sculptor, ceramicist and painter. Yuristy's work includes sculpture, ceramics, and paintings of people, cattle and other animals, farm machinery and vegetables. Although Yuristy has a wide background in art, he appears to have been influenced by FOLK ART. He has been quoted as saying: "The effect on my work of artists like MOLLY LENHARDT and W.C. McCARGAR and so on, is hard to assess. However, I do admire the generally direct approach these people take in their art and their dedication often in spite of no feedback from their peers. I try to see it not as 'folk' art." **Citations**: Ferguson 1976; *artscanada* 1979; NGC 1982; Bringhurst 1983;
Burnett/Schiff 1983; McKendry 1988; Lerner 1991.

ZACH, JAN (b1914), Victoria, BC. Sculptor. **Citations**: NGC 1982; Lerner 1991; Tippett 1992.

ZACK, BADANNA BERNICE (b1943), Toronto, ON. Sculptor and printmaker. **Citations**: Sisler 1980; NGC 1982; Lerner 1991; Tippett 1992; McMann 1997.

ZELENAK, EDWARD (ED) JOHN (b1940), West Lorne, ON. Sculptor. He shared a studio with WALTER REDINGER. **Citations**: Russell 1970; Sisler 1980; NGC 1982; Burnett/Schiff 1983; Lerner 1991; McMann 1997.

ZUBER, EDWARD (TED) (b1932), Kingston, ON. Painter and photographer. He was chosen as the official artist of the Canadian Armed Forces in the Persian Gulf crisis in 1991. **Citations**: NGC 1982.

ZEISSLER, WILLIAM (WILLY) (1902-91), Kingston, ON. Painter. Zeissler, a German emigrant, painted naïve landscapes, nudes and portraits. He portrayed his immediate neighbourhood, Portsmouth Village in Kingston. **Citations**: NGC 1982; McKendry 1988.

ZELDIN, GERALD (b1943), ON. Painter. **Citations**: Belshaw 1976; NGC 1982; Lerner 1991.

ZONTAL, JORGE. See GENERAL IDEA.

ZUCK, TIM (b1947), Nova Scotia. Painter. Zuck's work shows influence by folk traditions and has a maritime aspect. **Citations**: Spalding 1980; NGC 1982; Bringhurst 1983; Burnett/Schiff 1983; Lerner 1991.

ZWICKER, MARY MARGUERITE PORTER (b1904), Nova Scotia. Painter. **Citations**: NGC 1982; Tippett 1992.

BIBLIOGRAPHY

A

AGNS Information from the files of the Art Gallery of Nova Scotia.

ADAMSON 1969 Jeremy Adamson. *The Hart House Collection of Canadian Paintings.* Toronto: University of Toronto Press.

ADAMSON 1974 Anthony Adamson. *The Gaiety of Gables: Ontario Architectural Folk Art.* Toronto: McClelland & Stewart.

ADDISON 1969 Ottelyn Addison. *Tom Thomson: The Algonquin Years.* Toronto: Ryerson Press.

AGO 1969 Art Gallery of Ontario. *Canadian Cartoon and Caricature.* Toronto: Art Gallery of Ontario.

AIMERS 1981 Cotton Aimers. *Gordon E. Pfeiffer.* Montréal: Alain Stanke.

AINSLIE 1986 Patricia Ainslie. *The Wood Engravings of Laurence Hyde.* Calgary: Glenbow Museum.

ALBERTA 1981 *Public Art in Alberta: the Results of a 1980 Survey.* Edmonton: n.p.

ALLEN 1970 Ralph Allen. *André Biéler 50 Years: A Retrospective Exhibition 1920-1970.* Kingston: Agnes Etherington Art Centre.

ALLODI 1974 Mary Allodi. *Canadian Watercolours and Drawings in the Royal Ontario Museum.* Toronto: Royal Ontario Museum.

ALLODI 1980 Mary Allodi. *Printmaking in Canada: The Earliest Views and Portraits.* Toronto: Royal Ontario Museum.

ALLODI 1989 Mary Allodi and Rosemarie L. Tovell. *James Smillie: An Engraver's Pilgrimage in Québec 1821-1830.* Toronto: Royal Ontario Museum.

ANDRE 1967 John Andre. *William Berczy, Co-Founder of Toronto.* Toronto: Borough of York.

ANDRUS 1966 Donald F.P. Andrus. *Artists of Atlantic Canada.* Ottawa: National Gallery of Canada.

ANDRUS 1968 Donald F.P. Andrus. *Drawings and Pastels c1930-1967 by Miller Gore Brittain.* Fredericton: Beaverbrook Art Gallery.

ANDRUS 1974 Donald F.P. Andrus. *Annie Savage: Drawings and Watercolours.* Montréal: Sir George Williams Art Galleries.

ANNETT 1975 Margaret R. Annett. *Dawn, an Exhibition by Women Artists of British Columbia.* Vancouver: University of British Columbia.

ANNETT 1976 Margaret R. Annett. *Frederick Arthur Verner: Paintings, Watercolours, Drawings.* Journal no. 20. Ottawa: National Gallery of Canada.

ANTONIOU 1981 Sylvia A. Antoniou. *Anne Kahane: Sculpture, Prints and Drawings, 1953-1976.* Hamilton: McMaster Univesity.

ANTONIOU 1982 Sylvia Antoniou. *Maurice Cullen 1866-1934.* Kingston: Agnes Etherington Art Centre.

ARMITAGE 1933 Merle Armitage. *Henrietta Shore.* New York: E. Weyhe.

ARMOUR 1975 Charles A. Armour and Thomas Lackey. *Sailing Ships of the Maritimes.* Toronto: McGraw-Hill Ryerson.

ARMSTRONG 1976 Tom Armstrong, Wayne Craven, Norman Feder, Barbara Haskell, Rosalind Krauss, Daniel Robbins, Marcia Tucker. *200 Years of American Sculpture.* New York: David R. Godine.

ARMSTRONG 1979 Audrey Armstrong. *The Blacksmith of Fallbrook: The Story of Walter Cameron, Blacksmith, Woodcarver, Raconteur.* Don Mills, ON: Musson Book Company.

ARNASON 1968 H.H. Arnason. *History of Modern Art.* New York: Harry N. Abrams.

ART GALLERY OF WINDSOR Information from the files of the Art Gallery of Windsor.

ARTISAN'78 A catalogue of contemporary Canadian crafts. Ottawa: Canadian Crafts Council.

artscanada Periodical. Bimonthly, Society for Arts Publications, Toronto, 1943-.

ARTS OF FRENCH CANADA *The Arts of French Canada 1613-1870.* Detroit: Detroit Institute of Arts, 1946.

ATKINSON 1976 Bobby Atkinson. *Québec Nostalgie.* Toronto: Collins Publishers.

AYRE 1963 Robert Ayre. *A Retrospective Exhibition of the Work of André Biéler.* Kingston: Agnes Etherington Art Centre.

AYRE 1977 Robert Ayre. *The Laurentians: Painters in a Landscape.* Toronto: Art Gallery of Ontario.

B

BAIGELL 1981 Matthew Baigell. *Albert Bierstadt.* New York: Watson-Guptill Publications.

BAKER 1980 Suzanne Devonshire Baker. *Artists of Alberta.* Edmonton: University of Alberta Press.

BAKER 1980(2) Victoria Baker. *L'Art des cantons de l'est 1800-1950.* Sherbrooke: Université de Sherbrooke.

BAKER 1981 Victoria A. Baker. *Images of Charlevoix 1784-1950.* Montréal: Montréal Museum of Fine Arts.

BALKIND 1971 Alvin Balkind. *Joe Plaskett and his*

Paris: In Search of Time Past. Vancouver: University of British Columbia.

BALKIND 1977 Alvin Balkind and Ann Pollock. *From This Point of View: 60 British Columbia Painters, Sculptors, Photographers, Graphic and Video Artists*. Vancouver: Vancouver Art Gallery.

BALLANTYNE 1848 Robert Michael. *Hudson's Bay; or, Everyday Life in the Wilds of North America*. Edinburgh and London.

BANFF 1977 *Enns, Evans and Ulrich*. Banff, Alberta: Walter J. Phillips Gallery.

BARBEAU 1928 Marius Barbeau. *Exhibition of Canadian West Coast Art*. Toronto: Art Gallery of Ontario.

BARBEAU 1934 Marius Barbeau. *Cornelius Krieghoff, Pioneer Painter of North America*. Toronto: Macmillan.

BARBEAU 1934(1) Marius Barbeau. *Au Coeur de Québec*. Montréal: Editions du Zodiaque.

BARBEAU 1936 Marius Barbeau. *Québec Where Ancient France Lingers*. Québec: Librairie Garneau.

BARBEAU 1936(1) Marius Barbeau. *Kingdom of the Saguenay*. Toronto: MacMillan.

BARBEAU 1938 Marius Barbeau. *Henri Julien, 1851-1908: Memorial Exhibition*. Ottawa: National Gallery of Canada.

BARBEAU 1941 Marius Barbeau. *Henri Julien*. Toronto: Ryerson Press.

BARBEAU 1942 Marius Barbeau. *Maîtres artisans de chez-nous*. Montréal: Editions du Zodiaque.

BARBEAU 1943 Marius Barbeau. *Coté the Wood Carver*. Toronto: Ryerson Press.

BARBEAU 1946 Marius Barbeau. *Painters of Québec*. Toronto: Ryerson Press.

BARBEAU 1948 Marius Barbeau. *Cornelius Krieghoff*. Toronto: Ryerson Press.

BARBEAU 1950 Marius Barbeau. *Totem Poles*. 2 vols. Ottawa: National Museum of Canada.

BARBEAU 1955 Marius Barbeau. *The Tree of Dreams*. Illustrated by Arthur Price. Toronto: Oxford University Press.

BARBEAU 1957 (Québec) Marius Barbeau. *I Have Seen Québec*. Toronto: Macmillan.

BARBEAU 1957 (TRESOR) Marius Barbeau. *Trésor des Anciens Jesuites*. Ottawa: Musée National du Canada.

BARBEAU 1957 (HAIDA) Marius Barbeau. *Haida Carvers in Argillite*. Ottawa: National Museum of Canada.

BARBEAU 1958 Marius Barbeau. *Medicine-Men on the North Pacific Coast*. Ottawa: National Museum of Canada.

BARBEAU 1960 Marius Barbeau. *Indian Days on the Western Prairies*. Ottawa: National Museum of Canada.

BARBEAU 1961 Marius Barbeau. *Tsimsyan Myths*. Ottawa: Department of Northern Affairs and National Resources.

BARBEAU 1962 Marius Barbeau. *Cornelius Krieghoff*. Toronto: McClelland & Stewart.

BARBEAU 1968 Marius Barbeau. *Louis Jobin Statuaire*. Montréal: Librairie Beauchemin.

BARBEAU 1973 Marius Barbeau. *Ceinture Fléchée*. Québec: Editions l'Etincelle.

BARBEAU 1973(1) Marius Barbeau. *The Downfall of Temlaham*. Edmonton: Hurtig Publishers.

BARNET 1975 Will Barnet. *Marion Nicoll: A Retrospective, 1959-1971*. Edmonton: Edmonton Art Gallery.

BARRAS 1970 Henri Barras. *Fernand Toupin*. Paris, France: Galerie Arnaud.

BARRETT 1976 Harry B. Barrett. *The 19th-Century Journals and Paintings of William Pope*. Toronto: M.F. Feheley Publishers .

BARRIO-GARAY 1981 Jose L. Barrio-Garay, Roso Woodman, Paddy O'Brien. *Jack Chambers: The Last Decade*. London, ON: London Regional Art Gallery.

BARSS 1980 Peter Barss. *Older Ways, Traditional Nova Scotia Craftsmen*. Toronto: Van Nostrand Reinhold.

BARWICK 1975 Frances Duncan Barwick. *Pictures from the Douglas M. Duncan Collection*. Toronto: University of Toronto Press.

BATES 1973 Maxwell Bates. *Maxwell Bates in Retrospect 1921-1971*. Vancouver: Vancouver Art Gallery.

BAYER 1984 Fern Bayer. *The Ontario Collection*. Markham: Fitzhenry & Whiteside.

BAZIN 1980 Jules Bazin. *Cosgrove*. Québec: Marcel Broquet.

BC ART 1981 *British Columbia Art Collection , 1974-80*. Victoria: Cultural Services Branch.

BC SCULPTORS 1976 Sculptors' Society of British Columbia. *A Preview Look at Large Outdoor Sculptures...* Vancouver.

BEAMENT 1968 Harold Beament and Thomas R. MacDonald. *Robert W. Pilot Retrospective*. Montréal: Montréal Museum of Fine Arts.

BEAULIEU 1981 Michel Beaulieu. *P.V. Beaulieu*. LaPrairie: Marcel Broquet.

BELAND 1986 Mario Béland. *Louis Jobin: Master Sculptor*. Québec: Musée du Québec.

BELAND 1991 Mario Béland. *La peinture au Québec 1820-1850*. Québec: Musée du Québec.

BELAND 1992 Mario Béland. *Painting in Québec 1820-1850*. Québec: Musée du Québec.

BELL 1973 Michael Bell. *Painters in a New Land from Annapolis Royal to the Klondike*. Toronto: McClelland & Stewart .

BELL 1976 Michael Bell and Goodridge Roberts. *William Goodridge Roberts 1904-1974: Drawings*. Kingston: Agnes Etherington Art Centre.

BELL 1978 Michael Bell. *W. Sawyer, Portrait Painter*. Kingston: Agnes Etherington Art Centre.

BELL 1980 Lynne Bell. *The University of Saskatchewan Permanent Art Collection*. Saskatoon: University of Saskatchewan.

BELL 1982 Lynne S. Bell. *Dmytro Stryjek*. Saskatoon: Mendel Art Gallery.

BELLERIVE 1925 Georges Bellerive. *Artistes - peintres canadiens-françois: les anciens*. Québec: Librairie Garneau.

BELSHAW 1976 Linda Belshaw. *Four Ontario Realists*. Brantford: Art Gallery of Brant.

BENGLE 1974 Celine Bengle. *Evolution picturale de l'oeuvre de Guido Molinari*. Maitrise. Montréal: Université de Montréal.

BENGOUGH 1974 J.W. Bengough. *A Caricature History of Canadian Politics*. Toronto: Peter Martin Associates.

BENHAM 1977 Mary Lile Benham. *Paul Kane*. Toronto: Fitzhenry & Whiteside.

BENNETT 1971 Paul Bennett. *Alan C. Collier Retrospective*. Oshawa: Robert McLaughlin Gallery.

BENNETT 1983 Lynn Bennett and Catherine Williams. *Tales of Old Toronto, the Folk Art of William J. Davis*. Toronto: Lester and Orpen Dennys.

BERGERON 1946 René Bergeron. *Art et Bolchevisme*. Montréal: Fidés.

BERRY-HILL 1968 Henry Berry-Hill and Sidney Berry-Hill. *Ernest Lawson: American Impressionist 1873-1939*. Leigh-on Sea, England: F. Lewis.

BIELER 1941 André Biéler and Elizabeth Harrison, eds. *The Kingston Conference of Canadian Artists*. Kingston: Conference of Canadian Artists.

BIGSBY 1850 John Jeremiah Bigsby. *The Shoe and Canoe or Picture of Travel in the Canadas*. London: Chapman & Hall.

BIHALJI-MERIN 1971 Oto Bihalji-Merin. *Modern Primitives*. London: Thames & Hudson.

BIHALJI-MERIN 1985 Oto Bihalji-Merin and Nebojsa-Bato Tomasevic. *World Encyclopedia of Naïve Art*. Scranton: Scala/Philip Wilson.

BINGHAM 1979 Russell Bingham. *The Alberta Landscape*. Edmonton: Edmonton Art Gallery.

BINGHAM 1980 Russell Bingham. *Alberta Now*. Edmonton: Edmonton Art Gallery.

BINGHAM 1981 Russell Bingham. *The Big Picture: Large Scale Landscape Painting on the Prairies*. Edmonton: Edmonton Art Gallery.

BIRD 1977 Michael S. Bird. *Ontario Fraktur*. Toronto: M.F.Feheley Publishers.

BIRD 1981 Michael Bird and Terry Kobayashi. *A Splendid Harvest*. Toronto: Van Nostrand Reinholdt

BIRD 1983 Michael Bird. *Canadian Folk Art*. Toronto: Oxford University Press.

BIRD 1994 Michael Bird. *Canadian Country Furniture 1675-1950*. Toronto: Stoddart.

BIRRELL 1978 Andrew Birrell. *Benjamin Baltzly: Photographs and Journal of an Expedition Through British Columbia 1871*. Toronto: Coach House.

BISHOP 1974 Robert Bishop. *American Folk Sculpture*. New York: E.P. Dutton & Co.

BISHOP 1979 Robert Bishop. *Folk Painters of America*. New York: E.P. Dutton & Co.

BISMANIS 1980 Maija Bismanis. *The Continental Clay Connection*. Regina: Norman Mackenzie Art Gallery.

BLACK 1966 Mary Black and Jean Lipman. *American Folk Painting*. New York: Bramhall House.

BLACKSTOCK 1977 C.R. Blackstock. *Hagan: The Mind and the Hand*. Grimsby, ON: Grimsby Public Library and Art Gallery.

BLAIN 1982 Brad Blain. *Heritage Waterloo, the Art of Woldemar Neufeld*. Kitchener, ON: Kitchener-Waterloo Art Gallery.

BOGGS 1971 Jean Sutherland Boggs. *The National Gallery of Canada*. Toronto: Oxford University Press.

BORCOMAN 1969 James Borcoman, Robert Ayre, Alfred Pinsky, Goodridge Roberts. *Goodridge Roberts: A Retrospective Exhibition*. Ottawa: National Gallery of Canada.

BORCOMAN 1988 James Borcoman. *Intimate Images: 129 Daguerreotypes 1841-1857*. Ottawa: National Gallery of Canada.

BORDUAS 1948 Paul-Emile Borduas. *Refus global*. Montréal: Mithra-Myth.

BORDUAS 1978 Paul-Emile Borduas. *Paul-Emile Borduas Writings 1942-1958*. Halifax: Press of Nova Scotia College of Art and Design.

BORSA 1983 Joan Borsa. *Seven Saskatchewan Folk Artists*. Saskatoon: Mendel Art Gallery.

BOUCHARD 1978 Laurent Bouchard and Michel Champagne. *René Richard*. Québec: Musée du Québec.

BOUCHARD 1979 Claude A. Bouchard. *Henri Masson: la vision d'un peintre*. Ottawa: Lecha.

BOULANGER 1973 Rolland Boulanger, John Browne, François Bujold, Georges Dor, C.-L. Gagnon, Armand Hoog, Gaston Laurion, Gaston Miron, M.-F. O'Leary. *La Sculpture de Suzanne Guite*. Montréal: Aquila.

BOULET 1977 Roger Boulet. *Frederic Marlett Bell-Smith (1846-1923)*. Victoria: Art Gallery of Greater Victoria.

BOULET 1981 (1) Roger Boulet. *The Tranquility and the Turbulence*. Markham: M. B. Loates Publishing.

BOULET 1981 (2) Roger Boulet. *Toni Onley: A*

Silent Thunder. Thornhill: Cerebrus.

BOULIZON 1989 Guy Boulizon, Yvon Daigle and Anne-Marie Bost. *Naïfs - Ces Peintres du Québec et de L'Acadie*. Ville Saint-Laurent: Editions du Trécarré.

BOVAY 1976 Emile Henri Bovay. *Le Canada et les Suisses, 1604-1974*. Fribourg, Suisse: Editions universitaires Fribourg.

BOVEY 1975 Patricia E. Bovey. *Lionel LeMoine FitzGerald, Bertram Brooker: Their Drawings*. Winnipeg: Winnipeg Art Gallery.

BOVEY 1976 Patricia E. Bovey. *The Railway: Patron of the Arts in Canada*. Winnipeg: Winnipeg Art Gallery.

BOVEY 1978 Patricia E. Bovey. *Lionel LeMoine FitzGerald: L'evolution d'un artiste*. Winnipeg: Winnipeg Art Gallery.

BOYANOSKI 1982 Christine Boyanoski. *Sight and Insight*. Toronto: Art Gallery of Toronto.

BRADFIELD 1970 Helen Pepall Bradfield. *Art Gallery of Ontario: The Canadian Collection*. Toronto: McGraw-Hill.

BRAIDE 1979 Janet Braide. "William Brymner (1855-1925): The Artist in Retrospect." M.F.A. Thesis. Concordia University.

BRAIDE 1980 Janet Braide. *Prudence Heward (1896-1947): An Introduction to her Life and Work*. Montréal: Walter Klinkhoff Gallery.

BRIDGES 1977 Marjorie Lismer Bridges. *A Border of Beauty, Arthur Lismer's Pen and Pencil*. Toronto: Red Rock Publishing.

BRIDLE 1916 Augustus Bridle. *Sons of Canada*. Toronto: Dent.

BRIDLE 1945 Augustus Bridle. *The Story of the Club*. Toronto: The Arts and Letters Club.

BRINGHURST 1983 Robert Bringhurst, Goeffrey James, Russell Keziere, Doris Shadbolt, eds. *Visions: Contemporary Art in Canada*. Vancouver: Douglas & McIntyre.

BRITANNICA Milton Rugoff, ed. *The Britannica Encyclopedia of American Art*. Chicago: Encyclopedia Britannica.

BRITISH COLUMBIA 1909 British Columbia Society of Artists. *Annual Exhibitions 1909-1967*. Vancouver.

BRITISH COLUMBIA 1932 *B.C. Artists Annual Exhibition 1932-1968*. Vancouver: Vancouver Art Gallery.

BROWN 1964 F. Maud Brown. *Breaking Barriers: Eric Brown and the National Gallery*. Ottawa: Society for Art Publications.

BROWN 1975 Lynn Hutchinson Brown. *Leonard Hutchinson, People's Artist: Ten Years Struggle, 1930-1940*. Toronto: NC Press.

BROWN 1981 Annora Brown. *Sketches from Life*. Edmonton: Hurtig Publishers.

BRUCE 1982 William Blair Bruce. *Letters Home: 1859-1906*. Moonbeam: Penumbra Press.

BRUNET 1951 Pierre Brunet. *Descriptive of a Collection of Water-colour Drawings by Alfred Jacob Miller (1810-1874) in the Public Archives of Canada*. Ottawa: King's Printer.

BUCHANAN 1936 Donald W. Buchanan. *James Wilson Morrice*. Toronto: Ryerson Press.

BUCHANAN 1945 Donald W. Buchanan, ed. *Canadian Painters: From Paul Kane to the Group of Seven*. Oxford: Phaidon Press

BUCHANAN 1947 Donald W. Buchanan. *James Wilson Morrice*. Toronto: Ryerson Press.

BUCHANAN 1950 Donald W. Buchanan. *The Growth of Canadian Painting*. Toronto: Collins.

BUCHANAN 1960 Donald W. Buchanan and Paul Gladu. *Alfred Pellan*. Ottawa: National Gallery of Canada.

BUCHANAN 1962 Donald W. Buchanan. *Alfred Pellan*. Toronto: McClelland & Stewart.

BUERSCHAPER 1977 Peter Buerschaper. *Arctic Journey*. Toronto: Pagurian Press.

BULL 1934 William Perkins Bull. *The Perkins Bull Collection*. Brampton: By the author.

BURCH 1910 R. M. Burch. *Colour Printing and Colour Printers*. London: Sir Isaac Pitman and Sons.

BURLEIGH 1980 H.C. Burleigh. *Tales of Amherst Island*. Kingston: By the author.

BURLINGAME 1954 Robert Burlingame. *Marsden Hartley: A Study of his Life and Creative Achievement*. Providence: Brown University.

BURNETT 1983 David Burnett. *Colville*. Toronto: Art Gallery of Ontario.

BURNETT 1986 David Burnett. *Town*. Toronto: Art Gallery of Ontario.

BURNETT/SCHIFF 1983 David Burnett and Marilyn Schiff. *Contemporary Canadian Art*. Edmonton: Hurtig Publishers.

BURNHAM 1972 Harold B. Burnham and Dorothy K. Burnham. *Keep Me Warm One Night*. Toronto: University of Toronto Press.

BURNHAM 1981 Dorothy K. Burnham. *The Comfortable Arts: Traditional Spinning and Weaving in Canada*. Ottawa: National Gallery of Canada.

BURNHAM 1986 Dorothy K. Burnham. *Unlike the Lilies, Doukhobor Traditions in Canada*. Toronto: Royal Ontario Museum.

BURNS 1977 Florence Burns. *M. William Berczy*. Toronto: Fitzhenry & Whiteside.

BUSHNELL 1940 David I. Bushnell. *Sketches by Paul Kane in the Indian Country, 1845-1848*. Washington: Smithsonian Institution.

C

CAHILL 1950 Holger Cahill. *The Index of American Design*. Washington: National Gallery of Art.

CALLAGHAN 1975 Barry Callaghan. *Ronald: 25 Years*. Oshawa: Robert McLaughlin Gallery.

CALLEN 1982 Anthea Callen. *Techniques of the Impressionists*. Secaucus: Chartwell Books.

CAMERON 1976 Christina Cameron and Jean Trudel. *The Drawings of James Cockburn: A Visit Through Québec's Past*. Toronto: Gage Publishing.

CAMERON 1989 Christina Cameron. *Charles Baillairgé: Architect and Engineer*. Montréal: McGill-Queen's University Press.

CAMPBELL 1907. Wilfred Campbell. *Canada Painted by T. Mower Martin R.C.A.* London: A. & C. Black.

CAMPBELL 1971 Henry C. Campbell. *Early Days on the Great Lakes, the Art of William Armstrong*. Toronto: McLelland & Stewart .

CANADIAN ANTIQUES AND ART REVIEW Periodical. Canadian Antiques and Art Review, Halifax, 1979-81.

CANADIAN ART Periodical. Quarterly, Maclean Hunter & Key Publishers, Toronto, 1984-.

CANADIAN ART REVIEW Periodical. See also *RACAR*, 1974-.

CANADIAN COLLECTOR Periodical. Canadian Antiques and Fine Arts Society, Toronto, 1975-86.

CANADIAN GEOGRAPHICAL JOURNAL Periodical. Royal Canadian Geographical Society, Ottawa, 1930-78 and, as the *Canadian Geographic*, 1978-.

CANADIAN ILLUSTRATED NEWS Periodical. Weekly, Desbarats Company, Montréal, 1869-83.

CARPENTER 1981 Ken Carpenter. *The Heritage of Jack Bush: A Tribute*. Oshawa: Robert McLaughlin Gallery.

CARR 1946 Emily Carr. *Growing Pains*. Toronto: Oxford University Press.

CARR 1953 Emily Carr. *Pause: A Sketch Book*. Toronto: Clarke, Irwin.

CARR 1966 Emily Carr. *Hundreds and Thousands*. Toronto: Clarke, Irwin.

CARR 1972 Emily Carr. *Fresh Seeing: Two Addresses by Emily Carr*. Toronto: Clarke, Irwin.

CARROLL 1912 Luscombe Carroll. *Catalogue of an Exhibition of Water Colours Representing the "Canadian Rockies" by Charles John Collings*. London: Carroll Gallery.

CARTER 1967 David G. Carter. *The Painter and the New World*. Montréal: Montréal Museum of Fine Arts.

CARTER 1968 David G. Carter, Harold Beament and T. R. MacDonald. *Robert W. Pilot Retrospective*. Montréal: Montréal Museum of Fine Arts.

CARTER 1975 Alexandra E. Carter. *Lyttleton's View of Halifax: Microscopic Cosmos*. Bulletin 25. Ottawa: National Gallery of Canada.

CASSON 1982 A. J. Casson. *My Favourite Watercolours 1919-1957*. Toronto: Cerebrus/Prentice Hall.

CAUCHON 1971 Michel Cauchon. *Jean-Baptiste Roy-Audy*. Québec: Ministère des Affaires Culturelles.

CAVELL 1988 Edward Cavell and Dennis Reid. *When Winter Was King*. Banff: Altitude Publishing.

CCFCS Information from the files at the Canadian Centre for Folk Culture Studies, Canadian Museum of Civilization, Ottawa.

CENTURY HOME Periodical. Bluestone House, Port Hope, ON.

CGP 1933 Canadian Group of Painters. *Exhibition*. Annual catalogues, 1933-1968. Art Gallery of Toronto and National Gallery of Canada.

CHAMBERS 1978 Jack Chambers. *Jack Chambers*. London: Nancy Poole.

CHAMPLAIN 1911 Samuel de Champlain. *The Voyages and Explorations of Samuel de Champlain (1604-1616)*. 2 vols. Reprint ed. Toronto: Courier Press.

CHAUVIN 1928 Jean Chauvin. *Ateliers*. Montréal: Louis Carrier.

CHICOINE 1970 Rene Chicoine. *Armand Filion: sculpteur*. Montréal: Québec Sculptors' Association.

CHILVERS 1988 Ian Chilvers and Harold Osborne, eds. *The Oxford Dictionary of Art*. Oxford: Oxford University Press.

CHIPP 1968 Herschel B. Chipp. *Theories of Modern Art*. Berkeley: University of California Press.

CHRISTIE 1976 Robert Christie. *Douglas Bentham: "Enclosures and Opens" 1975/76*. Toronto: York University Art Gallery.

CHRISTIE 1980 Robert Christie. *Watercolour Painting in Saskatchewan 1905-1980*. Saskatoon: Mendel Art Gallery.

CHRONICLE AND GAZETTE Newspaper. Kingston, 1833-47.

CITY & COUNTRY HOME Periodical. MacLean Hunter, Toronto.

CLARK 1970 Ian Christie Clark. *Indians and Eskimo Art of Canada*. Barcelona: Ediciones Poligrafa.

CLAY 1978 Jean Clay. *From Impressionism to Modern Art*. Secaucus, N.J.: Chartwell Books.

CLIMER 1967 John Climer. *Eleven Saskatchewan Artists*. Saskatoon: Mendel Art Gallery.

CLIMER 1975 John Climer. *Saskatchewan Primitives*. Saskatoon: Mendel Art Gallery.

CLOUTIER-COURNOYER 1979 François Cloutier-Cournoyer and Louise Letocha. *La Collection Borduas du Musée d'Art Contemporain*. Montréal: Ministère des Affaires Culturelles.

CLUTESI 1969 George C. Clutesi. *Potlatch*. Sidney,

BC: Gray's Publishing.

CNE CATALOGUES Canadian National Exhibitions catalogues of the Department of Fine Arts 1879-1961 (except 1942-46). Toronto: Canadian National Exhibition.

COLGATE 1943 William Colgate. *Canadian Art: Its Origins and Development.* Toronto: Ryerson Press.

COMFORT 1956 Charles Comfort. *Artist at War.* Toronto: Ryerson Press.

COOKE 1978 W. Martha E. Cooke. *The Last "Lion"...Rambles in Québec with James Pattison Cockburn.* Kingston: Agnes Etherington Art Centre.

COOKE 1983 W.Martha E. Cooke. *W. H. Coverdale Collection of Canadiana.* Ottawa: National Archives Canada.

CORBEIL 1970 Danielle Corbiel. *Canadian Water-Colours of the 19th Century in the National Gallery of Canada.* Ottawa: National Gallery of Canada.

CORBEIL 1973 Danielle Corbeil. *Claude Tousignant.* Ottawa: National Gallery of Canada.

COURTHION Pierre Courthion. *Impressionism.* New York: Harry N. Abrams.

COX 1960 Trenchard Cox. *Collecting for a Nation.* Ottawa: National Gallery of Canada.

COY 1982 Helen Coy. *FitzGerald as Printmaker.* Winnipeg: University of Manitoba Press.

CSGA 1924 Canadian Society of Graphic Art. *Annual Exhibition,* 1924-1976. Catalogues.

CUMMING 1981 Mark Cumming. *The Group of One: Joseph Bradshaw Thorne.* Stratford: Cumming Publishers.

CUNLIFFE 1979 Barry Cunliffe. *The Celtic World.* New York: McGraw-Hill.

CURNOE 1974 G. Curnoe and P. Théberge. *The Review of the Association for the Documentation of Neglected Aspects of Culture in Canada.* London: London Public Library and Art Museum.

CUTHBERTSON 1931 George Adrian Cuthbertson. *Freshwater: A History and Narrative of the Great Lakes.* Toronto.

D

DAIGNEAULT 1981 Gilles Daigneault and Ginette Deslauriers. *La Gravure au Québec (1940-1980).* Saint Lambert, QC: Heritage Plus.

DAILY NEWS (KINGSTON DAILY NEWS) Newspaper, Kingston, 1851-1905.

DAILY WHIG (DAILY BRITISH WHIG) Newspaper, Kingston, 1834-1926.

D'ALLEMAGNE 1968 Henry René D'Allemagne. *Decorative Antique Ironwork.* Paris: J. Schemit, 1924; reprint ed., New York: Dover Publications, 1968.

DANZKER 1981 Jo-Anne Birnie Danzker. *J. Fenwick Lansdowne.* Vancouver: Vancouver Art Gallery.

DARROCH 1981 Lois Darroch. *Bright Land, A Warm Look at Arthur Lismer.* Toronto: Merritt.

DAULT 1980 Gary Michael Dault. *Barker Fairley: Landscapes and Portraits.* Kingston: Agnes Etherington Art Centre.

DAVIES 1935 Blodwen Davies. *Paddle and Palette, The Story of Tom Thomson.* Toronto: Ryerson.

DAVIES 1967 Blodwen Davies. *Tom Thomson.* Vancouver: Mitchell Press.

DAVIS 1974 Ann Davis. *Christiane Pflug, 1936-1974.* Winnipeg: Winnipeg Art Gallery.

DAVIS 1976 Thomas Davis and Karin Ronnefeldt, eds. *People of the First Man: Life Among the Plains Indians in their Final Days of Glory: The Firsthand Account of Prince Maximilian's Expedition up the Missouri River, 1833-34.* New York: E.P. Dutton.

DAVIS 1979 Ann Davis. *The Drawings of Christiane Pflug.* Winnipeg: Winnipeg Art Galley,

DAVIS 1979(2) Ann Davis. *Frontiers of Our Dreams: Québec Painting in the 1940s and 1950s.* Winnipeg: Winnipeg Art Gallery.

DAVIS 1989 Ann Davis. *The Griffiths Brothers.* Windsor: Art Gallery of Windsor.

DE BRUMATH 1912 A. Leblond de Brumath. *The Makers of Canada, Bishop Laval.* Toronto: Morang & Co.

DE DORA 1989 Brian Dedora. *With WK in the Workshop: A Memoir of William Kurelek.* Stratford: Aya Press.

DE GROSBOIS 1978 Louise de Grosbois, Raymonde Lamothe and Lise Nantel. *Les Patenteux du Québec.* Montréal: Les Editions Parti.

DEMPSEY 1978 Hugh A. Dempsey. *Tailfeathers: Indian Artist.* Calgary: Glenbow-Alberta Institute.

DENNIS 1984 Eva Dennis. *Trick Riders of the Delightsome Valley School and Other Stories: Narrative Paintings by Eva Dennis.* Regina: Dunlop Art Gallery.

DE PEDERY-HUNT 1978 Dora De Pedery-Hunt. *Sculpture.* Toronto: Prince Arthur Galleries.

DE PENCIER 1987 Honor de Pencier. *Posted to Canada: The Watercolours of George Russell Dartnell 1835-1844.* Toronto: Dundurn Press.

DESBARATS 1979 Peter Desbarats and Terry Mosher. *The Hecklers: A History of Canadian Political Cartooning and a Catoonist's History of Canada.* Toronto: McClelland & Stewart.

DE VOLPI 1962 Charles P. de Volpi and P.H. Scowen. *The Eastern Townships.* Montréal: Dev-Sco Publications.

DE VOLPI 1963 Charles P. deVolpi and P.S. Winkworth. *Montréal.* Montréal: Dev-Sco Publica-

tions.

DE VOLPI 1964 Charles P. de Volpi. *Ottawa*. Montréal: Dev-Sco Publications.

DE VOLPI 1965 Charles P. de Volpi. *Toronto*. Montréal: Dev-Sco Publications.

DE VOLPI 1966 Charles P. de Volpi. *Niagara Peninsula*. Montréal: Dev-Sco Publications.

DE VOLPI 1971 Charles P. de Volpi. *Québec*. Toronto: Longman Canada.

DE VOLPI 1972 Charles P. de Volpi. *Newfoundland*. Toronto: Longman Canada.

DE VOLPI 1973 Charles P. de Volpi. *British Columbia*. Toronto: Longman Canada.

DE VOLPI 1974 Charles P. de Volpi. *Nova Scotia*. Toronto: Longman Canada.

DE VOTO 1947 Bernard de Voto. *Across the Wide Missouri: Illustrated with Paintings by Alfred Jacob Miller, Charles Bodmer and George Catlin*. Boston: Houghton Mifflin.

DICKASON 1974 Olive Patricia Dickason. *Indian Arts in Canada*. Ottawa: Indian and Northern Affairs.

DICKENSON 1992 Victoria Dickenson. *First Impressions: European Views of the Natural History of Canada from the 16th to the 19th Century*. Kingston: Agnes Etherington Art Centre.

DICTIONARY 1966 *Dictionary of Canadian Biography*. Toronto: University of Toronto Press, 1966-

DILLOW 1971 Nancy E.Dillow. *Saskatchewan: Art and Artists*. Regina: Norman Mackenzie Art Gallery.

DILLOW 1973 Nancy E. Dillow. *Emma Lake Workshops, 1955-1973*. Regina: Norman Mackenzie Art

DILLOW 1975 Nancy Dillow. *Reta Cowley*. Regina: Norman Mackenzie Art Gallery.

DILLOW 1976 Nancy E. Dillow and Jane Rule. *Takao Tanabe, 1972-1976: The Land*. Regina: Norman Mackenzie Art Gallery.

DILLOW 1976(1) Nancy E. Dillow. *Frank Nulf*. Regina: Norman Mackenzie Art Gallery.

DILWORTH 1945 Ira Dilworth. *Emily Carr: Her Paintings and Sketches*. Toronto: Oxford University Press.

DOBSON 1982 Barbara and Henry Dobson. *A Provincial Elegance*. Kitchener: Kitchener-Waterloo Art Gallery.

DOMPIERRE 1986 Louise Dompierre. *John Lyman 1886-1967*. Kingston: Agnes Etherington Art Centre.

DOW 1921 Charles Mason Dow. *Anthology and Bibliography of Niagara Falls*. 2 vols. Albany: State of New York.

DOW 1972 Helen J. Dow. *The Art of Alex Colville*. Toronto: McGraw-Hill Ryerson.

DUFF 1975 Wilson Duff. *Images: Stone: B. C.: Thirty Centuries of Northwest Coast Indian Sculpture*. Toronto: Oxford University Press.

DUFFY 1982 Helen Duffy and Frances K. Smith. *The Brave New World of Fritz Brandtner*. Kingston: Agnes Etherington Art Centre.

DUGUAY 1978 Rodophe Duguay. *Carnets Intimes*. Montréal: Boreal Express.

DUMAS 1944 Paul Dumas. *Lyman*. Montréal: L'Arbre.

DUMAS 1981 Paul Dumas. *Picher*. LaPrairie: Marcel Broquet.

DUNBAR 1976 Nancy J. Dunbar. *Images of Sport in Early Canada*. Montréal: McCord Museum.

DUNLOP ART GALLERY Information supplied by the Dunlop Art Gallery, Regina.

DUPONT 1988 Jean-Claude Dupont. *Légendes*. 5 vols. Sainte-Foy: Légendes du Coeur du Québec.

DUQUETTE 1980 Jean-Pierre Duquette. *Fernand Leduc*. LaSalle, Québec: Hurtubise HMH.

DUVAL 1951 Paul Duval. *Alfred Joseph Casson*. Toronto: Ryerson Press.

DUVAL 1952 Paul Duval. *Canadian Drawings and Prints*. Toronto: Burns & MacEachern.

DUVAL 1954 Paul Duval. *Canadian Water Colour Painting*. Toronto: Burns & MacEachern.

DUVAL 1965 Paul Duval. *Group of Seven Drawings*. Toronto: Burns & MacEachern.

DUVAL 1967 Paul Duval. *The McMichael Conservation Collection of Art*. Toronto: Clark Irwin.

DUVAL 1972 Paul Duval. *Four Decades*. Toronto: Clarke, Irwin.

DUVAL 1973 Paul Duval. *A Vision of Canada: The McMichael Canadian Collection*. Toronto: Clark, Irwin.

DUVAL 1974 Paul Duval. *High Realism in Canada*. Clarke, Irwin.

DUVAL 1975 Paul Duval. *A.J. Casson*. Toronto: Roberts Gallery.

DUVAL 1976 Paul Duval. *Ken Danby*. Toronto: Clarke Irwin.

DUVAL 1977 Paul Duval. *The Art of Glen Loates*. Scarborough: Cerebrus.

DUVAL 1978 Paul Duval. *The Tangled Garden*. Toronto: Cerebrus.

DUVAL 1984 Paul Duval. *Ken Danby: The New Decade*. Toronto: Stoddard.

DUVAL 1990 Paul Duval. *Canadian Impressionism*. Toronto: McClelland & Stewart.

DYONNET 1913 Edmond Dyonnet. *French-Canadian Painting and Sculpture - The Year Book of Canadian Art*. Toronto: Dent.

DYONNET 1951 Edmond Dyonnet. *Memoirs of a Canadian Artist*. Montréal.

DYONNET 1968 Edmond Dyonnet. *Memoires d'un*

artiste canadien. Ottawa: Les Editions de l'Université d'Ottawa.

E

EBER 1971 Dorothy Eber. *Pitseolak: Pictures Out of My Life.* Toronto: Oxford University Press.
ECKHARDT 1958 Ferdinand Eckhardt. *L.L. FitzGerald 1890-1956, A Memorial Exhibition 1958.* Winnipeg: Winnipeg Art Gallery.
ECKHARDT 1962 Ferdinand Eckhardt. *Painting at Stratford, 1962: Nine Prairie Province Painters.* Stratford, Ontario: Stratford Festival.
ECKHARDT 1966 Ferdinand Eckhardt. *Christiane Pflug.* Winnipeg: Winnipeg Art Gallery.
ECKHARDT 1970 Ferdinand Eckhardt. *150 Years of Art in Manitoba.* Winnipeg: Winnipeg Art Gallery.
EDISON 1973 Margaret E. Edison. *Thoreau MacDonald: A Catalogue of Design and Illustration.* Toronto: University of Toronto Press.
EDMONTON 1921 Edmonton Art Club. *Annual Exhibition.*
EICHENBERG 1976 Fritz Eichenberg. *The Art of the Print: Masterpieces, History, Techniques.* New York: Harry N. Abrams.
ELWOOD 1976 Marie Elwood. *Folk Art of Nova Scotia.* Halifax: Art Gallery of Nova Scotia.
ELWOOD 1977 Marie Elwood. "The State Dinner Service of Canada 1898." *Material History Bulletin.* 3 (Spring 1977): 41-9.
EMERY 1969 Anthony M. Emery. *Jack Shadbolt.* Vancouver: Vancouver Art Gallery.
EMPRESS Periodical. Aircom Publishing, Toronto.
ENRIGHT 1981 Robert Enright. *Figure in Landscape Drawings by Denis Nokony.* Saskatoon: Mendel Art Gallery.
ERICKSON 1975 Arthur Erickson. *The Architecture of Arthur Erickson.* Montréal: Tundra Books.
ETHIER-BLAIS 1979 Jean Ethier-Blais. *Autour de Borduas: essai d'histoire intellectuelle.* Montréal: Les Presses de l'Université de Montréal.
EQUINOX Periodical. Telemedia Publishing, Camden East, ON., 1982-.
EWERS 1955 John C. Ewers. *George Catlin: Painter of Indians of the West.* Washington: Smithsonian Institution.
EWERS 1973 John C. Ewers. *Artists of the Old West.* Garden City: Doubleday.

F

FAIRCHILD 1907 G.M. Fairchild. *From My Québec Scrapbook.* Québec: Frank Carrel.

FAIRCHILD 1908 G.M. Fairchild. *Gleanings From Québec.* Québec: Frank Carrel.
FAIRLEY 1981 Barker Fairley. *Barker Fairley Portraits.* Toronto: Methuen.
FALARDEAU 1936 Emile Falardeau. *Un Maître de la peinture, Antoine-Sebastien Falardeau.* Québec: Albert Levesque.
FALARDEAU 1940 Emile Falardeau. *Achim, Auclair, Desnoyers, Hay.* Montréal: G. Ducharme.
FALARDEAU 1943 Emile Falardeau. *Rapin.* Montréal: G. Ducharme.
FALARDEAU 1969 Emile Falardeau. Marc-Aurèle-alias-Suzor-Cote, peintre et sculpteur, *1869-1937.* Montréal: Galerie des Anciens.
FARR 1975 Dorothy Farr and Natalie Luckyj. *From Women's Eyes, Women Painters in Canada.* Kingston: Agnes Etherington Art Centre.
FARR 1977 Dorothy Farr. *Horatio Walker.* Kingston: Agnes Etherington Art Centre.
FARR 1981 Dorothy Farr. *J.W. Beatty.* Kingston: Agnes Etherington Art Centre.
FARR 1981 (1) Dorothy Farr. *Lilias Torrance Newton, (1896-1980).* Kingston: Agnes Etherington Art Centre.
FARR 1982 Dorothy Farr. *Contemporary Primitives.* Kingston: Agnes Etherington Art Centre.
FARR 1988 Dorothy Farr. *The Artist Inspired: A History of Art in Kingston to 1970.* Kingston: Agnes Etherington Art Centre.
FEDER 1969 Norman Feder. *American Indian Art.* New York: Harry N. Abrams.
FENTON 1967 Terry Fenton. *Painting in Saskatchewan, 1883-1959.* Saskatoon: Mendel Art Gallery.
FENTON 1969 Terry Fenton. *Saskatoon: Thirteen Artists.* Regina: Norman Mackenzie Art Gallery.
FENTON 1970 Terry Fenton. *Jan Wyers, Robert N.Hurley: An Exhibition of Two Prairie Painters.* Regina: Norman Mackenzie Art Gallery.
FENTON 1971 Terry Fenton. *Watercolour Painters from Saskatchewan.* Ottawa: National Gallery of Canada.
FENTON 1976 Terry Fenton. *Jack Bush: A Retrospective.* Toronto: Art Gallery of Ontario.
FENTON 1978 Terry Fenton and Karen Wilkin. *Modern Painting in Canada.* Edmonton: Hurtig.
FERGUSON 1967 George Ferguson. *Signs and Symbols in Christian Art.* New York: Oxford University Press.
FERGUSON 1967 (1) Bruce Ferguson. *Messages from Southern Saskatchewan.* Halifax: Dalhousie Art Gallery.
FERGUSON 1980 Bruce Ferguson. *Canada Video.* Ottawa: National Gallery of Canada.

FERGUSON 1981 Bruce Ferguson. *Joe Sleep Retrospective.* Halifax: Art Gallery of Nova Scotia.

FERGUSON 1984 Gerald Ferguson. *Decoys of Nova Scotia.* Halifax: Art Gallery of Nova Scotia.

FERGUSON 1987 Gerald Ferguson, ed.. *Marsden Hartley and Nova Scotia.* Halifax: Mount Saint Vincent University.

FIELD 1981 Richard Field. *An Exhibition of Canadian Gameboards of the 19th & 20th Centuries from Ontario, Québec and Nova Scotia.* Halifax: Art Gallery of Nova Scotia.

FIELD 1985 Richard Field. *Spirit of Nova Scotia: Traditional Decorative Folk Art 1780-1930.* Halifax: Art Gallery of Nova Scotia.

FIELDING 1974 Mantle Fielding. *Dictionary of American Painters, Sculptors and Engravers.* Greens Farms, Conn.

FINLEY 1978 Gerald E. Finley. *George Heriot: Painter of the Canadas.* Kingston: Agnes Etherington Art Centre.

FINLEY 1979 Gerald E. Finley. *George Heriot.* Ottawa: National Gallery of Canada.

FIRESTONE 1979 O. J. Firestone. *The Other A.Y.Jackson.* Toronto: McClelland & Stewart.

FISET 1989 Ghislaine Fiset. *Les Maîtres Canadiens de la Collection Power Corporation du Canada.* Québec: Musée du Seminaire de Québec.

FISHER 1981 Jennifer Fisher. "A Portrait ... the Ultimate Gift." *Home Decor/Canada* (Winter): 56-60.

FITZGERALD 1964 Doris M. Fitzgerald. *Thornhill 1793-1963.* Thornhill, ON: n.p.

FLEMING 1974 Marie Fleming. *John Meredith: Fifteen Years.* Toronto: Art Gallery of Ontario.

FLEMING 1987 Patricia Fleming, ed.. *Traditions in Wood.* Camden East, ON.: Camden House.

FLEMING 1994 John A. Fleming. *The Painted Furniture of French Canada 1700-1840.* Camden East, ON: Camden East House Publishing; and Hull, QC: Canadian Museum of Civilization

FOLCH-RIBAS 1971 Jacques Folch-Ribas. *Jacques de Tonnancour: le signe et le temps.* Montréal: Les Presses de l'Université du Québec.

FORAN 1988 Max Foran with Nonie Houlton. *Roland Gissing: The People's Painter.* Calgary: University of Calgary Press.

FORBES 1973 J. Allison Forbes. *J.B. Taylor: Landscapes.* Charlottetown: Confederation Centre Art Gallery.

FORSEY 1975 William C. Forsey. *The Ontario Community Collects.* Toronto: Art Gallery of Ontario.

FORSTER 1928 J.W.L. Forster. *Under the Studio Light: Leaves from a Portrait Painter's Sketch Book.* Toronto: Macmillan.

FOWKE 1976 Edith Fowke. *Folklore in Canada.* Toronto: McClelland & Stewart.

FOWKE 1985 Edith Fowke and Carole H. Carpenter. *Explorations in Canadian Folklore.* Toronto: McClelland & Stewart.

FOWKE 1988 Edith Fowke. *Canadian Folklore.* Toronto: Oxford University Press.

FRASER 1975 Ted Fraser. *R.L. Bloore.* Windsor: Art Gallery of Windsor.

FRASER 1979 Ted Fraser. *Caven Atkins.* Windsor: Art Gallery of Windsor.

FRENCH 1981 Gary E. French. "Captain Julius Hümme, Muskoka Artist and Photographer." *East Georgian Bay Historical Journal.* 1 (1981): 68-84.

FRERE-COOK 1972 Gervis Frere-Cook. *The Decorative Arts of the Christian Church.* London: Cassell

FRIED 1920 Frederick Fried. *Artists in Wood.* New York: Bramhall House.

FRY 1972 Philip Fry. *Manitoba Mainstream: People's Art/Fine Art.* Ottawa: National Gallery of Canada.

FRY 1972(1) Jacqueline Fry, K.J. Butler and Sheila M. Butler. *Baker Lake Drawings.* Winnipeg, Manitoba.

FRY 1980 Jacqueline Fry. *Irene Whittome 1975-1980.* Montreal: Montréal Museum of Fine Arts.

FRY 1984 Jacqueline Fry. *Visions and Models: African Sculpture from the Justin and Elisabeth Lang Collection.* Kingston: Agnes Etherington Art Centre.

FRY 1987 Jacqueline Fry. *African Sculpture from the Justin and Elisabeth Lang Collection.* Kingston: Agnes Etherington Art Centre.

FRY 1988 Jacqueline Fry. *Heroic Figures: African Sculpture from the Justin and Elisabeth Lang Collection.* Kingston: Agnes Etherington Art Centre.

FULFORD 1969 Robert Fulford. *Harold Town Drawings.* Toronto: McClelland & Stewart.

FULFORD 1982 Joan Murray and Robert Fulford. *The Beginning of Vision, The Drawings of Lawren Harris.* Toronto: Douglas & McIntyre.

G

GAGNON 1970 François-Marc Gagnon. *André Fournelle, sculpteur.* Montréal: Association des Sculpteurs du Québec.

GAGNON 1972 François Gagnon. *Arthur Villeneuve's Québec Chronicles.* Montréal: Montréal Museum of Fine Arts.

GAGNON 1975 François-Marc Gagnon. *La Conversion par l'Image: un Aspect de la Mission des Jesuites auprès des Indiens du Canada au XVIIe Siècle.* Montréal: Bellarmin.

GAGNON 1976 François-Marc Gagnon. *Paul-Emile Borduas.* Ottawa: National Gallery of Canada.

GAGNON 1976(1) François-Marc and Nicole

Cloutier. *Premiers peintres de la Nouvelle-France*. 2 vols. Québec: Ministère des affaires culturelles.

GAGNON 1978 François-Marc Gagnon. *Paul-Emile Borduas (1905-1960):biographie critique et analyse de l'oeuvre*. Montréal: Fides.

GAGNON 1979 Jean-Gilles Gagnon. *Artistes du Saguenay-Lac-Saint-Jean*. Québec: Musée du Québec.

GALE 1976 Peggy Gale, ed. *Video by Artists*. Toronto: Art Metropole.

GALE 1977 Peggy Gale. *In Video*. Halifax: Dalhousie University.

GATES 1982 Bernie Gates. *Ontario Decoys*. Kingston: The Upper Canadian.

GATES 1986 Bernie Gates. *Ontario Decoys II*. Kingston: The Upper Canadian.

GAUTHIER 1974 Raymon de Gauthier. *Les tabernacles anciens du Québec des XVIIe et XIXe siècles*. Québec: Québec: Ministère des affaires culturelles.

GAUVREAU 1940 Jean-Marie Gauvreau. *Artisans du Québec*. Montréal: Les Éditions du Bien Public.

GENEST 1979 Bernard Genest. *Massicotte et son temps*. Montréal: Boreal Express.

GENEST 1982 Bernard Genest. *Les Artisans traditionnels de l'est du Québec*. Québec: Gouvernement du Québec.

GEORGE 1980 John George et al. " Art and Artists in Québec." Special Issue *Art and Artists* (May 1980).

GIANNATTASIO 1977 Sandra Giannattasio. *Forma e Crescita nella Sculptura di Wertheimer*. Roma: Trevi ed.e.

GIBBON 1938 John Murray Gibbon. *Canadian Mosaic*. Toronto: McClelland & Stewart.

GILMORE 1980 Berenice C. Gilmore. *Artists Overland*. Burnaby: Burnaby Art Gallery.

GILMORE 1980(1) Berenice C. Gilmore. *H. Eric Bergman 1893-1958*. Burnaby: Burnaby Art Gallery.

GINGRAS 1981 Marcel Gingras. *Henri Masson*. LaPrairie: Marcel Broquet.

GLOBE AND MAIL. Daily newspaper, Toronto, 1936-. Began as the *Globe*, 1844.

GLOVER 1972 Patricia E. Glover. *Charles Fraser Comfort*. Winnipeg: Winnipeg Art Gallery.

GODIN 1984 Deborah Godin and David Pugh. *The Critical Development of David Pugh*. Moonbeam, ON: Penumbra Press.

GOETZ 1977 Helga Goetz. *The Inuit Print*. Ottawa: National Museum of Man.

GOETZMANN 1986 William H. and William N. Goetzmann. *The West of the Imagination*. New York: W.W. Norton & Company.

GOLDWATER 1986 Robert Goldwater. *Primitivism in Modern Art*. Cambridge: Belknap Press.

GOOD 1976 E. Reginald Good. *Anna's Art*. Kitchener: Pochauna Publications.

GOODRIDGE 1975 Edythe Goodridge. *28 Women Artists in Newfoundland*. St John's: Memorial University.

GOODRIDGE 1978 Edythe Goodgridge. *Traditional Newfoundland Mats: Louise Belbin*. St John's: Memorial University.

GOSSELIN 1981 Claude Gosselin, Martine Bousquet-Mongeau, David Moore. *François Sullivan rétrospective*. Montréal: Musée d'art contemporain.

GOUR 1950 Romain Gour. *Suzor-Côté: artiste multiforme*. Montréal: Editions Eoliennes.

GOWANS 1955 Alan Gowans. *Church Architecture in New France*. Toronto: University of Toronto Press.

GOWANS 1966 Alan Gowans. *Building Canada: An Architectural History of Canadian Life*. Toronto: Oxford University Press.

GOWANS 1966(2) *Dictionary of Canadian Biography* 1966-. (articles by Alan Gowans and others). Toronto: University of Toronto Press.

GRAHAM 1972 Colin David Graham. *Ina D.D. Uhthoff Memorial Exhibition*. Victoria: Art Gallery of Greater Victoria.

GRAHAM 1975 Mayo Graham. *Some Canadian Women Artists*. Ottawa: National Gallery of Canada.

GRANT 1882 George Munro Grant, ed. *Picturesque Canada*. 2 vols. Toronto: Belden Bros.

GRATTAN 1976 Patricia Grattan. *Folk Memory: Three Newfoundland Painters*. St John's, NF: Memorial University of Newfoundland Art Gallery.

GRATTAN 1977 Patricia Grattan. *Folk Images'77*. St John's, NF: Memorial University of Newfoundland Art Gallery.

GRATTAN 1980 Patricia Grattan. *The Ferryland Tapestry*. St John's, NF: Memorial University of Newfoundland Art Gallery.

GRATTAN 1983 Patricia Grattan. *Flights of Fancy, Newfoundland Yard Art*. St John's, NF: Memorial University of Newfoundland Art Gallery.

GRATTAN 1987 Patricia Grattan. *Sticks and Stones House - Clyde Farnell's Folk Art*. St John's, NF: Memorial University of Newfoundland Art Gallery.

GRAY 1976 Margaret Gray, Margaret Rand and Lois Steen. *Charles Comfort*. Toronto: Gage.

GRAY 1977 Margaret Gray, Margaret Rand and Lois Steen. *Carl Schaeffer*. Toronto: Gage.

GREENAWAY 1986 Cora Greenaway. *Interior Decorative Painting in Nova Scotia*. Halifax: Art Gallery of Nova Scotia.

GREENBERG 1961 Clement Greenberg. *Art and Culture: Critical Essays*. Boston: Beacon Press.

GREENBERG 1980 Reesa Greenberg. *The Drawings of Alfred Pellan*. Ottawa: National Gallery of Canada.

GREENHILL 1965 Ralph Greenhill. *Early Photography in Canada*. Toronto: Oxford University Press.

GREENHILL 1979 Ralph Greenhill and Andrew Birrell. *Canadian Photography: 1839-1920*. Toronto: Coach House Press.

GREENWOOD 1973 Michael Greenwood. *Kostyniuk: Relief Sculptures, 1969-1972*. Calgary: Glenbow Art Foundation.

GRIBBON 1978 Michael J. Gribbon. *Walter J. Phillips*. Ottawa: National Museum of Canada.

GROUP OF SEVEN CATALOGUES Art Museum of Toronto: 1920, 1921, 1922; Art Gallery of Toronto: 1925, 1926, 1928, 1930, 1931.

GROVES 1968 Naomi Jackson Groves. *A. Y.'s Canada: Pencil Drawings by A. Y. Jackson*. Toronto: Clarke, Irwin.

GUEST 1981 Tim Guest, ed. *Books by Artists*. Toronto: Art Metropole.

GUILBAULT 1980 Nicole Guilbault. *Henri Julien et la tradition orale*. Montréal: Boreal Express.

GUILLET 1933 Edwin Clarence Guillet. *Early Life in Upper Canada*. Toronto: Ontario Publishing.

GUILLET 1954 Edwin Clarence Guillet. *Pioneer Inns and Taverns*. 5 vols. Toronto: Ontario Publishing.

GUILLET 1957 Edwin Clarence Guillet. *The Valley of the Trent*. Toronto: Champlain Society.

GUTTENBERG 1969 A. Ch. de Guttenberg. *Early Canadian Art and Literature*. Vaduz, Liechenstein: Europe Printing.

GUY 1963 Robert Guy. *Pellan: His Life and His Art*. Montréal: Editions du centre de psychologie et pedagogie.

GUY 1964 Robert Guy. *Ecole de Montréal: situations et tendances*. Montréal: Editions du centre de psychologie et de pedagogie.

GUY 1970 Robert Guy. *Albert Dumouchel: ou la poetique de la main*. Québec: Les Presses de l'Université du Québec.

GUY 1970 (1) Robert Guy. *Yves Trudeau, Sculpteur*. Montréal: Québec Sculptors' Association.

GUY 1972 Robert Guy. *Borduas*. Montréal: Les Presses de l'Université du Québec.

GUY 1973 Robert Guy. *L'Art au Québec depuis 1940*. Montréal: Les Editions LaPresse.

GUY 1977 Robert Guy. *Borduas ou le dilemme culturel Québecois*. Montréal: Stanke.

GUY 1978 Robert Guy. *La peinture au Québec depuis ses origines*. Saint-Adèle: Iconia.

GUY 1978(2) Robert Guy. *Lemieux*. Toronto: Gage.

GUY 1979 Robert Guy. *Rousseau et le moulin des arts*. Verdun: Marcel Broquet.

GUY 1980 Robert Guy. *Dallaire ou l'oeil panique*. Montréal: Editions France-Amerique.

GUYETTE 1983 Dale and Gary Guyette. *Decoys of Maritime Canada*. Exton, Penn.: Schiffer Publishing.

H

HACHEY 1980 Paul A. Hachey. *The New Brunswick Landscape Print 1760-1880*. Fredericton: Beaverbrook Art Gallery.

HALE 1933 Katherine Hale. *Canadian Cities of Romance*. Toronto: McClelland & Stewart.

HALE 1952 Katherine Hale. *Historic Houses of Canada*. Toronto: Ryerson.

HALL 1988 Michael D. Hall. *Jahan Maka: Retrospective*. Regina: Dunlop Art Gallery.

HALPIN 1981 Marjorie M. Halpin. *Totem Poles: An Illustrated Guide*. Vancouver: University of British Columbia Press.

HAMILTON 1936 Ross Hamilton. *Memorial Exhibition of Original Paintings by Homer Watson, R.C.A., L.L.D., 1936*. n.p.

HAMMOND 1930 M.O. Hammond. *Painting and Sculpture in Canada*. Toronto: Ryerson Press.

HANKS 1974 Carole Hanks. *Early Ontario Gravestones*. Toronto: McGraw-Hill Ryerson.

HARPER 1955 J. Russell Harper. *Canadian Painting in Hart House*. Toronto: University of Toronto Press.

HARPER 1962 J. Russell Harper. *Everyman's Canada*. Ottawa: National Gallery of Canada.

HARPER 1962 (2) Russell Harper, Franco Rusoli, Guy Viau, Pierre Schneider. *Jean-Paul Riopelle: Paintings and Sculpture*. Ottawa: National Gallery of Canada.

HARPER 1963 J. Russell Harper. *Homer Watson, R.C.A. 1855-1936 Paintings and Drawings*. Ottawa: National Gallery of Canada.

HARPER 1964 J. Russell Harper. *A Century of Colonial Painting: The Seven Years War to Confederation*. Ottawa: National Gallery of Canada.

HARPER 1966 J. Russell Harper. *Painting in Canada: A History*. Toronto: University of Toronto Press.

HARPER 1967 J. Russell Harper and Stanley Triggs. *Portrait of a Period*. Montréal: McGill University Press.

HARPER 1967 (1) J. Russell Harper. *William G.R.Hind (1833-1888): A Confederation Painter in Canada*. Windsor: Willistead Gallery.

HARPER 1968 J. Russell Harper. *Québec 1800: A 19th Century Romantic Sketch of Québec*. Montréal: Editions de l'Homme.

HARPER 1969 J. Russell Harper. *Carl Schaefer Retrospective Exhibition Paintings from 1926 to 1969*. Montréal: Sir George Williams University.

HARPER 1970 J. Russell Harper. *Early Painters and Engravers in Canada*. Toronto: University of Toronto Press.

HARPER 1971 (1) J. Russell Harper. *Paul Kane's*

Frontier. Fort Worth: The Amon Carter Museum.

HARPER 1971 (2) J. Russell Harper. *Fritz Brandtner 1869-1969*. Montréal: Sir George Williams University.

HARPER 1972 J. Russell Harper. *Scenes in Canada: C. Krieghoff*. Montréal: McCord Museum.

HARPER 1972 (2) J. Russell Harper. *Exhibition of Prints in Honour of C. Krieghoff 1815-1872*. Montréal: McCord Museum.

HARPER 1972 (3) J. Russell Harper. *Paul Kane 1810-1871*. Ottawa: National Gallery of Canada.

HARPER 1973 J. Russell Harper. *People's Art: Naive Art in Canada*. Ottawa: National Gallery of Canada.

HARPER 1974 J. Russell Harper. *A People's Art*. Toronto: University of Toronto Press.

HARPER 1976 J. Russell Harper. *William G.R. Hind*. Ottawa: National Gallery of Canada.

HARPER 1977 J. Russell Harper. *Cornelius Krieghoff: The Habitant Farm*. Ottawa: National Gallery of Canada.

HARPER 1977 (DONOVAN) Jennifer Harper. *City Work at Country Prices: The Portrait Photographs of Duncan Donovan*. Toronto: Oxford University Press.

HARPER 1979 J. Russell Harper. *Krieghoff*. Toronto: University of Toronto Press.

HARPER 1981 J. Russell Harper. *Painting in Canada: A History*. 2nd ed. Toronto: University of Toronto Press.

HARPER 1981 (1) J. Russell Harper. *Miller Brittain - Painter*. Sackville: Owens Art Gallery.

HARRIS 1964 Lawren Stewart Harris. *The Story of the Group of Seven*. Toronto: Rous & Mann.

HARRIS 1969 Lawren Harris. *Lawren Harris*. Toronto: Macmillan.

HARRIS 1973 *Where are the Works by Robert Harris?* Ottawa: National Gallery of Canada.

HART 1985 E.J. Hart and Jon Whyte. *Carl Rungius: Painter of the Western Wilderness*. Vancouver: Douglas & McIntyre.

HASHEY 1967 Mary W. Hashey. *Maritime Artists, vol.1*. Fredericton: Maritime Art Association.

HASSRICK 1975 Peter H. Hassrick. *Frederic Remington*. New York: Harry N. Abrams.

HASSRICK 1981 Royal B. Hassrick. *The George Catlin Book of American Indians*. New York: Promontory Press.

HAWKINS 1834 Alfred Hawkins. *Hawkins's Picture of Québec*. Québec City: Neilson & Cowan.

HAWTHORN 1956 Audrey Hawthorn. *People of the Potlatch: Native Arts and Culture of the Pacific Northwest Coast*. Vancouver: Vancouver Art Gallery.

HAY 1967 Denys Hay, ed. *The Age of the Renaissance*. New York: McGraw-Hill.

HEATH 1976 Terrance Heath. *Western Untitled*. Calgary: Glenbow-Alberta Institute.

HEATH 1991 Terrance Heath. *Ronald L. Bloore: Not Without Design*. Regina: Norman Mackenzie Art Gallery.

HEBERT 1973 Bruno Hebert. *Philippe Hebert, sculpteur*. Montréal: Fides.

HEMBROFF-SCHLEICHER 1978 Edythe Hembroff-Schleicher. *Emily Carr: The Untold Story*. Vancouver: Hancock House Publishers.

HENAULT 1970 Gilles Henault and Henri Barras. *Panorama de la sculpture au Québec, 1945-1970*. Montréal: Musée d'art contemporain.

HENAULT 1981 Gilles Henault. *Pierre Clerk: oevres recentes, peintures et sculptures*. Paris: Centre Cultural Canadien.

HENDRICKS 1974 Gordon Hendricks. *Albert Bierstadt: Painter of the American West*. New York: Harry N. Abrams.

HERALD *Calgary Herald*. Newspaper. Calgary, 1883-.

HERIOT 1807 George Heriot. *Travels Through the Canadas*. London: Richard Phillips.

HERIOT 1971 George Heriot. *Travels Through the Canadas*. Rutland, Vermont: Charles E. Tuttle.

HIGGINSON 1975 T. B. Higginson. *Bengough and Burks Falls*. Burks Falls, ON: Old Rectory Press.

HIGHLIGHTS 1947 Alberta Society of Artists. *Highlights (1947-1964)*. Calgary.

HIGHWATER 1980 Jamake Highwater. *The Sweet Grass Lives On: Fifty Contemporary North American Indian Artists*. New York: Lippincott & Crowell.

HILL 1974 Ann Hill. *A Visual Dictionary of Art*. London: Heinemann.

HILL 1975 Charles C. Hill. *Canadian Painting in the Thirties*. Ottawa: National Gallery of Canada.

HILL 1976 Charles C. Hill and Paul Dumas. *Louis Muhlstock: A Survey of Forty-five Years*. Windsor: Art Gallery of Windsor.

HILL 1988 Charles C. Hill and Pierre B. Landry, eds. *Canadian Art: Catalogue of the National Gallery of Canada*. Volume one *A-F*. Ottawa: National Gallery of Canada.

HILL 1995 Charles C. Hill. *The Group of Seven: Art for a Nation*. Toronto: McClelland & Stewart.

HIND 1863 Henry Youle Hind. *Explorations in the Interior of the Labrador Peninsula, the Country of the Montagnais and Nasquapee Indians*. 2 vols. London: Longman.

HIND 1908 A. Hind. *A Short History of Engraving and Etching*. Boston: Houghton, Mifflin.

HIRSH 1971 Michael Hirsh and Patrick Loubert. *The Great Canadian Comic Books*. Toronto: Peter Martin Associates.

HO 1980 Rosa Ho. *Sherry Grauer...So Far...* . Surrey: Surrey Art Gallery.

HODGE 1974 F.W. Hodge. *Handbook of Indians of Canada*. Toronto: Coles Publishing.

HODGSON 1976 Tom Hodgson. *Creativity is Change*. Toronto: Merton Gallery.

HOGARTH 1972 Paul Hogarth. *Artists on Horseback: The Old West in Illustrated Journalism, 1857-1900*. New York: Watson-Guptill.

HOOD 1974 Robert Hood. *To the Arctic by Canoe, 1819-1821: The Journal and Paintings of Robert Hood, Midshipman with Franklin*. Montréal: McGill-Queen's University Press.

HOVER 1948 Dorothy Hoover. *J W. Beatty*. Toronto: Ryerson Press.

HOPKINS 1898 J. Castell Hopkins, ed. *Canada: Encyclopedia of the Country*. Toronto: Linscott.

HORNUNG 1976 Clarence P. Hornung. *Treasury of American Design*. New York: Harry N. Abrams.

HOULE 1982 Robert Houle. *New Work by a New Generation*. Regina: Norman Mackenzie Art Gallery.

HOUSSER 1929 Frederick B. Housser. *Yearbook of the Arts in Canada 1928-1929*. Toronto: Macmillan.

HOUSSER 1974 F.B. Housser. *A Canadian Art Movement: The Story of the Group of Seven*. Toronto: Macmillan, 1926; reprint ed., Toronto: Macmillan, 1974.

HOUSTON 1967 James A. Houston. *Eskimo Prints*. Barre: Barre Publishers.

HOUSTON 1994 C. Stuart Houston. *Arctic Artist: The Journal and Paintings of George Back, Midshipman with Franklin, 1819-1822*. Montréal: McGill-Queen's University Press.

HOWAT 1972 John K. Howat. *The Hudson River and Its Painters*. New York: Penguin Books.

HUBBARD 1954 R.H. Hubbard. *F. H. Varley: Paintings, 1915-1954*. Toronto: Art Gallery of Ontario.

HUBBARD 1957 R.H. Hubbard, ed. *Catalogue of Paintings and Sculpture, Volume I: Older Schools*. Ottawa: National Gallery of Canada.

HUBBARD 1959 R.H. Hubbard. *Catalogue of Paintings and Sculpture, Volume II: Modern European Schools*. Ottawa: National Gallery of Canada.

HUBBARD 1960 R.H. Hubbard. *Catalogue of Paintings and Sculpture, Volume III: Canadian School*. Ottawa: National Gallery of Canada.

HUBBARD 1960(1) R.H. Hubbard, ed. *An Anthology of Canadian Art*. Toronto: Oxford University Press.

HUBBARD 1963 R.H. Hubbard. *The Development of Canadian Art*. Ottawa: National Gallery of Canada.

HUBBARD 1967 R.H. Hubbard and J.R. Ostiguy. *Three Hundred Years of Canadian Art*. Ottawa: National Gallery of Canada.

HUBBARD 1970 R.H. Hubbard. *Antoine Plamondon 1802-1895, Theophile Hamel 1817-1870, Two Painters of Québec*. Ottawa: National Gallery of Canada.

HUBBARD 1972 (1) R.H. Hubbard. *Thomas Davies c1737-1812*. Ottawa: National Gallery of Canada.

HUBBARD 1972 (2) R.H. Hubbard. *Thomas Davies in Early Canada*. Ottawa: Oberon Press.

HUBBARD 1973 R.H. Hubbard. *Painters of Québec*. Ottawa: National Gallery of Canada.

HUBBARD 1973 (2) R.H. Hubbard. *Canadian Landscape Painting 1670-1930*. Madison: Elvehjem Art Center.

HUBBARD 1977 R.H. Hubbard. *Rideau Hall*. Montréal: McGill-Queen's University Press.

HUBBARD 1989 R.H. Hubbard. *Ample Mansions*. Ottawa: University of Ottawa Press.

HUGHES 1979 Kenneth James Hughes. *Jackson Beardy, Life and Art*. Winnipeg: J.Lorimer.

HULBERT 1929 M. Allen Hulbert. *Sketch of the Activities of the Canadian Handicraft Guild and the Dawn of the Handicraft Movement in the Dominion*. n.p.

HUME 1958 Robert M. Hume. *One Hundred Years of B.C. Art*. Vancouver: Vancouver Art Gallery.

HUNKIN 1971 Harry Hunkin. *There is no Finality ... A Story of the Group of Seven*. Toronto: Burns & MacEachern.

HUNTER 1855 William Stewart Hunter. *Hunter's Ottawa Scenery*. Ottawa: William S. Hunter, Jr.

HUNTER 1857 William Stewart Hunter. *Hunter's Panoramic Guide from Niagara Falls to Québec*. Boston: J.P. Jewett.

HUNTER 1860 William Stewart Hunter. *Hunter's Eastern Townships Scenery*. Montréal: J. Lovell.

HUNTER 1940 E.R. Hunter. *J.E.H. MacDonald: A Biography & Catalogue of His Work*. Toronto: Ryerson Press.

HUNTER 1942 Edmund Robert Hunter. *Thoreau MacDonald*. Toronto: Ryerson Press Canadian Art Series.

HUNTINGTON 1978 Christopher Huntington. *Joe Norris: Paintings and Furniture*. Halifax: Dalhousie Art Gallery.

HUNTINGTON 1984 Christopher Huntington. *Charlie Tanner: Retrospective*. Halifax: Art Gallery of Nova Scotia.

HUYGHE 1964 René Huyghe, ed. *Larousse Encyclopedia of Renaissance and Baroque Art*. London: Hamlyn.

HUYGHE 1980 Rene Huyghe, ed. *Larousse Encyclopedia of Modern Art from 1800 to the Present Day*. London: Hamlyn.

HUYGHE 1981 Rene Huyghe, ed. *Larousse Encyclopedia of Byzantine and Medieval Art*. London: Hamlyn.

I

IBM 1940 *Contemporary Art of Canada and New-foundland: Collection of the International Business Machines Corporation.* Toronto: Canadian National Exhibition.

IHRIG 1978 Bob Ihrig and Tony Urquhart. *Tony Urquhart: Twenty-five years: Retrospective.* Kitchener: Kitchener-Waterloo Art Gallery.

ILLUSTRATED LONDON NEWS Periodical. London, England, 1842-.

IMREDY 1980 Peggy Imredy. *Guide to Sculpture in Vancouver.* Vancouver: D.M. Imredy.

INGLIS 1983 Stephen Inglis. *Something Out Of Nothing, The Work of George Cockayne.* Ottawa: National Museums of Canada.

INSTITUT 1975 *Quebec 75: Arts, 1975.* Montréal: Institut d'art contemporain.

INUIT 1971 *Sculpture/Inuit: Sculpture of the Inuit: Masterworks of the Canadian Arctic.* Ottawa: Canadian Eskimo Arts Council.

INVERARDEN MUSEUM Information from the Inverarden Museum, Cornwall.

INVERARITY 1947 Robert Bruce Inverarity. *Art of the Northwest Coast Indians.* Berkeley, Cal.: University of California Press.

J

JACKSON 1943 A.Y. Jackson. *Banting as an Artist.* Toronto: Ryerson Press.

JACKSON 1948(1) A.Y. Jackson. *Prudence Heward.* Ottawa: National Gallery of Canada.

JACKSON 1948(2) A.Y. Jackson. *Lawren Harris Paintings 1910-1948.* Toronto: Art Gallery of Toronto.

JACKSON 1951 A.Y. Jackson. *Sarah Robertson 1891-1948: Memorial Exhibition.* Ottawa: National Gallery of Canada.

JACKSON 1958 A.Y. Jackson. *A Painter's Country: the Autobiography of A.Y. Jackson.* Toronto: Clarke, Irwin.

JACKSON 1979 Henry Alexander Carmichael Jackson. *Mr Jackson's Mushrooms.* Ottawa: National Gallery of Canada.

JACKSON 1982 A.Y. Jackson. *A.Y. Jackson: The Arctic 1927.* Moonbeam, ON: Penumbra Press.

JANSON 1977 H.W. Janson. *History of Art.* New York: Prentice-Hall.

JARVIS 1962 Alan Jarvis. *David Milne.* Toronto: McClelland & Stewart.

JARVIS 1974 Alan Jarvis. *Douglas Duncan: A Memorial Portrait.* Toronto: University of Toronto Press.

JEFFERYS 1942 C.W. Jefferys. *The Picture Gallery of Canadian History.* Toronto: Ryerson Press.

JEFFERYS 1948 Charles W. Jefferys. *A Catalogue of the Sigmund Samuel Collection of Canadiana and Americana.* Toronto: Ryerson Press.

JENKINS 1925 Jenkins Art Galleries. *Memorial Exhibition of the Paintings of the Late Florence Carlyle ARCA.* Toronto.

JENNESS 1932 Diamond Jenness. *The Indians of Canada.* Ottawa: Department of Mines.

JOHNSON 1975 J.K. Johnson. *Historical Essays on Upper Canada.* Toronto: McClelland & Stewart.

JOHNSTON 1965 William R.M. Johnston. *J. W. Morrice.* Montréal: Montréal Museum of Fine Arts.

JOHNSTON 1969 George Johnston and Carl Schaefer. *Carl Schaefer: Retrospective Exhibition, Paintings from 1926-1969.* Montréal: Sir George Williams University.

JONES 1934 Hugh G. Jones and Edmond Dyonnet. *History of the Royal Canadian Academy of Arts.* Montréal: E. Dyonnet.

JONES 1968 Agnes Halsey Jones. *Hudson River School.* Geneseo, NY: State University College.

JOSEPHY 1970 Alvin M. Josephy. *The Artist Was a Young Man: The Life Story of Peter Rindisbacher.* Fort Worth: Amon Carter Museum.

JOUVANCOURT 1971 Hugues de Jouvancourt. *Cornelius Krieghoff.* Toronto: Musson Book.

JOUVANCOURT 1978(1) Hugues de Jouvancourt. *Suzor-Côté.* Montréal.

JOUVANCOURT 1978(2) Hugues de Jouvancourt. *Maurice Cullen.* Montréal.

JOUVANCOURT 1978(3) Hugues Jouvancourt. *René Richard.* Montréal: Editions La Fregate.

JULIEN 1916 Henri Julien. *Album.* Montréal: Libraire Beauchemin.

K

KALMAN 1994 Harold Kalman. *A History of Canadian Architecture.* 2 vols. Toronto: Oxford University Press.

KANE 1859 Paul Kane. *Wanderings of an Artist Among the Indians of North America.* London: Longman. (numerous reprints)

KANE 1969 *Paul Kane Sketch Pad.* Toronto: Musson.

KANGAS Gene and Linda Kangas. *Decoys: A North American Survey.* Spanish Fork, Utah: Hillcrest Publications.

KAREL 1987 David Karel. *Horatio Walker.* Québec: Musée du Québec.

KARSH 1946 Yousuf Karsh. *Faces of Destiny: Portraits by Karsh.* Chicago: Ziff-Davis.

KARSH 1976 Yousuf Karsh. *Karsh Portraits.* Toronto: University of Toronto Press.

KARSH 1978 Yousuf Karsh. *Karsh Canadians.* Toronto: University of Toronto Press.

KASTEL Information from Galerie Kastel Inc., Westmount.

KEIRSTEAD 1979 James Lorimer Keirstead. *My Art and Thoughts.* Kingston: Hawkins Gallery.

KEIRSTEAD 1991 James Lorimer Keirstead. *Keirstead's Canada.* Glenburnie: Jimbo Saurus Books.

KELLY 1980 Gemey Kelly. *Elizabeth S. Nutt: Heart and Head and Hand: Paintings from Nova Scotia Collections.* Halifax: Dalhousie Art Gallery.

KENNEY 1925 James F. Kenney. *Catalogue of Pictures.* Ottawa: National Archives of Canada.

KERR 1959 J .Lennox Kerr. *Wilfred Grenfell: His Life and Work.* New York: Dodd, Mead.

KILBOURN 1966 Elizabeth Kilbourn. *Great Canadian Painting: A Century of Art.* Toronto: Canadian Centennial Publishing.

KING 1979 J.C.H. King. *Portrait Masks from the Northwest Coast of America.* London: Thames & Hudson.

KINGSTON DAILY NEWS - see *DAILY NEWS.*

KINGSTON GAZETTE Newspaper. Kingston, 1810-1818.

KINGSTON HERALD Upper Canadian Herald. Newspaper. Kingston, c1819-c1840.

KINGSTON WHIG-STANDARD - see *WHIG-STANDARD.*

KOBAYASHI 1985 (1) Terry Kobayashi and Michael Bird. *Folk Treasures of Historic Ontario.* Toronto: Ontario Heritage Foundation.

KOBAYASHI 1985 (2) Terry Kobayashi and Michael Bird. *A Compendium of Canadian Folk Artists.* Erin, ON: Boston Mills Press.

KOZAR 1975 Andrew J. Kozar. *R. Tait McKenzie: The Sculptor of Athletes.* Knoxville: University of Tennessee Press.

KUHNS 1978 William Kuhns. *Sam Borenstein.* Toronto: McClelland & Stewart.

KURELEK 1973 William Kurelek. *Someone With Me: The Autobiography of William Kurelek.* Ithaca, NY: Cornell University.

KURELEK 1980 William Kurelek. *Someone With Me: The Autobiography of William Kurelek.* Toronto: McClelland & Stewart.

KURELEK 1983 William Kurelek and Joan Murray. *Kurelek's Vision of Canada.* Edmonton: Hurtig.

L

LABERGE 1938 Albert Laberge. *Peintres et ecrivains d'hier et d'aujourd'hui.* Montréal: Edition privée.

LABERGE 1945 Albert Laberge. *Journalistes, ecrivains et artistes.* Montréal: Edition privée.

LABERGE 1949 Albert Laberge. *Charles de Belle: peintre-poète.* Montréal: Edition privée.

LACROIX 1978 Laurier Lacroix, Sylvia Antoniou, Victoria Baker, J. Craig Stirling, Janice Seline. *Dessins inedit d'Ozias Leduc / Ozias Leduc the Draughtsman.* Montréal: Galeries d'art Sir George Williams, Concordia University.

LAING 1979 G. Blair Laing. *Memoirs of an Art Dealer.* Toronto: McClelland & Stewart.

LAING 1982 G. Blair Laing. *Memoirs of an Art Dealer 2.* Toronto: McClelland & Stewart.

LAING 1984 G. Blair Laing. *Morrice: A Great Canadian Artist Rediscovered.* Toronto: McClelland & Stewart.

LALIBERTE 1934 Alfred Laliberté. *Légendes-Coutumes, métier de la Nouvelle-France bronzes d'Alfred Laliberté.* Montréal: Librairie Beauchemin.

LALIBERTE 1978 (1) Alfred Laliberté. *Mes Souvenirs.* Montréal: Les Editions du Boreal Express.

LALIBERTE 1978 (2) Alfred Laliberté. *Les Bronzes d'Alfred Laliberté.* Québec: Ministère des Affaires Culturelles.

LALIBERTE 1986 Alfred Laliberté. *Les Artistes de mon temps.* Montréal: Les Editions du Boreal Express.

LANGDON 1960 John Emerson Langdon. *Canadian Silversmiths and Their Marks.* Lunenburg, Vermont: Stinehour Press.

LANGDON 1966 John E. Langdon. *Canadian Silversmiths 1700-1900.* Toronto: By the author.

LANGDON 1968 John E. Langdon. *Guide to Marks on Early Canadian Silver: 18th and 19th Centuries.* Toronto: Ryerson Press.

LANGTON 1904 Anne Langton. *Langton Records, Journals and Letters from Upper Canada 1837-1846 with Portraits and Sketches.* Edinburgh: R.R. Clarke.

LARMOUR 1972 W.T. Larmour. *The Art of the Canadian Eskimo.* Ottawa: Minister of Indian Affairs.

LATOUR 1975 Thérèse Latour. *Art Populaires du Québec.* Québec: Musée du Québec.

LATOUR 1980 Thérèse Latour. *Folk Treasures of Québec.* Québec: Musée du Québec.

LAURETTE 1978 Patrick C. Laurette. *Scottish Painting in Canada.* Halifax: Art Gallery of Nova Scotia.

LAURETTE 1979 Patrick Condon Laurette. *Ellen Gould Sullivan: Hooked Mats.* Halifax: Art Gallery of Nova Scotia.

LAURETTE 1980 (1) Patrick Condon Laurette.

Charles Wm MacDonald. Halifax: Art Gallery of Nova Scotia.

LAURETTE 1980 (2) Patrick Condon Laurette. *Acadia Nova - 15 Artists.* Halifax: Art Gallery of Nova Scotia.

LAURETTE 1980 (3) Patrick Condon Laurette. *Annapolis Valley: Seven Artists 1980.* Halifax: Art Gallery of Nova Scotia.

LAURETTE 1984 Patrick Condon Laurette. *John O'Brien 1831-1891.* Halifax: Art Gallery of Nova Scotia.

LAVALLEE 1968 Gérard Lavallée. *Anciens ornemanistes et imagiers du Canada français.* Québec: Ministère des Affaires culturelles.

LEACOCK 1941 Stephen Leacock. *Canada: The Foundations of its Future.* Montréal: Seagram.

LEADER-POST Newspaper. Regina, c1883-.

LEAVITT 1879 Thad W.H. Leavitt. *History of Leeds and Grenville.* Brockville: Recorder Press.

LEBLANC 1979 Pierre Leblanc. "L'Association des artistes non-figuratifes de Montréal." M.A. Thesis. Université de Montréal.

LEE 1956 Thomas R. Lee. *Albert H. Robinson.* Montréal: By the author.

LEFEBVRE 1972 Germain Lefebvre. *Pellan.* Montréal: Musée du Québec.

LEFEBVRE 1973 Germain Lefebvre. *Pellan.* Toronto: McClelland & Stewart .

LEMIEUX 1974 Irénée Lemieux. *Artistes du Québec.* 2 vols. 1974/1978. Québec: Editions Irénée Lemieux.

LEGGET 1957 Robert Legget. *Rideau Waterway.* Toronto: University of Toronto Press.

LEMOINE 1876 James MacPherson Lemoine. *Québec Past and Present: A History of Québec, 1608-1876, in Two Parts.* Québec: Augustin Coté.

LEMOINE 1882 James MacPherson Lemoine. *A Sequel to Québec Past and Present.* Montréal: Dawson Brothers.

LERNER 1991 Loren R. Lerner and Mary F. Williamson. *Art and Architecture in Canada: A Bibliography and Guide to the Literature to 1981.* 2 vols. Toronto: University of Toronto Press.

LESIEUTRE 1978 Alain Lesieutre. *The Spirit and Splendour of Art Deco.* Secaucus, N.J.: Castle Books.

LESSARD 1971 Michel Lessard and Huguette Marquis. *Encyclopedie des Antiquités du Québec.* Montréal: Les Editions de l'Homme.

LESSARD 1974 Michel Lessard. *Complete Guide to French-Canadian Antiques.* Agincourt, ON: Gage Educational Publishing.

LESSARD 1975 Michel Lessard and Huguette Marquis. *L'Art traditionnel au Québec.* Montréal: Les Editions de l'Homme.

LEVESQUE 1936 Albert Lévesque and Pierre Dagenais. "La Canadienne français et les arts." *Almanache de la langue français.* (1936): 59-69.

LINDBERG 1978 Ted Lindberg. *Toni Onley: A Retrospective Exhibition.* Vancouver: Vancouver Art Gallery.

LIPMAN 1974 Jean Lipman and Alice Winchester. *The Flowering of American Folk Art 1776-1876.* New York: Viking Press.

LIPMAN 1980 Jean Lipman and Tom Armstrong, eds. *American Folk Painters of Three Centuries.* New York: Hudson Hills Press.

LISMER 1926 Arthur Lismer. *A Short History of Painting with a Note on Canadian Art.* Toronto: Andrews Bros.

LISMER 1953 Arthur Lismer. *A.Y. Jackson: Paintings 1902-1953.* Toronto: Art Gallery of Ontario.

LITTLE 1970 William T. Little. *The Tom Thomson Mystery.* Toronto: McGraw-Hill.

LIVINGSTON 1966 John A. Livingston. *Birds of the Northern Forest.* Toronto: McClelland & Stewart.

LIVINGSTON 1968 John A. Livingston. *Birds of the Eastern Forest: 1, Paintings by J.F. Lansdowne.* Toronto: McClelland & Stewart.

LONDON 1964 *Surrealism in Canadian Painting.* London, ON: London Public Library and Art Museum.

LONDON 1978 *Nine Regional Nineteenth Century Artists.* London, ON: London Public Library and Art Museum.

LORD 1974 Barry Lord. *The History of Painting in Canada.* Toronto: NC Press.

LORD 1979 Barry Lord. *Survival Atlantic Style: Works by 16 artists from the Atlantic Provinces.* Halifax: Mount Saint Vincent Art Gallery.

LORNE 1885 Marquis of Lorne. *Canadian Pictures.* London: The Religious Tract Society.

LUCIE-SMITH 1984 Edward Lucie-Smith. *The Thames and Hudson Dictionary of Art Terms.* London: Thames and Hudson.

LUCKYJ 1978 Natalie Luckyj. *Other Realities: The Legacy of Surrealism in Canadian Art.* Kingston: Agnes Etherington Art Centre.

LUMSDEN 1969 Ian G. Lumsden. *New Brunswick Landscape Artists of the 19th Century.* Saint John: New Brunswick Museum.

LUMSDEN 1970 Ian G. Lumsden. *Esther Warkov.* Fredericton: Beaverbrook Art Gallery.

LUMSDEN 1973 Ian G. Lumsden. *The Beaverbrook Gallery Presents Nine New Brunswick Artists.* Fredericton: Beaverbrook Art Gallery.

LUMSDEN 1975 Ian G. Lumsden. *Wallace S. Bird Memorial Collection: An Exhibition of the Works of Artists from Atlantic Canada.* Fredericton: Beaverbrook Art Gallery.

LYMAN 1945 John Lyman. *Morrice.* Montréal: Edi-

tions de l'Arbre.

LYNCH 1980 Colleen Lynch. *The Fabric of Their Lives; Hooked and Poked Mats of Newfoundland and Labrador.* St John's, NF.: Memorial University.

LYNCH 1985 Colleen Lynch. *Helping Ourselves: Crafts of the Grenfell Mission.* St John's: Newfoundland Museum.

M

MCCRACKEN 1947 Harold McCracken. *Frederic Remington, Artist of the Old West.* Philadelphia: n.p.

MCCRACKEN 1957 Harold McCracken. *The Charles M. Russell Book.* New York: Garden City.

MCCRACKIN 1959 Harold McCrackin. *George Catlin and the Old Frontier.* New York: Bonanza Books.

MCCULLOUGH 1959 Norah McCullough. *Folk Painters of the Canadian West.* Ottawa: National Gallery of Canada.

MCCULLOUGH 1966 Norah McCullough. *The Beaver Hall Group.* Ottawa: National Gallery of Canada.

MACDONALD 1925 Adrian Macdonald. *Paul Peel: Canadian Portraits.* Toronto: Ryerson Press.

MACDONALD 1944 Thoreau MacDonald. *The Group of Seven.* Toronto: Ryerson Press.

MACDONALD 1955 T.R. MacDonald. *Albert Robinson: Retrospective Exhibition.* Hamilton: Art Gallery of Hamilton.

MACDONALD 1967 Colin S. MacDonald. *A Dictionary of Canadian Artists.* 7 vols. Ottawa: Canadian Paperbacks.

MACDONALD 1979 J.E.H. MacDonald. *Sketchbook 1915-1922.* Moonbeam, ON: Penumbra Press.

MACDONALD 1980 Thoreau MacDonald. *Note Books.* Moonbeam, ON: Penumbra Press.

MCDOUGALL 1977 Anne McDougall. *Anne Savage: The Story of a Canadian Painter.* Montréal: Harvest House.

MACEWAN 1971 J.W. Grant MacEwan. *Portraits From the Plains.* Toronto: McGraw-Hill.

MCGILL 1980 Jean McGill. *The Joy of Effort: A Biography of R. Tait McKenzie.* Toronto: J. McGill.

MCGILL 1984 Jean S. McGill. *Edmond Morris, Frontier Artist.* Toronto: Dundurn Press.

MACGREGOR 1974 John M. MacGregor. *The Imaginary Portrait, the Work of Hertha Muysson.* Kingston: Agnes Etherington Art Centre.

MCINNES 1950 Graham McInnes. *Canadian Art.* Toronto: Macmillan.

MCKENDRY 1979 (QUILTS) Ruth McKendry. *Quilts and Other Bed Coverings in the Canadian Tradition.* Toronto: Van Nostrand Reinhold.

MCKENDRY 1979 (PHOTOGRAPHY) Jennifer McKendry. *Early Photography in Kingston.* Elginburg, ON: Blake McKendry .

MCKENDRY 1980 Jennifer McKendry. *The Old Kingston Road.* Toronto: Oxford University Press.

MCKENDRY 1983 Blake McKendry. *Folk Art, Primitive and Naïve Art in Canada.* Toronto: Methuen.

MCKENDRY 1984 Blake McKendry. *Four Articles on Folk Art.* Elginburg, ON: Blake McKendry.

MCKENDRY 1987 Blake McKendry. "Folk Art: What Is It?" *Queen's Quarterly* 94 (Winter 1987): 868-887.

MCKENDRY 1988 Blake McKendry. *A Dictionary of Folk Artists in Canada from the 17th Century to the Present with Inclusions of Popular Portrait, Topographical, Genre, Religious and Decorative Artists of the 17th, 18th and 19th Centuries.* Elginburg, ON: Blake McKendry .

MCKENDRY 1993 Jennifer McKendry. *Town and Country Houses: Regional Architectural Drawings from Queen's University Archives.* Kingston: By the author.

MCKENDRY 1995 (1) Jennifer McKendry. *With Our Past Before Us: Nineteenth-Century Architecture in the Kingston Area.* Toronto: University of Toronto Press.

MCKENDRY 1995 (2) Jennifer McKendry. *Weep Not For Me: A Photographic Essay and History of Cataraqui Cemetary.* Kingston: By the author.

MCKENDRY 1996 Jennifer McKendry. *A Guide to Historic Portsmouth Village, Kingston.* Kingston: By the author.

MCKENDRY 1997 Ruth McKendry. *Classic Quilts.* Toronto: Key Porter Books.

MACLACHLAN 1980 Mary Evans MacLachlan and Catherine Judah-Daniel. *The Portrait Sculpture of Doris M. Judah.* Halifax: Mount Saint Vincent University.

MACLAREN 1971 George MacLaren. *The Woodcarvers of Nova Scotia.* Halifax: The Nova Scotia Museum.

MCLEISH 1973 John A.B. McLeish. *September Gale: A Study of Arthur Lismer of the Group of Seven.* Toronto: J.M. Dent & Sons.

MCLENNAN 1918 J.S. McLennan. *Louisbourg from its Foundation.* London: Macmillan.

MCLUHAN 1977 Elizabeth McLuhan. *Contemporary Native Art of Canada: Silk Screens from the Triple K Cooperative, Red Lake Ontario.* Toronto: Royal Ontario Museum.

MCLUHAN 1984 Elizabeth McLuhan and Tom Hill. *Norval Morrisseau and the Emergence of the Image Makers.* Toronto: Art Gallery of Ontario.

MCMANN 1997 Evelyn de R. McMann. *Royal*

Canadian Academy of Arts: Exhibitions and Members, 1880-1979. 2nd ed. Toronto: University of Toronto Press.

MCMICHAEL 1986 Robert McMichael. *One Man's Obsession*. Scarborough: Prentice-Hall.

MCNAIRN 1959 Ian McNairn. *7 West Coast Painters*. Vancouver: University of British Columbia.

MCNAIRN 1963 Ian McNairn, ed. *Lawren Harris Retrospective Exhibition, 1963*. Ottawa: National Gallery of Canada.

MCRAE 1944 D.G.W. McRae. *The Arts and Crafts of Canada*. Toronto: Macmillan.

MACRAE 1963 Marion MacRae. *The Ancestral Roof: Domestic Architecture of Upper Canada*. Toronto: Clarke Irwin.

MACRAE 1975 Marion MacRae and Anthony Adamson. *Hallowed Walls: Church Architecture of Upper Canada*. Toronto: Clarke Irwin.

MACTAVISH 1925 Newton MacTavish. *The Fine Arts in Canada*. Toronto: Macmillan.

MACTAVISH 1938 Newton MacTavish. *Ars Longa*. Toronto: Ontario Publishing.

MAINE ANTIQUE DIGEST Periodical. Waldoboro, Maine.

MAKARIUS 1988 Michel Makarius. *Chagall*. London: Bracken Books.

MARINE MUSEUM Information from the Marine Museum of the Great Lakes, Kingston, ON.

MARKET GALLERY 1984 *Toronto Primitives*. Toronto: Market Gallery.

MARSH 1985 James H. Marsh, ed. *The Canadian Encyclopedia*. 3 vols. Edmonton: Hurtig Publishers.

MARSH 1988 James H. Marsh, ed. *The Canadian Encyclopedia*. 4 vols. 2nd ed. Edmonton: Hurtig.

MARTEAU 1978 Robert Marteau. *L'Oeil ouvert*. Montréal: Editions Quinze.

MARTIN 1974 J. Edward Martin. *Paul Peel, Canadian Artist: A Raisonné*. Ottawa: n.p.

MARTIN 1892 Horace T. Martin. *Castorologia or the History and Traditions of the Canadian Beaver*. Montréal: Wm. Drysdale.

MATINSEN 1980 Hannah E.H. Martinsen. *The Scandinavian Artists Influence on the Canadian Painters in the Group of Seven*. Stockholm, Sweden: Stockholms Universitet.

MARZOLF 1989 Helen Marzolf. *Scottie Wilson: The Canadian Drawings*. Regina: Dunlop Art Gallery.

MASTERS 1987 *Painting in Alberta: The Early Years*. Calgary: Masters Gallery.

MATHER 1973 Eleanor Price Mather. *Edward Hicks, A Peaceable Season*. Princeton: Pyne Press.

MATTIE 1981 Joan I. Mattie. *Folk Art in Canada*. Plattsburgh: Clinton County Historical Museum.

MAURAULT 1929 Olivier Maurault. *Marges d'Histoire: l'art au Canada*. Montréal: Librairie d'Action.

MAURAULT 1940 Olivier Maurault. *Charles de Belle et Georges Delfosse*. Montréal: Archonte.

MAVOR 1913 James Mavor. *Year Book of Canadian Art*. Toronto: Dent.

MAYER 1970 Ralph Mayer. *The Artist's Handbook of Materials and Techniques*. New York: Viking Press.

MAZELOW GALLERY Information from the Mazelow Gallery, Toronto.

MELLEN 1970 Peter Mellen. *The Group of Seven*. Toronto: McClelland & Stewart.

MELLEN 1978 Peter Mellen. *Landmarks of Canadian Art*. Toronto: McClelland & Stewart.

MELLEN 1980 Peter Mellen. *Le Groupe des Sept*. LaPrairie: Marcel Broquet.

MELLORS 1937 Mellors Gallery. *Loan Exhibition of Works by Tom Thomson*. Toronto: n.p.

MELLY 1986 George Melly. *Its All Writ for You: The Life and Work of Scottie Wilson*. London: Thames & Hudson.

MENDEL 1964 Mendel Art Gallery. *The Mendel Collection*. Saskatoon: Mendel Art Gallery.

MENDEL 1977 Mendel Art Gallery. *Selected Saskatchewan Drawings*. Saskatoon: Mendel Art Gallery.

METSON 1981 Graham Metson and Cheryl Lean. *Alex Colville, Diary of a War Artist*. Halifax: Nimbus Publishing .

MIDDLETON 1944 J.E. Middleton. *Canadian Landscape, as Pictured by F.H. Brigden RCA OSA*. Toronto: Ryerson Press.

MIKA 1970 Nick and Helma Mika. *Fun and Profit With Screen Printing*. Belleville, ON: Mika Silk Screening.

MIKA 1987 Nick and Helma Mika. *Kingston: Historic City*. Belleville, ON: Mika Publishing.

MILES 1963 Charles Miles. *Indian and Eskimo Artifacts of North America*. New York: Bonanza Books.

MILLARD 1984 Robert Millard. *Robert Vincent: Selected Works*. Saskatoon: Mendel Art Gallery.

MILLARD 1988 Peter Millard. *Stryjek: Trying the Colors*. Saskatoon: Fifth House.

MILLER 1938 Muriel Miller. *Homer Watson: The Man of Doon*. Toronto: Ryerson.

MILLER 1973 Alfred Jacob Miller. *Braves and Buffalo*. Toronto: University of Toronto Press.

MILLER 1987 Muriel Miller. *George Reid: A Biography*. Toronto: Summerhill Presss.

MILLER 1988 Muriel Miller. *Homer Watson: The Man of Doon*. Toronto: Summerhill Press.

MINER 1946 Muriel Miller Miner. *G.A. Reid: Canadian Artist*. Toronto: Ryerson Press.

MONK 1978 Philip Monk. *Colette Whiten*. London,

ON: London Regional Art Gallery.

MOPPETT 1986 George Moppett. *Robert Newton Hurley: A Notebook*. Saskatoon: Mendel Art Gallery.

MORAY 1990 Gerta Moray. *Mary Pratt*. Toronto: McGraw-Hill Ryerson.

MORGAN 1940 Patrick Morgan. *Exhibition of French Canadian Primitives*. Montréal: Art Association of Montréal.

MORGAN 1976 Wayne Morgan. *Wesley C. Dennis - Eva C. Dennis*. Regina: Dunlop Art Gallery.

MORGAN 1983 W.P.Morgan. *Harold J. Treherne*. Regina: Dunlop Art Gallery.

MORISSET 1936 Gérard Morisset. *Peintres et tableaux*. 2 vols. Québec: Editions du Chevalet.

MORISSET 1941 Gérard Morisset. *Coup d`oeil sur les arts in Nouvelle France*. Québec: n.p.

MORISSET 1943 Gérard Morisset. *Philippe Liébert: ouvrage orné de 24 gravures*. Québec: Gerard Morisset.

MORISSET 1944 Gérard Morisset. *La Vie et l'oeuvre du Frère Luc*. Québec: Medium.

MORISSET 1952 Gérard Morisset. *The Arts in French Canada*. Québec: Musée du Québec.

MORISSET 1952(1) Gérard Morisset, Jean-Marie Gauvreau and André Lecoutey. *L'Art Religieux Contemporain au Canada*. Quebec: L'Université Laval.

MORISSET 1959 Gérard Morisset. *Canadian Portraits of the 18th and 19th Centuries*. Ottawa: National Gallery of Canada.

MORISSET 1959 (ARTS) Gérard Morisset. *The Arts in French Canada*. Vancouver: Vancouver Art Gallery.

MORISSET 1960 Gérard Morisset. *La Peinture traditionnelle au Canada Français*. [Ottawa]: le Cercle du Livre de France.

MORISSET 1964 Gérard Morisset. *Treasures from Québec*. Ottawa: National Gallery of Canada.

MORITZ 1982 Albert Moritz. *Canada Illustrated: The Art of Nineteenth-Century Engraving*. Toronto: Dreadnaught.

MORLEY 1986 Patricia Morley. *William Kurelek*. Toronto: Macmillan.

MORRIS Edmund Morris. *Art in Canada: The Early Painters*. [Toronto 1911 ?].

MORRIS 1965 Jerrold Morris. *On the Enjoyment of Modern Art*. Toronto: McClelland & Stewart.

MORRIS 1969 Jerrold Morris. *Hugh MacKenzie*. Toronto: Jerrold Morris Gallery.

MORRIS 1972 Jerrold Morris. *The Nude in Canadian Painting*. Toronto: New Press.

MORRIS 1980 Jerrold Morris. *100 Years of Canadian Drawings*. Toronto: Methuen.

MOWAT 1973 Farley Mowat and David Blackwood. *Wake of the Great Sealers*. Toronto: McClelland & Stewart.

MULCASTER 1969 Wynona Mulcaster and Thecla Zeeh. *Recent paintings by Allen Sapp*. Saskatoon: Mendel Art Gallery.

MUN Information from Memorial University Art Gallery, St John's, NF.

MURDOCH 1982 Su Murdoch. "'The Wish to Take a Sketch of It' George Hallen and Family." *East Georgian Bay Historical Journal*. 2 (1982): 1-35.

MURRAY 1971 Joan Murray. *The Art of Tom Thomson*. Toronto: Art Gallery of Toronto.

MURRAY 1972 Joan Murray. *Ontario Society of Artists: 100 Years*. Toronto: Art Gallery of Ontario.

MURRAY 1973 Joan Murray. *Impressionism in Canada 1895-1935*. Toronto: Art Gallery of Ontario.

MURRAY 1974 Joan Murray. *Helen McNicoll, 1879-1915: Oil Paintings from the Estate*. Toronto: Morris Gallery.

MURRAY 1975 Joan Murray. *William Blair Bruce*. Oshawa: Robert McLaughlin Art Gallery.

MURRAY 1976 Joan Murray. *The Objective Object*. Oshawa: Robert McLaughlin Art Gallery.

MURRAY 1977 Joan Murray and Dennis Burton. *Dennis Burton Retrospective*. Oshawa: Robert McLaughlin Art Gallery.

MURRAY 1978 Joan Murray. *Ivan Law Carvings*. Oshawa: Robert McLaughlin Gallery.

MURRAY 1978 (2) Joan Murray. *A. J. Casson*. Windsor: Art Gallery of Windsor.

MURRAY 1978 (3) Joan Murray. *Louis de Niverville Retrospective, 1978*. Oshawa: Robert McLaughlin Gallery.

MURRAY 1978 (4) Joan Murray. *The Robert McLaughlin Gallery, Oshawa: Permanent Collection*. Oshawa: Robert McLaughlin Gallery.

MURRAY 1979 Joan Murray. *Painters Eleven in Retrospect*. Oshawa: Robert McLaughlin Gallery.

MURRAY 1979 (2) Joan Murray. *Gordon Raynor Retrospective*. Oshawa: Robert McLaughlin Gallery.

MURRAY 1979 (3) Joan Murray. *Fourteen Artists of the Durham Region*. Oshawa: Robert McLaughlin Gallery.

MURRAY 1980 Joan Murray. *Ivan Eyre Exposition*. Oshawa: Robert McLaughlin Gallery.

MURRAY 1980 (2) Joan Murray. *Twelve Canadian Artists*. Oshawa: Robert McLaughlin Gallery.

MURRAY 1981 Joan Murray. *Good Heavens: Conrad Furey, Lynda Lapeer, Gordon Law, George Steadman*. Oshawa: Robert McLaughlin Gallery.

MURRAY 1981 (2) Joan Murray. *Mary Pratt*. London, ON: London Regional Art Gallery.

MURRAY 1981 (3) Joan Murray. *Canadian Artists of the Second World War*. Oshawa: Robert McLaughlin Gallery.

MURRAY 1981 (4) Joan Murray. *Jock Macdonald's*

Students. Oshawa: Robert McLaughlin Gallery.

MURRAY 1982 Joan Murray. *Foiling Around*. Oshawa: Robert McLaughlin Gallery.

MURRAY 1982 (2) Joan Murray, ed. *The Letters of William Blair Bruce: Letters Home 1859-1906*.Moonbeam, ON: Penumbra Press.

MURRAY 1982 (3) Joan Murray. *Kurelek's Vision of Canada*. Oshawa: Robert McLaughlin Gallery.

MURRAY 1984 Joan Murray, ed. *Daffodils in Winter: The Life and Letters of Pegi Nicol MacLeod, 1904-1949*. Moonbeam, ON: Penumbra Press.

MURRAY 1984 (2) Joan Murray. *The Last Buffalo: The Story of Frederick Arthur Verner: Painter of the Canadian West*. Toronto: Pagurion Press.

MURRAY 1986 Joan Murray. *The Best of Tom Thomson*. Edmonton: Hurtig.

MURRAY 1987 Joan Murray. *The Best Contemporary Canadian Art*. Edmonton: Hurtig.

MURRAY 1988 Joan Murray. *New Sculpture/Montréal*. Oshawa: Robert McLaughlin Gallery.

MURRAY 1993 Joan Murray. *The Best of the Group of Seven*. Toronto: McClelland & Stewart.

MURRAY 1994 Joan Murray. *Tom Thomson: The Last Spring*. Toronto: Dundurn.

MURRAY 1994 (1) Joan Murray. *Northern Lights: Masterpieces of Tom Thomson and the Group of Seven*. Toronto: Key Porter.

MURRAY 1996 Joan Murray. *A Tom Thomson Sketchbook*. Brampton: Art Gallery of Peel.

MURRAY 1996 (1) Joan Murray. *Confessions of a Curator: Adventures in Canadian Art*. Toronto: Dundurn.

MURRAY 1996(2) Joan Murray. *Tom Thomson: Design for a Canadian Hero*. Toronto: Quarry Press.

MURRAY 1997 Joan Murray. *Home Truths: A National Album, from Paul Peel to Christopher Pratt*. Toronto: Key Porter.

MUSEE DU QUEBEC 1975 *Arts Populaires du Québec*. Québec: Musée du Québec.

MUSEE DU QUEBEC 1978 *Les bronzes d'Alfred Laliberté: collection du Musée du Québec: legendes, coutumes, metiers*. Québec: Musée du Québec.

N

NASBY 1978 Judith M. Nasby. *Lillian Freiman: Paintings and Drawings*. Kingston: Agnes Etherington Art Centre.

NASBY 1980 Judith M. Nasby. *The University of Guelph Art Collection*. Guelph: University of Guelph.

NASGAARD 1977 Roald Nasgaard. *Peter Kolisnyk*. Toronto: Art Gallery of Ontario.

NASGAARD 1978 Roald Nasgaard. *Garry Neil Kennedy: Recent Work*. Toronto: Art Gallery of Ontario.

NB MUSEUM 1952 "Early Women Watercolourists in the Maritimes." *New Brunswick Museum Art Bulletin*. (Autumn 1952).

NEEDLER 1958 G.H. Needler. *Early Canadian Sketches by Mrs Jameson*. Toronto: Burns & MacEachern

NESBITT 1929 J. Aird Nesbitt. *A Short Biography of Canada's Oldest Artist, John Hammond, RCA*. Montréal: J.A. Ogilvy's.

NEWCOMBE 1930 W.A. Newcombe. *British Columbia Totem Poles*. British Columbia Provincial Museum of Natural History Report.

NEW ERA 1974 New Era Social Club. *Three Years Later: A Catalogue of British Columbia Artists and Their Work*. Vancouver: New Era Social Club.

NEWLANDS 1979 David L. Newlands. *Early Ontario Potters*. Toronto: McGraw-Hill Ryerson .

NGC Information from the National Gallery of Canada, Ottawa.

NGC 1936 *Group of Seven 1919-1933*. Ottawa: National Gallery of Canada.

NGC 1945 *The Development of Painting in Canada*. Ottawa: National Gallery of Canada.

NGC 1958 *The National Gallery of Canada Presents: 1958-59, Painters Eleven*. Ottawa: National Gallery of Canada.

NGC 1965 *Treasures from Québec*. Ottawa: National Gallery of Canada.

NGC 1981 *Twentieth Century Canadian Painting*. Ottawa: National Gallery of Canada.

NGC 1982 *Artists in Canada, Union List of Artist's Files*. Ottawa: National Gallery of Canada.

NICHOLSON 1970 Edward J. Nicholson. *Brigdens: The First One Hundred Years*. Toronto: Brigdens.

NICOLL 1955 James Nicoll. *Jubilee Exhibition of Alberta Paintings*. Calgary: Calgary Allied Arts Centre.

NMM 1983 Canadian Centre for Folk Culture Studies. *From the Heart, Folk Art in Canada*. Toronto: McClelland & Stewart.

NORTH SHORE ART GALLERY Information from the North Shore Art Gallery, Sydenham, ON.

NORTHWEST 1956 Northwest Institute of Sculpture. *Open Air Sculpture Exhibition*. Vancouver.

NORTON 1977 Bettina A. Norton. *Edwin Whitefield: Nineteenth-Century North American Scenery*. New York: Crown Publishers.

NSA 1923 Nova Scotia Society of Artists. *Annual Exhibition*. 1923-1972.

NUTT 1932 Elizabeth Styring Nutt. "An Incident in the Golden Age of Fine Art in Nova Scotia." *Journal of Education* (Feb 1932): 71-75.

O

O'BRIAN 1981 John O'Brian. *David Milne: The New York Years 1903-1916*. Edmonton: Edmonton Art Gallery.

O'BRIAN 1986 John O'Brian. *Clement Greenberg. The Collected Essays and Criticism*. 4 vols. Chicago: University of Chicago Press.

O'BRIEN 1981 Mern O'Brien. *Early Nova Scotia Quilts and Coverlets*. Halifax: Dalhousie Art Gallery.

OJIBWA 1981 Ojibwa Cultural Foundation. *Anishnabe Mee-Kun: A Circulating Exhibition of Art by Anishnabe Artists of the Manitoulin Island Area*.

OKO 1980 Andrew J. Oko. *T.R. MacDonald, 1908-1978*. Hamilton, ON: Art Gallery of Hamilton.

OKO 1981 Andrew Oko. *The Society of Canadian Painter-Etchers and Engravers in Retrospect*. Hamilton, ON: Art Gallery of Hamilton.

OKO 1984 Andrew Oko. *Canada in the Nineteenth Century: The Bert and Barbara Stitt Family Collection*. Hamilton, ON: Art Gallery of Hamilton.

ONDAATJE 1974 Kim Ondaatje. *Tradition Plus One: Patchwork Quilts from South Eastern Ontario*. Kingston: Agnes Etherington Art Centre.

OROBETZ 1977 Christine Orobetz. *Heritage of Brant*. Brantford, ON: The Art Gallery of Brant.

OSA 1873 Ontario Society of Artists. *Annual Exhibition*. 1873-.

OSBORNE 1970 Harold Osborne, ed. *The Oxford Companion to Art*. Oxford: Oxford University Press.

OSBORNE 1981 Harold Osborne, ed. *The Oxford Companion to Twentieth-Century Art*. Oxford: Oxford University Press.

OSTIGUY 1971 Jean-René Ostiguy. *Un Siècle de peinture Canadienne 1870-1970*. Québec: Les Presses de l'Université Laval.

OSTIGUY 1974 Jean-Rene Ostiguy. *Ozias Leduc*. Ottawa: National Gallery of Canada.

OSTIGUY 1974(1) Jean-Rene Ostiguy. *Ozias Leduc: peinture symboliste et religieuse*. Ottawa: National Gallery of Canada.

OSTIGUY 1975 Jean-Rene Ostiguy. "Albert Dumouchel: peintre-graveur." *National Gallery of Canada Journal* 10 (Nov 1975): 1-8.

OSTIGUY 1982 Jean-Rene Ostiguy. *Modernism in Québec Art, 1916-1946*. Ottawa: National Gallery of Canada.

OUTRAM 1978 Richard Outram and Rebecca Sisler. *The Living Image: Three Contemporary Visions: Barbara Howard, Cecil Richards, Rebecca Sisler*. Toronto: Macdonald Gallery.

OZENFANT 1952 Amedee Ozenfant, translated by John Rodker. *Foundations of Modern Art*. New York: Dover.

P

PAGE 1939 Frank E. Page. *Homer Watson, Artist and Man*. Kitchener: Commercial Printing.

PAIKOWSKY 1978 Sandra R. Paikowski. *Robert Field*. Halifax: Art Gallery of Nova Scotia.

PAIN 1978 Howard Pain. *The Heritage of Upper Canadian Furniture*. Toronto: Van Nostrand Reinhold.

PALARDY 1963 Jean Palardy. *The Early Furniture of French Canada*. Toronto: Macmillan.

PANABAKER 1957 Frank Panabaker. *Reflected Lights*. Toronto: Ryerson Press.

PARSONS 1976 Bruce Parsons. *Atlantic Coast: An Illustrated Journal*. Ottawa: National Gallery of Canada.

PASSFIELD 1982 Robert W. Passfield. *Building the Rideau Canal: A Pictorial History*. Don Mills, ON: Fitzhenry & Whiteside .

PATTERSON 1973 Nancy-Lou Patterson. *Canadian Native Art*. Don Mills, ON: Collier-Macmillan.

PATTERSON 1974 Nancy-Lou Patterson. *Mennonite Traditional Arts*. Kitchener: Kitchener-Waterloo Art Gallery.

PATTERSON 1977 Freeman Patterson. *Photography for the Joy of It*. Toronto: Van Nostrand Reinhold.

PATTERSON 1979 (GERMANIC FLAVOUR) Nancy-Lou Patterson. *A Germanic Flavour*. Kitchener: Kitchener-Waterloo Art Gallery.

PATTERSON 1979 Nancy-Lou Patterson. *Swiss-German and Dutch-German Mennonite Traditional Art in the Waterloo Region*. Ottawa: National Museum of Man.

PATTERSON 1979 (3) Freeman Patterson. *Photography & the Art of Seeing*. Toronto: Van Nostrand Reinhold.

PATTERSON 1985 Nancy-Lou Patterson. *The Language of Paradise: Folk Art from Mennonite and Other Anabaptist Communities of Ontario*. London, ON: London Regional Art Gallery.

PEARSON 1954 Carol Pearson. *Emily Carr as I Knew Her*. Toronto: Clarke, Irwin.

PEDDLE 1983 Walter W. Peddle. *The Traditional Furniture of Outport Newfoundland*. St John's, NF: Harry Cuff Publications .

PENNELL 1919 Joseph Pennell. *Etchers and Etchings*. New York: Macmillan.

PEPPER 1966 Kathleen Daly Pepper. *James Wilson Morrice*. (Preface by A.Y. Jackson). Toronto: Clarke, Irwin.

PERREAULT 1975 Lise Perreault. *La Société d'art contemporaine 1939-1948*. Montréal: Université de Montréal.

PERRY 1970 Madeline Perry. *A Brief History of the Winnipeg Sketch Club*. Winnipeg.

PETERS 1978 Helen Peters. "Sketches From the Colonial Period." Thesis. University of Victoria.

PETERS 1979 Helen Bergen Peters. *Painting During the Colonial Period in British Columbia, 1845-1871.* Victoria: University of Victoria.

PETROV 1980 Petrov Restoration Gallery. *Tomtu H. Roberts: Early Canadian Artist (1859-1938).* Vancouver: Petrov Restoration Gallery.

PHILLIPS 1926 Walter J. Phillips. *The Technique of the Color Woodcut.* Winnipeg: Brown-Robertson.

PHILLIPS 1930 Walter Joseph Phillips. *An Essay on Wood Cuts.* Toronto: Thomas Nelson & Sons.

PHILLIPS 1954 Walter J. Phillips and Frederick Niven. *Colour in the Canadian Rockies.* Toronto: Thomas Nelson & Sons.

PHILLIPS 1978 Carol A. Phillips. *Obsessions, Rituals, Controls: An Exhibition of Sculptural Works.* Regina: Norman Mackenzie Art Gallery.

PICHON 1982 Yann le Pichon. *The World of Henri Rousseau.* New York: Viking Press.

PIERCE 1940 Lorne Pierce. *A Postscript on J.E.H. MacDonald, 1873-1932.* Toronto: Ryerson Press.

PIERCE 1949 Lorne Pierce. *E. Grace Coombs.* Toronto: Ryerson Press.

PIERCE 1987 James Smith Pierce. *From Abacus to Zeus: A Handbook of Art History.* Englewood Cliffs: Prentice-Hall.

PIERS 1914 Harry Piers. *Artists in Nova Scotia.* Nova Scotia Historical Society Collections.

PILOT 1956 Robert Pilot and T.R. MacDonald. *Maurice Cullen 1866-1934.* Hamilton: Art Gallery of Hamilton.

PILOT 1967 Joseph R.Smallwood, ed. *Book of Newfoundland.* (article by Robert W. Pilot, "Memories of My Youth in Newfoundland") St John's: Newfoundland Book Publishers.

PIPER 1981 David Piper, ed. *The Random House Library of Painting and Sculpture.* 4 vols. New York: Random House.

PIPER 1988 Sir David Piper, ed. *Dictionary of Art & Artists.* London: Collins.

PLAYER 1995 John Player. *The Origins and Craft of Antique Tin & Tole.* Brockville: Norwood Publishing.

PLOWMAN 1922 George T. Plowman. *Etching and Other Graphic Arts.* New York: Dodd, Mead.

POCIUS 1978 Gerald L. Pocius. *Traditional Newfoundland Mats: Louise Belbin.* St John's, NF: Memorial University.

POLLOCK 1969 R. Ann Pollack. *Jock MacDonald.* Ottawa: National Gallery of Canada.

POOLE 1984 Nancy Poole. *The Art of London 1830-1980.* London, ON: Blackpool Press.

PORTER 1973 John R. Porter and Leopold Desy. *Calvaires et croix de chemins du Québec.* Montréal: Hurtubise HMH.

PORTER 1978 John R. Porter. *The Works of Joseph Légaré.* Ottawa: National Gallery of Canada.

PORTER 1986 John R. Porter et Jean Belisle. *La Sculpture ancienne au Québec: trois siècles d'art religieux et profane.* Montréal: Editions de l'Homme.

PRICE 1928 F. Newlin Price. *Horatio Walker.* Montréal: Louis Carrier.

PRICE 1930 Frederic Newlin Price. *Ernest Lawson, Canadian-American.* New York: Feragil.

PRICE 1973 Art Price. *A Cross-section of Work by Art Price: Happiness is Where You Find It.* Ottawa: By the author.

PRICE 1979 Ralph and Patricia Price. *'Twas Ever Thus.* Toronto: M.F. Feheley Publishers.

PRINGLE 1890 J.F. Pringle. *Lunenburgh.* Cornwall: Standard Printing House.

PYE 1866 Thomas Pye. *Canadian Scenery, District of Gaspé.* Montréal: John Lovell.

R

RACAR Canadian Art Review/Revue d'art canadienne. Periodical. Universities Art Association of Canada, 1974-.

RADULOVICH 1978 Mary Lou Fox Radulovich et al. *Contemporary Native Art of Canada: Manitoulin Island.* Toronto: Royal Ontario Museum.

RAINVILLE 1946 Paul Rainville. *Exposition de Edmond Dyonnet RCA, Ozias Leduc ARCA, Joseph Saint-Charles ARCA, Elear Soucy.* Québec: Musée du Québec.

RALPH 1892 Julian Ralph. *On Canada's Frontiers.* New York: Harper.

RASKY 1967 Frank Rasky. *The Taming of the Canadian West.* Toronto: McClelland & Stewart.

RAVENHILL 1944 Alice Ravenhill. *A Cornerstone of Canadian Culture: An Outline of the Arts and Crafts of the Indian Tribes of British Columbia.* Victoria: King's Printer.

RCA 1880- Royal Canadian Academy of Arts. *Annual Exhibitions* 1880-.

READ 1994 Herbert Read. *Art and Artists.* London: Thames & Hudson.

READY 1969 Wayne J. Ready. *Early Canadian Portraits.* Ottawa: National Gallery of Canada.

REDEKOP 1979 Magdalene Redekop. *Ernest Thompson Seton.* Toronto: Fitzhenry & Whiteside.

REED 1914 Earl H. Reed. *Etching.* New York: G.P. Putman's Sons.

REID 1922 *Memorial Exhibition of Paintings by Mary Heister Reid ARCA, OSA.* Toronto: Art Gallery of Toronto.

REID 1969 Dennis Reid. *The MacCallum Bequest of Paintings by Tom Thomson and Other Canadian Painters, and the Mr and Mrs H.R. Jackman Gift of the Murals from the late Dr MacCallum's Cottage Painted by Some of the Members of the Group of Seven.* Ottawa: National Gallery of Canada.

REID 1970 Dennis Reid. *The Group of Seven.* Ottawa: National Gallery of Canada.

REID 1971 Dennis Reid. *A Bibliography for the Group of 7.* Ottawa: National Gallery of Canada.

REID 1972 Dennis Reid. *Toronto Painting: 1953-1965.* Ottawa: National Gallery of Canada.

REID 1973 Dennis Reid. *Bertram Brooker.* Ottawa: National Gallery of Canada.

REID 1976 Dennis Reid. *Edwin Holgate.* Ottawa: National Gallery of Canada.

REID 1979 Dennis Reid. *"Our Own Country": Being an Account of the National Aspirations of the Principal Landscape Artists in Montréal and Toronto 1860-1890.* Ottawa: National Gallery of Canada.

REID 1988 Dennis Reid. *A Concise History of Canadian Painting.* Toronto: Oxford University Press.

REID 1990 Dennis Reid. *Lucius R. O'Brien: Visions of Victorian Canada.* Toronto: Art Gallery of Ontario.

REID 1994 Dennis Reid. *Exploring Plane and Contour: the Drawings, Painting, Collage, Foldage, Photo-work, Sculpture and Film of Michael Snow from 1951 to 1967.* Toronto: Art Gallery of Ontario.

RENDER 1970 Lorne E. Render. *Glenbow Collects.* Calgary: Glenbow-Alberta Institute.

RENDER 1971 Lorne E. Render. *A.C. Leighton.* Calgary: Glenbow-Alberta Institute.

RENDER 1974 Lorne E. Render. *The Mountains and the Sky.* Calgary: Glenbow-Alberta Institute.

REWALD 1973 John Rewald. *The History of Impressionism.* New York: Museum of Modern Art.

RIORDON 1982 Bernard Riordon. *Francis Silver.* Halifax: Art Gallery of Nova Scotia.

RIPLEY 1977 S. Dillon Ripley. *Rails of the World, with Forty-one Paintings by J. Fenwick Lansdowne.* Toronto: M.F. Feheley Publishers.

ROBERT 1968 Guy Robert. *Jean Paul Lemieux.* Québec: Editions Garneau.

ROBERT 1970 Guy Robert. *Riopelle.* Montréal: Les Editions de L'Homme.

ROBERT 1973 Guy Robert. *L'Art au Québec depuis 1940.* Montréal: La Presse.

ROBERT 1978 Guy Robert. *Lemieux.* Toronto: Gage.

ROBERT 1978 (2) Guy Robert. *La peinture au Québec depuis ses origines.* Sainte-Adèle: Iconia.

ROBERT 1981 Guy Robert. *Riopelle: chasseur d'images.* Montréal: Editions France-Amerique.

ROBERTS 1983 Kenneth G. Roberts and Philip Shackleton. *The Canoe: A History of the Craft from Panama to the Arctic.* Toronto: Macmillan.

ROBERTSON 1911 J. Ross Robertson, ed. *The Diary of Mrs. John Graves Simcoe.* Toronto: William Briggs.

ROBERTSON 1977 Heather Robertson. *A Terrible Beauty: The Art of Canada at War.* Toronto: James Lorimer.

ROBILLARD 1973 Yves Robillard. *Québec Underground: 1962-1972.* 3 vols. Québec: Mediart.

ROBINSON 1967 Francis W. Robinson. *Catherine Reynolds (c1782-1864): An Early Canadian Artist in Essex County.* Windsor: Willistead Art Gallery.

ROBSON 1932 Albert H. Robson. *Canadian Landscape Painters.* London: The Studio .

ROBSON 1937 (1) Albert H. Robson. *Cornelius Krieghoff.* Toronto: Ryerson Press.

ROBSON 1937 (2) Albert H. Robson. *J.E.H. MacDonald.* Toronto: Ryerson Press.

ROBSON 1937 (3) Albert H. Robson. *Tom Thomson.* Toronto: Ryerson Press.

ROBSON 1938 Albert H. Robson. *Clarence Gagnon.* Toronto: Ryerson Press.

ROBSON 1938 (2) Albert H. Robson. *Paul Kane.* Toronto: Ryerson Press.

ROBSON 1938 (3) Albert H. Robson. *A.Y. Jackson.* Toronto: Ryerson Press.

ROLLASON 1982 Bryan Rollason, ed. *County of a Thousand Lakes: the History of the County of Frontenac 1673-1973.* Kingston: Frontenac County Council.

ROMBOUT 1967 L. Rombout. *John Hammond, RCA, 1843-1939.* Sackville: Owens Art Gallery.

ROMBOUT 1976 Luke Rombout and Peter Malkin. *Gordon Smith.* Vancouver: Vancouver Art Gallery.

RONALD 1983 William Ronald. *The Prime Ministers.* Toronto: Exile Editions.

ROSENBLUM 1982 Robert Rosenblum. *Cubism and Twentieth Century Art.* Englewood Cliffs: Prentice-Hall.

ROSENFELD 1981 Roslyn Margaret Rosenfeld. "Miniaturists and Silhouettists in Montréal 1760-1860." M.F.A. Thesis. Concordia University.

ROSS 1958 Malcolm Ross, ed. *The Arts in Canada.* Toronto: MacMillan.

ROUSSAN 1967 Jacques de Roussan. *Richard Lacroix.* Montréal: Lidec.

ROUSSAN 1968 Jacques de Roussan. *Philip Surrey.* Montréal: Collection Panorama.

ROY 1923 Pierre-Georges Roy. *Les monuments commemoratifs de le province de Québec.* 2 vols. Québec: Commission des monuments historiques.

ROY 1974 Maurice Cardinal Roy. *Le Diocise de Québec 1674-1974.* Québec: Musée du Québec.

RUBIN 1984 William Rubin, ed. *"Primitivism" in 20th Century Art: Affinity of the Tribal and the Mod-*

ern. 2 vols. New York: Museum of Modern Art.

RUSSELL 1970 Paul Russell. *Monuments 70: An Exhibition of Recent Canadian Sculpture.* Toronto: Univesity of Toronto.

RYDER 1953 Huia G. Ryder. *Edward John Russell: Marine Artist.* Saint John: New Brunswick.

RYDER 1967 Huia Ryder. *Arts in New Brunswick, History of Handicrafts.* University of New Brunswick.

S

SAA 1834 Society of Artists & Amateurs. *Catalogue of the First Exhibition.* Toronto: T. Dalton.

SABEAN 1989 John W. Sabean, ed. *J.E.H. MacDonald: The Barbados Journal 1932.* Kapuskasing, ON: Penumbra Press.

SALAMAN 1930 Malcolm C. Salaman. *The New Woodcut.* London: Studio.

SAMUEL 1934 Sigmund Samuel. *The Seven Years War in Canada 1756-1763.* Toronto: Ryerson.

SANTANA 1978 Hubert de Santana. *Danby: Images of Sport.* Toronto: Amberley House.

SAPP 1977 Allen Sapp. *A Cree Life: The Art of Allen Sapp.* Vancouver: J.J. Douglas.

SAPP 1996 Allen Sapp. *I Heard the Drum.* Toronto: Stoddart.

SCHAPIRO 1982 Meyer Schapiro. *Modern Art: 19th and 20th Centuries.* New York: George Braziller.

SCHLEE 1980 Ernst Schlee. *German Folk Art.* Tokyo: Kodanska International.

SCHWARZ 1969 Herbert T. Schwarz. *Windigo.* Toronto: McClelland & Stewart.

SCOTT 1947 Duncan Campbell Scott. *Walter J. Phillips.* Toronto: Ryerson Press.

SCULPTORS 1978 Sculptors Society of Canada. *Sculpture Canada '78 ... Survey of Contemporary Canadian Sculpture (1978).*

SEAVEY 1897 Various authors. Illustrations by J.R.Seavey. *Pen and Pencil Sketches of Wentworth Landmarks.* Hamilton: Spectator.

SEGUIN 1959 Robert-Lionel Séguin. *L'Equipement de la ferme canadienne aux XVIIe et XVIIIe siècles.* Montréal: Libraire Ducharme.

SEGUIN 1963 Robert-Lionel Seguin. *Les Moules du Québec.* Ottawa: Musée National du Canada.

SHACKLETON 1973 Philip Shackleton. *The Furniture of Old Ontario.* Toronto: Macmillan of Canada.

SHADBOLT 1968 Jack Shadbolt. *In Search of Form.* Toronto: McCelland & Stewart.

SHADBOLT 1973 Jack Shadbolt. *Mind's 2: Poems and Drawings.* Toronto: McClelland & Stewart.

SHADBOLT 1979 Doris Shadbolt. *The Art of Emily Carr.* Toronto: Clarke, Irwin.

SHADBOLT 1981 Jack Shadbolt. *Act of Art, The Image-making Process.* Toronto: McClelland & Stewart.

SHADBOLT 1990 Doris Shadbolt. *Emily Carr.* Vancouver: Douglas & McIntyre.

SHAKESPEARE 1975 Mel Shakespeare. *The April Antiques & Folk Art Show.* Uxbridge, ON: By the author.

SHAW 1972 Barbara B. Shaw. *The Village Blacksmith.* Halifax: Nova Scotia Museum.

SHERMAN 1982 Jim Sherman. *Celebration, The Marjorie Larmon Collection.* Windsor: Art Gallery of Windsor.

SHORT 1912 Sir Frank Short. *Etchings and Engravings.* London: Royal Society of Painters-Etchers.

SIBLEY 1913 C. Lintern Sibley. "A. Suzor-Côté, Painter." *The Year Book of Canadian Art 1913.* (1913), 149-157.

SIEBERT 1967 Erna Siebert and Werner Forman. *North American Indian Arts.* London: Paul Hamlyn.

SILCOX 1967 David P. Silcox. *David Milne 1882-1953.* Kingston: Agnes Etherington Art Centre.

SILCOX 1973 David P. Silcox. *Harold Town: The First Exhibition of New Work, 1969-1973.* Oshawa: McLaughlin Gallery.

SILCOX 1982 David P. Silcox and Merike Weiler. *Christopher Pratt.* Toronto: Prentice-Hall.

SILCOX 1996 David P. Silcox. *Painting Place: the Life and Work of David B. Milne.* Toronto: University of Toronto Press.

SIMARD 1975 Cyril Simard. *Artisanat Québecois.* Montréal: Les Editions de l'Homme.

SIMMINS 1961 Richard B. Simmins. *Five Painters from Regina.* Ottawa: National Gallery of Canada.

SIMMINS 1984 Geoffrey Simmins and Michael Parke-Taylor. *Edmund Morris.* Regina: Norman Mackenzie Art Gallery.

SINCLAIR 1979 Lister Sinclair and Jack Pollock. *The Art of Norval Morrisseau.* Toronto: Methuen.

SISLER 1972 Rebecca Sisler. *The Girls: A Biography of Frances Loring and Florence Wyle.* Toronto: Clarke Irwin.

SISLER 1980 Rebecca Sisler. *Passionate Spirits.* Toronto: Clarke Irwin.

SKELTON 1972 Robin Skelton. *The Limners.* Victoria: Pharos Press.

SMALLWOOD 1967 Joseph R. Smallwood, ed. *The Book of Newfoundland.* St John's: Newfoundland Book Publishers.

SMITH 1928 William Smith. *The Evolution of Government in Canada.* (Illustrations by Charles W. Simpson RCA). Ottawa: National Committee of the Diamond Jubilee of Confederation.

SMITH 1968 Frances K. Smith. *Agnes Etherington*

Art Centre Permanent Collection. Kingston: Agnes Etherington Art Centre.

SMITH 1972 Brydon Smith. *Canada: Gershon Iskowitz, Walter Redinger.* Ottawa: National Gallery of Canada.

SMITH 1972 (1) Wilfred I. Smith. *Archives: Mirror of Canada Past.* Ottawa: National Archives of Canada.

SMITH 1972 (2) Ernest W. Smith. *Lawren P. Harris 37/72.* Halifax: Dalhousie Art Gallery.

SMITH 1974 George L. Smith. *Norman Gurd and the Group of 7: A History of the Sarnia Art Movement.* Brights Grove, ON: By the author.

SMITH 1975 (1) Frances K. Smith. *George Cockayne.* Kingston: Agnes Etherington Art Centre.

SMITH 1975 (2) Frances K. Smith. *George Harlow White.* Kingston: Agnes Etherington Art Centre.

SMITH 1979 Frances K. Smith. *Daniel Fowler of Amherst Island.* Kingston: Agnes Etherington Art Centre.

SMITH 1980 Frances K. Smith. *André Biéler: An Artist's Life and Times.* Toronto: Merritt Publishing.

SMITH 1985 Frances K. Smith. *John Herbert Caddy 1801-1887.* Kingston: Agnes Etherington Art Centre.

SMITH 1987 Donald B. Smith. *Sacred Feathers.* Toronto: University of Toronto Press.

SMITH 1988 Frances K. Smith. *André Biéler in Rural Quebec.* Kingston: Agnes Etherington Art Centre.

SMYTH 1840 Coke Smyth. *Sketches in the Canadas.* London: Thomas McLean, 1840; reprinted, Toronto: Charles J. Musson, 1968.

SNIDER 1979 Gregory Snider. *Liz Magor.* Victoria: Art Gallery of Greater Victoria.

SOCIETY 1930 Society of Canadian Painter-Etchers. *William J.Thomson, Canadian Engraver, 1857-1927.* Toronto.

SOUCY 1993 Donald Soucy and Harold Pearse. *The First Hundred Years: A History of The Nova Scotia College of Art and Design.* Fredericton: University of New Brunswick.

SPALDING 1980 Jeffrey Spalding and Peter White. *Tim Zuck: Paintings.* Toronto: Art Gallery of Ontario.

SPENDLOVE 1958 F. St. George Spendlove. *The Face of Early Canada.* Toronto: Ryerson Press.

STACEY 1976 Robert Stacey. *Charles William Jeffreys.* Kingston: Agnes Etherington Art Centre.

STACEY 1989 Robert Stacey. *The View from Tabor Hill: Paintings and Drawings by Glenn Priestley.* Waterloo: University of Waterloo Art Gallery.

STEBBINS 1982 Joan Stebbins. *Irene McCaugherty Watercolours.* Lethbridge: Southern Alberta Gallery.

STEIN 1967 Jess Stein, ed. *The Random House Dictionary of the English Language.* New York: Random House.

STEVENS 1958 Gerald Stevens. *Frederick Simpson Coburn.* Toronto: Ryerson Press.

STEVENSON 1927 Orlando John Stevenson. *A People's Best.* Toronto: Musson.

STEWART 1973 J. Douglas Stewart and Ian E. Wilson. *Heritage Kingston.* Kingston: Agnes Etherington Art Centre.

STEWART 1973 (ARTIFACTS) Hilary Stewart. *Artifacts of the Northwest Coast.* Don Mills, ON: General Publishing.

STOKES 1933 I.N. Stokes and Daniel C. Haskell. *American Historical Prints Etc.* New York: New York Public Library.

STORY 1967 Norah Story. *The Oxford Companion to Canadian History and Literature.* Reprint with corrections 1968. Toronto: Oxford University Press.

SUSAN WHITNEY GALLERY Information from the Susan Whitney Gallery, Regina.

SUTTON 1968 Denys Sutton. *James Wilson Morrice 1865-1924.* Ottawa: National Gallery of Canada.

SWAIN 1976 Robert Swain. *Pertaining to Space: An Exhibition of Works by Robert Sinclair.* Toronto: Art Gallery of Ontario.

SWEENEY 1983 J. Gray Sweeney. *Great Lakes Marine Painting of the Nineteenth Century.* Muskegan, Mich.: Muskegan Museum of Art.

SWINTON 1961 George Swinton. *Five Winnipeg Artists.* Winnipeg.

SWINTON 1965 George Swinton. *Eskimo Sculpture.* Toronto: McClelland & Stewart.

SWINTON 1972 George Swinton. *Sculpture of the Eskimo.* Toronto: McClelland & Stewart.

SYMONS 1971 Scott Symons. *Heritage: A Romantic Look at Early Canadian Furniture.* Toronto: McClelland & Stewart.

T

TARASOFF 1969 Koozma J. Tarasoff. *A Pictorial History of the Doukhobors.* Saskatoon: The Western Producer.

TATE 1938 *A Century of Canadian Art.* London: Tate Gallery.

TEITELBAUM 1987 Matthew Teitelbaum and Peter White. *Joe Fafard: Cows and Other Luminaries_1977-1987.* Saskatoon: Mendel Art Gallery.

TETU 1896 Henri Têtu. *Histoire du palais épiscopal de Québec.* Québec: Pruneau & Kirouak.

TEYSSEDRE 1968 Bernard Teyssedre. *Seven Montréal Artists.* Cambridge Mass: Hayden Gallery.

THAUBERGER 1976 David Thauberger. *Grassroots Saskatchewan.* Regina: Norman Mackenzie Art Gallery.

THEBERGE 1976 Pierre Theberge. *Guido Molinari.*

Ottawa: National Gallery of Canada.

THEBERGE 1979 Pierre Theberge; Rigina Cornwall; Kunstmuseum; Stadische Galerie im Lenbachhaus, Munchen; Rheinisches Landesmuseum, Bonn. *Michael Snow: Works 1969-1978, Films 1964-1976*. Lucerne, Switzerland: Kunstmuseum Luzern.

THIBAULT 1978 Claude Thibault. *Landscape Painting in Québec (1800-1940)*. Québec: Musée du Québec.

THOM 1980 Ian M. Thom. *John Meredith: Drawings, 1957-1980*. Victoria: Art Gallery of Greater Victoria.

THOM 1980 (2) Ian M. Thom. *Jack Shadbolt: Early Watercolours*. Victoria: Art Gallery of Greater Victoria.

THOM 1980 (3) Ian M. Thom. *W.P. Weston*. Victoria: Art Gallery of Greater Victoria.

THOM 1985 Ian M. Thom. *The Cartoons of Arthur Lismer*. Toronto: Irwin Publishing.

THOM 1991 Ian M. Thom, ed. *David Milne*. Vancouver: Douglas & McIntyre.

THOMAS 1972 Ann Thomas. *Notes on the Relationship of Photography and Painting in Canada 1860-1900*. Ottawa: National Gallery of Canada Bulletin.

THOMAS 1979 Ann Thomas. *Canadian Paintings and Photography (1860-1900)*. Montréal: McCord Museum.

THOMAS 1980 Jane Thomas. *Playful Objects*. Edmonton: Alberta Culture.

THORNTON 1966 Mildred Valley Thornton. *Indian Lives and Legends*. Vancouver: Mitchell Press.

THURO 1979 Catherine Thuro. *Primitives & Folk Art: Our Handmade Heritage*. Paducah, Kentucky: Collector Books.

TILNEY 1973 Philip V.R. Tilney. *Artifacts from the CCFCS Collections: Sampling #1*. Ottawa: National Museum of Man.

TIPPETT 1974 Maria Tippett. *Contemporaries of Emily Carr in British Columbia*. Burnaby, BC: Simon Fraser Gallery.

TIPPETT 1977 Maria Tippett and Douglas Cole. *From Desolation to Splendour: Changing Perceptions of the British Columbia Landscape*. Toronto: Clarke, Irwin.

TIPPETT 1979 Maria Tippett. *Emily Carr*. Toronto: Oxford University Press.

TIPPETT 1984 Maria Tippett. *Art at the Service of War: Canada, Art, and the Great War*. Toronto: University of Toronto Press.

TIPPETT 1992 Maria Tippett. *By a Lady: Celebrating Three Centuries of Art by Canadian Women*. Toronto: Penguin Books.

TODD 1978 Patricia Ann Todd. "James D. Duncan (1806-1881); Catalogue of Works." Thesis.

Concordia University.

TOKER 1970 Franklin Toker. *The Church of Notre-Dame in Montréal: an Architectural History*. Montréal: McGill-Queen's University Press.

TONNANCOUR 1944 Jacques G. de Tonnancour. *Roberts*. Montréal: Collection Art Vivant.

TORONTO STAR Newspaper. Toronto, 1892-.

TOVELL 1974 Rosemarie Tovell. *Mountain: A Lithograph by James B. Spencer*. Ottawa: National Gallery of Canada.

TOVELL 1980 Rosemarie L. Tovell. *The Prints of David Milne*. Ottawa: National Gallery of Canada.

TOVELL 1991 Rosemarie Tovell, M. McCauley Allodi and P.N. Moogk. *Berczy*. Ottawa: National Gallery of Canada.

TOWN 1964 Harold Town. *Enigmas/Enigmas/Enigmes*. Toronto: McClelland & Stewart.

TOWN 1969 Harold Town. *Harold Town Drawings*. Toronto: McClelland & Stewart.

TOWN 1977 Harold Town and David P. Silcox. *Tom Thomson*. Toronto: McClelland & Stewart.

TOWNSEND 1970 William Townsend, ed. *Canadian Art Today*. Greenwich, Conn.: New York Graphic Society.

TRAQUAIR 1940 Ramsay Traquair. *The Old Silver of Québec*. Toronto: Macmillan.

TRAQUAIR 1947 Ramsay Traquair. *The Old Architecture of Québec*. Toronto: Macmillan.

TRASK 1978 Deborah E. Trask. *Life How Short, Eternity How Long: Gravestone Carving and Carvers in Nova Scotia*. Halifax: Nova Scotia Museum.

TREMAINE 1952 Marie Tremaine. *A Bibliography of Canadian Imprints 1751-1800*. Toronto: University of Toronto Press.

TRIGGS 1985 Stanley G. Triggs. *William Notman: The Stamp of a Studio*. Toronto: Art Gallery of Ontario.

TROTTER 1937 Reginald Trotter et al, eds. *National Aspects of Contemporary American and Canadian Painting*. Boston: Ginn.

TRUDEL 1967 (PEINTURE) Jean Trudel. *Peinture traditionelle du Québec*. Québec: Ministère des Affaires Culturelles.

TRUDEL 1967 (SCULPTURE) Jean Trudel. *Sculpture traditionelle du Québec*. Québec: Ministère des Affaires Culturelles.

TRUDEL 1969 Jean Trudel. *Profil de la sculpture Québécoise*. Québec: Musée du Québec.

TRUDEL 1974 Jean Trudel. *Silver in New France*. Ottawa: National Gallery of Canada.

TRUDEL 1976 Jean Trudel. *William Berczy: The Woolsey Family*. Ottawa: National Gallery of Canada.

TSA 1847 Toronto Society of Arts. *Exhibition*. 1847 and 1848.

TUELE 1978 Nicholas Tuele. *Sophia Theresa Pemberton, 1869-1959*. Victoria: Art Gallery of Greater Victoria.

TURNER 1960 Brenda Bowman Turner. *The Montréal Museum of Fine Arts*. Montréal: Montréal Museum of Fine Arts.

TWEEDIE 1967 R.A. Tweedie with Fred Cogswell and W. Stewart MacNutt, eds. *Arts in New Brunswick*. Fredericton: University Press of New Brunswick.

TYLER 1982 Ron Tyler, ed. *Alfred Jacob Miller: Artist on the Oregon Trail, with a Catalogue Raisonné*. Fort Worth, Texas: Amon Carter Museum.

TYRWHITT 1968 Janice Tyrwhitt. *Bartlett's Canada: A Pre-Confederation Journey*. Toronto: McClelland & Stewart.

U

UKRAINIAN 1951 Ukrainian Canadian Committee. *Program of the First Ukrainian Display of Fine Arts in Winnipeg*. Winnipeg.

UPPER CANADIAN Periodical. Smiths Falls, ON: 448243 Ontario Inc.

V

VACHON 1973 [G.A.Vachon et al]. *Ozias Leduc et Paul-Emile Borduas*. Montréal: Les Presses de l'Université de Montréal.

VACHON 1985 André Vachon. *Taking Root: Canada from 1700-1760*. Ottawa: National Archives of Canada.

VAILLANCOURT 1920 Emile Vaillancourt. *Une Maitrise d'Art en Canada (1800-1823)*. Montréal: G. Ducharme.

VANEVERY 1967 Jane VanEvery. *With Faith, Ignorance and Delight: Homer Watson*. Doon: Homer Watson Trust.

VARLEY 1980 Christopher Varley. *The Contemporary Arts Society: Montréal 1939-1948*. Edmonton: Edmonton Art Gallery.

VARLEY 1981 Christopher Varley. *F.H. Varley: A Centennial Exhibition*. Edmonton: Edmonton Art Gallery.

VARLEY 1983 Peter Varley. *Frederick H. Varley*. Toronto: Key Porter Books.

VARLEY 1986 Christopher Varley and Barry Fair. *William Nicoll Cresswell (1818-1888): Man From Seaforth*. London, ON: London Regional Art Gallery.

VEZINA 1972 Raymond Vezina. *Cornelius Krieghoff, peintre de moeurs (1815-1872)*. Ottawa: Editions du Pelican.

VIAU 1967 Guy Viau. *Modern Painting in French Canada*. Québec: Department of Cultural Affairs.

VIAU 1971 Guy Viau. *Philip Surrey, le peintre dans la ville*. Montréal: Musée d'art contemporain.

VIE DES ARTS Periodical. La Vie des Arts, Montréal, 1956-.

VIE DES ARTS 1978 *16 Québec Painters in their Milieu*. Toronto: McClelland & Stewart.

W

WADDINGTON Auction catalogues published by Waddington McLean & Co., Toronto.

WADDINGTON 1972 George Waddington. *Gord Smith: Sculptor*. Montréal: Québec Sculptors' Association.

WALTERS 1975 Louise Walters. *Major Saskatchewan Artists*. Saskatoon: Mendel Art Gallery.

WARNER 1984 Glen Warner. *Glen Loates: A Brush with Life*. Toronto: Prentice-Hall.

WAS 1889 Women's Art Association of Canada. *Catalogue of the Exhibition*. Annual 1889-1901. Toronto.

WATSON 1931 William R. Watson. *Maurice Cullen, R.C.A.* Toronto: Ryerson Press.

WATSON 1974 William R. Watson. *Retrospective, Recollections of a Montréal Art Dealer*. Toronto: University of Toronto Press.

WATSON 1977 Jennifer C. Watson and Joan Murray. *Alexandra: A Tribute*. Oshawa: Robert McLaughlin Gallery.

WATSON 1982 Jennifer Watson. *Albert H. Robinson: The Mature Years*. Kitchener: Kitchener-Waterloo Art Gallery.

WAY 1863 Charles Jones Way. *North American Scenery*. Montréal: W. Notman.

WEBSTER 1971 Donald Webster. *Early Canadian Pottery*. Toronto: McClelland & Stewart.

WEBSTER 1977 Judith Webster, ed. *Voices of Canada: An Introduction to Canadian Culture*. Burlington: Association for Canadian Studies in the United States.

WHIG-STANDARD Kingston Whig-Standard. Newspaper. Kingston, 1926-.

WHITE 1988 Peter White. *David Thauberger: Paintings 1978-1988*. Regina: Mackenzie Art Gallery.

WHITEWAY 1952 Louise Whiteway. *History of the Arts in Newfoundland*. Newfoundland Government Bulletin.

WIELAND 1971 Joyce Wieland. *True Patriot Love*. Ottawa: National Gallery of Canada.

WIGHT 1980 Darlene Wight. "Watercolour and Landscape in Early Canada." M A Thesis. Carleton University.

WIGHT 1987 Darlene Wight. *The Swinton Collection of Inuit Art*. Winnipeg: Winnipeg Art Gallery.

WILKIN 1973 Karen Wilkin. *Art in Alberta: Paul Kane to the Present.* Edmonton: Edmonton Art Gallery.

WILKIN 1973 (1) Karen Wilkin. *Chester & Bentham.* Edmonton: Edmonton Art Gallery.

WILKIN 1973 (2) Karen Wilkin. *Dan Christensen: Recent Paintings.* Edmonton: Edmonton Art Gallery.

WILKIN 1974 Karen Wilkin. *The Group of Seven in the Rockies.* Edmonton: Edmonton Art Gallery.

WILKIN 1974 (1) Karen Wilkin. *Canada X Ten.* Edmonton: Edmonton Art Gallery.

WILKIN 1976 Karen Wilkin. *The Collective Unconscious: American and Canadian Art, 1940-1950.* Edmonton: Edmonton Art Gallery.

WILKIN 1976(1) Karen Wilkin. *Changing Visions.* Edmonton: Edmonton Art Gallery.

WILKIN 1979 Karen Wilkin. *Milly Ristvedt-Handerek: Paintings of a Decade.* Kingston: Agnes Etherington Art Centre.

WILKIN 1980 Karen Wilkin. *Painting in Alberta, An Historical Survey.* Edmonton: Edmonton Art Gallery.

WILKIN 1981 Karen Wilkin. *Goodridge Roberts: Selected Works.* Saskatoon: Mendel Art Gallery.

WILKIN 1981(1) Karen Wilkin. *Pierre Gauvreau: the First Decade.* Kingston: Agnes Etherington Art Centre.

WILKIN 1984 Karen Wilkin, ed. *Jack Bush.* Toronto: McClelland & Stewart.

WILKINSON 1981 Alan G. Wilkinson. *Gauguin to Moore: Primitivism in Modern Sculpture.* Toronto: Art Gallery of Ontario.

WILLIAMSON 1970 Moncrieff Williamson. *Robert Harris 1849-1919: An Unconventional Biography.* Toronto: McClelland & Stewart.

WILLIAMSON 1973 Moncrieff Williamson. *Robert Harris (1849-1919).* Ottawa: National Gallery of Canada.

WILLIAMSON 1983 Moncrieff Williamson. *Island Painter: The Life of Robert Harris (1849-1919).* Charlottetown: Ragwood Press.

WILLIS 1842 N.P. Willis. *Canadian Scenery.* London: James S. Virtue.

WILLIS 1967 N.P. Willis. *Canadian Scenery.* Facsimile edition. n.p.: Peter Martin Associates.

WILLSHER 1979 Betty Willsher and Doreen Hunter. *Stones: A Guide to some Remarkable Eighteenth Century Gravestones.* New York: Taplinger.

WILLSON 1911 Beckles Willson. *Catalogue of the Memorial Exhibition of Pictures Left by the Late Henry Sandham, Royal Canadian Academician.* London: Earle Court Exhibition.

WILMERDING 1980 John Wilmerding. *American Light: The Luminist Movement 1850-1875.* Washington: National Gallery of Art.

WILSON 1962 John Francis Wilson. *The Story of the Migration of Skivens and his First Year in Western Canada.* Toronto: Macmillan.

WINNIPEG 1916 Winnipeg Sketch Club. *Annual Exhibition.* Winnipeg, 1916-.

WITHROW 1889 William Henry Withrow. *Our Own Country Canada, Scenic and Descriptive.* Toronto: Briggs.

WITHROW 1972 William Withrow. *Contemporary Canadian Painting.* Toronto: McClelland & Stewart.

WITHROW 1974 William J. Withrow. *Handbook.* Toronto: Art Gallery of Ontario.

WODEHOUSE 1968 R.F. Wodehouse. *Check List of the War Collections.* Ottawa: National Gallery of Canada.

WOLFF 1978 Hennie Wolff, ed. *The Index of Ontario Artists.* Toronto: Visual Arts Ontario.

WOODMAN 1977 Ross Woodman. *Clark McDougall: Paintings Since 1953.* Vancouver: Vancouver Art Gallery.

WOODS 1971 Kathryn Reid Woods. *History of Painters Eleven.* Oshawa: Robert McLaughlin Gallery.

WOODS 1972 Kay Woods. *Painters Eleven, 1953-1959.* Oshawa: Robert McLaughlin Gallery.

WOOLAVER 1996 Lance Woolaver. *The Illuminated Life of Maud Lewis.* Halifax: Nimbus Publishing Limited/Art Gallery of Nova Scotia.

WOWK 1969 Stephanie Wowk. *James Henderson.* Saskatoon: Mendel Art Gallery.

Y

YOUNG Robert Young. *Eastern Canadian Quilts and Hooked Rugs.* Uxbridge: Uxbridge-Scott Historical Society, [n.d.].

YOUNG 1985 Deborah A. Young. *A Record for Time.* Halifax: Art Gallery of Nova Scotia.

Z

ZDUNIC 1981 Grago Zdunic, ed. *Primitive Painting: An Anthology of the World's Naive Painters.* New York: Alpine Fine Arts.

ZEMANS 1981 Joyce Zemans. *Jock Macdonald: The Inner Landscape, A Retrospective Exhibition.* Toronto: Art Gallery of Ontario.

ZEPP 1984 Norman Zepp and Michael Parke-Taylor. *Horses Fly Too.* Regina: Norman Mackenzie Art Gallery